VARIORUM COLLECTED STUDIES SERIES

ISLAMIC VISUAL CULTURE, 1100–1800

The Aga Khan Award for Architecture, award presentation ceremony (Marrakesh, 23–25 November 1986), ready to enlighten architects and decision-makers on the values of history (photo: Gary Otte)

Oleg Grabar

Islamic Visual Culture, 1100–1800

Constructing the Study of Islamic Art, Volume II

ASHGATE
VARIORUM

Published by
Ashgate Publishing Limited
Gower House
Croft Road, Aldershot
Hampshire GU11 3HR
England

Ashgate Publishing Company
Suite 420
101 Cherry Street
Burlington, VT 05401–4405
USA

Ashgate website: http//www.ashgate.com

British Library Cataloguing in Publication Data
Grabar, Oleg
 Islamic visual culture, 1100–1800. – (Constructing the study of Islamic art ; 2) (Variorum collected studies series)
 1. Art, Islamic 2. Architecture, Islamic 3. Islamic antiquities
 I. Title
 709.1'767

Library of Congress Cataloging-in-Publication Data
Grabar, Oleg
 Islamic visual culture, 1100–1800 / Oleg Grabar.
 p. cm. – (Constructing the study of Islamic art; vol. 2)
 (Variorum collected studies series; CS825)
 Includes bibliographical references and index.
 ISBN 0–86078–922–5 (alk. paper)
 1. Art, Islamic. I. Title. II. Collected studies; CS825.

 N6260.G6915 2006
 709'.17'67–dc22 2005053079

ISBN 0 86078 922 5

Typeset by Manton Typesetters, Louth, Lincolnshire, UK and printed and bound in Great Britain by TJ International Ltd, Padstow, Cornwall

VARIORUM COLLECTED STUDIES SERIES CS825

Contents

List of Illustrations

Part One: Objects

Part Two: Art of the Book

VI A Newly Discovered Illustrated Manuscript of the *Maqamat* of Hariri

Preface

Beyond the usual objectives of prefaces to thank those who helped in the preparation of these books and to identify the technical idiosyncrasies of their appearance, this particular preface is also meant to explain and justify these four independent volumes given the general title of *Constructing the Study of Islamic Art, 1954–2004.*

These volumes include eighty-three articles published during a period of half a century. These articles constitute about two thirds of the contributions I made over the years to periodical literature, encyclopedias and collective books of one sort or another (with some exceptions noted below). Almost all book reviews have been eliminated, as have articles which contain major mistakes or which lead to incorrect conclusions without the redeeming value of useful reasoning or of otherwise unavailable data. Chapters or sections in historical or art-historical surveys or in introductions to Islamic culture have been excluded for the most part. Most of these, like those written for volumes 4 and 5 of the *Cambridge History of Iran,* for *The World of Islam* (London, 1976, with many subsequent editions), for the Larousse *Histoire de l'Art* (Paris, 1985), the *Encyclopedia Britannica* (Chicago, 1974), or the *Grove Dictionary of Art* (New York, 1996), are reasonably valid summaries of the state of knowledge at the time of their appearance, sometimes a generation ago. But they are dated by now and make better sense in the context of the volumes in which they appear rather than as contributions to scholarship. And, in any event, nearly all of them are available in most reference libraries.

Just as with any retrospective, there is an element of self-centered vanity for any author or artist to present anew his or her achievements. The usefulness of the task lies, primarily, in making accessible items which were often spread in many different and sometimes inaccessible places and, secondarily, in reflecting the evolution of a field and of a person during decades of many changes in the academic as well as political and cultural spheres. Even this large selection reflects only part of the energies and efforts of a life of learning and of teaching. Large numbers of files, photographs and hand-written notes have been preserved in the archives kept under the names of André and Oleg Grabar at the Getty Research Institute in Los Angeles. Some documents were passed on to former students and colleagues or given to a few institutions in places with restricted facilities for learning or to young scholars who could profit from them immediately. In providing

such gifts, I followed, more modestly, the example of Eric Schroeder (1904–71), curator of Islamic art at the Fogg Museum of Art, Harvard University, who, when he knew that his days were numbered by a fatal disease, passed on to me and to a few other young colleagues some of his books and notes. What he gave me is now, duly inscribed by him, at the Getty Research Institute or in the possession of younger scholars. And there is something soothing in continuing in this manner to preserve the use of resources for scholarship.

The first decision to be made, after selecting the articles to be included, was how to organize them. One way could have been according to the different methodological directions taken by these studies. Such an approach could have been justified by the two directions suggested in a couple of short articles written when I was in my early twenties, which are not included in this selection. One is a precise and detailed presentation of two unusual and until then unpublished bronze coins of the early thirteenth century minted by a minor ruler of the northern Jazirah, the upper Mesopotamian valley now in Turkey; their analysis led to comments on the meaning of the word *sultan* as a title.[1] The other one is the hypothesis that a verse attributed to an Umayyad caliph can explain a very fragmentary painting in the bath of Qusayr 'Amrah, even though there is no reason to believe that the verse or its author had anything to do with the painting.[2] In the first instance, all references are to written or numismatic evidence from the time of the coins involved, in the second one none are (even the verse is only known from a later source), and much of the bibliography deals with arguments around the representation of royal power. The information in the first article has by now been superseded and the second one was incorporated in a later book, *The Formation of Islamic Art*.

Alternately, the articles could have been put in the chronological sequence of their appearance, which would have illustrated the development of an individual's scholarly thinking and interests and the ways in which that thinking and these interests were affected by new information and by changing intellectual fashions. But we finally settled on a compromise: two volumes reflecting the history of the Islamic world and of its art, and two others with a thematic focus.

There is, first, the early Islamic period, these first centuries which transformed an enormous area into a primarily Muslim one. Then there is the Islamic visual culture which overwhelmed these territories and which is still the dominant one from Senegal to the Philippines. But then, no one dealing with Islamic art can avoid explaining to himself or herself and to

[1] "On Two Coins of Muzaffar Ghazi," *American Numismatic Society Museum Notes* 5 (1953).

[2] "The Painting of the Six Kings at Qusayr Amrah," *Ars Orientalis*, 1 (1954).

others what it is that characterizes that art in contrast or as a parallel to other traditions, especially, for the medievalist that I was as a student, to Christian art with many of the same sources. The search for verbal formulas to explain visual phenomena or for the ideological bases of the arts is an endless pursuit that often has to respond to new challenges of thought and of political and cultural events. Furthermore, the unique ways of Islamic art as it formed itself and as it developed lead to important issues of the history and criticism of art. In the late 1970s, I began a long and fruitful association with the Aga Khan Foundation and I was introduced to contemporary activities in art and architecture, as well as in the complex operation of cultural policies. Thus a third volume is devoted to general ideas on Islamic art up to our own time and to the theories derived from it or applied to it. And then, partly by accident, I began my acquaintance with the Islamic world and with the Near East in Jerusalem, and I have devoted much time and effort to understanding its monuments and their meaning over the centuries. A whole volume is devoted to that extraordinary city and it includes one totally new contribution, a lengthy response and reaction to the many works on Jerusalem which have appeared during the past fifteen years.

This division is an interpretation of fifty years of scholarly activities. But I hope that it will be of better use for other scholars than a purely chronological one would have been or the artificial one of various poles of scholarly procedures. Yet it is not entirely possible to separate the shadows of one's scholarly life from one's written accomplishments. For this reason, short introductions to each volume seek to recall the atmosphere surrounding many of the works and especially the people and institutions who over the decades created a context for learning and for growing which is almost impossible to imagine in the academic world of today. For Volume I, I shall introduce the archaeologists and archaeological institutions which helped and inspired me, especially in the 1950s and the 1960s. In Volume II, I shall mention the teaching and research institutions that became my home for nearly forty years and the fascinating evolution that took place in the ways students and colleagues in the United States and elsewhere became involved in the study of Islamic art. For Volume III, I shall sketch out the festival of ideas that accompanied so much of my academic life and some of the non-academic activities which, from the late 1970s, played an important role in the processes of my learning. Finally, when dealing with Jerusalem, I shall sketch the unique circumstances of working in the Holy City during the 1950s and 1960s.

The initial division of the articles was proposed as early as the late 1990s by Professor Cynthia Robinson, who first assisted me in sorting them out. But I had too many other commitments to fulfill at that time and could not manage to concentrate on the project in suitable fashion. Then, in 2001, the Institute for Advanced Study agreed to support the project of a retired professor and the Mellon Foundation provided the funds needed for a full-

time assistant. Mika Natif, a finishing graduate student at the Institute of Fine Arts of New York University, took on the job. She helped in making the final choice of publications to be included, devised and proposed the arrangement of articles found in these volumes, and undertook the tasks of scanning articles published in many different journals into a single format, of gathering illustrations, and, in general, of keeping the project going. Her sharp and critical mind was essential in transforming what could well have become a disorganized exercise into a reasonably coherent whole for future scholars and critics. Without her energy, dedication and commitment, these books could not have been completed and I owe her a deep debt of gratitude for having stuck with the life and works of an older generation than hers. Additional help was gracefully and intelligently provided by Elizabeth Teague, the copy editor, and I am most grateful to her.

Thanks are also due to two institutions. One is the Aga Khan Trust for Culture, which contributed to the publication of these books through ArchNet, a branch of the Aga Khan Program in Architecture at Harvard University and the Massachusetts Institute of Technology. I was involved in the early creation of the program and am grateful to Dr Shiraz Allibhai, manager of the program, and to Dr Luis Monreal, the head of the Trust in Geneva, for having continued to support my work so many years later. The second institution is the Institute for Advanced Study from whose School of Historical Studies I retired in 1998. Two successive directors, Dr Philip Griffith and Dr Peter Goddard, supported all aspects of the work involved in preparing these volumes and in making available to Mika Natif and to me the technical facilities of the Institute and the expertise of its staff in particular Julia Bernheim, who compiled the index. A special word of thanks is due to Rachel Gray, Associate Director of the Institute, through whom all needs and requests were channeled. A last expression of gratitude goes to John Smedley from Ashgate Publishing, who, I suspect, did not quite know what he was getting himself into when he agreed to consider the publication of the eighty-odd articles found in these volumes. His gracious help and patience and the quiet efficiency of Celia Hoare were essential to the completion of the work. The following institutions gave permission to reproduce articles and pictures published under their copyright: Pennsylvania State University Press, Dumbarton Oaks, E. J. Brill, Freer Gallery of Art, Smithsonian Institution, New York University Press, Ukrainian Research Institute, Harvard University, Metropolitan Museum of Art, State University of New York Press, *Israel Exploration Journal*.

A number of editorial decisions were made to ensure consistency across all four volumes, to simplify the task of publishing them, and to facilitate the use of the books. Diacritical marks and macrons were given up altogether. The *hamza* is shown as ' and the *'ayn* as '. The date and place of the original publication of each article are indicated with an asterisk on the first page of each article. All notes are put at the bottom of pages. References to the

original pagination are given in square brackets. Not all original illustrations have been included. Some prints or negatives could no longer be located and scanning or photographing anew a mediocre print seemed senseless. At times substitutions were found and in a few instances original illustrations were simply omitted. Typos were corrected whenever we noticed them and minor emendations were made to the original texts to ensure clarity of expression. Bibliographical notes were not brought up to date, except when works announced in the notes were actually published. I should add that several chapters in this volume complement each other and reuse or modify comparable arguments. We did not try to correlate them to each other.

Acknowledgments

The chapters in this volume were first published as follows:

I "Two Pieces of Metalwork at the University of Michigan," *Ars Orientalis*, 4 (1961), pp. 360–68.

II "Les arts mineurs de l'Orient musulman à partir du milieu du XIIe siècle," *Cahiers de Civilisation Médiévale* (Université de Poitiers, Avril–Juin 1968), pp. 181–90.

III "Trade with the East and the Influence of Islamic Art on the 'Luxury Arts' of the West," *Il Medio Oriente e l'Occidente nell'arte del XIII Secolo*, ed. H. Belting (Bologna, 1982), pp. 27–32.

IV "The Shared Culture of Objects," *Byzantine Court Culture from 829 to 1204* (Washington, DC, 1997), pp. 115–29.

V "*Epigrafika Vostoka*, A Critical Review," *Ars Orientalis*, 2 (1957), pp. 547–60.

VI "A Newly Discovered Illustrated Manuscript of the *Maqamat* of Hariri," *Ars Orientalis*, 5 (1963), pp. 97–109.

VII "Notes on the Iconography of the 'Demotte' *Shah-nama*," *Paintings from Islamic Lands*, ed. R. Pinder-Wilson (London, 1969), pp. 31–47.

VIII "The Illustrated *Maqamat* of the Thirteenth Century: The Bourgeoisie and the Arts," *The Islamic City*, ed. A. Hourani (Oxford, 1970), pp. 207–22.

IX "Pictures or Commentaries: The Illustrations of the *Maqamat* of al-Hariri," *Studies in Art and Literature of the Near East in Honor of Richard Ettinghausen*, ed. Peter J. Chelkowski (Middle Eastern Center University of Utah and New York University Press, 1974), pp. 85–104.

X "About an Arabic Dioskorides Manuscript," *Byzantine East, Latin West: Art-Historical Studies in Honor of Kurt Weitzmann* (Princeton, 1995), pp. 361–3.

XI "Toward an Aesthetic of Persian Painting," *The Art of Interpreting: Papers in Art History* (Pennsylvania State University, 1995), pp. 129–39.

XII "About two Mughal Miniatures," *Damaszener Mitteilungen* (Festschrift Michael Meinecke), 11 (1999), pp. 179–83.

XIII "A Preliminary Note on two 18th century representations of Mekka and Madina," *Jerusalem Studies in Arabic and Islam*, 25 (2001), pp. 268–74.

XIV "The Inscriptions of the Madrasah-Mausoleum of Qaytbay," *Studies in Honour of George Miles*, ed. Dickran K. Kouymjian (American University of Beirut, 1974), pp. 465–8.

XV "Isfahan as a Mirror of Persian Architecture," in R. Ettinghausen and E. Yarshater, eds, *Highlights of Persian Art* (Boulder, 1979), pp. 213–42.

XVI "Reflections on Mamluk Art," *Muqarnas*, 2 (New Haven and London: Yale University Press, 1984), pp. 1–12.

XVII "An Exhibition of High Ottoman Art," *Muqarnas*, 6 (1989), pp. 1–11.

XVIII "The Meanings of Sinan's Architecture," A. Akta-Yasa, ed., *Uluslararasi Mimar Sinan Sempozyomu Bildirileri* (Ankara, 1996), pp. 275–83.

XIX "The Many Gates of Ottoman Art," *Art Turc/Turkish Art*, tenth international Congress of Turkish Art (Geneva, 1999), pp. 19–26.

XX "The Crusades and the Development of Islamic Art," in A. E. Laiou and R. P. Mottahedeh, eds, *The Crusades from the Perspective of Byzantium and the Muslim World* (Washington, 2001), pp. 235–45.

XXI "Islamic Architecture and the West: Influences and Parallels," *Islam and the Medieval West*, ed. Stanley Ferber (Binghamton, 1975), pp. 60–66.

XXII "Patterns and Ways of Cultural Exchange," in V. P. Goss, ed., *The Meeting of Two Worlds* (Kalamazoo, 1986), pp. 441–6.

XXIII "Europe and the Orient: An Ideologically Charged Exhibition," *Muqarnas*, 7 (1990), pp. 1–11.

XXIV "Classical Forms in Islamic Art and Some Implications," *Künstlerischer Austausch: Artistic Exchange, Akten des XXVIII. Internationalen Kongresses für Kunstgeschichte*, Berlin 15–20 July 1992. Herausgegeben von Thomas W. Gaehtgens, pp. 35–42.

XXV "Memorie dell'arte classica nel mondo islamico," S. Settis, ed., *I Greci*, vol. 3 (Turin, 2001), pp. 797–815.

We would like to thank all individuals, publishers and institutions for their permission to reproduce articles and illustrations published under their copyright. Every effort has been made to trace the copyright holders, but if any have been inadvertently overlooked the publisher will be pleased to make the necessary arrangement at the first opportunity.

Introduction

The articles gathered in this second volume of *Constructing the Study of Islamic Art* cover the centuries between the eleventh and the sixteenth that witnessed the development of Islamic art as an original cultural phenomenon in all lands ruled by Muslims. Priority is given to what has, wrongly, been called the Seljuq period in the central lands of the Near and Middle East, from Egypt to Central Asia in the twelfth and early thirteenth centuries. And then there are extensions of what was happening in the Ottoman, Mamluk, post-Mongol Iranian and Mughal worlds of Anatolia, the Balkans, Syria, Egypt, Iran, Central Asia, and even India. The study of illustrated manuscripts predominates over essays on architecture and objects. The reason for this imbalance lies in some of the academic directions I was given as a graduate student at Princeton University and in the many weeks of investigations in the manuscript collections of the Bibliothèque Nationale in Paris, the British Library (then Museum), the Bodleian in Oxford, and the many libraries in Istanbul.

Most of my work in Istanbul took place before the major transformations in the organization of the museums and collections of that city which made everything more accessible and more bureaucratic, but so much less adventurous. In the Süleymaniye library, the one attached to Aya Sofya, or in Ahmet III's pavilion in the Top Kapı Serai museum, I was usually the only reader, occasionally joined by an eccentric gentleman who was or had been an art teacher at Galataseray and claimed to be the only practicing *yogi* in Istanbul. We spoke French and became good friends to the point that he invited me for what I thought was dinner in the house he shared with his mother on a crooked street somewhere beyond Taksim Square, an area that was still a lonely and quiet village in these days. The dinner never materialized, for his real purpose was to make a *yogi* out of me. Having failed all the tests that would have led me to a perfect state of non-being, I decided that it was time to go back to my hotel in Sirkeci, at the other end of town. With some difficulty I liberated myself and in the middle of the night managed somehow to find my way to the recently built Hilton hotel. I did not have enough money to hire a taxi and walked through Istanbul at night. It was lonely and a bit frightening, but a proper enough adventure for a budding scholar of 27 or 28.

All manuscripts were available without any problem except those which were exhibited, fortunately very few from the earlier periods that concerned

me primarily. My searches were helped there by a long list of call numbers given to me by Richard Ettinghausen, then at the Freer Gallery in Washington, about whom I will have more to say further on. I saw the soon-to-become celebrated albums when they were still bound in leather binders and I felt like a youthful explorer in a territory that had hardly been charted and whose magic key was the box of sweets from Haci Bekir which I shared regularly with all the guards and with whoever was in the reading rooms. I managed to obtain microfilms of many of these early illustrated manuscripts from the newly created photographic center at the Süleymaniye. They are now deposited at the University of Michigan, but I fear that half a century of rolled-up existence has not preserved well documents in a technology by now obsolete and on poor-quality film.

The most significant feature of these studies and essays is that, in contrast to the archaeological bent of Volume I, the theoretical considerations of Volume III, and the focus on Jerusalem of Volume IV, they illustrate my involvement with the History of Art in the second half of the twentieth century.

Until the latter part of the century, the art of Islamic lands played an ill-defined role among the concerns of the History of Art. It was ignored by the grand tradition of attributions and interpretations that issued from the study of the Renaissance, southern or northern, except when it occasionally appeared as an "influence" or as a form of exoticism. Nor did it have much to do with the national or post-modernist concerns of those who dealt with Europe or the United States in the nineteenth and twentieth centuries, for these were centuries for which, at least at that time, the uniqueness of the European development of the arts was not questioned. It did, however, become a sort of avocation for three very different groups of scholars and amateurs, often with unusual intellectual pedigrees and idiosyncratic personal histories.

There were, first of all, medievalists and practitioners of the newly established cultural sphere of Late Antiquity who saw in Islamic art either a competing parallel to the Christian art with which they primarily dealt or one of the ends of a long-evolving formal development that issued from classical and Iranian Antiquity. Alois Riegl and Josef Stzygowski in Vienna were the torch-bearers for reflections and investigations that were picked up in a more systematic scholarly form by Meyer Schapiro, Rudi Wittkower, André Grabar, Kurt Weitzmann, Hugo Buchthal, E. Baldwin Smith, Ernst Kantorowitz and Jorgis Baltrusaitis, among others. None of these scholars learned or knew the languages of the Islamic world and none claimed a competent understanding of Islamic culture, but they all felt that their own medieval studies of the arts were incomplete without the presence of the Islamic world.

I was trained and formed by this particular tradition, partly because several among these men were my teachers, but mostly because they

encouraged their students to enter into areas they had only partly investigated and sometimes wished they knew better. Even now, more than half a century later, it is with some emotion that I recall how Baldwin Smith, Kurt Weitzmann and André Grabar, with whom I associated most particularly, encouraged me, because they had the vision of a broad spectrum of history, some of whose components they were not able to handle. The tall, austere, and reserved Baldwin Smith took notes and carefully recorded bibliographical information (these were days before easily available techniques for the preparation of handouts) during my seminar report on Sasanian royal art as well as during another student's report on Mshatta. Kurt Weitzmann encouraged me to study the *Maqamat* illustrations and the Demotte *Shahname* because he thought that these sets of miniatures would demonstrate the global validity of his ways of dealing with manuscript illustrations. I, together with Wen Fong, who was destined for a brilliant career in Princeton and the Metropolitan Museum of Art, were to be the missionaries into Asia of Weitzmann's methods with *Buchwesen*.

Yet, even though I was formed by this art-historical tradition, it was not the tradition that first inspired me. Nor was I inspired by a second tradition consisting of men involved with Islamic art who did not come from the university but either from the making of works of art, particularly but not exclusively the technology of architecture, or from the exciting adventure of collecting. From the time, in the early nineteenth century, of Owen Jones's *Grammar of Ornament* to the creation, in the second half of the century, of the Victoria and Albert Museum in London, the Musée des Arts Décoratifs in Paris, or the Museum für angewandte Kunst in Vienna, institutions and technical experts, the latter often associated with the development of colonial empires in North Africa, Egypt, or India, found in the Islamic world concrete motifs of decoration, techniques for the transformation of surfaces, and architectural forms that were used as exoticisms but could also compel revisions in a Western-oriented history, as with providing an honorable place for ornament next to works of "higher" arts. Whatever aspect of Islamic art was involved, the arts themselves seduced many legitimate and respectable collectors like Henri Vever, Raymond Koechlin and Louis Cartier in France, Wilhelm von Bode and P. Schultz in Germany, Ivan Stchoukine in Russia, Chester Beatty and Basil Robinson in England, David in Denmark, and also more disreputable ones like the Swedish diplomat F. R. Martin who acquired, probably illegally, many treasures from Istanbul libraries, or a French ambassador to Turkey and Iran who obtained a first-rate gathering of Persian painting in the countries in which he served and who took it out of these countries in the diplomatic pouch.

The collecting instinct led to the growth of a highly sophisticated system of dealers who, especially in Iran, toured the countryside, organized excavations of their own, and distributed their finds through shops, often held by their relatives, in Paris, London, or New York. Collecting always

involved money and sometimes deals that were not always legal or proper. But the more repulsive side of collecting, the side which is so clearly opposed to the aims of scholarship, is secrecy. There is a secrecy of information and a secrecy of ownership. The former is intellectually unacceptable because the unwritten code of honor of the academic profession is that knowledge must always be shared and cannot be copyrighted. Secrecy of ownership is equally reprehensible, because it withholds from view some of the most important works of Islamic art and often introduces into research a social and snobbish component which does not belong there. When I was working, at the University of Michigan in Ann Arbor, on the so-called Demotte *Shahname*, which had been split between many collections, some miniatures were simply unavailable for study, because they were in private hands. I was thus refused the possibility of seeing one of these miniatures, which was in the possession of a notable New York family. Once I joined the Faculty at Harvard University, an institution of allegedly higher social prestige, the invitation to see the miniature was extended to me. I refused the offer and only saw the painting once it entered a public collection.

There is still something revolting about all the treasures allegedly, and often actually, kept in the vaults of Swiss banks. The activities that surrounded the break-up of the great sixteenth-century *Shahname* of Shah Tahmasp and the ultimate fate of its miniatures are among the saddest episodes of the fairly recent history of Islamic art. It is sad, even though the exchange of *Shahname* pages for an abstract painting by an American artist on the tarmac of the Vienna airport smacks of comedy rather than of serious scholarly pursuit. An equally disreputable story was spun in the 1950s and 1960s around a Persian manuscript known as the *Andarzname*, whose ninety-odd miniatures were dated to the late eleventh century, which would have made them the earliest example of the Islamic art of the book. The Cincinnati Art Museum had acquired one half of the manuscript, while the other half remained invisible in the hands of a dealer who exhibited it once only in a Paris show of Persian art. All but one of the then specialists in the field thought that the manuscript might well be genuine, but some doubts were slowly creeping in. The dealer who then owned half of the manuscript used the occasion of a Congress of Orientalists in Munich in 1956 or 1957 to gather most of us for a lunch in a fancy restaurant and, in a fiery speech, chided the profession for not trusting its eyes to judge new works of art but preferring the judgment of laboratory technicians. He was right, for, at a later meeting in New York of the Congress for Persian Art, some time in the mid-1960s, Richard Ettinghausen dramatically opened a sealed letter which contained laboratory-made pigment analyses of some five or six miniatures which clearly showed them to be fakes. Whether this judgment should stand for the whole manuscript is still an open question to my mind, although after the time of the New York meeting, I became aware of many doubtful features on pages which had not been analyzed. What is remarkable is that

no one even talks about the manuscript any longer, however interesting the lessons may be which can be drawn from it, even if it turns out to be indeed a forgery.

Possessiveness did occasionally affect public institutions. Edgar Blochet, a serious scholar well versed in Persian and Arabic, even though given at times to wild interpretations, was curator of oriental manuscripts at the Bibliothèque Nationale in Paris. He considered that particular public collection so profoundly his own that his own published catalog of its Persian manuscripts identified each manuscript with a different number from its actual call number. The latter can be found by those who know the system he created within the mass of technical information provided about each manuscript. But his aim was to discourage access to manuscripts by printing false information about them, certainly an immoral procedure. This was no doubt an extreme case, but still now manuscripts in libraries and objects in museums cannot always be studied simply and automatically like a printed book or a periodical in libraries.

It is relatively easy to condemn these secretive practices, especially when they are indulged in and enforced by the bureaucracies that run some public institutions. But it is important to recall that a degree of control over access to precious objects or books is necessitated by the fragility of so many remains from the past. Furthermore, and more importantly, it is the passion of collectors and dealers that preserved so many works of Islamic and other arts. At times, as with ceramics or miniatures, this passion channeled the field in the direction of connoisseurship and attributions that may no longer be fashionable today but that certainly set the tone for research and investigations for a long time. And then passions, even when wrong-headed and improperly restrictive, have certain rights and privileges, because they extol the endless variety of men and women rather than the drab sameness of institutions. Arbitrary restrictions were few in those days, but personal contacts and recommendations played a major role in providing access to often uncataloged and unclassified documents. There is little doubt that, for me, my father's name and reputation were often a password to many institutions.

Collectors and museums provided an approach to the arts which was, possibly still is, perfectly acceptable, but certainly not one I appreciated. A curious episode in which I made the decision not to work in a museum without quite realizing what I was doing occurred some time in the 1950s. I had come to New York to give a lecture, I believe, at the Metropolitan Museum of Art. The then curator or acting curator of Islamic art was Charles Wilkinson, a particularly attractive combination of orientalist archaeologist and connoisseur of beautiful things, who invited me and my wife for dinner at his home, in those days a routine procedure for visiting lecturers. The other guests turned out to be James Rorimer, the Director of the Metropolitan Museum of Art, and his wife. Soon after the exchange of

normal preliminary social vacuities, Rorimer reported to me that he had heard that I was not interested in a museum job. He wondered whether I might not still consider joining the staff of the Metropolitan Museum from which its long-term curator, Maurice Dimand, had retired. I instinctively reacted by saying that I was quite happy in a university and the matter did not go any further. I am sure that, at that time, I had not given any thought to whether I preferred university employment to museums, but I realize now that more experienced administrators were aware of basic differences in attitude and expectations. Once, probably in the late 1960s, I was again approached to consider a museum position, this time in the Louvre. There also, a venerable scholar and collector, Jean David-Weil, had retired. De Gaulle had just appointed as director of all French museums the former head of the French Institute in Beirut, Henri Seyrig, with whom I was well acquainted through my father and through my own work in the Near East. But I did not pursue the matter for reasons that had more to do with my lack of experience with the administrative bureaucracy of French museums than with the job itself. Henri Seyrig, an unusually independent individual who was viscerally immune to bureaucracies, himself did not last very long in his job. The differences between universities and museums were only, to my knowledge, bridged, at that time, by one scholar of Islamic art, Richard Ettinghausen. But, even in his case, the commitment to museums far outstripped his concern with universities.

The third avenue that, in those days, led, or could lead, to the study of Islamic art was the one known, in a very positive way, as Orientalism. Its formative component was the study of languages and cultures or travel and residence in the lands of the Islamic world. Many archaeologists, in the richest and widest ways of the profession, as was the case with Ernst Herzfeld, were formed on that path and some, like Jean Sauvaget, wrote scathingly and rather unfairly about the foibles of art historians when compared to orientalizing archaeologists. A very different kind of of art history came out of the remarkable work of peripatetic architects, who, like André Flandin, Pascal Coste, Max Herz, André Godard, became historians of the arts they encountered in new lands, even if they did not set out to be historians. From Morocco (Henri Terrasse and Georges Marçais) to India (Charles Ferguson and the compilers of the Archaeological Survey of India) or Central Asia (the Circle of Friends of Archaeology in Tashkent), these men recorded what they saw, often visited remote areas (like André Maricq, essentially a philologist and historian with a taste for exotic travel who discovered the still almost inaccessible Jam minaret in Afghanistan), noticed important monuments even when they were not within their sphere of competence (D. Stronach and T. C. Young Jr, both specialists in the ancient Near East who encountered the Kharraqan mausoleums of the eleventh century, now well known to all historians of Islamic architecture), and willy-nilly became historians, at times first-rate

ones. The paragon of this architectural Orientalism was K. A. C. Creswell (1879–1974). His local linguistic talents were limited, but he spent his life in Cairo, traveled from Iraq to North Africa, and certainly shared many of the ethnic and racial prejudices associated with the caricature of the Orientalist. Yet he was devoted to the study of Islamic architecture and knew how to ask help from those who knew languages better than he did. And, as a parallel to Creswell, there was also in Cairo Gaston Wiet, a patriotic veteran of World War I and a good Arabist who became director of the fairly new Museum of Islamic (then Arab) Art. He wrote himself or sponsored others to write many catalogs of objects and was one of two or three standard-bearers of Arabic epigraphy. I knew him well when he became a professor at the Collège de France in Paris and was particularly anxious to help organize the work of younger scholars.

It was some sort of mix of training in general medieval art history under the intellectual guidance of a very special group of original thinkers and of an Orientalism in which other worlds had not yet become the "Other" that directed my first steps in this field. And this is where the striking role of Richard Ettinghausen in my career as well as the peculiarities of my professional life come into play.

All those who knew Richard Ettinghausen remember his tall and lanky body with a sharply defined head that made him look at times like a bird of prey, for instance when he was surveying the wares in a dealer's shop. His gentleness and quiet generosity were also proverbial. He had been formed as an Orientalist. But he came from a family with a great deal of taste for the arts, and he turned at some point to the study of Islamic art. He had learned Arabic first, but then during World War II switched to Persian, partly to teach it within some US government program to develop soldiers with linguistic training. He loved to speak Persian, although specialists were amused by some of his expressions, just as he loved to speak French, in a very old-fashioned European way. But what really happened to him in the late 1930s and 1940s, in New York and later Ann Arbor, was the extraordinary growth of an "eye" that would notice the smallest detail on an object and a memory that could make often unexpected formal, iconographic, or technical connections. His eyes would shine when he described how he discovered the importance and the secrets of a given object, as he does for the Wade Cup in the Cleveland Museum of Art in a film on the collecting of Iranian art in the United States.

Ettinghausen was a friend and colleague of my father and, partly thanks to that, he became for me a mentor rather than a teacher, who taught me a great deal in an unsystematic way, sharing knowledge and information and especially putting me in contact with people, objects, ideas. He particularly enjoyed calling me early in the morning, aware as he was that I slept late, to provide some information on an object we had discussed the day before. It was only much later, after my father's death, that I discovered that he

exercised a sort of beneficent surveillance over my professional life by reporting, in long letters to my father, about the lectures I gave, the ideas we discussed, or even the places where we lived.

Three examples illustrate the kind of relationship I had with Ettinghausen, which was as rare as it was beneficial. The first example took place when I had written what I thought was the final draft of an article on the Dome of the Rock and offered it to Ettinghausen for publication in *Ars Orientalis*. He wrote back that he would be happy to publish the article, but also that the article would be much better if I spent another year on it. In those days, when there was no pressure to publish, I followed his advice and the article as published is still read almost fifty years later, apparently with profit.

Then, second example, several years later I returned from Beirut having acquired a few ceramic objects and fragments of glass for the University of Michigan Art Museum. I was very proud of my acquisitions and showed them to Ettinghausen on the occasion of one of his frequent visits in Ann Arbor. He spent a long time looking at the glass fragments through the magnifying glass he always kept in his pocket. Then, without saying anything, he gave me the fragments and the magnifying glass and asked me what I saw. I answered that I saw very clearly the grooves outlining the design on the glass. He pointed out to me that these lines were perfectly straight, not jagged as they would have been if done manually, and that they were etched with acid, not with a sharp engraving instrument. The design was a contemporary forgery made with acid, while the glass may well have been old. His point was not to emphasize to me my amateurish status, but to show how essential is the observation of details.

And, as a third example, for every one of the trips I organized for graduate students from the University of Michigan to the Freer Gallery in Washington, Richard Ettinghausen prepared selections of fragments from the Freer collection or from his own, nearly all of which had a detail which would "tell" (his favorite verb, just as "missing link" was his favorite definition of a detail or even of a whole object) something about the object. He loved to lead me and the students down the path of mistakes before dramatically revealing the truth. The writings of Richard Ettinghausen, available in a single large volume, are wonderful examples of the highest form of scholarship, creative in imagination and in opening new paths for investigations. There are unfortunately many works of his that remained unfinished at his death, lingering only in the memory of those who heard them as lectures or as items of conversation. Traces of a few of them are found in his letters. He was an unstoppable correspondent and I still cherish the hand-written pages he would send from wherever he took his holidays. Many of my elders in his generation were inveterate letter writers, a habit which no longer exists in our age of telephones and of email.

Until 1989, when I joined the peaceful and quiet Institute for Advanced Study in the woods near Princeton University, I had been involved for

thirty-five years in teaching at two very different institutions, in departments both called then, but no longer now, Departments of Fine Arts.

The University of Michigan had a relatively new department of the History of Art, but it had the distinction of being the first American institution, and for a long time the only one, to have a professor of Islamic art. The post was occupied first by Mehmet Aga-Oglu, a scholar I never met who was from Azerbayjan and trained in Russia and Vienna. Aga-Oglu must have been an energetic and creative scholar, who had to leave the University of Michigan for personal reasons. No one seems to know what happened to what I heard were elaborate archives of Islamic art. He was replaced by Richard Ettinghausen who, in turn, moved to the Freer Gallery in Washington in 1944. No one taught Islamic art there until David Storm Rice in 1953–54, but his personality did not fit easily with the mood of the university at that time. He returned to the School of Oriental and African Studies in London and his departure made it possible for me to be hired at the young age of 25.

The department was a curious amalgam of old and new. There were a few ghosts from times when the department was a minor oasis of visual culture in a university with very different strengths. There was Adelaide Adams, a kind and pleasant woman who taught American art or whatever else needed to be taught and from whom I acquired a complete set of *Ars Islamica*, the only periodical devoted to Islamic art, published by the University of Michigan and by then out of print. There was James Plummer, who learned about Chinese art during his many years in the Chinese Customs Service. His knowledge of Chinese ceramics in particular was immense, but his intellectual horizon was restricted to a simple evolution of all artistic traditions from "primitive" to "decadent." By the time I came to Ann Arbor in 1954, he was already quite deaf and somewhat eccentric. I remember being struck by an incident at a lecture, I assume on Japanese ceramics, by Soames Jenyns, of the British Museum. After Plummer had uttered the appropriate words of praise in introducing the speaker, he sat in the front row and conspicuously turned off the hearing aid hanging on his chest. As I recall it, the lecture was indeed quite dull.

Next to these representatives from another age, there were three very different but equally striking individuals who were the active senior strength of the department. There was Harold Wethey, a specialist in late Renaissance and Baroque art, mostly in Spain; he was a dedicated and hard-working traditional scholar and connoisseur, full of knowledge and rigorous in scholarship, but often pedantic and weak on interpretations, a stickler for rules both in learning and in departmental affairs. There was Max Loehr, a German Sinologist, who had spent the war years in China after years of studying in Munich. He impressed me enormously in relating that he spent seventeen years learning Chinese, Japanese and Sanskrit in order to return to the study of the arts with which he had begun his university life. From the study of prehistoric objects all over northern China and Siberia, he had

turned to Chinese painting and developed a unique approach to the appreciation of the painter's art. Since, during these first years, I had few students of my own, I attended a couple of Max Loehr's seminars and was bathed in totally new ways of seeing paintings. We observed the slides on the screen in total silence before anyone dared to make a comment or to ask a question. We often argued socially and I remember a particular time when I made what I thought was a very cogent argument that an ideal history of art would consist in words alone, without pictures, since a history is a verbal and mental construct. After a few moments of silence, Max Loehr replied that an ideal history of art would consist of details of works of art arranged in such a fashion that evolution or whatever else one wanted to demonstrate would be obvious to anyone and that no words were needed.

The third member of the scholarly faculty was George H. Forsyth Jr, an architect, medievalist and architectural historian. He was a true American aristocrat, tall and handsome, somewhat aloof at first glance, meticulous in his work, a man of enormous generosity of spirit with a vision for the future. He had been brought in from Princeton, where he had studied and taught for many years, in order to create a new and strong department of the history of art. He became one of the last powerful chairmen who used to run American universities. Their departments were their fiefdoms and they saw themselves as providers of funds and support for their vassals, the assistant professors. I was one of those, many of whom came to play an important role in the growth of an American history of art. My position among them was a somewhat privileged one, because of the connection between the University and the Freer Gallery in Washington, because of the University's past history in my area, and because of the existence of a fund for research and publications. George Forsyth understood how important it was to provide for me time to learn the centuries of artistic growth between the Atlantic Ocean and China; he negotiated for me three free semesters during my first four years of teaching which turned out to be of inestimable value in forming my scholarship and teaching.

Two examples of Forsyth's direction stand out in my mind nearly fifty years later. One was an extraordinary six-weeks trip he organized from Beirut to Beirut via Damascus, Palmyra, Baghdad, Mosul, Urfa and Aleppo, and for which he invited a select group of scholars as well as a photographer. He then went to Egypt and Mt Sinai. Out of this trip emerged eventually my excavations at Qasr al-Hayr East in Syria and the Michigan–Princeton expedition to Sinai. There are many stories attached to this trip from a time of relatively easy movement in the Near East, but my main point is the sense George Forsyth had for exploring research possibilities for himself and for others. The other example took place when he and I realized that young American students were not likely to flock to the lessons on Islamic art by a young unknown. He thus proposed that I join the group of instructors taking turns in teaching the general introduction to the History of Art. Not

only did I have to adjust to classes of 200 students after a few years of five or six poor souls, but it was a wonderful occasion to develop that integration of Islamic art into world art which led eventually to the appearance of the field in so many universities.

I should add that such successes as I had were also due to the wonderful group of young men (this was before the appearance of women on the faculties of major universities) who came, sometimes only for a few years, and often shaped a lively and invigorating department, where a full exchange of ideas was possible without professional jealousies, and where everything could be tried. These years of innovation affected also my involvement with young colleagues in a department of Near Eastern Studies developed energetically, if at times haphazardly, by the Assyriologist and Iranist George Cameron and in all departments dealing with Asia or in a budding Center for Middle Eastern Studies which made possible academic and linguistic opportunities impossible at that time to include in traditional departments. Thanks to a grant, I think from the Rockefeller Foundation, five young men under 35 devised a then unique year-long introduction to Asia for undergraduates, in which we all taught all the sections regardless of the areas being covered. In these years of relatively easy access to funds and without worries about tenure or promotion, I could at the University of Michigan develop complex and detailed scholarly searches and find ways to present to the mass of students both the History of Art and the cultures of Asia.

I moved to Harvard in 1969 and joined a department of Fine Arts full of world celebrities, including Max Loehr who had left Michigan a few years before me, and a Department of Near Eastern Languages and Cultures as well as a Center for Middle Eastern Studies that were in the process of rejuvenating their involvement with the Islamic world. Harvard's Department of Fine Arts, better known as the Fogg, was still then the bastion of connoisseurship, a treasure box of magnificent works of art, the guardian of a truly astounding library of books and photographs. But, set as it was in its sedate ways and traditions, it lacked the excitement of the University of Michigan, and much in its organization was falling apart, physically and in a way even spiritually. Much of the following twenty years was spent dealing with practical problems of space and financing which eventually altered completely the looks of the institution and its spirit. What these years meant to me in my maturity can be easily summed up. Access to a wide variety of often first-rate students broadened my conception of my field, as I began to introduce into it other areas than those of the central Near Eastern lands and other periods than the Middle Ages. Then the daily contact with major works of art softened my preference for verbal expression over the sensuality of "things" themselves. And, finally, the association with the Aga Khan Trust, about which I will have more to say in the introduction to Volume III of this series, made me encounter my own times, meet the world of practicing

architects, and begin to reflect on the continuous values of an art I had seen until then as the medieval expression of a neighboring civilization.

For me the curiosity of this large volume has been the contrast between the work done in the 1950s and early 1970s on medieval subjects according to traditional methods of investigation and the articles of the last twenty years, which deal with many more areas and periods and which engage aesthetic as well as historical issues. To what degree these changes are the result of personal evolution or of changes in the expectations of the field, I do not know.

Part One

Objects

Chapter I

Two Pieces of Metalwork at the University of Michigan*[1]

In 1955 the Kelsey Museum of Archaeology at the University of Michigan acquired two pieces of metalwork formerly belonging to M. Sobernheim. One is a brass basin of the Ayyubid period, the other a small Mamluk box. From both objects the silver and gold inlay is almost entirely gone and, as a result, these pieces are not as striking or attractive as a number of well-known thirteenth- and fourteenth-century basins, ewers, boxes, trays, plates and candlesticks. However, the inscriptions and the decorative themes which can be reconstructed are of some interest for the historian of the period.

I. The Ayyubid Basin (Figs A, 1–4)

Both in size (46 cm in diameter and 20 cm in height) and in shape (bowl-like with curved-in rims and a rounded bottom) (Fig. 1), this object belongs to a common enough type in the Ayyubid and Mamluk periods.[2] Its surface is only partially decorated. On the outside a wide band, which has lost all its inlay and parts of which have been rubbed beyond recognition, decorates the upper part of the basin. It is divided into four superposed registers of unequal width. Starting at the top there is first a narrow band consisting of three braided lines. In the intervals there occur vegetal motifs and, at times, whole animals or parts of animals, mostly heads. At times one of the lines widens to the shape of an animal. It is practically impossible to distinguish the exact varieties of animals represented, but there are birds, a number of horned beasts, and, probably,

* First published in *Ars Orientalis*, 4 (1961), pp. 360–68.
[1] I should like to thank Professor E. E. Petersen, Director of the Kelsey Museum of Archaeology, for putting at my disposal the facilities of his museum and for providing me with photographs.
[2] Examples can easily be multiplied; cf. D. S. Rice, "Brasses of Ahmad al-Daki al-Mawsili," *Ars Orientalis*, 2 (1957), pp. 301 ff.; and the same author, "Studies in Islamic Metalwork I," *BSOAS*, 15 (1952), pp. 565 ff., for Mamluk examples.

3

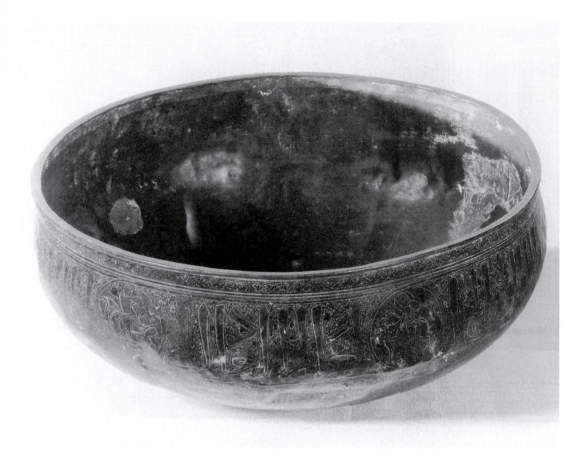

1 The Ayyubid basin

a few female-headed monsters. Below this motif appears a wide band with an [361] inscription. This band is divided into six parts by six medallions. The subject matter of the medallions, largely distinguishable (Fig. 2) in spite of the loss of inlay, belongs to the common iconography of the hunting prince: a rider, accompanied by a dog, about to take his sword out of the sheath; a rider attacking an unidentifiable beast with his sword, while another beast is artfully fitted into the limited area of the medallion behind the rider; a rider attacking an animal behind him; a rider about to strike an animal going in an opposite direction to his; a rider with a dog (or prey?) between the front legs of his horse shooting from a bow; a rider being attacked from the back. The first three scenes appear to be like a "comic strip" of the same event, while the last three illustrate other possible hunting adventures. The figures are set over a geometric spiral pattern probably derived from similar vegetal motifs, but here almost entirely

3 For another example of this special motif see the Fano cup in the Bibliothèque Nationale, D. S. Rice, *The Wade Cup* (Paris, 1955), pl. 15; compare with fig. 37, p. 313, in Rice, "Brasses".

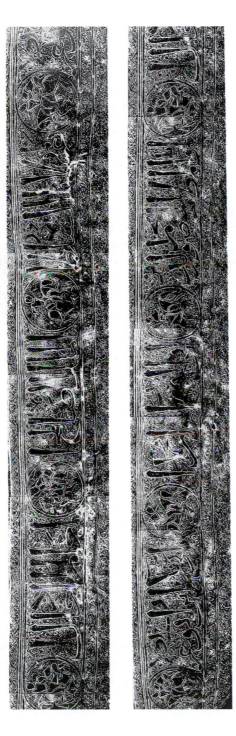

2 The Ayyubid basin

devoid of any vegetal character, except in a few cases where a flower or a leafy motif is apparent in the center of the spiral.³ The scenes themselves are represented quite conventionally. The inscription, which is partly vocalized, is in excellent Ayyubid cursive, and is set over an arabesque motif which, in most places, develops independently from the inscription and not only in the spaces between the letters. Here the arabesque has a much more definitely vegetal character.

Below the inscription is another narrow band, a scroll pattern within which appear animals. These are practically indistinguishable, but most seem to be winged and horned quadrupeds. The last part of the decoration is unframed and consists of an arabesque design comprising interlacing scroll patterns repeating themselves around two axes.⁴ One terminates with three leaves, the other with what may be a horned animal head. The rest of the design is much too damaged to permit more than a very schematic interpretation; it may be that there were animals set amidst the scrolls.

The inscription on the basin reads as follows:

Glory to our lord this sultan al-Malik al-Salih, the wise, the just, the assisted, the victorious, the defeater, Najm al-Din abu al-Fath Ayyub ibn Muhammad ibn abi Bakr ibn Ayyub, may his victory be glorious.

This personage was the last Ayyubid prince to maintain a semblance of control over the vast territory ruled by the Kurdish princes and their vassals. A poor general, but an adept manoeuverer in the complex feudal diplomacy of the time, he is perhaps best known as the husband of Shajar al-Durr, that most extraordinary woman who was, so to speak, the transition between Ayyubid and Mamluk rule. His career carried him all over the Ayyubid realm. From 629/1232 to 635/1238, he was in Diyarbakır and the northern fringes of the Diyar Mudar. In 636/1239 he went to Damascus and the following year to Egypt, where he ruled until his death in 647/1249, trying, generally successfully, to control Palestine and most of southern Syria, and having, through his son and successor, Turanshah, some control [362] over Ayyubid possessions in the Jazirah.⁵ Throughout his reign he was an active builder, and inscriptions commemorating his construction have come to light in Amida-Diyarbakır as well as in Cairo.⁶ Three other pieces of metalwork are known to have been made for him. One is the very well-

4 The structure of the design is comparable to that of the ewer in the Türk ve Islam Müzesi in Istanbul, Rice, "Studies, III," fig. 2.
5 See article "(al-Malik) al-Sâlih Najm al-Din Aiyub," in *Encyclopedia of Islam*, by M. Sobernheim; G. Wiet, *L'Egypte Arabe*, in G. Hanotaux, *Histoire de la nation égyptienne*, vol. 4 (Paris, 1937); and G. Wiet, "Les Biographies des Manhal Safi," in *Mémoires presentés à l'Institut d'Egypte*, vol. XIX (Cairo, 1932), No. 627, with full bibliography.
6 E. Combe, J. Sauvaget, G. Wiet, *Répertoire chronologique d'épigraphie arabe*, vol. II (Cairo, 1942), Nos 4136–4137, 4217–4220, 4223, 4278, 4298–4301.

3 The Ayyubid basin

known d'Arenberg basin, now in the Freer Gallery of Art in Washington, which has never been properly published. The other one is an unpublished basin formerly in the Harari collection. The third one, recently published by Gaston Wiet, is now in the Louvre.[7]

On the outside of our basin are also four graffiti of later owners or users, which may tell us something of the further history of the basin. Two of these inscriptions are perfectly clear:

a (Fig. 4a) For the house of Mukhtar al-Rashidi
b (Fig. 4b) For the *tishtkhanah* of Malik Mansur

The *tishtkhanah* is defined by Quatremère as "un lieu où l'on gardait les étoffes destinées pour l'habillement du sultan, les différentes espèces de pierreries, les cachets, les épées, et autres objets du même genre, et où on

7 Both in *Répertoire*, Nos 4302–4303; Rice, "Brasses," p. 311. The Louvre piece, published by G. Wiet, "Inscriptions Mobilières de l'Egypte Musulmane," *Journal Antique*, 246 (1958), pp. 239 ff.

4a The
Ayyubid basin

4b The
Ayyubid basin

4c The
Ayyubid basin

4d The
Ayyubid basin

lavait les habits."[8] It was, in other words, a vestiary or wardrobe. As to Malik Mansur, he could have been any one of a large number of Ayyubid, Rasulid, or Mamluk princes of that name,[9] including such important figures as Qalawun and Lajin.

The last two inscriptions (Fig. 4 c–d) have been obliterated through the engraving of two horizontal lines and several oblique ones over the original graffito. The first one begins with "for the house." The last word seems to contain the letters "*ainwan*," which could be read as '*unwan*. The *dar 'unwan* may have been the office in which titles were made for official documents, an office of considerable importance in the Mamluk chancery.[10] But, in that case, one would expect the article in front of '*unwan,* and it is perhaps more likely that we deal simply with a proper name ('Imran?). The second obliterated inscription has defied my attempts at interpretation. The last word seems to be *al-turbah.* The first one may be *qa'ah.* This might possibly mean a specific "hall or pavilion of the grave" if the inscription refers to a locale in a Mamluk or Ayyubid palace, or else the name of some shop. But the reading here is very doubtful and the interpretations of the last two inscriptions cannot be more than suggestions so long as such graffiti are not gathered and studied as a body instead of individually. The only safe conclusion we can draw from the graffiti of the University of Michigan basin is that, at least for a while, this basin was kept in one and perhaps even two "offices" of the Ayyubid and, more likely, Mamluk administration. At some [363] date it passed into the possession of some individual by the name of Mukhtar al-Rashidi.[11]

The inside of this basin is much barer than the outside. It is only at the bottom that a very complex design appears (Fig. 3). Its complexity is further heightened by the complete loss of inlay. The main part of the decoration consists of a wide medallion. It is surrounded by an unframed arabesque motif, quite similar to, and simpler and clearer than, the one on the outer part of the basin. The intersections of the scrolls are held together by alternating rings and heads. It is the central motif which is the most original feature of the basin and it is most unfortunate that it has been so badly damaged, since it was probably a most striking design. The drawing, Figure A, is an attempt to suggest the main lines of the organization of the decoration. The only addition made is that of facial features in order to emphasize the position of the motifs. There is some justification for this addition, beyond

8 M. Quatremère, *Histoire des Sultans Mamlouks*, I (Paris, 1857), p. 162, n. 40; one may note that the word derives from *tasht* which means "basin," probably of the type here described.

9 See G. Wiet, *Biographies sub Malik Mansur.*

10 W. Björkman, *Beiträge zur Geschichte der Staatskanzlei im islamischen Ägypten* (Hamburg, 1928); see '*unwan* in index.

11 There were many individuals of the name of Mukhtar in Mamluk times (cf. G. Wiet, *Biographies*), but none is mentioned with the surname al-Rashidi.

A The Ayyubid
basin

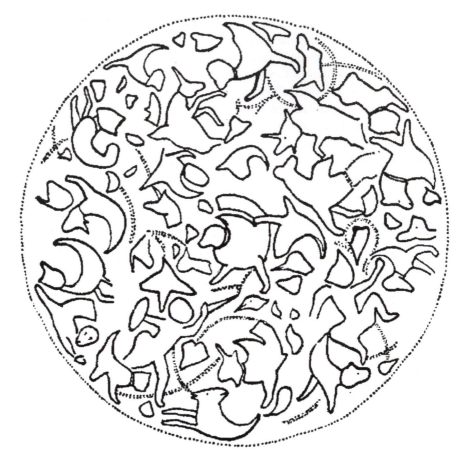

the desire for clarity, since complete surviving examples of comparable types clearly show that eyes, nose and mouth were generally indicated.

It has proved impossible to define a logical system in the web of stems, here and there punctuated by leaves, which occur between the main elements of decoration. It would rather seem that there was no clear independent pattern of scrolls or arabesques, but that scrolls and stems were used as simple fill-ins. In this the system of decoration inside the bowl is less advanced than the pattern found on the outside. The disparity indicates that the object should be considered as a transitional one between the group of metalwork with arabesques as fill-ins and the group with independent arabesques.[12]

The subject matter of the medallion is a group of animals and human beings, with animals largely predominating. The center of the composition is occupied by a type of bird-headed(?) monster with two paws and a long tail curving upward, a motif going back to the Sasanian *senmurv*. Roughly

[12] See the rough scheme of development of backgrounds suggested by Rice, "Seasons and Labors of the Months," *Ars Orientalis*, 1 (1954), pp. 25–6.

two rows of figures surround it. These rows are not clearly separated from each other and many a figure serves rather as a transition from one area to the other. The first row, nearer to the central beast, and the narrower one of the two, consists essentially of animal heads, among which one can distinguish a bird, a unicorn, a horse, a rabbit, and one or two bovines or mountain goats. One full animal, probably a variety of the female-headed monster, occurs there too. Most of these figures show stems originating from their necks or mouths, but not leading anywhere. The second and wider row also contains animal heads, but they are used more sparsely, generally simply as fill-ins between [364] more complete figures. These seem to have been used in two ways: the majority of the figures along the edge of the design are parallel to the edge, while the ones farther from the edge are larger and more or less perpendicular to it. Insofar as they can be made out, these figures, five of which are fairly well outlined, were variations on the *karkadann-unicorn* motif[13] and two of them are images of human beings. One shows a running man with a knife in one hand and a shield in the other, a fairly common hunting posture.[14] The other personage is seated with out-stretched knees and appears to be gesticulating. While the first figure seems to be bare-headed, the second may have worn a cap or a crown, since one end of the top of his head is slightly pointed. I cannot determine the exact type of activity in which he was involved. As to the figures on the near edge of the design, insofar as their outline can be clearly ascertained, they seem to consist almost exclusively of variations on the theme of the walking or lying griffin or of winged bovines.

This design in the center of the basin shows several characteristics which are common enough in Islamic decoration of the period, but which are rarely combined into one pattern. The circular organization of a pattern in the center of an object occurs throughout the Islamic world of the thirteenth century.[15] The use of human and animal forms – either complete or partial – in a decorative way and without prejudice as to possible symbolism (outside of the well-known examples of "animated" writing) occurs, long before Islam, in the Pazyryk finds[16] and, in medieval times, from Khorasan to the Mediterranean, in works made both for Muslims and for Christians.[17] The

13 R. Ettinghausen, *The unicorn* (Washington, 1950), pls 1–6, especially canteen 41.10 in the Freer Gallery, where very similar motifs occur.

14 See, for instance, the personages in the "animated" script of the Fano cup, Rice, *Wade Cup*, fig. 28; or of the Wade Cup, ibid., fig. 19 (esp. upper image, extreme left). Also Rice, "Studies, III," pl. 6.

15 Rice, "Studies, III," pp. 235 ff.; *Wade Cup*, pp. 12 ff.; see also R. Ettinghausen's comments, "The Wade Cup," *Ars Orientalis*, 2 (1957), pp. 341 ff., where many additional examples are brought up.

16 S. I. Rudenko, *Kultura Naseleniia Gornovo Altaia* (Moscow, 1953), fig. 60 ff.

17 A few Islamic examples bearing directly on our basin: D'Arenberg basin, *Ausstellung von Meisterwerken Muhammedanischer Kunst in München*, vol. 2 (Munich, 1912), pl. 147; there mythical animals like those of our plate occur on the narrow friezes, while

specific animals found on our pattern are also quite common.[18] Where [365] the motif of the Kelsey Museum basin differs from most known examples is in the apparent lack of symmetry, axiality and repetition of the units of decoration (which is quite different from what appears either on the arabesque design around the medallion or on the outside of the basin) and in the apparent lack of relation between the animals and the vegetal arabesque. The absence of symmetry is pointed up by comparison with the somewhat later Rasulid tray in the Metropolitan Museum which uses quite similar animals. In the relationship of the animals to the arabesque, our motif differs from the d'Arenberg basin made for the same prince and from the usual "animated" arabesque. The only work to show a very similar design, although smaller in size and in a less central position, is the "canteen" with Christian subjects in the Freer Gallery of Art; there we meet with the same animals, real and fantastic, the same general organization without symmetry or repetition and without a coherent web of stems.[19]

We can see then that with its "animated" arabesque on the outside and with its medallion inside, the basin in the Kelsey Museum of Archaeology, although severely mutilated, is of considerable interest. The question arises

patterns with stems and animal or human heads appear on medallions; a Rasulid tray in the Metropolitan Museum, M. S. Dimand, "Unpublished metalwork of the Rasulid Sultans," *Metropolitan Museum Studies*, 3 (1931), pp. 231 ff., fig. 3; drawing by Rice in "Brasses," p. 292, which shows the same animals, but arranged very symmetrically and in more logical relation to the arabesque design; E. Kühnel, "Zwei Mosulbronzen," *Jahrbuch des preussischen Kunstsammlungen*, 60 (1939), fig. 10; A. U. Pope, ed., *A Survey of Persian Art* (New York, 1939), pl. 1331, which shows also a very large medallion with a motif made up of animals and human beings; little symmetry is shown and there is no coherent arabesque system, but the individual elements are of a very small size and the "whorl" effect is striking. For Christian examples, see especially Armenian works: G. Goian, *2,000 let armianskovo teatra*, vol. 2 (Moscow, 1952), figs 23, 66–7, color pl. 2; S. Der Nersessian, *Armenia and the Byzantine Empire* (Cambridge, 1945), pls 24–5; J. Strzygowski and M. von Berchem, *Amida*, Heidelberg, 1910, fig. 313. It is interesting to note that the closest parallel to our motif is found on three medallions of the Eumorfopoulos "canteen," now in the Freer Gallery of Art in Washington, M. S. Dimand, "A silver inlaid bronze canteen," *Ars Islamica*, 1 (1934), p. 171, since, just as the d'Arenberg basin, the canteen shows Christian subjects.

18 Most of them will be found in the objects mentioned above. Since al-Malik al-Salih had governed at Amida, it may be worthwhile mentioning that winged monsters and bovines of all types are quite common among the sculptures of Amida and northern Mesopotamia in general. See Strzygowski and van Berchem, *Amida*, figs 31, 38, 42, and 300 ff., for stucco fragments in Istanbul said to have come from Amida; A. Gabriel, *Voyages archéologiques dans la Turquie Orientale* (Paris, 1940), pls 68 and 68 bis; Rice, "Studies, V," pp. 210–11. Other unpublished fragments remain in the Diyarbakır Museum and in a room of the *madrasa* of Sultan 'Isa in Mardin. Some very close monumental motifs appear also farther north, at Sivas, and should perhaps be connected with contemporary or earlier Armenian and Georgian examples; see, for instance, A. Gabriel, *Monuments turcs d'Anatolie*, II (Paris, 1934), pl. 58.

19 The Louvre piece does not seem to use animal motifs for decorative purposes, and its splendid central design is much more symmetrical than ours, although not perfectly so. I should like to thank Prof. G. Wiet and M. Jean David-Weil for providing me with photographs of the object.

whether it is possible to assign it to a specific area and to date it. In the case of Najm al-Din Ayyub, localization and dating are connected questions, since he ruled first in northern Mesopotamia and then in Syria and Egypt. If by comparison with other objects of his time one can establish a coherent stylistic sequence, the earlier objects may be attributed to Diyarbakır and the northern part of the Diyar Mudar. If, on the other hand, certain objects of his time show affinities with the art of northern Jazirah, then they might be considered as early in his reign.

The formulary of the inscription on the basin does not help, since all the known inscriptions of Ayyub bear the titles and epithets found on our object. One point, however, is borne out by a comparison of inscriptions: that the d'Arenberg basin belongs to the last years of Ayyub's reign, since the basin and late Cairene inscriptions give the Ayyubid the title of *khalil amir al-mu'minin,* while the other and earlier inscriptions have other titles in *amir al-mu'minin.* But since our basin does not have any caliphal title, this particular point cannot lead to dating it securely and one would need a complete publication of the Harari, Louvre and d'Arenberg brasses and a comparison with the undated Freer "canteen" in order to suggest a stylistic development within which the Kelsey Museum basin can be fitted. This is a task which is beyond the scope of the present publication. The following remarks, however, might be made. The shape of our basin is, as we mentioned, typical of Ayyubid and early Mamluk works. The organization of the decoration, with only an inscription on the outside and a complex design in a limited area inside, is also more typical of early Mamluk works[20] than of the usual piece of metalwork, especially of the so-called Mosul group, in the first half of the thirteenth century.[21] The Freer "canteen" has been generally attributed to a Syrian workshop. If one adds to [366] these points that the subsequent history of the basin seems to have been Egyptian, it could be suggested that the Syro-Egyptian area was the place of manufacture of the object and that it should be dated late rather than early during the rule of Najm al-Din Ayyub.

On the other hand, the specific elements of the decoration show very clearly the impact of northern Mesopotamia and of the so-called Mosul school. This in itself would not be an argument for assigning the object to that area, as D. S. Rice has pointed out in a recent contribution,[22] inasmuch as our closest parallels have been works which are generally claimed to have been made under the influence of the "Mosul" school, but not in Mosul itself. Some of the animal motifs on the basin could perhaps be related to

[20] Rice, "Studies, I," pls 6–8; Wiet, *Cuivres,* pls 37, 42, 45, etc.

[21] There are, of course, exceptions, as Rice, "Studies, III," but the Türk ve Islam Müsezi ewer dated in 627/1229 is of an "ordinary," not royal, type (p. 232), while the Bologna brass bowl was made for a simple officer, not for a ruling prince, and is out of the ordinary in many respects.

[22] "Brasses," in *Ars Orientalis,* 2, pp. 319 ff.

the region of Diyarbakır. Relationship with Christian subjects need not always point to Syria and Mosul, but may also be the result of contacts made farther north along the Tigris and the Euphrates. Furthermore, the roughness and vigor of the central pattern differentiates it sharply from the organized sophistication of works such as the d'Arenberg basin, other Syro-Egyptian objects, and the later Rasulid plate in the Metropolitan Museum. The basin could be attributed to a provincial center influenced by Mesopotamia and in contact with Christian currents. The region of Amida could well be such a center.

Allowance must be made, however, for the fact that in as complex a period as the first half of the thirteenth century it may be adventurous even to try to establish a proper sequence of styles. The movements of princes and of artisans from one place to the other could easily have led to the simultaneous existence of several different styles in the same area, while the *nouveau riche* culture of many a Kurdish or Turkish prince could well have resulted in the revival of older styles and ideas – a revival which is evidenced in other media – or in the experimentation with new motifs or with themes developed outside of the normal metalwork tradition. If at all possible, a more definitive localization and date should await the publication of the d'Arenberg basin and a fuller understanding of the origins of Ayyubid decorative motifs.

II. The Mamluk Box (Figs 5–6)

The second object acquired by the Kelsey Museum is a rectangular brass box with curved edges, 27 cm in length, 7.5 cm in width and 6 cm in height. The silver inlay has completely disappeared from the top of the box (Fig. 5), where the decoration consisted of a simple narrow scroll pattern along the edge and of an inscription in two parts set between three medallions in the middle. The two side medallions have empty centers – probably a space set aside for a blazon – and a motif of flying birds over an arabesque design around them. The central medallion is similarly organized but bears a decoration of flowers instead of birds. Both birds and flowers were common in the Mamluk period.[23] More inlay has remained on the decoration around the body of the box. There we have another inscription divided by eight medallions. The medallions have a common six-armed swastika in the middle[24] and alternating bird and flower patterns around the swastika. Some of the swastikas seem to have been inlaid with gold instead of silver. A third inscription is found in a cartouche inside the box. Its inlay has remained almost entirely. [367]

23 Wiet, *Cuivres*, pls 4, 6, 15, 37, etc.
24 Rice, "Studies, I," p. 565, pl. 8.

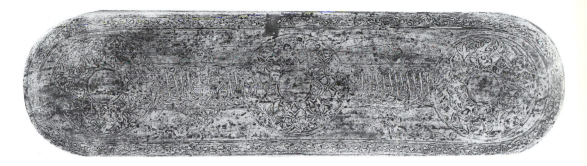

(a) Inscription around the box:

The noble and high Excellency (*maqarr*) our Lord, the Great Amir, the Ghazi, the Warrior for the Faith, the Defender of the Frontiers, the Warden of the Marches, the Helper, the Treasure, the Shelter, the Administrator, the Royal, the Amir Sharaf al-Din, the Chamberlain, (the former slave) of al-Malik al-Nasir.

(b) Inscription on top of the box:

The high Excellency (*maqarr*) our Lord the Amir Sharaf al-Din Musa, the Chamberlain, of al-Nasir.

(c) Inscription inside the cover:

The high Excellency (*janab*), our Lord, the Great Amir, the Ghazi, the Warrior for the Faith, the Defender of the Frontiers, Sharaf al-Din, the Amir Chamberlain, of al-Malik al-Nasir.

The person for whom this box was made can be identified as Sharaf al-Din Musa ibn al-Azkashi.[25] The text of the *Manhal* has this to say about him:

Musa ibn al-Azkashi, the amir Sharaf al-Din, was one of the captives of Sultan Hasan.[26] His whole life was spent as an *amir*. He fulfilled a number of official functions, among which were that of chamberlain (*hajib*) in Egypt and that of *ustadar*. He also ruled over a large number of districts. Then he was appointed counsellor of state (*mushir al-dawlah*). He was exalted in offices of state. He used to ride in great majesty and with his household. When he rode, one of his *mamluks* used to carry behind him an ink-bottle and a sand box. After the death of al-Malik al-Ashraf Sha'ban, his power declined a little and he became one of the group of *amirs* of the *tablkhanat* (of the drums) until his death in his house at al-Husayniyah on the 16th of *dhu al-qai'dah* in 780. He had been respectable, pious, temperate, noble, kindly to the learned and to the righteous. May God have mercy upon him.[27]

5 The Mamluk box

25 Wiet, *Biographies*, p. 384, No. 2551. Taghribirdi, *al-Nujum al-Zahirah*, ed. W. Popper, V (Berkeley, 1933–36), p. 337.

26 His full name was Malik Nasir abu al-Ma'ali Hasan ibn Muhammad; hence the *maliki Nasiri* of our inscription.

27 Since I did not have at my disposal a manuscript of the *Manhal*, I used a copy made by Sobernheim of the text of fols 372 a–b of vol. 3 of the Cairo manuscript, inasmuch as the Paris manuscript is incomplete and, in particular, has no reference to our man.

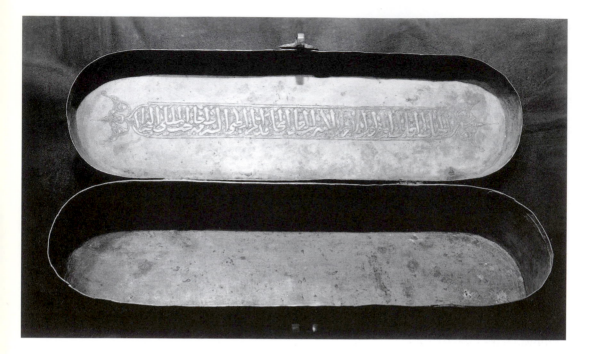

6 The Mamluk box

Little else is known about his life, except that he was involved a number of times in palace intrigues.[28] It is not possible to give a precise date to the object under discussion. It must have been made before the death of [368] Sha'ban in 778/1377, since after that Musa was in partial disgrace. He appears already as *ustadar* and *hajib* in 762,[29] although he seems to have lost the former office, at least for a short while, in 763. It would be to a period when Musa was only *hajib* that we would have to attribute the box, but the texts are insufficient to determine the date. All one can say is that it was made during a period extending from some time before 762 to 778. It is a period from which a great number of objects have remained[30] and the box described here is quite typical of the time. Its main interest is in reviving the memory of one of the thousands of *amirs* who were at the same time the main support and the source of decay of the Mamluk state, whose individual historical importance was secondary, but whose processions through the streets of Cairo preceded by drummers and followed by slaves (future *amirs*) carrying symbols of office, such as perhaps this box, were an everyday occurrence and, next to mosques and mausoleums, one of the most characteristic forms of "conspicuous consumption" in their fast and often precarious lives.

28 *Nujum*, pp. 156–7, 160, 177; Maqrizi, *Khitat*, Bulaq, 1270, II, pp. 317–18.
29 Maqrizi, *Khitat*, calls him *amir hajib*, while Taghribirdi uses the title of *ustadar*.
30 Wiet, *Cuivres*, pp. 195 ff., lists over 150 pieces of metalwork datable between 730 and 780; see also Rice, "Studies, I" and "Studies, IV."

Chapter II

Les arts mineurs de l'Orient musulman à partir du milieu du XIIe siècle*[1]

Parmi les difficultés majeures que pose l'étude des arts du Proche-Orient musulman se trouve l'absence d'une périodisation valable qui aurait été acceptée par la majorité des savants et qui, même si elle était imparfaite, pourrait servir de cadre utile pour l'étude de monuments ou de problèmes précis.[2] L'accord n'a pas encore été fait entre diverses catégories dynastiques, géographiques ou chronologiques possibles et bien des erreurs ont été commises dans l'interprétation des monuments par suite de la confusion qui règne encore dans ce domaine. La difficulté est particulièrement sérieuse pour le spécialiste d'un domaine voisin de l'art musulman – par exemple celui de l'art chrétien du moyen âge, – car il lui est généralement difficile de savoir quels objets, techniques ou bien motifs décoratifs, sont particuliers à une époque ou à une région nettement délimitées et quels monuments sont, par contre, typiques pour l'ensemble de la civilisation. Ce que Max van Berchem appelait jadis "l'index archéologique" des monuments musulmans nous échappe encore dans la majorité des cas. Par ailleurs, sauf quelques exceptions sur certaines desquelles nous reviendrons, nous manquons de système d'interprétation des monuments préservés. Les éléments précis que nous savons décrire – tel motif iconographique ou bien décoratif, telle unité architecturale – n'ont généralement pas été intégrés dans un langage cohérent dont les règles et l'histoire nous seraient connues. Il est certes vrai que, sauf

* First published in *Cahiers de Civilisation Médiévale* (Université de Poitiers, Avril–Juin 1968), pp. 181–90.

[1] Ce travail est fondé sur une série de trois conférences faites pendant l'été 1966 au Centre d'Études Supérieures de Civilisation Médiévale. La présentation qui suit a été simplifiée et ne fait que résumer les conférences. C'est ce qui en explique le caractère schématique. De même, il a été nécessaire de réduire l'illustration a quelques documents essentiels.

[2] Il faut cependant mentionner des ouvrages utiles, quoique incomplets et à bien des égards imparfaits, comme: E. Kühnel, *Die Kunst der Islam* (Stuttgart, 1962), trad. anglaise, *Islamic Art and Architecture*, Ithaca, 1966; K. Otto-Dorn, *Kunst der Islam* (Baden-Baden, 1964). L'excellente introduction générale de G. Marçais, *L'art de l'Islam* (nombreuses éd. depuis 1946) est trop succincte pour servir aux fins qui nous intéressent.

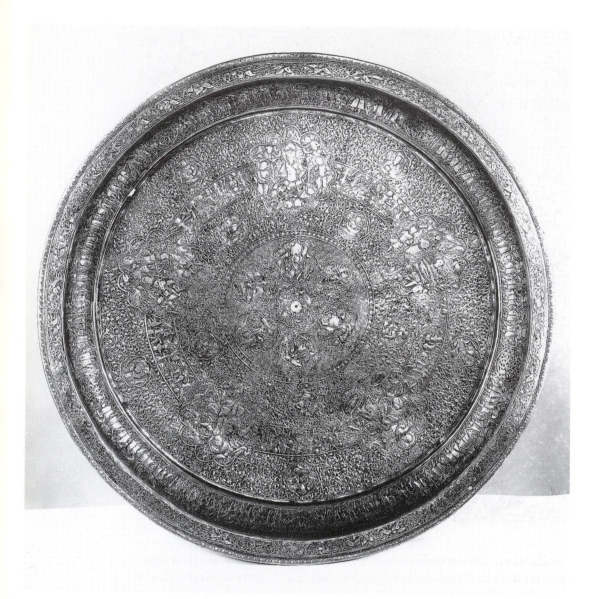

1 Cleveland.
Museum of Art.
Plat.

dans le cas spécial de la calligraphie,[3] le monde musulman a rarement transformé sa foi en thèmes artistiques précis; on n'y trouve pas la base plus ou moins canonique de thèmes iconographiques et d'interprétations spirituelles à partir de laquelle l'art chrétien du moyen âge se laisse définir. Les arts séculiers, qui à première vue semblent avoir été tellement plus développés dans le monde de l'Islam que les arts religieux, sont en général beaucoup plus difficiles à comprendre dans le détail, car leur utilisation et

3 J. Sourdel-Thomine, "Écriture arabe," dans *L'écriture et la psychologie des peuples* (Paris, 1964).

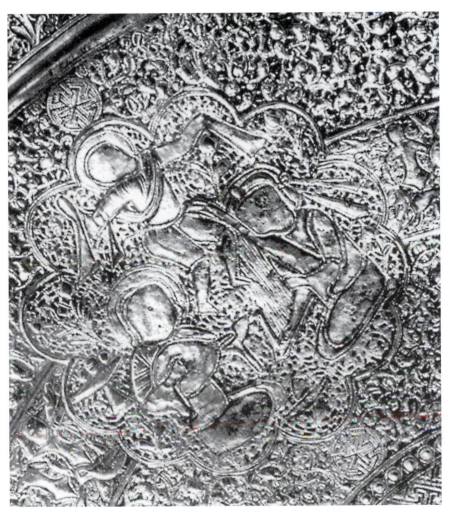

2 Cleveland.
Museum of Art.
Plat. Détail

signification contemporaines tenaient souvent à des considérations uniques qu'il est difficile de débrouiller sans documentation littéraire. Et pourtant il est difficile d'imaginer *a priori* qu'aucun sens ne puisse être donné à l'énorme masse de motifs artistiques des monuments de l'art de l'Islam sans cette aide extérieure.

Notre connaissance du détail de la production artistique du monde musulman et du cadre historique et social dans lequel cette production s'est développée est encore bien trop primitive et ce n'est qu'avec beaucoup de circonspection que l'on peut essayer de débrouiller certains fils conducteurs et proposer une interprétation précise non seulement d'un moment artistique concret mais aussi [182] des thèmes et motifs qui l'illustrent. Je voudrais de cette manière souligner qu'il ne s'agit dans cet exposé que d'une tentative d'explication et que de nombreux travaux de détail sont encore nécessaires pour transformer nos hypothèses en conclusions. Mais ce n'est peut-être

3 Cleveland.
Museum of Art.
Plat. Détail

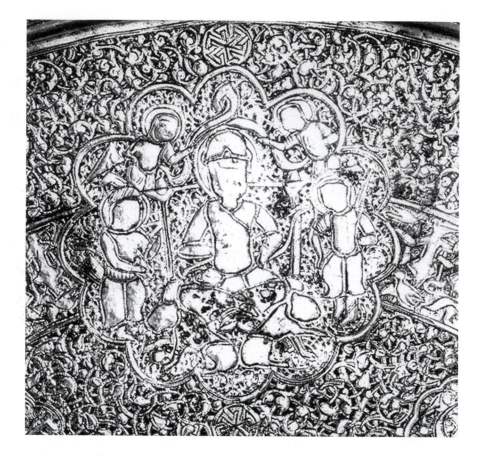

qu'à partir d'hypothèses que notre connaissance et notre compréhension de l'art musulman feront des progrès.

Le point de départ de notre étude et ce qui la rend possible c'est le fait apparent de changements considérables dans les arts musulmans à partir de 1150.[4] La quantité d'objets préservés est à un tel point plus grande que pour les siècles précédents que l'on ne peut pas considérer le phénomène comme étant un accident, mais comme le résultat d'une production accrue. L'existence d'une grande masse d'objets permet aussi d'en proposer un classement plus valable que s'il ne s'agissait que de quelques fragments isolés. Les changements qui ont eu lieu apparaissent dans plusieurs techniques différentes que l'on a généralement tendance à étudier séparément, et je tâcherai en premier lieu d'exposer les modifications qui sont intervenues dans l'art du métal, dans la céramique et dans l'art du livre. Mais ces modifications de techniques diverses possèdent aussi des caractéristiques communes et dans une deuxième partie je voudrais examiner ces caractères communs et essayer d'en tirer certaines

4 Pour un aperçu général sur cette époque et sur son histoire, dans la mesure où elle influa sur les arts, voir mon introduction à l'exposition *Persian Art before and after the Mongol Conquest* (Ann Arbor, 1959).

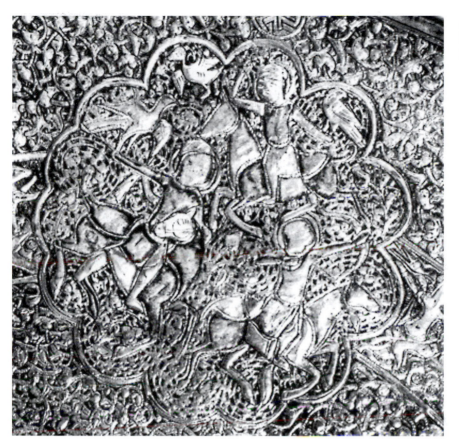

4 Cleveland.
Museum of Art.
Plat. Détail

conclusions. Une dernière remarque préliminaire serait que ces changements sont caractéristiques des arts de la deuxième moitié du XIIe et du XIIIe siècles. Aux environs de 1300, et en partie seulement sous l'influence de la conquête mongole, le patronage et le goût de l'Orient musulman seront modifiés et un art basé sur des besoins et des formules nouveaux sera créé. Il s'agit donc bien d'un phénomène limité dans le temps et, dans une certaine mesure, dans l'espace.[5] Il faudrait ajouter que, quoique le phénomène en question ait créé des styles artistiques tout à fait distincts, il n'est pas certain qu'il ait entièrement remplacé tous les techniques et styles des siècles précédents. Mais c'est là un point de détail que nous laisserons de côté dans le contexte de cette étude.[6]

[5] Un cas particulier se pose autour de l'Égypte, dont les arts seront influencés par le phénomène dont nous parlons à partir du milieu du XIIIe siècle. Mais il y a en Égypte le problème spécial de l'art fatimide dont certaines caractéristiques se rapprochent des arts que nous allons décrire et ont même pu les précéder. C'est là une période et une tradition artistique qu'il serait bon de reprendre en entier.

[6] Ce maintien de techniques et de types plus anciens existe certainement dans la céramique et dans l'art du métal. Il faudrait évidemment ajouter aussi les tissus et l'art du verre.

5 Léningrad.
Musée de
l'Ermitage.
Inscriptions

Quoique les objets en argent et en or aient certainement été communs autour des grandes cours princières du monde musulman, ces objets nous sont surtout connus par les textes. Le petit nombre d'objets préservés en rend l'histoire difficile à établir, sauf peut-être dans les cas de la série de plats et d'aiguières du type dit post-sassanide.[7] Par contre, dès le VIIIe siècle apparaissent les premiers exemples d'un art du bronze et du cuivre qui deviendra la technique caractéristique de l'art du métal dans les pays musulmans.[8] Pendant les premiers siècles les qualités principales de ces objets étaient la valeur sculpturale de leurs formes (surtout dans le cas d'objets zoomorphes) et la complexité plus ou moins grande d'un décor gravé. Or, au milieu du XIIe siècle apparaît une technique qui n'est pas nouvelle en soi, mais dont l'utilisation était rare au cours des siècles précédents. Il s'agit de l'incrustation d'un objet en bronze ou en cuivre avec de l'argent et, plus rarement, avec de l'or ou du cuivre rouge. Le premier objet daté dans cette technique nouvelle est un écritoire, au Musée de l'Ermitage à Leningrad, qui porte la date de 1148.[9] Cet objet, comme d'ailleurs la [183] plupart des objets datés les plus anciens, provient de la région de Herat en Iran oriental et il semble certain que les techniques nouvelles furent

7 État de la question et bibliographie dans O. Grabar, *Sasanian Silver* (Univ. of Michigan Museum of Art, Ann Arbor, 1967).

8 L'exposé général le plus récent est celui de E. Kühnel, *Islamische Kleinkunst* (Braunschweig, 1963); voir aussi D. Barrett, *Islamic Metalwork in the British Museum* (Londres, 1949).

9 L. T. Giuzalian, "Un kalemdan en bronze de 1148," dans *Pamiatniki Epohi Rustaveli* (Léningrad, 1938). Une publication plus complète du même objet par le même auteur est paru dans le tome 7 d'*Ars Orientalis* (1968).

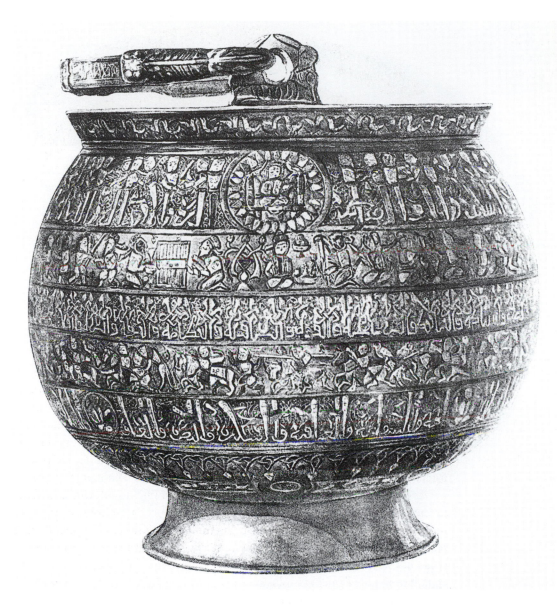

développées dans le Khorasan et puis transmises vers l'ouest. À partir du milieu du XIIe siècle – et sans que les techniques plus anciennes aient nécessairement été abandonnées – les cuivres incrustés d'argent devinrent les objets en métal les plus typiques de l'art musulman jusqu'à la fin du XIIIe siècle. Divers ateliers et diverses écoles ont pu être établis,[10] mais il me semble encore difficile de savoir si des styles précis peuvent être associés avec ces

6 Léningrad. Musée de l'Ermitage. Chaudron

[10] Pour s'orienter dans ces problèmes voir surtout D. S. Rice, "Inlaid Brasses from the workshop of Ahmad al-Dhaki al-Mawsili," dans *Ars Orientalis*, 2 (1957), surtout p. 319 et ss. On y trouvera d'excellentes notes bibliographiques.

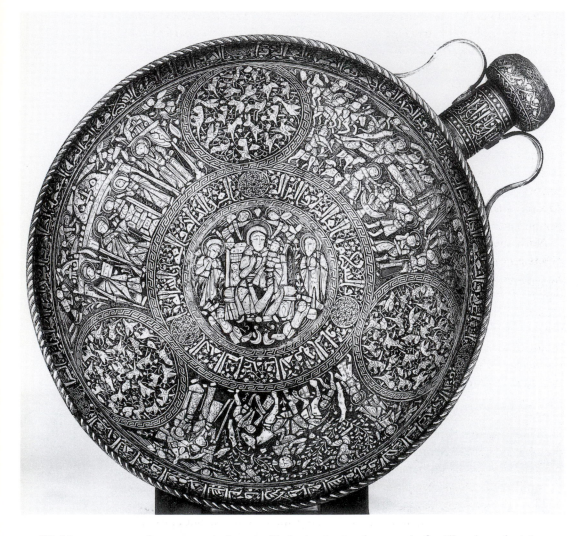

7 Washington.
Freer Gallery of
Art. Gourde

ateliers et ces écoles ou s'il s'agissait simplement de familles de techniciens et d'artisans qui pouvaient adapter leur talent aux goûts de leurs patrons. Dans le cadre préliminaire des observations qui vont suivre, il me semble préférable de considérer tous ces objets dans leur ensemble.

L'intérêt principal de la technique de l'incrustation est qu'elle ne modifie pas la forme de l'objet mais en transforme la surface en permettant à la décoration de ressortir d'une manière beaucoup plus nette que sur les objets gravés. Il est donc légitime de conclure que, pour des raisons sur lesquelles nous allons revenir, une importance nouvelle fut donnée aux thèmes précis de la décoration des objets. Ces derniers représentent toute la gamme des besoins utilitaires de la vie courante: plats, écritoires, aiguières, chandeliers, coupes, bassins, encensoirs. Il s'agit donc d'une transformation voulue de la surface des objets utilitaires par la décoration, dont les sujets acquièrent ainsi une importance primordiale.

Deux objets du Musée de Cleveland, un objet de l'Ermitage et un objet de la Freer Gallery of Art (Figs 1–7) peuvent servir d'illustration partielle de la richesse étonnante de cette décoration. On y trouve un cycle princier (prince trônant, musiciens, danseuses, acrobates, jeu de polo, combats, chasse), un cycle astrologique (mois et saisons, planètes, signes du zodiaque), un cycle de la vie courante (caravanes en voyage, repos, chasse populaire, labours), et même un cycle chrétien.[11] Il est certain que des études de détail plus poussées en découvriront d'autres encore, mais le fait capital est celui de l'animation de l'objet par un grand nombre de représentations de personnages et d'animaux dans diverses activités. Cette animation peut d'autant plus être considérée comme caractéristique de l'art du métal de cette époque qu'elle apparaît aussi dans les inscriptions (Fig. 5) dont les lettres se transforment en personnages ou bien en animaux.[12]

Nous sommes aussi assez bien renseignés sur le patronage qui a créé ces objets en métal. La majorité des plus anciens, l'écritoire de l'Ermitage, daté en 1148, le chaudron de l'Ermitage, daté en 1163, une aiguière au Louvre, datée en 1190, ont été commandés par des marchands ou bien par des artisans, c'est-à-dire par des représentants de la bourgeoisie des villes. D'autres objets, surtout au XIIIe siècle, ont été faits pour des princes. La grande majorité furent fabriqués en masse et accessibles à quiconque pouvait se les permettre. Si souvent ces objets portent le nom d'un prince, ce n'est certes pas qu'ils furent faits pour un prince précis mais simplement pendant son règne.

Même si les objets en métal étaient commandés et utilisés par des personnages d'origines sociales diverses, il n'en est pas moins vraisemblable que c'étaient des objets comparativement chers et il est curieux de noter par exemple qu'à ma connaissance aucun fragment de métal incrusté n'a été découvert au cours de fouilles. Les objets communs étaient ou bien en métal non décoré ou gravé ou bien en céramique. Or l'art de la céramique a, lui aussi, subi des changements importants aux XIIe et XIIIe siècles. Ces changements sont surtout apparents dans la céramique de l'Iran. En Mésopotamie, en Syrie et en Égypte les modifications qui se laissent identifier semblent avoir été influencées [184] par l'art de l'Iran, mais c'est là encore un sujet qui mérite une étude plus approfondie.[13] Du point de vue technique, la découverte la plus caractéristique

[11] En dehors des ouvrages déjà cités, voir la série d'articles de D. S. Rice, "Studies in Islamic Metalwork," dans *Bull. School Orient. and Afric. Stud.*, à partir du tome 14 (1952); Rice, *The Wade Cup* (Paris, 1955); Rice, "The Seasons and the Labours of the Months," dans *Ars Orientalis*, 1 (1954); R. Ettinghausen, "The Wade Cup," *Ars Orientalis*, 2 (1957); O. Grabar, "Two Objects in Metal," *Ars Orientalis*, 4 (1961).

[12] Rice, "The Wade Cup," p. 21 et ss.

[13] Quelques travaux préliminaires: J. Sauvaget, "Tessons de Rakka," dans *Ars Islamica*, 13/14 (1948); G. Reitlinger, "The Interim Period in Persian Pottery," dans *Ars Islamica*, 5 (1938); "Unglazed Relief Pottery from Northern Mesopotamia," dans *Ars Islamica*, 15/16 (1948); P. J. Riis et V. Poulsen, *Hama, Les verreries et poteries médiévales* (Copenhague, 1957).

8 New York.
Metropolitan
Museum of Art.
Plat.

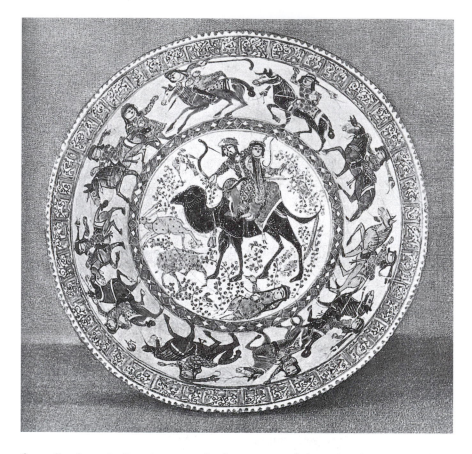

fut celle du *minaʾi* qui permet la fixation sur l'objet de plusieurs couleurs différentes. Ainsi donc la méthode nouvelle de cette époque, comme l'incrustation pour le métal, a fourni la possibilité d'augmenter la qualité des images. Cette technique, cependant, ne fut pas universellement acceptée et les méthodes plus anciennes de peintures sous glaçures et de reflets métalliques continuèrent à être utilisées et atteignirent une perfection technique inégalée. Le *minaʾi* peut pourtant servir de symbole des changements de l'époque car toutes les techniques, même les plus simples, furent utilisées pour transformer la décoration de l'objet en utilisant systématiquement des sujets avec personnages. Finalement ce fut l'époque du développement d'une céramique de revêtement qui transforma l'architecture de l'Iran en particulier en un vrai festival de couleurs.[14] Les carreaux de revêtement eux aussi furent décorés de personnages.

Les sujets iconographiques de la céramique de cette époque sont beaucoup plus vastes que ceux des métaux, car leur caractère beaucoup plus commun et moins onéreux leur a permis de refléter des goûts beaucoup plus variés.

[14] D. Wilber, "Development of Mosaic Faience in Islamic Architecture," dans *Ars Islamica*, 6 (1939).

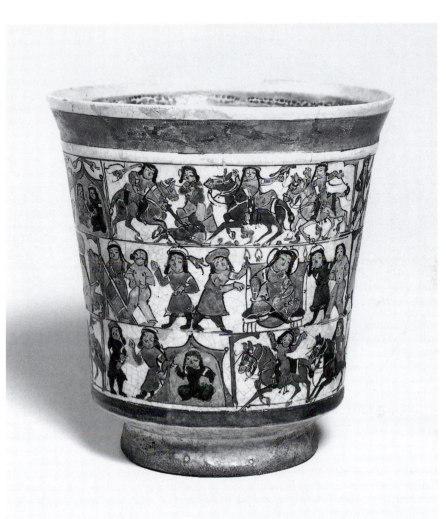

9 Washington.
Freer Gallery of
Art. Gobelet

On y retrouve certes les thèmes princiers et astrologiques des bronzes, mais
on y découvre aussi un certain nombre de thèmes tirés des grandes légendes
épiques de l'Iran (Fig. 8), même, dans un cas précis (Fig. 9), tout un épisode
du *Shah-nameh* en bande dessinée, des événements contemporains, comme
sur un plat célèbre de la Freer Gallery (Fig. 10) décrivant la prise d'une
forteresse par une bande de soldats dont les noms sont donnés, et enfin
toute une série d'images montrant divers personnages méditant autour d'un
lac ou dans un paysage schématique (Fig. 11) ou bien jouant des instruments
de musique. Beaucoup de ces images sont assez difficiles à décrire et donnent
souvent l'impression d'un langage iconographique dont les termes exacts
nous échappent (Fig. 12). Nous y reviendrons plus bas. En attendant, il
faudrait ajouter qu'à côté de la masse d'objets avec des représentations
peintes, on trouve un certain nombre de sculptures en céramique, surtout

10 Washington.
Freer Gallery of
Art. Plat.

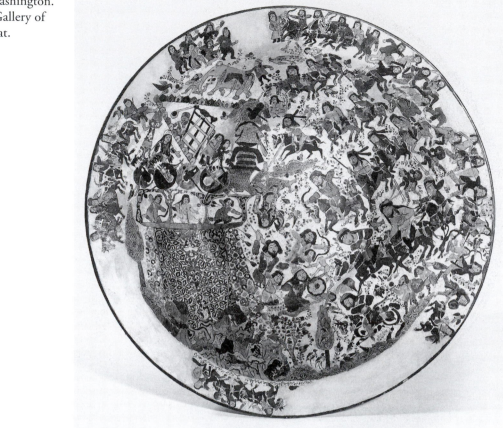

des animaux, mais parfois aussi des personnages, telle une femme allaitant, ou même des modèles de maisons entières.[15]

Les céramiques sont plus rarement datées que les métaux et il est donc difficile d'établir avec précision l'époque exacte des changements de style et de sujets décoratifs. Les exemples les plus anciens qui sont datés proviennent des années autour de 1170. Il est vraisemblable cependant que les changements dans l'art de la céramique ont été graduels et les nouveautés qui y apparaissent sont à tel point semblables aux nouveautés de l'art du métal qu'il nous semble légitime de considérer le milieu du XIIe siècle comme étant le moment du changement.

Avec l'apparition d'un art de la miniature, les changements qui caractérisent l'art du livre en pays musulmans sont bien plus révolutionnaires. Quelques

[15] En dehors du livre de Kühnel cité plus haut, la documentation la plus abondante et la plus accessible se trouve dans A. U. Pope, *A Survey of Persian Art* (Oxford, 1939); le gobelet de la Freer Gallery avec scènes du *Shah-nameh* a été étudié par Grace D. Guest, "Notes on the Miniatures of a Thirteenth Century Beaker," dans *Ars Islamica*, 10 (1943); d'autres références seront données plus loin.

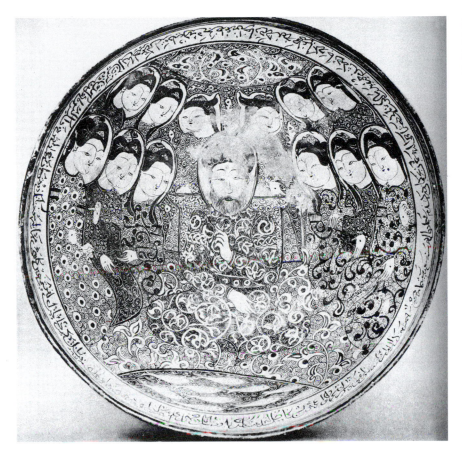

11 New York.
Metropolitan
Museum of Art.
Plat.

fragments anciens existent bien et divers textes suggèrent que des manuscrits illustrés n'étaient pas entièrement absents de l'art des cinq premiers siècles de l'Islam.[16] Il est vraisemblable, en particulier, que des ouvrages comme le roman de Kalilah et Dimnah, qui avaient une origine plus ancienne que l'Islam, avaient été pourvus d'illustrations dès le Xe siècle et il est possible, quoique nous soyons mal renseignés sur ce sujet, qu'il en ait été de même pour certains poèmes épiques persans. Rien, cependant, dans ce que nous savons [185] de l'art du livre avant le XIIe siècle, ne semble préparer le succès de livres illustrés qui allait se produire. Les manuscrits scientifiques, comme ceux de Galien ou bien de Dioscoride, qui avaient toujours eu des illustrations techniques, adoptèrent de vraies miniatures dont le but ne fut plus de fournir simplement un diagramme ou un moyen de vérification visuel des données du texte, mais des illustrations supplémentaires au texte sans valeur explicative immédiate.[17]

[16] T. Arnold et A. Grohman, *The Islamic Book* (Londres, 1929), pl. I et ss.; D. S. Rice, "The Oldest Illustrated Arabic Manuscript," dans *Bull. School Orient. and Afric. Stud.*, 22 (1959).

[17] R. Ettinghausen, *La peinture arabe* (Genève, 1962), est maintenant l'ouvrage de base pour tous ces problèmes et pourvu d'une excellente bibliographie.

12 Washington.
Freer Gallery of
Art. Plat.

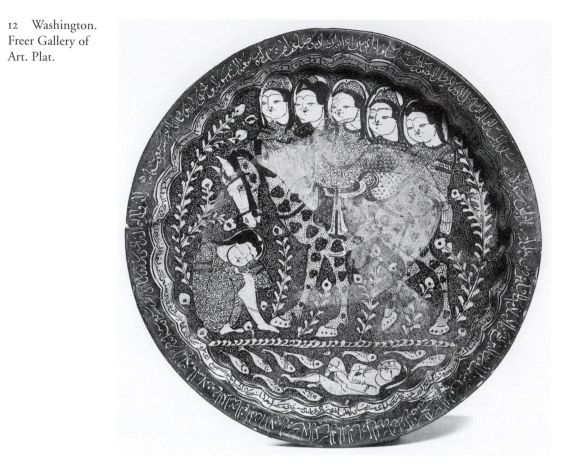

Une image d'un manuscrit de Dioscoride (Fig. 13) montre le cabinet d'un médecin, tandis que d'autres dépeignent un bateau ou bien des scènes de travaux aux champs et des paysages. La moindre occasion est utilisée pour créer des images qui n'apparaissent plus comme documents scientifiques, mais comme motifs décoratifs, comme si la valeur du manuscrit dépendait de l'existence d'images. Cet aspect des images se trouve confirmé par l'existence d'un grand nombre de frontispices avec thèmes princiers ou astrologiques.

Le changement qui apparaît dans les manuscrits scientifiques est important parce que la connaissance que nous avons par ailleurs du passé des manuscrits scientifiques permet d'apprécier le caractère révolutionnaire du goût nouveau. Mais, esthétiquement et historiquement, l'événement le plus important est l'apparition de cycles d'images autour d'une œuvre littéraire remarquable, *les Maqamat* de Hariri. Cet ouvrage, composé au début du XIIe siècle, est un mélange unique d'aventures picaresques et de virtuosité linguistique utilisant d'une manière étonnante la richesse de la langue arabe. Ces exercices en

13 Washington. Freer Gallery of Art. Ms. de Dioscoride, *De Materia Medica*

"acrobatie verbale"[18] eurent un succès immédiat et l'ouvrage devint un *best-seller* dans le monde cultivé de l'Islam. Six manuscrits illustrés en sont connus avant 1260.[19] Nous reviendrons plus tard sur divers aspects de ces illustrations. L'important pour l'instant est d'indiquer que, de même que les manuscrits scientifiques reçurent des images qui ne peuvent en aucun cas

[18] L'expression est de R. Blachère dans al-Hamadhant, *Choix de Maqamat* (Paris, 1957), p. 46.

[19] Liste des manuscrits par Rice dans *Bull. School Orient. and Afric. Stud.*, 22 (1959), p. 215; il faut y ajouter le manuscrit d'Istanbul découvert par R. Ettinghausen et publié par O. Grabar, "A newly discovered Manuscript," dans *Ars Orientalis*, 5 (1963).

14 Paris.
Bibliothèque
Nationale. Ms.
Maqamat de
Hariri. Arabe
3929, fol. 26

être considérées comme contribuant à la compréhension du texte, de même les *Maqamat*, connus et admirés pour leur qualité de style – c'est-à-dire pour des qualités verbales *a priori* intraduisibles en images – servirent d'excuse à la formation de cycles d'images dont certaines sont de simples commentaires du texte écrit (Fig. 14), tandis que d'autres nous offrent un panorama étonnant de la vie contemporaine (Fig. 15).

Les manuscrits datés les plus anciens sont à la Bibliothèque Nationale, un *Livre de la Thériaque*, daté en 1199, et un exemplaire des *Maqamat* (Arabe 6094), daté en 1222.[20] Étant donné qu'un grand nombre de manuscrits ne sont pas pourvus de colophon et ont pu précéder les manuscrits datés, il est légitime de conclure que l'art de la miniature était déjà développé pendant les dernières décades du XIIe siècle. Dans l'état de nos connaissances il me semble difficile de le reporter plus haut.

Une dernière remarque s'impose au sujet des manuscrits illustrés. La grande majorité sont des manuscrits arabes composés dans des régions arabophones. En dehors de quelques textes scientifiques, il n'y a qu'un manuscrit illustré persan de cette époque.[21] Si l'on considère l'essor étonnant

20 B. Fars, *Le Livre de la Thériaque* (Le Caire, 1953).
21 A. Ates, "Un vieux poème romanesque persan," dans *Ars Orientalis*, 4 (1961); il serait
 juste d'ajouter qu'il existe un manuscrit persan plus ancien avec de nombreuses

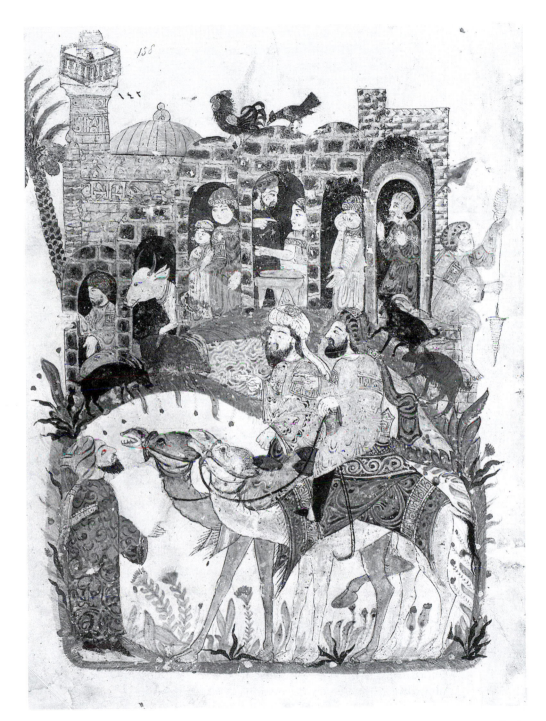

15 Paris.
Bibliothèque
Nationale. Ms.
Maqamat de
Hariri. Arabe
5847, fol. 138

de la miniature persane à partir de la fin du XIIIe siècle et l'importance des images d'origine littéraire sur les céramiques, cette lacune est curieuse et mérite être notée. Son examen dépasserait, cependant, le cadre de notre étude. [186]

Ainsi, l'art de la deuxième moitié du XIIe siècle peut se définir par une explosion d'images dans trois techniques qui, jusqu'à cette époque, n'en avaient que fort peu. L'animation par les personnages de l'objet utilitaire ou du livre est donc bien un phénomène nouveau.[22] Je voudrais rappeler aussi que cette explosion coïncida avec une extension considérable du patronage des arts. Les inscriptions de certains cuivres le prouvent pour l'art du métal; la céramique a toujours été une technique populaire à des niveaux sociaux différents; quant aux livres illustrés, le fait que les *Maqamat* par exemple demandent une culture littéraire poussée suggère une fois de plus qu'ils furent surtout appréciés par la bourgeoisie cultivée des villes arabes et non pas par les princes. Ce double phénomène de l'animation de l'œuvre d'art et de l'extension du patronage est particulier aux XIIe et XIIIe siècles. Il survivra pendant un siècle dans l'Égypte et dans la Syrie des *mamluks*, mais, même si de grands chefs-d'œuvre comme le Baptistère de Saint Louis,[23] ou bien comme le manuscrit des *Maqamat* de Vienne,[24] semblent continuer les thèmes et les idées du XIIIe siècle, ce sont là les derniers soubresauts d'un goût plus ancien, car, dès la fin du XIVe siècle, les personnages disparaissent des objets et les manuscrits illustrés se font rares. En Iran, s'il est vrai que la céramique et les bronzes maintiennent certains thèmes plus anciens jusqu'à la fin du XIIIe siècle, il n'en est plus de même au XIVe siècle, et ce sera le patronage princier qui créera le goût nouveau de la miniature persane.

Le phénomène dont nous parlons est donc bien limité à une époque précise qui va du milieu du XIIe siècle à la fin du XIIIe, et il s'agit maintenant d'essayer de l'expliquer. Nous n'avons, à ma connaissance, aucun texte, ni aucune autre source extérieure aux monuments, qui permettrait de fournir une explication valable. Il nous faut donc nous pencher sur les monuments eux-mêmes et essayer d'en découvrir le secret. Tout en reconnaissant ce qu'il y a encore d'incertain dans l'explication qui va être proposée et combien de

illustrations dans une collection privée et au Musée de Cincinnati; certains doutes ont été émis au sujet de son authenticité et nous avons préféré l'écarter de notre discussion en attendant une étude officielle et complète.

[22] Je voudrais rappeler ici le problème particulier de l'art fatimide en Égypte qui, à en juger par certains textes, par sa céramique, par ses boiseries, et par son influence sur les peintures de la Chapelle Palatine à Palerme a connu des cycles iconographiques fort développés avant 1150; voir U. Monneret de Villard, *La pitture musulmane al soffitto della Cappella Palatina* (Rome, 1950); R. Ettinghausen, "Painting in the Fatimid Period," dans *Ars Islamica*, 9 (1942). Il est possible qu'il faille exclure l'Égypte de notre règle.

[23] D. S. Rice, *The Baptistère de Saint Louis* (Paris, 1953).

[24] K. Holter, "Die Galen-Handschrift und die Makamen des Hariri der Wiener Nationalbibliothek," dans *Jahrb. der kunsthist. Sammlungen in Wien*, n.s., 11 (1937).

travaux de détail sont encore nécessaires pour la rendre acceptable, je voudrais signaler tout d'abord qu'elle est basée sur deux présuppositions de méthode. La première est qu'une explication d'images pour lesquelles il n'y aurait pas de sources extérieures n'est possible que grâce à l'existence d'une grande série d'exemples. Notre explication n'est donc pas basée sur tel ou tel objet précis, mais sur une considération de l'ensemble des documents connus; une œuvre individuelle peut donc être une exception sans nécessairement invalider l'explication. La deuxième présupposition est celle d'intelligibilité, c'est-à-dire que les formes et les thèmes que nous pouvons définir avaient un sens pour les contemporains, même si ce sens nous échappe. En théorie, certes, l'existence de contre-sens et même de non-sens n'est pas en soi impossible. Les imitations d'inscriptions si courantes sur les céramiques en particulier peuvent servir d'exemple de motifs décoratifs dont l'origine avait certainement un sens précis, mais dont l'utilisation subséquente n'avait plus de sens linguistique.[25] Des exemples iconographiques existent aussi, surtout dans les manuscrits postérieurs des *Maqamat*,[26] dans certaines imitations des cuivres ou bien dans certaines céramiques populaires. Mais, tout en ayant conscience [187] de ces possibilités, il nous a semblé que le fait même de l'apparition soudaine de l'animation des œuvres d'art permet d'en maintenir l'intelligibilité. Notre analyse sera limitée à l'étude iconographique des images de cette époque. Les problèmes posés par les formes et surtout par l'origine des images demandent encore à être étudiés.

Les sujets de représentations sur les objets et dans les livres des XIIe et XIIIe siècles peuvent être groupés en six cycles principaux. Tout d'abord, nous avons un cycle princier. Quoique certaines nouveautés aient pu y être introduites,[27] ce n'est certes pas un cycle nouveau et on le trouve déjà dans l'art des palais musulmans du VIIIe siècle.[28] L'intérêt du cycle à notre époque est qu'il n'apparaît plus seulement comme illustration d'un art princier, mais d'un art pour les besoins d'un public plus vaste. Il est peu vraisemblable que les marchands qui avaient commandé des objets comme le chaudron de l'Ermitage (Figs 6 et 7) ou bien qui lisaient les manuscrits des *Maqamat* s'adonnaient à la boisson, à la chasse ou à la guerre, même si l'on admet qu'ils aimaient contempler des danseuses et écouter de la musique. Ce n'est pas la vie de ceux qui possédaient ces objets qui y est décrite, et nous voudrions proposer de considérer les thèmes princiers comme une illustration

[25] G. Miles a proposé que le terme "koufesque" soit donné à ces transformations décoratives des lettres ("Byzantium and the Arabs," dans *Dumbarton Oaks Papers*, 18 (1964).

[26] Cela est surtout vrai du manuscrit de Vienne et la chose sera démontrée, je l'espère, par l'étude générale de tous les manuscrits illustrés des *Maqamat* que nous préparons.

[27] Par exemple le jeu de polo et peut-être certains thèmes de chasse. Il serait utile qu'un savant reprenne en détail toutes les représentations de la chasse qui nous sont connues et les compare à ce qui peut être connu par les textes.

[28] Il s'agit surtout des peintures et sculptures trouvées à Qusayr Amrah, à Qasr al-Hayr al-Gharbi et à Khirbat al-Mafjar.

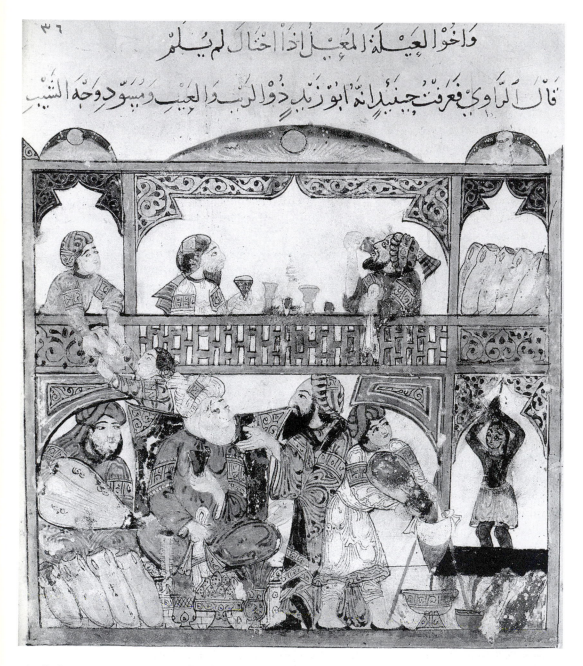

٣٦

وَاخْوُ الْعِيلَةِ الْمُعِيلِ اِذَا اِخَالَ لَهُ يَلُمُ

قَالَ الرَّاوِي فَعَرَفْتُ جُنَيْدِهِ اِنَّهُ ابُو زَيْدٍ ذُو الرَّيْبِ وَالْعِيبِ وَمُسَوِّدٍ وَجْهِ الشَّيْبِ

16 Paris.
Bibliothèque
Nationale. Ms.
Maqamat de
Hariri. Arabe
5847, fol. 33

concrète de thèmes abstraits comme le luxe, la richesse, le plaisir. L'art
princier, connu depuis des siècles, apparaît donc comme une série de signes
qui peuvent être utilisés à d'autres fins que celles pour lesquelles ils avaient
été créés. En voici un exemple tiré d'un des manuscrits des *Maqamat* (Fig.
16). L'artiste, pourtant fortement innovateur qu'était al-Wasiti, a transformé
le héros picaresque de l'histoire en prince, car il voulait le représenter en
train de boire dans une taverne et seule l'iconographie princière avait un

"signe" pour l'acte de boire en tant que plaisir. Dans ce cas précis il n'est pas exclu qu'al-Wasiti ait aussi cherché à être ironique et satirique. Le fait important est ailleurs. C'est que le thème iconographique princier avait acquis une valeur ambiguë, à la fois concrète et abstraite, à la fois acte de boire et représentation du plaisir ou du bien-être Le personnage qui boit (ou qui est assis sur son trône) est une figure abstraite, mais peut aussi bien être interprété en tant qu'individu concret. Parfois, comme dans la miniature des *Maqamat*, c'est le contexte qui fournit l'interprétation voulue; dans d'autres cas, c'est une inscription;[29] parfois même c'était l'observateur contemporain qui interprétait en termes concrets ce que l'exécutant n'avait *créé* qu'en termes généraux. Le cycle princier apparaît ainsi comme ayant été formé d'un ensemble complet de "signes" précis dont le sens et l'utilisation ont été très variés.

Le deuxième cycle est un cycle astronomique ou astrologique. Comme le cycle princier, c'est un cycle aux origines anciennes. Il existe à la fois à un niveau scientifique et descriptif, comme dans les manuscrits sur les étoiles fixes et les constellations d'al-Sufi,[30] et à un niveau pseudo-scientifique comme dans les représentations des signes pseudo-planétaires[31] que l'on trouve sur certains monuments d'architecture et sur des objets, et finalement à un niveau folklorique où, qu'il s'agisse de symboles précis comme dans le groupe des représentations des mois ou encore des signes du zodiaque ou bien de symboles célestes plus généraux comme sur certains frontispices, un petit nombre de motifs se retrouvent constamment répétés. Le cycle astronomique demande à être étudié dans le détail, mais sa signification générale nous semble claire et conforme à ce qu'elle a été depuis l'Antiquité: un symbole de bien-être et un vœu de bonne fortune.

Un troisième cycle d'images pourrait être appelé littéraire, car ses origines remontent dans la [188] plus grande partie des cas à des faits connus ou transmis par la parole ou par l'écriture. Tels sont les thèmes épiques persans que l'on trouve sur les céramiques, et il est difficile de savoir si ces images remontent à des livres illustrés ou bien si elles sont simplement des traductions en termes visuels d'histoires racontées dans les bazars.[32] Il est fort vraisemblable qu'une certaine proportion d'images que nous ne comprenons pas pour l'instant dérive d'une littérature folklorique que nous connaissons mal. Le

29 Je pense à un exemple des frontispices du *K. al-Aghani* qui a été le sujet d'un long débat entre D. S. Rice et B. Farès; voir D. S. Rice, "The Aghani miniatures," dans *Burlington Magazine*, 95 (1953); B. Farès, "Vision chrétienne et signes musulmans," dans *Mém. Inst. d'Égypte*, 61 (1962).

30 E. Wellesz, "An early al-Sufi manuscript," dans *Ars Orientalis*, 3 (1957); Ettinghausen, *La peinture arabe*, p. 50.

31 W. Hartner, "The pseudo-planetary nodes of the Moon's orbit," dans *Ars Islamica*, 5 (1938).

32 Il s'agit là d'un point de méthode d'interprétation de certains types d'images qui a été le sujet de nombreux débats dans l'art chrétien, mais sur lequel les historiens de l'art musulman ne se sont pas assez penchés.

cas le plus remarquable de thèmes littéraires est évidemment celui des manuscrits illustrés où, de plusieurs manières différentes suivant les manuscrits, un cadre visuel est créé pour des sujets précis et connus. Un cas particulier de ces thèmes littéraires serait celui des sujets chrétiens sur les cuivres.[33]

Les scènes de la vie courante forment un quatrième cycle, caractéristique de certains manuscrits scientifiques aussi bien que des trois principaux manuscrits des *Maqamat* à Paris (Arabe 5847), Léningrad et Istanbul. On retrouve ces scènes sur un petit nombre d'objets en métal[34] ou en céramique. Dans la plupart des cas, ces images de la vie de tous les jours à la ville ou à la campagne sont inconnues avant le milieu du XIIe siècle, et il est curieux de noter que bien souvent elles ont un caractère quelque peu ironique.

Une cinquième catégorie est plus difficile à définir. Je voudrais proposer de l'appeler un cycle d'images privées. Il s'agirait d'images semblables à nos photographies de famille, dans lesquelles les événements commémorés, et parfois même les poses et les compositions, ont un caractère culturel commun, mais la signification, émotionnelle ou autre, n'en serait accessible qu'à un petit nombre de contemporains. Un exemple de ce type serait celui du plat de la Freer Gallery avec son groupe de personnages aux noms donnés montant à l'assaut d'une forteresse. Il s'agit vraisemblablement d'un événement contemporain, mais d'un événement mineur, et l'objet semble avoir été une espèce de "souvenir" des "anciens" d'une campagne militaire de troisième ordre. Au revers, ce plat est décoré de représentations de héros épiques auxquels nos illustres inconnus se comparaient sans doute. Si la coïncidence des inscriptions identifiant une série de braves soldats nous permet de présenter cette hypothèse dans le cas du plat de la Freer Gallery, il serait peut-être dangereux de suggérer que toutes les images dont le sens nous échappe auraient été des images à caractère privé. Mais – et ceci d'autant plus qu'une étude à paraître bientôt, due à M. Giuzalian, du Musée de l'Ermitage, montrera comment l'écritoire de 1148 à l'Hermitage a été une affaire de famille[35] – la possibilité d'un tel cycle d'images privées n'est nullement exclue.

Finalement, nous avons affaire à un cycle d'images que, faute de meilleur terme, je proposerais d'appeler "méditatif". C'est un cycle nouveau et qui a probablement de fortes attaches avec le cycle princier aussi bien qu'avec le cycle privé. L'interprétation nouvelle que l'on peut proposer de ce groupe d'images, qui ne sont connues que par certaines céramiques persanes, est

33 Une étude en préparation sur quelques objets de la Freer Gallery permettra de mettre en lumière certains de ces problèmes. Voir en attendant J. Leroy, *Les manuscrits syriaques à peintures* (Paris, 1964), p. 63 et ss.

34 Cf. Rice, dans *Ars Orientalis*, 2, figs 11–20; R. Ettinghausen, "The Bobrinsksi Kettle," dans *Gazette des beaux-arts* (1943); "Early Realism in Islamic Art," dans *Studi Orientalistici G. Levi Della Vida* (Rome, 1956).

35 Giuzalian dans *Ars Orientalis*, 7 (1968).

entièrement basée sur l'admirable analyse que M. Ettinghausen a faite d'un plat de la Freer Gallery of Art (Fig. 12).[36] Le savant auteur a pu montrer que chaque motif iconographique qui se laisse définir correspond à des images précises de la poésie mystique contemporaine. L'image entière peut ainsi être interprétée comme la représentation d'un personnage qui, après avoir abandonné ses soucis et ses désirs charnels symbolisés par le cheval, contemple une vision de l'âme unie à Dieu et transmet sa connaissance du divin à un groupe de suivants. M. Ettinghausen a bien montré [189] que ce n'est pas la seule explication que l'on puisse proposer de cette image et qu'elle avait vraisemblablement cette même qualité d'ambivalence que nous avons suggérée pour le cycle princier. En soi, cependant, l'existence d'images inspirées par la poésie mystique s'expliquerait aisément en raison de l'énorme importance prise par les organisations des *sufis* dans la société de l'époque.[37]

Il nous reste à passer en revue une dernière catégorie de renseignements que l'on trouve sur les objets. Il s'agit des inscriptions. Ces inscriptions peuvent se diviser en quatre groupes principaux. Un premier groupe comprend simplement de bons vœux adressés à un possesseur anonyme. Ce sont les inscriptions les plus fréquentes et elles ne sont nullement particulières à cette époque. La seule chose importante à noter, c'est qu'on les trouve à la fois sur des objets de qualité secondaire et sur des objets de premier ordre. Ce serait une preuve du fait que presque tous ces objets, même les plus chers, étaient fabriqués d'une manière semi-industrielle.

Une deuxième série d'inscriptions comprend surtout des textes littéraires. C'est le grand mérite de M. Giuzalian d'en avoir lu un grand nombre et d'avoir pu montrer que dans beaucoup de cas ce n'est pas la tradition manuscrite mais la tradition orale de ces textes que l'on retrouve sur les objets.[38]

Une troisième série semble assez rare, mais elle est admirablement illustrée par l'inscription d'une aiguière de 1182 à Tiflis. Cette inscription reproduit un poème en l'honneur de l'aiguière et de l'artisan qui l'a faite: "O ma chère et douce aiguière, qui donc en possède une autre comme toi? … Regarde l'aiguière et ton âme revit, car c'est de l'eau fraîche qui en coule … Que la grâce divine vienne à celui qui a fait une pareille aiguière … ".[39] On pourrait interpréter ce type d'inscription comme correspondant aux images de type privé.

[36] R. Ettinghausen, "The Iconography of a Kashan Luster Plate," dans *Ars Orientalis*, 4 (1961).

[37] L'histoire sociale de l'époque n'étant pas faite, il serait vain de fournir une longue note bibliographique; voir F. Taeschner, "Dis islamische Futuwwab onde," dans *Zeitschr. der Deutsche Morgenlandgesellsch.*, 12 (1934); C. Cahen, "Mouvements populaires," dans *Arabica*, 5 et 6 (1958/9).

[38] Série d'articles dans *Epigrafika Vostoka*; résumé et commentaires par O. Grabar, dans *Ars Orientalis*, 2 (1957), pp. 550–51.

[39] L. T. Giuzalian, "Aiguière de bronze de 1182," dans *Pamiatniki Epohi Rustaveli* (Léningrad, 1938).

La dernière catégorie d'inscriptions semble être exclusivement persane et consiste en quatrains aux qualités poétiques souvent médiocres mais aux sentiments clairs. En voici deux exemples : "Avec ton âme j'ai accepté ton amour et je t'ai dit tous mes secrets; depuis que je porte ton sceau sur ma langue, j'ai finalement contemplé l'univers tout entier"; "Ta chevelure est aussi longue que mon chagrin (d'amour); dans chaque pli de ses boucles elle attire les cœurs; tu m'as demandé qui possède ton cœur; O âme du monde, je ne le dirai pas devant toi, c'est un ami qui le possède".[40] Comme certaines des images, ces quatrains ont un caractère ambigu et peuvent être interprétés comme des déclarations à la fois érotiques et mystiques. Il n'y a pour ainsi dire pas d'exemple où l'inscription et l'image coïncideraient d'une manière nette et absolue et nous sommes obligés de conclure que, comme sur nos cartes de Noël, l'image et la parole écrite appartiennent à deux systèmes de communication différents et qu'il ne s'agit pas de traduction exacte d'un système à l'autre.

L'importance des inscriptions que l'on trouve sur ces objets me semble résider dans le parallélisme qui existe entre images et mots ou phrases. On y trouve des essais littéraires et des thèmes populaires, des motifs généraux et abstraits aussi bien que des termes précis et privés. On y retrouve même des idées ambiguës, comme sur les images. Une conclusion cependant ressort des inscriptions beaucoup plus clairement que des images. C'est qu'une grande proportion des cuivres, des céramiques, et peut-être même des livres illustrés, était utilisée non seulement pour le plaisir ou les besoins de l'acheteur, mais aussi pour être donnée comme cadeau à l'occasion de fêtes ou de [190] cérémonies officielles ou privées. Avec l'extension du patronage des objets dont nous avons déjà parlé, nous avons donc affaire à une extension des fonctions de l'objet créé par les artistes et les artisans de l'époque.

Essayons maintenant de résumer ce que nous avons décrit d'un point de vue technique d'abord et puis du point de vue de l'iconographie. Une série de changements majeurs dans les arts du livre, du feu et du métal peuvent être datés entre 1150 et 1200 et tendent à disparaître aux environs de 1300. Quoique sous des formes différentes d'une région à l'autre, ces changements ont caractérisé le Moyen-Orient tout entier. L'élément le plus original de ces changements est l'animation systématique des objets et des livres, comme si ce n'était que par la représentation de personnages dans diverses activités ou bien comme symboles qu'un objet ou un livre pouvaient acquérir leur valeur et leur prix. Diverses qualités des manuscrits aussi bien que des objets permettent aussi de conclure que le goût qui a créé ces changements ne fut pas un goût princier mais un goût bourgeois des villes, et c'est en particulier dans les milieux urbains que se développèrent les mouvements mystiques à

40 M. Bahrami, *Recherches sur les carreaux de revêtement lustré* (Paris, 1937), p. 65 et ss.; *Gurgan Faïences* (Le Caire, 1949), *passim*.

affinités sociales dont nous avons vu l'influence sur les images.[41] Par ailleurs les inscriptions et par extension certains cycles d'images indiquent que les objets, sinon les manuscrits, remplissaient non seulement un but utilitaire ou de plaisir personnel, mais aussi toute une série de fonctions dans les relations sociales de l'époque; ils sont comparables à nos propres cartes de vœux divers. L'hypothèse de travail – ce ne peut être une conclusion, sans un grand nombre d'études de détail pour l'étayer – que nous proposons donc serait celle-ci: les changements aux ramifications multiples que nous avons essayé de décrire en partie auraient été le résultat de l'accession de la bourgeoisie des villes du monde musulman – une bourgeoisie non seulement musulmane mais aussi chrétienne – à un niveau de richesse et de pouvoir culturel qui lui permit d'imposer des formes et des sujets nouveaux aux arts du Proche-Orient.

Bien des problèmes restent encore. Comment expliquer le fait que ce n'est qu'au milieu du XIIe siècle que ces changements se produisirent, alors que le développement de la bourgeoisie est bien plus ancien?[42] Quelles sont les origines des images que nous voyons? Pourquoi cette passion pour les thèmes à sujets figuratifs? Quels sont les styles de l'époque? Il faudra à l'occasion revenir sur toutes ces questions, mais en conclusion il n'est pas inutile de rappeler que c'est aussi dans les villes des Flandres et d'Italie qu'aura lieu la grande révolution des arts qui mènera aux diverses renaissances et que l'art gothique lui-même a un fort caractère urbain. A cet égard le phénomène musulman semble bien appartenir à un phénomène médiéval général, et les méthodes valables pour l'Orient peuvent être valables aussi bien pour les arts de l'Occident. Ce qui différencie le fait musulman des XIIe et XIIIe siècles de l'Occident contemporain c'est qu'en fin de compte les changements révolutionnaires que nous avons esquissés y avortèrent et n'eurent qu'une influence secondaire sur la grande floraison artistique du XIVe siècle et des siècles postérieurs.

[41] Une étude préliminaire sur le goût bourgeois va paraître lors de la publication par A. Hourani et S. M. Stren de la conférence sur la ville musulmane qui a eu lieu à Oxford en 1965.

[42] Je pense surtout aux conclusions obtenues par S. D. Goitein par suite de ses études sur les fragments de la Geniza. On en trouvera de nombreux exemples dans ses *Studies in Islamic History and Institutions* (Leyden, 1966).

Chapter III

Trade with the East and the Influence of Islamic Art on the "Luxury Arts" in the West*

For this working section on the thirteenth century, I was given a task of far greater complexity than I, or, I hope, Professor Belting had anticipated. How can one possibly come up with any sort of conclusion or even hypothesis about art and trade, art and cross-cultural relations, or objects and Prachtkunst, when the individuals or groups of people involved are Frederic II, the Franciscans, Joachim of Flora, Jalal al-Din Rumi, Marco Polo, Baybars, Genghis Khan, the Seljuq Turks, and Cilician Armenians? It is not only that no scholar can claim to have even elementary awareness of all the problems and monuments, it is also that my subject raises very peculiar questions of method, and I should like to deal first with two of them directly suggested by my title.

Few art-historical questions are as fraught with dangers as questions of influence. Three particularly complicated and elusive attributes of any monument need to be isolated for a meaningful discussion: (1) how significant within the monument is the motif or theme for which an "influence" is claimed? (2) how does one decide what is an influence; is it through the existence of outside models or through inconsistencies within the synchronic or other set to which the monument belongs? (3) how important is the monument; is it part of an established typology or an a-typical one?

These questions require the understanding of two aspects of a work of art: its own "semantic field" and the semantic field of any one of its parts and, second, the social or personal motivations and associations which surround it. Both semantic field and motivation–association possess two axes or vectors: a *re*-gressive one involving models, impacts, patronage, expected function and whatever else *preceded* the creation of a monument, and a *pro*-gressive one consisting of its actual uses, its impact on other monuments, the ways in which it was judged, altogether whatever happened to it after its creation. To deal with influences without possessing even partial monographic or

* First published in *Il Medio Oriente e l'Occidente nell'arte del XIII Secolo*, ed. H. Belting (Bologna, 1982), pp. 27–32.

typological studies of groups of pertinent monuments automatically leads back to lists of ill-digested motifs, at best the occasional discovery of an important document, most often a curiosity of little significance.[1] It is, for instance, true that some of the thirteenth-century lunettes at San Marco can easily be related, by their geometry of total covering of surfaces, to Islamic ornament,[2] but in the totality of San Marco, these little details are of secondary importance and thus their semantic field is quite small. Lists of *bacini* are interesting but so far have been more important for dating certain types of [28] Near Eastern ceramics than in helping to explain anything about an Islamic impact on Europe.[3] And, to use a slightly earlier example, studies on the imitations of Arabic writing on the doors of the cathedral at Le Puy have only shown, I feel, the existence of a strange and out-of-the-ordinary detail, not that a pattern can be established either for Romanesque architecture or for imitations of Arabic inscription.[4] Except for a group of Romanesque aquamaniles of the twelfth century,[5] an "Oriental" connection for a cohesive group of monuments or motifs has never to my knowledge been worked out or explained.

The second half of the title assigned to me poses an equally complicated methodological problem. Its implication is that there is a relationship between commercial movements and artistic contacts. Here we are faced with a choice between two methods. One is to identify trade routes and then seek and study appropriate monuments on these routes. The other is to discover whether formal or thematic parallels which are visually justified can be explained by commercial patterns. The second possibility requires the prior establishment of influences and I indicated how difficult it is to do so without ending up saying something obvious or useless. For instance, it can be shown that the celebrated Pisa griffin was brought to Pisa in a merchant ship from North Africa; for the Pisa griffin the information is very important, as it dates it and explains something of its background,[6] but for "influences" the information is of no importance, as the impact of the griffin was minimal.

The first possibility – the identification of routes (or of other means of contact) and then the search for monuments – may be more fruitful, especially

[1] Such is my criticism of otherwise useful lists such as K. Erdmann, *Arabische Schriftzeichen als Ornamente in der abendländischen Kunst des Mitteralters* (Mainz 1953–4), or S. D. T. Spittle, "Cufic Lettering in Christian Art," in *The Archaeological Journal*, 3 (1954). For a full bibliography see R. Ettinghausen, "Impact of Arts on the Arts of Europe," in J. Schacht and C. E. Bosworth, *The Legacy of Islam* (Oxford, 1974), pp. 316–20.

[2] O. Demus, *The Church of San Marco* (Washington, 1960), fig. 88 and pp. 104–105.

[3] G. Ballardini, "Note sui bacini romanici e in particolare su altuni bacini orientali in San Sisto di Pisa," in *Faenza*, 17 (1929), pp. 113–21.

[4] A. Firky, *L'Art Roman du Puy* (Paris, 1934).

[5] E. Dodd, "On the Origins of Medieval Dinanderie," in *The Art Bulletin*, 51 (1969).

[6] Information supplied by Dr L. Jenkins, of the Metropolitan Museum of Art, who is completing a study of the griffin.

if the routes or contacts can be shown to be new. Let me give two examples. One of the most important novelties of trade in the thirteenth century is the opening up of major trade routes in Anatolia, as the Seljuq Turks sought to attract business by building fancy caravanserais.[7] Among the rich architectural façades which identify nearly all buildings along the trade routes and in the cities they served, there is the striking façade of the Divrigi hospital, whose decorative themes are unmistakably Islamic but whose articulation in recessed splayings obviously derived from the visual and technical memory of some Western façade.[8] We cannot go much beyond that, as nothing known so far connects the local patrons (in this case a woman, perhaps born a Christian) and the builder with a Muslim name (but he could be a convert) with the West. In theory at least, impressions fostered by trade could be seen as influencing this unusual monument, but how significant can this rare example be?

My second example is the far better documented sack of Constantinople in 1204. Hardly a peaceful commercial enterprise, it *was* a "contact" between cultures, and we all know how enriched Venice became with treasures of all sorts and how much the conquest opened up Venice's trade with northeastern Europe and Asia. But does it matter for the development of Venetian art? Hardly at all. Contact is clear, visible, but, if there is an impact of Near Eastern forms, it is made only diffusely visible in certain arcades or in details from the façade of the [29] Palazzo Ducale, precisely elements and expressions which do not appear in those objects for which a contact can be demonstrated.

I shall return later to another aspect of medieval Venetian art. Let me simply say at this time that what seems known of the art of Pisa, Genoa, or Venice in the thirteenth century (at least to an outsider to the arts of Italy and of the West) does not seem to reflect the respective changes in the commercial or other Islamic connections of the three cities. And why should art reflect this trade? The lists of traded items (spices, precious stones, unfinished silk or cotton) hardly lend themselves to aesthetic impressions, with the partial exception of some textiles,[9] and the restricted life of merchants in alien lands hardly lent itself to more than occasional collections of local "souvenirs" and vague visual memories. Although not entirely fair, the comparison can be made with contemporary technicians and businessmen who stay at Hilton hotels and buy rugs in their shops.

So far my points have been primarily negative: imprecision of the very notion of influence without better understanding of artistic and thematic "sets" or better knowledge of patronage and motivation; difficulty in connecting obvious major events like the sack of 1204, the Venice–Genoa

[7] Basic publication by K. Erdmann, *Das Anatolische Karavanseray* (Berlin, 1961–76).
[8] The most available source is O. Aslanapa, *Turkish Art and Architecture* (London, 1979), pl. 14.
[9] W. Heyd, *Histoire du Commerce du Levant* (Leipzig, 1883–5), vol. II, pp. 556 ff.

commercial rivalry, or the opening up of Anatolian trade with well-defined artistic phenomena; danger of excerpting a single example, however fitting and appropriate it may seem.

But then, it can be argued, the thirteenth century in the Mediterranean is a most peculiar century and, in our perspective of Islamic–Christian contacts, a particularly unsettling one. Four examples of political events and monuments will, I hope, prove my contention of a confused century and suggest a way of interpreting it.

The first example is the monastery of Santa Maria de las Huelgas de Burgos, begun in 1187 (with many additions) and used throughout the thirteenth and early fourteenth centuries as the main place of burial for the ruling family of Castille. Its stuccoes and especially textiles form a remarkable series of reasonably well-dated thirteenth- and fourteenth-century works, and Gómez Moreno has successfully separated purely Islamic works from *mudejar* and already Gothic ones.[10] The interesting points are two. One is that the chronological sequence based on whatever is known about the life of the deceased does not correspond neatly to a stylistic sequence; the cultural assumption of a growing "northernization" does not quite work, especially if stuccoes and woodwork are also taken into consideration. The other point is that this century of particularly successful *reconquista* (by the end of the century the kingdom of Granada alone remains in Muslim hands) is also the century of full formation of *mudejar* art. There is, therefore, an apparent contradiction between cultural appreciation and political antagonism, a contradiction which is just as clear in the Sicily of Frederic II and which, I will suggest later, is more apparent than real.

I am more hesitant about my second example, Italy, because we are, at least to my knowledge, lacking in clearly datable sequences or [30] in an obvious stylistic or ideological focus around which even an intellectual construct can be built. To be sure, there are church façades in Siena, Assisi, Perugia, Pisa, and pavements in San Miniato whose tight geometry, unarchitectonic sheathing and animal motifs can easily be related to Near Eastern or Spanish Islamic ornament. Then a sequence of textiles from Palermo or Lucca can easily be put together suggesting that, while Islamic patterns of medallions with animals or personages may have initially inspired Italian weavers, during the thirteenth century novelties and changes occur which do not owe much to Islamic sources: growing vivacity of poses for hitherto frozen forms, incorporation of themes (towers, for instance) from the visible world. Two such changes are particularly far-reaching and have already been pointed out by Weibel or Podreider, among others: the abandonment of the dictatorial medallion for a more fluid and more sophisticated composition of equally weighted units; and the reworking of traditional ornamental animal motifs into Christian ones, as

10 M. Gómez Moreno, *El Panteón Real de las Huelgas de Burgos* (Madrid, 1946), pp. 45 ff.

gazelles may well have become the Lambs of God in a silk now in Düsseldorf.[11] Reworking may even become translation, as a Lucca silk has "Felice" written on its wings in the very form and manner characteristic of Islamic textiles. We know from a text published by Bertaux many decades ago that there were many Muslim artisans in southern Italy and that toward the end of the thirteenth century they were relocated;[12] such is the traditional explanation for the early styles of Lucca during that century. What is troubling in these Italian examples is not merely, as I have indicated earlier, that Pisa, Genoa, Venice – the key trading intermediaries with the Orient – do not exhibit obvious or extensive impacts from the Orient, but, much more significantly, that Sicily and southern Italy, those provinces where Frederic II constructed his unique synthesis with a large number of Muslim artisans, soldiers or advisers, do not exhibit Islamic features even remotely comparable to those of the preceding century.[13] Bertaux has well shown the dangers of seeing a Saracen behind every fortress wall.

My third and fourth examples may help in formulating an explanation and series of hypotheses for the thirteenth century. I have already alluded in another context to the façades on Anatolian buildings. Since these are probably less familiar to medievalists, let me expand on them. Although conquered from Byzantium at the end of the eleventh century, it is during the thirteenth that the Seljuq rulers covered Anatolian cities and roads with mosques, *madrasas*, caravanserais, hospitals, mausoleums – in short, all the functions of the urban culture of Islam. Among many unique characteristics of these monuments is their predilection for impressive façades, a form, in my judgment, of conspicuous consumption. A great deal is known about the patrons and builders of these façades; they ranged from Christian converts to Islam to Turks recently arrived from Central Asia. But the important point for our purposes is the immense variety of their formal vocabulary within a technique of stone construction which is clearly Anatolian: flat surface of designs of many kinds, stalactite half-domes, and a series [31] of unique attempts at three-dimensional articulation. These façades, which are contemporary with each other and the products of the same social milieu, do not form a *style* in the standard meaning of the term. They do, however, illustrate a taste, a taste for the externalization of whatever set of forms struck an individual's fancy or whatever habits and practices an artisan had at his command. Experimentation was rife because the spread of possibilities was, for historical and cultural reasons, unusually wide.

[11] O. von Falke, *Decorative Silks* (New York, 1922), figs 22, 223, 226; A. C. Weibel, *Two Thousand Years of Textiles* (New York, 1952), pp. 59 ff.; F. Podreider, *Storia dei Tessuti d'Arte in Italia* (Bergamo, 1928), pp. 29 ff.

[12] E. Bertaux, "Les Arts de l'Orient Musulman dans l'Italie Méridionale," in *Mélanges d'Archéologie et d'Histoire*, 15 (1895).

[13] The issue is a very complicated one, as can be seen from *Federico II e la cultura musulmana, Atti del Convegno Internazionale di Studi Fredericani* (Palermo, 1952).

My fourth example consists in a fairly well-known although little studied group: practical objects (ewers, candlesticks, plates, bottles, cups) of bronze inlaid with silver containing Christian subjects.[14] The technique has been common in the Muslim world since the middle of the twelfth century, but the objects with Christian subjects are limited to, roughly, the first half of the thirteenth century and to the Fertile Crescent, that is Palestine, Syria, northern Mesopotamia, possibly (but not very likely) Egypt and Anatolia. Hitherto these objects were considered as examples of the art of Christians all over the Levant. But a recent investigation by two students at Harvard University has brought out a more novel and probably more accurate explanation.[15] Three of their arguments are pertinent to our purposes. One is that the Christian imagery on these objects is always defective from a strictly Christian point of view and never deals with critical themes of Christian dogma. The second is that nearly all objects contain the full range of the so-called Muslim princely cycle, and the third is that this kind of object disappears from existence shortly after the middle of the century. The explanation is that these objects were made for the primarily Muslim but also Christian feudal lords of the Levant, as the early decades of the thirteenth century are times of a sort of feudal balance of territorial and personal treaties in which individual deals took precedence over religious and ethnic allegiance. Charles of Anjou, in his efforts against Michael VIII Paleologus, signs treaties with Hungary, Bulgaria and the Tatars. Gregory IX denounced Frederic II for his arrangements with infidels. Muslim religious leaders, on the other hand, criticized Ayyubid leadership for exactly the same reasons, that they established a political and cultural, aristocratic, *modus vivendi* with Christians in the Levant. The inlaid metal with Christian subjects would appear as the visual illustration of this *modus vivendi*.

Thus my introductory remarks introduced a methodological concern with superficiality in the arbitrary choice of an accidental motif or with the easy assumption that expanded trade *has* to have results. Examples of monuments of different kinds and in different regions possessing both Christian *and* Muslim components permit another conclusion. *It is the absence of a coherent pattern in that art of the Mediterranean where contacts between cultures were most obvious, and at times even the appearance of visual tendencies which seem contrary to expectations.*

The contrast is striking with the twelfth century, when in Sicily a reasonably clearly defined semantic field is provided for Byzantine or Islamic forms, and, in Spain or in the Levant, Christian and Muslim [32] forms coexist but

[14] These objects have often been mentioned but rarely discussed. For an exception, see L. T. Schneider, "The Freer Canteen," in *Ars Orientalis*, 9 (1973).

[15] Ronnie Katzenstein and Glenn Lowry are completing a study of all these objects; see their article in *Muqarnas*, vol. 1. Ms Katzenstein also helped me a great deal with the documentation which led to this paper. I am most grateful.

hardly interfere with each other; it is as though the role of each set of forms and themes was clear and accepted. The contrast is also striking with the fourteenth century, when Lucca textiles lost almost completely their Islamic prototypes, but occasionally add a pseudo-Kufic inscription or even a Chinese dragon; when Hugh IV de Lusignan orders an inlaid brass to be made for him in Egypt;[16] when the first steps of Venetian inlaid metalwork occur; and when the robes or haloes of Virgins acquire imitations of Arabic inscriptions, culminating in Gentile de Fabriano's *Adoration of the Magi,* where one can even recognize the beginning of the Muslim profession of faith: there is no God but God. The Orient, Islamic or Far Eastern, has become exoticism, luxurious carpets or objects leading to the *turqueries* and *chinoiseries* of later centuries.

What happened then in the thirteenth century? I would like to propose the following explanation, being fully conscious of its hypothetical character. The thirteenth century is a turning point in the history of Mediterranean forms, because it was the century during which the cultural equilibrium of the Mediterranean was modified. The failure of the Crusades, the weakening of Byzantium, the growth of Italian cities and of Spanish Christian kingdoms (not to speak of what was happening in northern centers) – all of these changes led, first of all, to a less fluid and less continuous relationship between Muslim and Christian cultures, in a way also between Eastern and Western Christian cultures; a political and fiscal control ruled over contacts and Oriental objects became luxury items, for which substitute and at times improved techniques eventually developed in the Christian world. But a more interesting conclusion would be that in the thirteenth century, and especially in the fourteenth, forms and subjects began to acquire a nationality or, perhaps more appropriately, they were no longer simply useful or beautiful attributes of power and prestige. They were associated with a place and eventually with a person, an artist; they became works of art and, to a degree, escaped from life.

This point, however, leads to the far more important and more fascinating issue of the relationship between object and works of art within medieval social systems, but it is an issue which is not directly pertinent to this paper.

Let me conclude on an entirely different note. Many of the Anatolian monuments I mentioned were restricted to Muslims, but the feature in them which is pertinent to our purposes is their most public one, precisely the one which was not restricted. On inlaid metalwork, on the other hand, the reverse occurs. The object is not culturally restricted; its Christian imagery was initially culturally restricted but its occurrence on the objects and its association with entirely different themes weakened its original cultural restrictions. Gentile de Fabriano or the very Christian kings of Castille never

[16] D. S. Rice, "Arabic Inscriptions on a brass made for Hugh IV de Lusignan," in *Studi Orientalistici in onore di Georgio Levi della Vida* (Rome, 1956).

worried about the restricted meaning of the inscriptions they copied or used. All these monuments are in a secular *mode* which is characterized by a lower and less compulsory intensity of meaning associated with any one form. Islamic art, [33] it has been argued by some, lent itself to such secular use, because of its abstraction and possibly its own lesser intensity of meaning.[17] But a more accurate explanation would rather be that Islamic and Christian art could fulfill this secular function for each other, because of ignorance of each other's restricted meanings. It is this ignorance, even tainted with antagonism, which grew in the thirteenth century. Roger II could still endow his Islamic ceiling and his Islamic coronation robe with specific meanings, because the nationality of forms and themes was not very important to him, only the ideological or aesthetic effect they had. After 1204 Venice used its looted treasures as "things," sometimes transformed into chalices or patens, most often kept in treasure rooms, eventually even making and selling back to the Orient cheap imitations of their techniques.[18] It is in the thirteenth century that the psychological and motivational changes occurred in the relationship of Western Christian and Islamic cultures which eventually led to the use of Persian and Indian miniatures as wall-paper in Schönbrunn.

Thus it is that the main changes of the thirteenth century are not really formal ones but changes in point of view.[19] It is the eyes of the cultures which become different. Why did the change take place? In part, no doubt, for the political reasons mentioned earlier. But a more interesting and in the long run a more fruitful explanation can be proposed, although its full elaboration requires totally new investigations. To the intercultural art taste of kings and princes there was substituted (or simply added), with the same and at times improved technical sophistication, the art and taste of an urban bourgeoisie, more localized in its use, but also beginning to be affected by what can be called an art market. The sources for this development are certainly in the twelfth century[20] and the fruition will be in the fourteenth.

17 This is implied by R. Ettinghausen, "The Decorative Arts and Painting," in J. Schacht and C. E. Bosworth, *The Legacy of Islam* (Oxford, 1974).
18 Heyd, *Histoire*, p. 711. Note also the very perceptive remarks made by O. Demus about the exoticism of thirteenth-century Venetian art, "Oriente e Occidente nell'arte Veneziana," in *La Civilta Veneziana del Secolo di Marco Polo* (Venezia, 1955), p. 114.
19 For an entirely different side of these "points of view" of the thirteenth century, see A. Grabar, "Art du XIIIe siècle. Problèmes et Méthodes d'Investigation," in *L'Art Byzantin du XIIIème siècle* (Belgrade, 1967).
20 O. Grabar, "Imperial and Urban Art in Islam," in *Colloque International sur l'Histoire du Caire* (Cairo, 1972), reprinted in *Studies in Medieval Islamic Art* (London, 1976).

Chapter IV

The Shared Culture of Objects*

In 1959 the distinguished philologist Muhammad Hamidullah published a text entitled *The Book of Treasures and Gifts*.[1] The manuscript of the text, preserved in the public library of Afyonkarahisar in Turkey, is, as far as we know, unique, and it contains a number of oddities and misunderstandings introduced by later copyists. However, Hamidullah established that the original author of the text was one al-Qadi al-Rashid Ibn al-Zubayr, probably an official of the Fatimid court or an administrator of some sort in Cairo, who had been, among other things, an eyewitness to the dramatic events that shook the Fatimid regime after 1060 and that included, in 1067–68, the looting of the imperial palace in order to pay the army. No dated or datable event recorded in the text is later than 1071.

The book consists of 414 separate accounts, some quite short, others going on for several pages, of treasures kept, found, looted, or inherited by, mostly, Muslim rulers and of gifts exchanged within ruling circles of the Muslim world on the occasion of marriages, convalescences, circumcisions and other social or personal events, as well as between Muslim and other rulers. These accounts are organized into uneven sections dealing with the functions around which objects were exchanged or acquired. The book is not a work of *belles-lettres*, as it is poorly composed and makes little effort at literary effects, in spite of several quotations from poetry. It is in reality a sort of digest, with information restricted to the relatively limited topic of gifts and treasures.[2] It does not claim completeness (in fact, the copy we possess may well have been a summary from some larger opus), but there is a curious coherence in the book, a coherence of tidbits strung together, akin to the coherence of the "living" or "home" sections of today's newspapers and magazines. The book does not include moral judgments about the evils

* First published in *Byzantine Court Culture from 829 to 1204* (Washington, DC, 1997), pp. 115–29.

[1] Muhammad Hamidullah, ed., *Kitab al-Dhakha'ir wa al-Tuhaf* (Kuwait, 1959).
[2] The exact literary genre to which it belongs is unclear to me, and the book is not mentioned in the great encyclopedias such as C. Brockelmann, *Geschichte der arabischen Literatur*, 5 vols (Leiden, 1936–42), or F. Sezgin, *Arabische Schrifttum*, 11 vols (Leiden, 1975 ff.).

of wealth, a common theme of medieval writing in Arabic or Persian. It is not a "Mirror of Princes" proposing patterns of behavior for rulers, nor is it an account of marvelous and odd things from remote lands. In short, there is something unclear about the genre to which the book belonged or the exact medieval audience for which it was destined.

Some of the accounts in Ibn al-Zubayr's book are clearly legends and fancy stories [116] dealing with exotica like the treasures of the kings of China and the peculiarities of Tibetan and Hindu rulers. But an unusually large number of his stories are verified or verifiable through other sources, plausible for a variety of reasons, or actual eyewitness accounts. It is the latter, more particularly the reports about the looting of the Fatimid palace, that brought attention to this text when it was first published.[3] A number of the stories pertaining to relations between Muslim and non-Muslim courts were already noted some thirty years ago, but were not often used by scholars of medieval art whose reading habits do not usually include *Arabica* or *The Journal of the Pakistan Historical Society*.[4] The recent completion of a translation of the text with various commentaries, which one hopes will soon be published,[5] is an occasion for me to return to this source and to explore the topic of Byzantine court culture from the very special point of view of the information found in a book on past and present gifts and treasures for readers from the Arab, primarily Muslim, world.

Regardless, however, of the audience to which it was directed, this text contributes to something I would like to call the anthropology of the object. What I mean by that is an understanding or an appreciation of the thousands of items, which we usually exhibit or publish in terms of technique, time and place of manufacture, and decoration, as active ingredients in the fabric of daily or ceremonial life or as carriers of real or contrived memories. But this fabric of common or ceremonial behavior and these memories are not, most of the time, provided directly by the objects, but indirectly through their appearance in a written text. The difficult question is always to define the boundaries between a written document meant to be read or heard and images or objects meant to be seen or used. The problem is a well-known

3 Although not the last word on the subject, O. Grabar, "Imperial and Urban Art in Islam," *Colloque International sur l'Histoire du Caire* (Grafen, 1972; repr. in *Studies in Islamic Art* [London, 1976]), pp. 183–5, contains most of the operative bibliography with respect to the arts. It is sad that the evidence from this event has not been picked up, to my knowledge at least, for further discussions of the arts available in Cairo in the eleventh century.
4 Muhammad Hamidullah, "Embassy of Queen Bertha of Rome to Caliph al-Muktafi billah in Baghdad, 293H/906," *Journal of the Pakistan Historical Society*, 1 (1953); idem, "Nouveaux documents sur les rapports de l'Europe avec l'Orient musulman au moyen age," *Arabica*, 7.3 (1960), pp. 281–300.
5 Ghada H. Qaddumi, *A Medieval Islamic Book of Gifts and Treasures*, Ph.D. diss. (Harvard University, 1990), now published as *Book of Gifts and Rarities* (Cambridge, Mass.: Harvard University Press, 1996).

one for sculpture and painting, where a one-to-one relationship can be established between a text and an existing or destroyed work of art.[6] It is a more difficult one for objects, since texts are related to classes and types of objects rather than to individual ones. A full discussion of this particular and more theoretical topics should include those accounts in Ibn al-Zubayr's book which deal with lands other than Byzantium. However, that discussion will not be pursued in this essay, even though it is probably the most interesting contribution of this book to the history of the arts.

I shall begin by providing all the examples from the *Kitab al-Dhakha'ir* which deal with Byzantium. Most of them had already been translated into French over thirty years [117] ago by Hamidullah himself, but he did not attempt to go beyond the identification of their historical circumstances. Some of them are known in part or as a whole from other Arabic, Muslim or Christian, sources as well, but I have not sought such parallels as may exist in Greek sources, nor have I culled anew classical Arabic texts.[7] With one or two exceptions, all the examples will be between 900 and 1070. The closing date is obviously such because the source stops around 1072. It is also a legitimate one, because the twelfth century introduces, at least within the context of Seljuq domination in the Muslim world and as a result of the Crusades, a largely different configuration in the anthropology of courtly objects.[8] I shall suggest at the end that the tenth and eleventh centuries set the stage for that configuration in more interesting ways than those of merely preceding it.

A more curious point is the relative absence of examples before 900. The four that exist are remarkably short and imprecise: a present of silver, gold, precious stones and silk (all raw materials) given to Emperor Maurice by Khosro Parviz in the sixth century (account 5); the gold and mosaics (again raw materials) given to al-Walid for the mosque of Damascus (account 9); musk and sables added by al-Ma'mun for a present to the Byzantine emperor, probably Theophilos, in order to outbid the latter in a munificence which is not otherwise specified (account 31); fancy silk cloth and an equally fancy belt given by a Byzantine king to a governor of Azerbayjan who, in turn, gave it to Caliph al-Mu'tadid between 892 and 902 (account 62). There is not much for the historian to garner in these accounts, and all they evoke is

6 Without going back to Pausanias or to Pliny, the issue has been raised, among others, by H. Maguire, *Art and Eloquence in Byzantium* (Princeton, 1981); Paul Magdalino, "The Bath of Leo the Wise and the 'Macedonian Renaissance' Revisited: Topography, Iconography, Ceremonial, Ideology," *DOP* 42 (1988), pp. 97–118, and M. Baxandall, *Patterns of Intention* (New Haven, Conn., 1985).

7 A. A. Vasiliev and M. Canard, *Byzance et les Arabes*, 2 vols (Brussels, 1935; repr. 1968), vol. II, pp. 278–9, mentions Ibn al-Zubayr's recently published book and contains the only comparative sources I used systematically.

8 Much has been written about the artistic changes that characterize architecture from the late eleventh century on and the other arts from the middle of the twelfth century. See R. Ettinghausen and O. Grabar, *Islamic Art, 650–1250* (London, 1987), pp. 328 ff.

within the standard statement of known and obvious facts or of perfectly trite minor events. Both the tone of the texts and the character of the information change drastically as we move into the tenth century.

After presenting Ibn al-Zubayr's stories, I will discuss briefly where possible visual illustrations for his accounts can be found. There is not a single instance where I (or anyone else so far) have been able to match a textual reference with a specific remaining object. All that can be done is to identify types and classes of things that existed in the past and that have at times been preserved through accidents of history. Then a series of additional observations derived from the texts will lead me to wider issues of interpretation and to some comments on objects of courtly art between the tenth to twelfth centuries.

(1) Accounts 73 and 74 deal with an event recorded otherwise in several Arabic chronicles but not in the detailed fashion of Ibn al-Zubayr.[9] The event is the arrival in Baghdad of a Byzantine embassy with gifts sent to Caliph al-Radi by Romanos Lekapenos, together with Constantine and Stephen ("leaders of the Byzantines", the Arabic [118] being ra'is, "head"),[10] presumably his children.[11] What is given is the text of the Arabic translation of the letter allegedly sent from Constantinople which accompanied the gifts. The Greek text was written in gold and the Arabic translation in silver, thereby indicating that the letter was written down in both languages in Constantinople. The indicative value of the letter is complicated by the following words found at the end of the presumed translation, as reported in the eleventh century: "I, the translator, ask you to excuse my description of the gifts since I have not seen them with my own eyes so that I could describe them properly." The interpreter of today has even further difficulties in that he cannot understand or translate appropriately into English many technical terms that may have been clearer to the tenth-century writer or the eleventh-century copyist.[12] For the purposes of this paper, I shall skip these technical issues, which are not central to this volume's concerns with the Byzantine court, but rather to techniques of manufacture, although at some point the latter must receive full scholarly attention by gathering together practicing artisans from different lands as well as classical Hellenists and Arabists.

9 Vasiliev and Canard, *Byzance et les Arabes*, II, pp. 278–9.
10 Since we are dealing with a translation from the Greek, it is curious that the relationship of Constantine and Stephen to Romanos is not more explicit. This may have something to do with the assumed Greek original.
11 There was around that time a patriarch named Stephen, but his dates (925–8) do not quite fit and the Constantine is unlikely to have been Romanos' predecessor.
12 Qaddumi's thesis is the first attempt to find appropriate contemporary equivalents for these technical terms, but some of her interpretations are only first steps in what should become a major investigation of the vocabulary for manufacturing in classical Arabic.

The formal letter is addressed from Romanos, Stephen and Constantine, highest placed (*al-'usama*) in Byzantium and "believers in God", to "the honorable and magnificent sovereign of the Muslims", and avoids references to Christ or the Prophet which could create friction. After wishes for peace and for characteristic ransom and truce settlements, it continues:[13]

we have sent ... some fine articles which reveal the deep-rooted affection and sincere sympathy we have for your brethren [presumably the Muslims]. The articles are:

three gold beakers inlaid with precious stones;

a rock crystal flask encased in gilded silver, decorated and studded with precious stones and pearls; on top of its lid there is a rock crystal lion;

another rock crystal flask which was on one side encased with gilded silver latticework studded with precious stones, in the center of which there are roundels; on the other side there were four silver threads overlaid with gold;

a silver gilded vessel in the shape of a gourd and a tankard, both inlaid with precious stones;

a gilded bucket-like jar inlaid with precious stones and studded with precious stones and pearls; it is inscribed at the mouth with [the statement]: "God's voice over waters (or over life)";[14] [119]

another two-handled jar of gilded silver studded with pearls and various kinds of gems; on its lid is mounted the sculpture of a peacock;

a gilded silver bucket inlaid with precious stones and studded with pearls and precious stones;

another gilded bucket studded with precious stones;

a small three-handled gilded silver jar inlaid with precious stones and engraved with representations of small birds and of narcissi, and inscribed at the mouth;[15]

a small eight-sided gilded silver casket inlaid with precious stones, its oblong lid studded with pearls and precious stones; inside the box are three narrow scarves (?) of linen decorated with gold and large gilt roses, three narrow scarves decorated with gold and small roses; three raw-silk turbans, the edges of which are decorated with gold;

a silver case for several large goblets, inlaid with precious stones and inscribed at the mouth: "O God, strengthen king Romanos";

a small gilded silver jar with two small handles studded with precious stones and pearls; on its handle and rim there are three figurines of peacocks;

a case containing two knives whose handles are of bezoar encased with gold wires and inlaid with precious stones; on top of the handles are profusely ornate emeralds decorated with gold;

13 What follows is a simplified translation that avoids almost all problematic terms and does not provide the Arabic equivalents, which can be found in Qaddumi's work.

14 Hamidullah edited the text with "life" (*al-hayat*) and suggested "water" (*al-miyah*) as an alternative, but preferred the latter in his translation because it correctly identifies a passage from the psalms (29:3) which was in fact used on objects, as was pointed out by I. Ševčenko, and therefore serves to authenticate the text of the letter.

15 Qaddumi's translation here differs from Hamidullah's, but seems to reflect the text more accurately.

two other knives with handles decorated with small pearls and other stones; their case is studded with rubies, pearls, and black stones, and their scabbards are of gold profusely adorned with pearls;

a heavy battle-axe with a head made of gilded silver inlaid with precious stones and studded with pearls; on its shaft there is silver latticework profusely adorned with gilded silver;

three knives, one of which is profusely decorated with gold; the other two are of silver, and one of them has a gilded handle;

seven brocade covers, one with a design of eagles in two colors, another with a floral design in three colors, another with three-colored stripes, a red one with colored foliate design, the design of yet another one consisting of trees on a white ground, two with the design of a hunter set in a roundel on a white ground, two with crouching lions on a yellow ground, two with eagles set in roundels;

ten pieces of red *siqlatun* fabric;[16] ten more pieces of violet cloth; five pieces of multicolored *siqlatun*, five pieces of white *siqlatun*; twenty pieces of striped cloth;

four pelts, one of which is called *kabak* (with sable collar), the second of white fox, the third is *balis*, and the fourth is called *baks*;[17]

as to covers, two are of velvet with a design on a violet ground representing an eagle in a roundel and horse riders above;

two more wrappers with a similar design but without velvet pile;[120]

another one with a palm tree design and a green background;

ten pieces of thin brocade, one with the representation of a riding king with a flag in his hand, another with a bird fighting a lion with its two wings. Two others with a winged beast, another with an eagle seizing an onager, one with a unicorn, another one with wild goats in six roundels, another one with fifteen roundels on a white ground; one more with a rhinoceros seizing a leopard, another with a winged quadruped with small eagles in the four corners;

ten large velvet outer garments, one of emerald green *siqlatun* cloth with elephants within its stripes; the other had within its borders rosettes, in the center of which there are ducks and other birds;

a *siqlatun* cloth with birds within its borders, another one with unicorns, while the borders of another one are decorated with a yellow lion; another one has lion heads with wide-open mouths and a tree in the center;

another has inside its borders figures of riding kings and a unicorn and inside a winged quadruped;

ten colored pieces with borders decorated in the *barmaniyah* (?) way; ten green hooded mantles with borders with ten protomes of beasts of burden;

ten kerchiefs with images.[18]

Such is a slightly simplified English version of a presumed translation into Arabic of a Greek text accompanying gifts brought from Byzantium to Baghdad. Most of these objects are plausible in the sense that, except perhaps

[16] For the various uses of this term, which also means "scarlet," see R. B. Serjeant, "Material for the Study of Islamic Textiles," *Ars Islamica*, 15–16 (1951), p. 301, for further references.

[17] These terms are all unclear, and there has been no attempt to elucidate them further.

[18] Other translations are possible, such as "borders" or "representations." The point seems to me that identifiable items were shown, whatever they were.

for a certain extravaganza of precious stones, verbal descriptions agree with types of objects, techniques and decoration known otherwise. At this stage of presenting the accounts in Ibn al-Zubayr's text, however, the response of Caliph al-Radi to the "three leaders of the Byzantine people" is particularly interesting: "the Commander of the Faithful has complied with what you have anticipated from your gift and has provided the envoy with what manifests his respect for you, instead of exposing you to shame and loss of pride, so as to prove yourself to be above [mere] opportunism. A list of this gift [i.e., the one al-Radi sends back with the Byzantine envoy] will be attached to this letter." The meaning is, I believe, that a comparable set of presents was sent to Romanos, so as not to humiliate the Byzantine emperor by appearing to treat his gift as a sort of bribe. Unfortunately we do not possess, at least to my knowledge, an Arabic or Greek list of the other half of the exchange.

This long passage also suggests a remarkably extensive cast of characters involved in the making of the text we possess: in Constantinople, some official gathering the gifts and making a list in Greek, having it translated into Arabic by someone who has not seen the gifts, which were presumably already packed; then in Baghdad, a process of administrative and ceremonial acknowledgment of reception and eventually the copying of the text put together in Constantinople into a work for the general public. Even larger numbers of people must have been involved in the packaging, protecting, delivering and [121] eventual storing of the objects. The budgetary implications of this text are quite staggering, above and beyond the value of the items it describes. It may well be possible to identify within the service structure of the Byzantine as well as 'Abbasid courts the individuals or at least positions involved in the transactions suggested by this gift and the spaces needed for the successful enactment of these transactions.

(2) Account 82. In 1046 Constantine IX Monomachos sent a gift to the Fatimid caliph al-Mustansir on the occasion of the signing of a treaty renewing for ten years the armistices at the frontier between the two realms. The mercantile attitude of a contemporary observer establishes first that the value of the gift was 216,000 Rumi (i.e., Byzantine) gold coins plus 300,000 Arabic dinars. Perhaps economic historians can establish the value involved in the gifts, which included one hundred fifty beautiful mules and selected horses, each of them covered with a brocaded saddle cloth, and fifty mules carrying fifty pairs of boxes covered with fifty pieces of floss-thin silk brocade. The animals were led by two hundred Muslim prisoners of war who had been held in captivity, and the boxes contained one thousand pieces of different kinds of brocade, three hundred pieces of thin brocade, red Rumi belts bordered with gold, high turbans embroidered with gold, drapes for curtains, and brocade kerchiefs in which clothes were wrapped.

(3) Accounts 84 and 85. In 1053 Michael VI sent a gift to al-Mustansir which included: Turkish slave boys and girls; partridges, peacocks, cranes, aquatic birds, ravens, and starlings, all of which were white; huge bears that played musical instruments; Saluqi hounds and guard dogs; boxes and chests that numbered over seven thousand and contained "fine things," unfortunately not described. Two boats were used to transport all of this. The more interesting part of this story is that, after delivering the gifts in Cairo, the Byzantine messenger sailed to Jaffa, accompanied by Fatimid sailors, whence he went to pray in the church of the Holy Sepulcher in Jerusalem and to deliver gifts from the Byzantine emperor to the church rebuilt about a generation earlier. The list of these gifts is provided: a short sleeveless gold waistcoat studded with all kinds of splendid precious stones; two gold crosses, the length as well as the width of each being three and a half cubits, weighing one whole qintar (around 45 kg)[19] and adorned with rubies and other precious stones; many gold trays adorned with precious stones; two gold ewers, the capacity of each being twenty Baghdadi *ratls* of wine; several gold chandeliers with gold chains and in their center small birds of rock crystal; many long drapes or curtains of thick embroidery with an abundance of gold threads and precious stones; and other such church equipment. All of this was exhibited on Easter day.[20]

(4) Account 91. In 1057 the Seljuq ruler Tughrilbek sent to the Byzantine emperor, presumably Michael VII, a pearl-encrusted vest on the front of which was sewn or [122] otherwise affixed the seal of Solomon in red rubies and weighing 45 *mithqals* (*c.* 20 grams); a hundred silver candlesticks with large ceremonial candles; one hundred and fifty apricot-colored Chinese[21] porcelain dishes; one hundred garments, each composed of two pieces of cloth interwoven with gold; two hundred pieces of *siqlatun* cloth; two hundred pieces of black and white striped cloth; ten drum-shaped scent baskets lined with leather and filled with camphor and aloeswood. All of this, reports our author, was valued at 2,400 dinars, which seems rather cheap by comparison with what the Byzantine emperor sent to Cairo, but then the text adds that he (emperor or ambassador) also "was paid 50,000 dinars in cash."

(5) Accounts 97 to 99. Our author goes back in time and recalls that the Byzantine emperor Michael, probably the same Michael VII, had offered to

[19] These and subsequent evaluations of weight and length measures are approximate guesses based on Walther Hinz, *Islamische Masse und Gewichte* (Leiden, 1970).
[20] The events that led to the sending of this gift have been discussed by R. Ousterhout, "Rebuilding the Temple," *Journal of the Society of Architectural Historians*, 48 (1989), pp. 66 ff.
[21] The term used is *sini*, which could either mean "Chinese" or refer to a fancy technique of manufacture, such as one of several varieties of luster wares.

the mother of al-Mustansir five bracelets of jewelry inlaid with glass of five colors: deep red, snow white, jet black, sky blue, and deep azure. It was beautifully fashioned, and its inlaid design was of the finest craftsmanship. The same emperor is also supposed to have sent to al-Mustansir three heavy saddles of enamel inlaid with gold. He mentioned that they were from among the saddles of Alexander the Great. But in the following account a saddle is described in great detail and, says our author's informant, on the saddle there was a piece of paper with the handwriting of al-Mu'izz, the Fatimid caliph who established Cairo in 969, saying: "the Byzantine emperor offered us this saddle and the bridle after we entered Egypt." And the minister of the time added that it was one of the saddles that had belonged to Alexander the Great and had been transferred by the latter to the Byzantine treasury.

(6) Account 101. In 1062 our author hears from a freed slave of the governor of Sicily that Basil, the Byzantine king (in this story probably a generic Basil), had given to the former slave's master a casket in which there was a medium-sized stone that could be used to cure dropsy.

(7) Account 105. In 1071 the Hamdanid Nasir al-Dawlah gave to Emperor Romanos IV Diogenes a gift worth 40,000 dinars. It included: two long sticks of aloeswood; five unique rock crystal objects with characteristics that are difficult to understand; a large tapering bucket with enormous capacity; brocade cloth with representations of wine-colored eagles on white ground, weighing 4,000 *mithqals* (168 kg) and valued at 1,000 dinars; cloth embroidered with gold and heavily encrusted; all sorts of pieces of cloth cut for a variety of purposes; beautiful jewelry, and all sorts of utensils. In exchange the Byzantine emperor sent to Nasir al-Dawlah gifts that included a compact embroidery with gold threads that was so heavy it was all a single mule could carry.

(8) Account 105. The felt cloak of Romanos IV that had been taken from him when he besieged Aleppo in 1031 was given to the new governor of Aleppo by the daughter [123] of the previous one. "Its trails, sleeves, and openings were adorned with pearls of great weight. At the back and front of the cloak were gold crosses adorned with rubies."

(9) Accounts 161 to 164. This is another version of the celebrated story of the Byzantine embassy that went to Baghdad in 917.[22] It does not bear directly on the present subject, except for being a striking illustration of the display throughout the whole city of Baghdad of practically every person,

22 Vasiliev and Canard, *Byzance et les Arabes*, II, pp. 239–43; O. Grabar, *The Formation of Islamic Art*, 2nd edn (New Haven, Conn., 1987), pp. 159–64.

animal and object controlled by the caliph. Such showy displays existed also on a more modest scale. Thus, according to account 173, when a certain Basil was sent as an envoy to Caliph al-Hakim, fairly early in Fatimid times, the latter "wished to furnish the throne room with unusual furnishings and to hang up extraordinary wall hangings. He ordered that the storerooms of furniture be searched, and twenty-one bags of such things were found, which had been carried by caravan from Qayrawan in Tunisia to Cairo." Each piece had a slip attached to it which identified its technique and the time of its manufacture. In the foreground of the throne room a shield was hung which was adorned with all sorts of costly precious stones, illuminating its surroundings. "When sunlight fell on it, the eyes could not look at it, as they became tired and dazzled." Aside from its rare reference to the visual impact made by objects, this account offers a glimpse into what may be called the curatorial world of court treasuries, with identifying cards attached to every object.

(10) Account 229. When Marwan was captured by the 'Abbasids in Egypt in 750, there was in his treasury a table of onyx with a white background and black and red stripes. It had gold legs. There was also a goblet of Pharaonic glass with an image in high relief representing a lion and a man kneeling in front of him while fixing an arrow on his bow. These particular objects, the second one of which was certainly some late antique gem, were kept by the 'Abbasids and eventually given to a king of India. The interest of this story is that, like several other accounts (none, however, involving Byzantine objects from the period under consideration), it indicates a double mobility of objects. There was an internal mobility, whereby the imperial households used for practical purposes or played with things found in the treasury and passed them on to children, slave girls, or convalescing spouses. A precious object with a known pedigree was once found as a door stopper in Cairo or Baghdad, and many a wondrous item was destroyed as children's toys. And then there was an external mobility, as the gifts found in one place or belonging to one person were sent to someone else, in a continuous exchange of expensive white elephants.

(11) Account 263 is a curious passage that is like a moment from the *Book of Ceremonies* seen by a Muslim Liutprand, but without the venom of the bishop of Cremona. In 1071 one Ibrahim b. Ali al-Kafartabi, who had been in Constantinople, related that he saw [124] Emperor Romanos Diogenes on the day of their (the Christians') great feast, probably Easter.[23]

[23] Although not an important point for our purposes, it should be noted that at Easter time of 1071, the fateful year of Mantzikert, the emperor was campaigning in Armenia. Al-Kafartabi must have been relating something he had seen earlier.

He was wearing a garment of the kind their emperors wear with great difficulty, as they are neither able to bear it properly nor to sit with it, because of its heavy weight and because they are too weak. The garment contained thirty thousand pearls, each of which weighed about one *mithqal* [this makes something like 126 kg, which is certainly too much]; it is priceless, nothing comparable being known on earth. Al-Kafartabi told me that the emperor was accustomed to wear, during his travels, casual garments adorned with precious stones and large pearls of various kinds. Each garment was worth about 200,000 dinars. He saw Emperor Michael frequently wearing some of these clothes, in different styles, on his military expeditions. He also informed me that the Byzantine emperors had crowns for different occasions that were suspended over their heads. One was the "largest crown;" which was of gold adorned with various rubies, together with a variety of other jewels. The crown was usually suspended over the emperor's head when he sat in his audience room to receive the natives of his empire and the envoys of kings. Another was the crested crown, which he set on his head when he returned from a campaign in which he had vanquished his enemy. This crown was studded with precious stones, and its crest which protrudes over his face had pieces of ruby in it. The emperor sat on his gold throne studded with precious stones or on a studded gold *salin* [probably a rendering in Arabic of the Greek *sellion*]. He always let his legs come down from the throne or the *salin* to rest them on a footstool upholstered with heavily embroidered brocade. He had two red boots on his feet. A complete pair was worn only by the emperor. Those inferior to him wore one boot in red and the other in black. He also told me that he saw there [presumably the Byzantine palace] a piece of ambergris that looked like a huge camel kneeling in the center of a large platform.

This text is a wonderfully contemporary one, as it exhibits the ignorant curiosity so characteristic of most of our own press of today.

(12) Account 340. A very short one and a very peculiar one, which I will quote in its entire brevity.

When Basil, son of Romanos, the emperor of Byzantium, died in the year 410 [1019–20], he left 6,000 baghdadi *qintars* of gold coins and jewels worth 54 million dinars.

Such are the stories and accounts in the *Kitab al-Dhakha'ir* which pertain to Byzantium: I have left out only the indirect references found in the description of the Fatimid [125] treasures, but these texts are, relatively speaking, better known and would not add much substance to my argument.

Before turning to a number of concluding statements, I would like, however, to bring out one last account, which is only tangentially pertinent to Byzantium, but which can serve as a sort of foil for my conclusions. It is account 69 dealing with the gifts sent in 906 by Bertha, the Frankish queen, to al-Muktafi in Samarra.[24] The gifts involved are: fifty swords, fifty shields,

[24] This is the passage translated by M. Hamidullah in the *Journal of the Pakistan Historical Society*, 1 (1953).

fifty Frankish spears; twenty pieces of cloth woven with gold threads; twenty Slavic eunuchs; twenty pretty and gentle Slavic slave girls; ten huge dogs that even lions and other beasts of prey cannot withstand; seven falcons; seven hawks; a silk tent with all its furnishings; twenty pieces of cloth, much of a special wool that is in an oyster from the bottom of the sea and assumes different colors according to the hours of the day; three Frankish birds which, when they see poisoned food or drinks, utter horrible screams and clap their wings until the message gets across; beads that extract arrowheads and spear tips painlessly, even after flesh had built around them. The letter that accompanied the gift was on white silk in a script that "was similar to the Rumi (i.e., Greek) script, but more harmonious." Among its more bizarre features, the letter contained a proposal of marriage.

The problem was that no one at al-Muktafi's court could read Latin. Finally a Frank was found in the department of fancy garments who read the letter and translated it into Greek. Then Ishaq b. Hunayn, the well-known figure in translations from Greek into Arabic and in early 'Abbasid science, was summoned, who translated the Greek into Arabic. The plausibility, if not veracity, of this account seemed assured until the appearance of Ishaq b. Hunayn, which is a bit as though Shakespeare was called to translate some missive received by Queen Elizabeth from the doge in Venice. But, of course, it is precisely this sort of mediation by a well-known figure in cross-cultural connections which gave the seal of authenticity in the eleventh century to an account that would have remained a hearsay story without it.

What sort of conclusions or hypotheses can one draw from these accounts which vary in tone, verisimilitude, and objectivity and whose complete understanding *as texts* would also require comparison with stories in the same book involving Central Asia, China, Tibet and India? I will only pick up a few specific threads from the stories and then elaborate a number of wider considerations.

The first specific point is that there exists a body of artefacts from the tenth, eleventh and twelfth centuries which is typologically and functionally related to the items listed or described by Ibn al-Zubayr.[25] In the absence of specific identifications of described objects, the examples that can be proposed have the peculiarity that they come from both Byzantine and Islamic sources, or in reality alleged sources, as in many cases several places of manufacture can be proposed for the objects involved. What is more important [126] than the place of origin of the objects and even than their date is that their utilization and appreciation was shared by all courts, Christian or Muslim,

25 A simple list can be made from catalogs of exhibitions such as: *Arts de l'Islam* (Orangerie, Paris, 1971), nos 127, 129, 227–30, 271, 273, 294; Musée du Louvre, *Byzance* (Paris, 1992), esp. pp. 208–407; and H. R. Hahnloser, *Il Tesoro di San Marco* (Florence, 1971), pls LXXXIX ff.

once exclusively Christian signs and images are removed or avoided altogether.[26]

Three examples of objects associated with courts which are at times later than the texts I have quoted but which are very much within the period considered by this volume can help in elaborating the point of a shared culture. The first one is the celebrated cup in the San Marco treasury, presumably made in Constantinople, with perfectly clear but meaningless Arabic letters and perfectly clear but iconographically senseless classical figures.[27] The other one is the mantle of Roger II with a legible Arabic inscription different in content from any known inscription on an object and with a perfectly understandable imagery which cannot be easily explained, if at all, and with a shape and a lining that make it Latin European.[28] The third one is the Innsbruck cup with its nearly illiterate princely inscriptions in Arabic and Persian, its images which are at the same time quite clear and too numerous to make sense, its almost vulgar covering of every side of the cup, and its technique for which a Georgian source has recently been proposed but which is not associated with the northern Mesopotamian area of its patron.[29] In these instances, three different patrons used simultaneously Arabic letters, classical and mythological motifs for objects that do not fit within the narrow boundaries imposed by religious art or within the art sponsored by the faiths involved, but which belong to a common court art of luxury comparable to the art of couturiers and cooks today.[30]

None of these impressive creations has in fact a geographical or historical, probably not even a temporal, home. They reflect a culture of objects shared by all those who could afford them and transformed by their owners or users into evocations of sensory pleasures. The visual effects of the objects were then transferred into written form, in Ibn al-Zubayr's text, with two additional components. One is the almost vulgar physicality of objects identified in

[26] In fact, one of the examples I gave mentions the crosses found on an imperial robe.

[27] A. Cutler, "The Mythological Bowl in the Treasury of San Marco in Venice," in D. K. Kouymjian, ed., *Studies in Honor of George C. Miles* (Beirut, 1974), for an early interpretation, and I. Kalavrezou-Maxeiner, "The Cup of San Marco and the 'Classical' in Byzantium," *Studien zur mittelalterlichen Kunst, 800–1250: Festschrift für Florentine Mütherich* (Munich, 1985), for a more recent one that moves toward the explanation I am proposing here.

[28] The mantle is often illustrated, as in J. Sourdel-Thomine and Bertold Spuler, *Die Kunst des Islam* (Berlin, 1973), fig. 199 and p. 265, with a brief bibliography. For recent work see T. Al Samman, "Arabische Inschriften," *JbKSWien*, 78 (1982), pp. 114 ff. The lining is now dated in the thirteenth century: Arne E. Wardell, "Panni Tartarici," *Islamic Art*, 3 (1988–9), p. 110, with references.

[29] See now Scott Redford, "The Innsbruck Plate and Its Setting," *Muqarnas*, 7 (1990), pp. 119 ff, with references to earlier publications.

[30] H. Belting, "Kunst oder Objekt-Stil," in *Byzanz und der Westen* (Vienna, 1984), for a general statement about this common art; G. T. Beech, "The Eleanor of Aquitaine Vase," *Gesta*, 32 (1993), for a rock crystal belonging to the common arts. There are many comparable examples.

medieval texts or modern descriptions as large, heavy, shiny, expensive, and covered with precious stones or gold threads or with striking images or magic inscriptions. The second is the awareness of technical and functional distinctions in the sociological sense of the word, that is to say, as statements of quality and worthiness rather than of ways of manufacture. This awareness is expressed in the presence [127] of a specific vocabulary of verbs and nouns which are often impossible to translate and for which my own competence, at least, is limited both as an Arabist and as a technologist. The importance of this linguistic differentiation lies in its implication that the reading of words elicited some form of recognition or wonderment on the part of readers who were probably no more competent than I am, because the differentiation itself was important regardless of what it meant. The further elaboration of this particular point would take me away from the more immediately significant conclusion I propose, which is that a culture of shared objects implies a certain commonality of court behavior and of court practices. This commonality seems to me more appropriate than the "influences" from the East which had, in the past, identified the tenth century.[31]

A second specific point is that there are several concurrent hierarchies in the items listed in Ibn al-Zubayr's text. For instance, there are raw materials among them (I include in this category animals and slaves), semi-manufactured products like a piece of cloth, and fully manufactured objects ready to be used. The first category, that of raw materials, is relatively rarely ever mentioned in exchanges between Muslims and Byzantines, just as it is rare for China and India, also centers of old civilizations. But raw materials dominate in things coming from Western Europe, North Africa, steppic Eurasia, and eventually Africa and southeast Asia. Semi-manufactured products are mostly textiles (and, curiously, medical or pseudo-medical items like aphrodisiacs), and they are more frequent among items sent from Cairo or Baghdad to Constantinople than the other way around, but the evidence from this single source is too thin to secure the conclusion that the Byzantine court imported more semi-manufactured items than it exported.

A more interesting point concerning hierarchies of objects and of their use may be that all but one of the examples above deal with exchanges between the highest-ranking authorities, the Byzantine emperor and the caliphal courts of Byzantium, Cairo and Cordoba (there are no examples of Cordoba–Byzantine exchanges in Ibn al-Zubayr, but these exist elsewhere).[32] The one major exception occurs in 1071–2, when a Hamdanid *amir,* a second-rank ruler, sends a present to the Byzantine emperor, who, admittedly, was camping nearby. When we turn to the twelfth century, however, the loci of exchanges increase enormously, as the whole of Spain, Sicily, Anatolia, the Caucasus, Syria and Mesopotamia

31 A. Grabar, "Le succès des arts orientaux," *MünchJb,* 2 (1951), for example.
32 Vasiliev and Canard, *Byzance et les Arabes,* II, pp. 324–8, among many other places.

all develop centers involved in exchanges of gifts with each other and with Byzantium, in fitting response to the multiplication of centers of authority.[33] In the ninth century, booty and very limited local exchanges predominated, as 'Abbasid or Byzantine rulers apparently dealt with each other only for the exchange of prisoners.[34] Should one attribute an apparent change, some time early in the tenth century, in the climate of the relationship between Byzantine and Muslim courts to changed politics or to economic and technological changes? Is it in fact valid to conclude that there occurred a change in the behavior between courts? [128]

A third factual detail is the paucity of mythical or unusual objects in these accounts involving Byzantium and the Muslims, the saddles of Alexander the Great being the only exception. This contrasts with other accounts in Ibn al-Zubayr's book and in many other sources of the same times which are full of fantastic stories about the tables of Solomon, David, the Prophet Qarun, and Constantine, strange animals, gigantic women, roaring lions, singing birds, and many other imaginary or mythical fixtures. *Mirabilia* came from the East, strange animals from the East and from North Africa, prophetic or imperial souvenirs from the Mediterranean with occasional detours elsewhere.[35] The speculative conclusion that emerges is once again that the objects shared by the Byzantine and Muslim courts were used as expressions of a competition, but one that, like the sporting events of today, involved the same functions, forms and values. And in Cordoba, Aght'amar, or Palermo, smaller but not always poorer or cheaper versions of the same games occurred. But these games were not shown in quite the same way everywhere, as Muslim courts enjoyed the pageantry of enormous displays like the 917 one in Baghdad, which was repeated on a smaller scale elsewhere.[36] I do not quite know what the Byzantine court did with its treasures and with the gifts it received.

Before concluding, one nagging difficulty should be mentioned in these interpretations of passages in an eleventh-century written text. A whole century before Ibn al-Zubayr, the great historian al-Mas'udi used the very same descriptive terms (but without Ibn al-Zubayr's technological precision) to refer to the gifts given or received by Khosro Anushirvan in the sixth century from China and India and especially to the gifts exchanged by the Byzantine emperor Maurice and the Persian grandee Bahram Chobin.[37] And

33 Lucy-Anne Hunt, "Comnenian Aristocratic Palace Decoration," in M. Angold, ed., *The Byzantine Aristocracy IX to XIII Centuries* (London, 1984), for examples.

34 See Vasiliev and Canard, *Byzance et les Arabes*, I, for a list of these meetings.

35 Ibid., pp. 366 ff.; C. J. F. Dowsett, trans., *The History of the Caucasian Albanians* (London, 1961), p. 129. And there are many examples in Ibn al-Zubayr. An anthology of such sources would be a most welcome enterprise.

36 See above.

37 Mas'udi, *Tanbih*, trans. B. Carra de Vaux (Paris, 1897), p. 236, for an early example of Byzantine merchants in Cairo.

so the skeptical historian may wonder whether his eleventh-century text is a conventional rather than specific description of expensive things. The lovingly listed beautiful things which can be identified through remaining types of objects may just be empty verbal formulas. Or perhaps, since Mas'udi wrote in the tenth century, that is to say, the very century when exchanges increased between Byzantium and the Muslim world, it is the reality of a new art of fancy objects which created in Mas'udi's time a new vocabulary for the description of objects, and this vocabulary was artificially used for earlier times, but unnaturally continued for the following two centuries.

On the whole, I prefer, therefore, to assume the authenticity of Ibn al-Zubayr's text and to argue that we are not yet at the next stage, the one that grows in the twelfth century and commercializes both the making of objects and the memories associated with them. This later stage is symbolized by a celebrated aquamanile in the Louvre with two inscriptions on the breast of the bird. One, in Arabic, says *'amal 'abd al-malik al-Nasrani*, which could mean "the work of the slave of the Christian king," or "the work of Abd al-Malik the Christian." The other inscription, preceded by a Maltese cross, is in Latin, and says *opus Solomonis erat,* which could be translated as "this was the work of [129] Sulayman (a Muslim or Jewish or Christian artisan somewhere in the Mediterranean area)," or "this was a terrific job," or "of Solomon (the Hebrew king, as a souvenir sold to an unsuspecting Crusader or merchant)."[38] If we put it together with so many silver bowls found in Ukraine and published by Darkevich,[39] or with the numerous inlaid or simply chased candleholders, ewers and kettles all over the Near East, we have, I believe, the massively multiplied, feudal or urban, reflection, at times handsome and impressive, at other times vulgar and clearly imitative, of the court art of objects in the tenth and eleventh centuries. What had been created in the latter can be summed up in the words Peter Brown has used recently for the fourth century: "the vigorous flowering of a public culture that Christians and non-Christians [I would add Muslims and non-Muslims] alike could share."[40]

But, obviously enough, these objects did not represent *the* culture of the Byzantine court with its icons, church visits and prayers, with a visual as well as literary Christianity overwhelming everything. They did, on the other hand, represent much more of the culture of Muslim courts, whose piety was not expressed as much in visual terms and whose rulers were not

[38] The object has often been illustrated and used in exhibition catalogs, as in *Arabesques et jardins de paradis* (Paris, 1989), no. 119, p. 148. The only in-depth study is still the one by A. de Longpérier, "Vase Arabo-Sicilien," *Revue archéologique*, 6 (1865), pp. 356–67, repr. in *Œuvres*, vol. I (Paris, 1883), pp. 442 ff.

[39] V. P. Darkevich, *Svetskoe iskusstvo Vizantii* (Moscow, 1975), all of whose interpretations I do not share, but whose groups of objects are quite accurate.

[40] P. Brown, "The Problems of Christianization," *Proceedings of the British Academy*, 82 (1993), p. 96.

accompanied by an organized ecclesiastical system and by a highly developed and precise liturgical practice. Where, then, did these objects operate within Byzantine court culture, if icons were brought to cure the sick, to promote victories or happy births, to celebrate weddings, or to crown emperors? They appeared, I submit, *after* the event. Once cured, wedded, crowned, or victorious, the emperor and his entourage sought a pleasure they rarely wrote about, as in the exceptional case of Constantine VII admiring the Arabian cup from which he drank before going to bed,[41] or in the materials used for the making of the official clothes in which princes were represented in something like the Skylitzes manuscript.[42] My contention is that this culture of sensory pleasure was much more widely shared than the religiously specific one of the church and the icon, the mosque and the Holy Book, which, then as now, separated people from each other while winning for all of them eternal life.

[41] Quoted in Kalavrezou-Maxeiner, "The Cup of San Marco," p. 173, on the basis of an indication by I. Ševčenko.

[42] A. Grabar and M. Manoussacas, *L'Illustration du manuscrit de Skylitzes* (Venice, 1979), color pl. II, figs 42, 72, 75, etc., as just one set of examples of clothes that could have come from either culture.

Chapter V

Epigrafika Vostoka, A Critical Review*

Under the aegis of its Central Asian branch, the Academy of Sciences of the Union of the Soviet Socialist Republics founded, in 1947, the first journal to be devoted exclusively to Oriental epigraphy. The journal is under the editorship of Professor V. A. Krachkovskaia, and is entirely in Russian.

At the time of this writing, eight issues had reached the United States. Volume I was published in 1947, volume II in 1948, volume III in 1949, volumes IV and V in 1951, volume VI in 1952, and volumes VII and VIII in 1953. (Volumes IX and X have since appeared, and will be reviewed, together with later volumes, at a future date.)

The journal is illustrated with a great number of photographs and drawings, although the former, especially in the earlier issues, are not always of the first quality. The issues vary in length between 51 pages (Vol. I) and 143 pages (Vol. V), but all comprise a main body of articles and a few pages of general information dealing with bibliography, excavation notes, and technical problems pertaining to epigraphy.

The purpose and scope of the journal were defined by its editor in the first issue (pp. 2–3). It plans, first, to make available to the scholarly world epigraphical material found within the boundaries of the Soviet Union, without linguistic or racial limitations. Central Asia, with its treasures of Soghdian, Turkish, Arabic, Persian and Mongol monuments, is given primary attention. The Caucasus, a little-known area of Islamic expansion, but rich in Georgian and Armenian material, forms [548] a second center of investigations. A vast body of material comes from the museums and collections within the Soviet Union, not only the Hermitage, but also the numerous provincial collections, whose treasures are little known to scholars. The second aim of the journal will be equally welcomed by all orientalists. It is to make available again inscriptions that were published many years ago and inadequately so, or that appeared in obscure journals difficult or impossible to obtain. The third purpose is to provide the reader with a

* First published in *Ars Orientalis*, 2 (1957), pp. 547–60. *Epigrafika Vostoka (Oriental Epigraphy)*. Edited by V. A. Krachkovskaia. Akademija Nauk SSSR, Moscow–Leningrad. Volumes I to VIII.

survey of discoveries and books dealing with epigraphical problems, the emphasis being here again on Central Asia.

To review adequately all the articles published in *Epigrafika Vostoka* would require the efforts of scholars in different fields. The majority of the articles that deal with the Islamic period are treated here in greater detail than the others, which are simply noted. Three large categories have been established: General, Islamic and non-Islamic. After each title the volume and pages are given in parentheses.

General

1. V. A. Krachkovskaia, "On the question of the alphabet" (V, 5–9), examines briefly the problem of the origins and formation of the alphabet within the framework of Marxist theory as expounded by Stalin in his 1950 study of linguistics.

Islamic

The great majority of articles deal with medieval Islamic monuments and problems. Either a chronological or a geographical classification was possible, but it was felt that a combination of the two might make it more convenient for readers of varied interests to find the material that concerns them. Seven categories have been established: *A*, Early or pre-Seljuq (i.e., before the middle of the eleventh century); *B*, Seljuq (i.e., to the middle of the thirteenth century); *C*, Mongol (i.e., to about the middle of the fifteenth century); *D*, Central Asia; *E*, Caucasus; *F*, Later than the fifteenth century; *G*, Others. In the sections on the Caucasus and Central Asia, articles have been included which, whatever period is involved, deal with local problems or with problems significant only to the two areas involved.

A. EARLY OR PRE-SELJUQ (BEFORE THE MIDDLE OF THE ELEVENTH
 CENTURY)

1. M. M. Diakonov, "On an early Arabic inscription" (I, 5–8), publishes the inscription found on a ewer described as having an "egg-shaped ribbed body on a foot in the form of a truncated cone, a high neck, and a handle topped by a beautiful palmette" (illustrated), located in the State Museum of Georgia in Tiflis.[1] The inscription dates the object in 69 (or 67) AH/AD 688–9 (or 686–7), places its manufacture in Basrah, and gives the name of a certain

[1] Cf. R. Ettinghausen, "An early Islamic glass-making center," *Princeton University, Record of the Museum of Art*, vol. 1 (1942), pp. 4–7.

Ibn Yazid. It is thus one of the earliest, if not the earliest,[2] inscription on a manufactured object from the Islamic period.

2. ———, "Arabic inscription on a bronze eagle from the collection of the Hermitage" (IV, 24–7) deals with the inscription on a remarkable vessel (inadequately photographed) in the shape of an eagle, acquired in 1939 by the Hermitage. It is dated in the year AH 105/AD 723–4 and gives the name of a certain Sulayman. The name is preceded by two words which are translated by Diakonov, who translates them as: "this [is] what Sulayman ordered to be made," a most unusual expression. It must be pointed out that in both this object and the one published in the first article, the pious expressions are not common and sometimes are not even grammatically correct. While these errors could be attributed to foreign (Persian?) artisans working in Mesopotamia, Diakonov's suggestion that both objects were made for the same man, Sulayman Ibn Yazid, who was governor of Basrah in 95 AH/AD 714, cannot be fully accepted without a more complete study of the activities of this personage before and after the one year during which he was governor. Both Yazid and Sulayman were quite common names in Umayyad times. The author also suggests that both objects were made at Basrah. Their inscriptions are paleographically similar and Basrah was an important center of early Islamic times (especially noted for glass-making [549]), but the attribution of the second one to a specific center could only be tested through a stylistic analysis, which is not possible with the available photographs.

3. A. L. Mihailova, "New epigraphical data for Central Asian history in the IXth century" (V, 10–20), discusses the very interesting inscriptions mentioned by al-Azraqi,[3] which were set by al-Ma'mun on the crown and throne of Kabul-shah before they were sent to Mecca. The author dwells in great detail on the political reasons which led to the taking of Kabul by al-Ma'mun and on the significance of Kabul-shah's conversion to Islam. The two inscriptions are seen as a form of political propaganda. On a few points the author corrects the reading of the *Répertoire*.

4. ———, "About the formulary of state acts under the 'Abbasids" (VII, 3–6), comments on the exact significance of a few terms in the extremely important document in which Harun al-Rashid established his succession.[4] She argues

[2] The problem still remains of the exact dating of the lamps from the early Islamic period found at Jerash and elsewhere, of which several unpublished examples exist, among other places, in the museums of Jerusalem and Amman.

[3] Abu Walid ibn 'Abdallah al-Azraqi, *Kitab akhbar Makkah*, ed. F. Wüstenfeld, vol. 1 (Leipzig, 1858), pp. 158–9 and 168–9. See also *Répertoire chronologique d'épigraphie arabe*, ed. G. Wiet, E. Combe and J. Sauvaget (Cairo, 1931 to date), Nos 100 and 106.

[4] Al-Azraqi, vol. 1, pp. 160–61.

that the terms *khatama* and *wada'a al-tin* (or *tana*) indicate two separate activities in the process of sealing a document. While the first one is taken to mean "to apply the seal," the latter would mean specifically "to put (on the document) the *tin* (a special clay used as wax by the 'Abbasids on their documents)." She adds a useful list of the legends found on 'Abbasid seals.

B. SELJUQ (UNTIL THE MIDDLE OF THE THIRTEENTH CENTURY)

1. V. A. Krachkovskaia, "Inscription on a bronze basin of Badr al-Din Lu'lu'" (I, 9–22), publishes the inscription on a basin formerly in the Museum of the Ukraine Academy in Kiev, now No. 1036 in the Hermitage. This bowl was already known,[5] but Mme Krachkovskaia gives a new reading of the inscription, which supplements and improves that of the *Répertoire*. The major part of the article is devoted to a detailed and thorough analysis of the titles used in the inscription. Most of them are quite common. A few, however, are either new or show variations that are significant. Instead of the normal *qahir al-khawadrij wa 'l-mutamarridin*, the bowl has only *qahir al-mutamarridin*. There is no doubt that the latter term was used essentially for political "rebels," while *khawarij* had a religious connotation. The fact that *khawarij* is missing would strengthen Mme Krachkovskaia's argument that the *mutamarridin* may refer to a specific group of people. She suggests the *amirs* against whom Lu'lu' fought between 1218 and 1220. But the use of the title *sultan* implies that the basin was made after 631/1234, if not even after 646/1248. It may be wondered whether the wording of an epithet is likely to refer to an event that took place at least 15 years before. The question of how far such expressions should be taken as referring to specific events is not yet very clear, except in a few limited cases such as the use of the title of *sultan* (at any rate before the middle of the thirteenth century). But the fact that in a funerary chapel of Mosul dated AH 646/AD 1248–9[6] we also meet with *mutamarridin* alone seems to indicate that the two inscriptions, which are probably contemporary, may have referred to a more or less contemporary event.[7]

Another curious feature of the inscription is the lack of any Turkish or Persian title; in particular the title of *atabek* does not occur. Mme Krachkovskaia has not been able to find an explanation for this phenomenon. A third title has puzzled the author. It appears to be *qatil al-muhl*, "the killer

5 *Répertoire*, No. 4458; D. S. Rice, "The brasses of Badr al-Din Lu'lu'," *Bull. School Oriental and African Studies* (*BSOAS*), 13 (1950), p. 628.

6 Max van Berchem, "Monuments et inscriptions de l'atabek Lu'lu' de Mossoul," *Orientalische Studien Theodor Nöldeke ... gewidmet*, Giessen, 1906, vol. 1, p. 200.

7 H. A. R. Gibb, in a private letter to I. Krachkovskij (quoted in *Epigrafika Vostoka*, vol. 2, p. 4), suggested, *à propos* of another title in the inscription, that it may refer to Lu'lu' as a defeater of the Mongols, since there is one literary reference to the effect that the ruler of Mosul had defeated a band of "Tartars."

of barrenness." A final problem dealing with this basin is that of authorship. Mme Krachkovskaia points out (pp. 18–19) that on one of the borders appears a badly preserved inscription with, apparently, the signature of an artist, whose name ends in Yusuf. Mme Krachkovskaia asserts that no Yusuf is known with the *kunya* al-Mawsili. However, under [550] the number 4267, the *Répertoire* lists a brass bowl in the Walters Art Gallery in Baltimore, made in 1246, and signed by Yunus Ibn Yusuf, *al-naqqash al-Mawsili*.[8] Both the name and the date are quite close to those indicated for the Hermitage basin.

2. In the following issue of the journal, Prof. I. Iu. Krachkovskij ("On an epithet in the inscription of Lu'lu's bronze basin," II, 3–8) proposes a solution to the problem of the title *qatil al-muhl*. He points out that the title exists in a poem of Abu'l-'Ala' al-Ma'arri,[9] where it is used for a tribal chieftain in northern Syria. This discovery led Prof. Krachkovskij to reinterpret another title of the vessel transliterated by Mme Krachkovskaia as *hami al-thughur bi 'l-ta'n fi 'l-thaghr* and translated as "defender of frontiers by blows [of the spear] in the face." G. Wiet had translated the same expression as "le protecteur des marches en frappant à la machoire,"[10] where the word *thaghr* is more correctly rendered. On the basis of a line from the same poem by al Ma'arri, Prof. Krachkovskij suggests that the word should be read as *al-thughar* (plural of *al-thughrah*), which means "the upper part of the breast below the neck." Horses were trained to meet enemy blows with this part of the body. Hence he proposes that the expression should be understood as meaning "defender of frontiers by striking with the spear at the breasts (of enemy horses or men)." This interpretation is extremely suggestive, and it is also important from a methodological point of view, since it indicates that the explanation for eulogies and titles in Islamic inscriptions should not be sought only in political or ideological developments, but also in what we know of poetical usage and current customs.

3. L. T. Giuzalian, "Inscription with the name of Badr al-Din Lu'lu' on a bronze chandelier of the Hermitage" (II, 76–82; partial photograph), publishes the inscription from another undated object with the name of Lu'lu'. The *naskhi* of the inscription is of rather poor quality and the text seems, on the whole, to have been carelessly written.[11] It is unfortunate that the author did not add a photograph of the inscription. His reading of the fifth line of the drawing as *al-mahmud fi al-shukr wa al-asa'il al-masalik* shows a very unusual

8 See also D. S. Rice, "Studies in Islamic Metalwork III," *BSOAS*, 15 (1953), p. 231.
9 Yusuf al-Badi', *Biographie d'Abou'l 'Ala al-Ma'arri*, ed. I. Keilani (Damascus, 1944), p. 45.
10 G. Wiet, *Catalogue général du Musée Arabe du Caire, objets en cuivre* (Cairo, 1932), p. 273.
11 See also Rice, "The brasses," *BSAOS*, 13.

title and his translation "famous for his gratitude and for forcing roads," is both unclear and grammatically unacceptable. If Giuzalian's drawing is to be trusted, no alternative could be suggested for the first part of the expression. To read the latter part as *al-atabek al-malik*, while theoretically possible since the title *atabek* usually preceded the *kunyah abu 'l-fadā'il*,[12] is difficult, for this reading would make the *waw* before *al-atabek* meaningless. Furthermore the engraver tended to bend his *kaf* toward the left, while the last part of this word is perfectly straight.[13] However unclear and unelegant, *al-asā'il* should stand, but it seems that the reading *al-malik* is more adequate for the last word of the expression. The meaning of the whole inscription is still obscure and there is here an epigraphical problem, which, if it can be solved at all, would require a photograph of the whole inscription.

4. L. T. Giuzalian's "Frieze-like tiles of the thirteenth century with poetical fragments" (III, 72–81) can be considered an introduction to the question of the significance of poetical fragments found on tiles. The author first asks what was the purpose of such inscriptions, inasmuch as in many cases the whole poem cannot be read and was probably not meant to be read. He suggests that the answer will most likely be found, not in the polygonal tiles, often with figures in the center, but in the rectangular or square tiles which contained only inscriptions and which formed friezes. He analyzes first a group of seven such tiles from Russian and Western collections with *Shahname* fragments. He suggests that the friezelike tiles with a specific text precede the polygonal ones – figured or not – and that they created a tradition of copying literary texts on the latter. The friezelike tiles themselves originated in imitation of the stone and brick friezelike inscriptions, whose history goes much farther back.

Giuzalian also investigates the origin of the specific custom of writing poems on wall surfaces. He points out that tiles were used inside houses as [551] well as in mosques and on exteriors. Hence one possible explanation for the use of poetical texts may be found in a practice that started in private houses and was then taken to the outer walls of buildings. This hypothesis, Giuzalian believes, is only tenable insofar as excerpts from large poems are concerned. Individual *rube'iyat*, which were also common, have a more complex origin, partly to be sought in a study of the texts found on ceramics. Giuzalian does not overlook the fact that many problems, particularly chronological ones, are posed by his interpretation. Yet he has opened up an area so far overlooked by most scholars.[14]

[12] Ibid., pp. 628–9.
[13] This has been pointed out to me by D. S. Rice.
[14] See, however, M. Bahrami, *Recherches sur les Carreaux de revêtement lustrés* (Paris, 1937), a work which was apparently unavailable to Giuzalian. In his *Gurgan faiences* (Cairo, 1949), the same Bahrami published more readings from Persian ceramics and tiles, but never excerpts from long poems.

One of the problems posed by the study of the inscriptions on tiles concerns not the art historian, but the historian of literature. Considering that the thirteenth-century tiles are earlier than any of the manuscripts we possess of the great Persian literary masterpieces, the problem is to know whether the tiles provide us with a different reading of the texts.

5. In two consecutive articles, "A fragment of the Shah-nameh on pottery tiles of the thirteenth–fourteenth centuries" (IV, 40–55, and V, 35–50), Giuzalian compares the text of the story of Sohrab in the known manuscripts[15] with a text provided by 13 tiles and other objects, 6 of which are in Russian collections, and also with the Arabic version of the *Shahname* made in the thirteenth century, i.e., closer in time to the tiles than to the manuscripts. The result of his very careful examination of the evidence is that 17 verses found on tiles correspond to 24 verses common to all manuscripts and to 19 verses in the Arabic version. Of the 24 verses in the manuscripts, several are shown to be later interpolations, and in the others, marked differences appear from the text found on the tiles. Although closer to each other than to the later Persian versions, the Arabic text and the tiles are also significantly different from each other. Giuzalian suggests that there may have been two traditions of the *Shahname*, one written, the other predominantly oral, and that it is the latter which appears on tiles. The exact relationship between the two cannot be established on the basis of a study of one passage only, and Giuzalian announces that he plans to continue his painstaking work.

6. The same author, in "Two fragments of Nizami on tiles of the thirteenth and fourteenth centuries" (VII, 17–25), turns now from the *Shahname* to Nizami, whose earliest manuscript is dated in 1362. Taking as an example two tiles (one in the Hermitage and one in the former Preece collection), he shows that the method used for the *Shahname* can also be applied to other literary masterpieces. Giuzalian realizes quite well that it is not likely that we shall be able to find and decipher enough fragments to enable us to reconstruct a complete text of any large poem through tiles alone. But he feels that a comparison between the texts found in manuscripts and those deciphered on tiles, even if it is made only in a limited number of cases, will permit a fairly precise definition of the nature of interpolations, and therefore it will be possible to detect interpolations in other parts of a manuscript without the help of tiles.

[15] Of the early fourteenth-century *Shahname* manuscripts Giuzalian mentions only the one in Leningrad. Many more are found in West European and American collections. See K. Holter, "Die islamische Miniaturhandschriften vor 1350," *Zentralblatt für Bibliothekswesen*, 54 (1937), and the *Supplement* published by H. Buchtal, O. Kurz and R. Ettinghausen in *Ars Islamica*, 7 (1940).

The specific value of Giuzalian's attempt in the examples from the *Shahname* and from Nizami can be judged only by a literary historian familiar with the complex textual problems posed by these manuscripts. Whatever their value may be, it must be pointed out that Giuzalian is introducing a method of working which is of great importance. By using works of art to solve literary problems, he is breaking down the barrier of compartmentalization in Oriental studies, which, as Sauvaget, among others, often remarked,[16] leads to a narrow view of Islamic civilization.

7. A. Iu. Jakubovskij, "Two inscriptions on the northern mausoleum (1152 A.D.) at Uzgend" (I, 27–32). The northern mausoleum is the best preserved of the two Qarakhanid structures remaining at Uzgend and mentioned by many travelers. It contains two inscriptions, one in Persian, the other in Arabic. The [552] first one is in *naskhi*, the other in Kufic.[17] The Persian text gives the date of the beginning of the construction (547/1152) and contains a number of peculiarities such as the word *dowlat-khaneh* for mausoleum, the expression *aghaz kardeh amad*, and the spelling *pānsad* for *pānṣad*. Unable to explain the first term, the author claims that the second refers to a typical *tajik* construction, while the latter is an archaism.

The second inscription, in Arabic, gives the name of the man for whom the mausoleum was built, Alp Kilij Tunga Bilga Turk Tughril Qara-khaqan Husayn ibn Hasan ibn ʿAli.[18] The rest of the article is devoted to a study of the Turkish names found in the inscription and to a brief study of the style of the writing. The author points out that at that time and in that area strictly Arabic influences were dwindling and he sees a proof of that in the mixture of Persian and Arabic.

8. M. M. Diakonov, "Some inscriptions on Kirghiz tombstones (kayrak)" (II, 9–15), deals with seven inscriptions, which have now disappeared, from a place east of Ferghana. Four are dated, two in the twelfth century, two in the thirteenth. All of them were near a *mashhad* where, according to the legend, a group of Companions of the Prophet had perished. One of the tombs is that of a merchant (No. 2) and on it is found the title *khwajah*, which has been thought not to have been used for merchants until after the Mongol period. But the author does not mention the fact that the twelfth-century "Bobrinsky kettle" in the Hermitage also exhibits the same title for a merchant.

16 J. Sauvaget, "Comment étudier l'histoire du monde arabe," *Revue Africaine*, 90 (1946), p. 14.

17 The association of the two ways of writing occurs also on the newly published and earlier minaret of Dawlatabad. See J. Sourdel-Thomine, "Deux minarets d'époque seljoukide en Afghanistan," *Syria*, 30 (1950), pp. 122–9.

18 The author mistranslated the expression *mujtaba khalifa Allah nasir amir al-muʾminin*; it should be: "chosen by the Successor of God, helper of the Commander of the Faithful," not "chosen by God, helper of the Commander of the Faithful."

Others are tombs of religious leaders and *sufis*, the former bearing titles quite similar to those of the Syrian and Egyptian lords. The author draws some interesting social and economic conclusions.

9. M. E. Masson, in "New data on the inscriptions of one of the minarets from Mashhad-i Misrian (sic)" (VII, 7–16), describes one of the ruined cities of Dihistan, in Jurjan. There remain the ruins of a mosque, which is generally attributed to the thirteenth century and to Muhammad ibn Tekesh, the Khwarezmshah, as the latter's name occurs on the portal. The ruins comprise two minarets and, near the southernmost one, what is called a portal by the author, although it is not clear whether it was the *eyvan* of a sanctuary or an actual gateway. The minaret near the arch belongs to the same period. But Masson shows that the other minaret, the northern one, is definitely earlier. It contains three partially legible inscriptions, one of which ends with the date X95. On stylistic grounds the author suggests that it should be understood as 495/1103. Both minarets are also interesting in that they give us the names of the builders. On the second minaret a father and a son are named.

10. The same author, in "Medieval tombal bricks from the oasis of Mari" (VIII, 24–35), publishes a group of bricks (average size 28 cm × 28 cm × 5 cm) found near Merv in 1951. The practice of using bricks for funerary inscriptions is otherwise evidenced in literary sources. Their importance is twofold. First, they provide us with a set of inscriptions useful for determining the development of epigraphy. Second, all these inscriptions are fairly simple and refer to common people, giving us thus a counterpart in Central Asia to the stone funerary inscriptions of Egypt.

11. E. A. Davidovich, in "A hoard of silver-covered bronze from Termedh in 617/1220" (VIII, 43–62), describes a hoard of 78 coins found in Termedh. As all the coins are of the same date, it is a type of discovery that should bring joy to all numismatists. Two types are represented, one by 3 coins, the other by 75. The author carefully lists all the titles found on the coins and gives a very complete table of measurements. He points out that there were certainly several dies and that some inscriptions were struck over older ones, which cannot, in most cases, be determined. Two problems are discussed in greater detail. First, these coins are called *dirhams* in the inscriptions. Yet they are merely copper coins with a thin plate of silver. Economic reasons probably lie behind such inflationary practices. The author analyzes them from a theoretical, Marxist point of view, without entering into an analysis of contemporary historical [553] documents, a task that is highly complex, given the difficulty of obtaining economic data from a medieval chronicler. The second problem consists of the fact that the name of the Caliph al-Nasir occurs on coins from Bukhara and Samarkand, but not on this specific group of Termedh coins. We probably have here a direct result of the

unsuccessful march on Baghdad organized in 616/1219–20 by Muhammad ibn Tekesh.

C. MONGOL (TO THE MIDDLE OF THE FIFTEENTH CENTURY)

1. A. A. Semenov, "Epitaph of pseudo-Sayyid 'Omar in the Gur-e Amir in Samarqand" (I, 23–6). Among the tombs of the Timurids in the Gur-e Amir, there is a tomb which, according to a tradition accepted by Barthold and others, was that of a Sayyid 'Omar, who had occupied the position of *muhtasib* in some city, perhaps Samarkand, and who died in 803/1400–01. The author publishes the inscription of the tomb, which does not contain any name or date. Then he shows that Sayyid 'Omar, who did exist, had been *muhtasib* at Shahr-e Sabz and was buried at Bukhara. There seems to be no information about the identity of the personage who was actually buried in the Samarkand tomb.

2. The same author in "Inscriptions on the tombs of Timur and of his descendants in the Gur-e Amir" (II, 49–62), deals with the inscriptions on the tomb of Timur himself. There are two groups of inscriptions. The first is on the plinth over the actual tomb in the vault of the monuments.[19] The second is found on the top and front of the jade sarcophagus which was set over the place where Timur was buried, on the ground floor of the mausoleum. Aside from the fact that the first one contains a lengthy religious text, the inscription on the tomb itself and that on the top of the jade sarcophagus comprise essentially the titles and genealogy of the great conqueror. This genealogy is of considerable interest, as it has two purposes, both of which appear to be of fundamental importance for understanding Timurid ideology. On the one hand, it attempts to connect Timur with Genghis Khan. On the other, it strives to make Timur a descendant of 'Ali. The latter claim is introduced in most curious fashion, and it is expressed in greatest detail on the jade sarcophagus. After giving the name of the last paternal ancestor, the inscription says: "And no father was known to this glorious [man], but his mother [was] Alanquva. It is said that her character was righteous and chaste, and that she was not an adulteress. She conceived him through a light which came into her from the upper part of a door and it assumed for her the likeness of a perfect man.[20] And it [the light] said that it was one of the sons of the Commander of the Faithful, 'Ali son of Abu Talib."

The author discusses the literary evidence for Shi'ite influences in Timurid times and shows that Timur, Ulugh Beg, Baysunghur and others knew and

19 For an elevation of the building cf. J. Smolik, *Die timuridischen Baudenkmäler in Samarkand aus der Zeit Tamerlans* (Vienna, 1929), fig. 70.

20 Qur'an, XIX, 17.

admired the great mystic and Shi'ite heterodox Qasim-e Anvari.[21] Whether on the basis of this inscription one can say definitely that Timur was Shi'ite is not certain, but it seems clear that he was under strong Shi'ite influences. An interesting problem of comparative religion, which is not brought up by the author, is that of the manner in which the relation between an unnamed son of 'Ali and Timur's ancestor is established.[22] The qur'anic quotation refers to the story of Mary and it seems to me that a more direct Christian impact (or perhaps a conflation of a Christian theme with a pagan one) should be presumed. We know, for instance, that there existed in eastern Christianity, in the early Middle Ages, a very specific symbolism relating the story of the "closed door" in Ezekiel (Ezekiel 44: 1–3) with the virgin birth of Mary.[23] [554] To ascertain whether we are dealing with a direct impact of some Christian idea on the Timurids or whether the idea was already adopted in Muslim religious thought at an earlier date would require a lengthy study. At any rate the Timurid inscription poses a very interesting problem of religious syncretism.

3. The jade sarcophagus contains yet another inscription. It is at the foot of the sarcophagus and only about three-quarters of it remains *in situ*. But, by a most extraordinary coincidence, the missing chunk was discovered in a private house in Samarqand and is published in this same issue of *Epigrafika Vostoka*, by M. E. Masson ("The third piece of the jade tombstone of Timur," II, 63–75). It is unfortunate that Semenov and Masson do not appear to have known about each other's work. Their readings do not always agree and the reader is compelled to flip pages back and forth in order to understand the inscription. Here is a tentative translation of this inscription based on the versions given by Semenov and Masson:

1 Glory to God who was true to His promises, [who] helped His servant, strengthened His (servant's) army and routed the bands of robbers[24]
2 [He is] One and there is nothing after Him. And [may there be] blessings over His Prophet who liberates booty and incites to [fight and over]

21 E. G. Browne, *A literary history of Persia* (Cambridge, 1920), vol. 3, pp. 473–86.

22 This theme seems already to have been in existence under the Ilkhanids. See B. Vladimirtsov, *Genghis Khan*, Fr. tr. (Paris, 1948), p. xvi.

23 Cf. Theodoret, Bishop of Cyprus in Migne, *Patrologia Graeca* (Paris, 1864), vol. 81, pp. 1233–4; see, in general, W. Neuss, *Das Buch Ezekiels in Theologie und Kunst* (Münster, 1912). For an earlier study of this theme and a comparison with the legends dealing with Alexander, cf. E. Herzfeld, "Alongoa," *Der Islam*, 6 (1916), pp. 317 ff. Herzfeld's knowledge of the inscription derives from Blochet's reading of the "facsimiles" brought from Samarkand by I. Östrup and A. Christensen. Semenov and Masson both show that these writers did not see the whole inscription. For other examples of Christian themes in Mongol times, see R. Ettinghausen, "Some paintings in four Istanbul albums," *Ars Orientalis*, 1 (1954), pp. 97–8, figs 59–62, and idem, "An illuminated manuscript of Hafiz-i Abru," *Kunst des Orients*, 2 (1955), figs 5–9.

24 Semenov translates *al-akhrab* as "a band of [his] opponents." He also suggests that there may have been a *la ilaha* at the end of this line, but it does not seem to me that there is enough space for the whole expression.

3 His (Prophet's) family, strong against unbelievers and merciful to the just. This [is] the stone[25] ...

4 Which was brought by the khaqan Duva Sajan khan from Udan (Aydan?) to the place of his throne called Qarshi[26] on the bank of the Quyash;

5 And it was brought back from there by Ulugh Bek Kuregan, when he went to [the land of] the Jita ...[27]

6 He subdued them (the *akhrab*) [555] with his sword (?). Had Noah come near him (?) on his ark, he would not have been safe unless ...[28]

7 Had the Friend of God (Abraham) alighted there (?), they would have both been burnt with their ancestor (?)[29] ... 828 (i.e. 1424–1425).

In spite of the numerous epigraphical difficulties presented by this text, it gives us several important indications on the origin and the date of the sarcophagus. These have been fully exploited by Masson (pp. 69 ff.), who has worked out all the details of Ulugh Beg's inconclusive, although victorious, war against the nomads of Mongolia in 1424, and of his finding there and bringing to Samarkand the jade piece that was set over Timur's tomb in 828/1425. In the last pages of his contribution Masson asks whether there were originally one or several pieces of jade, as there are three at present. He concludes that there was only one and that its present bad condition is the result of its having been moved out of Samarkand by Nadir Shah.

4. In a third article under the same title (III, 45–54), A. A. Semenov describes the last four tombs in the mausoleum. The first one is that of Shah Rokh, with an inscription partly in Persian and partly in Arabic. There are no qur'anic texts on this tomb, but a description of the tomb as a garden. The inscription also tells us that it was not Ulugh Beg who moved the body of Shah Rokh to Samarkand, as is generally believed, but Paendeh, Shah Rokh's daughter. A curious detail reported by Semenov is that, when the tomb was opened, 144 small stones were found in it, carefully laid in a box.

The second tomb is that of Ulugh Beg (in the crypt). Its inscription is also in both Persian and Arabic. Ulugh Beg is called a *khalifah*. The tomb was probably erected by his second son, since the first son is accused in it of

[25] Both Semenov and Masson believe that the letters which follow were the beginning of a word meaning "black."

[26] Masson translates : "... brought by the khaqan Duva Sajan khan Merawdan to the place of his evil throne at Qarshi."

[27] Semenov, whose text stopped at *jidan*, translated "he is very skillful." Masson, who does not give his reading for the first part of the line, translates: "whose (the Jita's) armies he put to flight and overcame." Neither translation seems fully satisfactory. There are other possibilities but none can be advanced with certitude before we know whether or not a word is missing.

[28] This is Masson's reading. The first letters seem to me to be *bin* rather than a *sin*. Here there is no doubt that a piece is missing.

[29] This is Semenov's translation. Masson does not even attempt one and simply mentions that the text refers to Noah and Abraham.

having murdered his father. Apparently Ulugh Beg was buried as a *shahid*, i.e., in the clothes in which he died.

The third tomb is that of Timur's nephew, Muhammad Sultan, a favorite of the conqueror who designated him as heir to the throne. Muhammad Sultan died, however, before his uncle, and in the inscription he is called *wali al-'ahd*. The tomb is particularly brilliantly decorated and Semenov suggests that Muhammad Sultan and Timur were probably the only two Timurids who were originally intended to be buried in Gur-e Amir. The fourth tomb is that of Miranshah, son of Timur, who died in 1407–8. It is very similar to Timur's.

This group of four articles dealing with the inscriptions of the Gur-e Amir is certainly one of the most important published in *Epigrafika Vostoka*. Although one may regret that the authors have not included more numerous photographs of the building and of the tombs themselves, one must acknowledge the extraordinary service performed by A. A. Semenov in reading the often very complicated and tiresome inscriptions found on the six tombs of the Gur-e Amir. Their historical interest is very great and both Semenov and Masson have dealt with many of the problems posed by them. But their religious significance is equally interesting and should lead to an investigation of the religious beliefs and practices of the Timurids.

5. M. E. Masson, "The date and history of the construction of the Gunbaz Manas" (III, 28–44). The Gunbaz Manas is a mausoleum some 12 kilometers east of Talas, in the present-day Kirghiz Republic. An inscription indicates that the mausoleum was made for a certain Kanizak Khatun, daughter of Abuka (or Abukan), but the inscription stops after stating that Kanizak died on the first of Ramadan of a year whose last digit is 4. On stylistic grounds the author dates the mausoleum in the twenties or thirties of the fourteenth century. He then attempts to identify the personage who was buried in it. Choosing the reading Abuka, he believes him to be one of the sons of Dava Khan, and one of the first ones to be converted to Islam. A study of the complex wars and successions in the Mongol empire leads Masson to the conclusion that Kanizak must have died on the first of Ramadan 734/May 6, 1334.

It may be argued that the author dismisses too readily the reading Abukan, which would make his identification impossible. Even if the identification is not accepted as certain, the commentaries on the epigraphical style and on the history of the period are extremely valuable (see in particular p. 41, a genealogical table of the Mongol branch that ruled the area).

6. The preceding inscription, without thorough commentary, and a few others from the valley of Talas are mentioned also in a short article by A. M. [556] Belenitzkij, "From Muslim epigraphy in the valley of Talas" (II, 16–18).

7. O. D. Chehovich, "A waqf document from the time of Timur in the collection of the Samarqand Museum" (IV, 56–67). This earliest *waqf* document from Central Asia is in Persian. Its beginning and end are lost. It was made out for 'Abd al-Malik, who was *shaykh al-Islam* under Timur. His genealogy is given in the document, together with a long description of the lands whose revenues were to be used for a group of religious structures. It is an interesting document for the historian and the economist.

D. CENTRAL ASIA

1. V. A. Krachkovskaia, "The evolution of Kufic in Central Asia" (III, 3–27), gives a survey of the epigraphical material on stone, textiles, ceramics, parchment, coins, paper and brick which come from Central Asia, more specifically from Transoxiana, and which is written in Kufic script. Together with monuments and works of art already known to scholars, the author has collected a number of examples found in the Soviet Union, previously unpublished or very little known: Afrasiyab fragments in the Hermitage (figs 3, 4, 11; pl. II), a Qur'an in the Uzbek State Museum (pl. IIIa), a minaret inscription from Urganj dated in 401/1010–11 (fig. 15 and pl. Vb), another minaret inscription from Uzgend (figs 24–6), and a final one at Mashhad-e Mesreyan dated in 596–617/1200–1220 (fig. 27).[30] A number of late examples show that Kufic was used, if only as a decorative motif, as late as the sixteenth century. In the course of her study, Mme Krachkovskaia suggests the attribution to Central Asia of a textile in the University of Michigan and of its companion pieces,[31] on the basis of paleographical similarities to a Merv textile dated in 278/891.[32] She also suggests that the name of Ahmad ibn Isma'il, the Samanid, was written in cursive script on his coins, in order to emphasize the "power of the Samanids and their limited dependence on the caliph" (p. 8). The article is full of such small remarks and studies which tend to show that there was a definite Central Asian development of epigraphical style. The question may be asked, however, whether it is justified, at this stage of our knowledge, to assign certain trends and phenomena to one geographical area only. Too little is known about the epigraphy of Persia itself, for instance, in the first centuries of Islam, to enable us to know whether the developments evidenced in Central Asia may not have had a counterpart in neighboring areas.[33] Taking into consideration the extraordinary development of civilization at the time of the Saffarids, Samanids, Ghaznevids, Seljuqs and Khwarezmshahs, we know too little

[30] Cf. above, p. 77.
[31] Florence E. Day, "Dated tiraz in the collection of the University of Michigan," *Ars Islamica*, 4 (1937), pp. 426–7.
[32] H. Hawary, "Un tissu abbaside de la Perse," *Bulletin de l'Institut d'Égypte*, 16 (1934), pp. 61–71.
[33] See, for instance, the minarets published by J. Sourdel-Thomine.

about their art, which must have been quite varied, to be able to determine in detail that certain types and epigraphical trends are peculiar to a limited geographical area within a wide unit, which comprises Khorasan, Afghanistan, Transoxania and Khorezm. The term "Central Asia" may not correspond exactly, in the Middle Ages, to a unit of cultural development. The various dynasties, whose capitals were in Merv, Samarkand, Nishapur, or Bukhara, ruled in fact over a much wider area than what is today understood as Central Asia. Perhaps an analysis in the nature of the one made by Mme Krachkovskaia, extremely valuable in presenting new monuments and new interpretations, should be widened to include an area extending as far west as Rayy and as far east as Herat and Ghazna.

2. ——, "Monuments of Arabic writing in Central Asia and Transcaucasia before the eleventh century" (VI, 46–100). This article, of great length and touching on a great number of different problems, appears to be essentially a sort of prolegomenon to the complex and very significant problem of the ways in which and purposes for which Arabic was used in lands which were not primarily Arabic-speaking, but which had been conquered by the Arabs and, within the chronological limits of Mme Krachkovskaia's work, were ruled by them. As an introduction the author sketches in a few pages (pp. 48–68) the development of Semitic alphabets in general and of Arabic in particular, using mainly for the first part the works of Diringer and Lidzbarski, and for the second those of Moritz, [557] Grohmann, Littmann and Cantineau.[34] In a second part (pp. 68–86) Mme Krachkovskaia discusses the history and characteristics of the script (or scripts) used in the first-century AH papyri of Egypt and on monumental inscriptions found in Syria, Palestine and Egypt.[35] A detailed analysis of the most significant documents is accompanied by a series of very enlightening plates with drawings of the forms taken by the various letters. Turning then to the area under consideration, Mme Krachkovskaia deals with three monuments: a *dirham* from Merv (76/695–6), the unique letter of Divashti (99–100/718–19),[36] and a milestone from Tiflis (undated; appended photograph of a squeeze). While basically the coin reproduces a type that was common throughout most of the Umayyad empire, Mme Krachkovskaia points out (p. 87) a few differences in epigraphy and suggests that the missing *waw* in the word *al-mashrikun*

[34] Unfortunately Mme Krachkovskaia does not seem to have been aware of the important studies by Nabia Abbott, in particular her *The rise of the north Arabic script* (Chicago, 1939), which covers the same ground and deals with similar problems in very thorough fashion.

[35] An important omission is the inscription of Ta'if, published by G. C. Miles, "Early Islamic inscriptions near Ta'if in the Hijaz," *Journal of Near Eastern Studies*, 7 (1948), pp. 236–42.

[36] First published by I. Krachkovskij and V. Krachkovskaia in the *Sogdiskij Sbornik*, 1 (1934), which was unavailable to me.

was the result of a lack of familiarity of the Central Asian mint master with Arabic. The point does not seem very convincing, since, as far as possible, representatives of the central power were controlling the minting of coins and, furthermore, errors occur also on coins minted in a purely Arab city like Basra.[37] The letter of Divashti to the Arab *amir* al-Jarir ibn 'Abdatlah, which was discovered in the 1930s by the Russian expedition to Soghdia, is much more significant, since it is one of the very few documents – other than monumental inscriptions, which are not numerous – we possess from the early Islamic period outside of Egypt. Mme Krachkovskaia shows that the type of script is sufficiently different from the usual first-century script of Egypt to suggest that it was probably from a different calligraphic school, a calligraphic school whose influence does not appear in Egypt until several decades later. The letter is unfortunately not illustrated, although a table is provided with an alphabet. It would be interesting to compare it in detail with the various scripts identified by Miss Abbott. The milestone from Transcaucasia is interesting in another respect. It is quite similar to the milestones found in Syria and serves to indicate the extent to which, already in the Umayyad period, Transcaucasia, actually even the Caucasus itself, was fully fitted into the new empire.

Then (pp. 91 ff.) the author goes back to Egypt and studies in great detail the documents of the second century AH. It will be apparent from this summary of Mme Krachkovskaia's learned article that its title is somewhat misleading. Only three Central Asian or Transcaucasian documents are mentioned in any detail, only one of which is new. The main point of the article is to establish the trends of early Arabic scripts, presumably as a preface to further studies more specifically devoted to Central Asian problems. It is constantly emphasized that throughout the history of Semitic writing, there was a constant influence of cursive writing on other types. Hence a thorough understanding of early scripts and the influences they underwent is necessary for the study of later monumental and manuscript writing. A complete critical analysis of Mme Krachkovskaia's thesis and interpretations would require a detailed examination of all the documents mentioned by her. It would appear, however, that her article does not replace Miss Abbott's studies, which used not only early documents, but also literary sources on calligraphic problems. On a few points it supplements it and suggests that, at a very early date, calligraphic traditions which do not appear in Egypt can be found in Central Asia.

3. The same author's "Central Asian epigraphy" (VII, 45–69) is subtitled "pioneer epigraphists: the Turkestan circle of the friends of archaeology." It is an analysis of the works done by the early Russian travelers and scholars in Central Asia (Lerh, Khanikov, etc.), with particular emphasis on the active

[37] S. Lane-Poole, *Catalogue of oriental coins in the British Museum* (London, 1875), vol. I, p. II.

and successful society established in Turkestan itself. The article contains a very complete bibliography of works not easily available outside of Russia, but whose importance for the knowledge of [558] Central Asia, and especially of monuments now disappeared or badly damaged, is invaluable.

E. CAUCASUS

1. V. A. Krachkovskaia, "Unknown album of Arabic and Persian epigraphy" (II, 19–40), publishes extensive parts of a 56-page album from the Archives of the Russian Geographical Society, which contains pictures of 76 inscriptions in Arabic and Persian and 14 watercolors. Almost all the inscriptions are from the Caucasus and Mme Krachkovskaia shows that they were taken by Khanikov and various collaborators in the middle of the nineteenth century. Some of them have already been published.[38] Many, mostly tombal, were until now unknown.

2. ——, "Tomb inscriptions from Dmanis" (V, 21–32). About fifty Arabic inscriptions were found in 1936–7 in the ancient Georgian capital, about 100 kilometers southwest of Tiflis. The author publishes nine of them, all later than the middle of the thirteenth century, one of them probably monumental. One inscription is in Kufic, one in *thuluth*, the rest in *naskhi*. Although very fragmentary, the documents are interesting for a study of Islamic expansion into the Caucasus.

F. LATER THAN THE FIFTEENTH CENTURY

1. A. A. Semenov, "Two autographs of Khoja Ahruna" (V, 51–7). The author describes two autographs from an album of autographs of great men, and not of calligraphists (as was usual with such albums), collected by an unknown personage in the seventeenth century. The album is at present in the collection of the Uzbek Academy of Sciences.

2. ——, "A seventeenth century Persian cruet for spices" (V, 58–60). Description of a curious object made up of individual "cups" fitted within each other and inscribed with religious poems.

3. I. V. Megrelidze, "A Persian alphabet in Georgian transliteration" (V, 61–4). This document comes from a Georgian manual dated around 1800.

4. E. A. Davidovich, "Inscriptions on Central Asian silver coins of the sixteenth century" (VII, 30–40), discusses inscriptions of Shaybanid coins.

[38] N. de Khanikoff, "Mémoire sur les inscriptions musulmanes du Caucase," *Journal Asiatique*, 5ème série, 20 (1862).

On the whole there is comparatively little variation between the titles of the various rulers of the dynasty (five at the most). Some titles appear only in certain mints. The author has added a convenient table of all known mints from the period and of the dates of known coins from those mints.

5. A. A. Semenov, "Inscription on the tombstone of the amir of Bukhara Shah Murad Ma'sm, 1200–1215/1785–1800" (VII, 41–4), shows that the tombal inscription of the first Uzbek ruler of Bukhara was different from that of his successors.

6. M. A. Dobrynin, "Poetical legends on Safavid coins" (VIII, 63–76), performs a great service to numismatists by giving a short sketch of the history of poetical inscriptions on Islamic coins, and identifying and commenting on the poems found on Safavid coins. The commentary deals with historical, religious and ideological problems.

G. OTHERS

1. V. A. Krachkovskaia, "From the archives of Khanikov and Dorn" (IV, 28–39), outlines, with numerous excerpts, the correspondence between the two orientalists, mostly dealing with Dorn's trip to Central Asia and with the purchase in Paris of books for the library of St Petersburg.

2. ——, "V. V. Bartold, numismatist and epigraphist" (VIII, 10–23), contains, with a summary of the work accomplished by this great Russian scholar, a useful bibliography of some of his less known contributions.

3. A group of five articles dealing with the subject of Islamic epigraphy in Russia itself concerns essentially Tartar and Bulgarian tombstones from the thirteenth century on. Four of these articles merely publish monuments with short commentaries: (a) S. E. Malov, "Bulgarian and Tartar epigraphical monuments" (I, 38–45) and (b) "Bulgarian and Tartar epigraphy" (II, 41–8); (c) G. Iusupov and G. Hisamutdinov, "Bulgarian epigraphical monuments found in the summer of 1947" (IV, 68–75); and (d) G. V. Iusupov, "On some Bulgarian epigraphical monuments" (VII, 26–9). The fifth article, (e) G. V. Iusopov, "Tartar epigraphical monuments of the fifteenth century" (V, 78–94), is more developed and contains, besides a large group of tombs, a map showing the places where the inscriptions from different centuries were found. The map shows how [559] the Tartars moved toward the northeast and the west in the fifteenth and sixteenth centuries. The large number of inscriptions published here permits a more complete analysis of the textual and stylistic developments in this little-studied area of Islamic expansion.

Non-Islamic

A. NON-ISLAMIC CENTRAL ASIA

1. A. N. Bernshtam, "Uighur epigraphy in Semirechia I" (I, 33–7), discusses three inscriptions from the ninth to eleventh centuries found on dishes.

2. K. K. Yudahin, "Bouz or bu uz" (I, 46–8), is a commentary on a word found on a small pitcher from Saraychik.

3. A. N. Bernshtam, "New inscriptions from Central Asia" (III, 55–8), discusses an alleged Chinese inscription on a second millennium BC spearhead, a Saki inscription of the sixth to seventh centuries BC, and a fifth to eighth centuries AD seal from Talas.

4. O. I. Smirnova, "Soghdian coins from the collection of the numismatic section of the Hermitage" (IV, 3–23), is a complete description of the coins with technical and historical commentaries.

5. A. N. Bernshtam, "Old Turkish writing in the Lena River region" (IV, 76–86), is a study of recently found runic inscriptions with a map showing the spread of these inscriptions between the sixth and ninth centuries.

6. E. R. Rygdylon, "New runic inscriptions from the region of Minusinsk" (IV, 87–93).

7. E. R. Rygdylon, "Mongol inscriptions on the Ienissei" (IV, 94–101).

8. A. N. Bernshtam, in "Old Turkish documents from Soghd, a Preliminary report" (V, 65–75), suggests that a document found by the Soghdian expedition and so far not understood is in fact in Turkish. He also draws a few conclusions of a historical nature on the significance of the close relationship between the Turks of the Semirechia and the Soghdians.

9. Iu. L. Aranchyn, "Slab with an old-Turkish inscription at Saigyn" (V, 76–7).

10. E. R. Rygdylon, "Chinese signs and inscriptions on archaeological objects from the Ienissei region" (V, 113–20).

11. O. I. Smirnova, in "Materials for a catalogue of Soghdian coins" (VI, 3–45), discusses coins of the seventh and eighth centuries AD, "a group of copper coins whose inscriptions are in Soghdian and which are written in the official government script (cursive) of Soghd in the same period" (p. 7).

Many important problems are touched upon in the course of this lengthy study: the relation to Chinese coins, the means we possess to localize Soghdian coins, and the curious fact that no silver coins are found. The last point is explained through the practice mentioned by Arab geographers that many Central Asian cities had a coinage valid only within the limits of that city. More problems are posed by the discovery at Varahsha of coins with inscriptions whose script is Aramaic, but whose language is unknown. This general introduction is a remarkably clear presentation of the very complex monetary situation of Central Asia at the time of the Muslim conquest. It is followed by a long catalog.

12. A. N. Bernshtam, "Uighur inscriptions from Erski (Ferghana)" (VI, 101–5), deals with a group of seventh- to ninth-century inscriptions with historical commentary.

13. E. R. Rygdylon, "Remnants of a Mongol inscription in the cavern of Buhtaminsk" (VII, 77–80).

14. V. C. Vorobiev-Desiatovskij, "Tibetan documents on wood from the area of Lake Lob-Nor" (VII, 70–76, and VIII, 77–85).

15. E. R. Rygdylon, "On old-Turkish runes of the Pre-Baikal region" (VIII, 86–90).

B. ANCIENT NEAR EAST

1. B. B. Piotrovskij, "The 'city Teishebaini' on an Urartian cuneiform inscription" (II, 83–5).

2. I. M. Diakonov, "Fragments of cuneiform tablets from the 1946 excavations at Karmir Blur" (II, 86–9), gives a transliteration and transcription of three tablets dealing with judicial and legal problems.

3. G. V. Tzereteli, "Armazi script and the Problem of the origin of the Georgian alphabet" (II, 90–101, and III, 59–71). In the first article the author discusses the signs used for numbers. He is led to the conclusion that the "Armazi letters and numbers are genetically tied to Aramaic, to the specific variety of Aramaic appearing in the script of the Egyptian Aramaic papyri of the fifth to second centuries B.C." (p. 95). He shows also the close relationship between Armazi and various types of [560] Persian scripts. In the second article the author turns to a more general problem. "During the archaeological excavations at Mtzhet were found Greek, Hebrew, Persian, and Aramaic inscriptions, but so far no Georgian ones. Does it mean that at that time the Georgian alphabet did not exist as yet and that the supposition is then

justified that the Georgian alphabet was formed in the fifth century A.D.? Or perhaps that it [the lack of Georgian inscriptions] can be explained through other reasons and, in spite of the lack of monuments with Georgian inscriptions in Armazi times, we are still justified in supposing the existence there of a Georgian alphabet? The solution to the problem is entirely tied to the question of the relation between Armazi and Georgian scripts. If it will appear that the Georgian script is tied to the Armazi one, and, at the same time, if it can be shown that individual Georgian letters show a more archaic character than the Armazi ones, the suggestion of the existence of a Georgian script in Armazi times becomes more convincing; on the other hand, if it appears that the Georgian script has no genetic relation to Armazi, then the question of the origin of the Georgian script will still remain open" (p. 59). The author believes that the first possibility is correct and that, with a number of exceptions, the Georgian alphabet shows many similarities to Armazi.

4. I. M. Lurié, "The teaching of Amenemhet I on ostraca in the Museum of Representational Arts" (III, 83–7).

5. B. B. Piotrovskij, "Three Urartian inscriptions on bronze objects from Teishebaini (Karmir Blur)" (III, 88–9).

6. I. M. Diakonov, "Remarks on Urartian epigraphy" (IV, 102–16, and VI, 106–12).

7. I. M. Lurié, "Old Egyptian plaque with a donation to the earth" (V, 95–109).

8. B. B. Piotrovskij, "Cuneiform inscriptions on bronze bowls from the excavations at Karmir-Blur" (V, 110–12).

9. I. N. Vinnikov, "Newly found Phoenician inscription" (V, 121–33), presents an attempt at interpretation of the well-known Kara-tepeh inscription.

10. N. V. Artiunian, "The chronicle of Argusht I from Khorkhor" (VII, 81–119), is a transcription and translation of a new arrangement of the cuneiform inscriptions formerly published by Schultz, Guyard and others.

11. V. V. Struve, "P. K. Kokovtsov as an assyriologist" (VIII, 3–9).

C. GEORGIAN

1. I. V. Megrelidze, "Arabic alphabet in old Georgian transcription" (VIII, 36–42).

2. L. M. Melikset-Bekov, "The tetralingue of Garesdji from 1352" (VIII, 56–62), presents a graffito found in 1921 and written in Georgian, Armenian, Persian and Uighur.

Summary

Ranging in time from the second millennium BC to the early nineteenth century and in space from Tibet to Egypt and to Asia Minor, the contributions to *Epigrafika Vostoka* cover a great number of fields and problems. As is to be expected, the contributions vary in importance and value. To limit myself only to the medieval period, such works as those of Semenov on the inscriptions of the Gur-e Amir, of Mme Krachkovskaia on the plate of Badr al-Din Lu'lu' and the exploration of Central Asian and Caucasian epigraphy, of Mme Smirnova on Soghdian coinage, of Giuzalian on the epigraphical problems of tiles, and many others, are certainly of great significance to all Islamic scholars. A great number of new monuments and new inscriptions have been made available. In many cases the authors have not limited themselves to purely epigraphical problems, but have sought the wider implications of the texts they published. On the whole the presentation is good. Printing mistakes are few and the Arabic and Persian texts are generally correct. A list of corrections is often attached at the end of the issue.

However, the photographs are often unsatisfactory and, although excellent drawings are generally provided, the best drawing can never be trusted in the same way as a photograph. It is to be hoped that the subsequent issues of this journal devoted to an essential area of Oriental studies will continue to publish new documents and studies which exemplify the importance of the research done in the Soviet Union and which give us an opportunity to know better the significant discoveries recently made in Central Asia and the works of art in Russian museums, whose access is difficult for scholars outside the Soviet Union.

Part Two

Art of the Book

Chapter VI

A Newly Discovered Illustrated Manuscript of the *Maqamat* of Hariri*

It has been known for several decades now that one of the Arabic books to have been frequently illustrated in the thirteenth and fourteenth centuries was the *Maqamat* of Hariri. Ten manuscripts of this work with illustrations have been known for some time, though only one of them has ever been published in almost its entirety.[1] In the fall of 1960, Dr Richard Ettinghausen was fortunate in discovering in Istanbul a thirteenth-century manuscript of the *Maqamat* with an extensive cycle of illustrations and, with rare generosity, has provided me with his photographs and with the authorization to publish them, even though many of the remarks found below are based on his observations and careful notations made on the spot and elaborated in later correspondence. A complete publication with an exhaustive analysis of all the problems raised by this manuscript can be made only within the framework of the publication of all known manuscripts of Hariri's best-seller. For such a work the documentation has been gathered at the University of Michigan and it is my hope that it will soon be possible to present it in a completed form. It was felt that, in the meantime, it would be essential to present to the interested public this new document and to raise a few of the problems it poses. In the framework of a periodical it is not possible to illustrate all the comparative material to which allusion will be made, but by giving precise folio or page references it is hoped that our comparisons will be of some value.

The manuscript is found in the Süleymaniye library, Esad Efendi 2916. Its beginning and end are recent and a few new pages are found in the middle. The headings are in rather coarse black *thulth* on a ground decorated with red rinceaux and with a white border separating the writing from the

* First published in *Ars Orientalis*, 5 (1963) pp. 97–109.

[1] K. Holter, "Die Galen-Handschrift und die Makamen des Hariri," *Jahrb. der Kunsthistorischen Sammlungen in Wien*, n. f., vol. 11, 1937. There is no point in giving here once more the list of all known illustrated manuscripts of the *Maqamat*; cf. the latest list given by D. S. Rice, "The oldest illustrated Arabic manuscript," *BSOAS*, 22 (1959); the two to which we are going to refer most frequently are Paris, Bibliothèque Nationale, arabe 5847 (Schefer), and Leningrad, Academy of Sciences, MS. S. 23.

background; they are framed in gold. The pages are 301 mm in height and 223 mm in width. As it is now, the manuscript was illustrated with 56 miniatures. All of them were at one time severely damaged and it is only in a very few instances, for example, that faces of personages have been preserved. Fourteen images were either so damaged that it was not possible to reproduce them or were common repetitions of standard scenes, and it is therefore only 42 miniatures which are here presented. In spite of their poor condition, their importance is great for an understanding of the other illustrated manuscripts of the same work as well as for the general history of the art of the time.

1. Fol. 14v contains an illustration of the fifth *maqama*. It occurs at the beginning of the story, when the narrator, al-Harith, describes a group of friends gathered in a house as they hear a knock at the door. With its sliding roof, lamp on a tall stand, heatable brick bench, and elaborate knocker, this miniature is a faithful reproduction of a contemporary [98] house. No other manuscript has exactly the same subject illustrated, most of them concentrating on depicting scenes from the story told by Abu Zayd, the hero of the *Maqamat*, rather than on the place where he told the story. The one exception is the Leningrad manuscript, in which an elaborate house is depicted twice (pp. 27 and 29).[2]

2. The image on fol. 18 depicts the *diwan al-nazar* in Maraghah (sixth *maqama*) in which a group of scholars discuss a point of eloquence. This image occurs at the beginning of the *maqama* and belongs to a group, standard in all manuscripts, which consists of an assembly in front of a prince or a judge. In some manuscripts, such as the Schefer in Paris, a careful distinction is made between the generally non-Arab princes and the usually Arab *qadis*. The differentiation is usually achieved through varying clothes and facial features as well as through certain symbols of authority. While facial features cannot be examined in this manuscript, the long robe, the simple footwear and the ink pot are more characteristic of judges than of princes. Only the knotted tails give the personage a more official character. The other manuscripts which possess illustrations of this *maqama*, when, as here, they illustrate the setting of the story rather than a later episode, do not seem to identify precisely any one of the personages as a *qadi*. There are two exceptions: the Leningrad manuscript which has on page 35 a brilliant scene showing an enthroned judge; and British Museum or. 1200, fol. 16, in whose quite heavily redone images the judge is also identifiable.

3. Fol. 27v illustrates the ninth *maqama*, more precisely the moment at the beginning of the story when Abu Zayd's wife describes her life to the judge. The four personages inside the room are the judge in a magnificent

2 The Leningrad manuscript is paginated throughout.

long robe and on a high wooden bench, al-Harith, Abu Zayd, and his wife. But the most curious feature of this particular image is the section of the entrance shown to the right with its projecting screened window, its curtain, and a personage seated on a bench, who will later be involved in the action. The curious emphasis on the physical setting in the illustration of this story differentiates it quite clearly from all other illustrations of the ninth *maqama* except two. Most of them are quite simple and direct illustrations of the text, even if, as in the Schefer manuscript, the result is quite spectacular. The two exceptions are the Leningrad manuscript, pages 52 and 57, with two extraordinary tribunal scenes, and BM Add. 22114, fol. 15, in which a curiously complicated physical structure appears. In details, however, these two images are quite different from ours.

4. Fol. 34 contains the celebrated eleventh *maqama* whose illustrations have recently been analyzed by D. S. Rice.[3] This unfortunately terribly damaged miniature, with its numerous tombs, its trees, its crowds of mourners, and its precise and detailed depiction of a burial, clearly belongs to the same category as the corresponding images in the Leningrad and Schefer manuscripts. The main iconographic difference between them consists of the fact that the Istanbul miniature probably showed Abu Zayd to the upper left, whereas the other two images do not have the hero of the story clearly identified. It [99] should also be noted that several tombs were provided with what appear to have been actual inscriptions – not imitations – but these have been so damaged as to defy complete reading.

5. Fol. 41 contains an illustration of the beginning of the thirteenth *maqama* and presumably showed Abu Zayd disguised as a woman and preceded by small children, arriving in the presence of a group of "some *shaykhs* of the poets," sitting by the bank of the Zowrah. It is not much different from the usual "assembly-with-stranger" images found quite often in most manuscripts. Curiously, only one of them (BM 1200, fol. 35v) also emphasizes the fact that the scene takes place by a body of water.

6. On fol. 44, we see the arrival of Abu Zayd and of his son in a tent on the way to Mecca, as related in the fourteenth *maqama*. The personages are so damaged that it is difficult to determine the exact arrangement of the figures, although it would seem likely, from other parallels, that Abu Zayd and his son are the men standing at the left. The two major iconographic peculiarities of this illustration when it is compared to those found in other manuscripts are that all the personages are included inside the tent – which, to my knowledge, occurs only on BM Add. 7293, fol. 76 – and that the

[3] D. S. Rice, "The oldest illustrated Arabic manuscript," pp. 203 ff. I may use this opportunity to make a small addition to Professor Rice's otherwise complete article. With respect to Bibliothèque Nationale, arabe 3929, there are two more illustrations of the eleventh *maqama*: fol. 30 showing Abu Zayd "coming down from the hillock" (tr. of the *Maqamat* by Th. Chenery and F. Steingass, London, 1867 and 1898, vol. I, p. 167), and fol. 30v describing al-Harith upbraiding the crook.

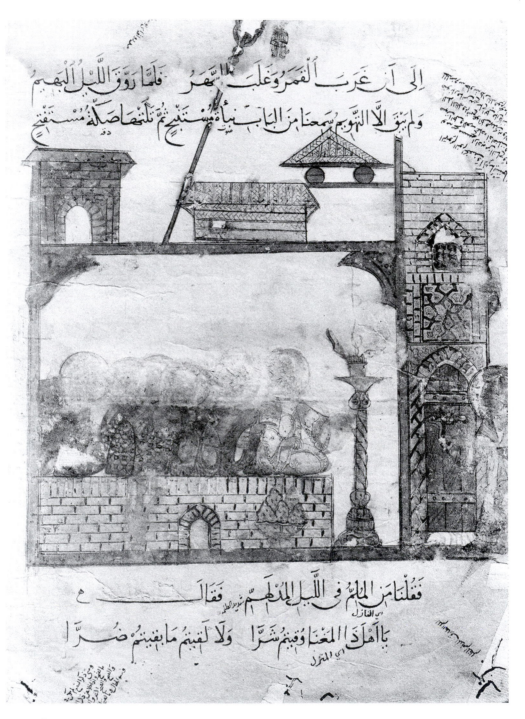

1 *Maqamat* of
Hariri, fol. 14v

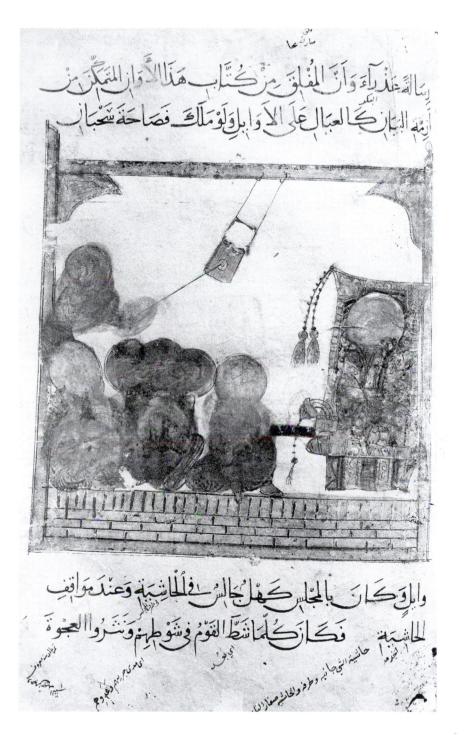

2 *Maqamat* of
Hariri, fol. 18

3 *Maqamat* of
Hariri, fol. 27v

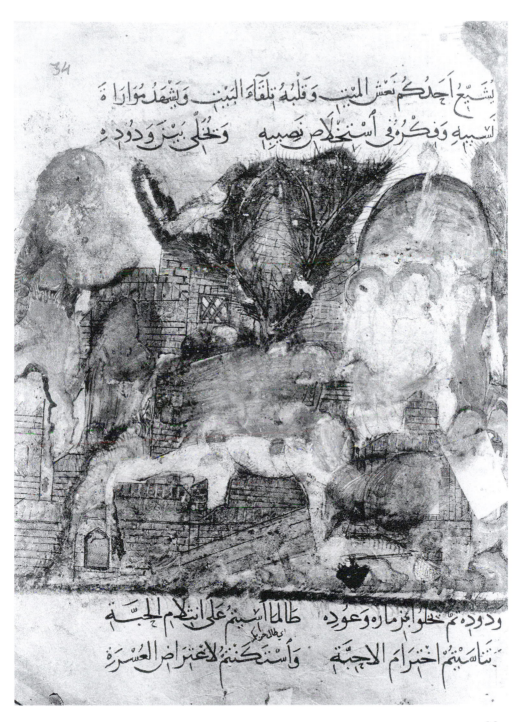

4 *Maqamat* of
Hariri, fol. 34

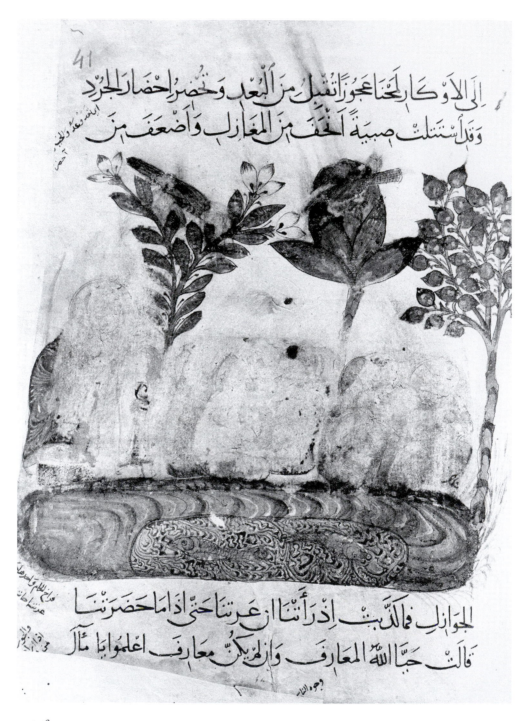

5 *Maqamat* of
Hariri, fol. 41

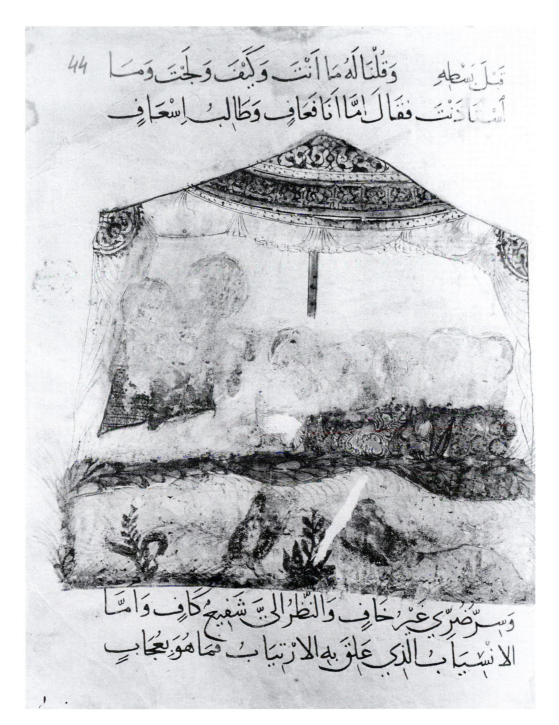

قَبْلَ بَسْطِهِ وَقُلْنَا لَهُ مَا أَنْتَ وَكَيْفَ وَلَجْتَ وَمَا

أَسْبَأَذَنْتَ فَقَالَ إِمَّا أَنَا فَعَافٍ وَطَالِبُ اسْعَافِ

وَسِرُّ ضُرِّي غَيْرَ خَافٍ وَالنَّظَرُ الَىَ شَفِيعِ كَافِ وَأَمَّا

الْإِنْسِيَابُ الَّذِي عَلَوْتَ بِهِ الِارْتِيَابُ فَمَا هُوَ بِعُجَابِ

6 *Maqamat* of
Hariri, fol. 44

ground is represented on two separate levels, one with the tent, the other with plants, a bird and an animal(?). This device, common enough in the thirteenth century for the representation of spatial depth, has been used with particular effectiveness in many images of the Leningrad manuscript, and in particular in the first image illustrating the fourteenth *maqama* (p. 85). The major difference between the two miniatures is that the Leningrad one has the two planes entirely separate, whereas the Istanbul one unites them by vertical lines of grass at either end.

7. Fol. 47 shows al-Harith in his house inquiring about the "how and when" of Abu Zayd, who has just come in (fifteenth *maqama*). The major characteristic of this image is its magnificent rendering of a house, with its door, its stairs and its movable roof. While most of it is on a flat two-dimensional plane, the door and the staircase introduce an interesting attempt at depth. A similarly elaborate setting occurs in BM Add. 7293, fol. 80, and especially in the Leningrad manuscript, page 90, where, in particular, the stairs, the jar under the stairs, and the respective size of the architectural parts are similar to ours.

8. On fol. 48v there is another illustration of the same *maqama* which refers to the moment[4] when the unknown *shaykh* presents Abu Zayd with a riddle written on a piece of paper. To the left, on a curious sort of shelf, are three glasses of milk and dates, together with a vendor. These items of food have their importance in the story, but are not supposed to be present at the time of the meeting of the two men. Although their meeting has been illustrated many times, the specific features of the background are here unique.

9. Fol. 55v illustrates the beginning of the seventeenth *maqama*, in which Abu Zayd, in the midst of a crowd of learned men, is ready to show his linguistic tricks. Whereas the grouping of personages around trees is common enough, the peculiarity of this image consists of the addition of a body of water, of which no mention is made in the text.

10. The image on fol. 64 illustrates the moment, in the nineteenth *maqama*, when the friends of the sick Abu Zayd are gathered around him. Set as it is on two planes related to each other by the standing personages to the left and right, this scene recalls in composition the illustration of the same story in the Schefer manuscript (fol. 53) and differs from the Leningrad image (p. 118) which is, [100] as usually, set in an elaborate interior. Dr Ettinghausen has noted that the personage on the right, in the common pose of one leg up, has left his shoe on the ground, as though trying to scratch his foot.

11. Fol. 67, at the beginning of the twentieth *maqama*, shows Abu Zayd appearing to a group of weary travelers who had settled down to rest. This rather simple image is merely another variation on the theme of the group,

4 Vol. 1, p. 189.

the more restful poses seen here being required by the text. Like all illustrations of the same scene, it has no external additions, except for the two birds, used here to indicate the outdoors, a fairly common decorative motif in thirteenth-century miniatures and in Persian ceramics, but rare in illustrated manuscripts of the *Maqamat*. The major peculiarity of the Istanbul image is that it avoids the obscenity found in many other images from the twentieth *maqama*, since the main subject of Abu Zayd's statements in the story is scabrous indeed.

12. Fol. 70 has an illustration placed in the middle of a sermon preached by Abu Zayd in the mosque of Rayy, as described in the twenty-first *maqama*. The sermon is attended by the local ruler together with a large crowd of people. It is not exactly certain whether the ruler was seated in the middle or above, as on the corresponding and extremely complex image of the Schefer manuscript (fols 58v and 59 forming really one single image),[5] but the former seems more likely, because, in spite of the damaged faces, it seems that only women were seated on the balconies above. There are several resemblances of detail between the Paris manuscript and the Istanbul one (such as certain groupings and the decoration of the *minbar*), but whereas the Schefer illustration, spread over two pages with a minimum of architectural background, has a widely conceived composition, everything is compressed in the Istanbul one with its complete architecture and its crowds of people. In that sense it comes much closer to certain images in the Leningrad manuscript, even though this particular scene is not illustrated there. Two more points may be made about this image. First, it shows a comparatively rare feature in thirteenth-century miniatures, the framing of parts of the text with an architectural element from the illustration. Second, parts of a qur'anic inscription are visible on the upper right; the specific passage beginning with *wa qalu* cannot be identified precisely.

13. Fol. 73v shows the well-known boat mentioned in the twenty-second *maqama*. The shape of the boat and the rather lively composition of figures, as well as the addition of low-flying birds, make this image come much closer to the two in Leningrad (pp. 135 and 139) than to any other illustration of the same story in other manuscripts, although the Leningrad images have an additional pavilion on the boat which is missing here.

14. Fol. 77 illustrates the moment, at the beginning of the twenty-third *maqama*, when Abu Zayd complains about his son. The scene is set in a tribunal with an "Arab" type of judge seated on a high platform. The particular interest of the illustration consists in the fact that, whereas the text is unclear as to whether this scene takes place in front of a *wali* or of a *qadi*, our illustrator has opted for the latter, while every single other illustration

[5] This extension of a single image over two pages facing each other is a characteristic of the Schefer manuscript and a rarity in most other versions.

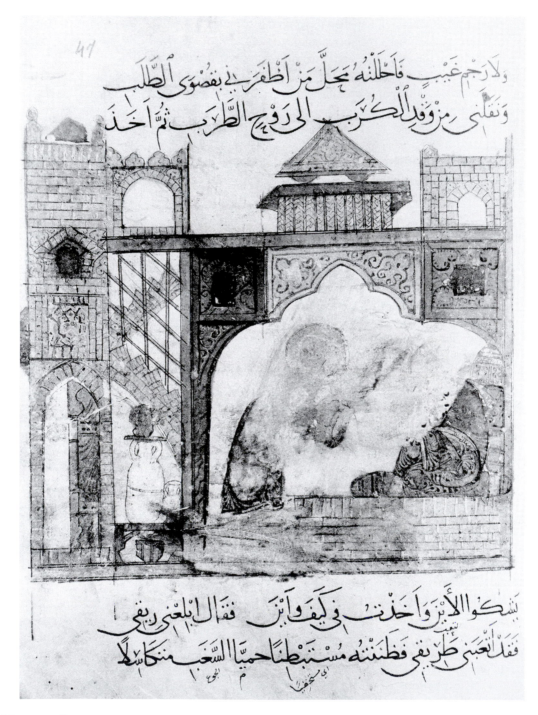

7 *Maqamat* of
Hariri, fol. 47

حتى هاجت لك الاسف على نقد من سلف فابرزرفعته من
كمه واقسم بابيه وامه لقد انزلها باعلام المدارس فالمنازل واعن

الاعلام الدوارس واستنطقها اجبار المحابر فخرسوا ولاخرس كان
المقابر فقلت ارسما فلعلى اغنى فيها فقال ما ابعدن فى المرام

وَتَجَلَّتْ فِي لَوْنَيْنِ وَصَلَتْ إِلَى جِهَتَيْنِ وَبَدَتْ ذَاتَ
وَجْهَيْنِ انْ بَزَغَتْ مِنْ مَشْرِقِهَا فَنَاهِيكَ بِرَوْنَقِهَا فَإِنَّ

طَلَعَتْ مِنْ مَغْرِبِهَا فِيَّا بِالْعَجَبِهَا قَالَ فَكَانَ الْقَوْمُ رَمَوْا بِالصَّمَاتِ
أَوْجَفَتْ عَلَيْهِمْ كَلِمَةُ الانْصَاتِ فَمَا بَسَ مِنْهُمْ انْسَانُ وَلَا

9 *Maqamat* of
Hariri, fol. 55v

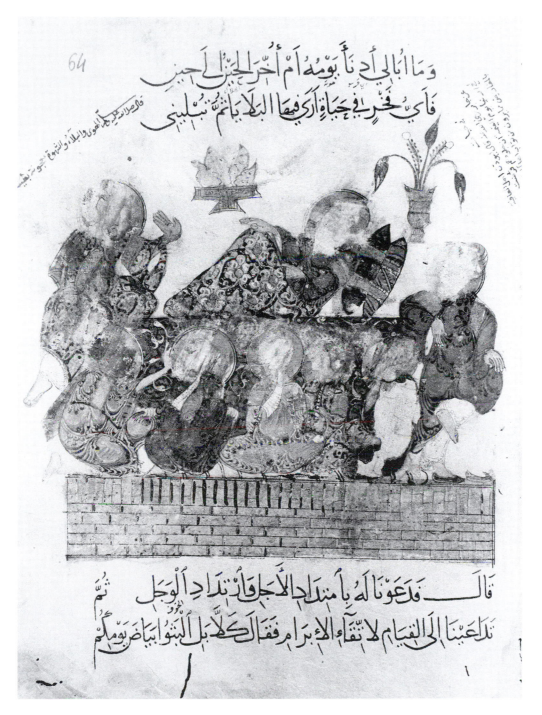

10 *Maqamat* of
Hariri, fol. 64

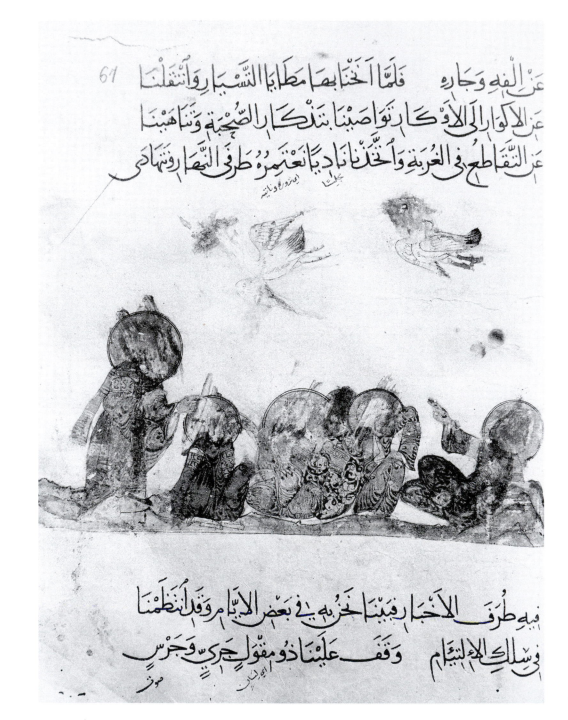

11 *Maqamat* of
Hariri, fol. 67

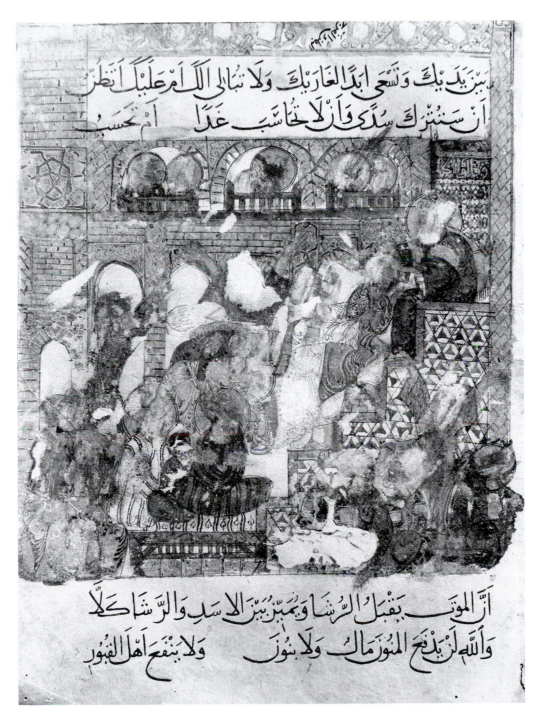

12 *Maqamat* of
Hariri, fol. 70

of the *maqama* represents a prince. One may note also the rather stiff curtain which characterizes many interior scenes in the Leningrad manuscript.

15. Fol. 82v shows a garden party at which Abu Zayd proffers grammatical riddles (twenty-fourth *maqamah*). The assembly is [101] one of merrymakers and so they are depicted with wine and musical instruments. The peculiarity of our manuscript is in the treatment of the landscape. Its size and the feature of three separate pools of water with fish and birds are unique. It is this landscape which differentiates this miniature from other illustrations of the same text. The Schefer manuscript, of course, does have an elaborate development of the scene (fol. 69v) with its well-known garden party around an artificial pool and fountain, but in conception and organization it shows considerable variance from our manuscript.

16. Fol. 89 illustrates the sudden appearance of "an old man, bare of skin, showing his nakedness, ... turbaned with a kerchief and breeched with a napkin. And around him was a crowd."[6] The most interesting features of our miniature are the addition of two horsemen to the "crowd," and the fact that the old man appears at the gate of a crenellated tower, although neither element is required by the text. The first feature is unique in the precise manner in which it was executed, although the Schefer manuscript does have (fol. 74v) al-Harith on a mule; the second feature occurs only in the Schefer manuscript (fol. 75) and is, curiously enough, missing from the Leningrad one. What is the point of such an imagery? Several explanations may be suggested. But the most plausible one may be that it expresses best the suddenness of the appearance of Abu Zayd to al-Harith, *fa-idha shaykh 'ari al-jildah*. ... Most of the other manuscripts show Abu Zayd on a rock and surrounded by people, an iconographic motif of old standing and relatable to the Christian imagery of Job, as was shown by Buchthal two decades ago.[7] But it is obvious enough that this motif did not really illustrate the text, whereas the innovation introduced by the Schefer and Istanbul manuscripts creates or utilizes iconographic formulas better adapted to what was needed here.

17. The image on fol. 92 depicts al-Harith's arrival at Abu Zayd's tent, as described at the beginning of the twenty-sixth *maqama*. The image develops on two levels, one showing Abu Zayd in his tent and al-Harith entering it, the other showing a fire being kindled and a horse being groomed. The technique of setting above each other two iconographic units which must be understood as being either in front of or alongside each other is a rather common one since Late Antiquity and often occurs in other illustrations of the *Maqamat*, particularly in the Leningrad manuscript. More interesting, however, are the omissions and additions to the text which occur here. The

6 Vol. 1, p. 254.
7 H. Buchthal, "'Hellenistic' miniatures in early Islamic manuscripts," *Ars Islamica*, 7 (1940), p. 126.

setting, as suggested by the story itself, is quite limited : "… there came to my sight a pitched tent and a kindled fire. I saw some fair boy-servants, and furniture which thou wouldest gaze at."[8] First, a fettered horse was added with a groom.[9] Then, instead of "fair boy-servants," we have a representative each of the *ahl al-qalam* and the *ahl al-sayf*, the civil and military authorities characteristic of a prince, which our rogue, Abu Zayd, has suddenly become, although there is no forewarning in the text. Other instances of such transformations occur elsewhere in illustrated manuscripts of the thirteenth century and they illustrate a very important step in the formation of contemporary miniatures.[10] In order to indicate success and power, [102] the painter – but not the writer – uses elements from a standardized princely iconography. This standardization contrasts with the freedom and inventiveness of so many other innovations introduced by the painter over and above the indications of the text and shows that a repertory of princely themes preceded the type of imagery developed in the *Maqamat* and in other similar works of the twelfth and thirteenth centuries. A corollary to these remarks is that, whenever possible, the artist of the *Maqamat* did indeed look for iconographic models adaptable to his needs, but such models existed in only a limited number of instances.[11]

18. Fol. 96v contains the poem in which, in the twenty-seventh *maqama*, Abu Zayd describes to al-Harith his way of life. Iconographically the scene is not much different from others illustrating the same subject.

19. The image on fol. 98 illustrates a passage which occurs a little farther on in the same story. In showing Abu Zayd on horseback charging against the thief of al-Harith's camel, it actually illustrates a moment in the story which occurs somewhat beyond the specific text which is found around it. Like the preceding image, this one does not differ in any major way from similar illustrations in other manuscripts, except the Leningrad one (p. 177), in which the thief is shown coming down from his beast.

20. Fol. 104 shows the mosque of Samarkand during Abu Zayd's sermon as told in the twenty-eighth *maqama*. The depiction of the mosque with its characteristic elements – arcades, *mihrab*, *minbar*, a *dikkah*, lamps, minaret – is remarkable for the completeness of its components and the peculiar oblique way in which the courses of stone are set on the minaret, the latter feature being used in a few other instances in the manuscript, perhaps with the intention of suggesting curved wall surfaces. It is also more appropriately

8 Vol. 1, p. 259.
9 On this theme as applied mostly to princely scenes see R. Ettinghausen, "On some Mongol miniatures," *Kunst des Orients*, 3 (1959).
10 Another instance of this occurs in the Schefer manuscript, fol. 33, a miniature which has recently been studied from a different point of view by D. S. Rice, "Deacon or drink," *Arabica*, 5 (1958).
11 H. Buchthal, in "'Hellenistic' miniatures," has indicated some of the Christian sources for Arabic thirteenth-century illustrations.

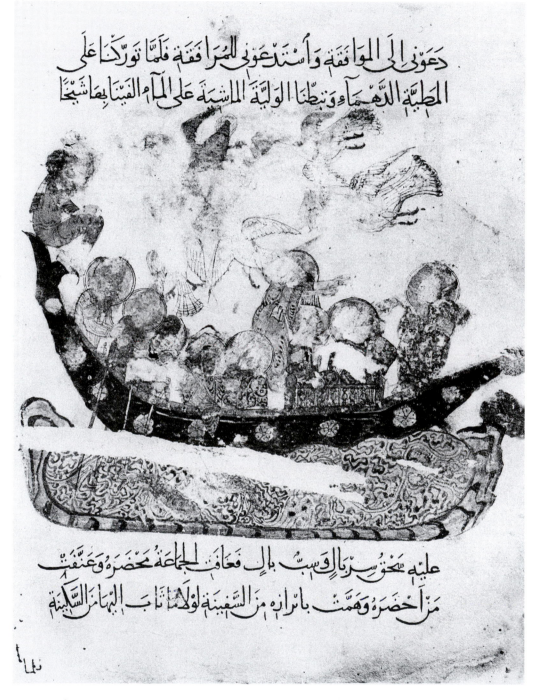

13 *Maqamat* of
Hariri, fol. 73v

رَبِّ اخْرَى مِنْ زَيْبِكَ وَهَلْ عَيْبَ اخْشٍ مِنْ عَيْبِكَ
وَقَدْ لَعِبْنَا سِحْرَى وَاسْتَلْحَقْتَه وَانْتَحَلْتُ شِعْرَى وَاسْتَرَقْتَه

وَاسْتِرَاقُ الشِّعْرِ عِنْدَ الشُّعَرَاءِ أَفْظَعُ مِنْ سَرِقَةِ الْبَيْضَاءِ وَالصَّفْرَاءِ
وَغَيْرُ نَصْهُمْ عَلَى بَنَاتِ الْأَفْكَارِ كَغَيْرِ نَصِّهِمْ عَلَى الْبَنَاتِ الْأَبْكَارِ

14 *Maqamat* of
Hariri, fol. 77

15 *Maqamat* of
Hariri, fol. 82v

16 *Maqamat* of
Hariri, fol. 89

17 Maqamat of
Hariri, fol. 92

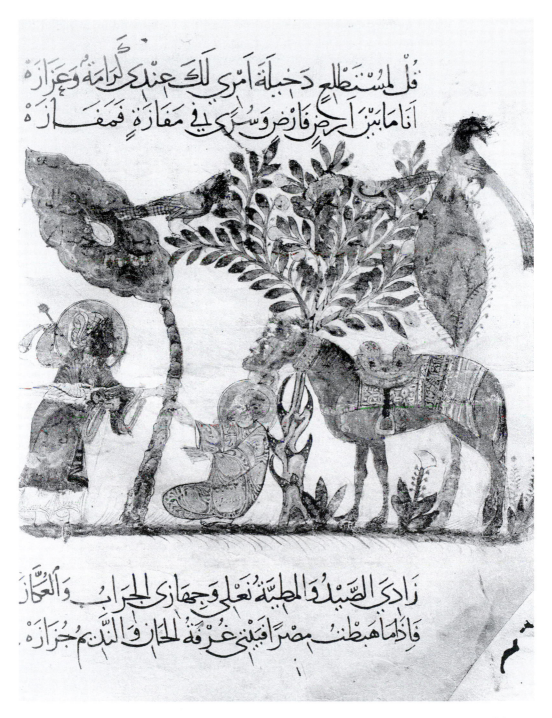

قُلْ لِمَنْ يَسْتَطِعْ دَخِيلَةَ أَمْرِي لَكَ عِنْدِي كَرَامَةٌ وَعِزَازَهْ

أَنَا مَا بَيْنَ أَرْضِ فَارِضَ وَسُرَّى فِي مَفَازَةٍ فَمَفَازَهْ

زَادِيَ الصَّيْدُ وَالْمَطِيَّةُ نَعْلِي وَجِهَازِي الْجِرَابُ وَالْعُكَّازْ

فَإِذَا مَا هَبَطْتُ مِصْرًا فَبَيْتِي غُرْفَةُ الْخَانِ وَالنَّدِيمُ جَرَازَهْ

18 *Maqamat* of
Hariri, fol. 96v

scaled to the personages than, for instance, the corresponding image in the Schefer manuscript (fol. 84v).

21. On fol. 110 we see an illustration of the key moment of the twenty-ninth *maqama*, in which al-Harith notices that the guests he and Abu Zayd have entertained have actually been doped, while Abu Zayd and his son are proceeding to rob them. The image with the *khan* as an architectural background for the activities of our heroes is very closely related to the corresponding images in the Schefer manuscript (fol. 89) and in the Leningrad one (pp. 194, 196), without being exactly similar to either one.

22. Fol. 117v contains part of the sermon delivered by Abu Zayd to the pilgrims on the road to Mecca (thirty-first *maqama*). Its illustration is curious in several ways. First of all, it does not illustrate the text in the midst of which it is set; Abu Zayd is not prominently apparent, as far as the rather damaged character of the image permits one to judge. Rather it is a picture of a *hajj* caravan about to alight. Second, the artist has introduced a curiously idyllic element in his picture by showing a small camel being fed by his mother, who is still carrying a basketful of travelers; this feature suggests a pictorial reminiscence with no textual backing of a type found in Byzantine manuscripts with classical backgrounds,[12] although it occurs also on Islamic ceramics. Finally, as in several other instances in this manuscript, the scene comprises two separate planes artificially united by rocks to the left and right; in addition, the [103] rocks to the left which extend into the margin above the text are an unusual feature in pre-Mongol miniatures and more characteristic of Persian than of Arab painting.

23. Fol. 131v has an illustration which once more represents a mosque, this time in Tiflis (thirty-third *maqama*). After prayer, Abu Zayd appears as a cripple and makes a moving plea for help. The main interest of this scene, otherwise poorly illustrated except in the Leningrad manuscript, lies in its composition. Two points should be brought out. The first is the division of personages into three groups separated by elements of a single architectural unit; this technique of composition is not the most common one in thirteenth-century illustrations of secular works, in which architecture is generally used as a background, rarely interwoven with the action (with certain major exceptions in the Leningrad manuscript), although it is common enough in Byzantine painting and in early Ilkhanid miniatures as well. The second point is the existence of two half-hearted attempts at giving illusions of depth: one consists in reproducing an inscription on the back wall of the mosque; the other one involves the almost triangular shape of the balustrades on the left and right, unless these should be considered as some kind of seat. Finally, a negative point may be worth bringing out, i.e., that the mosque here is quite different from most other mosques in this manuscript as well as

12 K. Weitzmann, *Greek mythology in Byzantine art* (Princeton, 1951), pl. XXXVI et seq.

in the related Schefer and Leningrad ones. There are no minarets, *mihrabs*, or *minbars*. The lamps, the colonnade and the unusually set inscription are the only features that may be definitely related to mosque architecture. This simplified mosque architecture is more closely tied to the bare minimum of an architectural frame in the simpler illustrations of such manuscripts as Paris 3929 and 6094, but, as Dr Ettinghausen suggests, it could very well be the depiction of a side *riwaq* rather than of a sanctuary.

24. Fol. 134 contains an illustration of the celebrated story in which al-Harith buys a slave, who turns out to be Abu Zayd's son (thirty-fourth *maqama*). The importance of this image lies in the fact that its double-deck organization, showing below the three protagonists of the story as they meet, and above the sale being transacted, is very closely related to the arrangement of the Schefer (fol. 105) and Leningrad (p. 231) manuscripts, and quite different from what is found in all other manuscripts where the two scenes are separated. The major difference between our image and those from other manuscripts is that the latter have integrated the two separate iconographic units within the single structure of a slave market, whereas the Istanbul manuscript merely has an artificial frame. But the comparison would lead one to explain the group at the upper right of our miniature as the slaves shown so prominently in the Paris and Leningrad manuscripts.

25. On fol. 136v we find another *qadi* scene from the same *maqama*, in which the judge points out to al-Harith that he has been swindled. Although details vary, the scene is closely related to other similar scenes in the manuscript, and in particular, the entrance seen in profile recalls the image of folio 27v. The depiction of one personage partly in and partly out of the room is an important and, at that time, rare device for indicating depth.

26. Fol. 138v contains an illustration of the thirty-fifth *maqama* and does not differ significantly from other similar scenes.

27. The image on folio 141 appears at first glance to illustrate a similar scene from the thirty-sixth *maqama*, but in fact it differs from all other such images in two major ways. The first one is that Abu Zayd, shown here arriving from the left, is completely outside [104] the picture and on a different scale from that of the main group of personages. The only possible textual justification for this anomalous relation is that the gathering took place on a hillock. The second peculiarity of this image is its landscape. At first glance it is nothing more than the previously noted system of two planes united on the sides by a vertical line of grass. Its novelty is that the lower part of the landscape is itself subdivided into three separate elements set one behind the other like a stage decoration. In addition, two of these elements are marked out by two animals, a gazelle or an antelope coming to drink water, and a leopard or cheetah. Both the organization of landscape through flat spaces set behind each other and the use of animals to identify them are typical of certain Persian miniatures of the early fourteenth

98

19 *Maqamat* of
Hariri, fol. 98

وللاسود والاحمر مسددا وصل الارحام وعلم الاحكام ورسم
الحلال والحرام ورسم الاخلاق والاحرام كرم الله محله

وكمل الصلاة والسلام له ورحم آل الكرماء واهله الرحماء
ما همز ركام وهد رجمام وسرح سوائم وسطا حسام

20 *Maqamat* of
Hariri, fol. 104

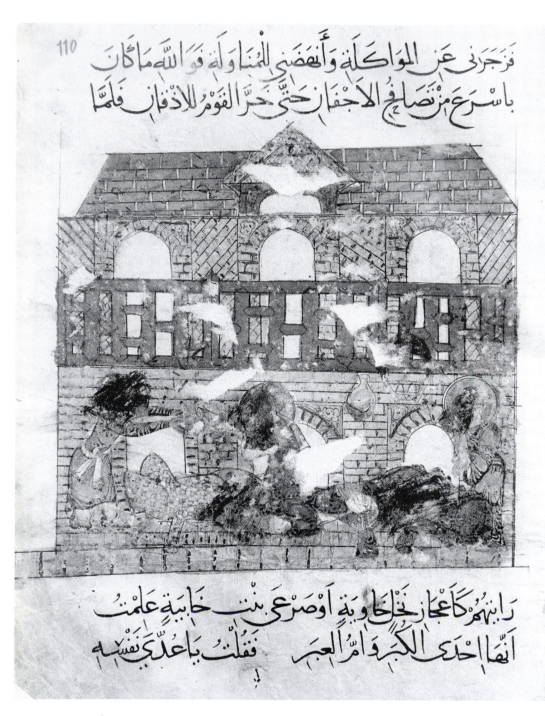

21 *Maqamat* of
Hariri, fol. 110

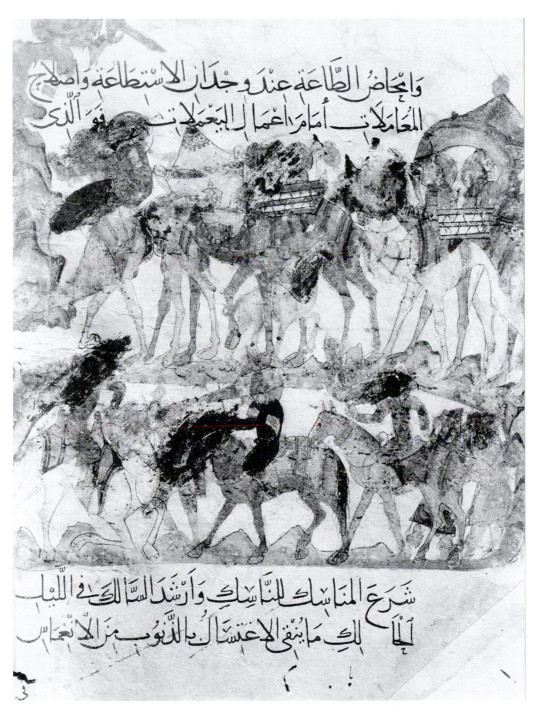

22 *Maqamat* of
Hariri, fol. 117v

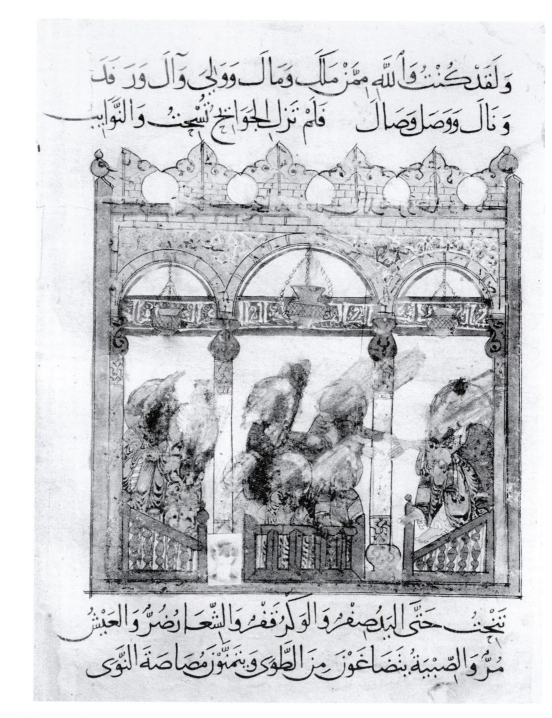

23 *Maqamat* of
Hariri, fol. 131v

134

لِعَبِّكَ وَشَفَّنَا فَغَارَكَ فِى الضَّحِكَ وَاَجَدَثُرَ اَنْغَضَرَ رَاسَهُ
اِلَى الرَّمِّ وَاَنْشَــدَ
يَامَنْ تَلَهَّبَ غَبْطَهُ اِذْ لَمْ اَخْ بِاَسىِ لَهُ مَاهَكَذَى مَنْ يَنْصِفُ

اِنْ كَانَ لَا يَرْضِيكَ اِلَّا كَشْفَهُ فَاَصْخَ لَهُ اَنَابُوسُفَ اَنَابُوسُفَ

century,[13] even though the first of the two features at least is not unknown in Arabic painting as well. A last point may be made with respect to this image. It is curious to note that the very mutilated manuscript of the *Maqamat* in the British Museum, or. 1200, dated 1256, illustrates the same scene (fol. 116) with the same two peculiarities of Abu Zayd outside the main plane of action and of a high landscape, although the latter is not as elaborate as in the Istanbul version. This point would confirm an impression based on a number of such instances, i.e., that the rather rustic British Museum manuscript actually used as a model one of the more luxurious illustrated manuscripts of Hariri's work.

28. On folio 150v we see an illustration of the scene in which Abu Zayd makes a speech in front of the governor of Merv (thirty-eighth *maqama*). The most remarkable feature of this image is the throne of the *wali*. First of all, it combines in a unique fashion two types of thrones. The first one, common enough in all Arabic manuscripts of the time and used for *qadis* as well as for princes, has as its most notable feature a high and rigid bolster behind the honored personage; its lower part may consist of a few steps leading to a flat bench or of a mere pillow on a rug. The second type of throne is a polygonal wooden construction with side railings; it may be of considerable size and, while it is not absent from early Arab miniatures (cf. below, fol. 192), it is more characteristic of later Persian ones. It is probably the anomaly of the combination which explains the awkwardness of the final result. A second point to be emphasized about this miniature is the quality of the designs of the textiles spread over the throne, in particular the adossed birds rather rarely found in early miniatures.

29. Fol. 153 illustrates the well-known boat on the Indian Ocean on which al-Harith and Abu Zayd leave for a mysterious island. Here again it is the illustrations of the same scene in the Schefer (fol. 122v) and Leningrad manuscripts (p. 260) which come closest to ours with their emphasis on the boat rather than on the personages. The Istanbul miniature, like the Leningrad one, differs from the Paris one in that it actually does show Abu Zayd asking to be taken aboard.

30. On fol. 154v we find another illustration of the same *maqama*. It is the scene of the arrival of our two heroes at the gate of a palace, where slaves are seen crying. The only element of a comparison we have is fol. 120v of the Schefer manuscript, which illustrates exactly the same scene. Although there are points of resemblance between the details of the two images (the central gate, the overhanging balconies, the arches of the windows), the Istanbul miniature is original in showing within outer walls elements of a sizeable garden around a central pavilion and in using a [105] different and interesting decorative design on the façade of the building. A study of these architectural

[13] D. Brian, "A reconstruction of the miniature cycle," *Ars Islamica*, 6 (1939), fig. 17.

façades has not yet been made, even though it would probably lead to interesting results for the little-known secular architecture of the Near East in the twelfth and thirteenth centuries.[14] It would therefore be premature to indulge now in speculations about the possible origins of this type of architecture, so completely different from all other architectural types known in *Maqamat* manuscripts, but not unlike those of certain contemporary Persian ceramics.[15]

31. The image on folio 167v uses the forty-second *maqama* for another variation on the theme of the group of people arguing with Abu Zayd. Its uniqueness consists in the fact that it is particularly lively and that one of the personages is set in a tree. While there are iconographic parallels to the latter in Christian imagery, its occurrence here may perhaps be explained by the statement in the text that this particular assembly was "thronged and densely crowded."[16]

32. Fol. 171v contains an often illustrated scene from the forty-third *maqama* in which Abu Zayd and al-Harith are seen resting after a night of camel riding. Practically all manuscripts show one of the heroes lying and the other one standing, and the variations in them concern the nature of the landscape. Here, as could now be expected, the rocky landscape is particularly developed and, once more, seems to include features belonging to different traditions. The two trees are typical of other contemporary Arabic manuscripts, but the hills with their wavelike knolls are much closer to some early and still insufficiently explained Persian landscapes,[17] although the Leningrad image illustrating the same subject (p. 285) has a related type of hill.

33. Fol. 176 has an illustration of the same *maqama*, which, once again, relates our manuscript to the Leningrad and Schefer manuscripts. The most passing reference in the text[18] to the arrival of Abu Zayd and al-Harith in a village is used in these three manuscripts for an extraordinary representation of village life, with its mosque, its houses, its animals, and its manifold activities. The three images vary and yet possess peculiarly similar details (such as the spinner to the right of our picture who is found in almost the same position in the Schefer manuscript), which argue for some common source of inspiration. As far as the Istanbul page is concerned, it is worth pointing out once again that the artist has used the rocks to the left of his image as a device for giving a sense of depth to the whole scene by separating the two major architectural elements and by introducing a man with a cow between the rocks. A last point to be made about this image is that it is

[14] One of the few studies is that of K. Erdmann, "Seraybauten," *Ars Orientalis*, 3 (1959), which deals only with Anatolia.

[15] One may compare our building with A. U. Pope, *A survey of Persian art* (London, 1939), vol. 5, pl. 675.

[16] Vol. 2, p. 114.

[17] For instance, the plate referred to in note 15.

[18] Vol. 2, p. 130.

الغلام قد بنهك فما ارعويت ونصح لك فما وحيت

فاسترداء بلهمك واكتمه ولنفسك ولا تلمسه

وحذار من اعتلاقه والطمع في استرفاقه فانه جر الاديم

غير معرض للتقويم وقد كان ابوه احضره امس قبيل

25 *Maqamat* of
Hariri, fol. 136v

قَدْ كَادَ بِنَامِرُ الْعُمْرَينِ فَجِئَ بِلِسَانٍ طَلِيقٍ وَإِبَازِ أَيَّانَةً مَنْطِيقٍ
ثُمَّ احْتَبَا حَبْوَةَ الْمُنَدَّدِينَ وَقَالَ اجْعَلْنَا اللَّهُمَّ مِنَ الْمُهَتَدِينَ

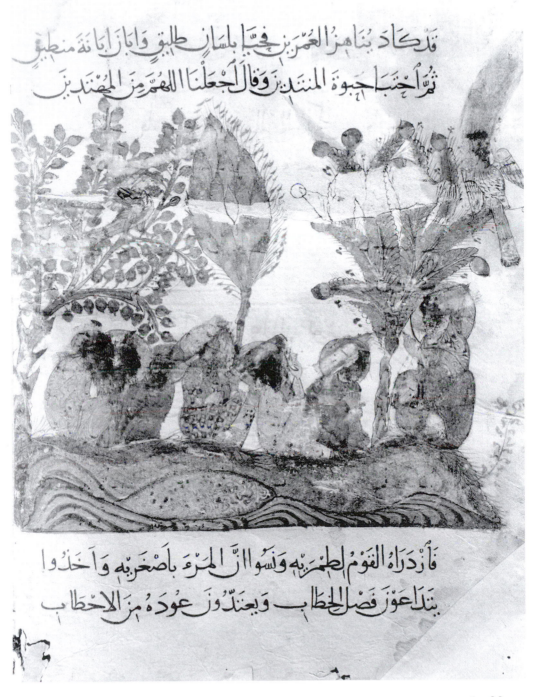

فَأَزْدَرَاهُ الْقَوْمُ لِطِمْرَيْهِ وَسُوا اَنَّ الْمَرْءَ بِأَصْغَرَيْهِ وَأَخَذُوا
بِتَدَاعُونَ فَصْلَ الْخِطَابِ وَيَعْتَدُّونَ عُودَهُ مِنَ الْاحْطَابِ

26 *Maqamat* of
Hariri, fol. 138v

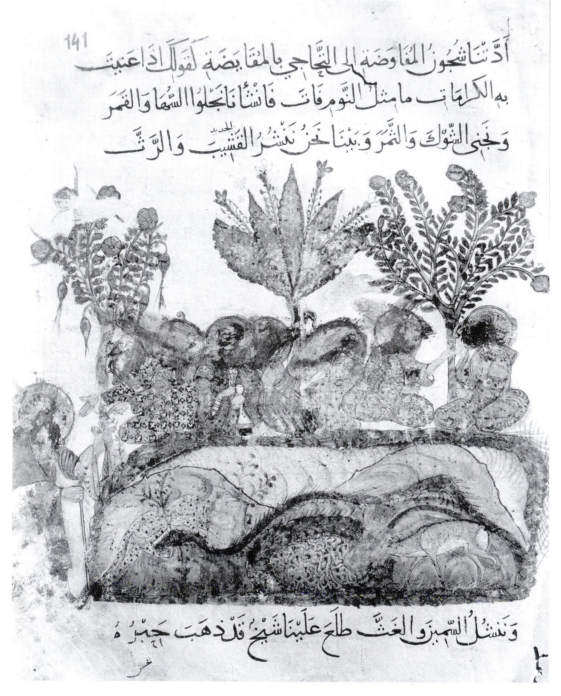

27 *Maqamat* of
Hariri, fol. 141

بِسَاحَتِكَ وَسَنْنَزِلُ الرَّاجِحَةَ مِنْ رَاحَتِكَ وَكَانَ فَضْلُ اللهِ عَلَيْكَ عَظِيمًا ثُمَّ إِنِّي شَيْخٌ تَرِبٌ بَعْدَ الْأَتْرَابِ

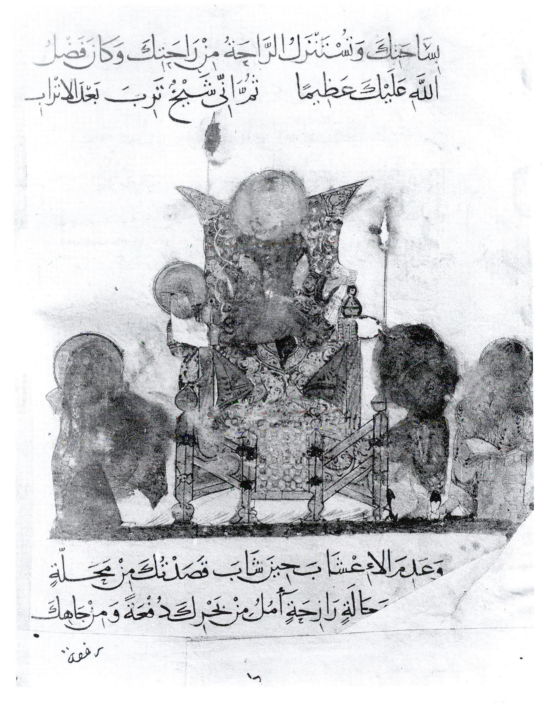

وَعَلَّمَ مَا الْأَعْشَا بِحِينِ شَبَابٍ قَصَدْتُكُمْ مِنْ مَحَلَّةٍ

حَالَةَ رَاجِيًا أَمَلَ مِنْ نَحْوِكَ دُفْعَةً وَمِنْ جَاهَكَ

رُقْعَة

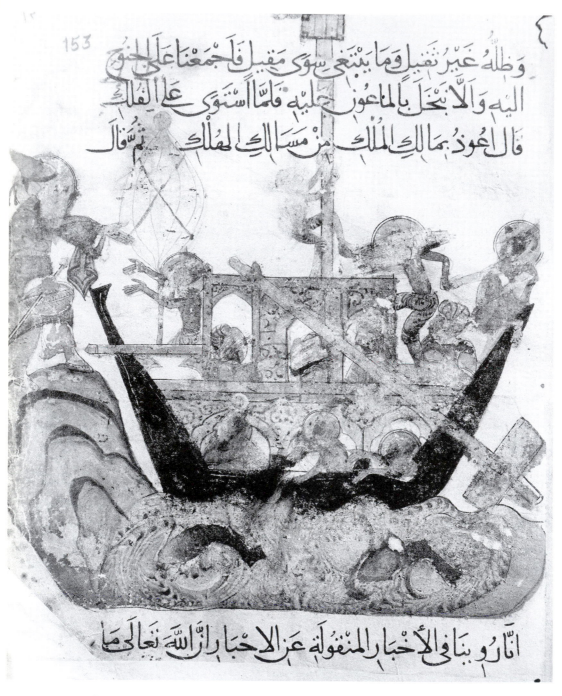

29 *Maqamat* of
Hariri, fol. 153

وكُمْ لا نَزَلَ بِمَالِكِ فَتِيلًا وَلا يَفْتَدِكَ فِيهَا سَبِيلًا فَاقْبَلْنَا

نَجُوسُ خِلالَها وَنَتَقَفّاطُلالَهَا حَتّى أَفْضَيْنَا الى قَصْرٍ مَشِيدٍ

لَهُ بَابٌ مِنْ جَلِدِ بَلِدٍ وَدُونَهُ زُمْرَةٌ مِنْ عَبِيدٍ فَنَاسَمْنَاهُمْ

لِنَنْفُذَهُمْ سُلّمَا الى الارْتِقَاءِ وأَرْشِيَةً لِلاسْتِنْقَاءِ فَالْفَيْنَاكُلّا

inserted in a part of the text which takes place long before the arrival of the heroes in the village (cf. the commentary to the following image).

34. Fol. 177v contains in reality an illustration of the same subject, from the same *maqama*, but this time at its correct place in the text. The first difference between this and the preceding image is that here the protagonists of the story, al-Harith, Abu Zayd and a local "lad," are more prominent. The second difference lies in the primitive and simplified character of the village shown here; its houses look like caves. The existence of two illustrations of exactly the same subject is [106] quite important for an understanding of the manuscript. It is typical of the Leningrad manuscript, where we meet with such duplications quite consistently throughout the book, generally with only minor changes from one image to the other. In the case of the Istanbul manuscript the difference in character between the two images suggests that the illustrator had several models to work from and that these models varied in type and quality. But, if so, why is there really only one pair of images in which this presumed reliance on two different models is so apparent? One will be able to answer this question, and to explain the peculiarities of the Leningrad image, only after a more thorough study has been made of the exact manner of working of a thirteenth-century illustrator. Or we may adopt an alternate explanation proposed by Dr Ettinghausen: fol. 177 is a sort of closeup of fol. 176, in which only the pond and dwellings in the foreground center of fol. 176 are depicted.

35. Fol. 180 illustrates a "tent-party" described in the forty-fourth *maqama*. Here again the image uses the typical formula of two planes set above each other and united at the side. In its depiction of the killing of a camel – not mentioned in the text – it follows an iconographic pattern already established in the Schefer manuscript (fol. 140), where the scene is illustrated on two pages facing each other in the manner common in that manuscript.[19]

36. Fol. 184v illustrates the end of the same *maqama*, when Abu Zayd addresses a poem to his camel. The scene has often been illustrated and the only point worth noting here again is the peculiar nature of the landscape.

37. Fol. 188v illustrates another scene in front of a judge, as described in the forty-fifth *maqama*. The image is quite characteristic of a number of interior scenes of the same type in other manuscripts, but is curious here in that it is much simpler than previous images of similar subjects.

38. Fol. 192 contains the representation of a school, in which Abu Zayd appears as the teacher (forty-sixth *maqama*). We are back here to an architecture which includes an entrance with a personage. It also has some uncommon details, such as the bastinado applied to some unfortunate pupil.

39. Fol. 198 has an image of the barber-shop around which the story of the forty-seventh *maqama* takes place. With its elaborate shop and the

[19] Cf. note 5 above.

throng of people around it, the image is quite similar to the ones found in the Schefer and Leningrad manuscripts. It differs from these in having divided the onlookers into two groups instead of putting them in a circle and in the curiously vivid detail of two mongrels fighting in front of the shop.

40. The image of fol. 204 illustrates a speech in a mosque, as described in the forty-eighth *maqama*. The mosque as such is similar to other mosques in this and other manuscripts. The most important point about this miniature, however, is that its mosque contains an inscription mentioning the caliph al-Musta'sim: "… and our lord the *imam* al-Musta'sim billah, Commander of the Faithful, may God prolong his days." Two points are important about this inscription. First, it must obviously be related to the celebrated inscription on fol. 164v of the Schefer manuscript with its mention of al-Musta'sim's father, the caliph al-Mustansir, which occurs on an illustration of the fiftieth *maqama*. Second, this inscription provides us with the date of the manuscript. [107] Since it assumes that the caliph was still alive, the manuscript must have been made between the end of 1242 (Jumada II 640) and 1258 (656), when al-Musta'sim was killed by the Mongols. A small digression may be made here. The inscription in the Schefer manuscript has often been used to imply that the mosque on which it was set was in fact the celebrated Mustansiriyah in Baghdad, and this has been used as an argument to attribute the manuscript to the 'Abbasid capital. Aside from the facts that the Schefer miniature in no way reflects what is known of the architecture of the Mustansiriyah and that the story of the fiftieth *maqama* does not take place in Baghdad, the present inscription proves conclusively that the Schefer one did not refer to a specific building, but was simply a reference to the caliph ruling at the time of the composition of the manuscript. For there is no mosque of al-Musta'sim which would have acquired the prestige and reputation of his father's construction in Baghdad. Hence, also, the inscriptions cannot be used to support a Baghdadi origin for the manuscripts. This is not to say, of course, that the manuscripts were not made in Baghdad, but simply that their localization in that particular city must be based on other arguments.

41. Fol. 207v shows Abu Zayd making his farewell speech to his son (forty-ninth *maqama*); there is nothing unusual in this image.

42. On fol. 211v we find another mosque scene illustrating this time the fiftieth *maqama*. The mosque itself is not much different from other mosques and the main interest of the image lies in the curious group of two birds set on the roof of the building.

Before concluding with a few general remarks on the manuscript, it may be worthwhile to list the miniatures which have not been illustrated. The number of the illustrated *maqama* is given in parentheses: 12 (4); 24v (8); 31 (10); 36v (12); 39 (12); 52 (16); 58v (18); 108v (29); 113 (30); 116v (31); 121 (32);

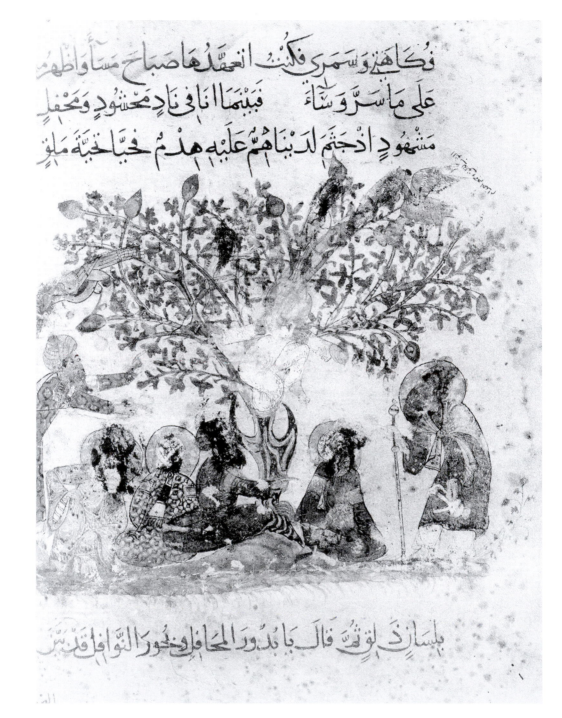

31 *Maqamat* of
Hariri, fol. 167v

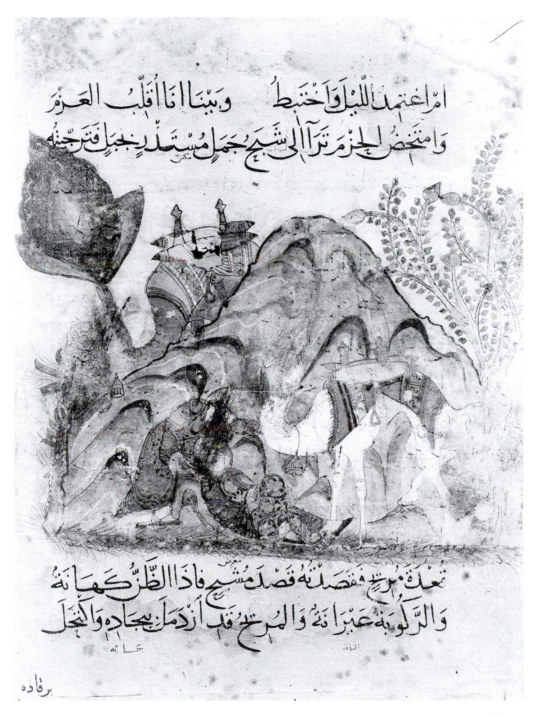

32 *Maqamat* of
Hariri, fol. 171v

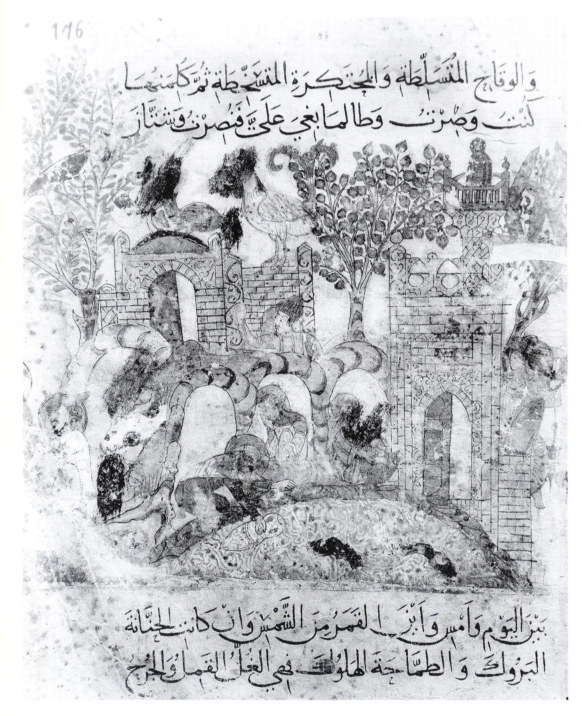

33 *Maqamat* of
Hariri, fol. 176

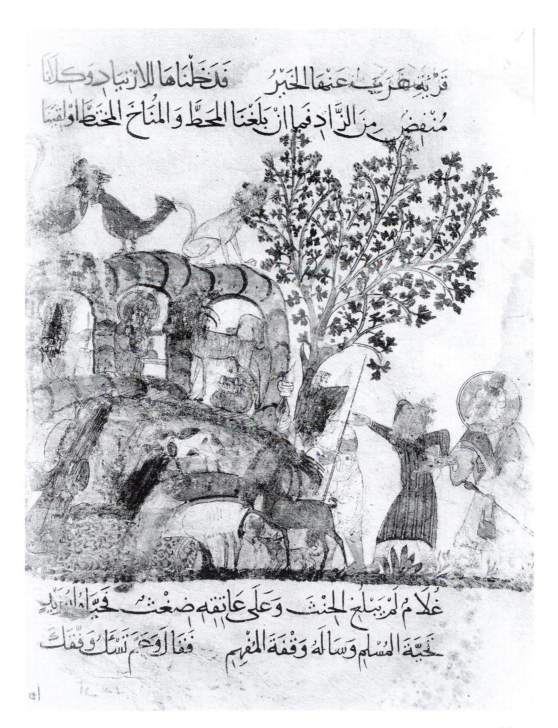

34 *Maqamat* of
Hariri, fol. 177v

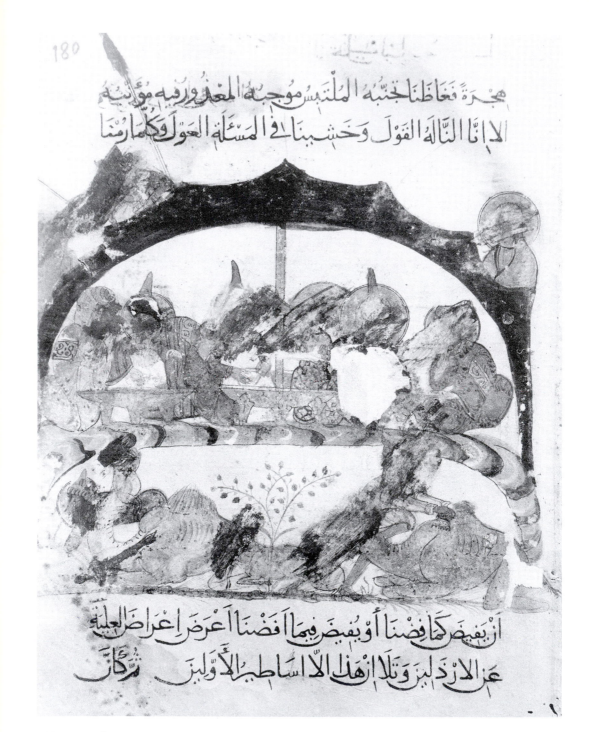

35 *Maqamat* of
Hariri, fol. 180

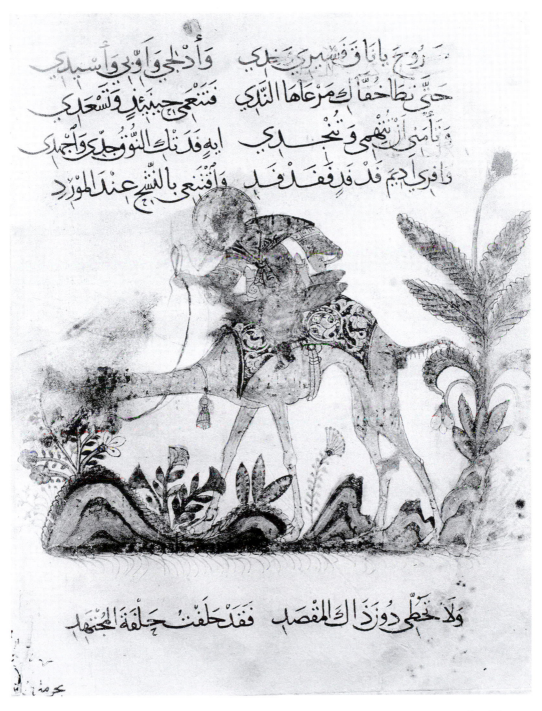

36 *Maqamat* of
Hariri, fol. 184v

146v (37); 157V (40); 165 (41). The statistical results of these lists are that 46 *maqamat* are illustrated (the missing ones are 1, 2, 3 and 7), 8 have two illustrations, and 1 (43) has three.

From this brief description of the 42 sufficiently well-preserved miniatures in the Istanbul manuscript and from the comparisons to which they have led, a certain number of conclusions and problems emerge.

We are dealing with a manuscript written and illustrated between 1242 and 1258, possibly in Baghdad. All of its illustrations belong to what may be called "expanded" images, i.e., images which are not simple running illustrations of the actions of the text (as are, in most instances, those of a manuscript like Paris, arabe 3929), but which are conscious attempts at compositions inspired by the text and often intermingled with various aspects of contemporary life. The nature of the text led, of course, to repetitions within these images: groups in nature, in mosques, and so forth, but exact repetitions are somewhat rarer here than in other manuscripts. These characteristics closely relate the Istanbul manuscript to two other illustrated versions of the *Maqamat*, the Paris Schefer manuscript and the Leningrad one. Of the two, it is the Leningrad manuscript which is most closely allied to ours, as we have seen in a number of details. Furthermore, the Paris manuscript is less consistently involved in "expanded" images and has certain peculiarities of composition which need not concern us here, but which are quite different from what is found in the Istanbul and Leningrad versions. This is not to say, however, that the Istanbul manuscript derives from the same iconographic source as the Leningrad manuscript. There is almost no instance where their images are [108] exactly alike, although it can be shown that there were models available to the artist of the Istanbul manuscript. It would be more appropriate to say that all three manuscripts are the product of the same "mood" of the time, a mood which contrived to have the artists use the story of the *Maqamat* for the depiction of their surroundings. How this came about and especially why it is the *Maqamat* that was chosen for these purposes – a work which was appreciated for its verbal qualities and not for the incidents of its stories – is a subject which is beyond my task of presenting a new manuscript, but one to which I hope to return in the near future.[20] The point of significance, however, is that, in addition to their artistic merit, unfortunately much tarnished by the greatly damaged state of most manuscripts, the illustrated *Maqamat*, and especially the three manuscripts with "expanded" images, are major documents for the social and cultural history of the Arab world just before the Mongol conquest and must be studied iconographically, something that has been done only too rarely so far.[21]

[20] The author gave a preliminary paper on this subject at the twenty-fifth Congress of Orientalists in Moscow in August 1960. A summary was published in the proceedings of the Congress.

[21] The two exceptions are the two articles by D. S. Rice mentioned above.

Our remarks on the individual images also brought out some significant conclusions with respect to the style of the manuscript. In certain aspects it is obviously quite closely related to the style of other thirteenth-century *Maqamat* illustrations. Personages with large heads, vivid facial features, and simplified bodies at times shown in action by violent, if puppet-like, movements of arms; heavily patterned costume and squatting poses; artificial treelike floral combinations; architectural compositions of large rectangular frames with a few precise additions such as rolling roofs, balconies and doorways; the grouping of personages in rows or in masses; a tendency to divide a scene into two planes one above the other as a formula for spatial representation; all these features are characteristic of most *Maqamat* manuscripts, and especially of the three with expanded imagery. But there are two areas in which the Istanbul images introduce a more original style. First, in a number of scenes there are attempts at more complex means of representing depth of field. In purely architectural scenes, the position of the personages, the shape of certain parts (railings, friezes with inscription, stairs) introduce a sense of spatial depth in a building which is practically unknown in the Schefer manuscript, although not uncommon and often quite artful in the Leningrad one. In other places, such as on fol. 176, elements of landscape and architecture are consciously set on separate planes, each of which is like a two-dimensional theatrical flat but whose combination is intended to give a sense of receding planes. The same technique is used in pure landscapes, such as on fol. 141. It is quite true that both the Schefer and the Leningrad manuscripts have used various devices to bring out this sense of depth, and, especially in the latter, some extraordinary compositions were thereby achieved. But it is almost never that we can find this particular technique which was destined for a great future in later Near Eastern painting. Second, landscape almost for its own sake and without any particular reference to textual needs appears here more often than in the other manuscripts. Also the character of this landscape differs from what we find in other manuscripts. The technique of painting hillocks (as on fols 153, 171v, 184) in thick dark wavelike strokes almost parallel to each other is comparatively rare in *Maqamat* manuscripts, although it does occur on certain Dioscorides. Nor do we find commonly the addition of animals to the landscape. [109]

The importance of these peculiarities in the Istanbul manuscript is that many among them are characteristic of the first century of Persian painting which flourished after the Mongol invasion and which is represented at different levels of quality by the Rashid al-Din manuscripts, the Demotte *Shahname*, and especially some of the so-called small *Shahnames*.[22] The implication is, therefore, either that our artist was influenced by certain existing Iranian artistic traditions of the thirteenth century other than the

22 L. Binyon, J. V. S. Wilkinson, B. Gray, *Persian miniature painting* (London, 1933), pls XVI, XXIII, XXIV; B. Gray, *Persian Painting* (Geneva, 1961), p. 59.

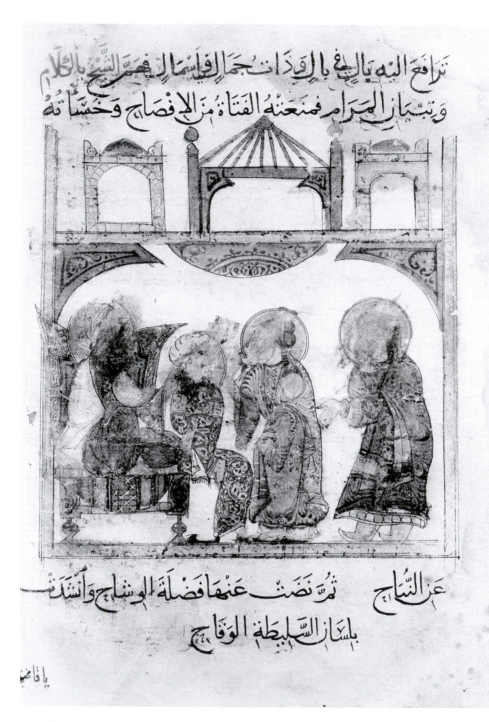

37 *Maqamat* of
Hariri, fol. 188v

192

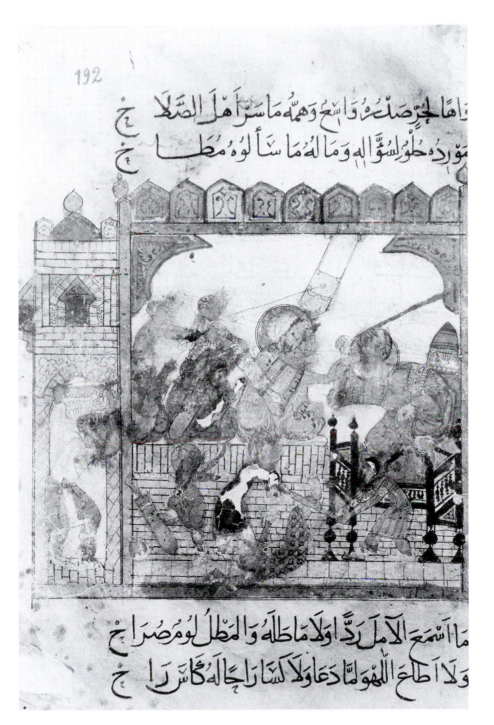

39 *Maqamat* of
Hariri, fol. 198

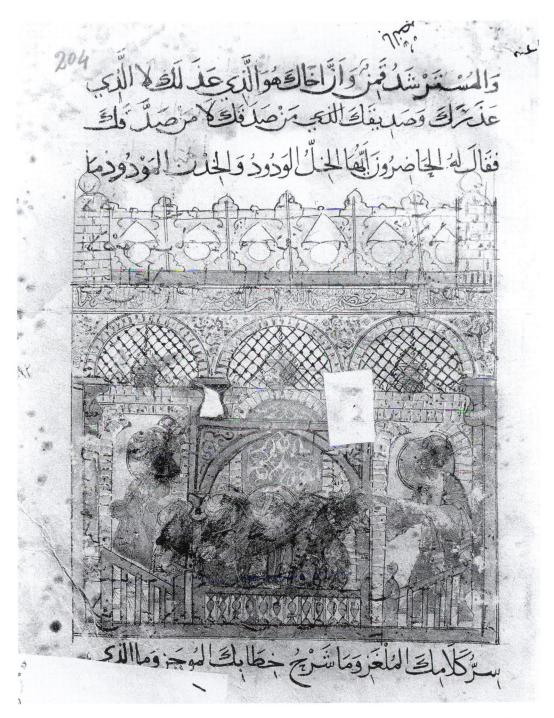

40 *Maqamat* of
Hariri, fol. 204

فيها عيشنَّه اما فرض الولايات وخلس الامارات

فكأضغاث الأحلام والفي المنتسخ بالظلام وناهيك

عصمة بمرارة الفطام واما بضامج التجارات

فعرضة للمخاطرات وطعمة للغارات وما اشبهها

بالطيور

41 *Maqamat* of
Hariri, fol. 207v

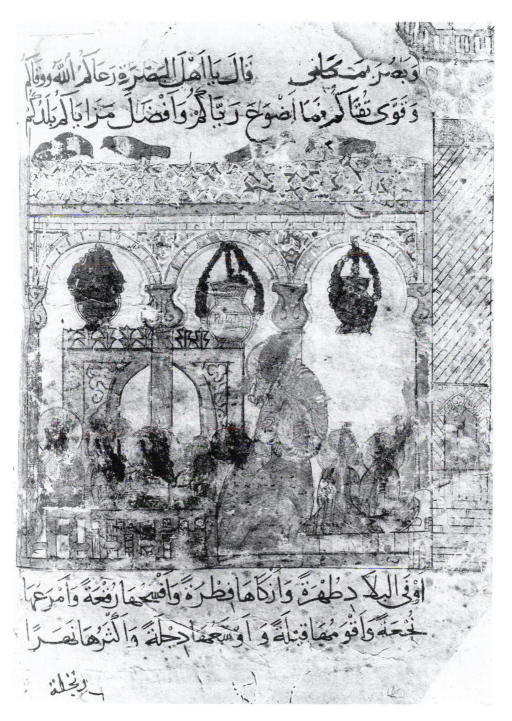

42 *Maqamat* of
Hariri, fol. 211v

pitifully few known today,[23] or that it is the style expressed in this particular group of Arab paintings which was later taken over and developed by the Persian painters. This is not to say, of course, that these themes are predominant. In general the style of the Istanbul manuscript corresponds to that of the other known versions of the same text. Yet its specific peculiarities are worth noting, for they provide it with its most original features and permit us to broaden our view of the various styles which were at work in the main centers of the Arabic-speaking world before the Mongol conquest.

These considerations make one all the more regretful that the manuscript has not been preserved in better condition. In this preliminary report only some of its iconographic and stylistic characteristics have been brought out. Their elaboration can be made only in the framework of a more complete study of the style and iconography of all *Maqamat* manuscripts, which we hope to have completed in the near future. In the meantime, the manuscript discovered by Dr Ettinghausen must take its place among the more important works of the thirteenth century.

[23] The latest discovery is that of the *Warqah and Gulshah* manuscript also in Istanbul, A. Ateş, *Ars Orientalis*, 4, (1961); and one should also study ceramic iconography for evidence of influence from miniatures.

Chapter VII

Notes on the Iconography of the "Demotte" *Shahname**

The unique character of the so-called "Demotte" *Shahname* has now been recognized for several decades and much has been written about its date (most probably the fourth decade of the fourteenth century with a number of later additions or retouches) and about the different hands involved in the execution of its miniatures.[1] Less effort has been devoted to its iconographic peculiarities or to its possible models except insofar as there is general agreement about the existence of "pathetic" scenes centering on death and about a clear influence of the Chinese-inspired school of painting developed in Tabriz during the first two decades of the fourteenth century.[2] Without trying to solve or even define the bewildering number of problems which are posed by the iconography and the background of the manuscript, I should like to discuss two points which have seemed to me to be of particular significance in evaluating the expressive and narrative qualities of the miniatures. The first point concerns the manner in which one can define and explain the manuscript's interpretation of the text, and the second deals with one possible source for the manuscript which has only fairly recently come to light. In both instances it will be found that much still remains tentative, and my remarks are based primarily on the assumption that it is only through a series of meaningful hypotheses that eventually the striking qualities of the manuscript will be fully understood.

A first remark to be made about the illustrations of the Demotte manuscript is the rather obvious one that they are the major *raison d'être* of the codex. The matter has long been recognized from the point of view [33] of the stylistic quality of the images and through the possible identification of the manuscript with the otherwise known revolutionary *Shahname* of Ahmad

* First published in *Paintings from Islamic Lands*, ed. R. Pinder-Wilson (London, 1969), pp. 31–47.
1 The main detailed discussions of the miniatures were made by E. de Lorey, E. Schroeder and I. Stchoukine. A bibliography and the latest position of research will be found in I. Stchoukine, "Les Peintures du Shah-nameh Demotte," *Arts Asiatiques*, 5 (1958).
2 Among other places see B. Gray, *Persian Painting* (Geneva, 1961), pp. 29 ff.

Musa,[3] but it is further confirmed by a detail of the layout of the miniatures within the page. The standard image is a rectangular one set across the whole page and usually with a title woven into the miniature. The exceptions to this rule, which had to have been planned when the text was written down, can usually be explained through precise iconographic needs. Thus in a number of enthronement scenes (such as nos 1, 14, 28, 58[4]) the central part of the image has been raised and, in most instances, contains a crenellation; the device is clearly used to emphasize the tripartite composition of the scene and suggests that the subject to be illustrated was planned in advance. In one instance, no. 40 (Ardashir and Gulnar), the motif has been used incongruously, but the image itself is a rather original one, whose significance and composition pose problems which need not concern us here. Of greater importance are miniatures which modified the standard format for iconographic reasons rather than simply for emphasis. Thus the staggered format of nos 46 (Hanging of Mani) and 38 (Alexander and the Talking Tree) serves to give particular relief to an unusual central feature of the subject matter: the Talking Tree and the tree with the body of the religious reformer. Imbalanced formats in nos 34 and 35 allowed the artists to make particularly striking the text's indication that Alexander climbed up a mountain in the first case and in the second one traveled with his army through a valley on the side of a dragon-infested mountain "which went up to the stars." Similarly, the odd structure of no. 9 (Zal climbing up the wall to Rudaba's room) gives particular strength to the movement of the image, although it may in part have been repasted at a later time. It may thus be concluded that the Demotte *Shahname* belongs to a very precise category of manuscripts like the Vienna Genesis, the Sinope or Rossano Gospels, the Utrecht Psalter, or a score of later Persian manuscripts, in which the *choice* of subjects to be illustrated was particularly meaningful and imposed some of its own iconographic necessities on the layout of the pages.

As a result it is of some interest to investigate whether any sense can be made out of the subjects which are illustrated. It is true of course that we only have somewhere between one third and one half of the manuscript. Yet enough has been preserved, especially in such more or [34] less uninterrupted sequences as the story of Faridun at the beginning and the stories of Alexander and Ardashir later on, that some conclusions may be hazarded.

A cursory glance at the list of 58 miniatures from the particular point of view of their general subject matter shows that 13 are essentially throne scenes (14, 15, 45, 28, 1, 11, 12, 17, 44, 52, 54, 55, 57), of which the first four are

3 E. Schroeder, "Ahmed Musa and Shams al-Din", *Ars Islamica*, 6 (1939).
4 The numbers here and elsewhere in the paper refer to D. Brian, "A reconstruction of the miniature cycle in the Demotte Shah-nama," *Ars Islamica*, 6 (1939). Although there is little doubt that a number of miniatures in Istanbul originally belonged to this manuscript, we have eliminated them from consideration at this stage.

simple *topoi* of enthronements, while all the others are transformed in varying degrees by specific iconographic details imposed by the text. Then 15 images are battle scenes either involving whole armies (19, 25, 27, 30, 31, 41) or single combats (20, 21, 23) or incidental events closely related to battles (3, still a rather difficult image to interpret, 6, 13, 16, 4, 42). Hunting images concern only Bahram Gur (51, 53) and dragon-slaying is illustrated for Alexander the Great (33, 34) and also Bahram Gur (49). Five miniatures (7, 8, 22, 24, 39) deal specifically with death and mourning, while five other images, all of which depict the story of Alexander (29, 32, 35, 36, 38), illustrate the moralizing theme of divine revelation to which we shall return. The last 15 images are precise illustrations of specific events in the text and do not lend themselves to a general classification, even though many among them pose very interesting iconographic problems.

The fact that 43 miniatures can be defined in general terms, regardless for the moment of the presence of details which may or may not give them a more precise literary context, is not in itself surprising, for, like most epics, the *Shahname* is repetitive, and the succession of princes symbolized by enthronements or battles of heroes or of armies are constant motifs of the story itself. Dragon-slaying or hunting scenes, although less common, also clearly belong to an epic cycle. If the preponderance of such images is not unusual and finds ample confirmation in other illustrated *Shahnames*, it is also true that, even though specific events such as the last battle of Rustam, Alexander's defeat of the Indian army, Bahram Gur's hunt with Azada, or the enthronement of Zahhak possess unique visually identifiable iconographic features, these images also belong to well-established standard iconographic themes found outside of the context of the *Shahname* in painting, ceramics, or metalwork: combat, hunting, or princely activities. It is, at least in part, in their relationship to the standard that these images of the Demotte manuscript must eventually be explained. More original, at least within our presently available documentation, is the existence of identifiable groups of images centering on death and mourning and concerned with fantastic revelation.

The possible meaning of these miniatures can be made more precise if we consider in slightly greater detail two cycles of images in their [35] sequential order, preferably cycles in which we can be fairly well assured that most of the illustrations have remained. For instance the twelve illustrations dealing with Alexander the Great show in that order the following subjects: the enthronement of the king when he became ruler of Iran (28), the trip of the Indian king to a mysterious sage who explains to him the irresistible character of Alexander's conquest (29), the extraordinary invention of iron horses to defeat king Fur (30), the single combat between Alexander and Fur (31), Alexander's visit to the Brahmans who tell him that his conquests do not affect the only true human reality, which is decay and death (32), the slaying of the Ethiopian monster by the king alone (33), the slaying of a mythical

beast (34), the visit to the Mountain of the Angel of Death with a message on the arbitrariness of human affairs and endless suffering (35, 36), the building of the wall against Gog and Magog at the end of the world (37), the visit to the Talking Tree with its message of impending death (38), the final victory of death in the celebrated image of Alexander being mourned (39). The simple list of the scenes suggests that the story of Alexander the Great was given in the choice of illustrations a precise moralistic aspect, that of the contrast between the conqueror of the universe who can defeat dragons and reach the outer limits of the world, and the mortal man who fails to conquer wisdom by seeing the Brahmans refuse his offer of worldly goods and who is constantly warned of death through various more or less fantastic means.

A second cycle of images illustrates a different point. The five miniatures dealing with Ardashir show Gulnar, daughter of Ardawan, coming to Ardashir (40), the battle between Ardawan and Ardashir (42), the execution of Ardawan (42), the failure of Gulnar's attempt at poisoning the king (43), and finally the revelation to Ardashir of the existence of his son (44). The choice of illustrations emphasizes here another central idea of Firdawsi's book, the idea of the legitimacy of the Sasanian dynasty, both in its lineage *par alliance* and in the protection it receives from fate.

These two central ideas, human frailty in the face of death and the legitimacy of Iranian kings, can be shown to exist as well in other groups of images, such as the cycle of the first eight images with the victory of the hero Faridun identified through his lineage over the anti-king Zahhak and then the tragedy of his succession through the death of Iraj (nos 1–8), in the Isfandiyar and Rustam cycle (nos 17–25) as well as in the in the striking miniature of the sleeping Darab (no. 26), who will mysteriously be identified as the legitimate heir to the Iranian throne.

Thus, in addition to the point that the miniatures were the main object of the manuscript, we may put forward the hypothesis that their [36] choice was directed, at least in part, by the desire to emphasize a number of precise philosophical or national ideas ultimately tied both to the literary themes of the *Shahname* itself and to a number of traditional attitudes of the medieval Islamic world. But we may be able to make these hypotheses more precise by analyzing in some detail a few miniatures which are particularly striking in the illustration of these ideas.

A first instance involves miniatures nos 41 and 42, the combat of Ardashir and Ardawan and the appearance of Ardawan in front of Ardashir. The text pertinent to both miniatures is fairly short.[5] The battle has been raging for forty days.

So all the wise one day, when fight was fiercest,
Asked quarter, and Ardshir charged from the centre;

[5] A. G. and E. Warner, *The Shahnama of Firdausi* (London, 1910), VI, pp. 227–8.

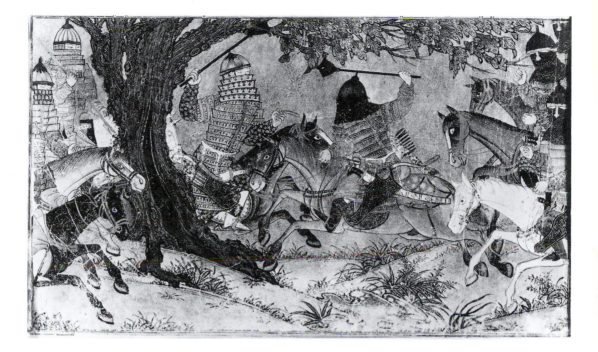

Arose a clashing while the arrows showered.
Amid most of the mellay Ardawan
Was ta'en, and for his crown gave up sweet life.
The hand of one Kharrad seized on his bridle,
And bare him captive to the atheling.
Ardshir saw him from far. King Ardawan
Lit from his steed, his body arrow-pierced,
His soul all gloom, and Shah Ardshir commanded
The deathsman: "Go, seize on the great king's foe,
Cleave him asunder with thy sword, and make
Our evil-wishers quail."
　　So did the deathsman:
That famous monarch vanished from the world.
　Such is the usage of the ancient sky!
The lot of Ardawan Ardshir too found;
　Him whom it raiseth to the stars on high
It giveth likewise to the sorry ground!

1　Battle between Ardawan and Ardashir

Quite obviously neither miniature follows the text very closely. The first image (Fig. 1) is one of two armored knights galloping toward each other in a simple and typical landscape setting and framed by elements of two armies.[6] It may be identified as an iconographic *cliché* of a battle between

6　A study of this miniature by Mrs Joanne Travis was published in the *Art Quarterly*, 31 (1968).

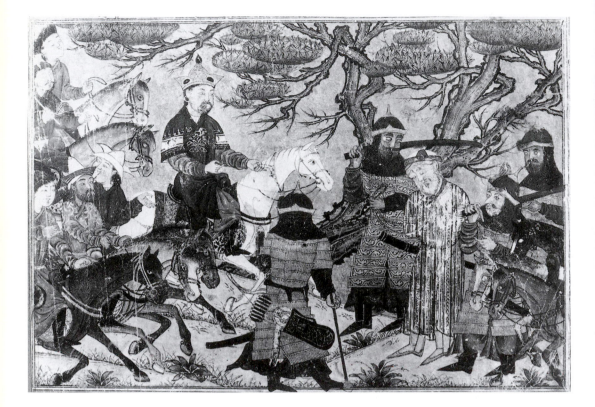

2 Execution of
Ardawan

two heroes in which nothing identifies either one as the specific personages involved in the story, and furthermore nothing is said in the text about a battle between Ardawan and Ardashir. The second image (Fig. 2), one of the most magnificent and most studied ones in the whole book with its triangular composition and its fascinating use of a *repoussoir* in front, is equally unrelated to the specifics of the text. [38]

Two explanations may be provided for this anomaly. One is that the illustrations reflect here some more involved cycle of the story of Ardashir, for instance some medieval version of the *Kar-namagh-i Ardashir-i Papakan*,[7] in which the battle and subsequent execution of Ardawan would have received peculiarly strong emphasis. But, without necessarily denying this possibility of an influence from an otherwise unknown cycle of images, a second explanation would perhaps elucidate the peculiarities of these two images more adequately. It is that the artist of the Demotte *Shahname* interpreted and enlarged his images beyond the text in order to emphasize specific concerns of his. If we begin with the image of Ardawan in front of Ardashir, its most striking iconographic feature is the contrast between the brilliantly impassioned victorious Sasanian at the head of his troops and the

7 A. Christensen, *L'Iran sous les Sassanides* (Copenhagen, 1944), p. 58. The existing version of the *kar-nama* (tr. D. Sanjana, Bombay, 1896) does not, however, explain our images.

dejected Arsacid prince surrounded by two grotesquely caricaturized soldiers with unusually long swords. The image does not illustrate so much a precise incident as two aspects of the mood of the story: the acceptance of a pre-ordained fate in the passage from one dynasty to the other through mute resignation on one side and noble acceptance on the other, but also the cruelty of fate which compels the execution of a man who was not evil, like Zahhak in earlier images, but who had fulfilled his destiny. It is this latter feature which transformed the executioners into horrifying instruments of fate rather than of justice, as, for instance, in the illustration of the beheading of the evil Nawdar (no. 13). Death, legitimacy and fate, as they appear in this particular image, help also in explaining the one that precedes it. The transformation of a rather prosaic discovery of Ardawan in the midst of his defeated army by an obscure follower of Ardashir into a heroic but standardized (i.e. without specific iconographic features which would make it clearly this particular battle) scene heightens the drama of the confrontation of kings and makes the following miniature all the more striking.

A second group of closely related images will help in defining even further the *modus operandi* of the artist or artists. It is the peculiar group dealing with death and mourning. The first two miniatures which belong to this group are nos 7 and 8, illustrating the story as Faridun was making preparations to greet his favourite son Iraj.[8] [39]

The eyes of Faridun were on the road,
Both host and crown were longing for the prince;
But when the time arrived for his return
How did the tidings reach his father first?
He had prepared the prince a turquoise throne
And added jewels to his crown. The people
Were all in readiness to welcome him
And called for wine and song and minstrelsy.
They brought out drums and stately elephants,
And put up decorations everywhere
Throughout his province. While the Shah and troop
Were busied thus, a cloud of dust appeared,
And from its midst a dromedary ridden
By one in grief who uttered bitter cries;
He bore a golden casket, and therein
The prince's head enwrapped in painted silk.
The good man came with woeful countenance
To Faridun and wailed aloud. They raised
The golden casket's lid (for every one
Believed the words of him who bore it wild)
And taking out the painted silk beheld
Within the severed head of prince Iraj.

[8] Warner, I, pp. 202–204.

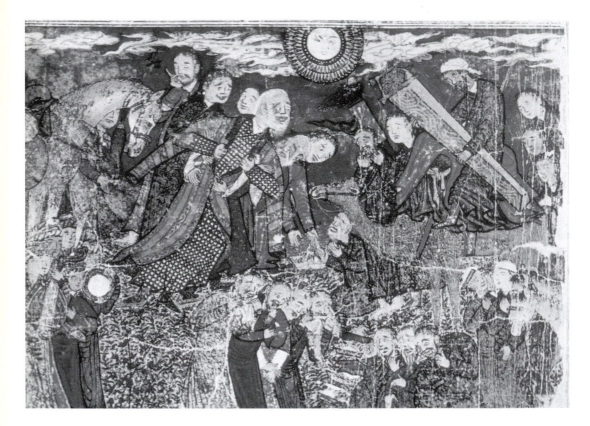

3 The coffin of
Iraj brought to
Faridun

Down from his steed fell Faridun, the troops
All rent their clothes, their looks were black, their eyes
Blanched with their horror, for the spectacle
Was other far than that they hoped to see.
Since in this wise the young king came again
The troops that went to meet him thus returned
Their banners rent, their kettledrums reversed,
The warriors' cheeks like ebony, the tymbals
And faces of the elephants all blackened,
The prince's Arabs splashed with indigo.
Both Shah and warriors fared alike on foot,
Their heads all dust; the paladins in anguish
Bewailed that noble man and tore their arms.

The first image (Fig. 3) is once again not a direct illustration of the text in the sense that it does not involve an iconographically clear moment of time in a precise sequence of events. It shows at the same time the arrival of the messenger with the head of Iraj (in a casket rather than in a box) and the transformation of the joyful crowd of greeters into a mournful assembly; there are no elephants and only the cymbals in the lower left corner refer to a precise term of the story. Yet this miniature is a remarkably meaningful and effective one, because in a series of stunning and highly complicated

compositional combinations which do not concern us here, it has managed to identify a central feature of the story, the suddenness of the shift in emotion, and to translate it into visually striking terms by dividing the personages into closely set groups separate from each other like a military parade suddenly gone berserk [40] and by emphasizing physical pain through the distortion of facial expressions. The following miniature (Fig. 4) is easier to explain iconographically. It depicts Faridun holding his son's head and the destruction of the palace's garden, in which at the extreme left there appears a curious frightened cat. The architectural features or the natural elements of this miniature are fairly close to the text, but the image of the three women (one of whom was later interpreted as the mother of Iraj, even though the text does not mention her) and especially the strange personage disappearing through the door on the right give to the miniature a mysterious quietude rather than a sense of violent physical pain.

The following related image, that of the funeral of Isfandiyar (no. 22) (Fig. 5), has an amazingly faithful central core with the bier, the mules, the horse, and the Chinese brocade over the bier, but the statement that the accompanying figures had "torn cheeks and hair, purple with blue dresses" is only followed to a degree with respect to the dominant color [41] effects in this linear image. Otherwise it has been transformed into a fascinating dance of death around the bier, which may have to be connected with specific Mongol funeral practices.[9] The funeral of Rustam (no. 24) (Fig. 6) is also faithful to the text in the details of the central subject but the processional cortège was given here a Far Eastern character which is in no way inspired by the story. And, finally, the celebrated and extraordinary image of the bier of Alexander (Fig. 7) has been inspired by the following lines: "the coffin was put in the plain ... children, men, and women gathered by the coffin and there were 100,000 of them. In the middle was Aristotle ... he put his hand on the narrow coffin" and pronounced a speech, followed by sages, noblemen, and finally Alexander's [42] mother.[10] The image was reinterpreted here in a different setting with a unique arrangement of personages and a striking mixture of many different stylistic devices of composition as well as of details of execution,[11] but with particularly clear Mediterranean, almost Giottesque, elements in the composition of three choirs around a bier, and with a more traditional but also definitely Western robe on the mother of the hero.

Granted our original point that for some reason the planners of the manuscript wanted to give particular stress to the point of the death of heroes, the explanation for the various ways in which this emphasis was shown can be done in several ways. It may be argued that there were in each instance precise

[9] H. Howorth, *History of the Mongols* (London, 1876–88), IV, p. 485, for a detailed description of royal funerals and mourning.

[10] Warner, VI, p. 187.

[11] The last analysis of the painting is by Gray, *Persian Painting*, p. 33.

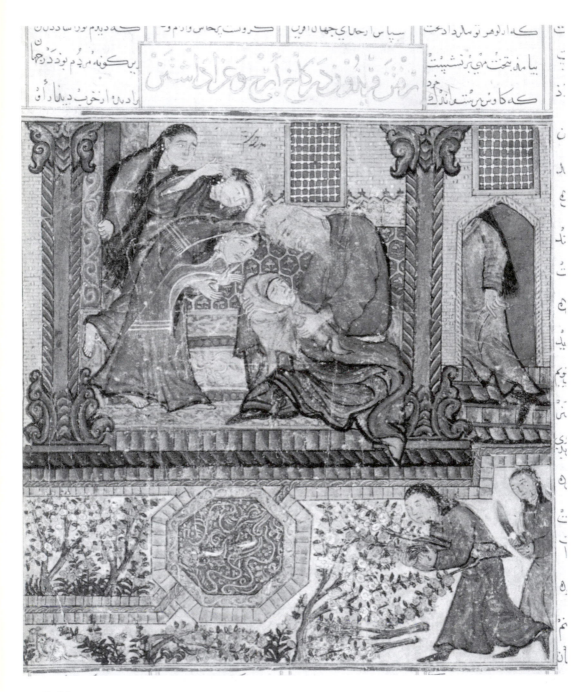

4 Faridun
holding Iraj's
head

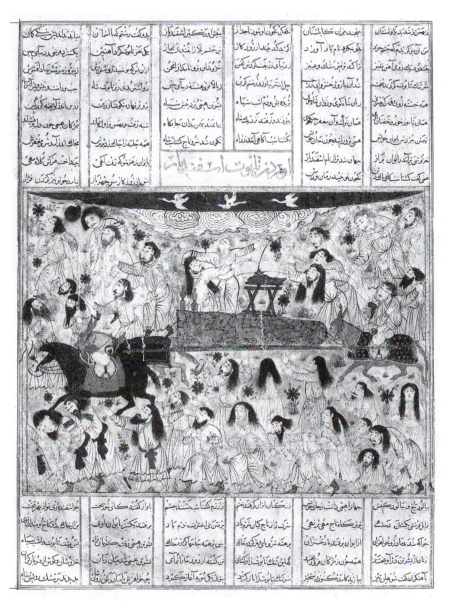

5 Funeral of Isfandiyar

iconographic models available for the stories. We know of the existence of an *Iskandar-nama,* so far unpublished,[12] which [44] may explain the Alexander scene, and it is possible that other epics existed around Isfandiyar, Rustam, or Faridun. It may also be thought that several different artists were involved, each of whom contributed his own version of the theme of mourning. But, from the point of view of the manuscript seen as a whole and without denying

12 G. Lazard, *La Langue des plus anciens monuments de la prose persane* (Paris, 1963), pp. 126–7.

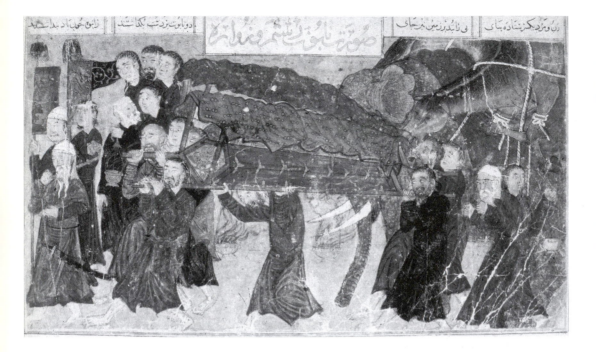

6 Funeral of Rustam

the possibility of either one of these explanations, it may be suggested that this variety of visual translations of a single theme served primarily to illustrate the specific intent of the manuscript's designer or patron who would have proposed a series of interpretations – emotional, simply illustrative, locally Mongol, Far Eastern, Western – for the subject of mourning. This particular group of miniatures may then serve to show the great variety of artistic models and ideas available around Ilkhanid times and perhaps in Tabriz itself, a conclusion which is fully confirmed by the diplomatic and cultural history of the first third of the fourteenth century.

It remains to be seen whether the peculiar emphasis which was given to the manuscript's choice of illustrations and manner of execution should be considered simply as the whim of an unknown patron or whether it may not be related to some characteristic trait of the time. The theme of legitimacy and the peculiar emphasis on mortality which occur in the Alexander cycle are clear reflections of the *Shahname* itself as Firdawsi had conceived it and interpret conditions around the year 1000, when non-Iranian dynasties were asserting themselves as champions of the Iranian past. But very much the same situation prevailed in the Ilkhanid period, when world conquerors like Alexander the Great had become Iranian Muslim princes, and in their architecture as well as in their mode of life sought to emulate and to outdo their Iranian predecessors.[13] The spectacular revival of the old Persian epic's central theme is

13 D. Wilber, *The Architecture of Islamic Iran, the Ilkhanid Period* (Princeton, 1985), p. 125, among other possible references.

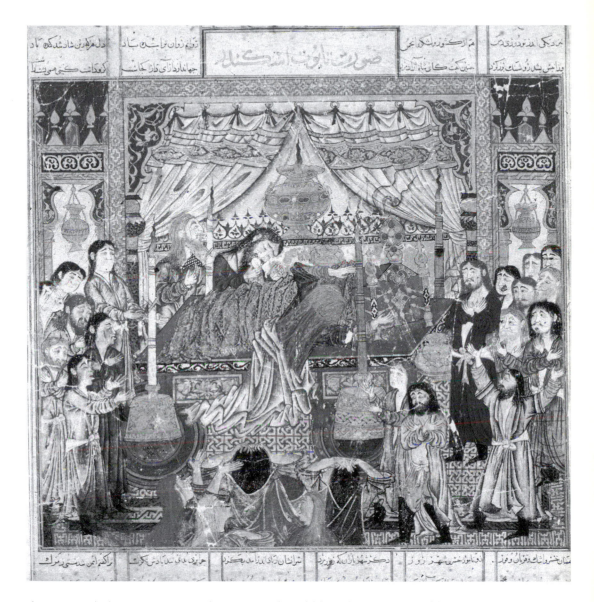

thus particularly appropriate to the times and could have been sponsored by a Mongol prince or, as is perhaps more likely, by one of the high Iranian officials who surrounded them. As to the theme of death, it is perhaps more difficult to explain, for in both the *Shahname* and in the more general *ethos* of medieval times in the Near East the frailty of human endeavor in the face of death was a constant literary and philosophical *cliché*. Yet its striking appearance in the Demotte manuscript may be explained by one specific development of Iranian literary taste up to that time. It seems that during the twelfth and thirteenth centuries the popularity of the *Shahname* itself was to a degree overshadowed by a large number of other epics, like the *Garshasp-nama*, the *Burzu-nama*, the *Kush-nama* [45] and many others which imitated the form of Firdawsi's

7 The Bier of Alexander

masterpiece but gave different emphases to their characters and to their long speeches: deeds of prowess against monstrous animals, mysterious visits to strange places at the edges of the world, discussions with sages, death in human affairs. To a degree, this shift of emphasis began with themes which were actually in the *Shahname*, but the overworking of a choice of motifs at the expense of the grandiose fresco drawn by Firdawsi served to illustrate a new taste, perhaps the taste of townsmen as opposed to that of an aristocracy.[14] At any event, it may be suggested that in the instance of the Demotte manuscript it is this taste of the preceding two centuries developed in other epics than the *Shahname* which inspired the illustration of the original model of all later poems.

These hypotheses about the manuscript are but one aspect of a more general problem which has always been brought up in discussions but never solved: the problem of the artistic background of the masterpiece. Most discussions so far have centered on stylistic criteria and quite consistently both contemporary relationships and possible older models have been brought into the pool of possible sources. Our own discussion of iconographic themes and of the taste implied in the images also led at the same time to contemporary and to older attitudes and practices. Thus, as a second aspect of this paper, I should like to comment briefly on one of the older strains which should be considered in attempting to understand the manuscript. It consists of the fresco paintings of the eighth century from Panjikent and of Soghdian art in general.[15] Although some controversy exists around the exact meaning of these paintings, it is generally agreed that many scenes illustrate subjects taken from the Iranian epics – such as the Siyavush story – which were later codified by Firdawsi.[16] Also M. M. Diakonov, A. M. Belenitski, N. V. Diakonova and O. I. Smirnova have on various occasions brought up the fact that some relation may be established between these frescoes and later miniature painting, while [46] conversely many a scholar dealing with fourteenth-century miniatures has thought of mural paintings as models for certain features of book illustrations.[17]

The problems are, in the latter instance, to discover or at least reconstruct the original mural paintings and, in the former instance, to explain how

[14] The preceding is based on J. Rypka, *Iranische Literaturgeschichte* (Leipzig, 1959), esp. pp. 144–5, 152 ff., 165, and on articles by M. Molé, "Garshasp et les Sagsar," *La Nouvelle Clio*, 3 (1951), "Un poème persan," ibid., 4 (1952), with further references.

[15] Main publications are *Zhivopis Drevnevo Piandjikenta* (Moscow, 1954), and *Skulptura i Zhivopis Drevnevo Piandjikenta* (Moscow 1959). Although important for Soghdian art, the paintings from Varahsha and Balalykh Tepe are of lesser significance for our precise purposes here.

[16] In addition to the commentaries in the two works cited in the preceding note, see N. V. Diakonova and O. I. Smirnova, "K voprosu ob istolkovanii pendzhikentskoy rospisi," *Sbornik v chest I. A. Orbeli* (Moscow, 1960), and M. M. Diakonov, "Obraz Siiavusha," *Krat. Soob. Inst. Ist. Mat. Kult.*, L (1951), pp. 34–44.

[17] Gray, *Persian Painting*, p. 59.

themes known in the eighth century survived until the fourteenth. The first problem is exacerbated by an almost total lack of appropriate remains, and the few known texts referring to such paintings are usually quite brief and tantalizingly uninformative,[18] although it is conceivable that further work – especially systematic analyses of literary texts – could bring some interesting results. The second problem lends itself somewhat better to a more precise definition. It seems clear that certain compositions of the Panjikent frescoes – such as the triangular composition for battles between armies[19] – or such features as the contrast between a "pathetic" and an "elegant" figure style[20] find striking parallels in some of the pages of the Demotte manuscript.[21] Yet one may wonder how a Soghdian tradition depicting Iranian heroic themes would have been revived in the fourteenth century or where it continued in the intervening centuries. From a stylistic point of view Diakonov has already pointed out the close parallels to Panjikent found in the frescoes of the Tarim basin as late as in the ninth and perhaps tenth centuries. There, largely thanks to their considerable mercantile activities, Soghdians maintained themselves after the Islamization of Central Asia and appear to have participated in the cultural transformation of Turks and Mongols. As late as in the thirteenth century a Persian source relates that the Turks learned both the Soghdian and the Uighur alphabets.[22] It may be suggested then that the Soghdians or people influenced by them gave to the new-coming Mongols their first taste of the culture which would be theirs in Iran and that the ancient themes of the epics and especially certain modes of expression found in manuscripts like the Demotte *Shahname* were brought *back* [47] by the Mongols rather than merely found by them in Iran itself and then transformed under their direct or indirect sponsorship.

The question whether to interpret the Demotte *Shahname's* iconographic characteristics as a revival inspired from the outside or as the continuation in new forms of an art which was already flourishing in Iran itself cannot as yet be answered. But the problems may be posed and further iconographic studies either in pre-Mongol art or in the *Shahname* itself may eventually provide us with enough information about the ideas expressed in its miniatures to permit a more precise identification of the men who made it and a better appreciation of its striking aesthetic qualities.

18 I hope to complete soon a list of such known texts; preliminary lists are found in Diakonov's article in the first of the two publications quoted in note 16.

19 *Zhivopis*, pl. XXV.

20 Ibid., pls XXII and XXXIII, for instance.

21 In the Demotte manuscript the matter is somewhat confused by the question of retouches but the existence of a contrast seems assured if we compare some of the "pathetic" scenes we have examined with some of the ones at the beginning of the manuscript (nos 2–4).

22 E. D. Ross and R. Gauthiot, "L'Alphabet Soghdien d'après un témoignage du XIIIème siècle," *Journal Asiatique* (1913), pp. 521 ff.

Chapter VIII

The Illustrated *Maqamat* of the Thirteenth Century: the Bourgeoisie and the Arts*¹

It is only too rarely that evidence provided by the arts other than architecture is used for the study of a social or geographical problem such as that of the city. It is even rarer that a historian of art be led, during the investigation of documents like miniatures, which seem to be meant primarily for aesthetic appreciation, to problems of possible consequence to social history. However, the preparation of what is expected to be a complete corpus with commentaries of the illustrations of the *Maqamat* of al-Hariri has led me to a series of questions which go beyond technical problems of stylistic and iconographic analyses or of relationships between manuscripts; and, as I will attempt to show, some of these questions are central to the problem of the colloquium, for they may permit the definition of certain intellectual and historical coordinates of a precisely identifiable segment of a city's population. In other words, this paper starts from a methodological premise which is quite different from the premises of most papers presented at the colloquium. Instead of beginning with some specific urban center or with some institution or problem which can be assumed to have existed in the Muslim city, the series of investigations which led to the foregoing remarks began with an attempt to solve in traditional techniques of the history of art a classic type of problem, i.e. the identification of the meaning of a body of images. But it soon became apparent, in the course of our investigations, that the illustrated *Maqamat* can also be seen as a rather curious document on the *taste* of their time and [208] that this taste

* First published in *The Islamic City*, ed. A. Hourani (Oxford, 1970), pp. 207–22.
¹ It will be apparent that this paper should be fully illustrated, as it was when presented. However, various considerations ranging from cost to permits made it impossible to provide a complete documentation, and the eight figures provided are no more than mere specimens. The matter is all the more regrettable since some of the main documents, especially the Leningrad manuscript, are still unpublished. Whenever essential, the precise reference to codices and folios is given. I simply hope that the lack of visual proof will not detract too much from whatever theoretical value the paper may have. In order to emphasize the latter, I have eliminated from the printed text those points mentioned in the lecture itself which are not understandable without pictures.

leads us directly into the problem of the intellectual and spiritual configuration of the urban order of Islam in the Middle Ages.

The very fact of the existence of illustrated manuscripts of the *Maqamat* raises three central questions which may serve to focus more clearly their documentary significance or what Max van Berchem would have called their "archaeological index."

The first one is that of the actual reasons for their creation. For, while it is true that al-Hariri picked his stories from a vast store of literary and folk sources, the central characteristic of his work and the principal reason for its success was its purely artificial, even if at times fascinating, "acrobatie verbale," as it has recently been called by Professor Blachère.[2] Examples of this are familiar to all Arabists, but for our purposes their central significance is that almost by definition these linguistic pyrotechnics cannot be illustrated. Hence, in almost all instances, the illustrations are dealing with the frame of events which serves as an excuse for speeches, poems, artful descriptions, puns, and the like. The extent of this frame varies from story to story, at times considerably; yet it is also true that, if we except half a dozen involved narratives, the general feeling for a reader is one of contrived repetitiousness. It is clear that the function of the events which were illustrated is secondary to the point of the book or at least to the reasons for its success. We have thus a paradox of illustrations which at first glance miss the most significant aspect of the book they illustrate. It would not be farfetched to suggest that there is as much outward need to illustrate the *Maqamat* as there is to illustrate a Platonic dialogue. In both cases there is a cast of personages and an audience; stories or adventures may be told or related, but these bear comparatively little relation to the main purpose of the work.

The few instances in which an illustrator of the *Maqamat* attempted to go beyond the simple story and to depict a more abstract idea or a more complex emotion are usually failures in the sense that the image by itself fails to convey its purpose without thorough awareness on the part of the viewer of details of the text. To give but one instance, fol. 6v of the so-called Schefer *Maqamat* illustrates the departure of Abu Zayd in the second *maqama* from the crowd he has just entertained: "then he rose and departed from his place, and carried away our hearts with him" (Fig. 1). All that appears on the miniature is al-Harith and a group of seated personages showing with the gestures of their hands and, in spite of retouches, with their facial expressions, their sorrow at the departure of an invisible Abu Zayd. The open composition is rather daring for a [209] medieval miniature, but the point is that an image with a limited attempt at expressing an emotion does not automatically identify itself visually as an illustration of the precise passage it illustrates. Furthermore, its specific depiction of sorrow is weak because no ready-made

2 R. Blachère and P. Masnou, *Al-Hamadani, Choix de Maqamat* (Paris, 1957), p. 46.

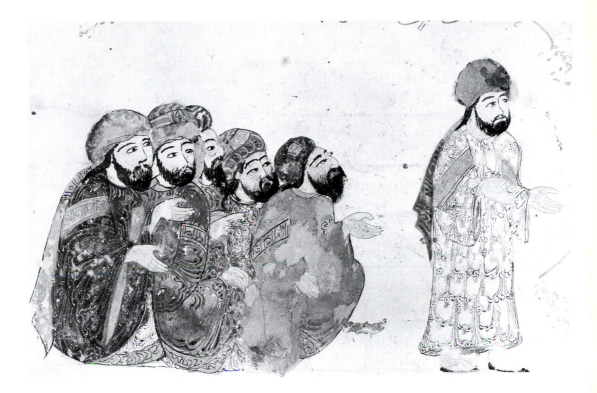

and understandable visual language existed for this purpose, as it did for instance in a Christian Pietà; elsewhere the same gestures and facial features express a different emotion: surprise, for instance. If as simple a subject and one as close to the narrative as this one finds it difficult to project its specific meaning, how much more unlikely is it that the more abstract values of the book as a whole could have been translated into images?

1 Abu Zayd departing. Paris, arabe 5847

Therefore some reason must exist for the development of *Maqamat* illustrations which is to a degree independent of the reasons for the actual success of al-Hariri's masterpiece, a success which was by its very nature different from that of *Kalila and Dimna* or of the *Shahname* where, regardless of the moral or esoteric meanings given to stories or heroes, an element of purely narrative entertainment always existed. Some explanation must clearly be found for the *fact* of the existence of these particular cycles of images.

A second problem posed by the illustrations of the *Maqamat* is chronological. Of the twelve known manuscripts, eleven were made within about 120 years. The earliest dated one is 1222 and the latest 1337.[3] Of these

[3] A complete and up-to-date list with a discussion of each manuscript will be found in D. S. Rice, "The oldest illustrated Arabic manuscript," *BSOAS*, 22 (1959), p. 215. To these should be added the manuscript discovered by R. Ettinghausen and published by O. Grabar, "A newly discovered manuscript," *Ars Orientalis*, 5 (1963).

manuscripts four are fourteenth century and can be shown to have a primarily derivative illustration, i.e. one based on earlier models. The six thirteenth-century manuscripts,[4] on the other hand, do not show obvious earlier models, at least not at first glance, and we may properly conclude that *prima facie* the illustration of the *Maqamat* is a phenomenon which grew in the first half of the thirteenth century. Although it is dangerous to judge from negative evidence, the point is strengthened by the fact that a number of twelfth-century manuscripts of the work are known, including two dated before al-Hariri's death, and none shows any sign of having been illustrated. It seems likely therefore that we are dealing with a fairly precisely definable moment of time. Its upward limit is the second half of the fourteenth century when there occurred a general decline in artistic creativity within the Arab world. Its lower limit may be put around 1200 [210] and some explanation must be found for the apparently sudden popularity of illustrations of the book about 100 years after its appearance as one of the most spectacular best-sellers of the medieval world.

The third problem is somewhat more complex to define. We may establish as a premise that the appreciation and appeal of a book of al-Hariri's *Maqamat* was limited to a highly literate Arab milieu.[5] Because of the presumption of elevated literary interest and because of the inherent financial investment involved in an illustrated book, this milieu may be, at least hypothetically, defined as that of the mercantile, artisanal and scholarly bourgeoisie of the larger Arabic-speaking cities. Thus the illustrations depict an element of the taste of a comparatively limited social stratum within the urban setting. And the problem then is: how did this particular Arab milieu create an imagery? In other words, what components went into the making of a visual language whose meaningfulness in its time we must as a working hypothesis at least assume? A definition of the language can on the other hand provide us with a unique instance of what may be called a self-view as well as a world-view of the literate Arab world of the thirteenth century.

Such then are the questions which are raised by the mere existence of illustrations to the *Maqamat*. The answers to them have to be sought almost entirely within the manuscripts themselves, since to my knowledge there is no outside literary source which even acknowledges the existence of these images, while such sources do exist for the book of *Kalila and Dimna* or for

4 These are three manuscripts in Paris (Bibliothèque Nationale arabe 3929, 5847, 6094), one in Leningrad (Academy of Sciences S 23), one in Istanbul (Süleymaniye, Esad Efendi 2916), and one in London (British Museum, oriental 1200).

5 The very Arab character of the audience can be shown, for instance, in the transformation of the preserved frontispieces of one of the manuscripts (Paris 5847) from the usual princely subject matter to a depiction of a group of personages listening to a story. For a description and discussion (but with a somewhat different interpretation), see R. Ettinghausen, *Arab Painting* (Geneva, 1962), pp. 110–15.

the *Shahname*.[6] The methods which I have followed are essentially an attempt to adapt certain practices developed in linguistics or ethnography by which one tries first to define the *structure* of the images in describing and explaining in as much detail as possible every element which appears in the 800-odd known illustrations. Then a first synthesis is put together in which the general characteristics of the visual language are identified and these are then related to other artistic traditions in order to make up what may be called the dialectal position of the *Maqamat* [211] miniatures within contemporary Islamic art as well as within other traditions of medieval Mediterranean art.

Since much of this work is still unfinished and many of its aspects concern technical problems of the history of art such as the identification of meaningful forms, the nature of narrative illustration, the relationship between pre-established typological models and specific needs of the text, and the internal characteristics of individual manuscripts, what I propose to do here is to concentrate on three separate questions which are particularly pertinent to the subject of the colloquium: (1) Can one define, from the miniatures, the ways in which the bourgeois milieu for which the pictures were made saw the city? (2) Is the art of the *Maqamat* the only available evidence of an art of the bourgeoisie? (3) Can one determine the ways in which this artistic tradition formed itself from other traditions of images? In conclusion I shall try to suggest an explanation for the existence of this unusual cycle of illustrations and ask a question which I am unable at the moment to answer.

To answer our first question, that of the way in which the artist of the *Maqamat* saw the city, the images provide us with three elements: landscape and natural setting, architecture, personages. There is not much to glean out of the first element, since it can be shown that almost all features of natural landscape are part of an artificial convention probably belonging to a general vocabulary of Mediterranean origin used almost exclusively for compositional purposes. It would seem, on the whole, that the milieu with which we are dealing did not go out to look at nature or for that matter at the animal world for its own sake. The few instances to the contrary are either small details, probably part of otherwise definable iconographic entities, or quite unusual, such as the celebrated drove of camels in the Schefer manuscript.[7]

The representation of architecture, on the other hand, suggests far more interesting conclusions. The three major manuscripts of the thirteenth century – one in Paris (5847), one in Istanbul, and one in Leningrad – have developed three more or less standardized architectural settings which occur throughout

6 For *Kalila and Dimna*, see, for instance, the celebrated text discussed by T. Arnold, *Painting in Islam* (reprinted edition, New York, 1965), p. 26. For the *Shahname*, the matter still awaits full elucidation, but the presumption of illustrated manuscripts is suggested by such objects as the Freer Gallery goblet, G. D. Guest, "Notes on the Miniatures on a thirteenth century beaker," *Ars Islamica*, 10 (1943).
7 Illustrated quite often, lastly in Ettinghausen, *Arab Painting*, p. 117.

with only minor variations from one miniature to the other, although more significant ones from one manuscript to another.

The first type may be broadly called the *house* type. At its most common it occurs in the Leningrad manuscript and shows usually a large central area covered with a wooden conical dome which can be opened up by having a section of the dome rolled to the side or by folding up mats set [212] over a wooden frame. This house also has chimneys for ventilation which can be turned in different directions, a stairway also used as a cooling place for water jars, and a heavy door with knockers generally sculpted. In most instances there is also a second floor, but it is rarely depicted. Details of internal arrangements are few and usually only brought in when required by the text. Altogether this general type is an artificial combination of features which can be assumed to identify a bourgeois *dar* in the city[8] (Fig. 2).

The second general type is that of the mosque. Variations occur here fairly often in the degree of elaboration but the most common system includes a *riwaq*, a *mihrab*, a *minbar*, at times a sort of *maqsura* railing, a dome on the axis of the building, and more rarely a minaret. Additional details of construction are found occasionally, but as a rule they do not alter the basic type, which is essentially that of the early Islamic hypostyle mosque and not the new centrally planned *iwan*-mosques or dome-mosques spreading from Iran in the twelfth century[9] (Fig. 3).

The third general type is of lesser significance to our purpose here but I shall mention it because it is a particularly fascinating one and because its origins still puzzle me. It is the type of the caravan at rest and its most remarkable utilization is found in the Leningrad manuscript. There, almost always regardless of the precise needs of the story, we find the same groups of tents: large square ones, circular ones, and an ubiquitous small blue and white tent-like object, which it is tempting to interpret as a *mahmal* or as a *markab*,[10] in which case we could formulate the hypothesis that it is the specific practice of the pilgrimage that created the general type for the depiction of the caravan. It should be added, however, that the tent type shows greater variations from manuscript to manuscript than the house type and that any final conclusions about its origin and significance must await a more complete analysis than can be made here.

8 For typical examples, see ibid., pp. 105, 107, 113 (unfortunately the examples shown here had to be chosen on the basis of aesthetic merit as well as state of preservation and do not show all the characteristic features of the house); Grabar, "A newly discovered manuscript," figs 1, 7, 37, 41. (Fig. 7 is reproduced here as Fig. 2.)

9 For examples see Grabar, figs 20, 23, 42. (Fig. 20 = Fig. 3 here.)

10 Ettinghausen, *Arab Painting*, p. 112. Exceptions occur either in such cases when a specifically Bedouin setting is required (ibid., p. 111) and the traditional wide and low black tent appears, or when, in the 26th *maqama*, the tent is supposed to be a luxurious one and a princely model is used (Grabar, fig. 17 for the only published example; p. 101).

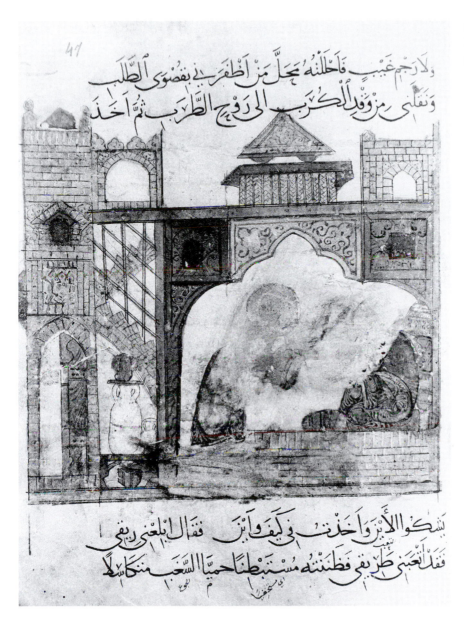

2 House.
Istanbul
manuscript

However interesting each of these three types may be in identifying some aspects of the material setting of the thirteenth-century world as seen by the Arab bourgeoisie, it is dangerous to go too far in utilizing them as [213] historical documents because to a degree they were iconographic types whose compositional significance as settings for a precise subject matter often overshadowed any attempt at verisimilitude. What is more significant is to relate the type to incidents or settings required by the text or to note exceptional compositions of architecture.

3 Mosque.
Istanbul
manuscript

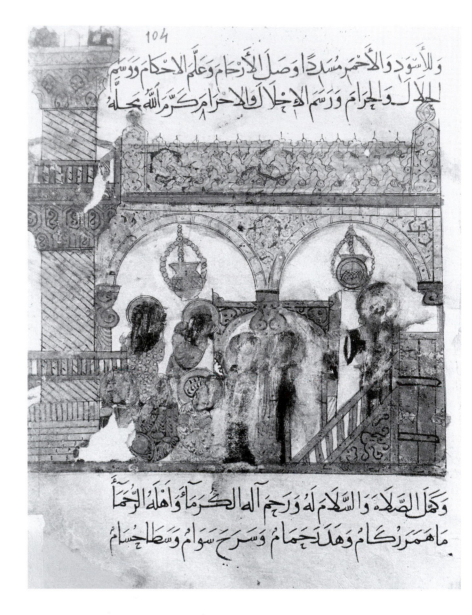

It may be noted first of all that what I have called the house type is not limited in its use to instances when the text requires a private dwelling. It is particularly interesting to note that it occurs consistently as an illustration of the courts of the *qadi* and of various officials, *walis* or heads of *diwans*, in front of whom Abu Zayd has occasion to perform. In other words – at least within the precise optical system with which we are involved – there does not seem to be an identifiable architectural vision of the publicly accessible official building, or else we should assume that these institutions did not have an architecturally identifiable setting different from the house. Such is likely to be the case for the school which forms the setting of the forty-sixth

maqama; it is architecturally undistinguishable from the house type and, like the court of the judge or of the governor, it is only identified by the actions which take place within it.

This point acquires its full significance, however, when it is related to the fact that certain other kinds of buildings were clearly and systematically shown as different. The most obvious instance occurs in the twenty-ninth *maqama* where all manuscripts without exception have introduced an architectural construction identifiable by its monumental proportions, two superimposed floors with rooms opening on a balcony, an exterior stairway, in one instance a well.[11] It is a *khan* and it may be worthwhile mentioning that the twelfth and thirteenth centuries are the first centuries for which we have clear architectural evidence of the existence of superb new caravanserais from Iran to Anatolia and Syria (Fig. 4).

A second modification of the architectural norm occurs in representations of the *suq*, of markets in general. In the forty-seventh *maqama*, the celebrated representation of the barbershop-cupping place shows a very small narrow building around which a crowd has gathered.[12] In the fifteenth *maqama* the shop of a seller of milk and dates is also shown suddenly as a small opening cut out of a wall and, in the Istanbul manuscript, it even appears in a unique profile elevation.[13] It seems clear that there was an original visual expression of the small shops in narrow covered streets which characterized the mercantile context: one may mention the slave-[214]market, which in two manuscripts is shown with a wooden architecture and a tiled roof quite different from other types of roofs,[14] and the representation of a tavern in the Leningrad manuscript. In the same context of a unique imagery dealing with a precise urban feature one should mention the well-known series of cemeteries discussed by the late D. S. Rice.[15]

A unique type of architectural background is provided in the illustrations of the forty-third *maqama*. There, for reasons that are not entirely clear, the illustrators of the three principal manuscripts decided to represent a panorama of a small village characterized in the text as a Boeotian village of stupid people. Two manuscripts, and especially the Schefer one, used the opportunity to give us a curious glimpse of the simpler people of a small town as they appeared to the large city's visitor: small houses and shops, pools of water, a few primitive activities like spinning, the silhouette of a mosque on the unusual central domical plan and not the proper traditional hypostyle one, and especially a mass of animals everywhere.[16] The very originality of this image testifies to its meaningful character as a document (Fig. 5).

[11] Grabar, fig. 21; E. Blochet, *Musulman Painting* (London, 1929), pl. XXX (= Fig. 4 here).
[12] Grabar, fig. 39.
[13] Grabar, fig. 8.
[14] Blochet, *Musulman Painting*, pl. XXVII.
[15] Above, note 3.
[16] Ettinghausen, p. 116 (= Fig. 5 here); Grabar, figs 33–4 and pp. 105–106.

4 Khan. Paris,
arabe 5847

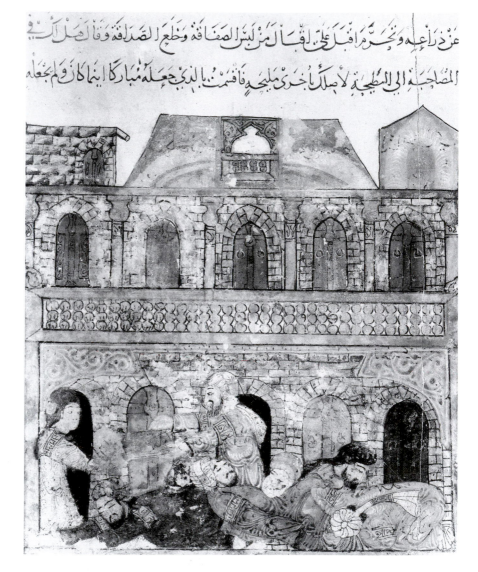

Finally, an original architecture occurs in the representation of a mysterious palace in a far-away island as illustrated in the thirty-ninth *maqama*. Projecting balconies, high walls, highly decorated exteriors and a garden illustrate an idealized vision of a palace, like a sort of kiosk for which we have evidence in texts but no remaining instances[17] (Fig. 6).

The conclusion to draw from this brief analysis is then that, however one is to explain the establishment of a generalized typology of architectural settings, the exceptions to it may serve better to illustrate a precise concern

17 Grabar, fig. 30, pp. 104–105; E. Blochet, *Les Enluminures des Manuscrits Orientaux* (Paris, 1926), pl. XIII (= Fig. 6 here).

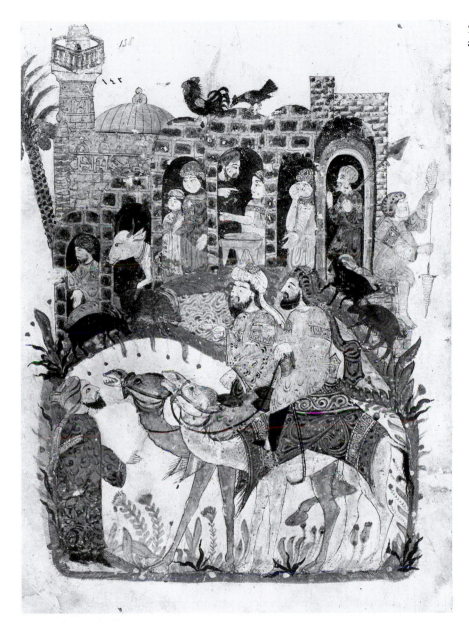

5 Village. Paris,
arabe 5847

of those for whom the manuscripts were made. And it would be primarily the city's mercantile features, markets, caravanserais, which were sufficiently significant to the users of the manuscripts that their interpretation had to be specific. Secondary subjects similarly treated were those which involved imagination of a higher life and a rather more earthy view of a socially lower setting. But therein also lies the limitation of the evidence provided by these images dealing with major architectural features. For they can only be used as archaeological documents when they depart from an

6 Palace. Paris,
arabe 5847

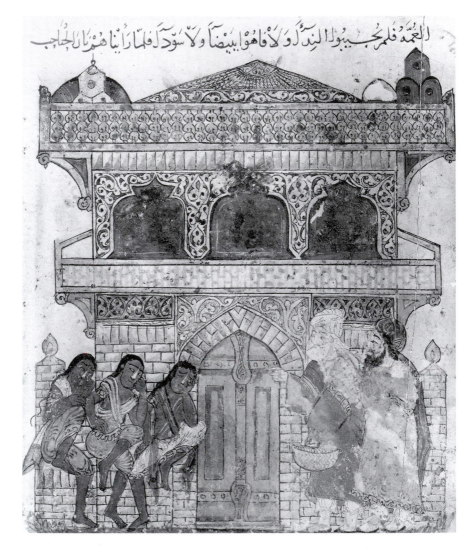

iconographic norm. It is only then that we can be assured that they are
meant to have the concrete meaning demanded by [215] the text. Elsewhere
the task of deciding between iconographic significance and standard
typology is fraught with danger and can never be pursued safely. The
problem exists, however, of the origins of the *topoi* and of their exact index
and to this I shall return below.

The same type of analysis can be used in attempting to discuss and
define the documentary value of the representations of personages, although
there matters are somewhat more complicated by the individual stylistic
peculiarities of each manuscript. The analysis may begin with the realization
of the existence of one personage basically common to all manuscripts.
Dressed in a long robe, the head covered with a simple turban, the face
usually provided with a beard and large eyes, he may be called the typical

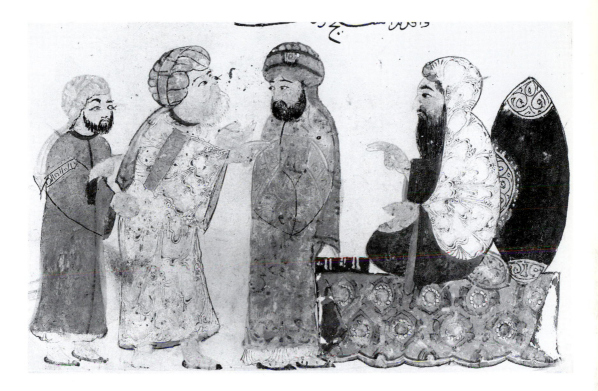

Arab male figure[18] (Fig. 7). His ubiquity in all manuscripts makes him an iconographic type without precise documentary value and here again the departures from the norm are more significant in identifying the world recognized by the milieu for whom the *Maqamat* were illustrated. Minor changes such as a veil around the face identify the Bedouin. Slaves and servants are shown as youths, usually with short robes and at times in high boots and braided hair. Dark colors and a mere loincloth depict Indian sailors. Women and children are rarely successfully represented but in one instance illustrating the eighteenth *maqama* we see the image of a paragon of beauty, a sort of Miss Arab World of the thirteenth century[19] (Fig. 8). More interesting are the representations of officials, judges wearing long *taylasans* and long beards, otherwise quite indistinguishable from the Arab crowds, or *walis*, usually in pseudo-military garb and accompanied by attendants; in most of the better miniatures these personages are always made to look a bit ridiculous, thereby illustrating the satirical intent of the author.[20] Within this motley crowd there is yet another essential personage, the beggar or the *sufi*, either in tattered clothes, or, more often, in a short robe, long tight trousers, a headgear with a long and usually pointed

7 Arab types with *qadi*. Paris, arabe 5847

18 A typical example is the central figure on p. 114 of Ettinghausen's book.
19 This is a hitherto unpublished miniature of Paris 3929, fol. 151.
20 Ettinghausen, p. 115.

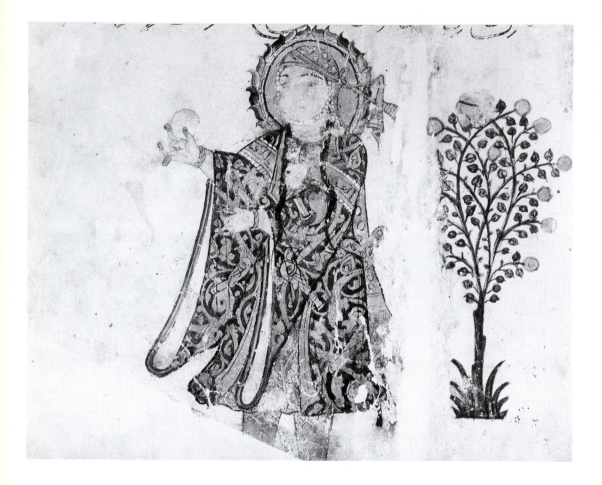

8 Woman.
Paris, arabe 3929

qalansuwa and a narrow long scarf around the neck, perhaps in imitation of the *tarha* or of the *taylasan* of the official *qadi*. It is the costume under which Abu Zayd is shown when he cannot clearly be identified by his action, although it is worthwhile to note that there is nowhere a clear iconographic identification of the hero of the stories.

The main significance of this rapid enumeration is, it seems to me, the very narrow range of its typology of human beings. To a degree, of course, [216] no medieval art, in the Islamic world or in Christendom, has seen fit, before the Renaissance, to translate into visual terms the variety of human types which existed in the large urban centers and of which we have written evidence. There was a general medieval tendency to cast all human types into a small number of optically perceived images. The variants on the basic type that do exist and the clear satiric intent of some of the representations of authority would suggest the secondary conclusion that the human vision of the particular world of this bourgeoisie was limited to a few precise groups with which it dealt personally and which would have been meaningless without some vestimentary or facial identification. The touch of exoticism

which appears in a few instances revolved around unusual themes such as that of the fantastic island from the thirty-ninth *maqama*.[21] In that sense the limited character of the world provided to the reader of the *Maqamat* is reflected in the poverty of the human types found in the illustrations.

Even though it may be regretted that the illustrations of the *Maqamat* do not provide us with a vaster panorama of a visually perceived Near East in the first half of the thirteenth century, still they do give us a specifically defined view of the scope and of the visual vocabulary which can clearly be assigned to the Arab bourgeoisie of the thirteenth century. Is this the only evidence we have at that time for an art of this particular segment of the population?

As far as architecture is concerned, it is extremely difficult to evaluate the evidence properly. This is true both of the archaeological evidence and of the literary, and one should avoid the temptation of generalizing on the basis of the considerable information available for Fatimid and Mamluk Cairo or for Aleppo and Damascus. To limit myself to archaeological evidence, it seems clear that the large number of caravanserais found in Anatolia certainly bear some relation to mercantile activities, as do bridges and *suqs* there and elsewhere and also the numerous commercial and industrial enterprises created as *waqfs* for religious institutions. Together with baths and warehouses they formed a major part of the official architecture of the city, but too little is known about them at that time to define their character with any degree of certitude.[22] In any event, the [217] mercantile function of a building like a caravanserai need not mean that it reflects an architectural taste or style properly to be associated with the bourgeoisie. A greater impact of a social patronage other than that of princes seems to have made itself felt in two other areas: first, in the growth of small sanctuaries, the *mashhads* which at this time begin to identify cities and quarters but whose significance is usually strictly local and whose sponsorship may come from a lower level than that of the bourgeoisie, at least at this time;[23] and second, in city planning or, more correctly, the directions in which cities grew.

Herzfeld noted many years ago that a peculiarity of the twelfth- and thirteenth-century monuments of Syria is their small and sometimes odd size, as though they had to be fitted within immovable existing architectural

21 I have discussed the illustrations of this story in a paper presented at the XXVth International Congress of Orientalists in Moscow; cf. *Proceedings* (Moscow, 1963), II, pp. 46–7. Typical illustrations in Ettinghausen, p. 122.

22 The precise typology of all these buildings is still to be done. For caravanserais, see K. Erdmann, *Das Anatolische Karavanserai* (Berlin, 1961), and Sauvaget's articles in *Ars Islamica*, 6 and 7 (1939 and 1940). For other buildings the best introduction is Sauvaget's *Alep* (Paris, 1941).

23 Some preliminary remarks in O. Grabar, "The earliest Islamic commemorative buildings," *Ars Orientalis*, 6 (1967).

entities.[24] And he had suggested that this was due to the impact of the local landowners, presumably the very type of rich bourgeois who would appreciate the *Maqamat*. Or in Cairo the transformation of the *shari'at bayn al-qasrayn* into a sort of Fifth Avenue or a rue de la Paix probably reflected internal social and economic transformations in Cairo itself as much as the impact of the newly arrived military aristocracy. Altogether, however, as far as architecture is concerned, the exact impact of the bourgeois component, seen as a taste-making social unit and not merely as a partaker of wider cultural trends, in the stylistic and formal changes brought in the twelfth and thirteenth centuries seems to me to be still very difficult to assess properly.

The matter is far more complex and far more suggestive when we turn to the work of artisans, ceramicists, metalworkers, glass-makers. The evidence there of the existence of a powerful city-bred bourgeois art, on several different levels of quality, is so vast that I should like to limit myself to three points illustrating three different ways in which this art can be approached.

The first point is that the typically Islamic transformation of the common utensil – a plate, a jug, a basin, a glass – into a work of aesthetic quality is a phenomenon which can clearly be attributed to the urban bourgeoisie of the Islamic world. It appeared first in eastern Iran, developed in Fatimid Egypt (not necessarily under the impact of the East), was acknowledged in theoretical writing by the *Ikhwan al-Safa'*, and grew to its most impressive heights in the twelfth and thirteenth centuries, to dwindle away as a mere appendix to princely workshops after the Mongol [218] conquest. The demonstration of this point would require a lecture by itself and need not be made here.

The second point concerns more particularly the twelfth and thirteenth centuries. During this time, and especially after 1150, two major changes took place in the art of the object. One is the growth of numbers of signed and dated pieces which suggests the increase in marketable value of an individual's work and the opportunity for the artisan to express his pride in his craft; at the same time we have a number of major pieces in metal (usually thought to be a princely medium) specifically made for merchants, like the celebrated Bobrinski bucket in the Hermitage.[25] The other change is the rather sudden tremendous spread of figural representations in all media, more especially in Iran than in other parts of the Muslim world, although it characterizes all eastern provinces. There occurred a sort of revolution in the visual vocabulary available to and understood by a larger social unit than the court of the prince, until then the major patron of representational arts. The consistent use on objects of figural themes was paralleled by the animation of every part of the object, as in the so-called animated scripts, as though at

24 E. Herzfeld, "Damascus, Studies in Architecture," *Ars Islamica*, 11–12 (1946), p. 37.
25 R. Ettinghausen, "The Bobrinski kettle," *Gazette des Beaux-Arts*, 6th ser., 24 (1943).

that time value could only be expressed properly through figures.[26] These changes in themselves need not all be necessarily connected with an urban art, although *a priori* the character of the objects on which they occurred and the fact that a large number of bronzes and almost all the early ones in the new techniques bear inscriptions with the names of merchants suggests the possibility.

But this is where my third point comes in. A study of the inscriptions and of the iconography actually does indicate that it is only within the urban world that these changes can be explained. Three examples may suffice. Giuzalian's study of a series of *Shahname* fragments found on pieces of ceramic has shown that the texts used were popular, spoken versions of the epic rather than courtly written ones.[27] In itself this fact only tells us something about the character and literary make-up of the artisan, but it also suggests the new appropriateness of the less sophisticated as creators of major works of industrial arts. Further, the existence of a large number of luxury objects with Christian subject matter – and perhaps with heterodox overtones although this particular matter still demands further investigation – suggests the participation of non-Muslims among [219] the users and patrons of the objects, a participation otherwise documented in the Geniza documents and which makes sense only within the context of the city. Finally, as a recent study by Ettinghausen has suggested,[28] the imagery on a large group of ceramics may be related to the imagery of Sufism and it is once again in the towns, with their guilds and associations, that we can best imagine the impact of the new vocabulary of a mystical movement whose social overtones have often been recognized.

It would appear then that, except for the ill-documented or improperly studied area of architecture, the illustrated *Maqamat* seen here as an expression of bourgeois art did not appear within a vacuum. In other parts of the Muslim world, however, quite different techniques seem to have been used for its expression and so far the illustrations of the *Maqamat* form the only major cycle of paintings which cannot be explained outside of the specific milieu of the bourgeoisie.

The problem of the relations between the *Maqamat* and the rest of what may be called bourgeois art lies elsewhere. It is that almost never can one show a clear contact between them. Here and there a tile or a glass object does show some stylistic or iconographic resemblance to the miniatures in the *Maqamat*,[29] and one rather odd image in the late Oxford manuscript represents a *jariya* just given as a gift to Abu Zayd in the odd shape of a

[26] A definitive study of this theme is being prepared by R. Ettinghausen. In the meantime, see D. S. Rice, *The Wade Cup* (Paris, 1955).

[27] Series of articles in *Epigrafika Vostoka*, 3, 4, 5 (1949–51).

[28] R. Ettinghausen, "The Iconography of a Kashan Luster Plate," *Ars Orientalis*, 4 (1961).

[29] For instance two tiles in the Walters Art Gallery illustrated, among other places, in ibid., figs 71 and 72.

nursing woman, which recalls a still unexplained group of objects in the same shape.[30] But these parallels are few and the sources of the illustrations made for the Arabic *Maqamat* are not the same as those of the Iranian ceramics, even though both can be associated with a related social milieu.

What then are the sources of the Arabic images? Three strands may easily be identified. One is Christian art, most probably Oriental Christian art rather than high Byzantine art. Obvious in one of the Paris manuscripts, this Christian influence is less immediately visible in the other manuscripts, but it is certainly there, as has been demonstrated by Professor Buchthal.[31] A second source is Islamic princely art. A scene in the Schefer *Maqamat* illustrating the twelfth *maqama* shows Abu Zayd drinking in a tavern.[32] Since the act of drinking was a central mode for the [220] representation of the prince, Abu Zayd has been transformed into a prince in pose and composition. Another scene from the Istanbul codex is supposed to represent Abu Zayd wealthy and powerful, and shows him seated in majesty in his tent and surrounded on each side by a military man and by a cleric, representing the *ahl al-sayf* and *ahl al-qalam* of a princely image.[33] Drinking and power have been so fully associated visually with royal images that it is only in such terms that Abu Zayd could properly be represented in these activities. A similar type of relationship exists between the *Maqamat* and a few other identified artistic traditions: the Dioscorides one for plants, travel tales for certain features of foreigners, and perhaps a few others.

The third source is more difficult to define. It has often been called realism in the sense of observation of nature and of man. There is little doubt that such observations played a part in the creation of the *Maqamat* of the thirteenth century. They appear in the formation of the physical type of the Arab, in the reproduction of a multiplicity of telling gestures or characteristic details, and in the many "genre" scenes. Yet, even though there is something tempting about positing a realism of intent, if not always of execution, in these paintings made for a bourgeois milieu – as in Flanders and Holland in the sixteenth and seventeenth centuries – the term should be used carefully. In the crucial areas of anatomical verisimilitude, formal compositions, or spatial representations, the art of the *Maqamat* shows very few signs of moving towards any sort of realism. The vision of the painters and of their patrons was still that of a very conventional ideographic system in which the viewer recognized and reinterpreted in his own mind separate visual units which he could understand because he knew the text. Apart from the few exceptions found almost exclusively in al-Wasiti's work, the art

30 Folio 65v.
31 H. Buchthal, "Hellenistic Miniatures in Early Islamic Manuscripts," *Ars Islamica*, 7 (1940).
32 This miniature was discussed in a totally different context by D. S. Rice, "Deacon or Drink," *Arabica*, 5 (1958), pl. VI.
33 Grabar, fig. 17.

of the *Maqamat* was not an attempt to capture the life and world of the Arab bourgeoisie but to illustrate the setting of the book of the *Maqamat*. Just as the book itself has elements of satire and is a significant source for the social and intellectual history of its time, so are the illustrations, but the point of the book was not to be a satire, and it is only in a relatively small number of images from three manuscripts that one can clearly see attempts to copy directly the physical reality of the contemporary world by differentiating certain elements from the standardized mass of images.

But then how can we explain what I have called the underlying typology of the images, that is the very standard forms in the representation of architecture, landscape or man which are repeated from image to image [221] with minor modifications and without necessarily fitting with the requirements of the text? It would be tempting to assume an iconographic background for these features outside of the *Maqamat* themselves, and in the case of two of the manuscripts we can do so. Paris 6094 clearly derives from Christian art, and the figures of Paris 3929 bear striking resemblances to the little that is known of popular shadow plays;[34] in both instances, it is standard types rather than specific exceptions which are definable as closely related to an external tradition. But no such interpretation of an outside imagery suggests itself for the mass of illustrations in the greater manuscripts in Leningrad, Istanbul and Paris, except in the instance of landscape. In line with the explanation I have suggested for the illustrations in general – i.e. that they illustrate a book and not life – I should like to propose the following hypothesis for the formation of the typology. Just as the setting of each *maqama* shifts from Cairo to Samarkand without alteration of its specifically Arab character, so it is that in a small group of manuscripts a setting was created which reflects at the same time two characteristics of the text's setting: precisely Arab features but also abstract and repetitious formulas like those of literature. It is the standardized typology far more than the exceptions to it which succeeds in illustrating the book itself, but it is the two together which define the vision of the world of the Arab bourgeoisie of the early thirteenth century. To keep to our architectural examples, the novelty of the *khan* was recorded because of its particular meaning to the mercantile class, but the *maison bourgeoise*, the traditional early Islamic mosque, the ancient organization of a caravan were seen as obvious abstract entities identifiable by certain characteristic details but not specific representations of a given house, mosque, or caravan. It is perhaps tempting to imagine that the peculiarities of the typology of the house – and in particular its elaborate system for ventilation – suggest a particularly warm part of the Arab world, namely southern Iraq, and thus that the term School of Baghdad for these manuscripts is justified. Yet I hesitate in doing so precisely because the basic character of the typology, of the standard forms, seems to me to be more

34 Ettinghausen, *Arab Painting*, pp. 82–3.

clearly identifiable with a social level than with a precise land. It remains the case, however, that of all the known expressions of an art of urban centers, this specific group of Arabic manuscripts is the only one which has clearly been interested in reproducing something of the world which surrounded it. Their limitations both as historical documents and as illustrations of the text bring us back to our original question of why it is that they were illustrated altogether. Chronological evidence suggests [222] that around 1150 almost all the arts of the Islamic world – outside of the West – underwent changes which can be attributed to the impact of the needs and tastes of the bourgeoisie. A most significant general characteristic of these changes is that they involved the development of representational images in all media.

Thus the *Maqamat* were illustrated because the milieu which had read them and appreciated them before 1200 developed at that time in a way that demanded a visual expression, just as today a slow-moving novel by Françoise Sagan or the *Leopard* of Lampedusa are automatically made into a film, whether they lend themselves to it particularly well or not. The Arab literate milieu of the city aristocracy, which did not have a tradition of meaningful images, chose its own best-seller, its favorite reading matter, and had it illustrated, because it wanted illustrations, not because this particular book especially lent itself to them.

But what change took place in the character of the urban bourgeoisie some time in the middle of the twelfth century that it suddenly demanded a new and quite revolutionary artistic expression? This I am unable to answer and it is the main question I should like to have answered by social historians. Is there any evidence in other sources which would justify the obvious changes in taste and in creativity?

Aside, then, from this or that archaeologically or historically significant detail provided by the miniatures, the major significance of the *Maqamat* to the historian is that its existence reveals one unusual facet of the complex world of the city in the Arab world of the Near East: its interest in and involvement in images for the sake of images even more than as an illustration of life. That, at the same time, a limited but definable vision of the world seen by a precise group in the city does emerge is due to the character of the book rather than to the character of the men who had it illustrated. All that they expected was a literarily faithful, imaginative and meaningful visual translation of their favorite text and thus an appropriate status symbol for their position. This interest in images did not remain for long. Just as the Iranian ceramic types of the thirteenth century disappear shortly after the Mongol conquest, so the *Maqamat* of the early Mamluk period show great artistic merit but are iconographically almost meaningless or copy earlier models or else are mere compendia. The original impetus for the illustrations was no longer there and the images tended toward dried-up formal compositions, thus closing an original chapter of Islamic art.

Chapter IX

Pictures or Commentaries: The Illustrations of the *Maqamat* of al-Hariri*

One of the most common illustrations found in manuals of Islamic art, in books on Muslim history or civilization, in very general works touching only briefly on the Near East or the Muslim world, even on such non-academic items as postage stamps and greeting cards is the representation of a [86] drove of camels with an apparently old and certainly stout woman guarding the animals or pushing them on (Fig. 1). It is indeed a striking image whose creator picked up a number of very characteristic natural details of camels – the long neck, the rather absurdly prehistoric head, the awkward legs, the peculiarly open mouth, the unique outline, the heavily pompous gait and stance – and then recomposed these details no longer realistically but in a rhythmic pattern of legs, necks, humps and heads. The pattern is set in an essentially two-dimensional space, although a suggestion of depth is provided by the very ancient convention of successive parallel outlines and by the fact that the two camels eating grass which serve to frame the drove itself are clearly if awkwardly set on different planes. Without entering into the detail of a composition of fascinating complexity, it may suffice to say that its charm and success lie not only in that it represents animals easily associated with the Middle East but also in its unique blend of visual observation and pictorial convention. The purpose of this paper is not to investigate the stylistic peculiarities of this representation by the painter al-Wasiti in a celebrated manuscript now kept at the Bibliothèque Nationale (arabe 5847, fol. 101) and completed in 1237.[1] The questions I should rather like to raise are: what exactly is represented in this well-known image? And why?

The book from which it comes is that of the *Maqamat* of al-Hariri. It was written in the early part of the twelfth century and deals with the adventures

* First published in *Studies in Art and Literature of the Near East in Honor of Richard Ettinghausen*, ed. Peter J. Chelkowski (Middle Eastern Center University of Utah and New York University Press, 1974), pp. 85–104.
[1] Although never published in its entirety, this manuscript, also known as the Schefer *Maqamat*, has often been discussed; see Richard Ettinghausen, *Arab Painting* (Geneva, 1962), pp. 111 ff.

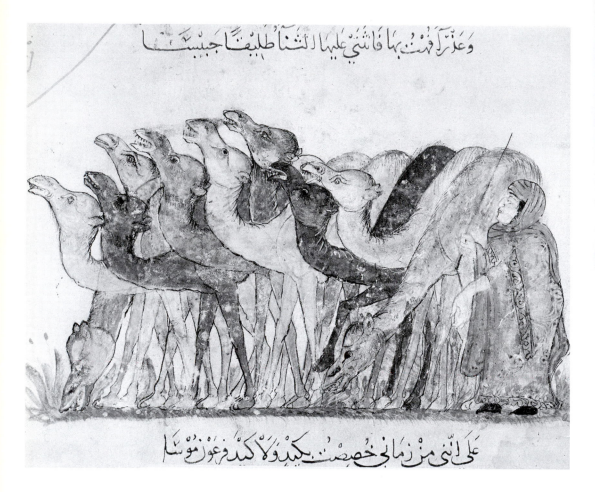

وَعَذَرَ أَقَنَتْ بِهَا فَاشْيَ عَلَيْهَا الثَّنَا طِلِفَا جِيِبْتَا

عَلَى أَنِّي مِنْ زَمَانِي خَصَّتْ كِيْدُ وَلَا كَيْدُ مِعُونَ مُوسُا

1 Paris arabe
5847, fol. 101;
thirty-second
maqama

of a picaresque hero, Abu Zayd, who lives off the world by his wits and by his
knowledge, at times through sheer dishonesty, but who succeeds in extricating
himself from difficult situations or in forcing others to accede to his needs
because of his incomparable use of the Arabic language.[2] Although the genre
of such individual stories about a roguish hero was not new, Hariri's work
became successful for several reasons. One is that he simplified his plots and
limited them to fifty stories, all but one of which are introduced by a witness-
narrator, al-Harith; some of his predecessors are reputed to have written four
hundred stories, a number which obviously made recall difficult. But a more
important reason for Hariri's success was his extraordinary mastery of [87]
Arabic, of its vocabulary, of its nuances, of its opportunities for all sorts of

2 For the most convenient summary of the history of the *Maqamat* as a literary genre, see
 Regis Blachère and Paul Masnou, *Al-Hamadani, Choix de Maqamat* (Paris, 1957).
 Introduction; art, "Hariri" in *Encyclopaedia of Islam*, Vol. II. There are many editions of
 the book; the translation into English to be quoted hereafter is by Chenery and
 Steingass (London, 1867 and 1898) with important commentaries.

linguistic puns and even visual tricks such as alternating dotted and undotted lines of poetry. These verbal pyrotechnics seem to have become almost immediately popular, as over two hundred twelfth- and thirteenth-century manuscripts of the work are known and the book was soon translated into other Semitic languages. Modern critics have often been surprised by this popularity, inasmuch as it appears to have declined somewhat after the fifteenth century, but we may agree on two key points about the book. One is that its appeal was primarily linguistic, and the other that this appeal was in all likelihood limited to a highly literate Arabic-speaking bourgeoisie.[3] The image of the camels is an illustration of the thirty-second *maqama*, a very long one without any real plot but consisting of Abu Zayd giving all sorts of legal opinions in fancy language. At the end the Beduins who had asked for these opinions gave him as a reward a "drove of camels with a slave-girl." Since it is rather difficult to interpret the woman in the illustration as the beautiful female singer suggested by the word *qaynah*, we must assume that in some fashion or other the represented personage comes with the camels and that sexiness is not one of her attributes. But a more important point is that even the identification of the exact subject of this image is difficult to make in visual terms alone. A very minor point was picked up by al-Wasiti and illustrated in a curious way, since the main hero of the story is not even present. In fact one may legitimately wonder whether any viewer of the image alone could recognize its exact subject and even that it is an illustration from the *Maqamat*. But, in this case, why was the image made? Part of the answer appears if one simply looks at folio 100, the page in the manuscript which precedes and faces the one with the camels (Fig. 2). There we see standing under a tree our two heroes, Abu Zayd and al-Harith, discussing the former's success. Abu Zayd is shown pointing toward the camels and both personages, one roguishly sly and the other stupidly amazed, are obviously involved with them. In other words, an image which has always been published alone, as a completed entity, is in fact only half of an iconographic unit extending over two pages of the manuscript. In two other manuscripts (British Museum, oriental 1200, fol. 106 and Leningrad, Asiatic Museum 523, fol. 223), these two halves have been unified into a single image (Figs 3 and 4). Although aesthetically quite ungainly, these miniatures are iconographically or as illustration [88] clearer than the much more brilliantly executed spread over two pages in the Schefer manuscript.

One could stop the investigation at this stage by simply pointing out that many other instances exist in the 1237 manuscript of such double-page compositions, that most of them are not clearly composed and seem to consist of two juxtaposed pictures, each one of which is a separate visual entity, even though only making iconographic sense in conjunction with its partner. One

3 H. Buchthal, *The Miniatures of the Paris Psalter* (London, 1938), p. 50; K. Weitzmann, *Roll and Codex* (Princeton, 1947), pp. 84 ff.

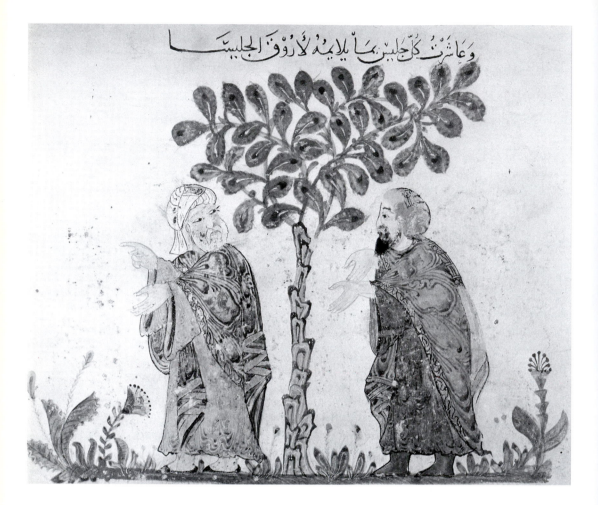

وَعَاشِرْنَ كَجَلِيسٍ مَا يَلائِمُهُ لَا رَوْقَ الجَلِيسَا

2 Paris arabe
5847, fol. 100v;
thirty-second
maqama

can even wonder whether we do not meet here with an extension into the body of the manuscript of a type of antithetic arrangement which occurs on many frontispieces and for which models may be found in Byzantine and Western manuscripts.[4] But the incongruity of the overall composition when compared to the quality of each of its two components and the peculiarity of the poor quality of iconographically more appropriate illustrations raise, it seems to me, [89] an entirely different question, that of the actual purpose of these miniatures in the *Maqamat*. For even if the image of the camels makes iconographic sense with the miniature facing it, and even if its belonging to the *Maqamat* is [90] evident because of the presence of the two heroes, why choose this very minor episode in an otherwise uneventful story? Is it purely arbitrarily that certain folios were provided with images? And what do these images do to a text which was only valued for its verbal acrobatics? The key

4 Kurt Weitzmann, "Islamic Scientific Illustrations," *Archaeologica Orientalia in Memoriam E. Herzfeld*, ed. G. C. Miles (Locust Valley, 1952).

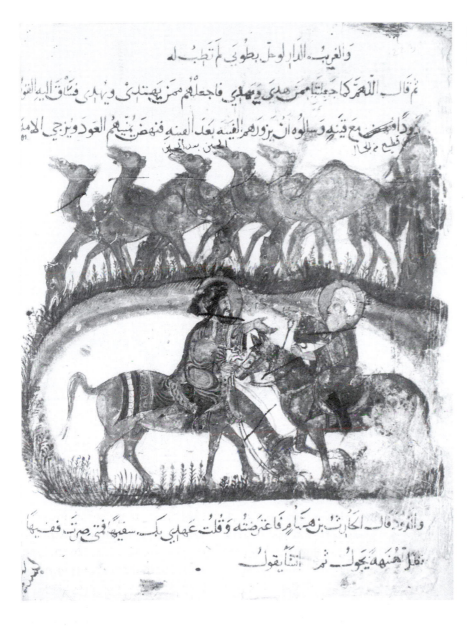

questions posed by the celebrated image of the camels seem to me those of the motivation and function of a visual addition to a written text. Is it a paraphrase or an explanation of the text? Is it a translation into another medium? Are these images commentaries to be seen and appreciated with the text or pictures which were perhaps inspired *by* the text but which are meant to be enjoyed separately as visual experiences? It is to these questions of much wider significance than the *Maqamat* that we shall seek to provide some tentative answers. Methodologically, however, a book without the complex liturgical or symbolic functions of the Bible and without the obvious narrative importance

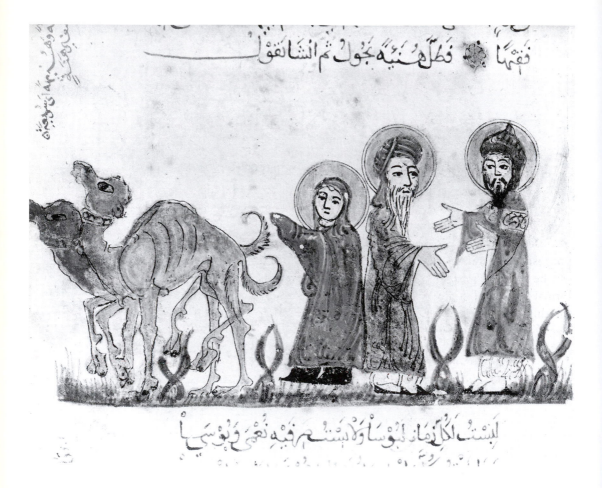

فقهما ‏ فطلهنيه جوك ثم الشافق‏

لبست الكل زمان لبوسا ولبست فيه نفي ويوسا

4 London,
oriental 1200, fol.
106; thirty-second
maqama

of the *Shahname* or of *Kalilah and Dimna* may serve as a particularly interesting case for a far more general theory of book illustration.

Thirteen illustrated manuscripts of the *Maqamat* are known, four in the British Museum, three in the Bibliothèque Nationale, one each in Oxford, [91] Vienna, Leningrad, Istanbul, Manchester, and in a library in Yemen.[5]

5 BM or. 1200 (dated 1256), or. 9718 (before 1310), add. 22.114 (undated), add. 7293 (between 1323 and 1376, unfinished); BN arabe 5847 (dated 1237), arabe 3929 (undated), arabe 6094 (dated 1222); Leningrad, Academy of Sciences 523 (undated); Oxford, Marsh 458 (dated 1337); Istanbul, Süleymaniye *esad efendi* 2916 (datable 1242–58); Manchester, John Rylands Library, arab 680 (later than the fifteenth century); Yemen, no location available, manuscript completed in 1709 but with a few early pages. The last of these manuscripts was discovered by Professor Mahmad al-Ghul of the American University of Beirut, who has kindly shown me his photographs. A discussion of nine of the others with full bibliography is found in D. S. Rice, "The Oldest Illustrated Arabic Manuscript," *BSOAS*, 25 (1959). He inadvertently forgot one of the London manuscripts discussed by H. Buchthal, "Three Illustrated Hariri Manuscripts," *Burlington Magazine*, 77 (1940). The Istanbul manuscript discovered by R. Ettinghausen was published by O. Grabar, "A Newly Discovered Manuscript," *Ars Orientalis*, 5 (1963).

These thirteen manuscripts divide themselves chronologically rather neatly. Two (Manchester and Yemen) are very late and highly derivative. Five of them are from the first half of the fourteenth century, probably made in Egypt. Six of them are from the thirteenth century, dating roughly from *c.* 1220 to *c.* 1260. These form the most interesting group, and with a few exceptions my remarks will concentrate on them. Before proceeding to a discussion of two stories and to an attempt at a typology of the images created in the various manuscripts, one point should be emphasized, although it will not be demonstrated. It is that, while there are in some 1,100 illustrations known to me several instances where the same iconographic details or interpretations are found, there is not a single instance in which one could prove that any one known manuscript derives from any other known manuscript or from its immediate model. While it is roughly possible to propose a general relationship between the manuscripts, this relationship can be better expressed through manners of illustration than through the formal system of stemmata developed in philological studies. The reasons for this conclusion form, however, an entirely different subject. For our immediate purposes what matters is that each manuscript must be seen as a creation independent of any other known one.

Let me begin with the eleventh *maqama*, whose illustrations have for the most part been published.[6] Al-Harith, the narrator, saddened by a personal misfortune, goes to a cemetery for peace and meditation. A burial is taking place and, before the mourners have departed, an old man appears on a neighboring hill, leaning on a staff and with his face hidden by his cloak. He makes a long and moving speech on human fickleness in the face of death and on the transitory character of life. Then he begs for money and comes down [92] from the hill; al-Harith stops him and upbraids him for his hypocrisy, but Abu Zayd answers that everything is fair in this world and the two part angrily. There are thirteen illustrations of this story. Seven of these deal with the main event, the speech at the cemetery; although varying in many details, all but one show one or more tombs, a group of mourners, and Abu Zayd making his speech. The exception (Fig. 5) is by al-Wasiti; its most remarkable feature is the absence of the hero of the story but, while it thus fails as an illustration of a precise event, it succeeds best in evoking the mood of the story. The frozen silence of the personages, the quietude of the setting, the elaborately massive composition, the gestures stopped in mid air, all paraphrase superbly the meditation on death of Abu Zayd's poem.

At the exact opposite pole as illustrations are the two poor images in BM or. 1200 and especially the four (not two, as was thought by Rice) miniatures in Paris 3929. Two of the latter have frequently been reproduced and show al-Harith walking distressedly in the midst of the tombs and Abu Zayd [93]

6 Rice, *BSOAS*, Pls II–VII; Grabar, "A Newly Discovered Manuscript," Fig. 4.

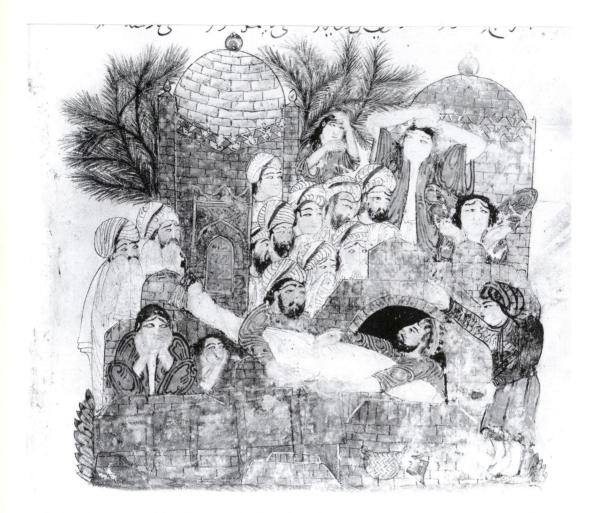

5 Paris arabe
5847, fol. 29v;
eleventh *maqama*

making his speech. But the other two are even more interesting for our purposes; one (Fig. 6) shows Abu Zayd descending from the hillside from which he spoke, while the other one (Fig. 7) illustrates in a strikingly precise fashion how al-Harith stopped Abu Zayd by pulling at the hem of his cloak, a direct translation of a passage from the text whose understanding is further made clear by a sort of caption introduced into the text.

As a second example we can take the twelfth *maqama*, in which Abu Zayd poses as a holy man and gets a lot of money from a caravan he accompanies across the desert. Then he disappears and al-Harith finds him in a tavern "amid casks and wine vats and about him were cup-bearers surpassing in beauty, and light that glittered, and the myrtle and the jasmine, and the pipe and the lute. And at one time he bade broach the wine casks, and at another he called the lutes to give utterance; and now he inhaled the perfumes, and now he courted the gazelles."[7] The comparison between the illustration [94]

7 Chenery translation, p. 173.

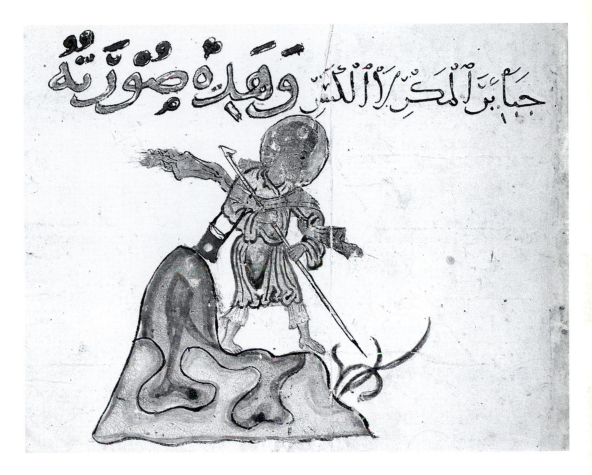

6 Paris arabe 3929, fol. 30; eleventh *maqama*

of this scene in Paris 5847 (Fig. 8) and Paris 3929 (Fig. 9) is clear enough. Whereas the latter fills its image with almost all the specific details of the text without composing them, the former skips many a detail but provides the picture of a bar in the thirteenth-century Muslim world and adds a number of elements not suggested by the story, including the representation of Abu Zayd as a prince, a detail very important in understanding the formation of the imagery. Another illustration, in the Vienna manuscript, is also quite specific and even shows the hero caressing a youth.

It would be easy to multiply examples of the ways in which individual stories were illustrated, but from these two the conclusion can be proposed that more than one attitude existed toward the text and that each one of these as well as their collective existence may suggest an answer to our original questions of why images could possibly have been added to manuscripts of the *Maqamat*. Five such attitudes can be identified.

The first, best exemplified by Paris 3929, is essentially *literal*. At certain places in the book, without any apparent reason, a passage in the text is suddenly followed by an image, frequently introduced as "and this is a picture [95] of it" (whatever immediately precedes). At times, as in a

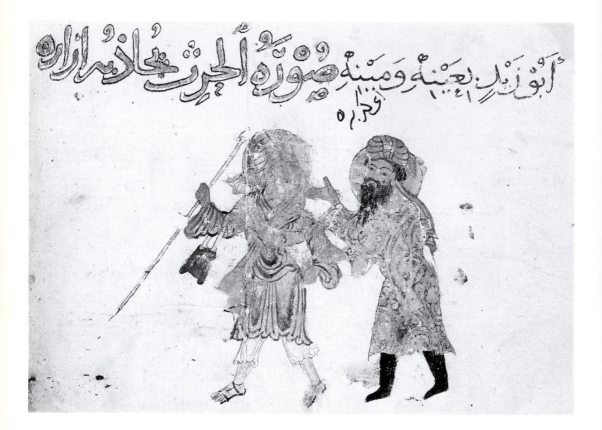

7 Paris arabe
3929, fol. 30v;
eleventh *maqama*

representation of Miss Near East, early thirteenth century,[8] or in a wonderful composition from the thirty-first *maqama* (Fig. 10) showing Abu Zayd and al-Harith embracing and becoming like an *alif-lam*, the results are quite striking visually or historically, and culturally interesting.[9] But as illustrations they are so closely related to the text that it is almost impossible to understand them without the literary referent. They are almost totally bound to the text, but it is difficult to determine in what way, if any, they add to the text. It is doubtful that they made it more accessible and they do not form a separate visual translation of the text, for their occurrence is not systematic enough within the text and the [97] internal structure of the imagery is not sufficiently consistent. The illustrations of Paris 3929, literal as they are, must be considered as a random commentary on a most elementary reading of the text rather than as a coherent visual interpretation of incidents or of characters. Two corollaries may be derived from this observation, although both require

8 Illustrated by O. Grabar in *The Islamic City*, ed. A. Hourani (Oxford, 1970), Fig. 8.
9 So far only Ettinghausen has discussed this manuscript (*Arab Painting*, p. 83) with any sort of seriousness; in fact it is an extremely curious one, full of very unusual and unexpected features which came out as I finally succeeded in identifying every single scene of its mixed-up folios.

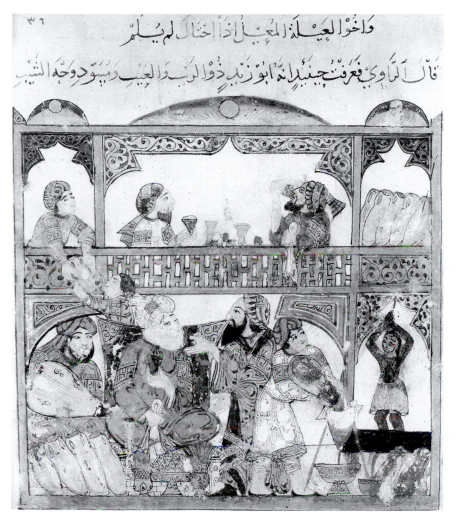

٣٦

واخوالعيلة المعيلة اذا اخاك لم يلم

قال الراوي فعرفت جنبذانه ابوزيد ذوالريب والعيب ومسود وجه الشيب

8 Paris arabe
5847, fol. 33;
twelfth *maqama*

deeper elaboration than can be developed within the context of this paper. One is that in a manuscript of this literal type the fact of the existence of illustration in general is more important than any one illustration; it is a book which was provided with images and not a text. The other corollary is that this type of illustration is more likely to arise as a result of already existing images than as a spontaneous generation from the text; it is an attempt to adapt to a new book a practice which was already reasonably common. A different kind of analysis from those provided here is needed to determine whether the inspiration for the illustrations of Paris 3929 had to come from earlier *Maqamat* illustrations or from illustrations of other texts, although my tendency is to prefer the former suggestion.

An entirely different attitude prevails in the Leningrad and Istanbul manuscripts as well as in Paris 5847. We may call it *descriptive*. Since the attitude has frequently been mentioned by other scholars and recently

ألقول بسيده والأنسلاك فما لسن من سلد أدخلا أ
الدكره في هيه منكره فاذ الشيخ فى حلا ممصره بين دنان
ومعصره وحوله شقاه تنصوسموع زهروأيس وعبهر
ومزمار ومزهر وهذه صورهم
أي عود العا

وهوان بسنر اللداز طوزا بسطو الغنيد أن
ابرالمر

ور بوسى

9 Paris arabe
3929, fol. 34v;
twelfth *maqama*

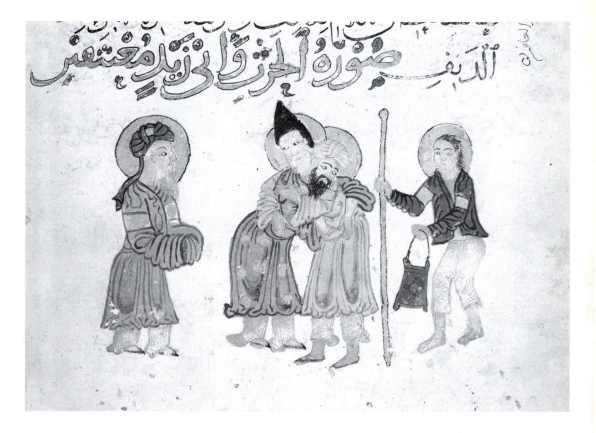

ذكر صورة الجزء الثاني وأبي زيد مغتص...

summarized [98] by Ettinghausen in the formula of "life encompassed," it does not require as much theoretical elaboration and most of its examples are well known.[10] From our point of view of understanding a body of images and their relationship to the text, this attitude led primarily to the visual elaboration of a setting for the stories. It is a physical setting of private houses, mosques, cities, villages, schools, caravans, outings on boats or in gardens, nomadic camps, caravanserais, and so forth. It is also a human center of governors, *qadis*, merchants, holy men, and simply passers-by; these people all appear in typical activities: riding, eating, praying, fasting, dying, being sick, having fun. Occasionally, but quite rarely, and generally limited to illustrations of the thirty-ninth *maqama*, there appears also a world of romantic fantasy. As I sought to argue elsewhere,[11] the setting is that of the Arab bourgeoisie of the twelfth and thirteenth centuries, the very world most likely to have enjoyed Hariri's text. From our point of view of understanding images, there is nothing surprising about the elaboration of

10 Paris arabe 3929, fol. 68v; thirty-first *maqama*

10 Ettinghausen, *Arab Painting*, pp. 104ff. for the most accessible group of illustrations: Grabar, *Ars Orientalis*, 5, for its Istanbul manuscript; unfortunately the Leningrad manuscript is mostly unpublished.

11 Grabar in *Islamic City*.

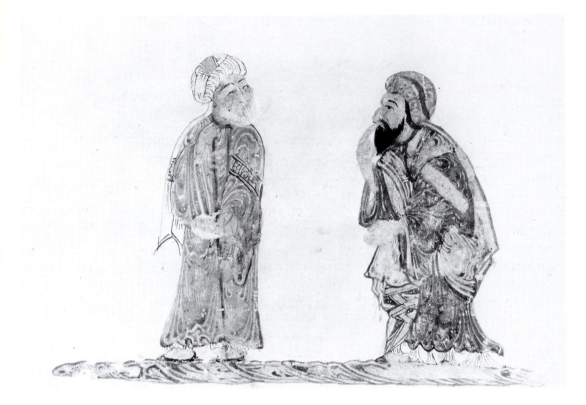

11 Paris arabe
5847, fol. 8v;
third *maqama*

this particular setting, nor is it surprising to note, as most characteristically
occurs in the Leningrad manuscripts, that this setting is quite repetitive and
becomes even predictably dull, for such is the case with the plot and setting
of the stories themselves. The interesting point lies, it seems to me, in the
fact that the emphasis on the setting can be understood either as a conscious
attempt to translate the literary work into one only of its components or as a
resigned realization that only the setting could be given a visual expression. I
shall return to some further implications of either alternative in conclusion,
but in the meantime we can say that this second attitude created pictures
rather than illustrations; it was concerned with formal problems and its
images are meaningful in themselves, almost independently of their actual
textual inspiration.

 A third attitude is limited to a relatively small number of miniatures by
Wasiti in Paris 5847 and may be called *interpretative*. In the illustration of
the eleventh *maqama* discussed earlier (Fig. 5), just as in the wonderful
representation of Abu Zayd in front of a governor in the tenth *maqama*
analyzed by Ettinghausen, Wasiti sought to transfer into visual terms a
perfectly valid psychological or intellectual interpretation of Hariri's text. As
simple an image as that of Abu Zayd explaining his ways to al-Harith in the
third *maqama* (Fig. 11) is a wonderful study of contrasts between the [99]
innocent-looking old rogue and the naïve and perennially gullible bourgeois.

And scores of such images appear in the manuscript, frequently satirical, at times deeply human, as in the cemetery miniature. Perhaps it is therefore on purpose that in the illustration of the camels with which we began this paper (Fig. 1) the singing girl appears as an old hag; the painter exercises his satirical wit at the expense of Abu Zayd. In order to appreciate these interpretations a knowledge of the text is necessary, but not in the literal sense of Paris 3929, for quite frequently Wasiti went beyond the objective requirement of the story. He sought to translate the text into visual terms and, as in any good translation, provided in fact his own commentary. Whether, as in Delacroix's illustration of Dante, we are dealing with a personal interpretation or whether, as in the Demotte *Shahname*, there is an ideological side to Wasiti's miniatures is still an unresolved matter. The former may be more likely since his impact seems to have been limited and, more importantly, the same quality and interest does not appear throughout the manuscript. It is as though only certain scenes and stories inspired him to create more than a simple description of a setting.

The last two attitudes are far less interesting from the point of view of visual commentaries around a text but they are important because they illus-[100]trate very common processes in book illustrations. London, add. 22.114, with a large number of consistently similar miniatures of good quality, is the only manuscript which provided Abu Zayd and al-Harith with the same physical characteristics throughout. The rogue always wears a light gray coat and the narrator always has a red beard (Fig. 12). The interesting points of this occurrence are that neither feature is inspired by the text but that such arbitrary means of identification are elementary requirements of any consistent mode of communication. A conscious effort was made to create an iconographic vocabulary and its arbitrariness indicates a predominating *visual* rather than literary concern. A similarly visual concern occurs in the Vienna manuscript, whose images are striking for their coloristic effects and for their frozen masses.[12] But, however impressive their pictorial success may be and whatever quality may exist in its expensive colors, the important aspect of the Vienna manuscript from an iconographic point of view is how frequently its miniatures are meaningless. To give but one example, it would be difficult to guess [101] that one of its illustrations of the twenty-first *maqama* (Fig. 13) represents a preacher speaking in a mosque to a huge crowd and to a prince. Actually the miniature's elements can be explained as arbitrary excerpts from earlier illustrations, but they are meaningless in their immediate context as well as in their interpretations. But they are "pretty pictures" adorning an expensive book. Their purpose was purely visual and they are no longer really illustrations.

[12] Ettinghausen, *Arab Painting*, pp. 147 ff.

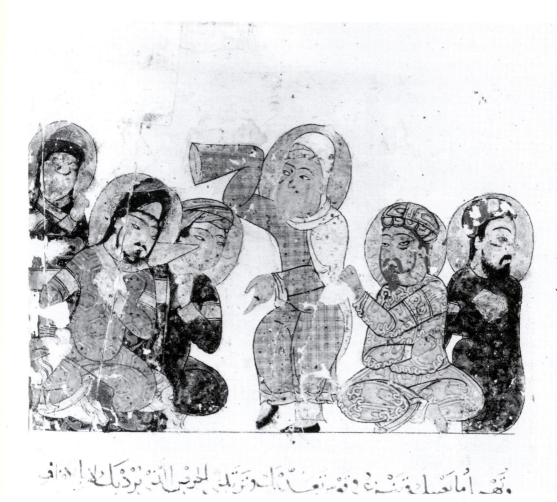

بْهَ أُمَاكَالِهَ شَنَعٌ وَقَوْمَتْ ذَادَ وَرِّبْدَ الحَوَّ اللَّهِ بَرَدْبِكَ لالِهِ إلَى افْ

12 London add.
22.114, fol. 59v;
twenty-first
maqama

The preceding remarks do not exhaust the problems posed by the illustrations of the *Maqamat*, either seen *en masse* or as sets illustrating any one of the fifty stories or any one of the thirteen manuscripts. Simplifying for the purposes of this paper a great deal of evidence, even about the miniatures which have been illustrated or discussed in some detail, our purpose was rather to propose some answers to the questions of how and why thirteenth- and fourteenth-century artists managed to provide a visual commentary to the literary values of Hariri's *Maqamat*.

The nature of the commentary is remarkable for its variety, from almost senseless literalness to visual systems, images, or psychological and satirical interpretations. Success was not consistent, but attempts at variety can be demonstrated and, except for some of the fourteenth-century manuscripts which share more than one feature, the amazing point is how different the remaining codices are from each other. These differences suggest a remarkable variety in contemporary taste, a conclusion confirmed by analysis of other

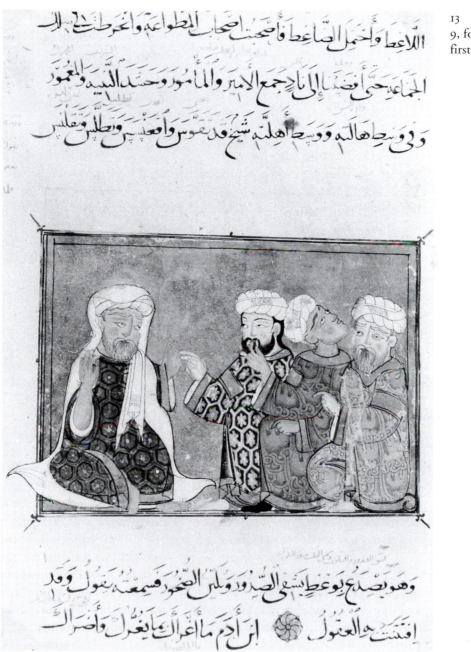

13 Vienna, AF
9, fol. 70; twenty-
first *maqama*

techniques such as metalwork or ceramics.[13] On a more specific level, two
further conclusions emerged. One is that the most successful miniatures

[13] Ettinghausen, "The Flowering of Seljuq Art," *Metropolitan Museum Journal*, 3 (1970);
O. Grabar, "Les Arts Mineurs à partir du milieu du XIIème siècle," *Cahiers de Civilisation
Médiévale*, 11 (1968).

sought to provide the setting for the stories, and the other is that the one attempt at deeper interpretation tended to be satirical rather than a translation into visual form of those verbal qualities which made the book famous. This is perhaps not surprising, for it takes centuries and complex as well as conscious visual concerns to elaborate an acceptable and understandable transfer into images of verbally defined ideas.[14] We still do not know the exact nature of the Muslim visual interests of these centuries, and not enough examples of illustrated *Maqamat* have remained to extrapolate a meaningful hypothesis from the miniatures, even though the job has been partly done but not yet [103] published. Satire, on the other hand, especially in its simplest form of caricature, is a natural visual function and existed even in the least visually oriented settings; it is therefore easy to see why it would appear in the earliest visual interpretations of a text.

But, even if partial answers can be given to the question of how the *Maqamat* were illustrated, it is much more difficult to suggest why. From the preceding remarks, several possibilities exist. One would be that, although verbal acrobatics may have been a formal literary reason for the appreciation of the *Maqamat*, it was not the true reason for the success of the book. Its satirical value as a social commentary would have been predominant in most circles, and Hariri's masterpiece would have been seen more as a description of its own time than as a literary exercise. In this fashion one would explain a success which has puzzled and perhaps misled literary historians; and we may recall that many successful eighteenth-century satirical works strike today's readers as cumbersome bores. Could this not be an instance where the mirror of illustrations serves as a good indicator of the actual nature of literary taste? In this hypothesis, illustrations would simply be the most direct manner for a culture or for a social layer to focus on its own surroundings, quite effectively in some manuscripts and in much cruder form in others, at times emphasizing setting, at other times human peculiarities. And when, in the fourteenth century, the text did become a school piece, instead of commentaries the miniatures became just pictures.

A second and much simpler explanation is to consider that these miniatures served a much more elementary purpose: they made a manuscript more agreeable to read and to behold. They would be simply redundancies which were imposed by the taste of a time and to which only limited importance should be given. At best we may consider them as metaphors, as parts of a system of visual signs parallel to the text, with its own set of rules, but which did not seek to illustrate so much as to provide pleasure, joy, or excitement as one read the book. Wasiti's creation would have been the exception, a unique attempt by one talented artist to give a more specific interpretation to the text. Paris 3929 would have been a primitive effort of the same sort

14 A. Grabar, *Christian Iconography* (Princeton, 1968), esp. pp. 109 ff.

whose partial success lay in its painter's wonderful gift for drawing. It should be remembered that neither one of these works had a significant impact, and it is easy enough to show that representations do characterize these centuries all over the Muslim world east of Egypt and that frequently there is a discrepancy between texts and images on contemporary ceramics. Thus it may indeed be [104] possible to see these miniatures simply as pictures only secondarily connected with the text.

Between these two interpretations or any combination of the two it is still difficult to choose. As working hypotheses both should be maintained, for their further elaboration leads to the far more important and far more complex question of the nature of the perception of visual forms which existed in the Arab thirteenth century. But to imagine and to reconstruct what may have been in the minds and attitudes of those who ordered, bought, made and appreciated these images requires the combination of still incomplete art historical investigations of the *Maqamat*[15] with many other techniques of historical and other research. Once this is done, we may have more than an explanation for a unique group of miniatures, and possibly the means to delineate the position of the visual world in medieval Islamic culture in general.

[15] Most of the immediate identifications of all *Maqamat* miniatures and the elaboration of their visual vocabulary have been completed, but not yet the necessary investigations in related monuments.

Chapter X

About an Arabic Dioskorides Manuscript*

Three themes, each with its own set of questions, have traditionally dominated nearly all studies dealing with the numerous Greek, Latin and Arabic manuscripts of Dioskorides' *De materia medica*. The text itself, together with Galen's so-called *Theriaka*, was the most famous and most frequently utilized medieval source book for the making of drugs from plants and for healing snakebites. As it was usually known, at least in the part of the medieval world that wrote in Arabic (there is, to my knowledge, one early copy in Persian), Dioskorides' work consisted of five chapters dealing with plants and two with various cures for snakebites; the latter two chapters are now usually thought to have been written by someone else. The Greek version of the text also existed in an alphabetical edition with all plants listed by the first letter of their names, even though Dioskorides himself seems to have been opposed to this unscientific use of his work.

The first scholarly theme around Dioskorides has been, and to a certain extent still is, the establishment of the text, whether in Greek or in Arabic. This traditional philological occupation is complicated in this instance by the constant modifications introduced into the text as a result of new observations or new attitudes toward medicine and pharmacology, but reasonably accurate texts have been put together with the traditional establishment of families of related manuscripts.[1]

* First published in *Byzantine East, Latin West: Art-Historical Studies in Honor of Kurt Weitzmann* (Princeton, 1995), pp. 361–3.
[1] For the most recent discussion of Dioskorides' place in history and for up-to-date bibliographies on Greek and Latin sources, see J. M. Riddle, *Dioscorides on Pharmacy and Medicine* (Austin, 1985); and "Dioscorides," in F. E. Kranz and P. O. Kristeller, eds, *Catalogus Translationum et Commentariorum*, vol. IV (Washington, DC, 1980), pp. 1–143. The classic study of families of manuscripts is by C. Singer, "The Herbal in Antiquity," *JHS*, 47 (1927), pp. 1–52. For the Arabic versions, see C. E. Dubler, *La "Materia Medica" de Dioscorides*, 6 vols (Barcelona, 1953–57), esp. vol. II, which has an established text, and vol. III, with a translation; and M. M. Sadek, *The Arabic Materia Medica of Dioscorides* (Quebec, 1983). For a summary introduction, see the article "Diyuskuridis," in *Encyclopedia of Islam*, 2nd edn, vol. II, pp. 349–50; and, in a more elaborate way, M. Meyerhof, "Die Materia Medica," *Quellen und Studien zur Geschichte der Naturwissenschaften und der Medizin*, 3 (1933), pp. 72–84.

A second theme has dealt more specifically with the illustrations found in many Greek and Arabic manuscripts. Two concerns, other than the purely philological ones of the derivations and sources of individual cycles of images, have dominated the scholarship dealing with images in Dioskorides manuscripts. The first concern, formulated by Kurt Weitzmann many years ago and developed by him in a justly celebrated article dealing with the relationship of antique and medieval Arabic images in scientific manuscripts, was to see these illustrations as exemplars of images necessary to the proper understanding and use of a text and strictly regulated by an expectation of visual clarity. The hypotheses of this particular concern are that miniatures in Dioskorides reflect unique early and classical prototypes and that every manuscript cycle can be evaluated in terms of its relationship to earlier models. The second concern, developed by other historians of art, derived from the existence in the early thirteenth century of a small number of Arabic manuscripts with an expanded imagery that goes beyond the technical requirements of a text. In reassembling one of these manuscripts, Hugo Buchthal argued for the impact on it of a new contemporary taste for images, often at the expense of the original precision of the illustrations. In short, both the synchronic and the diachronic approaches to scholarship on visual matters have been applied to Dioskorides manuscripts and have provided reasonable answers and hypotheses for whatever issues are raised by the manuscripts, even if many specific problems still remain unresolved; for instance, the curious multiplication of fancy frontispieces in the thirteenth century, all of which are different from each other.[2] [362]

A third theme of scholarly interest is less clearly defined in the literature but emerges from occasional remarks by various writers and one or two studies that grapple with it but do not state it precisely. We can call this theme a functional one, since it involves the many ways in which a given manuscript was used as an object or as the carrier of a text – that is, as a socially active instrument – over the decades or centuries of its existence in various living contexts, before it became an item in a collection. The idea of

2 The standard interpretation of this type of scientific text is found among several places, in K. Weitzmann, *Illustrations in Roll and Codex* (Princeton, 1947), pp. 94 ff.; and idem, *Ancient Book Illumination* (Cambridge, Mass., 1959), pp. 15–30. See also K. Weitzmann, "The Greek Sources of Islamic Scientific Illustrations," in *Archaeologica Orientalia in Memoriam Ernst Herzfeld*, ed. G. C. Miles (Locust Valley, NY, 1952), pp. 244–6, reprinted in *Studies in Classical and Byzantine Manuscript Illumination*, ed. H. Kessler (Chicago, 1971), no. II. See also the older study by P. Buberl, "Die antike Grundlagen der Miniaturen des Wiener Dioskurideskodex," *JDAI*, 51 (1936), pp. 114–36. The reconstruction of a key manuscript originally in Istanbul was accomplished by H. Buchthal, "Early Islamic Miniatures from Baghdad," *JWalt*, 5 (1942), pp. 18–39. The basic information on all Arabic illustrated manuscripts is found in E. Grube, "Materialen zum Dioskurides Arabicus," in *Aus der Welt der Islamischen Kunst*, ed. R. Ettinghausen (Berlin, 1959), pp. 163–93; and a general view of the position of these manuscripts in art-historical thinking can be gathered from R. Ettinghausen, *Arab Painting* (Geneva, 1962), pp. 67–89.

transforming a coherent text into an elaborate, alphabetically organized index, as was so magnificently done with the luxurious Vienna manuscript of the early sixth century, implies a practical need to consult a codex rather than to learn about pharmacological groups. The addition to this particular manuscript of notes and translations of names of plants into Hebrew, Arabic, Latin, Turkish and Persian is another indicator of its use by a relatively large number of different people at different times. It has been shown for Greek versions of the text, and implied for the Arabic versions, that modifications were constantly introduced, that they reflected changing practices, and that they form a series of documents as interesting for the diachronic history of medicine as the original is for the first century. A manuscript in the Bibliothèque Nationale in Paris (arabe 2849), which I will discuss further below, contains extensive marginal notes from a source (as it turns out, a Hispanic one) other than the original manuscript (which was probably copied in Mesopotamia), and these notes not only give original information for the history of medicine but are also written with medieval Spanish and vulgar Latin terms transliterated into Arabic. In short, almost every manuscript of Dioskorides' *De materia medica* is a document for an original text and for a host of other topics as wide and as numerous as the sleuthing capacities of scholars can make them out to be.[3]

The purpose of this note dedicated to the great twentieth-century master of manuscript illustrations is to make a small contribution to this third, functional aspect of Dioskorides studies, but, as I shall try to show, if my observations and the conclusions drawn from them are acceptable, they may have an impact on the second, more narrowly visual interpretation of the manuscripts.

The manuscript in Paris, arabe 2849 (anc. suppl. 1067), is a fine codex on paper of 143 folios containing the traditional five chapters on plants and two on poisons and animals. According to a simple colophon, it was completed in *ramadan* 616 AH, corresponding to November–December 1219. The sponsor of the book, or the one for whom it was initially copied, was an *isfahsalar*, a rather common title for military or civil officials. His name is Abu Ishaq

3 Here are a few bibliographical leads into the functional extensions of the significance of Dioskorides manuscripts: E. Bonnet, "Étude sur les figures de plantes et d'animaux," *Janus*, 14 (1909), pp. 294–303; M. L. Leclerc, "De la traduction arabe de Dioscoride," *JA*, 6th ser., 9 (1867), pp. 167–77, 225–32; K. J. Basmadjian, "L'identification des noms de plantes," *JA*, 230 (1958), pp. 167–91; J. M. Riddle, "Byzantine Commentaries on Dioskorides," *DOP*, 38 (1984), pp. 95–103; M. M. Sadek, "Notes on the Introduction and Colophon of the Leiden Manuscript," *International Journal of Middle East Studies*, 10 (1979), pp. 345–54; J. Scarborough and V. Nuttin, "The Preface of Dioscorides' Materia Medica," *Transactions and Studies of the College of Physicians of Philadelphia*, 4 (1982), pp. 187–227; G. F. Hourani, "The Early Growth of the Secular Sciences in Andalusia," *Studia Islamica*, 32 (1970), pp. 143–56. These studies, as well as many remarks in works describing individual manuscripts, lead to philological, linguistic, historical, cultural and even visual issues.

Ibrahim ibn Musa ibn Ya'qub al-Maliki al-Mu'azzami and he is provided
with a series of titles that have been badly damaged but which include that
of *ra'is* (or *zayn*) *al-Hajj wa al-Haramayn*, the leader of the pilgrimage to
Mecca. A search of the more obvious secondary sources has failed to elicit
the presence of this individual, probably an official at one of the many
Ayyubid or, in general, Atabek courts of the Fertile Crescent and of Egypt.
Sequences of names issued from the biblical prophetic tradition taken over
by Islam were not unusual within this particular feudal world, although the
combination of Isaac, Abraham, Moses and Jacob seems to be quite rare.

The originality and interest of this manuscript for the more general
purposes of *Buchwesen* lie in the second half of the six very damaged lines
with which the book begins. The first two lines identify the sponsor, or the
recipient, of the codex. Line three provides the title of the book of Dioskorides.
Line four, which is very damaged, begins: "All of this [i.e., of the book of
Dioskorides] is included within a single volume (*kitab mufrid*) ... in order
to facilitate [its use]." The first two words (or perhaps only one) of line five
are not legible, but they (or it) are followed by: "... [with or by] a second
book which has collected all the pictures (*suwar*) from this book of plants ...
animals, and metals and there is a mention [line six] by each of its [presumably
the book's] images the name [of the item represented] and its requirements
...." The last few words are not entirely clear.

In a note attached to the manuscript, William De Slane, the first cataloger
of the Arabic collection at the Bibliothèque Nationale, noted that there was
meant to be a separate volume of plates accompanying this particular
manuscript; in relatively more recent years, the point was picked up by
Ernst Grube in a footnote of his invaluable survey of illustrated manuscripts.[4]
But the implication of this passage seems to me to deserve more [363] than a
passing reference in a footnote, for we may well have here the earliest
medieval occurrence of a volume of plates separated from a volume of text,
the last step, so to speak, in the "emancipation" of images connected with
books which has occupied so much of Professor Weitzmann's life work.

Whether or not formally expressed, the idea of separating images from
their written source is, of course, not a new one. The celebrated Vienna
Dioskorides of the early sixth century already has plants occupying a whole
page and provided with a fancily written title. The text has been relegated to
the page facing the image, at least in most places.[5] Clearly, the requirement
of effective images dominated the making of this codex and it is possible

4 Grube, "Materialen" (as in note 2), p. 170 n. 38A; see also n. 31 for other comments on
the manuscript. See also Dubler, *Materia Medica* (as in note 1), vol. II, ix–x, who used
the manuscript extensively for its commentaries made in Spain but who fails to record
the dedicatory statement.
5 H. Gerstinger, *Kommentarband zu der Faksimile-Ausgabe, Dioscorides, Med. Gr. 1* (Graz,
1970). Actually, the book is not consistent: on folios 64 ff. the descriptive text is on the
back of the illustration.

that the very idea of making an alphabetical rather than thematic book came out of the pre-eminence given to images over the text. Comparable combinations of text and image, with the latter predominating, occur much later in sixteenth-century Iranian painting, as in the *Falname* spread between many collections, and in Mughal India with the *Hamzaname*, also scattered all over the world.[6] But, like its later parallels (and, with some exceptions, to be attributed to different times and different places), the Vienna codex is still a single object (or, in the case of the *Hamzaname*, a possible series of volumes) combining a text with images or, in these instances, images with a text. The 1219 Paris manuscript suggests the existence of books of pictures that were not model books for the making of other images, but separately bound visual companions to texts in a manner that became fairly common after the invention of printing. In fact, there are two Renaissance manuscripts of Dioskorides with pictures only; they were made in Italy and one of them seems indeed to have consisted only of plates, but they need to be studied more fully before we can fit them into any scheme of interpreting the history of relationships between texts and images.[7]

Two broader questions seem to me to be raised by this garbled message from a medieval manuscript copied somewhere in the Fertile Crescent in the early thirteenth century. One is whether, like a great deal in the art of that area and time, the type of book it suggests derived from antique or Late Antique prototypes,[8] or whether, again as befits an unusually creative period in the arts of western Asia, this was an original invention for some local and immanent purpose. The second question is not a new one but one that re-emerges every time we turn to the illustrated volumes of Dioskorides or Galen. Why were they prized so much that they became, at some times but not others, vehicles for representations that went beyond the immediate illustrative purpose of such images in technical texts? Answers to these questions require considerations that extend much beyond the limited purpose of a small contribution to that art of the book which has almost become second nature to all alumni of Kurt Weitzmann's seminars.

6 The *Falname* is the subject of a doctoral thesis being completed by Julia Bailey at Harvard University. In the meantime, see the pages by S. C. Welch in *Trésors de l'Islam* (Geneva, 1985), pp. 94–9. The *Hamzaname* has been the subject of a doctoral thesis at Harvard University (1989) by Zohra Faridani. See pp. 144–5 of *Trésors de l'Islam* or any book on Mughal painting for examples of these huge pages.

7 Riddle, "Dioscorides" (as in note 1), pp. 142–3; Weitzmann, *Ancient Book Illumination* (as in note 2), 11 ff.

8 T. Allen, A *Classical Revival in Islamic Architecture* (Wiesbaden, 1986) is the latest contribution to a topic that needs further investigation.

Chapter XI

Toward an Aesthetic of Persian Painting*[1]

Nearly every student or layman with a modicum of visual culture keeps in his or her memory a picture of Persian painting (Fig. 1): colorful images, almost always miniatures in books, with many personages in fancy clothing fighting, feasting, frolicking, or hunting; flowers and shrubs perennially in bloom, even at night; two-dimensional men, women and animals cavorting in a setting of spacious meadows or gardens with a brook somewhere in a

* First published in *The Art of Interpreting: Papers in Art History* (Pennsylvania State University, 1995), pp. 129–39.

[1] This paper began as a lecture given at Pennsylvania State University and I am very grateful to Professor Anthony Cutler, who initiated the invitation, for this opportunity to express views and judgments on Persian painting. Various versions of this paper were given at UCLA on the wonderful occasion of the Levi della Vida Award being given to Professor Ehsan Yarshater; at Columbia University to a group of Iranian students; and at the Institute for Advanced Study in Princeton. Furthermore, the text of the lecture was sent to a few colleagues who were not able to attend the talks themselves. On each one of these occasions, and from nearly every reader, I received comments and criticisms which affected subsequent statements and some of which are incorporated into the published text. I am most thankful to all those who asked questions or otherwise commented and the only reasons for not mentioning them all are that I did not record all names and that the most significant comments were conceptual rather than specific.

It is rather curious altogether that so little has been written on the visual qualities and aesthetic values of Persian painting, as contrasted with attributions, with chronological development or geographical localization, with the ideas and expectations of patrons, and with the technical competencies of painters. Information on these last aspects of Persian painting is easily accessible through the bibliographies found in general books such as R. W. Ferrier, ed., *The Arts of Persia* (New Haven and London, 1989), pp. 324–6 and Nasrin Rohani, *A Bibliography of Persian Miniature Painting,* Aga Khan Program, Harvard and MIT (Cambridge, 1982; quite complete, but not a critical bibliography).

For aesthetic considerations, the most valuable essays have seemed to me to be the following:
a. Eric Schroeder, *Persian Miniatures in the Fogg Museum of Art* (Cambridge, 1942), with wonderful evaluations of paintings;
b. Ehsan Yarshater, "Some Common Characteristics of Persian Poetry and Art," *Studia Islamica*, 16 (1962), pp. 61–72;
c. Priscilla Soucek, "Nizami on Painters and Paintings," in R. Ettinghausen, ed., *Islamic Art in the Metropolitan Museum* (New York, 1972), pp. 9–21;
d. Lisa Golombek, "Toward a Classification of Islamic Painting," ibid., pp. 23–34;
e. Chahriyar Adle, "Recherche sur le module et le tracé correcteur dans la miniature orientale," *Le Monde Iranien et l'Islam*, 3 (1975), pp. 81–105;

corner (Figs 2 and 3) and contorted rocks at the edges, or else in, under, or around a theatrical, flattened architecture of arches and vaulted halls with elaborate walls. A few exceptions notwithstanding, it is a world without shades in which men and women without emotions enact events whose purpose or drama, if there was one, appear sublimated into repetitive poses and canonical masks (Fig. 4).

A general appreciation of this sort is valid for the core centuries of an idiosyncratic Persian art of painting, a period which began in the last decades of the fourteenth century and which ended – or at least diminished in intensity and in quality – two hundred and fifty years later, in the seventeenth century, when a different type of individualized single paintings came to dominate (Fig. 5). Persian painting existed also before 1370 and, even though, for the purposes of my argument, I will use one or two examples of early fourteenth-century paintings, most of them lack the stylistic originality of what has properly been called the "classical" tradition of Persian painting.[2] From the sixteenth century onward a Persianate painting also dominated the

f. Johann Christoph Bürgel, *The Feather of Simurgh* (New York, 1988), a very compelling and original exploration of what he calls the "Licit Magic" of the arts in medieval Islam and which contains many texts of great usefulness for the purposes I am exploring.

g. Special mention should be made of various writings by S. Cary Welch culminating in the monumental (with Martin B. Dickson) *The Houghton Shahnameh* (Cambridge, 1981); although focusing primarily on the whims of patrons and the works of artists, Cary Welch's writing breathes his pleasure at what he sees and an aesthetic theory is implied in much of his work.

h. The special issue of *Marg*, 41 3 (1991), edited by Sheila Canby and with important contributions by J. M. Rogers, Thomas W. Lenz, Priscilla Soucek, Sheila Canby and Basil Robinson.

There are, no doubt, other valuable and challenging statements about the aesthetic qualities of Persian painting, and it will some day be interesting to gather them in a more systematic way than I am doing here. For I must stress that, like the lecture on which it is based, this essay is a tentative attempt at raising issues rather than a way to provide solutions.

I should add that concerns for and questions about Persian painting after the end of the fourteenth century were kindled or rekindled in me by the Timurid exhibition organized by Thomas Lentz and Glen Lowry (on which more below) and by theses or studies dealing with Persian painting written by Sheila Canby, Marianna Shreve Simpson, Michael Brand, Julia Bailey, John Seyller and Massumeh Farhad. While none of those wonderful former students should bear any responsibility for this particular paper, they may regret having gotten me back into that field.

2 Even though I will take issue later on with one of their methodological assumptions, the chapters by Ernst Grube, Eleanor Sims, Basil W. Robinson and Barbara Brend in Ferrier, *Arts of Persia*, pp. 200–241, are the most immediately accessible overview of Persian painting. The best older survey, partly outdated because of so many new discoveries, but still wonderful for its limpidity, is Ernst Kühnel, "History of Miniature Painting," in Arthur U. Pope and Phyllis Ackerman, eds, *A Survey of Persian Art* (Oxford, 1939), pp. 1829–97. The term "classical" has been used by Ernst Grube in the title of an exhibition catalog, *The Classical Style of Islamic Painting* (Lugano, 1968). Basil Robinson used "metropolitan" to deal with roughly the same grouping of works, although with different implications, in *Persian Miniature Painting from Collections in the British Isles* (London, 1967).

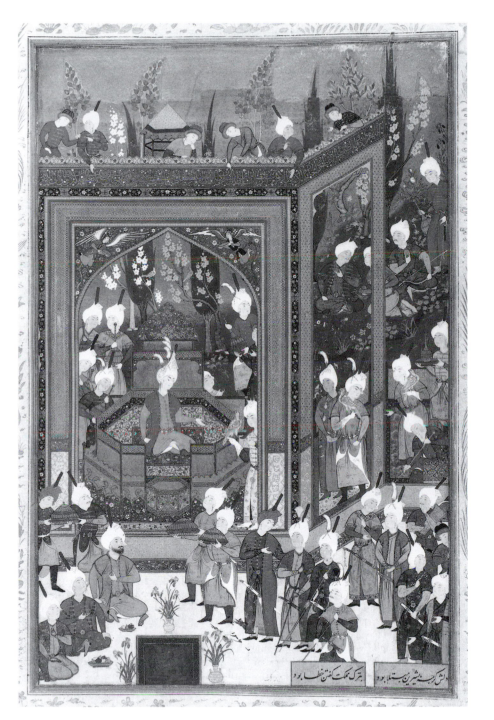

1 *Khosrow
Enthroned*, from
Nizami, *Khamseh*,
British Library or.
2265, fol. 60v;
ascribed to Aqa
Mirak, *c.* 1540

2 *Court Scene.*
Left side of a
double-page
frontispiece from
a manuscript of
the *Shahname* of
Firdausi. Colors
and gold on
paper. Iran
c. 1440

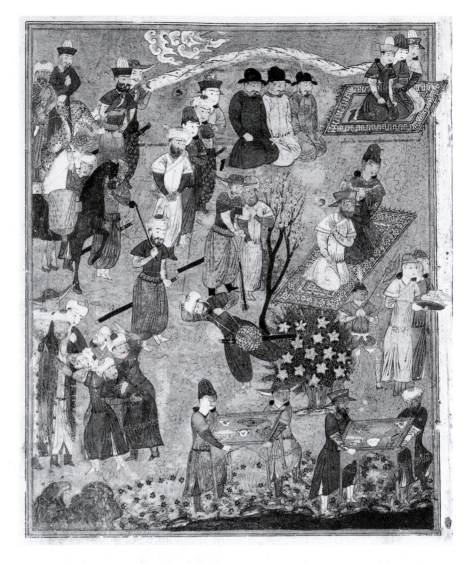

arts of the Ottomans in Istanbul and, in a far more spectacular and original
fashion, the creativity of the Mughals in India and of several lesser centers in
the Indian subcontinent. I shall not deal with these later works, partly
because of my ignorance of their intricacies, but partly also because even a
cursory look at Ottoman, Mughal, or other Indian miniatures and paintings
reveals a host of features which identify a different visual language from the
Persian one, even if a family resemblance is generally obvious.[3]

3 The best introductions to Ottoman painting and to Islamic painting in India are: Esin
 Atil, "The Art of the Book," in Esin Atil, ed., *Turkish Art* (Washington, 1980), pp. 137–
 236; S. Cary Welch, *The Art of Mughal India* (New York, 1963) and *India, Art and
 Culture 1300–1900* (New York, 1985); Mark Zebrowski, *Deccani Painting* (London, 1983).

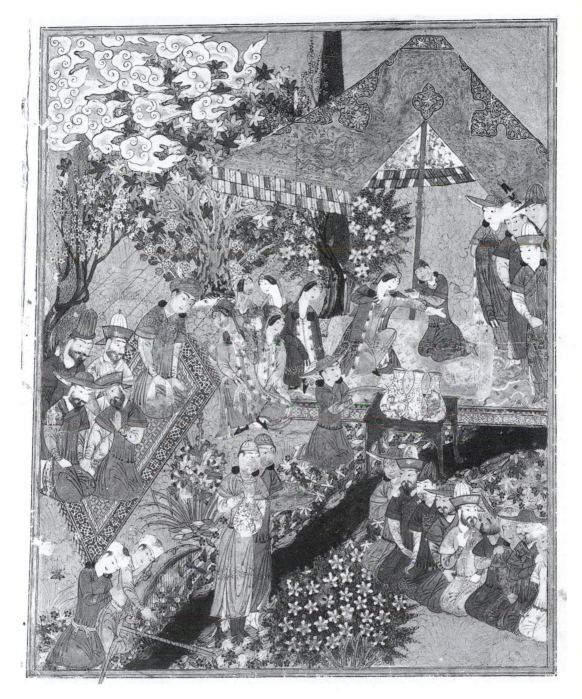

3 *Court Scene*.
Right side of a
double-page
frontispiece from
a manuscript of
the *Shahname* of
Firdausi.

4 *Humay and Humayun in a Garden*, from a lost Khwaju Kirmani, *Khamseh*, Paris, Musée des Arts Décoratifs, *c.* 1430

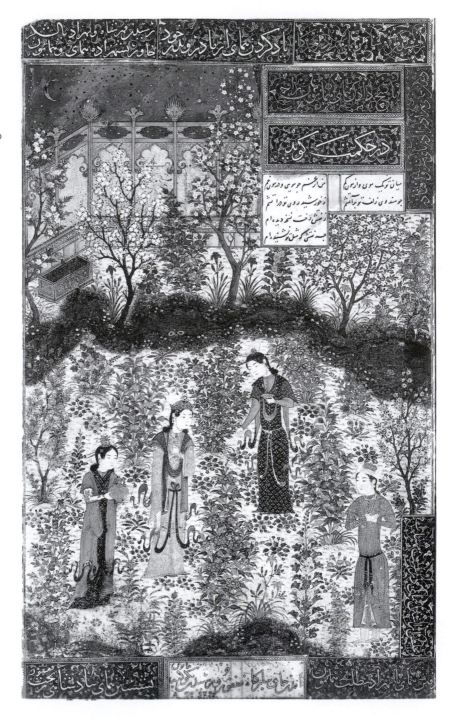

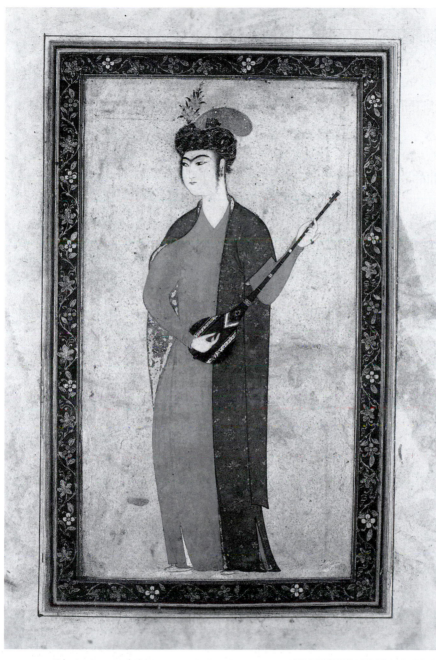

5 *Young Man Playing a Lute*, late sixteenth century.

I shall concentrate on a phenomenon restricted to a period of two or two and a half centuries. These are the centuries which created, honed and perfected a mode of expression significant enough in its effectiveness and/or in its meaning to serve as a model for the Ottoman Mediterranean and for the Indian peninsula and which was occasionally picked up by painters as early as Rembrandt and as recent as Matisse.[4] Within this long period over a vast land, many changes occurred and several, more or less identifiable, local or social variants can be detected. For the purposes of this paper, I shall discuss almost exclusively works from the fifteenth century or from the last decade of the fourteenth. It was the century known as the Timurid century, when, under the aegis of Mongol rulers, several spectacular centers of artistic production and architectural growth were developed in a wide land going roughly from Baghdad and present-day Iraq to Kashgar or Kashi, the westernmost city of Uighur China just a couple of hundred miles east of Samarkand. The centers themselves were generally the great cities of the Iranian plateau and of the Central Asian trade roads, like Shiraz, Yazd, Sabzevar, Tabriz, Meshed, Samarkand and especially Herat. But buildings of major importance were also built in smaller places hallowed by some holy men or proximate to the estates of rich patrons. Yasi (modern Turkestan in Kazakhstan), where still stands the shrine of Shaykh Ahmad Yasavi, is an example of the first type and Khargird in northeastern Iran near the present Afghan frontier is typical of the second. The patrons of these centers were, with notable exceptions, the Mongol descendants of Timur himself or else Mongol or Turkic feudal lords who had adopted Islam and a high Iranian culture as their mode of entry into legitimate power over ancient lands.[5] [132]

4 For Rembrandt, the key study is still Friedrich Sarre, "Rembrandt's Zeichnungen nach indisch-islamischen Miniaturen," *Jahrbuch der königlich Preussischen Kunstsammlungen*, 25 (1904), pp. 143–58. See also Richard Ettinghausen, "The Decorative Arts and Painting," in Joseph Schacht and C. Edmund Bosworth, eds, *The Legacy of Islam* (Oxford, 1974), esp. pp. 311–12, translated in Hendrik Budde, ed., *Europa und der Orient, 800–1900* (Berlin, 1989), where there are many comparable examples, especially pp. 741–57. For Matisse, see Pierre Schneider, *Matisse* (Paris, 1984), *passim*; see Index under "Orient."

5 The architecture and, by extension, patronage of this period have been recently studied in two fundamental books: Bernard O'Kane, *Timurid Architecture in Khorasan* (Costa Mesa, 1987), and Lisa Golombek and Donald Wilber, *The Timurid Architecture of Iran and Turan* (Princeton, 1988). Much has also been recently written (or is being completed) on the history and culture of the Timurid people. For preliminary investigations involving the arts, see Thomas Lentz and Glen Lowry, *Timur and the Princely Vision* (Washington and Los Angeles, 1989), and the texts gathered by Wheeler M. Thackston, *A Century of Princes*, Aga Khan Program at Harvard University and MIT (Cambridge, 1989). A series of articles from a symposium held in Toronto in 1990 is found in Lisa Golombek and Maria Subtelny, *Timurid Art and Culture, Muqarnas*, Supplement VI (Leiden, 1992). Particularly notable in their concern for the evaluation of patronage are various works by Maria E. Subtelny, such as "Socioeconomic Bases of Cultural Patronage under the Later Timurids," *International Journal of Middle Eastern Studies*, 20 (1988), pp. 479–505.
 In the last sentence of this paragraph I am adopting an argument developed at great length by Thomas Lentz in his thesis, *Painting at Herat under Baysunghar ibn Shahrukh*, Ph.D., Harvard University, 1985. It seems to me like a reasonable explanation, but it

The Iranian fifteenth century was remarkable in many more ways than the artistic. In itself, it is strikingly relatable to fifteenth-century Italy, Poland, Muscovy, Burgundy and India, but it is also comparable to the better-studied European lands in that so many of its institutions as well as of its patterns of thought, paradigms of knowledge, and creative myths and memories were fundamental to nearly all later Muslim dynasties and rulers except in the Arab world. Within the stunning creativity of that century in the lands of Iran and Turan, I shall deal with painting only, and with mainstream painting at that, but it must be recalled that there existed at that time, somewhere within the wider Iranian sphere, an art of painting attributed much later by Ottoman librarians to a fictional Black Pen. These paintings, preserved almost entirely in a group of albums in Istanbul, exhibit a voluminous ferocity and a powerfully distorted realism (Fig. 6) which are at odds with the main tradition.[6] At this stage, there is no consensus on the origins or the audience of these paintings.

6 Caricature (?) of holy people (?), Istanbul, Hazine 2153, fol. 46

assumes a solution to a complex problem raised by several listeners to the various versions of the lecture which preceded this paper. The problem is that of the intended and/or expected audiences for the illustrated manuscripts of the time. Did the princely patrons look at those images? Or do we simply have a system of peer competition between courtly librarians? To answer these questions, a more thorough study of the documents available is needed than I have been able to accomplish. See, however, the conclusion of this article.

6 Much has been written about these paintings, including some of the most exemplary research in the field; but they are still a mystery for the most part. The easiest access to the scholarship is through *Islamic Art*, 1 (1981), devoted entirely to paintings from the albums, while the most accessible color pictures are in M. S. Ipsiroglu, *Painting and Culture of the Mongols* (New York, 1966).

There are obviously dangers in drawing conclusions and even hypotheses about the whole of Persian painting, even the painting of two and a half centuries, when the examples on which the conclusions are based represent a fraction, albeit a dominant one, of a period's creativity. I feel justified in doing so for two reasons. The main one is that the painting mode with which I shall deal is not merely the dominant one, but the one which is most originally Persian and which demonstrably appears in the last quarter of the fourteenth century.[7] It is, therefore, reasonable to assume that it corresponded to some clear feature of Timurid taste and that whatever it accomplished remained meaningful to several generations of patrons, makers and users from the wide Iranian world. And the second reason for staying with only one tradition is the more prosaic one that I gave it more attention than the later ones.

My initial statement about this main tradition defined the image we have of Persian painting in visually formal ways, in terms of colors, patterns of composition, range of recognition of otherwise known features like men, women, flowers, or else of actions like hunting or playing a musical instrument. This is possible to do for images whose meanings we do not know and whose stories are not available to most of us because of a function of perception which, in a recent book, I have called "optisemic."[8] What I mean by this neologism is the ability to recognize a large number of represented items in generic terms, without being aware, or even needing to be aware, of their culturally directed references. One can recognize twelve lifesize standing men with or without beards at the entrance of a cathedral without knowing that they are Apostles and the carriers of Christ's message. A swastika can be seen without having a Nazi association and only Byzantinists see emperors whenever something is purple, while the redness of the enemy is no longer an operative slogan in our own society.

To recognize something optisemically may well be sufficient and satisfying. Thus, nearly sixty years ago, a great critic and historian of the arts East and West, Laurence Binyon, wrote the following:

Persia lies between the Mediterranean and the Farther East. If we seek for an extreme appearance of the Western spirit in art, we shall find it in Michelangelo ...

[7] The traditional date for the new mode is 1370, for a manuscript of the *Shahname* now in Istanbul (Hazine 1511, dated 1370), Basil Gray, *Persian Painting* (Geneva, 1961), p. 63, exhibits for the first time a large number of conventions which became part of the language of the new painting. Whether one should describe this collection of means of expression (high horizon line, monochrome gold or blue sky, small tufts of grass, flat personages, and so on) as a language – a consistent set of interchangeable units of composition – or as a mode – a pattern of expression which transforms the elements it uses into a coherent and meaningful whole – requires yet another kind of investigation.
[8] Oleg Grabar, *The Mediation of Ornament* (Princeton, 1992), pp. 172–4.

The god-like presence of Man obliterates all other objects of vision … In absolute contrast are the Chinese landscapes … Man is but a traveler, small and insignificant beside the towering crags and cloudy peaks …. The Persian conception is between the two … Persian painting betrays no intellectual grasp of the structure of things. The Persian outlook is essentially and incurably romantic. It enjoys what is marvelous, it is quite ready to believe the incredible. The painter stages his own and the spectator's enjoyment, much as it might be arranged in a theater …"[9]

There is no point in discussing the social, historical and aesthetic prejudices exhibited by the author. For, once one has removed terms like "romantic," which are no longer very fashionable in critical discourse, or notions like topographical location on a continental scale, as reflected in the arts by equal shares from both ends of the scale, Binyon's statement interprets a set of reactions to visual impressions in ways which may well be sufficient and still perfectly valid. There is a wonderfully pleasing fantasy world in the images of Persian painting and we could all simply be satisfied with it, engage the images as inspirational exercises for our own fantasy, and perpetuate a poetical language which is different from the one we would employ for Michelangelo or Manet, but which always implies a creative contact between a consistent set of images and a personal or cultural aesthetic or emotional sensitivity. This kind of discourse will always remain and I would like to call it *libertarian*. For it is an attitude toward the arts in which each one is relatively free to find his or her own interpretation, his or her own pleasure. In popular terms this attitude is identified with a statement [133] such as "I know what I like." The expression usually has a defensive side to it, as it implies garrulous ignorance on the part of whoever says it, but it probably corresponds to the kind of judgment most of us make most of the time about most things. We constantly express opinions or act out satisfaction about everything from people to food without really knowing what they are about.

Libertarian attitudes are generally saved by the poetic language of those who express them and, while, to my knowledge, no writer on Persian painting has matched the quintessentially libertarian and hardly open-minded positions of Ruskin or of the Goncourt brothers, a libertarian streak permeates

9 Laurence Binyon, J. V. S. Wilkinson and Basil Gray, *Persian Miniature Painting* (London, 1933), pp. 3–5. This book is a landmark in the study of Persian painting and still bears reading with admiration for its authors. Much of the periodization of Persian painting is based on this book. The Introduction, from which I have taken the sentences in the text, is, I believe, the first intelligent attempt to see this artistic tradition as a visual experience rather than as a bundle of influences. But it is interesting to note how Binyon could see Persian painting only in relationship to Renaissance painting, north and south, or to Chinese Sung to Ming art. Hence so often Persian painting is defined by what it is not rather than through positive features. It is further important to note that, in the age of Picasso and Matisse, Binyon identifies Michelangelo as the quintessential Western artist.

much of the literature on that painting, especially from the English-speaking world.[10]

A second type of discourse about, and thus of attitude toward, Persian painting can be derived from the following, at first glance depressing, passage adapted from a recently published chapter on Persian painting admittedly seen in a wider chronological context than mine in this paper: "This chapter is hardly the forum in which to deal with the complex significance and purpose of Persian painting in Persian society over a period of more than 1400 years. [What it is] is a historical survey ... intended to sketch the history of Persian painting by means of the slightly artificial framework of the schools that produced it."[11] The position slightly caricaturized by this excerpt can be called *taxonomic*, as its primary objective is to organize a large mass of data into coherent and cohesive groups; such groups have traditionally been called "schools" because of a classical art-historical model: there is a master, teacher–creator–innovator–employer, who radiates techniques of designing and of painting to students; the latter then continue these techniques, transfer them to new places, modify them, pass them on to others, and otherwise contribute to the relatively autonomous (that is to say from social, political and other non-artistic contingencies) evolution of an art of painting, or, for that matter, of any other technique. Within the framework of a taxonomic purpose and as a result of the methodological assumptions it makes, a given image is decomposed into a bundle of begetting influences and hopes for a place in the philological paradise of stemmata, that is to say of items, in this case miniatures or possibly motifs like landscapes or personages, related to each other by the lines with arrows of an organigram or of a flow chart.

It is easy to parody and to be impatient with an extremely inappropriate approach to Persian (or any other kind of) painting. But, in fact, much of what it has accomplished and still accomplishes now is not only true but necessary. I shall give only two instances of the truth and of the necessity of a primarily taxonomic approach, as well as of its limitations. One derives from literary sources and the other one from visual observation.

[10] This point is a bit unfair, since, for reasons which are beyond my present concern, most of what has been written on Persian painting has been written in English. The major exceptions among the traditional masters of the field are Edgard Blochet who did not like that painting, and Ivan Stchoukin and Friedrich Sarre who loved it but preferred Morellian dissections of details and lengthy discussions of painters' hands to statements about values. Their works can be found in Rohani's bibliography quoted above in note 1.

[11] Ernst Grube and Eleanor Sims in Ferrier, *The Arts of Persia*, p. 200. To be fair to the authors, they add that their chapter "is also intended to illustrate precisely where in the history of art are engendered fundamental issues that ought to animate the discussion of Persian painting in future years." I have singled out this passage as symptomatic of a certain type of scholarly endeavor and not as a criticism of a perfectly respectable position.

Several written sources from the fifteenth and sixteenth centuries provide information about the lives of painters and of calligraphers; in nearly all cases these sources identify the artists through the masters from whom they learned and through the "workshops," almost always at or around the court of a prince, in which they worked. It is, therefore, reasonable to consider as valid the grouping of existing paintings into two sets of sequences: the filiation of masters to pupils and the mutual relationship of princely courts.[12]

My other example is that of a miniature taken from a celebrated manuscript, a copy of the *Bustan* by the great Persian writer and occasionally social critic Sa'adi dated in 1488 and illustrated by Behzad, the most renowned of all Persian painters.[13] At first glance a representation of a mosque (Fig. 7) has all the characteristics of my earlier libertarian analysis: brilliant colors, small personages in diverse and apparently unconnected activities, flattened out composition of two theatrical settings set above each other, almost maniacal precision in the depiction of parts, and so on. But fairly rapidly one notices that the building has been made functionally specific. It is a mosque with a courtyard, a portico around the court, a *minbar* or chair for the preacher, a *mihrab* indicating the direction of prayer. Some of the personages are involved in the precise actions required by prayer, even in the more mundane act of washing one's feet. Others are shown teaching or conversing around a book, both learning and discussing texts being activities associated with mosques. The specificity of these actions makes one concentrate on the three personages in front and to the right who are neither praying nor engaged in actions expected in a public sanctuary. All three of them have visual peculiarities which distinguish them from other figures: a tall man at the door with a big stick, an older man dressed in rags holding a bowl or a cup, someone in the window in the lower right corner whose face has sunk into his clothes, as though he were trying to hide his expression. It is these three personages who form the narrative illustrated by the miniature: in a snooty upper-class mosque,

[12] The most important of these texts is Dost Muhammad's Introduction to the Bahram Mirza album in Istanbul. Parts of that text are available in Binyon, Wilkinson and Gray, *Persian Painting*, pp. 183–6, among other places. The most complete translation is by Wheeler Thackston, *A Century of Princes*, pp. 335–60. Other texts are found scattered throughout the literature. Particularly important examples for the chronology of painting are: Qadi Ahmad, *Calligraphers and Painters*, tr. Vladimir Minorsky (Washington, 1959); Sadiqi Bek in Dickson and Welch, *Houghton Shah-nameh*, pp. 254–69. An easily available collection of such texts can be found in Wheeler M. Thackston, *Album Prefaces and Other Documents on the History of Calligraphers and Painters* (Leiden; Boston: Brill, 2001).

[13] Neither the manuscript nor the painter have received the attention they deserve. On Behzad, the most complete information is still the one gathered by Richard Ettinghausen in "Behzad," *Encyclopedia of Islam*, 2nd edn. The Cairo manuscript is mentioned in all surveys. Full description by Ivan Stchoukine, *Les Peintures des manuscrits Timurides* (Paris, 1954), pp. 74–6. For more recent appreciations, see Lentz and Lowry, *Timur*, pp. 285–299.

7 *Beggar at a
Mosque*, from
Sa'adi, *Bustan*,
Cairo, National
Library, *adab farsi*
908, dated 1488 in
Herat, signed by
Behzad

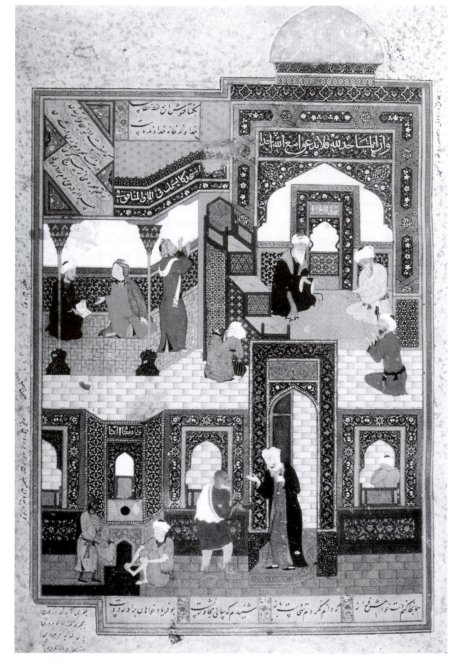

a doorman refuses entry to a poorly dressed beggar, while some obnoxious character laughs at the scene.[14]

The subtle transformation of the standard personages of fifteenth-century painting into actors within a specific story, the unheroic character of the story il-[134]lustrated, the concentration on architectural details with specified rather than generic functions, the manipulation of the representation of personages and of colors in order to create an additional effect of brilliant covering and puppet-like personages without emotions: all these features require, within classical art analysis,[15] a different setting in time, space, or patronage for this miniature than for many other ones, even though its colors, its layout, and its emphasis on small items make it part of a single overall tradition. The identification of the setting to which it belongs is not made by the image itself, but through associations between attributes or qualities of this miniature and similar components elsewhere. And it is a written source, usually an inscription at times hiding in the miniature itself (here in one of the books held by a pupil), which allows for the specific attribution to the painter Behzad and to the court of Herat in present-day Afghanistan. To say that this is a miniature attributable to Behzad and made in Herat in the latter years of the fifteenth century is, however, no more useful (although more attractive) than to conclude that the miniature belongs to group A which must be later than or different from group B. As in the establishment of any table of elements, such statements are true and necessary, but not exhaustive nor interesting. Most importantly, they hardly explain how and why the miniature attracts a viewer and provides him with some sort of information, intellectual challenge, or aesthetic satisfaction.

Taxonomy – the ordering of the hundreds of existing manuscripts, single pages, and fragments of all sorts into groups arranged according to space, time, and if possible attribution to individual painters – is the domain in which the study of Persian painting has made its most significant strides over the past three or four decades. Arguments will obviously remain on many specific items, but a basic structure exists for the straightforward labeling of Persian miniatures and for a sense of an evolution, of a process of change, which would have led from a dramatic imagery enacting epic battles and hunts or recording historical narratives so typical of the fourteenth century to the lyrical ways of early Timurid painting and eventually to the individualism of an approximate naturalism in the latter part of the fifteenth century. Quite naturally provincial and qualitative branches derived from the main line of this evolution, and the whole taxonomic construct does

14 It is an illustration of Sa'adi, *Bustan,* tr. G. M. Wickens, *Morals Pointed and Tales Adorned,* Leiden, 1974, pp. 106–108.

15 It is on purpose that I write "classical" for an analysis in the history of art which assumes chronological or topological incompatibility for significant differences in execution. The actual validity of this position may be open to question, but its discussion does not belong in this essay.

look like a tree-like body visible, among other places, in a catalog put together by one of the leading taxonomists of the twentieth century. More subtle but still initially taxonomic arguments have explored how individual painters, identified or anonymous, have woven their awareness of past traditions and their own idiosyncracies (or, at times, those of their patrons) into unique or differentiated visual statements.[16]

There is, of course, nothing wrong about this way of looking at Persian painting and, at one time or another and possibly with varying degrees of success, all students of Persian painting have practiced taxonomic activities. Something may be lost in poetic expression but the loss is more than made up for by accuracy and precision in analytical description and in the provision of correct information which brings joy to writers of museum labels and captions under illustrations: dates, places, attributions, provenance. The viewer of an exhibition or the reader of a book can look at the book's plates or at the pictures hanging on the wall and be a libertarian to his heart's content in the security of appropriate identification tags for the object of his study.

It is difficult to argue against taxonomies of any sort, but there are two lines of argument which suggest that this approach to Persian painting, without being wrong or incorrect, misses something essential about it, just as the libertarian approach may have put into that painting all sorts of features which were not there to begin with and whose presence is perhaps too closely tied to the peculiarities of the individual viewer.[17]

One line of argument is that an approach based on attribution to artists and on a hierarchy of classification transforms the work of art, Persian or not, into a commodity with a pedigree, a label of authentication and a price. Such transformations may well be justified by the collecting instinct of today, just as they existed at various moments of any artistic history, and

[16] The two most prolific and most successful taxonomists of Persian painting are Ivan Stchoukine and Basil W. Robinson. Their numerous books and articles can easily be found in the bibliographies and surveys listed above. The schematic chart of the evolution of Persian painting is found in Basil W. Robinson, *Persian Miniature Painting* (London, 1967), p. 32. More complex analyses, although also involving primarily taxonomic procedures and expectations like attributions and genealogies of paintings, are found in the numerous works by S. Cary Welch, especially the monumental publication of the Houghton *Shahname*, and in an equally sophisticated essay by S. Melikian-Chirvani, "Khwaje Mirak Naqqash," *Journal Asiatique*, 276 (1988), pp. 97–146, among several recent examples by younger scholars.
[17] I am, of course, aware of the position developed by M. Bakhtin and his followers that any object always contains the sum of the views expressed about it and, therefore, that it is impossible in any discourse to avoid or suppress libertarian pronouncements already made. The field of criticism of Persian painting is much too young to deal with these subtleties, but it is to the credit of Welch's analyses that some of the paintings of Shah Tahmasp's reign are marked by his eloquent words about them. These examples are precisely the beginning of a critical discourse about the arts which has not been picked up by scholarship after the publication of Welch's and Dickson's *chef d'œuvre*.

certainly in medieval and early modern Islamic history.[18] The morality of this approach may be questioned by some, but the more important point is that, only too often, it reduces the painting almost exclusively to its statistical and pecuniary role alone.

The second line of argument stating the limitations of a taxonomic approach is of a very different kind. It takes issue with the very action of removing, virtually if not actually (although too many examples exist of the latter),[19] images from their setting. To treat Persian miniatures like Rembrandt drawings or like paintings by Western European or even Chinese masters, that is like independent works of art which can be discussed from the walls of museums, is, at the outset, intellectually slightly fraudulent, for it is to study something quite different from what it really is. A libertarian point of view makes it possible, if not always legitimate, to look at paintings separately from the books of which they are a part, since the user's or the looker's view is the dominant one. But it is absurd to do so even if one's aim is only a taxonomic one, for the label or labels provided by taxonomy are not an explanation or an interpretation of an image – they merely become one of its attributes. In other words, it is le-[135]gitimate and possibly necessary to seek other approaches to the understanding of Persian painting, ways which stand somewhere between the anarchic freedom of individual opinions and the non-negotiable rigor of factual definitions.

Context was fashionable a few years ago before deconstruction came in and is itself being replaced by cognition as the hot procedure of academic discourse, unless something new has sprung up since then. Yet I will stay with *contextual* as the general definition of my third approach to Persian painting, but I will try to fit into a definition of context something more than or different from what is usually assumed, for instance by codicologists who limit their concerns to the physical pages of a book, to the writing on it, and to all the activities and processes which went into the making of a

[18] There is as yet no history of collecting in the Muslim world. For a few examples within a much broader context, see Joseph Alsop, *The Rarer Traditions of Art* (New York, 1981), pp. 253–5. For partial and preliminary suggestions, see the essays by several authors in Esin Atil, ed., *Islamic Art and Patronage, Treasures from Kuwait* (New York, 1990).

[19] The desecration of manuscripts or albums through the removal of miniatures from them has gone on for centuries but has become particularly destructive in the last decades of the nineteenth century and the early ones of the twentieth. The shameful break-up of the Houghton *Shahname* barely ten years ago shows that financial rewards at times still rule the fate of works of art. In reality, of course, the issue is not merely one of pitting virtuous scholars and lovers of art against dealers and investors in art, inasmuch as some of the latter are also lovers of art. The issue is that of preserving, as far as possible, the integrity and authenticity of individual works of art (which means keeping miniatures in the books for which they were made) versus the accessibility of these same works of art, often hidden in shamefully unavailable private collections.

book.[20] Nor shall I leap to social, economic and cultural problems of the time as the more progressive contemporary contextualism would expect one to do. One reason why I shall not do either one of these things is that information on both is sorely lacking and, since I did not engage myself in much pertinent basic research, I am limited by the paucity of available data and can propose only directions for work and hypotheses for confirmation, modification, or rejection. It is in fact extremely difficult to present Persian painting in its context in a public lecture or in an article because there is almost no way to provide the experience of holding and using a book and because the perception of images in any depth is almost impossible to compel in the absence of details. The data needed for any contextual definition of images require the initial "weighing in" and evaluation of every little detail, even if some of the details will end up with less significance than others.[21]

What I shall try to do, then, is to lead the reader into the images of a book through three examples. It will still be a somewhat superficial trip, a brushing acquaintance rather than a true relationship, but one which will, I hope, serve as an invitation to plunge into the works of Persian painting and to help define the operative hierarchies of meaning among the components of these works.

The first example is that of a manuscript in the Freer Gallery in Washington, the *Diwan* or collection of poems written by or attributed to a prince–patron, Sultan Ahmad Jalayir, who died in 1401. It is a volume of 377 pages probably completed in 1401 and it is possible that its text was copied by the most celebrated calligrapher of the time, Mir Ali Tabrizi.[22] On each

20 Well established for Latin, Greek and Slavonic manuscripts, codicology is relatively new in dealing with manuscripts in Persian, Turkish, Syriac, Coptic, or Arabic. A first series of studies has appeared in François Déroche, ed., *Les Manuscrits du Moyen-Orient: essais de codicologie et de paléographie* (Istanbul and Paris, 1989). All the papers in this record of a colloquium are important and most apposite studies are quoted by the learned participants. Two works merit special attention because of their contribution to typical as well as extreme cases of manuscripts from the Islamic world and because of the range of codicological issues they affect: François Déroche, *Les Manuscrits du Coran* (Paris, Bibliothèque Nationale, 2 vols, 1983–8); M. S. Simpson, "The Production and Patronage of the *Haft Aurang* by Jami in the Freer Gallery of Art," *Ars Orientalis*, 13 (1982), pp. 93–119.

21 There is nothing new nor particularly original about this procedure. The point is that it has not been followed systematically in dealing with Persian painting except for S. C. Welch and Thomas Lentz in his doctoral dissertation (above, note 5). But, even in these two instances, the necessary details are not easily available.

22 The key study of the miniatures from this manuscript is by Deborah Klimburg-Salter, "A Sufi Theme in Persian Painting," *Kunst des Orients*, 11 (1976–7), pp. 43–84. I accept most of the main arguments of this article except perhaps the identification of the painter which remains, to my mind, uncertain. It should be noted that one major scholar, Stchoukine, dated the illustrations to the seventeenth century, *Manuscrits Timurides* (above, note 13), pp. 35–7. While I do not agree with such a late date, the point is not very important for my purposes.

page a careful frame is set for the poems and before each one there is a proclamation of praise for the prince–poet. Of the 377 pages, seven, all located fairly close to the beginning of the book, have been chosen for an extraordinary marginal decoration (Figs 8 to 12). In a drawing technique derived from Chinese sources but already considerably modified by Iranian practice, personages, animals, genre scenes, clouds, landscapes are drawn around the text as fancy additions to the frames of the poems. The topic of these marginal images has been identified with a celebrated Persian mystical text, Attar's *Mantiq al-Tayr*, "Dialogue of the Birds," written almost two hundred years earlier.[23] In it the birds, in search of a savior–leader, cross seven valleys corresponding to various steps of mystical knowledge (Love, Understanding, Detachment, etc.) until they finally reach the realization that salvation lies within themselves. The seven valleys are represented: Quest with a family of people and a flock of birds moving out of the page (Fig. 8), Love with a couple in a landscape, Understanding with a tree and a stepped platform, Astonishment with a brilliant gold cloud encircling the page (Fig. 9), Detachment with a series of vignettes of idyllic life on two pages facing each other (Figs 10 and 11), Unity with a single tree cutting across and underneath the page, and birds returning from the right (Fig. 12).

From the point of view of the object which one holds, a book of mystical verses by a minor but living prince–poet, we witness the transformation of the mystical inspiration of one text into the visual forms of literary images and themes from another mystical text, an otherwise well-known classic, instead of the text of the book. It is as though an edition of Walt Whitman's poems had been illustrated by images inspired by *Paradise Lost*. It is probably not the text that was meant to be enhanced by the images but the book. And this leads to the hypothetical conclusion that the images of this book were set within it as so many surprises comparable to the surprising adventures of the search for salvation in Attar's poetical account; the book becomes the search by being transfigured through the presence of images. Or the images dealing with an otherwise celebrated text enhance the mystical implication of the poetry without dealing with it.

There is, obviously, much more to say about these unusual and strikingly beautiful drawings; a whole libertarian discourse can be imagined about them. But, within the limited contextuality I am defining here, these [136] images have three separate lives: one in the book which they make exciting by including an unexpected treasure to be hunted, another one in connection with a text which they do not illustrate but illuminate, and a third one as illustrations of a text which is not there.

23 Farid al-Din Attar, *The Conference of the Birds*, English version by C. S. Nott (London, 1954).

8 *Valley of Quest, Divan* of Sultan Ahmad Jalayir

9 *Valley of Astonishment*, *Divan* of Sultan Ahmad Jalayir

10 *Valley of Detachment, Divan* of Sultan Ahmad Jalayir

11 *Valley of Detachment, Divan* of Sultan Ahmad Jalayir

12 *Valley of
Unity, Divan* of
Sultan Ahmad
Jalayir

My second example is also a *Diwan* or Collection of Poems, this time three poetical stories by Khwaju Kirmani, who died in 1352. The manuscript is in the British Library (Add. 18113) and it is dated in 1396. The writing is also by Mir Ali Tabrizi and the paintings by Junayd, one of the painters mentioned in the Iranian histories of painting and calligraphy. It is probably because all the information needed to make a label is present in the manuscript itself that its nine miniatures, often published, had never been studied in their entirety. A first, primarily literary, article dealing with the author rather than the manuscript appeared only in 1991.[24]

I shall deal only with the five miniatures which illustrate the first of the stories, the romance of the prince Humay, with a name with complex mythical connotations, and the princess Humayun, also provided with a metaphoric name with, this time, high royal connotations.

The first miniature (Fig. 13) shows a garden closed by a wall and fronted with a brook; the crescent moon and two birds are all that exists outside and there is a curious ambiguity as to whether night or day or both are being represented. In the garden with beautiful trees and flowers Humay on the left and Azar, a young woman, meet because they were looking for Azar's companion Behzad, who is dead drunk under a tree. They see each other through their looking at the drunk young man, and one of the points of this image is an evocation of one of the constant themes of Persian poetry, drunkenness as the equivalent of love, and love as well as drinking, together or separately, as metaphors and means for the mystical love of and union with God.

In the second illustration, Humay at the court of China sees Humayun peeking out of an upper window to the left (Fig. 14). It is a fascinating image corresponding to a type often found in Persian paintings. The main event, the narrative proper, is but a minuscule part of an image which in reality depicts a reception at a royal court. Almost everything here is "typical" in the sense that it corresponds to standard forms of composition, representation and coloring with almost nothing seeming untoward, unexpected, except that mysteriously half-opened window suggesting other worlds, things which the rest of the image barely implies and which cannot be understood correctly without the text or without some other key to visual impressions. I shall return later to what this key may be. What is important is that the structure

[24] Teresa Fitzherbert, "Khwaju Kirman (689–753/1290–1352): An Eminence Grise of Fourteenth Century Persian Painting," *Iran*, 29 (1991), pp. 137–51. The identification of the scribe with the celebrated inventor of the *nasta'liq* script is doubted by Basil Gray, "History of Miniature Painting," in Basil Gray, ed., *The Book in Central Asia, 14th–16th Centuries* (Unesco, 1979), p. 116, but he gives no reason for his doubts. See, however, Priscilla Soucek, "The Art of Calligraphy," p. 24 of the same volume. The Khwaju Kirmani manuscript is mentioned in every survey of Persian painting with a most complete description in Stchoukine, *Manuscrits Timurides*, pp. 33–5. But even the latter misidentifies the subject matter of folio 11.

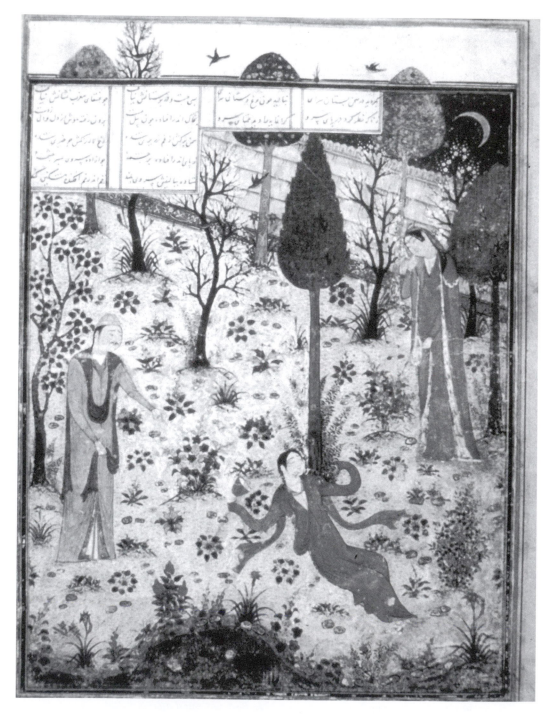

13 *The Meeting of Humay and Azar, Divan* of Khwaju Kirmani

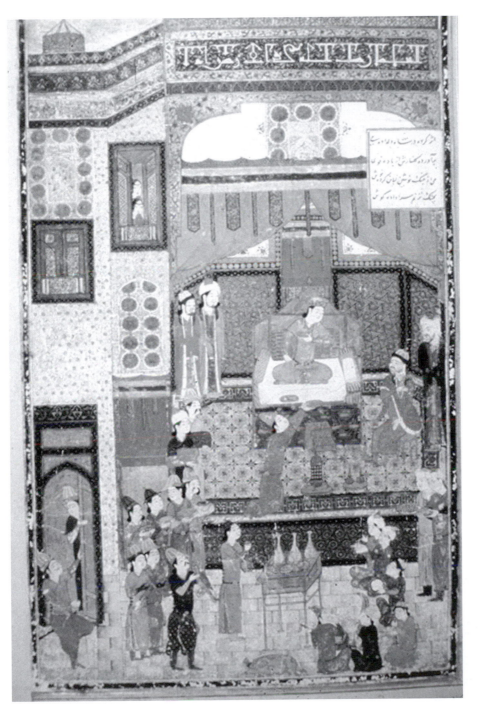

14 *Humay at the Court of China, Divan* of Khwaju Kirmani

and components of the image suggest a secret, a mystery, both mystery and the pursuit of secrets being constant themes of story-telling.[25]

The third and fourth illustrations are frequently reproduced because of the richness of their gray-green-and-yellow tonality in which nature, buildings and people have melted into physical sameness. But there is more to them than their coloristic brilliance. One image shows Humay arriving at the castle of Humayun (Fig. 15). There is a walled and locked building with a young woman on the top of the tower located on an island floating in thin air. From some other space a youthful princely rider has come to its gate with a finger to his mouth, the traditional Persian gesture to indicate any emotion a viewer may wish to provide, probably love in this particular case. The contact is between him and the building, as nothing in his or her gaze leads to each other. In fact it is only a rather peculiar flock of birds that is allowed to move in and out of the walled area. There is also the striking contrast between monochrome exteriors and multi-colored interiors or between blooming trees inside and mangy vegetation outside. Except for the birds, no one moves in this image. Nothing is happening, has happened, nor will happen. It is all a dream, a fantasy, and that fantasy without event, without story, has been expressed with a stunning visual clarity in which every part, every brick or tile, every bit of inscription has been defined with utmost precision.

The other image in the same pattern of color shows Humay engaging in battle with Humayun (who had disguised herself as a man) and discovering her gender (Fig. 16). A lot must be known before the story can be understood and it is clearly something other than a precise and rather silly event which is here represented through the excuse of a story. That something else may well be the overall domination of all reality by the one power and presence of the divine, symbolized by a single pattern of color, or else the demonstration that things are not what they seem to be and that Humayun, in spite of appearances, is not a man. As will be suggested shortly, another and more general explanatory theory may also be proposed.

The last two images from this manuscript also share domination by a single color, this time red and red-associated colors, and they too are remarkable for the differences between them in spite of the colorful sameness of tone. Humay and Humayun enthroned are celebrating their union. They are seated together on a high throne and all around them beautifully and expensively dressed men and women are going [137] through the ritual gestures of a feast: internal conversations in small groups, side-plays with flowers above the main scene, eating, drinking, music making. It is an image of orderly, organized, possibly slightly boring formality in an ideal world.

[25] It is a theme common to the many illustrations of a Nizami hero watching through a barely open window the erotic playfulness of young women bathing or of Alexander seeing sirens bathing from behind a rock.

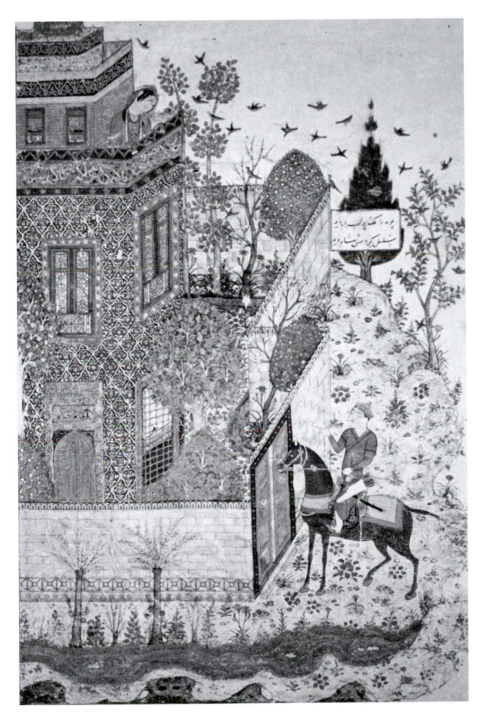

15 *Humay in
front of Humayun's
Castle, Divan* of
Khwaju Kirmani

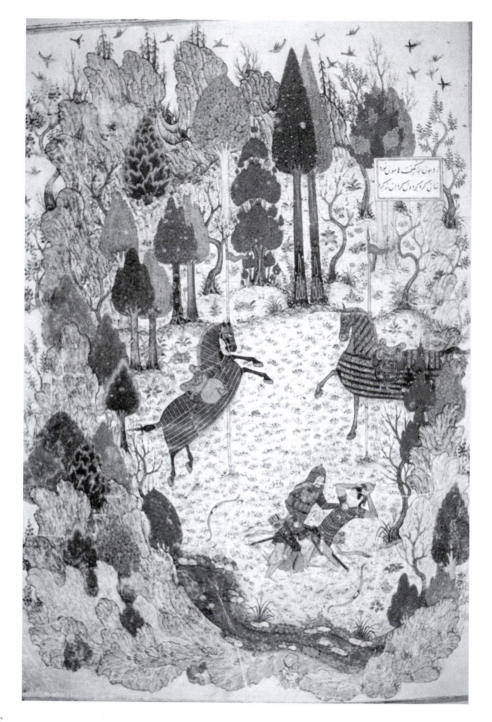

16 *Combat of*
Humay with
Humayun, Divan
of Khwaju
Kirmani

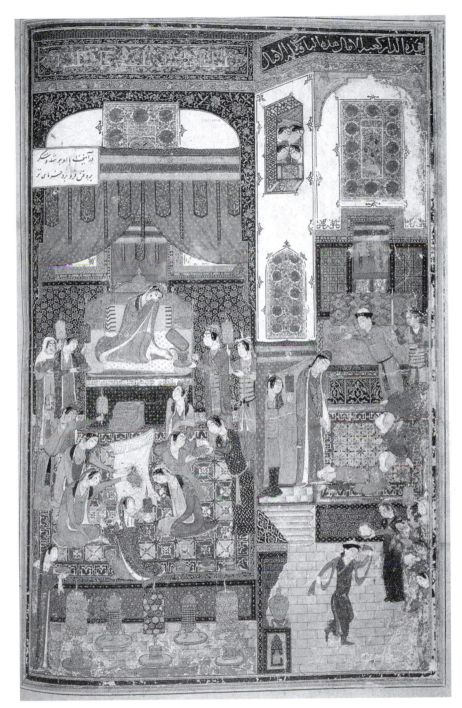

17 *After the Consummation of the Wedding, Divan* of Khwaju Kirmani, British Library Add. 18113, dated 1396, painted by Junayd, fol. 45

The last image (Fig. 17), on the other hand, shows Humay leaving the bridal chamber after the consummation of his wedding and is of an astounding richness of activities. The blood-stained sheet is displayed in front of a coy Humayun seated on a rug. Gold coins are being showered on attendants. There is a wild and possibly drunken dancer. In fact, it would take a whole paper just to unravel and explain every detail of the architectural and human setting of this miniature. Its liveliness and variety are amazing once one gets inside it, and I even feel that the artist sought to fit into the limited size of a book page more than he was quite capable of composing in a single image. However, for my present purposes, the point of putting these two images together is a different one. It is that two totally different interpretations of a narrative suggested by the text could be expressed through the same basic patterns and designs.

But something else is even more important to the thread I am following. It is that once again the enhancement of the book is a more visible function of these few images than the illustration of a specific passage. For the illustrations are not a visual commentary on a narrative text, but an apparently random selection[26] of places to make a codex of relatively large size an attractive object to behold and to handle. At the same time and in addition, each image is composed in such a manner that it can be understood or even comprehended only by plunging into it, by seeking to explain every one of its details, in other words by a lengthy process of visual entanglement which removes the viewer from the book.

The paradox I am leading to can be further explored by my third and last manuscript, another example of the *Mantiq al-Tayr* already mentioned once before. This manuscript, a particularly splendid one, is in the Metropolitan Museum of Art and is dated in 1483.[27] Every one of its eight miniatures deserves discussion, but I shall limit myself to one, fol. 35 (Fig. 18), which shows a burial scene, with a casket arriving from the right, attendants greeting it at the door of the cemetery, the digging of the tomb, a representation of a more elaborate elevated burial place (a special kind of enclosed burial place known as a *hazirah*), and a tree escaping into the

[26] The randomness is just a hypothesis, for there may well be a deeper iconographic unity to the choice of images, as there seems to have been for some of the illustrated epic manuscripts of the earlier half of the fourteenth century; Oleg Grabar and Sheila Blair, *Epic Images and Contemporary History* (Chicago, 1980). See also Jill S. Cowen, *Kalila wa Dimna: An Animal Allegory of the Mongol Court* (New York, 1989). The arguments of the latter are not always convincing, just as the date proposed by the author has been challenged. But then the first of these volumes may also be wrong in this sense.

[27] The manuscript has received an exemplary preliminary study by Marie Lukens Swietochouski, "The Historical Background and Illustrative Character of the Metropolitan Museum's Mantiq al-Tayr of 1483," Richard Ettinghausen, ed., *Islamic Art in the Metropolitan Museum of Art* (New York, 1972), pp. 39–72. A further and very perceptive discussion of its meaning is found in Melikian-Chirvani, "Khwaje Mirak Naqqash," pp. 117 ff.

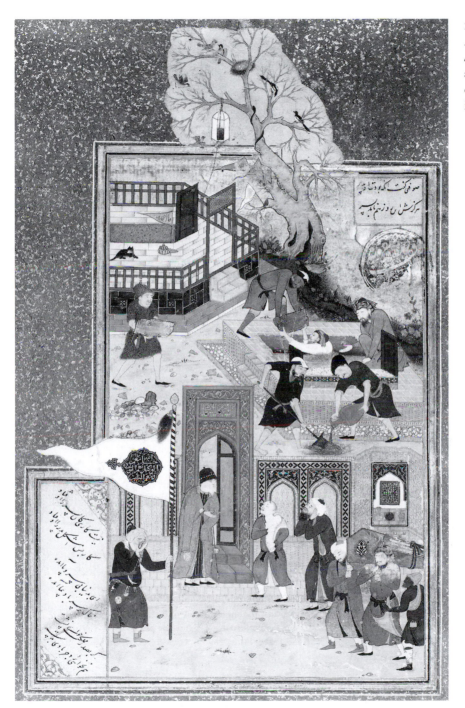

18 *Funeral Procession, Mantiq al-Tayr* by Farid al-Din Attar, copied in Herat in 1483

margins. It is an illustration not of a story from the text but of a poem, parts of which surround the image. The poem goes as follows:

The son approached the coffin of his father./ He shed copious tears and said, O Father/ Even though fortune has blighted my life/ Never for me may life itself be called ignoble./ A Sufi said, He who was to thee a father,/ He will never again this day call his son by name,/ It is not an event which only befell the son,/ An event as tragic has also befallen the father./ Oh, thou who entered the world without anything,/ Already the wind has stirred the dust on thy grave./ Even if thou will sit on the very throne of the king,/ Still thou will hold nothing except the wind in thy hand.[28]

The sentiments expressed by these verses about the impermanence of things are not original nor are they particularly beautiful, but they are also not really the subject of the painting. The latter's subject is the contradictions of the world, as the funeral procession marches on, preceded by a single mourner, to be greeted by a funeral attendant holding a banner and covering his nose to avoid the stench, and by a door-keeper hardly concerned with opening the gate. Then there is in great detail the digging of the new grave, not far from an older and more important grave, perhaps of a holy personage, with a black cat seated as a sort of protector.[29] Finally, there is a tree carrying life in the shape of birds and their nests full of eggs, but also with a snake winding its way up to destroy the eggs. Altogether we start with a death which occurred and end with several about to happen. Such, implies the poem and argues the image, is the message of life. This sinister, depressing statement is conveyed with the same brilliant colors and compositional patterns as in several of my earlier examples, but here more texture is given to the representation of space as well as to the personages, trees and other details. The changes in style and in the technique of representation do not alter the point that the image is not an illustration of a text, not a visual impulse that leads one back to a story or to an event, but the transmitter of a message vaguely intimated by the text but corresponding to some other purpose, some other input than that of elucidating a written passage.

What I have tried to show through these examples of specific manuscripts can be summarized in the following manner. During the fifteenth century there developed an art of painting whose aim was not to illustrate texts but to decorate books. A small number of pages are selected for miniatures which are almost always full-page images.[30] They are inspired, at times very generally and very approximately, by something in the text, but mostly they

[28] After Swietochowski, p. 56. The poem is not in Nott's version.
[29] The presence of cats in obvious or hidden parts of Persian miniatures is a curious feature which may deserve investigation.
[30] Actually, as has been shown in some detail by Adle (above, note 1) and by many other scholars in a more simple manner, passages of writing are often artfully fitted into miniatures. The full classification of the various patterns involved still requires study.

are affected by fads, references, needs and impulses other than those of the book itself. [138]

In order to discover what these sources of inspiration may have been, all that is required is to look into the miniatures themselves, for they are the answers we seek, in this gigantic game of *Jeopardy* that contextual history of the arts or of anything else has become. As in any iconographic study so fashionable for these very centuries in Western European art, the aim is to learn to distinguish that which is typical from whatever appears to bring an unexpected, at times a jarring, note. Such variants may be technically iconographic, but they can also involve formal decisions and unusual combinations of colors or of people. Here are a few, literally randomly chosen, examples of clues for possible contexts: the lively and imaginative fantasies of monstrous figures frolicking in nature from a great sixteenth-century manuscript;[31] the sudden introduction of a dramatic depiction of the attempted seduction of Joseph by Zulaykha;[32] the visionary conception of space implied by a visit of Alexander the Great to an Indian sage;[33] the depiction of a construction site with the potential for a highly comic disaster;[34] the personalized depiction of a court with portrait-like sages and the bizarre shadow of a devil over an otherwise pedestrian topic of a good king (Sultan Sanjar) meeting an old woman who criticizes his rule;[35] acrobatically impossible staging for a royal life beyond the wildest dreams of man;[36] and, finally, in a festival of colors, the dream of creation in which all is good and beautiful.[37]

I do not have an explanation for each one of these specific and for the most part unique details. Hardly any of them is explained directly by the text, but I can easily imagine the kind of research into visual vocabulary, text criticism and contemporary history which may elucidate many of them, while the rest will enter into the limbo of answers whose questions are lost forever. But, without denying the probable validity of *ad hoc* explanations of individual images, it is also necessary to provide a framework for the visual language that would have made individual answers possible and presumably understandable. This framework can be imagined with the help of aesthetic theories developed precisely in the early part of the fifteenth century around the major courts of Iran. These theories deal primarily with literature and probably with music, and to a smaller degree with architecture.[38] For the

[31] Dickson and Welch, *Houghton Shah-nameh*, fol. 21v.
[32] Lentz and Lowry, *Timur*, p. 296.
[33] Ibid., p. 250.
[34] Ibid., p. 288.
[35] Ibid., p. 283.
[36] S. Cary Welch, *Wonders of the Age*, pp. 126, 155, 157.
[37] Dickson and Welch, *Houghton Shah-nameh*, color pl. 8. This magnificent painting has been frequently reproduced, as in Welch, *Wonders*, opposite p. 18.
[38] For architecture, what was known until *c.* 1985 is in Golombek and Wilber, *Timurid Architecture,* especially pp. 78 and ff. See also Renata Holod, "Text, Plan and Building," in M. Ševčenko, ed., *Theories and Principles of Design in the Architecture of Islamic*

purposes of this paper I shall use only one example, that of a treatise written in 1423 by one Sharaf al-Din Rami.[39] He defines the beauty of the human body in terms of nineteen parts of the body (all but six above the neck) and then lists and explains all the attributes and metaphors associated with each one of these parts. For instance there are thirty-three epithets to describe hair which are common and eleven which are rare and one hundred different qualities of hair. I will give only two examples of the ways in which poets used these linguistic possibilities: the hair curling down on the cheek is called *zolf* and is a snake rolled in a bed of flowers; and the sentence "on the part of your hair Moses has shown his white hand, so that you took one hundred out of nineteen" means that you are bald, because the white hand of Moses means blankness and hair is the one of the nineteen parts of the body that has one hundred attributes.

The point of these examples is that literary theory allows for the proposition that the detailed structure of the illustrations I have shown can be understood as a language of images with an almost infinite number of possible interpretations, because every part has so many meanings attached to it. How to disentangle these meanings remains a task for other times, but before concluding I should like to bring up a curious parallel to these miniatures which was brought to my attention when I gave an informal talk on Persian painting at Columbia University. It is that Persian miniatures are typologically relatable to contemporary comic strips (more intelligently known in French as *bandes dessinées*, as comedy is only occasionally their aim), in the senses that a first impression of forms is supposed to grab the viewer's interest, that general moods (violence, love, travel, exoticism, etc.) are immediately visible, but that the real point of the images comes through only by plunging into this sequence within books. The success of the books as visually perceptible narratives indicates something of the social depth of this sort of experience.[40]

Societies, Aga Khan Program (Cambridge, 1988), pp. 1–12. New and pertinent discoveries of drawings have been published by Gülrü Necipoglu, *The Topkapi Scroll: geometry and ornament in Islamic architecture* (Santa Monica, Calif.: Getty Center for the History of Art and the Humanities, 1995). There is, to my knowledge, no systematic study of literary theories of the time. Preliminary discussions by Z. Safa and E. Yarshater in Peter Jackson, ed., *The Cambridge History of Iran* 6 (Cambridge, 1986), pp. 913–94.

39 Sharaf al-Din Rami, *Anis al-'Ushshaq*, tr. and notes by Clément Huart, *Traité des termes figurés relatifs à la description de la Beauté* (Paris, 1875). An important analysis based on Nizami is that by Priscilla Soucek, while many important texts and suggestive comments are found in Christopher Bürgel's book (all in note 1). But none of these studies and resources, which are not easily available anyway, can replace a true book of sources.

40 Contemporary criticism has rarely dealt with comic strips, but see the attempts by Alan Gowans on posters, *Images of an Era* (Washington, 1976), and David Kunzle, "Art of the new Chile," in Henry A. Millon and Linda Nochlin, eds, *Art and Architecture in the service of politics* (Cambridge, 1978). See also Michel Thiébout, "Approche du Monument," *Monuments Historiques de la France*, 132 (1984), pp. 18–27.

From these remarks which are but the beginning for an eventual construction of the aesthetic – or rather of the several aesthetics – of a Persian tradition of painting, I will derive two conclusions and one question.

The first conclusion is that what I have called the contextual approach has consisted primarily in seeking to understand the immensely complex details of fifteenth- and sixteenth-century miniatures. It is a context in which the book became the meeting place of five independent traditions and purposes: texts of all sorts which were part of a rich secular lyrical and epic literature developed in written form since the eleventh century; the need for images which roughly in the twelfth century became an important aspect of Iranian Islamic culture; the patronage of Turco-Mongol courts which saw in the making of books a way of legitimizing their rule and giving it an appearance of gentility and of civility; the growth of theories around the beautiful; and a host of concrete events, memories, references, expectations, desires, emotions, which can [139] be disentangled only by the human depth of observers poring over masses of details.[41]

The second conclusion is the sophistication of the process by which these images operated. Often hidden in heavy codices, they do not appear immediately, as do the illuminated front pages and the fancy designs around title pages and titles of chapters (Fig. 19). Once they do appear, they seek attention by brilliance of color, imagination of design on the page, or some other unexpected "come-on," like the transformation of margins in the manuscript from the Freer Gallery discussed earlier or the design like the geometry of tesselation with the holy name of Ali found in an Istanbul album.[42] And once a viewer is caught, he wanders within the miniature trying to understand how it works and what is in it, so as almost to forget that he is holding a book. Only after this immersion can one be deemed ready to handle something as automatic as the taxonomic issues of date and attribution and perhaps acquire the right to some libertarian comments of one's own. But, in the meantime, miniatures made to enhance a book rather than to illustrate a text become pictures in their own right not because of the ways artists operated (which is the current theory), but because of the ways in which the pictures engage the viewer into interpreting them.

And, finally, the question. What made this particular art possible? And, especially, what made it succeed? The real answer must await many analyses and discussions and studies of all sorts, but I can propose two directions for

41 Every one of these five components, except the last one which is clearly restricted to *ad hoc* issues, deserves a more elaborate investigation than can be provided in the context of this essay. Most of them involve dealing with complex problems of social, political and cultural history. An initial introduction to most of these problems can be found in the several volumes of the *Cambridge History of Iran*, especially vols 3–6 (Cambridge, 1968–86), with the earlier one obviously more dated than the later ones.

42 It is a frequently illustrated image, as it found its way into the second edition of H. W. Janson, *A History of Art* (New York, 1978), color pl. 30.

19 *Assar, Mihr and Mushtari*, dated 1477, copied by Shaykh Murshid al-Katib

an answer. One, as has been suggested by the most recent investigators of these times, is the creation of a highly organized and highly specialized crew of craftsmen in the arts of the book who could do almost anything.[43] A lot is known about them and they would deserve a whole separate study as the providers of the technical competencies needed to formulate standards of visual behavior. The other one is the creation in the fourteenth century among the ruling classes in Iran of something that did not exist to the same extent in the Ottoman or Arab worlds to the west of them but which will be present in India and, in a much better studied way, in contemporary Italy, but even more so in Flanders. That "something" is that the world of visual literacy and of visual impacts is an essential part of whatever it is that holds society – or at least some levels of that society – together. How it worked and why this thought developed at that particular time are still partly speculative issues that will certainly be resolved with more work on the

43 This is the hypothesis put forward by Thomas Lentz and developed in Lentz and Lowry, *Timur*.

thousands of monuments which have been preserved and on the specific contingencies of Iranian history of the fifteenth century.

But, in a deeper sense, the questions raised by these monuments of classical Persian painting can be extended even further, for they raise troubling questions about truth and beauty. For my argument has been in part that classical Persian painting willfully withdrew from the compulsory equation of representation with the represented or from a rational logic of space, time, or even actual meaning for forms. It did so because what it shows is not what you see, nor is it something else. It is what you wish to put into what you see and what you know can be put there. Every image, in other words, can justifiably be construed as a multiple answer to the physical need of ornamenting a book. There is no one truth, even though there are falsehoods. The logic of it all was expressed by the writers of the fifteenth century in their own ways, as in this quotation from Khwaju Kirmani, the illustrations of whose work I have referred to several times:

We are all particles and who would give absolute knowledge to a particle? We are all particles and when will we reach totality? We have only just begun, so how can we achieve it? Wise men, although they are many, will achieve nothing singly. All should go forward together, and if not, each should pluck a flower from the garden. Whatever is in this world is neither completely good nor completely bad, and the one to step on the path of total knowledge has not yet been born. My wisdom has not seen anyone who knows everything …[44]

What the writer tells us and what the painter evokes is that Truth and Beauty are not enough without Wisdom and Goodness, but that Goodness may only be found through Truth and Beauty. Or is that what the painter or the writer really mean? After all, like any humanist scholar or any artist, the Persian writer of the fourteenth century ended his poem with the words with which I too shall end my essay:

I have spent my life telling stories. Alas, I am but a teller of tales.[45]

[44] Fitzherbert, *Iran*, p. 147.
[45] Ibid., p. 149.

Chapter XII

About two Mughal Miniatures*

The best way, it has seemed to me, to commemorate the memory of Michael Meinecke was to contribute to this volume in his honor a few recently acquired impressions about a remarkable work of Islamic art. I would have liked to share these impressions with Michael in the way in which scholars of yore used to share with each other, at times through published correspondence, their almost immediate reactions to some new or newly available information. Scientific knowledge was thereby enhanced by a continuous exchange of thoughts, ideas and interpretations. But, mostly, a community of learning was established which exchanged views in writing about these ideas and thus a record was preserved of the processes and, at times, vagaries of scholarly and intellectual pursuit.

The work involved lies outside of the main concerns Michael Meinecke and I have shared over the years in terms of time, area or even method. Neither of us was particularly involved with the study of Islamic India, especially the Mughal period, and our professional involvement with history and archaeology left little room for criticism. I know how much I (and perhaps others as well) would have profited from his critical reactions to my remarks.

As many found out from press reports, one of the more memorable exhibitions of 1997 was that of the *Padshahname* of Shah Jahan belonging to the Windsor Castle library, shown first in London and then scheduled to begin a long tour of American museums. The text, only about the first third of the original, was copied in 1657–58 and is enhanced by forty-four miniatures attributed to several artists associated with the imperial court. The catalog with its several essays is a joint effort of Milo C. Beach, Ebba Koch and Wheeler Thackston,[1] and it contains translations of the appropriate passages of the chronicle, presentations and discussions of each miniature, a codicological introduction, and two essays, one on the manuscript's

* First published in *Damaszener Mitteilungen* (Festschrift Michael Meinecke), 11 (1999), pp. 179–83.
[1] M. C. Beach and E. Koch, *King of the World* (Smithsonian Institution, Washington, 1997).

relationship to Mughal historical manuscripts and the other on the miniatures themselves with a description and evaluation of what the author (Ebba Koch) calls the "hierarchical principles" of the paintings.

The published essays stressed two important points about these illustrations for a chronicle which was also a panegyric. One is that nearly every one of their formal and iconographic features – from the choice of topics to the order in which personages are represented and even [180] the portrait-like quality of so many facial and bodily characteristics – is meant to illustrate imperial power, to reproduce its hierarchical order, and to show everyone's place within that hierarchy. In fulfilling this ambitious aim, the miniatures of the *Padshahname* are original in the specifics of what they show, but, as an ideological type, they are part of a tradition which first appeared in the art of ancient Egypt. The other point is a more subtle one. It is that the expression of this (or any other) idea required a striking language in order to be effective. The Iranicate, Timurid-imperial, mode of Mughal painting was, or so the argument seems to go, not quite able to meet the challenge of these aims. And, just as Iranian art adopted Chinese techniques and conventions in its search for a new art of representation in the fourteenth and, to a smaller degree, fifteenth centuries, so the artists of Shah Jahan's time turned to European painting, known to them through prints and drawings, for appropriate formulas of representation.

Both of these conclusions are quite reasonable and appropriate. There is no doubt that the pageantry of the court, assisting or witnessing the ruler or his sons exercising their power in having enemies executed, presiding over weddings of relatives, hunting, conquering fortresses, or receiving visitors is shown with a wealth of details which clearly exceeds the importance of the events themselves. Just as in David's *Coronation of Napoleon*, although obviously on a different scale, every event in this manuscript acquires additional value and meaning by being held in front of precise individuals, many of whom can still be identified today, all of whom could be identified at the time of the event. But, in line with a wonderful paradox inherent to all arts intimating the representation of specific events, whenever the representation of immanent specificity is of sufficiently high quality, it loses its immanence, its relationship to its subject fades away, and it becomes a painting from which successive generations can derive visual pleasure and enlightenment without quite knowing what it was about. It is, thus, possible, probably even necessary, to extend a classical and perfectly justified iconographic and ideological explanation of a group of miniatures into an interpretation of these images no longer as illustrations of given topics or of ideas but as feasts for the eye, as aesthetic involvements. The point becomes even more telling when one considers that the value and the impact of an ideologically charged message differ considerably when they are expressed in manuscripts which could not be seen by more than two people at any one time rather than on walls available to all.

Similarly, it is indeed true that all sorts of technical devices of European origin were incorporated into the canvas of traditional Iranicate Mughal painting and that many of them were woven so artfully that they no longer appear as artificial borrowings but as integral parts of the language used by the painters. These are not hybrid paintings, but learned compositions in which very different artifices were used to make visual effects. In other words, while it is proper and correct to point out the sophisticated integration of European techniques of representing man or space, this conclusion requires further elaboration on the impact these and other devices had on the viewer in the past and, of course, today.

I will elaborate on these and other observations around two miniatures. Each one belongs to a set of comparable ones within the manuscript. The first one (Fig. 1) is supposed to represent the siege, in fact the conquest, of Dawlatabad (fol. 144, fig. 34 in the catalog). It is dominated by the striking picture of a city with three rings of walls on the lower level, then a moat and a higher city in two walled sections towering over the lower city. There are seven other representations of cities in landscapes, all but two of them shown in the process of being conquered, and all are different from each other. They are: fol. 92B, the fort of Dharur, fig. 15 in the catalog; fol. 102B, the siege of Qandahar, fig. 18; fol. 117, taking of Fort Hoogly, fig. 20; fol. 166B, a royal procession with an interesting depiction of a city in the background, fig. 34; fol. 174, capture [181] of Orchha, fig. 35; fol. 204B, surrender of Udjir, fig. 40; fols 205B–206, visit to the shrine of Khwaja Mu'inaddin Chishti at Ajmeer, figs 41–42.

My second example (Fig. 2) is a reception scene (fol. 192B, fig. 37), in this instance of Jahangir receiving his son, Prince Khurram. Eleven other images (figs 5, 8–9, 12–13, 14, 17, 19, 32, 38, 39, 43, 44) are also reception scenes and all but three of them are constructed in the same manner as the one I have chosen: an upper level with the ruler, an attendant and the principal co-actor, in this instance Prince Khurram; a lower level with courtiers and attendants arranged in several different kinds of rows. These scenes are all divided vertically into three parts usually separated by architectural devices, with the ruler dominating or occupying alone the central section.

Details in both images can be explained in terms of whatever information is provided by the text surrounding them or by otherwise existing accounts of the events involved. The writers of the catalog have dealt quite intelligently and imaginatively with most such iconographic issues of relating an image to whatever it is supposed to have represented. But I would like to argue that these two miniatures, like most of the other ones in the manuscript, raise a much more curious question with significant theoretical ramifications: what is the exact nature of the truth or verisimilitude which is proposed by the painters?

Let us look carefully at the "Siege of Dawlatabad" (Fig. 2). Its major key of clearly delineated shapes and colors includes two elements. One is a town

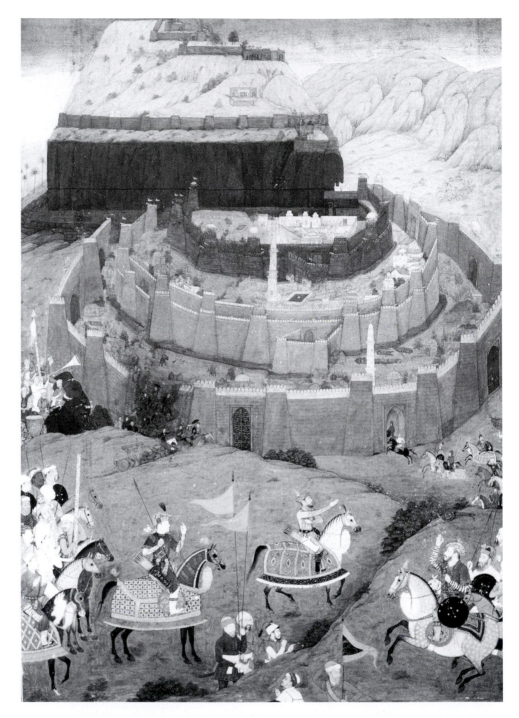

1 *Padshahname*:
The siege of
Dawlatabad, Ex.
Cat. 31

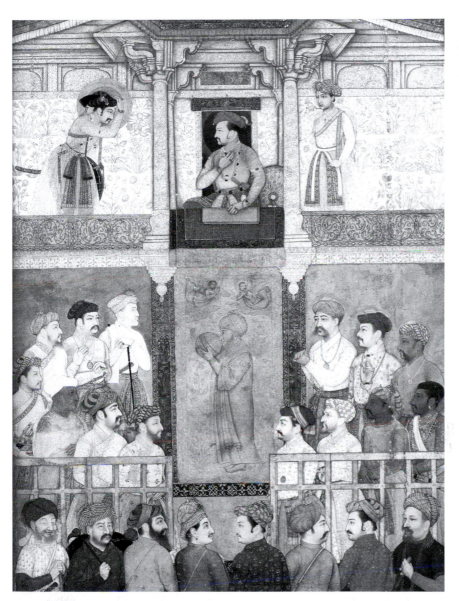

2 *Padshahname*:
Jahangir receives
Prince Khurram,
Ex. Cat. 37

in two sections, one above the other, with heavy fortifications on which many red imperial flags signal possession, and with a smattering of smaller buildings inside. The main ones are highlighted in sharper and clearer colors, as though a spotlight has been directed at them. They seem to be official or privileged places like mosques whose minarets alone are depicted,[2] water reservoirs, a walled garden which could be part of a palace, a pavilion

[2] It is just possible that these were not attached to mosques but signposts in cities to be seen from afar. A separate study should be devoted to the representation of architecture in this manuscript.

within an enclosure on the highest point of the city, a cluster of houses (?), and a smattering of other complexes whose meanings are not very clear. But there is a second series of buildings, barely outlined and almost merging with the brown-colored ground. Most of these are houses, sometimes with a tree next to them. One, in the upper city, may be a shrine with a platform in front of a domed building. Yet, there are, all together, very few houses in the city.

Together with buildings, the other major component of the miniature consists in people. There are many colorful riders and a few walking standard-bearers arranged in two groups facing each other in the front of the picture and, then, two smaller colorful groups actually attacking or entering the city, one through a gate, the other one after a successful explosion had destroyed parts of the wall. In the first group, three leaders are gesturing toward each other with arms raised in dramatic poses going back to ancient Egyptian and Assyrian art. No colorful personage appears inside the walls, where, however, several groups of artfully sketched riders and foot-soldiers (?) are shown patrolling an apparently empty city, with one dead inhabitant lying on the ground. There are no soldiers in the uppermost part of the city, but a band of horsemen is faintly visible on the upper right, either pursuing some enemy riders away or simply practicing their horsemanship.

It is obvious that the character of the city, the specifics of the activities carried out in or around it, and the gestures of the personages in front depict a concrete event, probably the one [182] that occurred in June 1633, when Dawlatabad was taken for the Mughal emperor. But, as Milo Beach and Ebba Koch have shown, the painter telescoped several separate occurrences into one picture. This sort of conflation is common enough in illustrations whose purpose is relatively rarely to relate an exact sequence of events, but, much more frequently, to recall the circumstances and peculiarities of that event. And, also in line with observations that could be made in many other artistic traditions, certain features are highlighted to ensure their recognition and, by extension, the recognition of an event's singularity. Such are the peculiar topography of the city, which differs from the other six representations of cities in the manuscript, the surprise of the explosion, and the differences in physical features of the three main protagonists saluting each other.

But why this contrast between two different degrees of visibility in the representation of people and buildings, when that difference does not seem to be inspired by the text or by important iconographic variables?[3] Two answers, compatible with each other, can be proposed. One is, in part, iconographic and follows the hierarchical principle developed for the miniatures by Ebba Koch. It is that the main topic, the success of a group of

3 Iconographic distinctions can explain a similar contrast on fol. 204B, pl. 40, where an army about to surrender is barely visible behind the first set of walls and where a whole city is sketched out in the back, perhaps suggesting remoteness in space.

military leaders in the name of the ruler, can only make sense if its expression is contrasted with the rest of the world staying in shadows. The other answer is perceptual in that an image requires means of access into all parts of its surface. This access can only be achieved by inviting the viewer into details and, as a result, into total immersion within the picture. What is involved here is a double visual operation. One deals with broad strokes of contrasts and of moods, the other with an almost infinite breakdown into independent parts, each of which is an image in its own right. The viewer is thus expected to operate, simultaneously or sequentially, at two separate levels, one handling the general impact of a miniature and the other the mass of its details.

My second example (Fig. 2) is, at first glance, of a totally different kind. It is a two-dimensional representation of a *darbar*, a reception at which a specific event, although in this case apparently one which cannot be identified with certainty, takes place: Jahangir receiving his son Prince Khurram who offered his father a fancy pearl. The structure of the image is typical of many other such images and, just as in my first example, there is a contrast between the colorful highlighting and precision of personages and the nearly monochrome, although quite rich in details, architectural background with the striking figures of a shaykh and angels almost merging, like ghosts, into the turquoise background. As Ebba Koch correctly pointed out, the emphasis on the ruler is here greater than elsewhere. Father and son are frozen in the expression of gestures of respect and acceptance, and the assembly of courtiers, many of whom can still be identified, has been squeezed into less space than in most other miniatures. As in many of the latter, there is something mesmerizing about the collection of courtiers, all different from each other, with minimal gestures of the hands restricted to only three of them, all molded into a sort of eternal profile (with five out of twenty-two in three-quarters view). Just as in a parlour game, one knows that in a second they will all move, but in the precise moment of representation they have just assembled for a photo opportunity.

The contrast between overall impact and details appears in this image in the individuality of the faces and clothes of the personages, drawing the attention of the viewer away from the overall [183] point of the picture, yet always returning his gaze to it. In this respect, although with different components and in a very different key, the perception of this miniature is comparable to what we have observed in the "Siege of Dawlatabad." The impact of the whole miniature is always contrasted with the richness of its details.

But one striking detail opens up another avenue for critical thought. It is the figure at the lower left which, together with its neighbor, does not seem to participate in the central ceremony. The existence of such individuals creating some sort of visual coherence within groups is already encountered in fourteenth-century painting in Iran and in Italy, whenever large groups of identical personages (courtiers, soldiers, saints, or angels) surround some

major scene or event. In the case of our manuscript, not only do these personages face away from the rest of the crowd, but one of them is shown with a silly grin, in total contrast to the formulaic seriousness of everyone else. Why? There could have been a specific reference to something that happened then and which will probably never be known. It could also be the introduction into the picture of someone who did not belong to the assembled crowd, the artist for instance, although such instances which do exist are not usually that obvious. The only certain explanation is that this figure was meant to break the mummified standard for all other personages and, therefore, to invite the viewer to go back to them, to seek in them that which can make them alive, that can be made to move. A few visible gestures of hands and a few potential glances can suddenly become filled with thought or with emotion and, just as in a museum of life-size wax figurines, artificial bodies become real ones once something triggers their perception as such.

It is this intimation of reality through the device of a charged detail, not through the artfulness of the composition, that characterizes most of the paintings of this manuscript. Nearly all of its miniatures are invitations to disappear into the depth of their minute references in order to return to the whole and to see it better. This dialogue between part and whole, between detail and ensemble, engages the viewer from two directions and, even if the final results of visual appreciation are the same, the processes of comprehension are different.[4] In order to understand the ways involved and the history of this approach to the art of painting, many more images need to be examined and discussed.

4 In much of my reasoning, I was influenced by reading Daniel Arasse, *Le Détail* (1992).

Chapter XIII

A Preliminary Note on two Eighteenth-century Representations of Mecca and Medina*

For better or for worse, depending on one's own ideological bent, much of our perception of the world and its history was shaped during the eighteenth century. It is during this century that the Viennese architect Johann Bernhard Fischer von Erlach (1656–1723) published his *Entwurf einer historischen Architektur in Abbildung unterschiedener berühmten Gebäude des Alterthums und fremder Völker*, freely translated as "Project for a History of Architecture through Pictures of Various Important Buildings from Antiquity and Foreign People."[1] This "project" for a history of architecture is acknowledged as the first one of its kind to claim some sort of universal coverage.[2] It has practically no text, except for some lengthy captions under high-quality line drawings or next to them. The book consists of several parts and begins, of course, with the reconstruction of Solomon's Temple most fashionable in those times, and continues with the ancient Near East (Egypt, Persia, Syria), Greece and Rome, as well as with an image of Stonehenge, which was uncommon at that time. It ends with several of the author's own projects, and with a fascinating sequence of representations of antique vases and other containers, beginning with the "sea" of Solomon's Temple and including real or imaginative Egyptian vases, which are indirectly related to a long tradition of funerary urns.

Between the unoriginal historical scheme from Solomon and ancient Egypt to Rome and the self-promoting last section, there are thirteen architectural drawings from "foreign" lands, a striking novelty in the history of architecture. Four depict Far Eastern architectural ensembles, but nine portray Islamic architecture. The latter include an Ottoman bath in Budapest

* First published in *Jerusalem Studies in Arabic and Islam*, vol. 25 (2001), pp. 268–74.

[1] The first edition was published shortly before his death in 1721, and the second, posthumous edition appeared in 1725. Both early editions were published in Vienna; they contain extensive captions in German and French. An English version was printed in London in 1730. For a biography of Fischer von Erlach and a bibliographical guide, see Jane Turner, ed., *The Dictionary of Art* (London, 1996).

[2] Joseph Ryckwert, *On Adam's House in Paradise*, 2nd edn (Cambridge, Mass., 1984), pp. 130–31.

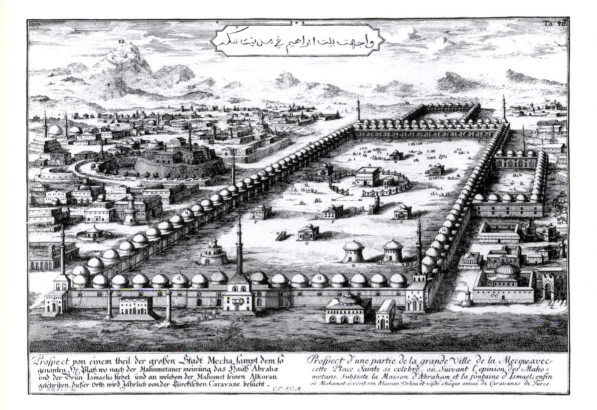

واجهت بيت ابراهيم فى مدينت مكة

Proſpect von einem theil der großen Stadt Mecha ſampt dem ſo
genanten Heg Platz wo nach der Mahumetaner meinung das Hauß Abrahæ
vnd der Brun Ismaelis ſtehet vnd an welchem der Mahomet ſeinen AlKoran
geſchriben, dieſer Orth wird Jährlich von der Jureklichen Caravane beſucht .

Proſpect d'une partie de la grande Ville de la Mecque.avec
cette Place ſainte ſi celebre, ou ſuivant l'opinion des Maho =
metans, Subſiſte la Maiſon d'Abraham et la fontaine d'Ismael; enfin
ou Mahomet ecrivit ſon Alcoran :Ce lieu eſt viſité chaque année de Caravanes de Turcs.

1 Mecca

(plan and elevation), a mosque in Hungary, the tomb of Orkhan in Bursa (a rather fanciful drawing), the Süleymaniye and Sultan Ahmet complexes in Istanbul (quite accurate in general impression), and [269] the Safavid *meydan-i Shah* and the Allaverdi bridge in Isfahan. Fischer's sources for all these buildings have been fairly certainly established as illustrated accounts by recent travelers to Istanbul and to Iran.[3]

There is nothing particularly unusual or surprising about these drawings, which are mixed with a rendering of Hagia Sophia and one of the stunning Byzantine underground cisterns. The connections between the Habsburg and Ottoman empires were numerous, if not always friendly, and various documents which reveal what they knew about each other are extant.[4] Similarly, Isfahan had been depicted and drawings were made of its main monuments by French, Italian and Dutch travelers in the seventeenth century.

3 U. Illig, *J.B. Fischer von Erlach, Ausstellung* (Graz, 1956–7) and G. Kunoth, *Die Historische Architektur Fischers von Erlach* (Düsseldorf, 1956), pp. 197–9. On the whole I have been struck, after a cursory search, by the paucity of scholarly discussions on Fischer's book as opposed to his architecture.

4 For the latest example concentrating on the arts, see Wien, Österreich Nationalbibliothek, *Österreich und die Osmanen* (Vienna, 1983) and Staatliche Kunstsammlungen Dresden, *Im Lichte des Halbmonds: das Abendland und der türkische Orient* (Dresden, 1995); both contain extensive bibliographies.

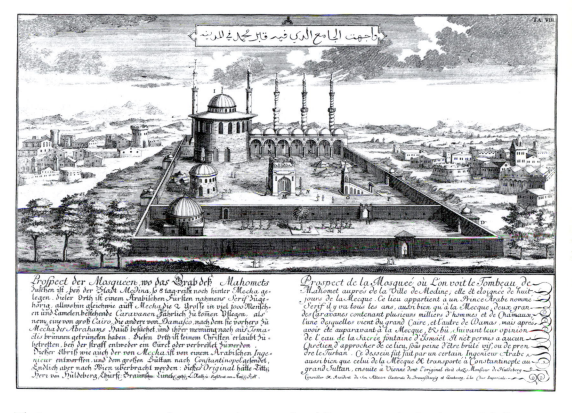

واجهت الجامع الذى فيه قبر محمد فى المدينه

Prospect der Masquéen, wo das Grab des Mahomets
zulchen ist, bey der Statt Medina, so 8 tag-reise noch hinter Mecha ge-
legen. dieser Orth ist einem Arabischen Fursten nahmens Serif zuge-
hörig, allwohin gleichwie auff Mecha, die 2 Grosse in viel 1000 Meinsch-
en und Lamelen bestehende Caravanen Jährlich zu kommen Pflegen, als
nemb, eine von gross Cairo, die andere von Damasco, nach dem sie vorhers zu
Mecha des Abrahams Hauß besuchet, und ihrer meinung nach aus Isma-
elis brunnen getruncken haben. Diesen Orth ist keinem Christen erlaubt zu
betretten, bey der straff entweder ein Circel oder verbrenet zu werden.
Dieser Abriss wie auch der von Mecha ist von einem Arabischen Inge-
nieur entworffen, und dem grossen Sultan nach Constantinopel gesendet,
Endlich aber nach Wien uberbracht worden: dieses Original hätte Tittl:
Herr von Huldeberg, Churfl: Braunsch: Luneb: geh: L. Rath u: Resident am Kayßl: Hoff.

Prospect de la Mosquée où L'on voit le Tombeau de
Mahomet aupres de la Ville de Medine; elle ét éloignée de huit
jours de la Mecque. Ce lieu appartient à un Prince Arabe nommé
Serif il y va tous les ans, aussi bien qu'à la Mecque, deux gran-
des Caravanes contenant plusieurs milliers d'hommes et de Chamaux,
l'une desquelles vient du grand Caire, et l'autre de Damas, mais apres,
avoir été auparavant à la Mecque, & bu, suivant leur opinion
de l'eau de la Sacrée fontaine d'Ismaël. Il n'ét permis à aucun
Chretien d'approcher de ce lieu, sous peine d'être brulé vif, ou de pren-
dre le Turban. Ce dessein fut fait par un certain Ingenieur Arabe
aussi bien que celui de la Mecque & transporté à Constantinople au-
grand Sultan, ensuite à Vienne dont l'original était chez Monsieur de Huldeberg
Conseiller & Resident de Son Altesse Electorale de Brounsvig et Lunebourg, à la Cour Imperiale.

Their accounts were popular among the general public, as were the Jesuit accounts of China and a French account of recently visited Siam/Thailand, all of which appear in Fischer's book. These accounts were adapted to his purposes by illustrating varieties of architectural expressions found all over the world.

2 Medina

The book's originality lies, however, in the presence of two drawings of places that were not accessible to European travelers and diplomats, or even to adventurers as far as we know. These are representations of the Muslim sanctuaries of Mecca (Fig. 1) and Medina (Fig. 2). To my knowledge, these are the two earliest renditions of the sanctuaries included in a European source. I believe that they also represent the first drawings of those holy places exhibiting the very special bird's-eye view developed since the Renaissance (on the basis of classical Roman models), which allows for the immediate visual comprehension of a large space. Both drawings pose a number of problems which, at this stage of research, can only be outlined. The purpose of these remarks is therefore simply to draw attention to these two images and, it is hoped, to initiate further research into their origins.

There are, of course, many earlier representations of the *haram* in Mecca. There are partial two-dimensional drawings of parts of the sanctuary in some of the medieval manuscripts of al-Azraqi's *Akhbar Makkah*. Hundreds of Ottoman tiles exist with images of the Ka'ba and of its immediate

surroundings.⁵ Illustrations of the sad life of Majnun or of the Prophet's Ascension (*mi'raj*), as well as more popular accounts of the lives of prophets or divination books of all sorts, also contain representations [270] of the Ka'ba, alone or in its surroundings.⁶ The earliest representation known to me is on a steatite plaque in the Iraq National Museum in Baghdad, dated from 486/1093 or 488/1095.⁷ All of these representations from the Islamic world itself are standardized evocations of an otherwise known space through placing two-dimensional (at times three-dimensional for the Ka'ba) sketches of constructions associated with that space in an order which makes them all recognizable. They are rendered without much concern for the accuracy of their actual location. The semi-circular *hijr*, the various *mihrabs*, the *maqam Ibrahim*, and the surrounding porticoes are usually included, at times with identifying labels, but they are not shown in the appropriate scale, individually or in relation to each other.

Fischer von Erlach did something quite different. He created a large enclosure seen in perspective within an urban context. Inside, most of the traditional and expected structures are represented (except for the Zamzam well, unless it is one of his unidentified buildings). Instead of labeling them, he identifies them by letters and then provides a key with captions on another page. The interpretation of these captions still requires much investigation, since many letters are defined as "unidentified in the original" (I shall return to what this "original" may have been). There is a building called "tomb of the four prophets of Muhammad," which reflects, I suspect, a confusion with the four schools of jurisprudence, each one of which had a building in the *haram*. Just outside the enclosure, a large octagonal building is identified as "the mosque where one prays before entering the holy place." It could have been a *masjid* of some sort, but may also have been misunderstood as the place for ablutions. A *madrasa* sponsored by Suleyman the Magnificent is depicted to the right of the main enclosure.

It should also be noted that the sanctuary is located in an urban area consisting of independent building ensembles with little cupolas and, at times, minarets. Such houses are occasionally found in Persian miniatures, but usually without domes and minarets. It is as though the designer of Fischer's drawing wanted to provide Mecca with an "Oriental" flavor. In fact, his urban clusters recall those of Matrakçi's celebrated illustrated account of Suleyman's trip to the eastern provinces of the empire.⁸ The mound to the left of the sanctuary is strikingly similar to the representation of Aleppo in that manuscript. The inscription on the drawing reads: *wajihat bayt Ibrahim*

5 K. Erdmann, "Ka'bah-Fliesen," *Ars Orientalis*, 3 (1959), pp. 192–7.

6 The latest book on this subject is R. Milstein, K. Rührdanz and B. Schmitz, *Illustrated Manuscripts of the Qisas al-anbiyd'* (Costa Mesa, 1999).

7 V. Strike, "A Ka'bah Picture in the Iraq Museum," *Sumer*, 32 (1976), pp. 195–201.

8 Nasuhu's-Silahi (Matrakçi), *Beyan-i menazil-i sefer-i 'iraqeyn-i Sultan Suleyman Han*, ed. Huseyin G. Yurdaydin (Ankara, 1976).

fī madīnat Makka, "façade of the house of Abraham in the town of Mecca." It is written in a rather [271] awkward script which stands in contrast to the fancy frame in which it is found. I shall return to this shortly.

On the whole, while a great deal was unclear to Fischer von Erlach regarding the functions of the various parts of the sanctuary, and while some of his explanations are misleading or incorrect, the overall picture of the Meccan sanctuary is a reasonable approximation of the place. The sources for most of its elements can probably be found in existing Ottoman images of the holy place to which an "Oriental" city would have been added. It may also have been inspired by Ottoman sources, although images provided by western travelers may account for some of the exotic aura.

Matters are quite different when one turns to the representation of the mosque of Medina, which had been rebuilt by 1487 under the rule of the Mamluk Sultan Qaytbay. It was then, as it has been since the time of al-Walid (AD 705–15) until today, a large hypostyle building, with, off center, a wider nave leading to the early *mihrab* and, not far from it, a separate construction, still within the confines of the mosque, enclosing the tomb of the Prophet. A two-dimensional sketch of the building exists, dated from between 1329 and 1423, which also depicts a hypostyle building.[9] However, this is not what Fischer represents. There is indeed a large rectangular enclosure divided into two unequal parts. The smaller one contains a few small buildings and serves primarily to identify two gates, one of which is permanently closed. It also contains a curious platform framed by candelabra. The large area consists mostly of open space with three large buildings identified or identifiable as a *minbar,* a large building framed by two enormous candelabras (M on the plan), several buildings (N) with unknown purposes, and a number of tents. In the back an enormous circular mausoleum is set in front of an arcade preceding a row of domes and five minarets set on the back wall. The mausoleum's size is in total contradiction to what actually was (and still is) the case in Medina, and it resembles the only slightly less fanciful depiction of Orkhan's mausoleum in Bursa, which also appears in Fischer's book. The source of inspiration for both buildings requires further investigation.

The caption for the drawing is once again written in a hesitant script which reads as follows: *wajihat al-jami' alladhi fihi qabr Muhammad fi al-Madina,* "Façade of the mosque in which [is found] the tomb of Muhammad in Medina." The inscription was obviously not composed by a Muslim, nor by anyone familiar with the common Muslim discourse on the Prophet. The buildings around the mosque are arranged in clusters, like those in the representation of Mecca, but there is not a single [272] orientalizing feature,

9 The classic study on the mosque is still J. Sauvaget's *La Mosquée Omeyyade de Médine* (Paris, 1947). Modifications and alternate theories developed since then deal primarily with the earliest mosque and are not of concern to our present topic.

and many of them look like standard signs of urban space found in the background of Christian scenes in northern European paintings. In contrast to the image of Mecca, that of Medina bears almost no relationship to the actual building, which has existed there since the eighth century.

One last bit of information is important before I propose an explanation for these two drawings. Fischer von Erlach wrote in one of his captions (Fig. 2) that he copied drawings in the possession of one Count von Huldenberg from Braunschweig, who was a British ambassador in Vienna, and who had acquired these drawings from an "Arab engineer" in Istanbul. Preliminary investigations in Germany and Austria failed to unearth these original drawings.[10] It is possible that they can be found in an Ottoman archive, since the "Arab engineer" would have gone to the Holy Places on behalf of some Ottoman government authority, most probably the army. But while such a source is reasonable for the representation of Mecca, it is not so for that of Medina. The representation of the mosque of Medina is a fanciful construction, unrelated to the mosque of that time. Yet the discrepancy between the mosque and this representation may be explained if the latter was not based on visual sources, but rather on written or oral accounts of early Islamic history. For the shape and interior arrangement of the mosque correspond best to the image one could draw upon hearing or reading the hallowed story of the original house of the Prophet. It consisted of a large open space used for prayers and meetings. There were tents, often used before the house was built, and rooms to the side, in one of which the Prophet was buried. There were indeed five minarets in the mosque in Ottoman times, instead of the four of the Umayyad building, but their absurd location can be explained as an attempt to transform something one had heard or read about into an image, without understanding it.

While further details need to be worked out through a survey of the sources which might have been available to an obscure "engineer" in Istanbul or to a Viennese architect, the hypothesis I am putting forward is that whoever produced the first drawing of the mosque in Medina translated information received orally or from one or more written sources into an image. For the representation of Mecca, on the other hand, we can assume the existence of a visual model made by Muslims for Muslim purposes, with many details that could not be understood by a non-Muslim ignorant of Arabic. Therefore, many features are left unexplained. There are hardly any in the picture of the Medinese sanctuary; once again this suggests that it was a novelty of Fischer's source.

My last remark deals with the Arabic captions or titles given to these two drawings, and it also applies to the captions found with other [273] pictures from Muslim lands. The script is awkward and certainly not befitting the

10 Kunoth, *Die Historische Architektur*, pp. 103 ff.

formal frames in which it appears. This can best be explained as Fischer von Erlach's (or his immediate and acknowledged model von Huldenberg's) own copy of something written in a language he did not understand. But the original Arabic is also rather strange, if perfectly clear and grammatical. No Muslim would make a reference to the Prophet without the *tasliya*, or identify the Medinese sanctuary as "the mosque in which the Prophet's tomb is located." The word *wajiha* does mean "façade" today, but I am not certain that this meaning was already in use in the seventeenth century. It translates the German "Prospekt" meaning "extended view," a kind of drawing which may not have had an Arabic equivalent. My own hypothesis is that these captions were made in Vienna, possibly by a Christian Arab[11] upon the request of Fischer von Erlach. The latter would have spelled out what he wanted to be translated; the author sought to provide a proper "Oriental" flavor for the illustrations of the architecture of "foreign" people, or those whom we would call today the "Other."

We can thus propose the following scenario for the creation of these two drawings. In his search for universal coverage, designed to fit his own architecture into a grand historical scheme, Fischer von Erlach discovered or stumbled upon a drawing of the Meccan sanctuary prepared for some purpose within the Ottoman empire and acquired by von Huldenberg, a diplomat active in gathering documents from foreign lands for his own collection, or for deposition in state archives and libraries. Either von Huldenberg himself or Fischer von Erlach discovered that Mecca is paired with Medina as a second, almost equally holy, Muslim sanctuary in Arabia, to which non-Muslims had no access. Failing to find a visual source for it, especially the sort of bird's-eye view which was available for Mecca and relatively easy to translate into European systems of representation, one of our heroes sought information about this second city. They may even have commissioned a Christian or a Jew from the Ottoman empire to find this information. Whoever did so was well versed in the history of early Islam, which was for a long time far more readily available than contemporary or even late medieval accounts. This individual came up with the sort of information that he himself, or someone else in Istanbul or in Vienna, transformed into the absurd drawing which we now possess. Fischer von Erlach appropriated it, added a standard "European" city to it instead of adapting the "Oriental" one he (or, more likely, his source) had provided for Mecca, and wrote captions and detailed explanations for whatever he understood.

This is probably only one of several possible scenarios which explain [274] these two unusual drawings. Further investigations, especially in the Ottoman archives, may clarify some of the problems they pose; likewise,

[11] Of course, it could also have been an Armenian, a Greek, or a Jew, or anyone familiar with Arabic without necessarily writing it well.

alternate explanations for many of their details are also possible. In the meantime, these drawings are left as an extraordinary document, possibly the earliest instance of trying to integrate Islamic architecture into the history of world architecture. But it is also a curious document in the long history of how images and language operate between different cultural strata, and how curiosity and a thirst for knowledge can be mixed with the search for the "exotic." Thanks to the travelers of the latter part of the eighteenth century, such as Niebuhr, Napoleon's expedition to Egypt, and numerous translations of "Oriental" religious, historical and literary texts, the amount of new and accurate information grew enormously. But it will take another century or more to find attempts to introduce a true history of world architecture, such as those of Perrot and Chipiez or Choisy. It is difficult to argue that any of them have succeeded in making a lasting impact on art historians. Ultimately, these drawings may in fact be more interesting as documents which illustrate the ways in which texts affected the making of images, and for revealing the fascinating ways in which European and Islamic cultures intersected with each other.

PART THREE

ARCHITECTURE AND CULTURE

Chapter XIV

The Inscriptions of the *Madrasa*-Mausoleum of Qaytbay*

It is well known that few periods in the rich history of Islamic architecture are as fully documented as the Mamluk centuries in Cairo. Hundreds of monuments have been preserved, many more are known through texts, chronicles and descriptions are comparatively easily available, and most inscriptions have been published. In other words it should be possible to begin writing a true history of this architecture, to identify its constructional, social, formal and aesthetic motors, and to explain how this extraordinary explosion of building activities could have taken place in the midst of a checkered and often brutal political history. In reality, however, we are still far from being able to write up the development of Mamluk architecture, for it is only occasionally that visual, epigraphic, literary, social and aesthetic documents have been put together in any sort of coherent and systematic form. In attempting to do so for one particularly celebrated monument, I shall rely primarily on inscriptions. In this fashion I hope to pay homage to George Miles in two ways. On the one hand it is an occasion to recall his admonition to me many years ago that any knowledge of Islamic art in its cultural setting requires a deep familiarity with the works and the thought of Max van Berchem. And then it is an opportunity to express in a very small fashion how much I owe to the sane wisdom and to the kindly learning of a most knowledgeable gentleman and scholar. As, I believe, the oldest Islamic alumnus of the Summer Seminars of the American Numismatic Society, it is perhaps not inappropriate for me to recall the endless trays of gold, silver and bronze coins through which so many of us learned most of what we know of Islamic history. But it is particularly proper to recall the wish often expressed by George Miles that a proper index of qur'anic quotations on monuments be put together for the help of scholars. What follows is a small contribution to this end.

* First published in *Near Eastern Numismatics, Iconography, Epigraphy and History, Studies in Honour of George Miles*, ed. Dickran K. Kouymjian (American University of Beirut, 1974), pp. 465–8.

The complex of Qaytbay in the Qarafah cemetery of Cairo is one of the most frequently visited and illustrated ensembles of the late Mamluk period. As it remains now, it consists of a *madrasa* on what van Berchem called a "plan déformé," of a fountain, of an elementary school, of a minaret, and of a mausoleum.[1] A number of other dependencies and possibly [466] a small palace existed around it and traces of these additions or annexes were still visible to early nineteenth-century travelers.[2] What remains, however, forms a coherent architectural ensemble tied together by the typically Mamluk elaboration of a stone exterior, dominated vertically by a particularly striking dome and minaret, and provided with a handsome entrance façade with a second-floor loggia. All of this is both characteristic of late Mamluk architecture and of striking quality.

The date of completion of the various parts is clearly indicated by inscriptions, AH 877 for the *madrasa*, 878 for its western *eyvan* (or at least its decoration), 879 for the mausoleum. These dates are corroborated and complemented by the chronicles. Ibn Iyas relates that the building was begun in 874 and that it was meant to consist of a mosque with a full complement of *sufis*, of cells, of a trough for animals, of a cistern, and of various additions for charitable purposes.[3] In 879 a group of officials whose names are provided were entrusted with the various liturgical and practical obligations of the building, the first funds were distributed for its upkeep, and in the month of Rajab the first *khutbah* was pronounced in the presence of all high officers and judges of the realm.[4] Altogether, then, it took five years to build the complex, a point which could be used eventually to determine something of the speed used in Mamluk constructions.

Even if both the physical character of the building and the time of its construction do not pose any major archaeological problem, some question remains about what it really was. For the chronicle refers to it as a mosque with a variety of charitable functions, while the inscriptions mention a *madrasa*, a *kuttab* and a *qubbah*, and occasionally simply refer to a "place," *makan*, as in the various parts of the *madrasa*. This apparent imprecision of the architectural and functional terminology is one of the more interesting developments of the medieval architecture in Egypt, in Anatolia, and in Iran. Its elaboration would, however, require assembling a documentation which is far too large for the context of this paper and I only mention it because its very lack of contemporary specificity when compared with modern

[1] Max van Berchem, *Matériaux pour un Corpus Inscriptionum Arabicarum: Egypte* (Paris, 1894–1903), vol. 19 of the *Mémoires de la Mission Archéologique Française*, pp. 431 ff. For the building itself the latest mention is in D. Brandenburg, *Islamische Baukunst in Ägypten* (Berlin, 1966), pp. 233–5. It deserves a full monograph on the pattern of S. L. Mostafa, *Kloster und Mausoleum des Farag ibn Barquq* (Glückstadt, 1968).

[2] Prisse d'Avennes, *L'Art arabe* (Paris, 1877; reprint Beirut, 1973), pl. XIX.

[3] Ibn Iyas, *Histoire des Mamlouks Circassiens*, ed. G. Wiet (Cairo, 1947), p. 49.

[4] Ibid., p. 112.

scientific certitude about the ensemble's functions and purposes contrasts quite sharply with the main document I should like to discuss: the qur'anic inscriptions.

These are remarkably numerous and, there as in so many other buildings, are usually dismissed as "mere" qur'anic inscriptions. At best a guide book or a writer may point out their calligraphic or ornamental value. In reality, of course, something else seems to me to be involved. The building is unusually rich in inscriptions and these can be divided into three groups, at least for this preliminary investigation and pending a more complete study of inscriptions in general.

A first group consists of generalized pious quotations. Such is the Throne verse, II, 256, found inside the *madrasa* or IX, 129–30, in one of its *eyvans*, which defines the Message of the Faith. In many other buildings, although curiously not Qaytbay's, occur either attributes of God or various other forms of the profession of the Muslim faith. A second [467] group consists of specific passages relatable to the functions of the building or of any one of its parts. Thus the entrance contains parts of II, 211, which begins as follows: "Whatsoever good you expend is for parents and kinsmen, orphans, the needy, and the traveler; and whatever good you may do, God has knowledge of it." Then the mausoleum contains inside II, 139, a passage requiring the faithful to turn toward the *qiblah*, and XLIV, 51–9, one of the eschatological passages describing eternal life. Similar meanings can be given to LVII, 21, and XV, 46, which are found in one of the *eyvans*. These passages are all indicative of functions and of purposes, and their utilization may be as common as IX, 11 or 18–19, used in so many mosques, or XXIV, 35, used in *mihrabs* or on lamps. Or they can be somewhat rarer, as the selection (X, 59; XVI, 71; XXVI, 78–80) found in Nur al-Din's hospital in Damascus which includes passages dealing with healing of the sick.[5] Whether common or rare, this second group of inscriptions is important for two reasons. One is that it makes it possible to identify concretely the contemporary purpose of a building, regardless of its later use; such identifications are essential when one recalls the lack of specificity of so many Islamic architectural forms.[6] The second reason is that through these inscriptions, through a study of their frequency and of the time of their appearance, we may be able to approximate an essential aspect of medieval Muslim relationships to architecture and in some ways also to objects and to painting: the process by which visually perceptible definition and presumably identification of monuments took place. For this second type of inscriptions defines the monument both functionally and socially; it implies a sort of consensus of

5 E. Herzfeld, "Damascus: Studies in Architecture," *Ars Islamica*, 9 (1942), p. 5.
6 A striking example lies for instance in the minarets of Iran, which can be separated into several functional groups through their inscriptions, even though their forms are very much alike.

the literate *ummah* about the association between chosen passages of the Qur'an and the uses of a monument. Its study thus is as justified as that of Byzantine or Gothic iconography, for, as was recently shown by Erica Dodd, the intellectual process is the same.[7]

But then we have a third kind of inscriptions on Qaytbay's ensemble. Inside the *madrasa* there occurs twice XLVIII, 1–3: "Surely We have given thee a manifest victory, that God may forgive thee thy former and thy latter sins, and complete His blessing upon thee, and guide thee on a straight path, and that God may help thee with mighty help." Then on the outside of the same were inscribed the first sixteen verses of *surah* XXXVI, the celebrated *surah Ya Sin* with its liturgical context of burials. It is one of the several passages in the Qur'an which establishes the Prophet's truth as against false prophets. I should like to extract two passages from it: "Surely We have put on their [disbelievers who follow other prophets] necks fetters up to the chin, so their heads are raised; (v.7) … the inhabitants of the city, when the Envoys came to it; when We sent them two men, but they cried them lies, so We sent a third as reinforcement (vv. 12–13)."

Now it is perfectly true that these two quotations can be understood quite simply as belonging to our first group indicating various forms of piety. But they are not very common and XLVIII, 1–5, for instance, is used in the al-Juyushi mosque with a highly concrete [468] meaning.[8] Their choice may become understandable when we turn to the chronicles of the time and to the main events of the years 874–9. Up to 874 the Mamluk regime was plagued by the revolt in the upper Euphrates area (near Ayntab) and in northern Syria of one Shah Suwar who, with his brothers, threatened Aleppo and Mamluk commercial, administrative and military communications. In 874 Qaytbay sends reinforcements and the brothers of Suwar are taken prisoner. Through various envoys Suwar seeks to make peace in exchange for a position in the Mamluk hierarchy. These negotiations fail and it is only in 876 that military victory is achieved and Suwar sues for peace. In 877 he is captured by an official plenipotentiary, Timraz, who gives him his word that his life will be spared. Another amir, Barquq, gives him a robe of honor which had fetters in the lining so that his neck was kept engaged. It is with irons around his neck that he was brought to Cairo, paraded all over the town, and eventually crucified, carried on the back of a camel around Cairo, and then hanged. As the chronicler put it, "it had been an unforgettable day, an extraordinary event, as one rarely sees them."[9] It should be added that the plenipotentiary who had negotiated for Suwar's safe-conduct felt betrayed and resigned for a while from his office.

7 Erica Dodd, "The Image of the Word," *Berytus*, 18 (1969), pp. 35–61.
8 O. Grabar, "The Earliest Islamic Commemorative Structures," *Ars Orientalis*, 6 (1966), pp. 28–9.
9 Ibn Iyas, *Histoire*, pp. 46, 80 ff.

The suggestion one could make, then, is that the choice of some of the qur'anic quotations was the result of the concrete events which coincided with the completion of the building. The victory mentioned in one excerpt was the one over Suwar and the truncated excerpt from the thirty-sixth *surah* was chosen because it seemed to refer to the manner of Suwar's punishment and to the rather tricky negotiations by several messengers which led to his capture. The coincidence of dates and the importance given by chronicles both to the affair of Suwar and to the building of Qaytbay's masterpiece make the interpretation possible if not plausible.

The point of this paper does not, however, lie so much in the elucidation of a detail of Mamluk architecture and history as in the elaboration of a major direction for research. It consists first of all in the creation of a corpus of qur'anic quotations done in such a manner that it becomes possible to separate at a glance the typical from the unique inscription.[10] For, as our knowledge of Islamic art progresses, it becomes more and more evident that qur'anic citations were used in the manner of biblical subjects in Christian iconography. They were the vehicles – or at least one of the vehicles – through which the culture separated the typical from the topical, the transcendent and permanent from the unique and permanent. And because of its wealth of sources and of monuments, the Mamluk art of Egypt and of Syria is an excellent area to begin an investigation of the concrete motors of medieval Islamic creativity. In this fashion, through its iconography, Islamic architecture will acquire a new dimension not only for the art historian but for the social and political historian as well. [469]

[10] A project in this direction has been initiated by Dr Erica Dodd and it is hoped that it will soon come to some sort of conclusion. See Erica Cruikshank Dodd and Shereen Khairallah, *The Image of the Word*, 2 vols (Beirut, 1981).

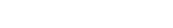

Chapter XV

Isfahan as a Mirror of Persian Architecture*

All travelers to Iran are aware of the saying that Isfahan is *nesf-e jehan*, "half the world," and few visitors to that city, even jaded and cynical scholars, have failed to be infected by an enthusiasm for it which is usually more characteristic of travel agents and cheaper guide books. In a way there is something odd about this enthusiasm, for most of its palaces are now gone, its great avenue, the Chehar Bagh, is crowded with bicycles, automobiles, souvenir shops, and cheaper versions of ten-cent stores, and its celebrated bridges cross a non-existent river blocked somewhere else by a modern dam. Isfahan is a modern industrial town and, while its setting is no doubt impressive, it does not at first glance have the spectacular quality of Persepolis or the deeply felt holiness of Qumm or Mashad, nor does it possess the feverish activity, the libraries or the museums of Tehran.

Why then this reputation? There are, I submit, two reasons. One is perhaps limited in its importance to students of traditional Iran and of classical Islamic civilization. It is that Isfahan is fairly well known, not only through its monuments but also through the life it contained in its heyday in the seventeenth century. The Persian sources have been combed and analyzed by Professor Falsafi and related in the four volumes of his *Zendegani-e Shah 'Abbas-e Avval*, but a sense of the city is also available through contemporary Western eyes. The critical businessman Tavernier, the enthusiastic traveler Pietro della Valle, and the longtime resident Chardin have recreated its streets and buildings. One can reconstruct its building activities, its mercantile excitement, its royal parades and ceremonies, its polo games and entertainment, its often cruel law enforcement, its varied population, even its seamy sides like the apparently flourishing prostitution in its main square. Only Cairo and Istanbul are similarly well documented, but the accounts pertaining to Isfahan are unique for their liveliness and for their literary merits. As they describe the glorious and the shoddy but mostly the immensely human mechanics of seventeenth-century life, they illustrate much more than one period only; they are [214] a document for

* First published in R. Ettinghausen and E. Yarshater, eds, *Highlights of Persian Art* (Boulder, 1979), pp. 213–42.

1 Isfahan, the
so-called Jurjir
mosque, façade,
tenth century

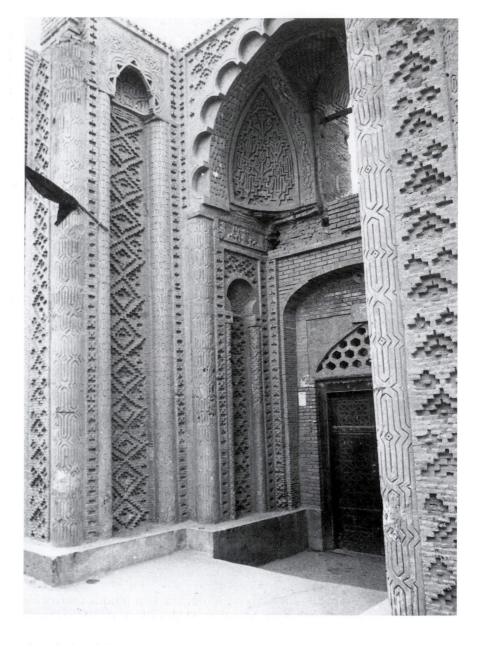

the whole of the Near East and, in a broader sense, a superb and precise panorama of one version of human experience.

The other source of Isfahan's reputation is its architecture. From the so-called Jurjir mosque façade (Fig. 1), probably of the tenth century, through the Masjed-e Jom'eh with its eleventh-, twelfth- and fourteenth-century elements, the Darb-e Emam or the Masjed-e 'Ali of the fourteenth and sixteenth centuries, ending with the seventeenth-century complex around the Meydan-e Shah and the eighteenth-century *madrasa* of the Madar-e

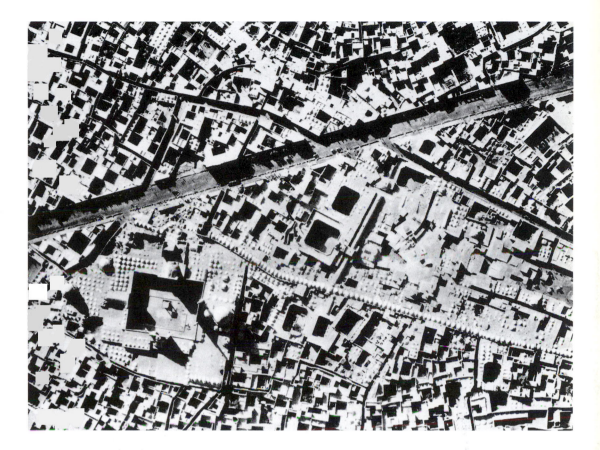

2 Isfahan,
Masjed-e Jom'eh,
air view

Shah, it is the whole panorama of Iranian Islamic architecture which is
visible in Isfahan. No other Iranian city possesses the same range and only
the early fourteenth and fifteenth centuries are better represented in Tabriz,
Soltaniyeh, Samarkand, or Mashhad. It is true of course that individual
monuments elsewhere – Oljaytu's Mausoleum, the *madrasa* of Khargerd,
the Kharraqan tombs, the fourteenth-century buildings of Yazd, or the
monuments of Herat – may be far greater masterpieces than all but two of
Isfahan's remaining buildings. But the presence in one city of so many
monuments and especially the preservation of the two unique ensembles
of the Masjed-e Jom'eh and of the Meydan-e Shah make it possible to pose
there better than anywhere else in Iran some fundamental questions about
Islamic Iranian architecture, in a way about any architectural tradition:
what kinds of meaning can and should be attributed to the visible and
measurable forms? How should one see and appreciate them? Are there
specific and unique characteristics of the Iranian architectural experiment
which in some fashion or other explain or illustrate a facet of the broader
culture of Islamic Iran? Or is the cultural uniqueness secondary to a more
general human search for sheltering a variety of activities? How are we to
interpret differences and changes which may have occurred? Do they

3 Isfahan,
Masjed-e Jom'eh,
qiblah dome from
the outside, late
eleventh century

illustrate variable aspects of the same culture or are they incompatible with each other?

Such are the kinds of questions which have so far hardly been investigated in Islamic or Iranian art, except in very recent months by Nader Ardalan, whose *Sense of Unity: The Sufi Tradition in Persian Architecture* is a revolutionary attempt at explaining at least one facet of Iranian architecture. Part of the reason for the paucity of such research is simply that it is a new field; few monuments are well published or archaeologically investigated and only fifty years ago most of them were not even accessible. Hence it seemed only natural that so much effort has been centered on apparently prosaic, but in reality essential, publications of standing or ruined monuments, on lists of inscriptions, and on the search for historical documents. But another reason is that traditional Iranian writing lacks the formally expressed [215] thoughts of practitioners like Vitruvius or Alberti to guide us in the interpretation of monuments. We have no contemporary aesthetic judgment to initiate discussion in the manner, for instance, of Rudolph Wittkower's study of Renaissance architecture in Italy; we do not even possess a coherent terminology for the parts of buildings or for their ornament, although some research is being carried out to record at least contemporary terms before they are submerged in a new vocabulary of building. The historian is, therefore, compelled to use principles and methods developed in other lands and for other times and, with them, to seek

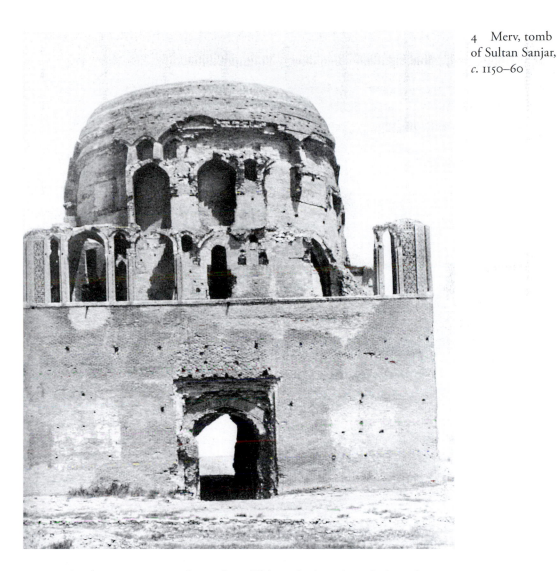

4 Merv, tomb
of Sultan Sanjar,
c. 1150–60

answers in the monuments themselves. This technique has obvious dangers of misinterpretation, either because it applies alien methods to an indigenous tradition or because it seeks to draw conclusions and to develop hypotheses before a sufficient number of monuments have been adequately published. The remarks which follow must, therefore, be considered as a very preliminary and very tentative attempt at setting up the sort of intellectual framework through which medieval Iranian monuments could be understood as aesthetic phenomena and not simply as historical or cultural documents for various types of human activities or for certain forms of piety. The manner in which I should like to present these remarks consists of describing briefly the two most impressive monuments of Isfahan, of proposing an aesthetic definition of each one, and then of drawing up a few hypothetical suggestions for further work and meditation.

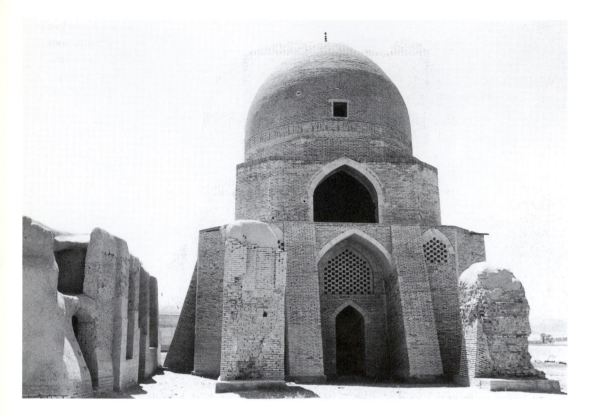

5 Dashti, *qiblah* dome in mosque, fourteenth century

The Masjed-e Jom'eh

This is not the place to discuss the immense chronological problems of this most celebrated building, often seen as the Chartres of Iran, for its archaeological investigation is in progress and preliminary reports have already brought to light many new documents. Our concern in the context of this essay is less with details of chronology or with specific dates than with the character and significance of its major features.

As it appears in air photographs (Fig. 2), it consists of a central open area with a typical façade of four *eyvans* around the open space; from this core, aesthetically a sort of inverted Parthenon whose fixed modular anchor is in the middle of the building rather than on the outside, the monument spreads out and almost melts into the surrounding city. There are many separate elements involved in the monument, including an almost independent fourteenth-century *madrasa*, and much discussion has taken place about the chronological development of the mosque. Without concerning ourselves with the possibly pre-Islamic fragments found recently, we may agree that there are Muslim remains ranging from the ninth to the seventeenth [217] century but that the central core existed in approximately its present architectural if not decorative scheme either in the twelfth or in the fourteenth century. Whichever date is to

be eventually adopted, the key point is that the mosque is a complex conglomerate which did not acquire its presently visible compositional unity until relatively late. Very much as at Chartres, therefore, any consideration of its aesthetic values must, at this stage of our knowledge, be limited to individual parts.

Two of these stand out as unique masterpieces and have been recognized as such since they became known. One is the *qiblah* dome (Fig. 3). It belongs to a well-established group of cupolas either standing alone as holy places or central foci of a larger mosque. The former appear most frequently as mausoleums, as for instance the tomb of Sultan Sanjar in Merv (Fig. 4); the latter are particularly characteristic of mosques from the eleventh to the fourteenth century in western Iran (Fig. 5) where they were frequently built separately from the rest of the building, while in later times they became integral parts of architectural compositions, as in Samarkand's Bibi Khanom mosque (Fig. 6). On the same axis, but at the opposite end of the monument, is found the so-called North dome (Figs 7–10), whose original purpose is still somewhat of a mystery. Both of these two domes are dated in the second half of the eleventh century and, while they differ in that the northern one possesses a far more complex elevation, they share a number of features as well. They are large, massive brick constructions towering above everything around them. From the outside the *qiblah* dome appears as an almost contemporary construction in which nothing is visible except the medium of construction and the solid purity of simple forms. The North dome is

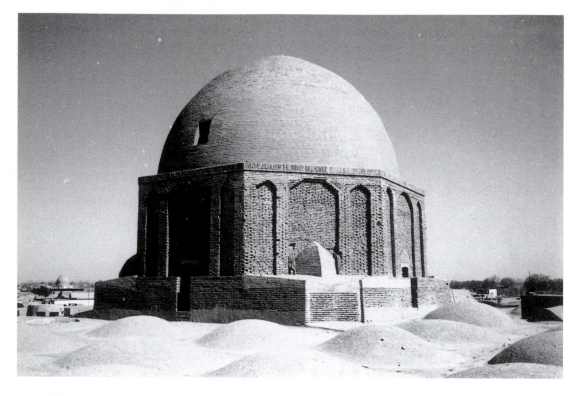

7 Isfahan, Masjed-e Jom'eh, North dome, outside, late eleventh century

articulated through a series of recesses on its octagonal section, but this articulation is accomplished through the bricks of the construction and only serves to emphasize the main lines of the monument.

The interior of both domes is more complex. In the *qiblah* dome the square, with its articulated heavy piers, appears as a separate entity from the octagonal zone of transition with *muqarnas* squinches providing the main rhythm of the zone and from a simple cupola with clearly visible ribs. The North dome is a much more unified composition, with the square and the zone of transition composed together through an elaborate articulation of piers logically connected with the superstructure. As has been demonstrated by Schroeder, every major point in the elevation was consciously determined according to the irrational proportions of the Golden Mean. The cupola itself is not connected with its lower part according to the same visible articulations [220], but it contains its own complex compositional rhythm based this time on a central pentagon from which a linear pattern is generated. While not an architectonic one, the latter utilizes the medium of construction and, even though it appears unnecessary to the construction, almost like an applied ornament, it is in reality intimately bound to the overall composition of the room, for its pentagonal design is also the result of the same type of numerical proportions as are required by the Golden Mean. It is almost like a two-dimensional elaboration of the three-dimensional room. [222]

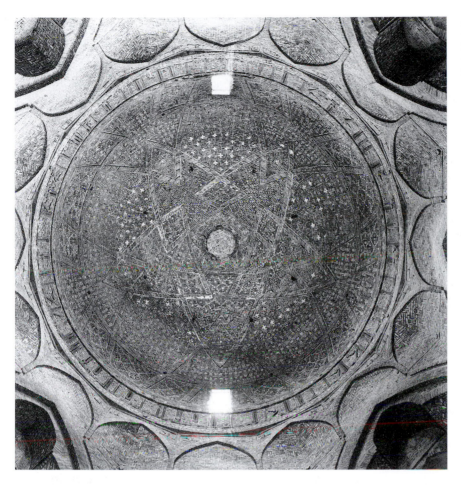

8 Isfahan, Masjed-e Jom'eh, North dome, inside of dome

In both cupolas the *muqarnas* in the octagon (Fig. 10) serves best to illustrate the main point. For this formal unit, which breaks up the curvature of the squinch niche and possesses only minimal structural value, if any, has been made to appear as belonging to the logic of construction. Its segments, which in many earlier and at times later monuments seem arbitrary combinations of vaulted parts, are here provided with architectural sense. Even if they do not really support the dome, their arrangement suggests that they may do so. And the surface decoration which exists in both domes in the form of stucco or [223] terracotta does not overwhelm the spatial and architectonic perception one acquires of the building.

Much more, of course, can and should be said about these two domes. But my main point is that, through their immediate visual impact as well as through an analysis of some of their parts, they illustrate what I should like to call an architectonic strand in Iranian architecture, a concern for solid large masses, for constructional logic, for a coherent and immediate identification of the spatial units of a [225] building. It is a tradition that is

9 Isfahan,
Masjed-e Jom'eh,
North dome,
interior of room

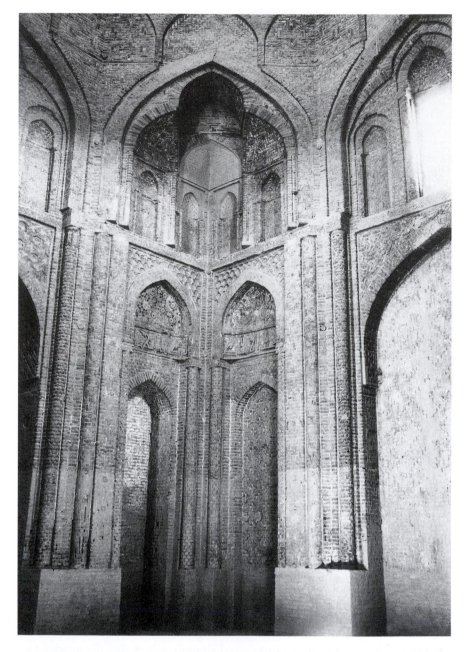

illustrated elsewhere in the mosque in many of its smaller domes and vaults; it appears in twelfth-century minarets in the area of Isfahan (Fig. 11), and in a celebrated series of twelfth-century mosques like those of Ardestan, Barsian and Zavareh or in many tower tombs and mausoleums of the eleventh and twelfth centuries, like the strikingly modern Gonbad-e Qabus (Fig. 12). It certainly continues in the fourteenth-century buildings with the spectacular and megalomaniac mosque of 'Ali Shah in Tabriz and with the mausoleum

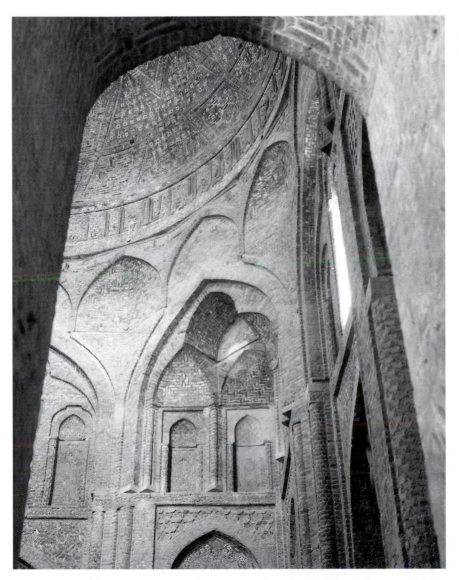

10 Isfahan,
Masjed-e Jom'eh,
North dome,
muqarnas squinch

of Oljaytu (Fig. 13). It reappears in fifteenth-century buildings like the
madrasa of Khargird, the Eshrat-khaneh in Samarkand, or the Tayabad
sanctuary (Fig. 14). In other words, even though it is most characteristic of
eleventh- and twelfth-century monuments, a primarily architectonic tradition
emphasizing engineering skills and structural values remained for several
centuries as a central concern of Iranian Islamic architecture, the extent and
temporal or geographical limits of the concern still requiring investigation.
[228]

A word of caution is, however, necessary. While the two late eleventh-
century Isfahan examples I have discussed are particularly brilliant examples

11 Ziyar (near
Isfahan), minaret,
twelfth century

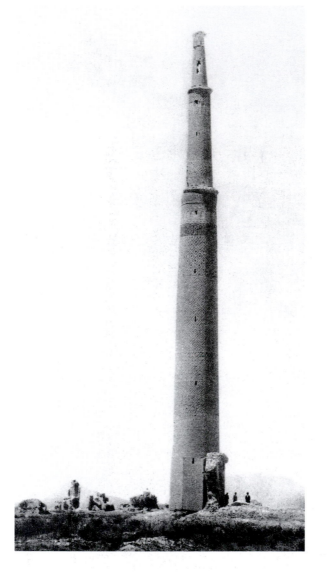

of an architectonic conception of a building, many details of these or of
contemporary and comparable buildings suggest something else. A detail
of a niche in the North dome of Isfahan (Fig. 15), or sides of mausoleums
like those of Demavend or of Kharraqan, or else the detail of many
minarets (Fig. 16) introduce another concern, with which I shall deal
presently, even though the buildings themselves possess the massive
sturdiness of the architectonic tradition. The question is to decide what
was primarily meant to be seen, the detail or the ensemble, and in what
relationship to each other. While the concern for overall proportions in
the North dome of Isfahan makes it likely that the whole unit took
precedence [229] over its details, the matter is not always clear, and research

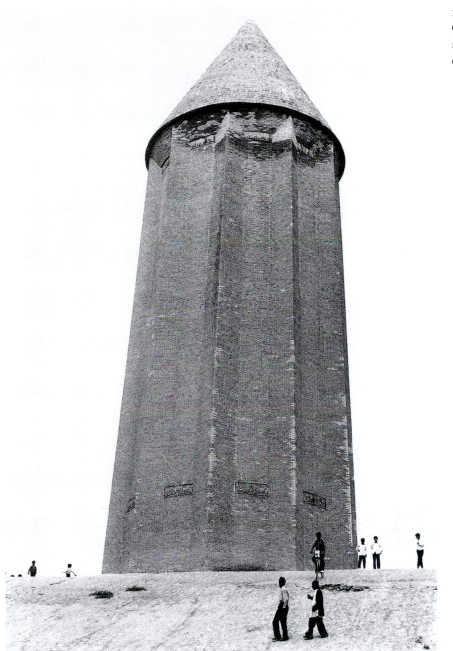

12 Gonbad-e Qabus, tower-mausoleum, early eleventh century

13 Sultaniyah, mausoleum of Oljaytu, early fourteenth century

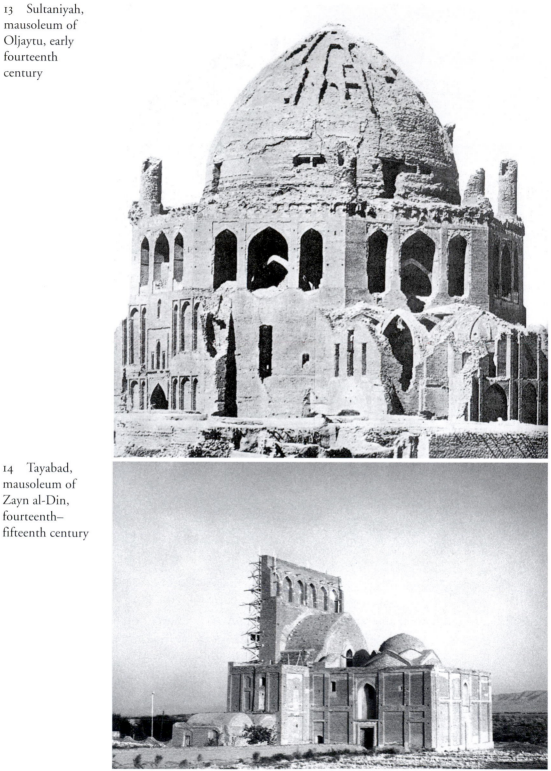

14 Tayabad, mausoleum of Zayn al-Din, fourteenth–fifteenth century

of a different kind other than art-historical analysis is necessary to find out
how these and other buildings were meant to be perceived. But in a
broader sense the conclusion I want to emphasize is that the tradition I am
seeking to isolate should not be considered as exclusive of other ways of
conceiving a work of monumental architecture.

15 Isfahan,
Masjed-e Jom'eh,
North dome,
detail of wall
decoration

Safavid Constructions around the Meydan-e Shah

The Meydan-e Shah and its immediate surroundings are a creation of Shah
Abbas between 1598 and 1628 with a number of additions and completions
under Shah Safi and other seventeenth-century monarchs. The center of the
composition (Fig. 17) is a huge (512 by 159 meters) open space used for a
variety of purposes: polo playing, [230] parades, games, festivals, executions
and so forth. The Meydan was lined with shops in what was originally,
according to Tavernier, a reasonably organized hierarchy of trading and
manufacture.

 On each side of the Meydan a monumental façade leads to some major
architectural unit. To the south it is a mosque, the celebrated Masjed-e
Shah. It has a monumental portal framed by two minarets (Fig. 18). While

16 Bukhara,
Kalayan minaret,
detail, early
twelfth century

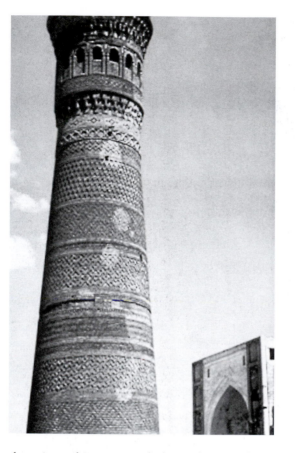

there is nothing unusual about the portal's *muqarnas* half-dome, its setting
in a sort of polygonal recess is original. The mosque itself is at an angle to
the portal because the Meydan was not canonically oriented. It is an almost
perfect mosque with four *eyvans*. Each *eyvan* is followed by a dome and the
eyvan qiblah is larger and [231] more monumental than the other three,
while its dome towers over the whole city (Fig. 19). The areas immediately
adjacent to the axial *eyvans* were divided into squares and covered with
smaller cupolas set on the modified pendentive construction developed in
Timurid times. The two corners of the building which are farthest from the
Meydan were left uncovered, somewhat like courts with an inner façade.
The whole building was lavishly decorated with tiles, thus transforming its
effect into a sort of festival of colors (Fig. 20).

On the opposite side of the Meydan stands the monumental entrance
into the bazaar. The bazaar is at this time being studied and surveyed by a
team of Iranian architects whose results have so far only [232] been partially
made public and, therefore, all that ought to be said about it is that it was an
enormous commercial enterprise organized around domed nodes and
intersecting covered streets, leading from the new Safavid creation all the
way to the earlier city surrounding the Masjed-e Jom'eh.

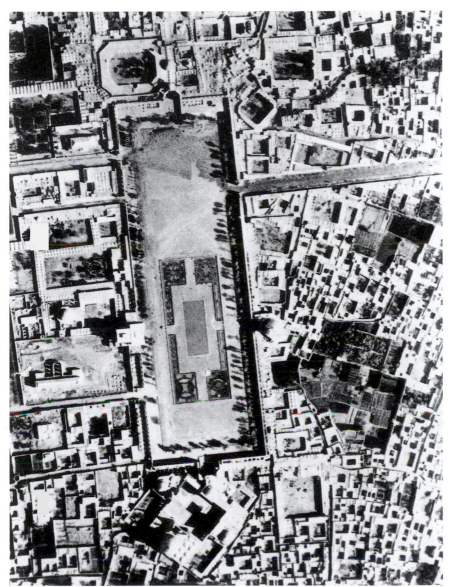

On the eastern side of the Meydan stands the jewel of Safavid architecture, the private oratory built in honor of Shaykh Lotfollah, the saintly father-in-law of Shah Abbas (Fig. 21). An architecturally less elaborate but decoratively far more complex portal than at the mosque leads through a series of passageways into a single square chamber covered with a dome (Fig. 22). [233]

Finally, the western side of the Meydan contains the Ali Qapu, the High Gate (Fig. 23). It is on the one hand the first unit in a string of royal buildings, mostly pavilions set in gardens, which extends all the way to the river. Of these only a few still remain, like the Chehel-Sutun or the Hesht

18 Isfahan,
Meydan-e Shah,
portal of Masjed-e
Shah, late
sixteenth century

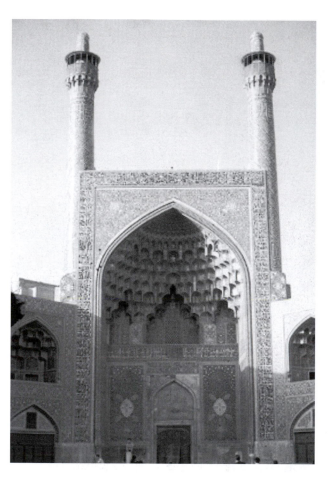

Behesht, recently restored by Italian teams of specialists. But the Ali Qapu is also a unique building on its own. It is like a series of individual boxes set within each other (Fig. 24). Some are mere passageways, horizontal ones leading into the gardens beyond, or vertical ones moving in and around a core of more official units of composition. The latter comprise the celebrated open platform on wooden columns which overlooks the Meydan and rooms of varying size with most extraordinary systems of vaults done entirely in thin [235] stucco and reproducing in a baroque – almost rococo – fashion themes of palace life: places for vases, cups, goblets, flowers, and other symbols of a life of pleasure (Fig. 25).

It is true, of course, that there is something grandiose and magnificent in the seventeenth-century constructions. But it seems appropriate to add that their grandeur lies in their planning, in their layout over a vast area, not in the character of any one of the units. For these were not conceived as architectonic masses but as elaborate surfaces, at times simple successions of flat panels, at other times more complex three-dimensional compositions or curved spaces. But in all instances the main point of the artistic effort

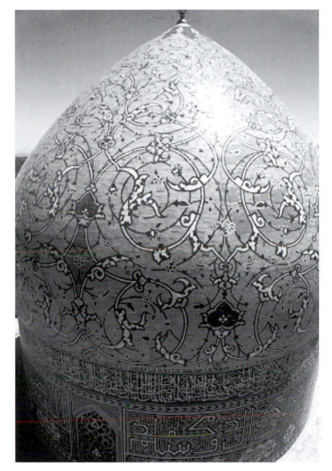

19 Isfahan,
Meydan-e Shah,
qiblah dome of
mosque

was a sort of transfiguration of the building through the covering of walls
with colorful tiles, whose designs tend (with a number of exceptions) to
develop inwardly within each panel rather than outwardly toward the unit
of construction. In contrast to the architectonic quality of the domes in
the Masjed-e Jomʻeh, the main characteristic of this tradition may be
called decorative, in the sense that its most immediately perceptible features
are not necessary for the buildings to stand up or to be used; they can
almost always be considered separately from the architecture. In fact, if
one looks for instance at a section of the Masjed-e Shah (Fig. 26) or of the
Ali Qapu, one can hardly avoid the feeling of an architecture of theatrical
flats which could be shifted around almost at will and whose surfaces
could be redone at any time with little effort and without affecting the
building.

While this tradition is superbly expressed in the imperial monuments of
Safavid Isfahan, it is not unique to the sixteenth or seventeenth centuries.
Partly subdued under the impact of numerous constructional experiments

20 Isfahan,
Meydan-e Shah,
detail of tile work

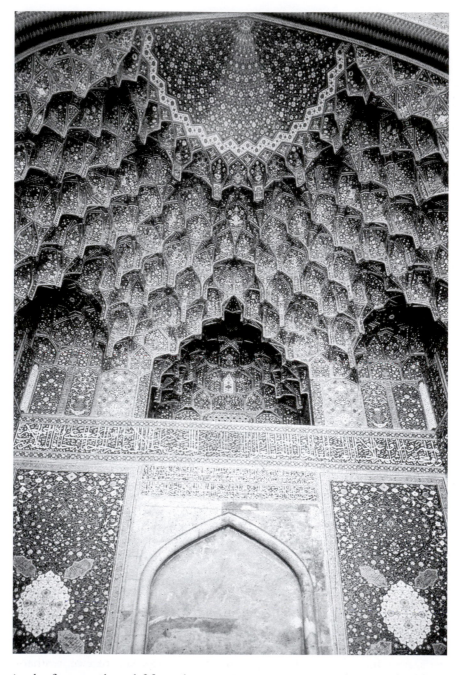

in the fourteenth and fifteenth centuries, it is present in the great buildings
of Mashad (Fig. 27), Samarkand, Khargerd, and in the sanctuary of Pir-e
Bakran near Isfahan, to name just a few examples. It is visible in many
mausoleums and minarets of earlier times and occurs in a particularly curious
form in the stucco ornament of the northeastern Iranian caravanserai at
Robat Sharaf dated in the middle of the twelfth century (Fig. 28).

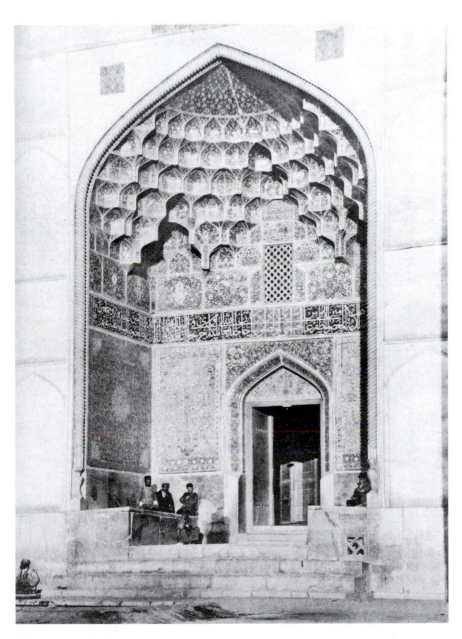

21 Isfahan,
Shaykh Lotfollah
sanctuary, façade

Thus the rapid analyses of two major ensembles created at different times in Isfahan have led to the suggestion of the presence of two aesthetic traditions or tendencies, one concerned with large masses and architectonic values, the other with surfaces and with decorative values. One should hasten to add that with both traditions it is not so much sharp contrasts that are involved as emphases. For one could not deny the spatial values of a building like the Masjed-e Shah, or the ornamental detail of brickwork in the North dome of the older [236] mosque. Should we then see in Isfahan's

22 Isfahan,
Shaykh Lotfollah,
dome from inside

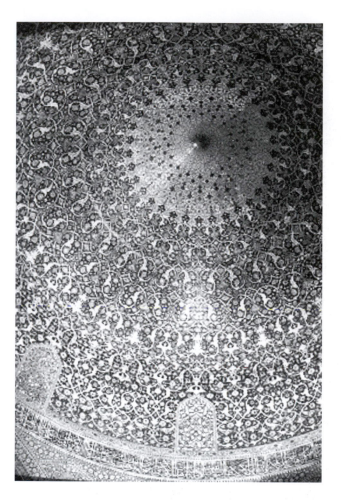

architecture an oscillation between two ultimately antagonistic but ever-present poles and envisage the whole of Iranian architecture *historically*, as taste or other reasons still not investigated compel one or the other tradition to come to the fore? Should we tend to contrast these poles and conclude that, just as Romanesque or Baroque churches are aesthetically incompatible, so are the monuments of Isfahan? They reflected such different purposes and visions that there is no point in envisaging them together as expressions of the *same* culture, except in the sense that, by harboring Santa Maria Maggiore, San Pietro and Gesu, Rome expresses in unique fashion the varieties of Christian architecture, but not the same Christian culture.

We may also interpret these monuments in a different way. We may suggest that temporal differences are secondary and that, beyond immediately perceptible oppositions, there remains a commonness of value which would identify a continuous culture, in the manner in which, for instance, the transfer of the Italian Baroque to France, [237] Germany, or Spain acquired features which presumably make some of the monuments in the new countries

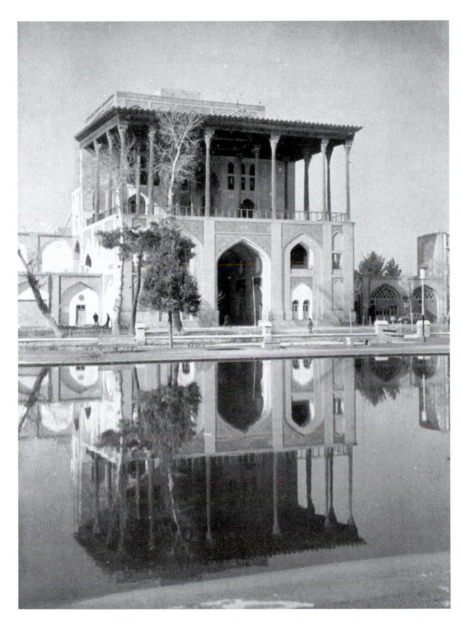

23 Isfahan, Ali Qapu

French, German or Spanish rather than only imported Italian. And indeed a unifying theme may exist in all these buildings and could be called an attempt to create an illusion of something other than the building itself. Thus, even though actual means of creating illusions vary from building to building or from time to time, the consistency with which exteriors and interiors differ from each other, or with which attention is caught in details of construction or decoration rather than in large ensembles, can be interpreted to mean that the point of monumental architecture was to create a means of suggesting something other than immediately perceptible common

24 Isfahan, Ali
Qapu section
(after Zander)

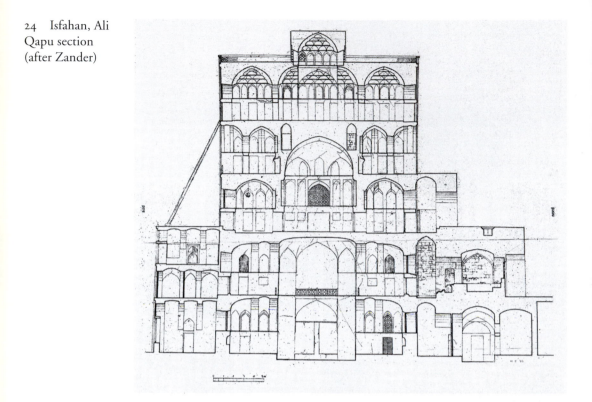

life. In this sense the brilliant colors of the mosque of Shaykh Lotfollah and
the interior façade of the Masjed-e Jom'eh serve the same aesthetic purpose
of proposing a rarefied and unreal mood to user or beholder, and, in
understanding or explaining the monuments of the eleventh and twelfth
centuries, the apparently minor key of their decoration should be considered
as their main effort. Or perhaps it is the subtle geometry and logic of the
architectural effect through design which should be seen as predominating
rather than the power of large masses.

Such a search for a mood and for an illusion in architecture can easily
be related to a series of deeply Islamic ideals. Monuments are [238] not
built for God but for men, and the creation of consistent and often
repetitive settings for very diverse human activities is a reminder of the
unreality of nature and of the world, not an attempt to compel a concrete
conception of the divine. The illusion of an artificial architectural creation
demands a meditation on the holy, and its abstract and arbitrary qualities
of ornament or even of planning transform monuments into settings for a
wide range of human activities or thoughts. Architecture, as in Hafez's
poem, is a messenger "only bound to carry the message sent," not to elicit
responses. It is an illusory setting in which anything can happen, for in
truth each man [239] is free to make his own choice of behavior. Architecture
is but the inactive setting of his good and evil deeds, having merely by its

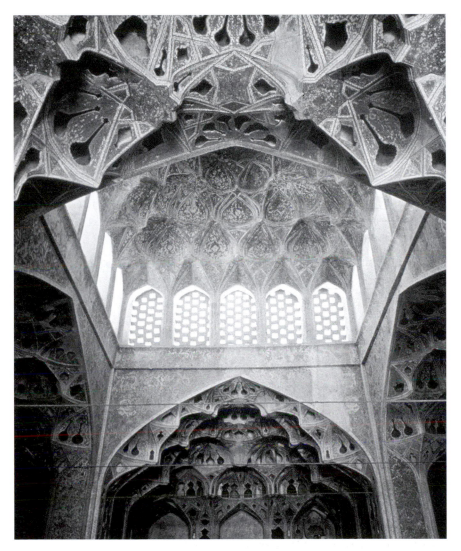

25 Isfahan, Ali Qapu, detail of stucco vaulting

artificiality sent the message of the transitory and unreal character of the world.

We are thus confronted with two ways of seeing Iranian architecture in the Middle Ages, in Isfahan or elsewhere. One, historical and scientific, emphasizes *differences* in taste and in types, searches for chronologies and influences, and sees each period and almost each monument as uniquely different, as an expression of highly immanent [240] needs and visions, often in willed contradiction to whatever preceded or followed. The other, more transcendental and more deeply embedded in cultural continuity, emphasizes *common* features and seeks in each period and each monument an illustration of a single attitude characteristic of a land and of a civilization, such as, for instance, the theme of illusion which was sketched here but

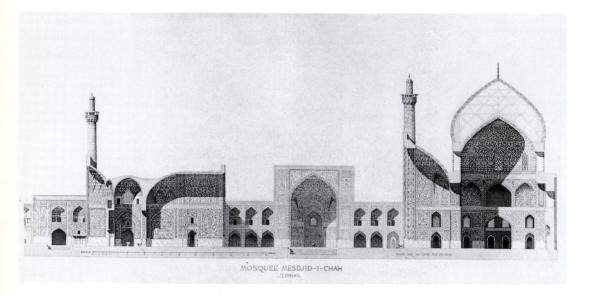

MOSQUEE MESDJID-I-CHAH
JSPAHAN.

26 Isfahan,
Masjed-e Shah,
section

which is only one of the many possible. Between these two views it is at this time impossible to choose. This is so in part because both need considerable further elaboration in details and in theoretical considerations. But it is possibly also so because the choice between them is not, in the final analysis, imposed by a knowledge of monuments as much as by the mind of the investigator. Perhaps, like the Iranian architecture we discussed, they are simply two contradictory but ever-present facets of man's mind and taste.

Bibliographical Note

An interpretative essay such as this one, given originally as a lecture, does not lend itself to organized annotation. What follows is instead a general bibliographical introduction to Islamic architecture divided into the two categories of broad surveys and works dealing specifically with Isfahan.

A. SURVEYS

The only fairly complete, although very out-of-date, survey is A. U. Pope and Ph. Ackermann, *A Survey of Persian Art* (Oxford, 1939), with an excellently illustrated summary in A. U. Pope, *Persian Architecture* (New York, 1965). A brilliant and controversial interpretation of Iranian architecture can be found in N. Ardalan, *The Sense of Unity* (Chicago, 1973). Two books contain numerous illustrations but more debatable texts: D. Hill and O. Grabar, *Islamic Architecture and its Decoration* (London, 1967) and S. Seher-Thoss, *Design and Color in Islamic Architecture* (Washington, 1968). Models of careful scholarship but limited in chronological scope are D. Wilber, *The*

27 Mashad, Gawhar Shad *madrasa*, façade on court, fifteenth century

Architecture of Islamic Iran: the Ilkhanid Period (Princeton, 1955) and M. B. Smith, "Material for a Corpus," *Ars Islamica*, 2, 4, 6 (1935–38). The best surveys of Islamic architecture in the Soviet Union are those of G. A. Pugachenkova and L. I. Rempel for Central Asia and L. Bretanitskij for Azerbayjan.

B. ISFAHAN

A. Godard, "Isfahan," *Athar-é Iran*, 2 (1937).

A. Godard, "Historique du masdjid-e Djum'a," *Athar-é Iran*, 1 (1936).

A. Gabriel, "Le masdjid-i Djum'a," *Ars Islamica*, 2 (1935).

Lutfallah Hunarfar, *Ganjiney-e Athar Tarikh-e Isfahan* (Isfahan, solar *hijrah* year 1344).

G. Zander, *Travaux de Restauration* (Rome, 1968).

E. Galdieri, *Isfahan* I and II, Rome (1972, 1973 and 1984).

O. Grabar, *The Great Mosque of Isfahan* (New York, 1990).

28 Robat
Sharaf,
caravanserai,
detail of wall
decoration,
twelfth century

Chapter XVI

Reflections on Mamluk Art*

The exhibition of Mamluk art organized by Esin Atil and the symposium held in Washington DC, at its opening were both memorable occasions. Jointly they provided one of the very few opportunities in the slowly growing field of Islamic art for the collective attention of a large number of art historians and a smaller number of historians to focus on a single period. This volume of *Muqarnas* records much of the material that was presented at the symposium.

As is both common and appropriate in a new field, the overwhelming majority of the papers are taxonomic: they seek to organize a quantity of objects or monuments of architecture into formal, technical, or other categories, to provide accurate definitions of those categories, to propose and justify dates, and to suggest an evolution of style and function. One cannot quarrel with those objectives, but at the same time Mamluk objects, whether or not they were in the exhibition, and the great masterpieces of Mamluk architecture raise more complex questions of meaning and perhaps require more speculative treatment. In answering those questions and in suggesting different interpretations we can perhaps add to our understanding both of the nature of Islamic art and of the methods of the history of art in general.

A priori, few periods of Islamic history lend themselves as well to a thorough and detailed analysis as does the Mamluk period in Egypt and the Levant.[1] Its chronological framework is clearly defined by major political events: although one can quibble over whether 1250 or 1260 signaled its beginning, there is general agreement that 1517 marks its end. Its geographical spread is equally clearly defined. Egypt was its center; Syria, Palestine, and most of the Arabian

* First published in *Muqarnas*, 2 (New Haven and London: Yale University Press, 1984), pp. 1–12.

[1] Esin Atil's catalog, *Renaissance of Islam: Art of the Mamluks* (Washington, DC, 1981), contains an extensive bibliography of secondary works that can easily serve as an introduction to Mamluk studies in general (pp. 266–82). For primary sources only piecemeal introductions are available, such as Donald P. Little's *An Introduction to Mamluk Historiography for the Reign of al-Nadir* (Wiesbaden, 1970), and Barbara Schäfer, *Beiträge zur mamlukischen Historiographie* (Freiburg, 1971).

peninsula were its provinces. Compared with the territorial uncertainties of
the beyliks of Anatolia or of the contemporary Turkic and Mongol dynasties
of Iran, the Mamluks were tied to a reasonably well-demarcated area, to which
they introduced a reasonably well-oiled administrative structure. Although
subject to numerous changes and at times to devastating crises, the economic
foundations of Mamluk wealth – primarily as middlemen in the transit trade
from the East to the West – remained fairly secure. Cairo was the largest
metropolitan center in the world throughout these two-and-a-half centuries.
It was also a haven for refugees from the whole of Muslim western Asia,
especially during the first half-century of Mamluk rule, and its stature as a
major intellectual center was maintained throughout the Mamluk period as
Muslims from independent North Africa and Spain came there to learn and to
work. Many of the intellectual, religious and legal leaders of the budding
Ottoman world were trained there.

The Mamluk period is superbly documented. Chronicles abound in great
variety, permitting a reconstruction of events that is more balanced than is
possible for earlier centuries, for which so often a single source predominates.
Although less accessible, legal and archival documents are also numerous,[2]
and there are masses of literary, pietistic, scientific, philosophical, and even
popular compendia, studies and texts of all kinds. Mamluk coins and
inscriptions have by and large been published. Mamluk history, society,
trade and institutions have been the subjects of numerous studies and – a
rare phenomenon in Islamic historiography – of actual scholarly debate.
Most important for our purposes, the monuments of Mamluk times are
visible. Cairo, Tripoli and Jerusalem are very much Mamluk cities, and
Damascus, Aleppo and the holy cities of Mecca and [2] Medina were
enormously modified during Mamluk times. According to the estimate of
Michael Meinecke, nearly a third of some 3,300 identifiable Mamluk
construction projects (new buildings and restorations) have been, at least in
part, preserved.[3] Thousands of Mamluk objects fill the galleries and reserves
of museums all over the world. In contrast to the situation for Iran, India, or
the Muslim West, studies of the architectural monuments and, to a lesser
degree, of smaller objects are available in books or articles. From the grand
volumes of Napoleon's *Expédition de l'Egypte* to recent monographs on
individual buildings or objects, the bibliography on Mamluk art is extensive
and, however critical one may be of its intellectual shortcomings, for the
most part reasonably accurate.[4]

2 See Muhammad M. Amin, *Catalogue des documents d'archives du Caire* (Cairo, 1981),
 and Donald P. Little, "The Significance of the Haram Documents," *Der Islam*, 57
 (1980).
3 "Regional Architectural Traditions," paper presented at "The Renaissance of Islam: The
 Art of the Mamluks," National Gallery of Art, Washington, DC, 13–16 May 1981.
4 What constitutes acceptable accuracy in publication is a complicated question. New
 surveying methods and the development of new technical knowledge about painting

The Mamluk period coincides with the most extraordinary changes in the arts and culture of Eurasia, which begin as the Pisani cautiously discover antique sculpture, as Gothic cathedrals cover Northern Europe, as Anatolian architecture hones its Seljuq models, and as literate and sophisticated Sung painting still rules in China. It ends in the time of Raphael and Leonardo, when Northern Europe and Spain discover Italy, when the Ottoman dome is ready for Sinan's perfection, and after two brilliant centuries of Persian painting. In the thirteenth century the Crusaders were finally and definitively defeated, and Western awareness of Asia depended on Marco Polo and some lonely Dominican friars; by the beginning of the sixteenth, Portuguese and Spanish vessels sailed the entire Indian Ocean, and the Ottoman fleet was barely able to stand up to Italian and Spanish navies in the Mediterranean Sea.

Thus, for three different reasons – internal cohesion and continuity; quantity, variety, and availability of information; and concomitant historical and cultural changes elsewhere – the Mamluk period offers opportunities for research that are rare in other areas or for other times.

Methodologically, problems of this period are simple enough and, on the whole, hardly unusual. Some result from the sheer quantity of documents: determining the qualitative range of Mamluk art, for surely with so many examples it is unlikely that the same quality was maintained throughout; identifying paradigmatic works through which other works can be evaluated; and establishing the social range of Mamluk art, as it is highly improbable that different kinds of patrons sponsored or acquired the same kinds of objects.

Other problems are essentially historical: the sources of Mamluk art, its stylistic evolution, the relationship between the Cairene center and the provinces or among the provinces themselves. A more specific subject arises from contrasting the two-and-a-half centuries of Mamluk art with the changes wrought in Anatolia, Iran and Italy over the same period. Both Anatolian–Ottoman and Iranian art are characterized by clear-cut and at times irreversible changes, while Mamluk art impresses one by its secure conservatism, by its numerous variations on the same themes. How valid is that impression? If it

and the decorative arts have introduced into art-historical research an expectation of precision that seems to require that nearly everything be restudied. While I am hardly willing to argue in favor of insufficient or incomplete information, I question whether a historian who studies taste and culture (as distinct from a historian who studies technology) necessarily profits from a surfeit of detailed information about some point that had no importance in its own time. For instance, to know where and even when certain ceramics were made is only pertinent to the historian of a culture if evidence exists to show that the time and place of manufacture were important within the culture itself. The same point could be made for masonry techniques and a number of other features. On the other hand, technical precision is essential if the objective of the investigation is to understand and explain modes of production, sources of materials, division of labor, technological know-how, and other similar issues.

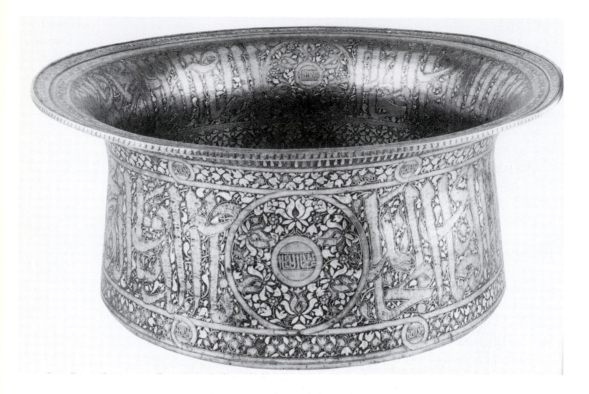

1 Basin, *c.* 1330. British Museum, London, no. 51, 1–41

is valid, should it be explained in social terms, as the visual and functional contract accepted by a stable society for an unusually long period of time, or in cultural terms, as evidence that inventions and new searches elsewhere simply did not reach the Mamluk world? Why did the Mamluk world appear so static and so stable in a Mediterranean world, both Christian and Muslim, in cultural ferment? The comparison with the Ottomans is particularly striking, as both cultures shared similar Sunni religious directions tinged with newly (at least in the Levant) fashionable Sufism, drew their elites from a comparable ethnic stock, and were in continuous, if not always friendly, contact with each other.

What posing these questions tells us, it seems to me, is that, however useful and indeed essential it may be to fulfill the taxonomic requirements of scholarship, these endeavors lose something of their import if they are bereft of their social, ideological or aesthetic contexts and divorced from their methodological implications. The variety of Mamluk forms that greets anyone visiting Cairo or Jerusalem, looking at the exhibition of Mamluk art in its many different locations, or perusing its catalog, provides a sumptuous feast for the eyes, but how does one recognize in these forms the will or the taste of the Mamluk world? I shall start with a number of almost random observations on some of the objects in the exhibition, then make a few remarks on Mamluk architecture, and finally sketch out a possible approach to Mamluk art as a whole.

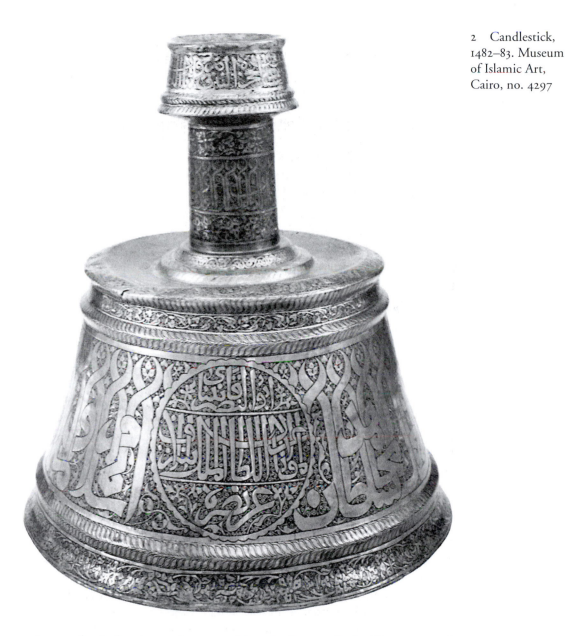

Let me begin by comparing two objects in brass, a basin (Fig. 1, *c*. 1330)
from the time of Nasir al-Din Muhammad in the British Museum, and a
candlestick (Fig. 2, dated 1482–83) in Cairo's Museum of Islamic Art donated
by Qaytbay to the mosque of Medina.[5] Both are decorated with a single

5 Atil, *Renaissance*, nos 26, 34; it is with purpose, if slightly perversely, that I write, "from
the time of" the sultan. Since we have at least one formula, *mimma 'umila* (as on no.
28), that identifies an object as being by or for a specific individual, should not objects
like these with a simple royal identification be put in a somewhat different category, at
least when determining patronage?

band broken up by several strongly accentuated medallions and framed by narrow bands above and below. The primary decorative motif consists in writing set over or contrast-[3]ing with vegetal ornament. The visual coherence of the decorative schemes, the powerful stress on movement within circular objects seen respectively as a ring and a cylinder, the contrast between the forcefully proclaimed identification of a prince in the inscriptions and the more complex but also more static and repetitive elaboration of ornamental details are all features of a Mamluk style. They are also found in qur'anic pages, glass lamps, textiles and architectural ensembles of the Mamluk period,[6] and they are different from the stylistic characteristics of similar objects of the twelfth and thirteenth centuries from Egypt, Syria, or Iran.[7]

The differences between the objects, such as the more elaborate and mannered style of writing on Qaytbay's candlestick, the technique of engraving in the later object versus that of inlaying in the earlier one, and the simplified ornamental motifs, represent differences of sub-periods within a single style. There is no difficulty in establishing some of the same stylistic distinctions by comparing al-Nasir's architecture to Qaytbay's or by surveying sequences of Mamluk domes.[8] Objects such as the Baptistère de St Louis (no. 21),[9] the candlestick in the Walters Art Gallery (no. 16),[10] the Rasulid basin (no. 22), the great basins, bowls and candlesticks from Cairo (nos 27, 28, 29, 30, 31) can all be identified and interpreted as personal, qualitative, or social variants of a single formal matrix. The penbox in the British Museum made by Muhammad ibn Sunqur in 1281 (no. 13) would be a transitional piece, and the one by Muhammad ibn Hasan al-Mawsuli made in 1269 (no. 10) a fascinating attempt to meet an emerging new taste with the fussy details of another style. The establishment of a set of formal characteristics for Mamluk metalwork (or, for that matter, any other technique), however broad, allows the traditional techniques of connoisseurship to operate, so that dating and

6 Ibid., nos 1, 53, 122. In architecture the same kind of equilibrium between writing and other types of decoration occurs in most examples, such as the Barquq and Shaykhu ensembles; Louis Hautecoeur and Gaston Wiet, *Les Mosquées du Caire* (Paris, 1932), pls 147, 166 ff.

7 Arthur U. Pope and Phyllis Ackerman, *A Survey of Persian Art* (London, 1939), vol. 6, pls 1321, 1324, 1332, for Iranian examples; Hayward Gallery, *The Arts of Islam* (London, 1976), nos 146, 198, 200, for Ayyubid examples.

8 For instance, the structure of the dome of Nasir's mosque, Hautecoeur and Wiet, *Mosquées* (pl. 86), is different from Qaytbay's, though a beautiful late fifteenth-century rug in the Metropolitan Museum (1970.105) contains a design strikingly similar to that of the wooden ceiling in Qaytbay's funerary complex. For the whole series of domes, see Christel Kessler, *The Carved Masonry Domes of Medieval Cairo* (London, 1976).

9 This number and similar ones in the text refer to Esin Atil, *Renaissance.*

10 Several problems surround the identification of this object, including that posed by the socket and neck from Cairo which are supposed to belong to it (no. 15): the neck of the Cairo piece has a pseudo-writing which is more Ayyubid than Mamluk, as are the medallions with astral symbols on the base of the candlestick. The possibility that both these objects were made by sticking together fragments of different origins cannot be excluded.

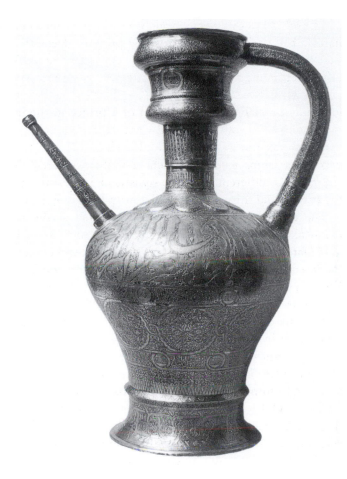

evaluation of objects can result. For instance, the basin in the Victoria and
Albert Museum (no. 18) has an interior decoration which appears to be a
pastiche of all the motifs of classical Islamic metalwork, and one ewer in the
Museum of Islamic Art (no. 19; Fig. 3) exhibits a striking and atypical
contrast between the upper and lower parts of the body's decoration. In both
instances the question is raised of the genuineness of the whole object or of
parts of it. [4]

Three brasses, however, complicate matters somewhat. Two are penboxes,
one in the Louvre (no. 23; Fig. 4), the other in the Museum of Islamic Art in
Cairo, made for Abu'l-Fida (no. 24); the third is a Qur'an box also in Cairo
(no. 25; Fig. 5). All three are dated or datable to the first third of the
fourteenth century, and all three bear some relationship to our hypothetical
type, especially through the presence of large and powerful inscriptions. But
all three also have areas of intricate and sophisticated designs whose effect is
not immediately striking from a distance, as it is in the vessels from the
times of al-Nasir Qaytbay; rather, they require close scrutiny and a personal,
almost solitary, attention to the object. The inscriptions on two of these

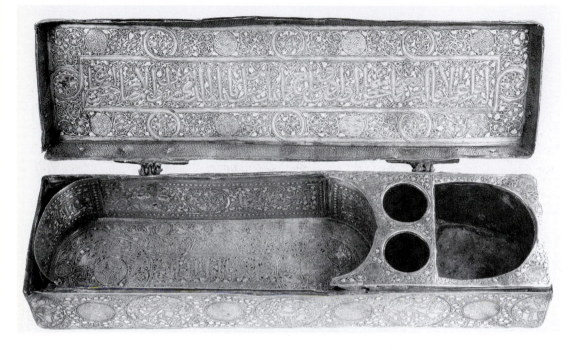

4 Penbox, 1304–05. Louvre, Paris, no. 3621

objects clearly indicate that they were meant for private use. Even if the name of the owner of the Louvre penbox can no longer be read, its long statement about the glories of penmanship suggests a testimonial in honor of years or decades of writing services. The Qur'an box is covered with carefully chosen qur'anic inscriptions; the commonly known Throne Verse is in bold letters, but less frequently quoted passages are visible only at close quarters.

From these random observations on a few brass objects, the working hypothesis can be proposed that several modes coexisted in Mamluk times using a vocabulary of forms from different sources. Some were earlier than the Mamluks, others were new inventions. One mode was strong, outer-directed, impersonal; the other was intimate, inner-directed, personal. At times, as on a late Mamluk lamp from Cairo (no. 32; Fig. 6), the two modes can be found on the same object. It is perhaps too risky to suggest that one mode was official, the other private, but the possibility is not excluded. They may also reflect two levels of piety, one official and proclamatory, the other individual and perhaps mystical, in their use respectively of well-worn and uncommon qur'anic quotations.

I began talking about the style of two types of objects and then went on to identify them, as well as others, through modes. Without wishing to fall into the difficulties encountered by so many art historians in recent years in trying to define style, I wonder whether the identification of modes – that is, of combinations of subjects and forms, adapted to a particular function – does not better suit the historian's need to understand objects as active [5]

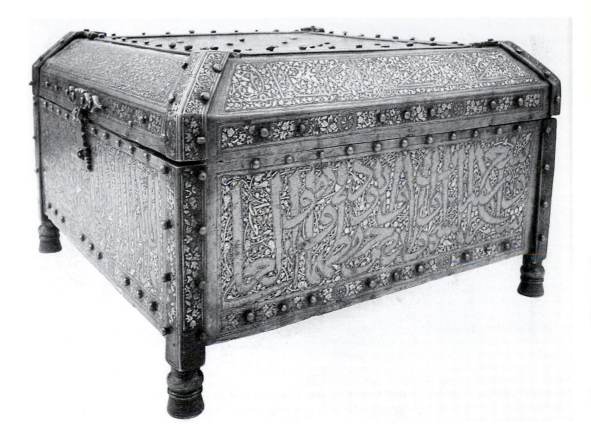

components of their contemporary life, especially when most of Mamluk art falls into the category of objects or buildings with primarily practical functions.

The problem of stylistic or modal definition is far more complex when one turns to the illumination and especially the frontis- and finispieces of spectacular Mamluk Qur'ans,[11] such as the magnificent ones of 1370 and 1334 (nos 4 and 5; Figs 7 and 8). Here the primary task, it seems to me, is not to describe them, nor to proclaim that they beautify the holy book, nor even to identify the sources or evolution of this or that motif in their decoration. The problem is first of all one of formal definition: what type or types of

5 Qur'an box, c. 1330. Museum of Islamic Art, Cairo, no. 183

[11] I am purposely avoiding dealing with calligraphy, as the techniques for appropriate judgment of this prototypical form of expression in the Muslim world have not been worked out. This is not meant as a criticism of the various publications of recent years that deal with calligraphy, such as Martin Lings and Y. H. Safadi, *The Qur'an,* British Library Exhibition (London, 1976); or Hassan Massoudy, *Calligraphie arabe vivante* (Paris, 1981). All of them make useful and sometimes very important contributions to the history and techniques of scripts, but they do not provide all we need for developing critical terms to understand such texts as the one found in Qadi Ahmad, *Calligraphers and Painters,* trans. Vladimir Minorsky (Washington, DC, 1959), pp. 57–9.

6 Lamp, second
half of the
fourteenth
century, Museum
of Islamic Art,
Cairo, no. 15123

design are found in these manuscripts? Book pages are two-dimensional, finite surfaces, and these examples illustrate two characteristic ways of covering those surfaces: in the 1370 Qur'an a single motif growing from a center, and in the 1334 Qur'an an allover repeat pattern of medallions. Both types of design occur on other flat surfaces, in ceramics (nos 69 and 72) or textiles (nos 116, 121, 125, 127), in Mamluk art and at other times or places as well. Once this level of formal generality is established, then detailed analyses of individual motifs and their origins serve to identify the historical and possibly cultural or social dimensions of a given page.

But neither formal typology nor historical morphology manages to answer a much more fundamental question: what led patrons of the same social and intellectual level (ruling princes), at roughly the same time (c. 1370) and for the same text (the Qur'an), to require or appreciate different kinds of illuminations? To postulate different religious meanings for these forms – for instance, esoteric and Sufi or establishment and Sunni – makes [6] sense because such meanings would reflect different interpretations of the holiness of the Qur'an, but no investigation, as far as I know, has identified the

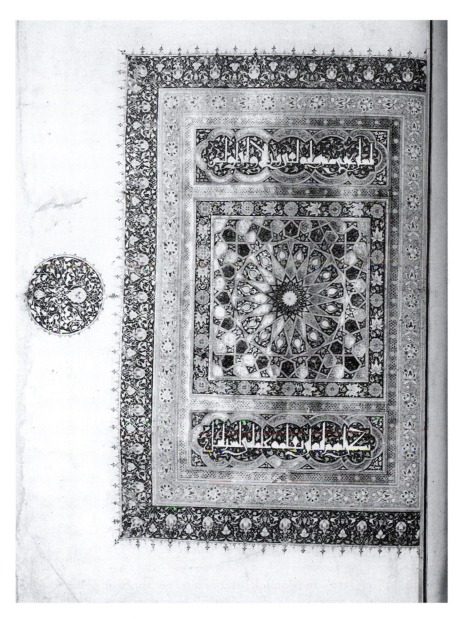

7 Frontispiece, Qur'an, *c.* 1370. Egyptian National Library, Cairo, MS 54, fol. 2a

processes by which these or any other visual forms relate to piety. The argument that these fancy frontispieces indicate royal patronage is weakened by the frontispiece of al-Busiri's *Kawakib* in the Chester Beatty Library (no. 9), where Qaytbay makes it perfectly clear that he is the patron of the manuscript by highlighting inscriptions proclaiming his titles and his sponsorship. Perhaps we have no choice but to see these designs simply as means of sensuous attraction or as homage to the holy text through rich and intricate designs. Illumination is in this case an attribute given to a book and not, like an illustration, issuing from it.

8 Finispiece,
Qur'an, 1334.
Egyptian
National Library,
Cairo, MS 81, fol.
378a

One last observation on Mamluk objects concerns their inscriptions. Metalwork in particular displays not merely a large number of inscriptions but an unusual variety of inscription types, ranging from straightforward statements of rank to personal statements or signatures. In the other media, only glass objects occasionally give a written indication of function, patronage, or location. Why is this so? With some hesitation, one might suggest that something about a hierarchy of media can be inferred from the presence or absence of inscriptions: not necessarily or simply a hierarchy of quality – that brass or glass were "higher" techniques than ceramics or textiles or ivory –

but one reflecting the relative ability to display individuality and peculiarities of taste. Metalwork demonstrated that quality as early as the middle of the twelfth century.[12]

Why these two media? Perhaps because, in contrast with ceramics, textiles and even architecture, the last stages of their ornamentation were artisanal and not industrial: the finishing touches, enameling or chasing, on glass or metal could be used to apply decoration at the whim of a single patron when the object was almost finished. This may explain, for instance, why the Baptistère de St Louis, the most elaborate work of early Mamluk *Prachtkunst*, depicting (or so it seems) the whole Mamluk court, has no royal inscription.[13] It did not need one, because it was made for an immediate and specific purpose, self-evident to those who used it.[14] The basin's maker, on the other hand, wanted to ensure that he was remembered so that he could receive new commissions: his signature can be found on the basin six times. As to the two other inscriptions on the Baptistère – the identification of a penbox as a penbox and of another vessel as one to carry food – they probably commemorate some concrete event that escapes us.

One conclusion we might draw from these remarks is that inscriptions serve to determine the [7] rarity or uniqueness of an object. Thus it is likely that the tray in the Metropolitan Museum made for al-Mu'ayyad (no. 22) was one of many similar objects, but unlikely that Abu'l-Fida's fancy pencase (no. 24) had any mates. A second conclusion is that inscriptions and other types of motifs were chosen to complement each other: with the exceptions of a problematic candlestick in the Walters Art Gallery (no. 16) and the basin in the Victoria and Albert Museum (no. 18), the fewer figures depicted, the more elaborate the inscriptions. Furthermore, the later the object, the less likely it is to have representations. Does this mean that the Mamluk period witnessed the replacement of one kind of visual vocabulary (representations) by another (writing) without necessarily implying changes in content? Or did the need for a different content for decoration lead to changes in vocabulary? The answer lies either in specific cultural and historical circumstances or in the mutually exclusive properties of certain visual terms.

Hypotheses such as those based on or derived from observations of individual objects can easily be multiplied to form a variety of combinations, which can then comprise what may be called the connoisseurship of Mamluk art. Connoisseurship is here defined as the web of impressions and associations triggered by a single object, which then, after appropriate comparisons with other objects, return to it as an attribution that is an explanation of place,

12 L. T. Giuzalian, "The Bronze Qalamdan of 542/1148 from the Hermitage Collection," *Ars Orientalis*, 7 (1968).
13 Atil, *Renaissance*, no. 21.
14 In spite of its masterful publication by D. S. Rice (*The Baptistère de St. Louis* [Paris, 1953]), the Baptistère is far from having been explained.

function, patron and artist. Until now, however, our discussions of objects have not really explained any one individual object so much as they have identified themes, motifs and questions addressed either to a class of objects or to elements of design and decoration seen independently of an object.

Another possible approach both to objects and to monuments of architecture is to group them by period and then to identify discrete Mamluk substyles. An opportunity to do just that arose when the Mamluk exhibition was shown at the Metropolitan Museum in New York, where the objects were arranged in roughly chronological order.[15] One rapid exercise using this approach will suffice. The reign of Qaytbay (1468–96) was the last fairly prosperous and relatively quiet period of Mamluk history, and it is notable for a large number of surviving monuments and objects. The monuments are fairly accessible, and some preliminary studies have been devoted to them.[16] They include some thirty buildings in Cairo alone, numerous constructions in Jerusalem, and the rebuilding of the holy places in Arabia.[17] About two dozen bronzes are attributed directly to Qaytbay's patronage or to his time,[18] as are many objects in glass and ivory, many manuscripts, and a quantity of textiles.

All these works display a number of common and consistent features. One is a sophisticated arabesque design that uses various motifs but always manages to transform surfaces in a way that makes the material of manufacture – whether stone, metal, paper, or fabric – lose its material quality and become a luxurious pattern, brilliantly reacting to the movement of sources of light, as Christel Kessler has so well shown for architecture.[19] Another is the predominance of certain vegetal designs, such as the three-lobed leaf, and of compositions based on coordinated medallions at different angles. Typical also are thick letters with playful finials, especially on the hastae, and an extremely complex geometry. Yet it is still very difficult to combine these details into a definition of a style, mainly because not one of these features seems sufficiently anchored in Qaytbay's reign to justify identifying it exclusively with that time.

In short, the strategies of traditional connoisseurship or of characterizing period styles do not seem appropriate to the study of Mamluk objects. Except in the case of the Baptistère, the analysis of a Mamluk object leads, not to a better understanding of any individual object, but to hypotheses,

15 The exhibition was arranged by Marilyn Jenkins and contained additional examples from the Metropolitan Museum, the Medina Collection, and private and public collections from Kuwait.

16 See Atil, *Renaissance, passim*.

17 Hautecoeur and Wiet, *Mosquées*, p. 307 and Michael M. Burgoyne, *The Architecture of Islamic Jerusalem* (Jerusalem, 1976), for a list.

18 A. Souren Melikian-Chirvani, "Cuivres inédits de l'époque de Qa'itbay," *Kunst des Orients*, 6 (1969).

19 Especially for bronzes and domes (Kessler, *Carved Masonry Domes*).

ideas and concepts valid for classes of objects (lamps, basins, pencases) or for classes of specific decorative motifs (calligraphic bands, cartouches, peonies, geometric order), or, more rarely, to the identity of an owner or an artisan.[20] Nearly the same conclusion can be reached about Mamluk architecture. Such otherwise dissimilar scholars as Alexander Papadopoulo and the late K. A. C. Creswell seem to have been almost instinctively drawn to compiling sequences of domes and minarets (they could have used gates just as well), as though those elements could be studied apart from the buildings to which they belonged.[21] The reason for this attitude is not difficult to find. Aside from some of the early monuments of Mamluk architecture (the mosque of Baybars, for example, or some of Qala'un's or al-Nasir's buildings), whose forms have deliberately archaizing features,[22] the hundreds of Mamluk monuments of Cairo, Jerusalem, Aleppo, Damascus and Tripoli have a sameness of purpose, of form, of ornament, and of effectiveness – or, in Humphreys's words, "expressive intent"[23] – that is striking. [8]

So far as function is concerned, they are mosques, *madrasas*, khanqahs, or more rarely hospitals or ribats, and nearly always associated with the mausoleums of founders. They illustrate the high Muslim ideal of an architecture of social service, supported by charity in the form of the economic and legal conditions of the *waqf* system and inspired by the ideological and religious reform of the Muslim system that began in the eleventh century and assumed many regional variants.[24] The problem with all these Mamluk foundations is that there are so many of them, located so close to each other – as in the Shari' Bayn al-Qasrayn in Cairo, on the western and northern side of the Haram al-Sharif in Jerusalem (Fig. 9), and in Cairo's eastern cemeteries – that one begins to doubt their actual social, religious, or intellectual uses and usefulness. At best, there is an apparent contradiction between the cost and quality of these buildings and their likely value to the surrounding population.

In form as well, the sequence of a large gate with a flanking minaret, a dark passageway, a court, a variety of public, covered areas (hypostyles or

20 This conclusion is not an original one for Islamic art, but one may wonder whether it is not so because much of the perception of Islamic art developed from Western knowledge of Egypt, which was familiar to us earlier than any other part of the Muslim world.

21 Alexander Papadopoulo, *L'Islam et l'art musulman* (Paris, 1976), figs 243–9, 267–70; K. A. C. Creswell, *The Muslim Architecture of Egypt*, vol. 2 (Oxford, 1959), pls 121 ff.

22 The mosque of Baybars is the subject of a reevaluation by Jonathan Bloom, "The Mosque of Baybars," *Annales Islamologiques*, 18 (1982); in the meantime, see Creswell, *Muslim Architecture of Egypt*, pp. 155 ff.

23 R. S. Humphreys, "The Expressive Intent of the Mamluk Architecture of Cairo," *Studia Islamica*, 35 (1972).

24 There is as yet no easily accessible study of the changes that began in the eleventh century. The best, but very difficult and often controversial, book on those times is Marshall G. S. Hodgson, *The Venture of Islam* (Chicago, 1974). Some important studies have been done on building functions, such as Jacqueline Chabbi on the ribat, "La fonction du ribat à Bagdad du Ve siècle au début du VIIIe siècle," *Revue des Études Islamiques*, 42 (1974).

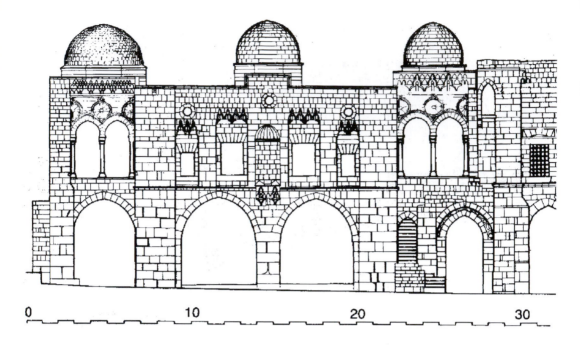

9 Haram al-
Sharif, Jerusalem;
elevations
(Drawing by
Michael
Burgoyne)

iwans), a smaller number of more restricted living or functional spaces (cells, libraries, lavatories and the like), and an exteriorized mausoleum dome repeats itself hundreds of times. Changes in, for example, the construction of domes or the ornamentation of minarets do occur, and even sudden innovations, such as the appearance of loggias in the fifteenth century, are apparent, as are occasional returns to older models. On the whole, however, we are dealing with a circumscribed number of set pieces organized according to a very limited number of formulas. The existence of one or more types with variations is, of course, true of any "classical" period. It is as true of Ottoman architecture in the sixteenth and seventeenth centuries as it is of Gothic architecture in the thirteenth. But if it is correct to conclude that Mamluk architecture is also such a classical moment of formal poise and equilibrium, then the question must be asked why this stage was reached in Mamluk Islam, but not in contemporary Turkish or Iranian Islam.

Mamluk ornament is not a subject I have studied in detail, but I suspect that, just as with three-dimensional forms, ornamental motifs can fairly easily be broken down into a relatively small [9] number of elements and treated in a relatively limited number of ways, and that, with occasional variations, exceptions, innovations and returns to older models, nearly the same motifs and visual interpretations of motifs prevailed for over two centuries.

Effectiveness or expressive intent is a combination of three separate things: the message conveyed by the monuments, the means used to convey that message, and the quality of those means. To identify the message itself, the only hypothesis we so far have for the Mamluks is the one developed by Humphreys: theirs is an architecture that embodies tension between religious

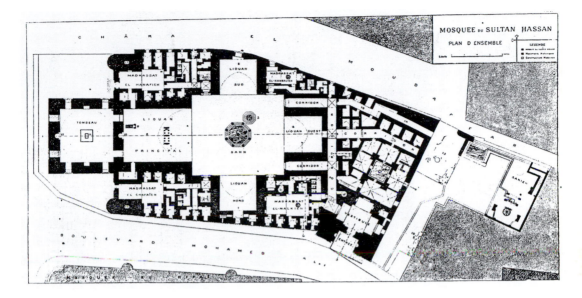

function and secular form because it is there to communicate to the population that the military aristocracy of the Mamluks, by accepting Islam and glorifying its precepts through buildings, asserts its political and economic domination of the local population. Except perhaps for a few early buildings, this interpretation still seems entirely applicable and has been confirmed by subsequent investigations.[25]

The means used to convey that message are more difficult to identify, but one possibly relevant observation is that, with the partial exception of the Sultan Hasan *madrasa*, which is anomalous in so many ways, a Mamluk building is very rarely perceived as a whole building, as almost any Ottoman mosque is, but rather as a small number of repetitive parts (dome, gate, minaret) which presuppose a building but are not necessarily visually integrated into it. Even an isolated building like the mausoleum and khanqah of Faraj ibn Barquq can be grasped as an architectonic entity only if it is seen from the air; on the ground, its separate sides have a fascinating asymmetry in the arrangement of the entrance, the minarets and the domes.[26] The powerful use of a continuous *muqarnas* molding around the whole building and perhaps a more spectacular siting in the city, which, among other things, makes it visually accessible from the height of the Citadel, differentiate the *madrasa* of Sultan Hasan from that norm, but even there the eccentricities of the plan (Fig. 10) – the location of the gate complex, for example – are

10 *Madrasa* of Sultan Hasan, Cairo; plan

25 Oleg Grabar, "The Inscriptions of the Madrasah-Mausoleum of Qaytbay," *Near Eastern Numismatics, Iconography, Epigraphy, and History*, ed. D. K. Kouymjian (Beirut, 1974).
26 The works of Faraj ibn Barquq have been admirably published by S. Lamei Mostafa, in *Kloster und Mausoleum des Farag ibn Barquq in Cairo* (Glückstadt, 1968), and in *Moschee des Farag ibn Barquq* (Glückstadt, 1972).

11 *Madrasa* of
Sultan Hasan,
Cairo

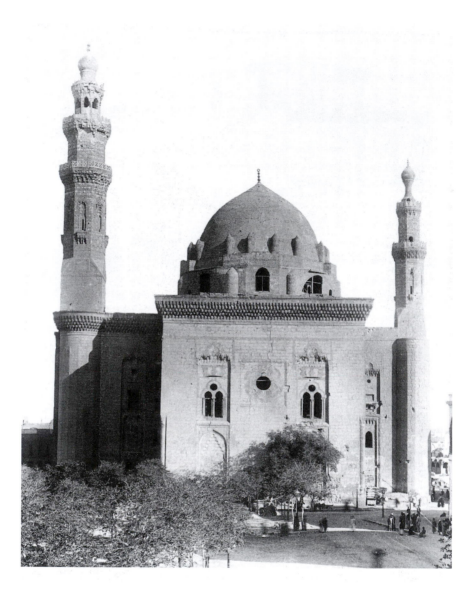

fully in accord with it. This Mamluk [10] architectural norm consisted of a
small number of signs (gates projecting into the street, minarets leading
from one monument to the next, domes focusing on the presence of a
benefactor or a holy man, *muqarnas* establishing some sort of qualitative
hierarchy, long bands of qur'anic or royal proclamations) that are all essentially
the same. At best, like faces in a crowd, they are recognizable and identifiable
only after a social or affective relationship has been established.

For all these reasons a qualitative evaluation of Mamluk architecture is
not, I think, an appropriate exercise, in spite of the large number of
monuments. Aside from the Sultan Hasan *madrasa* (Fig. 11) and possibly a
few others, it is not appropriate because the synchronic intent of the

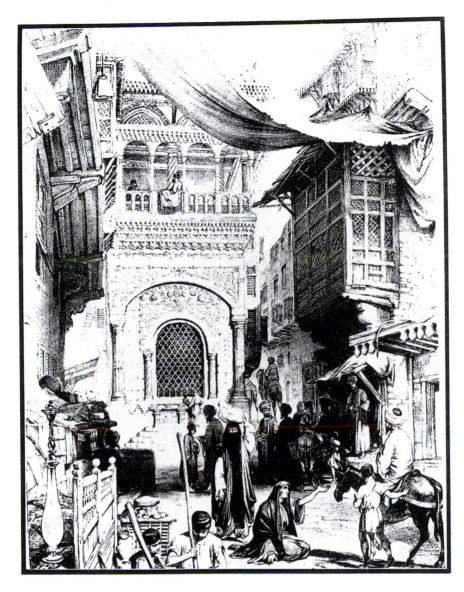

12 Nineteenth-century drawing of a street in Cairo (Drawing after Prisse d'Avennes)

monuments was social and ideological and not aesthetic. Perhaps this is why nineteenth-century descriptions of Cairo, whether that of Prisse d'Avennes, of Roberts, or of one of the many other observers, almost always deal with streets or other urban settings that include monuments (Fig. 12),[27] but not with a monument alone. Perhaps that is why, also, when the great world expositions of the second half of the nineteenth century wanted to reproduce the Muslim world in Philadelphia, Chicago, or Paris, they picked the

[27] The general public visiting the exhibition appeared to look almost as much at the large reproductions of Cairo from nineteenth-century drawings as at the Mamluk objects.

monumental streets of Cairo rather than the imperial monuments of Istanbul.[28]

Always granting such exceptions as Sultan Hasan's madrasa and the Baptistère de St Louis, the artistic creativity of the Mamluk world did not express itself in individual monuments or objects made or built to glorify a specific individual or occasion. Its aim was to fulfill a range of functions, from financial investment and piety to such mundane occupations as heating and lighting a room or a mosque or writing a book. In this sense the best works of Mamluk art – its architecture, its bronzes, its illuminated books – were often technically brilliant continuations, maybe even culminations, of medieval Islamic (and in many ways also Western Christian) art, but they hardly paved the way for the kind of development that just a few decades after the end of the Mamluk regime made an ensemble like the Süleymaniye in Istanbul possible. Except in a minor way for rugs, Mamluk objects had nothing to do with the explosion of *Prachtkunst* found in the new imperial worlds of Islam. However interesting they may be archaeologically, the illustrated manuscripts of the Mamluk period show neither the vivacity of thirteenth-century Arab paintings nor the sophisticated brilliance of Iranian ones.

Why is this so? Only prolonged scholarly debate will provide the answer, but I can at least [11] contribute two tentative hypotheses to that discussion.

The first is that, whether or not meaning can be given to any particular object or monument, the real concern of Mamluk patrons, artisans and users lay not in the buildings built or the objects made, but in the cities ruled by the sultans and amirs and the lives of the several social classes who inhabited them. In Jerusalem, the whole Haram al-Sharif with its attendant street was the object of Mamluk attention and care.[29] As any drawing shows (Fig. 13), the several buildings are blurred into a single street façade to form a mass, rather than a group of individual monuments. In Cairo, Mamluk minarets and gates guide and accompany one from the Hakim mosque to the Citadel.[30] Rather than ends in themselves (as they have become in museums), the objects should be seen as intermediaries between people and activities, as expressions of an attitude toward artistic creativity much more characteristic of bourgeois than of princely art. Perhaps one of the paradoxes

[28] For instance, the Chicago exhibition, as in Halsey C. Ives, *The Dream City: A Portfolio of Photographic Views* (St Louis, 1894), unpaginated.

[29] For the monuments of Mamluk Jerusalem, consult the articles of Archibald Walls, Amal Abu'l Hajj, and especially Michael Burgoyne in *Levant*, 2–12 (1968–80).

[30] The visual structure of Cairo is only now beginning to be investigated. I owe my conclusions to papers presented in a seminar at Harvard University in 1980 by Katherine Fischer and Hazem Sayyed and to a visual study by Nezar al-Sayyad, *The Streets of Islamic Cairo*, Aga Khan Program for Islamic Architecture Studies in Islamic Architecture 2 (Cambridge, Mass., 1981).

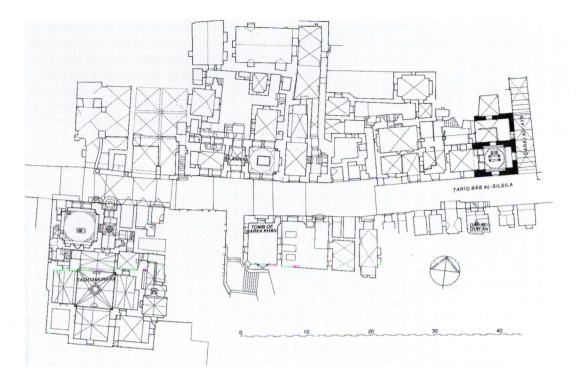

of Mamluk art is that it was a princely art that maintained and developed the visual forms not of princely or imperial ideas but of an urban elite.

A second hypothesis is that the disappearance of alien threat that followed the final defeat of the Crusaders and the Mongols allowed the city dwellers of Egypt and the Levant to establish an equilibrium among social, intellectual, religious and economic structures that could remain unchallenged from both inside and outside. That equilibrium leaves the historian who looks only for changes and evolutions without a task, because all one can do is penetrate Mamluk life and not seek in it some element of vitality that was never there. The implication of this conclusion extends beyond Mamluk art, for it raises the fundamental question whether the methods or strategies to be used in studying any one period should be determined by universal principles or by the cultural idiosyncrasies of a particular moment of history.

13
Reconstruction of a street in Jerusalem; plan (Drawing by Michael Burgoyne)

Chapter XVII

An Exhibition of High Ottoman Art*

First, in 1985, it was the Festival of India which, through two handsome large exhibitions in Washington and New York, several smaller ones in other cities, and a great deal of publicity, provided the American public with a vision of worlds other than its own, of desirable exotic cultures. Next it was Turkey, or rather the Ottoman Turkish world of the sixteenth century, whose relationship to today's Turkish republic is as remote as that of Charles V and the huge Habsburg empire to the republic of Austria, but whose architectural masterpieces adorn the three cities of Bursa, Edirne and Istanbul, and whose treasures and other remains are found, for the most part, in the Topkapi Museum.

The exhibition, "The Age of Sultan Suleyman the Magnificent," which opened at the National Gallery of Art in Washington, DC, in the winter of 1987, summered at the Art Institute in Chicago, and made its New York debut the following fall, was one of the most exquisite expositions of objects I have ever seen. It consisted of some twenty-seven examples of writing on paper or of aspects of book-making such as bindings; fifty-nine paintings, nearly all of them miniatures and most of them illustrating a text; sixty-one objects in various techniques of industrial or decorative arts; fifty-three textiles or rugs, and forty-eight ceramics. Their shapes were heterogeneous: at times they were totally two-dimensional; at other times they were meant to be viewed from several directions or even in movement (as, for example, with the fabulous robes). Their functions are prosaically mundane (underwear, a simple jug) or ceremonially and symbolically unique (a crown, an imperial signature, a map of conquered lands).

Shapes and functions made particularly arduous the task of designing an appropriate setting for objects which were all refugees from places other than museums. They were different from each other and collectively most of them deviated from the norm of exhibited objects of Western art, in which two-dimensional paintings and drawings made to be seen in public or semi-public contexts dominate. The National Gallery's presentation of such unusual and unexpected objects was truly spectacular. I did not see

* First published in *Muqarnas*, 6 (1989), pp. 1–11.

the Chicago version of the show, but the New York one, while spacious and softly mysterious, all too often had sets of objects so far from each other that the connection between them was lost. The visual judgments I shall produce are based primarily on the impressions given by the Washington exhibition.

Brilliance of presentation may have been the designers' responsibility, but the Turkish government deserves the credit for the show's very existence. It was a law passed as recently as 1985 that allowed for the lending of so many treasures from Turkish collections to foreign museums, although quite a few of the exhibited objects were in fact shown in a Smithsonian Institution exhibition which circulated between 1966 and 1968. The true creator of this show was Dr Esin Atil, longtime curator of Islamic art at the Freer Gallery of Art in Washington, for whom this had been a labor of love for many years. Her diplomatic efforts and skillful tact brought the exhibition together, and for this all must be grateful.

Following the pattern of many of her earlier and more modest shows, Dr Atil also produced two books to accompany the exhibition.[1] The first, *The Age of Sultan Suleyman the Magnificent*, is both a catalog, in the sense that it contains a list and illustrations of all exhibited objects, and a series of essays on the media (manuscripts, precious objects, textiles, ceramics) of the exhibited objects and the organization of artistic patronage and labor in the sixteenth-century Ottoman world. The second, *Suleymanname: The Illustrated History of Suleyman the Magnificent*, is a beautifully executed quasi-facsimile edition of the *Suleymanname*, the one available complete section of a dynastic epic written in the manner of the Iranian *Shahname* and illustrated with sixty-nine miniatures. The manuscript was included in the exhibition, but of course only a few of its miniatures could be seen at a time.

All the objects shown originated in the sixteenth century and in the Ottoman court symbolized by the presence of Suleyman I. He was born in 1494, crowned sultan in 1520 when he succeeded his father, who had been the conqueror of Egypt and the Levant and was [2] known ominously but justifiably as Selim the Grim; he died in 1566 while campaigning in Hungary. He was known as the Magnificent in the West and as the Lawgiver (*qanuni*) in Ottoman historiography. His long reign was filled with wars, successful ones for the most part, but thanks to a well-established and well-trained bureaucracy, it also included decades of reasonable internal and social order and of administrative reorganization. It was the time of the great architect Sinan, the only builder from the Muslim world until Hassan Fathy whose name was known in the West. Sinan's mastery of

[1] Esin Atil, *The Age of Sultan Suleyman the Magnificent* (Washington, DC and New York: National Gallery of Art and Harry N. Abrams, 1986), 360 pp., 209 illus.; idem, *Suleymanname: The Illustrated History of Suleyman the Magnificent* (Washington, DC and New York: National Gallery of Art and Harry N. Abrams, 1986), 270 pp., 65 illus.

domical forms transformed the profile of Ottoman cities and remained until the nineteenth century the standard against which all Ottoman buildings were measured.

It is noteworthy that the past decade has witnessed several other major publications on Ottoman art written in English and an enormous scholarly effort in Turkish.[2] The results of the latter are unknown to most scholars and amateurs who are not Ottomanists. The existence of books in English and the accessibility to tourists of Turkey and other formerly Ottoman lands have not as yet propelled the Ottoman world at its heyday in the sixteenth century into the mainstream of historical culture, nor even among the pleasures of jaded jetsetters. Yet a look at any map shows that in the times of Charles V, Henry VIII, Francis I, Ivan the Terrible, Shah Tahmasp, Babur, Michelangelo, Titian, Palladio, Calvin and the Counter-Reformation, only the Ottomans had dealings, peaceful or otherwise, with all the protagonists of sixteenth-century Eurasia except China. Their culture and therefore their art cannot *a priori* be seen simply as an "Oriental" exoticism.

It has long been recognized that Sinan's mosques are major examples of a grand tradition of domical compositions from the Pantheon to Sir Christopher Wren. But the other arts clearly have nothing in common with Michelangelo and Mannerism, nor even with Benvenuto Cellini. Why not, especially after a late fifteenth century that had many artistic connections with Italy? What is it that makes (or made) architecture so different from other arts? Or, to introduce a different way of understanding the arts, at what point do differences constitute otherness? Is it a definable, measurable yardstick of values which makes an art or a culture different? Or is it a subjective decision of a historical moment or of today's observer to proclaim some arts or some artistic traditions as alien to one's own?

These questions, with obvious implications for other places and other times, are central to our understanding of Ottoman art. They are not the questions which led to the exhibition and to the books, nor are they raised by them. Yet, precisely because the books and the exhibition arose from needs other than the questions of global historians and of comparative art historians, they bring to the elucidation of the latter a documentation gathered with the common and straightforward desire to present and explain within their own context a sizable collection of items associated, rightly or wrongly, with Suleyman the Magnificent. I shall first review the impact made by the exhibition, then relate it to evidence from the two books before returning to the wider issues raised at the beginning.

[2] Among easily accessible examples, Ekrem Akurgal, ed., *The Art and Architecture of Turkey* (Oxford, 1980); Esin Atil, ed., *Turkish Art* (Washington, DC, 1980); Yarim Petropoulos, ed., *Tulips, Arabesques and Turbans* (London, 1982); Oktay Aslanapa, *Turkish Art and Architecture* (London, 1971); Godfrey Goodwin, *A History of Ottoman Architecture* (London, 1971).

The primary statement made by the exhibition can be deduced from the objects shown in it. There is a bizarre but commonly held belief that objects speak for themselves. They do indeed, provided one knows their language, and on one level everyone does know the language of this particular selection. There was no way of escaping the dazzling display of gold. It was the medium for manufacturing nearly everything there, for emphasizing designs on miniatures or clothing, for embroidered textiles, for stamping book-bindings with involved arabesques. If one got tired of gold, there was a brilliant array of reds, stunningly tactile on robes, suddenly rising out of the surface of ceramics, enlivening the design of book illuminations, or reflecting light off hundreds of rubies. Even relatively mundane manuscripts, like Matrakçi's celebrated depictions of cities throughout the empire or the puppet-like soldiers and dignitaries of the historical manuscripts, were full of all sorts of reds. Less systematic but no less striking were the blues, greens and whites found on objects or as precious stones nearly everywhere.

This display was attached to things whose functions are, for the most part, easily recognizable. There were books with pictures or simply with non-representational illuminations which are meant to be read or simply perused. There were endless practical objects like ewers, plates, lamps (although there is some uncertainty as to whether the peculiarly shaped ceramics we usually know as "mosque lamps" were really that), canteens, bottles, shields, belts, buckles. There were clothes, undershirts or nightgowns, trousers and, of course, the great ceremonial robes. There were magnificent swords and daggers, so beautifully decorated that they no longer threaten. It was easy enough for the viewer to extrapolate from [3] these familiar objects an understanding of less familiar ones, shining jewel-studded helmets or maces. The manuscripts, on the other hand, may have seemed too obscure, too esoteric for immediate understanding, however elegant their writing. But a canteen or a penbox in rock crystal covered with gold filigree and precious stones was an intellectually and sensually imaginable gift for those who already had everything, and the powerful swirls of the imperial signature (*tughra*) projecting a simple name into exciting design gave an unexpected monumentality and dignity to the routine or ceremonial action of affixing one's name to a document.

At this level of perception, objects do speak for themselves. They appeal to our sense of luxury or appear decadent, perhaps, to puritanical strands in every culture. But these or comparable objects have been found in royal, imperial and even religious treasures since time immemorial. Wonderful descriptions have been preserved in medieval Arabic texts of ninth- or eleventh-century objects which were as impressive as the ones in the exhibition. The treasure room of the Hermitage, the Tower of London, and the National Bank of Imperial Iran contain similarly spectacular, expensive, shining crowns, necklaces and cups. This was a particularly rich and particularly varied selection of such expensive but useful objects, and the

only appropriate reaction to them was to acknowledge that one loved, liked, or loathed some or all of them. Visceral attraction generated an equally visceral judgment.

Another way of seeing the exhibition required some sense of signs or codes which were not universally known or accessible, yet which did not necessarily require full immersion in the Ottoman world and Ottoman culture to discern. It also required, as any good exhibition does, a progression, a movement through a prearranged space according to a rhythm created or compelled by the organizers. The sequence of objects created, whether intentionally or not, an interpretation which had, in turn, to be evaluated by historical or visual criteria derived from other sources.

The first room set the tone and provided the key for viewing the rest. That key was writing. In the first room the viewer was overwhelmed by it, surrounded by the ascetic monumentality of the imperial signatures, the limpid qur'anic quotations on a group of storage boxes, and the masses of books and bookbindings with jeweled covers opening onto the austere severity of classical Ottoman cursive, only occasionally alleviated by playful variations or by memories of older square and other Kufic modes of writing. It was in this first room that the two most striking and, as we shall see shortly, moving items in the exhibition were to be seen. One was a white linen shirt entirely covered with several complete surahs of the Qur'an inked in different colors and according to complex geometric patterns. Medallions with gold letters contained pious formulas or endlessly repeated the Arabic word for "God." The second item was the shirt made in 1564–65 for Selim II, Suleyman's son, a year before his father's death (Fig. 1); magical squares and formulas covered the whole shirt. In that first room nearly everything – whether a book, a wooden stand, or a shirt – was highlighted by writing, always in clear and legible modes. The exceptions were the huge signatures, ornamental codes within the written code. Their appreciation required an understanding of the ornamental as well as of the written conventions used in their design. This domination of writing suggests that meaning in Ottoman art is primarily conveyed through the word, and not through the image as it is in Western art. Conventional letters are combined into the words and sentences of a language instead of representations of otherwise existing or imagined reality or of mnemonically meaningful signs such as heraldic ones. Reading the writing is necessary both for determining the meaning of objects and for visually appreciating them.

The rest of the exhibition was not without writing, but most of it was didactic, as in the cartographic examples or the depictions of the empire, informative, as with dates or signatures, or oddly casual and at times downright senseless as it was on several ceramic pieces. But the initial impact of writing as the key to understanding the Ottomans explains in part the lack of impact made by Ottoman painting. While Sinan's architecture can easily be compared with contemporary architecture in Italy, Ottoman

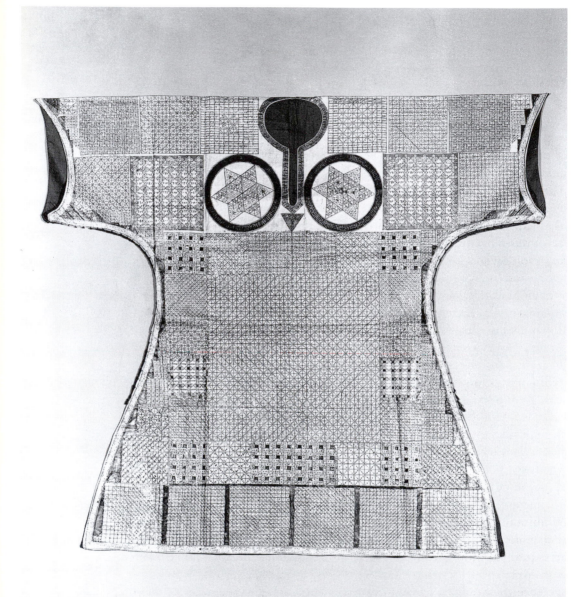

1 Shirt made for
Şehzade Selim in
1564–65. Istanbul,
Topkapı Serayi
13/1133

paintings show no awareness of anything done in Italy or elsewhere in the Mediterranean, although in the fifteenth century Italian artists and works certainly came to Istanbul, and a good third of the Ottoman empire was Christian and had been independent until a generation or two earlier.

The bright and cheerful lightness of colors in Ottoman painting was at times refreshing and its precise, even if schematic, recording of the surrounding world was often very useful, but Ottoman miniature painting abandoned the whimsical warmth, the manipulation of spatial conventions, the theatrical [4] arbitrariness, and the multiplicity of meanings that characterized the Iranian miniature painting from which its forms and many of its motifs derived. Furthermore, unlike Indian painters and Iranian painters in India, Ottoman manuscript illustrators did not, for the most part, investigate new ways within the tradition, nor did they innovate radically enough to create a truly novel art. Even the wonderful dragons and other imaginary beasts and angels so common on small drawings were totally overwhelmed by swirling leaves and [5] by forcefully thickened ink outlines. The procedure was one of pattern-making, not of representing, and animals or angels had to be discovered through a solitary process of visual analysis; they did not leap forward.

The reason for this absence of glitter and brilliance in painting is the willful rejection of representation as a significant mode for self-expression. It is telling and fitting that no portrait of Suleyman was included in the exhibition. A few exist, including Nigari's representation of the aged emperor which has a touching grandeur within a very restricted formal range. There may well have been technical reasons why that particular painting was not brought from Istanbul for the show, but the fact remains that the substitute "image" of the emperor consisted in a set of monumental signatures. Once again his portrait was the word, transmuted this time into flags dancing in the wind over the name and title of the ruler.

Images and representation, even if numerous, had to be sought out in the exhibition, for they had to be ferreted out of the manuscripts and albums. The main thrust of the show was to move the visitor along the dazzling row of luxury objects, which culminated in the stupendous official robes. There was no writing on them, neither a sign nor a symbol that would denote or connote anything other than themselves. These robes were amazingly silent. They were also physically restrictive, as their heavy cloth encumbered with gold threads hampered movement and compelled formal and ceremonial behavior. Form and silence were the main characteristics of the innermost space of the Ottoman palace, at the edge of the private harem. There an invisible sultan hidden behind curtains would communicate through formal gestures with the pages and officials of his entourage. The contrast between this external world of form and silence and the loquacious but usually invisible nightshirts illustrated, I think, the dichotomy between the external sense of power and certitude through ritual liturgies and the inner fear of a body which could only be protected by talismans.

The tension between fear of pain and death and certitude of power and authority is probably universal. Its visual expression elsewhere, as in the Italian Renaissance or Mughal India, was often found in astrology. It was absent from the Ottoman world that was presented in this exhibition, unless we do not know how to recognize its more arcane signs in decorative designs. Within the Christian world a series of mechanisms ranging from private confession to public (and private) court proceedings led to constant outpourings of feelings and of emotions about sins, conscious and unconscious. No such mechanisms existed within a Muslim society, except perhaps through mystical orders which were hardly likely at that time to be visible in and around the court. Fear was repressed and hidden in talismanic shirts; on the outside brilliance of form, design, or color ruled. But these brilliant forms and designs were used in silence, in carefully rehearsed ceremonies in which puppet-like characters went through motions without emotion, and lived or died (executions were numerous and swift) in pompous grace.

To understand Ottoman art as a luxurious array of ceremonially functional items, occasionally endowed with additional significance through writing, is a reasonable interpretation both of the ways of the Ottoman palace and of the selection of objects. For the historian of art, it brings up an additional problem. Little could be discovered from the objects themselves about who made them or who ordered them, but the transfer of motifs and compositions from one medium to another was evident throughout. There was a thematic, if not always stylistic, unity throughout the exhibition. This unity of high Ottoman art is usually explained by the institution known as the *naqqashhane*, what came to be known as the Palace School. To some it was both an École and an Académie des Beaux-Arts, but in the sixteenth century I think that it was more like a highly skilled specialized maintenance crew of artisans and craftsmen ready to meet the needs of the court. These needs could be very prosaic and immediate, like writing a letter, fixing a roof, or sewing a robe. They could also be very elaborate and long range, like the making of a circumcision robe or of an illustrated manuscript. These "schools" for the arts and crafts may also have been purchasing departments buying up the creations of artisans all over the city and even the world.

Concentrations of wealth always attracted providers of luxury goods and services, or in this case whatever pleased the court or was used by its members.[3] If we add that nearly all the salary sheets we have for people working on objects or paintings show a very heterogeneous group of individuals from many different places whose training took place *after* they were attached to the "school," the apparent stylistic and at least thematic unity of the objects in the exhibition could not have been achieved through

3 Allan Fisher and Carol Garret Fisher, "A Note on the Location of Royal Ottoman Ateliers," *Muqarnas*, 3 (1985), pp. 118–20.

traditional family- or guild-taught ways. It required the existence [6] of tangible models rather than training to maintain standards. What form these models took – pattern books, scrap books, samples of designs – is still a matter of controversy, but the key questions are clear. Who created this unity? Suleyman himself? A bureaucratic committee of court dignitaries? The learned and religious leaders with their Anatolian or Syro-Egyptian background? The political leadership which, at the time, consisted almost exclusively of men brought as children from the Balkans and trained in the Palace School?

These questions cannot be answered by visual means alone, but assessing the visual means is essential because it leads to yet another manner of looking at the particular selection in the show. The exhibition appeared to be a collection of objects that performed dozens of different functions presented as works of art, that is to say, as possessors of qualities that transcended their functionality. If this was so, then we must also learn to read them as works of art, to understand them as formal responses to a variety of cultural or individual needs, and to evaluate the pleasure they give now and gave in the past. Yet in the presence of the object it was difficult to behave like a traditional art historian or even art critic, to elaborate on the balance of patterns or colors found on a robe or on a bookbinding, to imagine why and how either was made, and to identify and justify criteria for judgment. One's instinct was not to look, but to touch, to lift, perhaps even to appropriate. The exhibition mechanisms which deal with and through the eyes alone were used there for items which affected other senses, the sense of touch primarily, and which teased the imagination away from the object toward its use.

This point is, of course, true of any exhibition dealing with the industrial arts, and it is particularly true of Islamic art, which has given such prominence to the products of skilled craftsmanship. I only raise this point in connection with the Suleyman show because the apparently unique quality of most of the objects had to be reconciled with the industrial process of their manufacture. That reconciliation was difficult to make visually. Even when the reconciliation is attempted, as it has been in a number of exhibitions more anthropological than art-historical, which rebuild for the visitor the place in which the objects are used, the visual experiences of active contexts are difficult to perpetuate. They were not attempted in the Suleyman show, but such contexts as were imagined or suggested did come out of the books accompanying the show. They remain, now that the objects have gone home, and through them one additional set of data comes to light for our attempt at understanding Ottoman art: the discourse of the organizers, the key in which they would have liked us to see the exhibition.

This is where the difficulties begin. I have nothing against beautiful large books with gorgeous illustrations, but, on a practical and nostalgic level, I do miss the small and handy catalogs with postage-stamp illustrations that each

viewer could fill with scribbles, drawings, readings of inscriptions, or general observations like "ugh!" They allowed the recording of a visitor's immediate feelings and reactions and, especially for loan exhibitions which show objects that will never again be brought together, they were indispensable. They have now been replaced by slick presentations of scholarly information and interpretation available to the organizer(s) of the exhibition long before the show takes place. Ideally, this initial statement should be balanced with a post-exhibition explanation of how the show modified or confirmed the views it espoused. This ideal sequence occurs only too rarely, and in this case the facsimile of a royal epic with sixty-nine miniatures dated 1558 and a book of essays on the making of books and paintings, on the *Schatzkammer*, on the imperial wardrobe, and the royal kilns, with a series of useful appendices, are what remain of the show. Elaborate and very complete bibliographies accompany each volume.

Both books are impeccably presented with stunning illustrations, and they reflect two decades of dogged descriptive and taxonomic scholarship carried out primarily but not exclusively by Turkish academics. But, as soon as we go beyond the levels of ornamental typologies, of technical virtuosity, and of immediate contexts, problems and queries arise which need to be fleshed out. One reason is that, as we shall see shortly, the books give a different impression of the objects from that produced by the exhibition. The second is that the books exhibit a paradox wonderfully exemplified by a Melchior Lorichs engraving from 1559 (Fig. 2), which is reproduced in the catalog. In it a mighty and severe Suleyman is standing in front of a masonry wall; he looks exactly as one would imagine him or anyone else wearing the caftans in the show to look, uncomfortable and overloaded. To the left is a deep archway with a peculiar elephant and riders holding flags; they sit on a rug with huge crescents. In the background but dominating the city, the recently built Süleymaniye exhibits the technical mastery and intellectual concep-[7]tualization of vaults that characterize Sinan's works, and exaggerated minarets pop up into the sky. On the top of the arch in a medallion is written "Allah," God. Lorichs, a knowledgeable visitor, represented strength using signs and symbols and through a type of monumental expression which cannot mean anything other than power, even if it is tainted by minor Orientalisms. In a ponderous, austere and slightly boring way, it is an image of Suleyman the Magnificent, even of the Lawgiver.

Nothing like this appears elsewhere in the books. Suleyman is more visible and original in his signature than in his person; the fifty or so representations we have of him in the *Suleymanname* are all conventional images. Is, then, the image of power and strength an exclusively Western one? Or did the Ottomans limit their expression of power to architecture and to ceremonial parades at regular religious festivals or occasional feasts like the circumcision of a prince? It is easy enough to see the new Solomon in the man who had the walls of Jerusalem rebuilt, the Dome of Rock

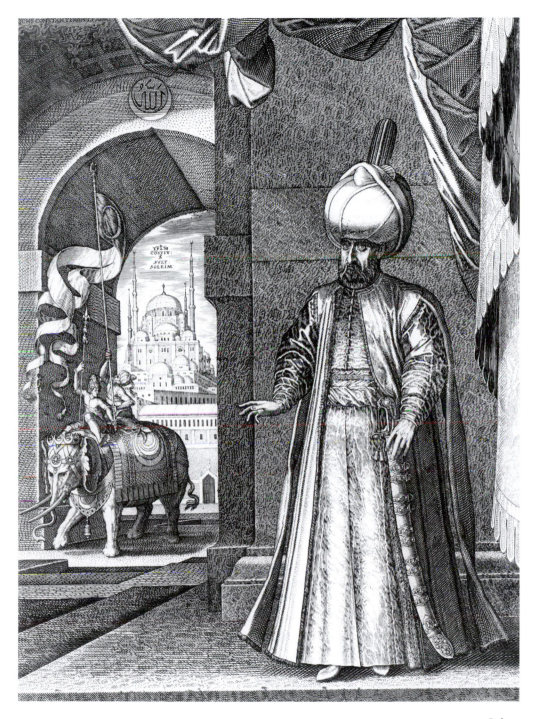

2 Suleyman the
Magnificent, as
seen by Melchior
Lorichs, dated
1559

re-covered with tiles, Mecca and Medina restored, and who outdid his predecessor Justinian in Solomonic comparisons ("I have now overtaken thee, O Solomon," Justinian is alleged to have said as he entered Hagia Sophia for the first time), with his great complex of the Süleymaniye. But *that* Suleyman, majestic "shadow of God on earth, ruler of the East and of the West," is absent from the books, although, with some difficulty, he can be conjured up in the exhibition.

One reason for this absence lies in Dr Atil's deliberate emphasis on a very different kind of Suleyman, on an almost superhumanly talented ruler who practiced crafts and especially writing – as old mirrors of princes used to advise kings to do – and who had a romantic family life. Such an image simply does not ring true for the sixteenth-century Ottoman world, but to argue against it requires an analysis of sources and events that does not belong in this review.

A more trenchant reason for Suleyman's absence is that less than one-fifth of the objects in the exhibition were directly and precisely associated with him and barely one-fourth were associated with any patron or with a specific date or place of manufacture. Only the manuscripts were consistently provided with vital statistics. This does not mean that the organizers missed any major examples of Suleyman's personal properties, nor that the Sultan's belongings have disappeared, although some no doubt have. It means rather that the Ottomans had no imperial art except the architecture of mosques which proclaimed visually and symbolically the presence of a new order from Tunis and Budapest to Baghdad and Mecca.[4] The Ottoman sultan in the sixteenth century had no need for art. He was alone at his level of power. Unlike Christian rulers, he did not get involved in endless political, matrimonial, geographical and economic deals which were celebrated through images and exchanges of symbols. Unlike the Mughals, he had at his disposal a working system for ruling over nearly everyone; he did not have constantly to pacify Hindu grandees. In the competition for the rule of Muslims, the Safavids of Iran were hardly a match. His only real equal could have been the Holy Roman Emperor. But by Suleyman's time, the brotherhood of kings was restricted to the same faith; an infidel could not belong to the club. [8]

If the art of the exhibition was not Suleyman's, whose was it? An answer comes from looking at the *Suleymanname*. A breakdown of its illustrations gives thirty images showing affairs of state such as receptions or gift-giving ceremonies, eighteen depicting war, eight of them with particularly gruesome deaths, ten representing executions of rebels, seven showing traditional

4 Gulru Necipoğlu-Kafadar, "The Süleymaniye Complex in Istanbul: An Interpretation," *Muqarnas*, 3 (1985), pp. 97–117. I owe a great deal also to Dr Necipoglu's dissertation on the Topkapi Serayi (Harvard, 1986), now published as *Architecture, Ceremonial, and Power, the Topkapi Palaces in the fifteenth and sixteenth centuries* (Cambridge, 1991).

hunting, and two with unusual topics to be discussed presently. It is reasonable that a royal panegyric would concentrate on conquests and on the activities of the court, but the emphasis on executions and often on an apparently gratuitous portrayal of massacres in Rhodes or the Caucasus is curious. One has to go back to Assyrian sculpture for such a vivid depiction of killing in the name of the state and of order. Ideologically, executions, especially of rebels, are the visible expression of justice, the central concern of a lawgiver, and their presence in the manuscript is indeed an attempt to portray justice.

For whom was this manuscript illustrated? The dedication, slightly mistranslated in the facsimile, identifies the book as a gift (*tuhfah*) of the treasury (*khizanah*) of Suleyman. The word *khizanah* could have referred to the library which was part of the imperial treasure-room, but the operative term is *tuhfah*, "gift," for it implies that the book was made by someone *for* – rather than by order of – the Sultan.

Who ordered it can be inferred from two further observations. The second miniature in the book, placed between Suleyman's accession and a meeting of the imperial court, before any of the gory details of later images, depicts the *devṣirme*, the recruitment of tribute children destined for the army and administration of the empire (Fig. 3). It fits quite properly into a text describing how the "slave" system strengthened the Ottoman army, but the image is striking for its quaint charm. Six little boys have been registered by two neatly dressed officials and are about to be led away, while two Ottoman guards hold back a local population of men, women (the only representation of women in the whole manuscript), and girls led by a gesticulating priest in a black robe. In a manuscript filled for the most part with standard images or concrete depictions of combat, this topic, apparently never illustrated before or after, is shown in an unusually bucolic and sentimental mode, like a departure for camp or for boarding school. The event is portrayed as wonderful, not so much for the state as for the children and their families.

This is where the second observation comes in. With a few exceptions, the Sultan is rarely identified in this book by his clothes. Only his location on the page or the activities around him help in determining which personage is the ruler. The mass of handsomely dressed and turbaned participants are always court officials; even the learned *ulema* hardly appear. Officials were the mainstay of the empire. They had come as children from the Christian provinces and had became the servants more of the state or system than of the emperor. It is they or, perhaps more likely, one of them who could well have commissioned the illustration of the *Suleymanname* as a gift to the ruler and who would have recalled in rather idyllic terms the departure of the boys from the villages at the beginning of a book dealing with the power and rights of the state. Who precisely may have done this can be imagined from folio 266 (Fig. 4), which shows a group of handsomely dressed and turbaned soldiers climbing up trees to avoid a suddenly rising river. This

3 The *devşirme.*
Suleymanname,
fol. 31b

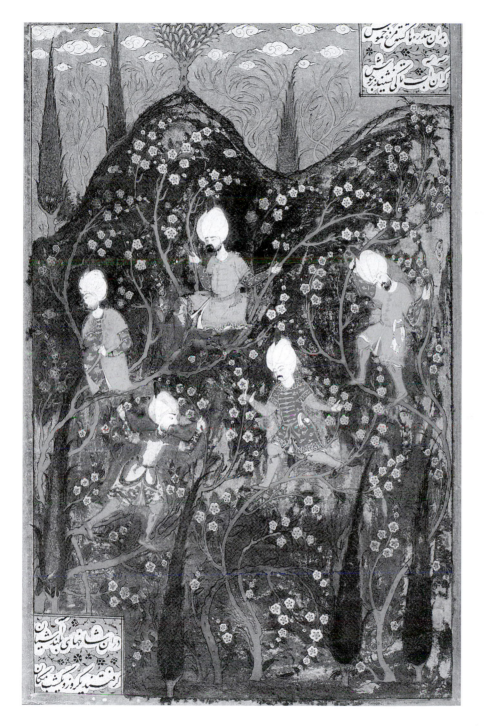

4 Soldiers in a
tree avoiding a
flood.
Suleymanname,
fol. 266a

episode suggests an anecdote about the hardship borne together by a group of veterans after one of the rare defeats of the Ottoman armies in the sixteenth century and recalled to the Sultan. One of these soldiers or the whole group might have ordered the manuscript for some festive occasion. It is also notable that the miniature is awkwardly composed, as though the painter did not quite know how to make the point requested by the patron.

This hypothesis can perhaps be extended to many other objects in the exhibition. What we see is neither an industrial art of luxury crafts, as existed in twelfth- and thirteenth-century Islamic art or in sixteenth-century Venice, nor a specifically imperial art in the fashion of Akbar's in India or of Francis I's in France. Instead it is the expression of the taste of a civil and military servant who is neither a technically trained mercenary nor the scion of a ruling class, but the uprooted alien who owes everything to his talents and to the beneficence of his ruler. This source would explain the anonymity of the forms, their lack of signifying charge, the relative poverty of written expression, the absence of expressions of faith from everything but a few restricted areas, and their visual brilliance. Some of the buildings attributed to the late Sinan may well have been built for that class.[5] Within this explanatory framework Suleyman recedes as a person and as a patron. He is replaced by a concept – Ottoman power – which constructs forms to act out and proclaim for itself the system's wealth and brilliance. The agents of this replacement were the products of the *devşirme*, and it is possible that further investigations will show the emergence of individual tastes among these grandees, [10] even though their loyalty to the state and the absence of a power base made unlikely the appearance of a duc de Guise or de Berry. The result was in line with an older Islamic tradition, a visual system which developed form over content and which made many simultaneous explanations possible for any one form.

It would, however, be wrong to see the Ottoman world simply as an antithesis to the Western Christian world of the time. It was rather the reverse of the same medal, struck originally in Assyria and honed ever after by all European and western Asian empires, and especially by the Roman empire and the myths developed, east and west, around it. Its Ottoman originality in the sixteenth century was not the quality of the ruling princes (extraordinary rulers existed elsewhere as well) but rather a constantly reformed and rejuvenated class of leaders, and it is therefore legitimate to attribute to that class the originality of the art. It is at least justified to do so in the sixteenth century. In the seventeenth and eighteenth centuries the art of the ruling class would become a *turquerie* in the West and would be replaced by Westernized forms in the Ottoman world itself.

5 This idea was developed by Jale N. Erzen, "Sinan as Anti-Classicist," *Muqarnas*, 5 (1988), pp. 70–86.

It may be regretted that the exhibition and its concomitant books did not raise broader questions of the operation of visual forms in the sixteenth century or of the meanings of objects within a courtly culture. Or perhaps it is wiser, at this stage of scholarly and general thinking about Ottoman art, to lay out the information, to propose a few keys for understanding, and to let others develop their own interpretation.

One such interpretation could be that there was a paradox in Ottoman art at the time of Suleyman and a particularly striking one for the sixteenth century. Nearly all of its achievements, with possibly the one exception of Sinan's Selimiye in Edirne, were buildings and objects or paintings which could be and at times were repeated and which were not meant to remain forever or to be used in their original shape. Again with the exception of the religious buildings, they were short-lived actors in endlessly repeated theatrical ceremonies. In one sense, therefore, they are not works of art in the restrictive sense imposed upon the world by Western painting from the early Renaissance onward. At the same time, the immediacy of their sensuousness, their dazzling desirability, trigger physical rather than intellectual feelings. They appeal to our sense of pleasure rather than to our judgment, and thus courtly objects made for practical ceremonial purposes become works of art by virtue of what they do to us rather than of what they were meant for in their time. The implications of this point for any general theory of the arts is considerable, as it introduces the time of judgment as a significant variable in dealing with the arts.

The *Age of Suleyman* was, however, more immediately important in its presentation of the Ottomans in the heyday of their power. What distinguishes their art is that it was destined so exclusively, so relentlessly, almost pitilessly, for their own restricted world and, within that world, probably for a very small group of potential users and viewers. The Ottomans acquired this restriction of the space of performance of each object from their Islamic inheritance, but in the showy Mediterranean of the time, it appears like a conscious decision to be different, separate. Even Sinan's mosques were accessible to others from afar, as an outline on the skyline, not as a theatrical façade in the Italian manner. What psychological, ideological, emotional, intellectual, or other motivations led the strongest power of Eurasia, whose empire extended from Algiers and Budapest to the Caspian Sea and Baghdad, whose population was mostly non-Muslim, whose ruling elite came from conquered lands, to concentrate its investments and energies on the rich and brilliant surfaces of ceremonial life? And all of this when the remote kings of Scotland or the tsars of Muscovy eagerly called Italian artists and craftsmen to give modernity to their capitals, just as Suleyman's grandfather, the conqueror of Constantinople, had done less than a century earlier. It is for others than historians of art to answer these questions. But it is the arts with a sensual appeal lacking in diplomatic or religious documents which lead us to pose them.

Chapter XVIII

The Meanings of Sinan's Architecture*

Among the glories of the Ottoman Golden Age are the many buildings built by or attributed to the architect Sinan. The majority of them are in Istanbul and they are still today the visual landmarks of the city. Their construction preceded and then overlapped the rebuilding of Rome under the leadership of the popes and through the genius of Bramante, Michelangelo, Sangallo, and eventually Bernini. Thus two of the three largest metropolises of the Mediterranean (and, at that time, of the world) were drastically modified in roughly the same period, the two which were the direct heirs of the first and of the second Rome. For comparative studies, this parallelism is of considerable interest and deserves some intelligent attention.

Some 470 buildings are attributed to Sinan, including eighty-four large mosques, fifty-four small ones, fifty-seven *madrasas*, thirty-five palaces and forty-eight baths, to name but a few of the functions which have been recorded. A large proportion, nearly two-thirds, of these monuments has been preserved and more or less adequate publications exist about most of them. Two biographies of Sinan have been preserved which still need philological investigation. The Ottoman archives have yielded their usual rich information and the *waqfiyah* of the Süleymaniye mosque has already created a significant literature on its content. Finally, a few interpretative articles have begun to raise aesthetic issues around Sinan's buildings.[1] All of this suggests that to talk about Sinan is to interpret available buildings during an unusually rich period of time and with a large array of documents. Even a non-Ottomanist like myself who has never worked in centuries as late as the sixteenth could have something to say which would not be a trite generality. It is in fact almost an intellectual obligation to develop and

* First published in A. Akta-Yasa, ed., *Uluslararasi Mimar Sinan Sempozyomu Bildirileri* (Ankara, 1996), pp. 275–83.
[1] Much has been written about Sinan and the Ottoman sixteenth century. I have profited primarily from the following: Aptulla Kuran, *Sinan* (Washington and Istanbul, 1987); Dogan Kuban, "Sinan," *Encyclopedia of Architecture;* Dogan Kuban, "The Style of Sinan's Domed Structures," *Muqarnas,* 4 (1987); Gulru Necipoğlu-Kafadar, "The Süleymaniye Complex in Istanbul: An Interpretation," *Muqarnas,* 3 (1985). All further bibliographical items will be found in these works.

publicize impressions and hypotheses so as to elicit reactions from those who are more continuously involved with the art and life of Sinan. [276]

Having said that, however, difficulties begin at several different levels. One is a question of perception which can best be illustrated by an anecdote. Some months ago, as I was visiting the Suleyman exhibition in New York, a group of visitors passed by the large air photograph of the complex of Suleyman the Magnificent. Someone asked: why did they put a picture of Hagia Sophia in an exhibition on Suleyman? These fairly well-educated visitors all associated a certain shape – a single-dome-dominated building with a set of supporting segments of domes – with one monument and one monument only, Hagia Sophia, built in the thirties of the sixth century AD, which was then, as it is now, a unique building. The existence of several hundreds of dome-centered Ottoman buildings from Algiers or Cairo to Baghdad and Yugoslavia (not to speak of the Turkish cities in Anatolia and Thrace) has not entered art-historical memory as an original creation but as an offshoot of Hagia Sophia.

A second difficulty of dealing with Sinan (as opposed to Michelangelo or Bramante) is that there has occurred an almost total break between scholarship and evaluation. Most of the new scholarship, done primarily in Turkey, is precise and factual, even in its occasional formalism, and, with a few significant exceptions, avoids the poetic expression which is often required of works of great art. Evaluation, still too often without a full immersion in the context of the time, tends to be superficial and reduces the Ottoman experience to an example of a stepchild of Roman architecture. It fits snugly, however, within a Western experience of architecture. The problem here is how to discover and develop a discourse of analysis and explanation which would at the same time acknowledge the originality of the Ottoman experience of the sixteenth century and relate it to a technological and formal history which is Mediterranean, if not universal.

And the third difficulty is that Sinan built for the most part buildings whose functions were clearly circumscribed by an almost millenary Islamic tradition. They were mosques, *madrasas*, baths, caravanserais, palaces, mausoleums, all part of a known and well-established tradition with dozens of local variants extending from India to Morocco. How well does his work fit with this tradition? Or did the very special circumstances of the Ottoman empire – its ethnic and religious variety, its unique manner of choosing its ruling elites, its close contacts with Europe and especially with Renaissance and Baroque Italy – alter the nature of the Islamic presence within the world of Sinan? Put in the jargon of contemporary intellectual practices, what was the collective memory of Sinan's world, the world of his patrons and of his surroundings? Was it the memory of ancient Turkish things in Central Asia? Of Harun al-Rashid and the glories of classical Islam? Of Rome and Constantinople, Caesar and Justinian, the Pantheon and St Irene, the world of Rum? Of Timur, the semi-legendary [277] conqueror who had inflicted

on the Ottomans a most costly defeat but whose name had remained among them as well as among the Mughals in India as a cultural ancestor? Each one of these historical explanations is possible and some have even been argued, but the difficulties are that each one has a different set of implications and that, therefore, different approaches are needed to investigate any one of them.

To deal with Sinan's architecture is, then, to deal not only with a set of buildings and their evolution but with an astounding spectrum of issues ranging from contemporary national and scholarly concerns all the way to transcultural relations or to many different moments of time or places in Western Asia or the Mediterranean. Therein lies the first meaning of Sinan's architecture. By the very nature of its circumstances, context and quality, it appears on two tracks: as a set of buildings which become sequences of objects to explain and understand and as a set of issues which extend meanings beyond an object.

Such a double track is a characteristic of any great artist's work and it is what makes his creation fascinating. In the scope of one paper, however, it is possible neither to discuss 470 individual buildings nor to deal with all the issues raised. I shall pick only two themes which will allow me to deal with three or four buildings. The themes are, first, how it was that Sinan created an appropriate setting for Muslim life, and, second, the unavoidable problem of Sinan's domes. I shall leave aside completely many of the problems which have occupied a great deal of recent scholarship: the evolution and evaluation of Sinan's treatment of forms, his growth as an architect, his use of decoration, and the relationship of his work to the Baroque age about to flourish, although I will come back to a special aspect of the last.

The vast majority of Sinan's buildings are destined for the by then well-honed and well-developed purposes of an Islamic society in which the proper act of the rich and powerful (and especially the latter) was to donate part of their fortune for the eternal upkeep of a set of functions restricted in their use to the Muslim community. Prayer is the best known of these functions, illustrated by the mosque. But all sorts of schools, from elementary to specialized training places for the legal and religious elites, were part of the system, as were hospitals, libraries, welfare kitchens, mausoleums and so forth. It was a complex system of functions, each of which has its own history and development. None of the functions, except perhaps public kitchens (*imaret*), were Ottoman inventions and few among them had clear forms or blueprints attached to them. Such broad functional requirements as existed (unified space for prayer, hot rooms in bath houses) could be met in any number of technical ways. Sinan, therefore, did not come to the Muslim function without an experience of older models and [278] memories. In Bursa and especially in Edirne the young Ottoman system had developed mosques based on a single dome or on sequences of domes. Mausoleums abounded, as did schools, but the challenge of Constantinople had not as

yet been met, a challenge which was of a unique urban space, of a unique building (Hagia Sophia), and of a unique history.

Let me show you what Sinan did with two examples. The first one is the group of buildings completed in 1571–2 and known as the Mosque of Sokollu Mehmet Pasha. This celebrated statesman and his wife, Esmahan Sultan, sponsored a typical ensemble consisting of a mosque, of a *madrasa*, and of a *tekke*, a cloister for holy men at times with mystical interests, often merely a form of welfare for the old and the transient. Sinan, whether directly or through his atelier, separated the *tekke* from the mosque and the *madrasa* and combined the last two by providing them with a single courtyard. All the terms involved – a large dome on a hexagon supported by six piers engaged in walls, four supporting half-domes, courtyard, portico, interior colonnade, domical cells, monumental entrance – have been common or at least current in Islamic Anatolian architecture for several centuries, and some of these terms go back to the obscure origins of Mediterranean architecture which so fascinate historians of art. Sinan's genius appears in the way in which he has ordered these elements in the very difficult setting of a sharp slope. He has made access to the mosque almost invisible from the outside, but dramatic once one finds the entrance and climbs toward the court; he has used admirably a large fountain to serve as a transitional visual stopover from the trabeated entrance of steps and the curves of the upper parts of the complex. And then, as one penetrates into the dome chamber, the spatial unity of the composition is fractured, like a crystal or a diamond, into a myriad of facets, some architectonic, other flat applications on walls or stained glass. Ottoman monuments have not been studied enough to know whether many iconographic meanings can or should be attributed to this mass of visual signs, at least in this particular instance. But, in opposition to current opinion which sees the Sokollu interior exclusively in terms of spatial daring, I prefer to see it as in a state of tension between a unified and logical upward movement and a broken-up downward cascade.

To my initial question of Sinan's response to the challenge of traditional Islamic piety as applied to the rich and powerful, the answer here is that Sinan used a difficult lot to close Mehmet Sokollu's mosque unto itself, to create a rich interior space which could hardly be guessed from the outside, as the section makes the dome, whose domination of the interior space is evident, more forceful from the outside than it really is. Sokollu's ensemble, an interiorized monument, meets wonderfully one Muslim tendency: withdrawal from the immediacy [279] of the city in order to meditate, dream and pray, but not withdrawal from the urban setting. In early references to the mosque, its relationship to the seashore was recalled, and Sinan knew how to manipulate known elements in order to create a rare contrast between a hidden and mysterious exterior (whose minaret is the weakest Sinan ever conceived) and a rich and clear interior. This contrast is *one* possible Muslim message.

The difference could not be more striking with the Süleymaniye, the grandiose ensemble built between 1550 and 1557 and still now dominating the city day and night. Yet, from my point of view of traditional Islamic functions, it is a very traditional ensemble with four *madrasas* instead of one and with a usually rare medical school. In Istanbul itself Mehmet the Conqueror had already provided the precedent of a group of eight monumentalized functions of three sides of a mosque–imperial cemetery axis. And it is easy to see the Süleymaniye simply as an expression of power and domination, as Sinan carves out of the highest hill of the city a monument which embodies Suleyman's rule. Many scholars have commented on the contrast between the symmetry of the central complex and the asymmetry of the surrounding areas, on the elevation of domes and cupolas cascading down from the central cupola or snugly set next to each other with their little chimneys like obedient children in a classroom. Nowhere in the history of architecture does the astounding versatility of the dome appear with such brilliance and testify to the imagination of Sinan's designs, nor is there any ensemble with so many axes, so many directions, and so many points of view. A recent study has also unraveled the several operational levels at which this ensemble functioned and shown in particular that the building was full of verbal or visual references to the great sanctuaries of Islam, to Hagia Sophia, and to paradise, in the peculiarly Muslim way in which paradise is both here and yet not quite present.

Thus, a first contrast with Sokollu is that of the multiplicity of meanings available in the Süleymaniye. In part this was no doubt due to the difference between a public and a private enterprise, and it is theoretically not excluded that a deeper knowledge of the Sokollu family may yield interesting results in the interpretation of the mosque. The earlier Turkish world of Anatolia was full of private references of this sort, but I simply do not know whether they are appropriate in an Ottoman context. For, in contradistinction to the West, with its fascination with mimetic representations and with the spirit of self-analysis issued from the practice of the confession, the Muslim world usually preferred not to expose the individual peculiarities of each believer and to subsume pain and fear under a decorous façade. At the public level, visual references to a paradise or to politics are better known and their presence at the Süleymaniye [280] is derived from obvious qur'anic quotations in doorways and from the parallelism between the tomb of Suleyman and the Dome of the Rock, probably because of a common relationship to Solomon. These public and official synchronic meanings were then read into the building by Ottoman historians and only withered away when the setting of these meanings disappeared in the nineteenth century and especially after the Kemalist revolution. The Süleymaniye is part of the setting of an empire and becomes the partner of the Topkapı Serayi. In the latter, the Palace school trained the future soldiers and administrators of the empire; out of the former came its intellectual and religious leaders. And what Sinan

succeeded in doing is in making visible the preeminence of the religious order as the foundation of the empire, as its rationale and its justification. It is the domination of Istanbul by the Süleymaniye which led dozens of similar buildings all over the empire to become signs of Ottoman presence. The architecture of the mosque, because of its simplicity and visibility, became *the* imperial statement, and it is Sinan who codified the form taken by the mosque in classical Ottoman times.

Sinan achieved this in part by his artful treatment of the hill, which has already been mentioned. He did it also with the plan of the mosque which consciously recalled Hagia Sophia with its central dome on huge articulated piers supported by two half-domes on the main axis of a square space. In other words, there is a movement toward an end in the building, toward the *qiblah*, the focus of prayer. There is an antespace to it, the court with four minarets as a separate composition; and then the platform has asymmetrical entrances, so that one walks around the building as through a spiral to get to its doorway. Several geometries of movements form patterns around the building. What we see in all of this is a manipulation of space and of movement in such a way that a competition takes place between the eyes and the feet. Clear and obvious from afar, the Süleymaniye is reached through several tortuous passages and appears or disappears as one moves toward it. What Sinan has done is once again to use admirably the setting of the city in creating a drama of accessibility toward a composition which then broadcasts a complex series of multi-leveled messages about the pious foundations of a universal Muslim empire.

In all of this we see again the striking use of domes as modules and as centers of composition. And thus I have an entry into the second of my major issues, Sinan's domes. Let me summarize, first, what the problems are. No one questions any more that, for reasons which need not concern us here, the Ottomans, more than any other Turkic principality after the thirteenth century, adopted the dome as their primary planning module. They used it in sequences of two or four or more units arrayed for instance in a T, or compacted into a single rectangle, or eventually as a single large dome dominating the rest of the building. In [281] Edirne's Uc Serefeli mosque (built between 1438 and 1447), that single dome was set over a hexagon, thus liberating side walls for eventual expansion of the interior space in four different directions.

Sinan became a master in the treatment of these domes. The plans of his buildings show every possible permutation from a dome on a square all the way to a dome on an octagonal space. Furthermore, he developed to its fullest logic the principle of the half-domes supporting the central dome. At least he created that particular visual impression, for, in a recent essay, a Turkish scholar argued that Sinan's dome was not really a means to cover space, but an independent baldaquin, that is to say a self-contained and independent unit with four, six, or eight supports. This independence of the

domed area explains the movement of supports away from the wall, their own independence, and the streamlining of the passages from square to dome. It also allowed for a greater flexibility of the sides which could then be adapted to various sizes, types and shapes. It allowed, finally, for the concentration of thrusts in a small number of points and, as a result, the opening up of walls through windows.

The modulation by which these changes and experiments took place is a problem for specialists and I do not dare enter into the hallowed grounds of chronology in the work of Sinan. What is certain is that the evolution of the dome and of the dome-based composition culminated in Sinan's masterpiece, the Selimiye in Edirne, built between 1564 and 1575. Not particularly original in its general plan (a court and a sanctuary), the Selimiye stands out, first of all, in elevation. Massive and elegant at the same time, it is framed by the four minarets which seem almost to protect it. It is as though the mosque has become a shrine, but not so much to a faith as to the art of building domes. It is an art which began with the Pantheon, acquired its longitudinal expansion with Hagia Sophia, and then a series of spatial variants in the early Ottoman period, while Alberti, Bramante and their European Baroque followers, like their Iranian and Indian counterparts, created a high dome on a drum which ordered space around it. Not so in the Ottoman dome, which is strictly and powerfully related to the building in which it is found, and which sends its tentacles into the whole building. This was Sinan's contribution: as opposed to Hagia Sophia which is a cover *toward* which one builds one's attention, the Selimiye dome is the first feature one perceives and, in a brilliantly calculated way, its membranes extend into the rest of the building. One of the expressions of this transmission is the two-colored (so-called *ablaq*) masonry of the arches which, like concrete slabs of today, emphasize this loadbearing quality. This intelligence of the supports probably reflects Sinan's early years as a military engineer; the result of the intelligence is the opening up of walls and the introduction of light on a grandiose [282] scale, so that the tile decoration appears less as a wall covering than as the reflection of a colorful outside world. The clarity of a light only partly filtered through glass gives volume to two-dimensional designs and flattens some traditional three-dimensional forms like the *muqarnas* in the pendentive.

In the Selimiye dome, Sinan finally meets the challenge of the Hagia Sophia. He does it first of all by creating a higher and wider cupola, as Sinan freely acknowledges in his autobiography. But this is a purely dimensional vanity. What Sinan has really done is to take ideas of the dome-baldaquin and of the dome-membrane to their most extreme point of growth. It is not merely that later mosques did not reach the level of sophistication and originality of the Selimiye, even if the dimensions of Sultan Ahmet or the outer lines of the Nurosmaniye are not without interest. It is rather that there was no way for them to go beyond Sinan's achievement. The sequence which began with Justinian's engineers, perhaps even with Hadrian's in the

Pantheon, finds here its logical end. Pared to its minimal support system within a technology of stone and concrete, the domed volume has found its purest expression in Sinan's buildings which, therefore, become a prototypical example, of which many more exist in the twentieth century, of an architectural formula which would have run its course. Although ultimately destined for the same fate, the Baroque church issued from the same Albertian decades in the West took longer to become repetitive, because it played constantly the dome against the façade (Invalides, St Paul). Sinan clearly relegated façades and doorways to another realm, even though his details are often exquisite. The reason, I submit, is that, to him as to his imperial masters, power of presence overshadowed the call for specific behavior.

The first meaning of Sinan's architecture was that it raised an unusual number of issues about architectural meanings. What, then, are some of these issues? One is technological and, on that level, I propose to see the meaning of Sinan's work, not in his structural achievements, but in the fact that he brought a certain domical tradition to its logical purity, somewhat in the way in which Cézanne and the Cubists brought to a logical end centuries of mimetic representation.

A second issue is that of power and domination. Here again the specific signs and codes are peculiar to the sixteenth century and would have been unlikely in the fifteenth. The relative absence of inscriptions in the Selimiye shows that the signs and codes were well understood by everyone who needed to do so. The meaning of this point is the creation of a contrast between an outer shell visible to all and an inner space restricted to some. This double life of the building could be seen as an example of the classical Islamic contrast between *batin* and *zahir*, between outward and inner meanings, visible and invisible. [283]

But perhaps it is more appropriate to see yet another meaning in these forms. Instead of imagining esoteric contrasts, we should perhaps see Sinan's achievement as the creation of works of art, perhaps as the creation of a work of art, the perfect dome. At this level Sinan's work lies somewhere in the celebrated trajectory which led from tents to Boulée's fantasies or to Buckminster Fuller's geodesic domes.

Chapter XIX

The Many Gates of Ottoman Art*

The point of this paper is to consider Ottoman art from the outside: what is the interest of Ottoman art to any theory of the history of art or to the aesthetic impulses of men and women everywhere and anywhere? The question is all the more pertinent and important since the four "great" centuries of Ottoman art and culture, from *c.* 1400 to *c.* 1800, are times during which the world underwent truly extraordinary changes, from the discovery of America to the French Revolution, from Masaccio to David, Alberti to Boulée, Gutenberg to Newton, and so on. The issue is not whether or not these changes affected the Ottomans or whether the Ottomans contributed to them, although both questions have been raised in the past. The question is rather: since the Ottoman empire and therefore an Ottoman art existed and, to a large degree, flourished during these centuries, what did their existence mean to a changing world? And I dedicate these remarks to a very old friend, Doğan Kuban, with whom I have argued and disagreed for some thirty-five years, but from whose lively imagination, insatiable curiosity about everything everywhere, and especially intellectual integrity, I have learned so much about Turkey, the Turks and the Ottomans.

Following a pattern borrowed from the classical Persian lyrical poetry so prized at the Ottoman court, I propose that there were seven gates to Ottoman art, to which I have given unpoetic names: Inner, Outer, Satellite, Imported, Collecting, Intermediary, Aesthetic. I shall elaborate on each one of them through a few examples and then conclude with a broader program of thinking about Ottoman art. I shall ask questions rather than provide answers and propose directions for thought and work rather than establish formal paths for investigation.

* Dedicated to Doğan Kuban, friend and colleague of many years. First published in *Art Turc/Turkish Art*, tenth International Congress of Turkish Art (Geneva, 1999), pp. 19–26.

Inner

What I mean by "inner" is what most research on Ottoman, and for that matter on any other, art has been: an explanation of its creativity within its own context. And much has been done and is being done to elucidate everything from [20] the evolution of mosque architecture to changes in the taste of patronage and the varieties of costume and ceramics. The inner workings of Ottoman art are, for the most part, the proper concern of the specialist, but they can also be important for broader issues of the study of forms. I will give two examples.

The first is the best-known one and involves the Ottoman dome. Doğan Kuban strikingly defined Sinan's domes as simultaneously organic exercises in geometry and reflections of man's life as the basic module of conception and composition.[1] The uniquely Ottoman transformations of the dome deal with a form which may or may not have had a consistent single history going back to Eskimo igloos or to reed-covered huts, which may or may not have had consistent symbolic meanings or practical functions, but which was certainly part of an architectural language prevalent from Central Asia or India to the Atlantic and beyond. The reasons for the Ottoman achievement become almost immaterial in the broader philosophical question whether, like the Baroque dome of Western Europe, the technical purity and the abstraction of the Sinanian dome are not ultimate and final developments of domes to the point where the form can be neither modified nor simplified any more. I shall return shortly to another aspect of this characteristic of the classical Ottoman dome, but, in the meantime, my contention is that this dome is philosophically important in that, by exhausting its structural possibilities, it has, in a way, escaped history.

My second example of inner "treasure" is Matrakçi's *Beyan-i Menazil-i Sefer*, the illustrations dated in 1537 of a description of Suleyman's expedition of 1533–36 in Iraq. Much has been written about these illustrations. Scholars have tried to identify and explain individual places, to reconstruct cities in the sixteenth century, to establish conventions for representing different types of buildings, to define the semiotic value of the visual terms used (are they signs or symbols or depictions?). Did Matrakçi work from memory or had he made sketches? How were pictorial conventions for the representation of architecture and of nature transformed? New questions or problems arise every time one opens the publication of the manuscript.[2] This is unusual enough, but it is not the point I wish to make about these images. Their importance for Ottoman studies is self-evident, but their interest lies in something much more complicated.

[1] D. Kuban, "The Style of Sinan's Architecture," *Muqarnas*, 4 (1987).
[2] H. G. Yurdaydin, *Matrakçi's Beyan-i Menazil* (Ankara, 1976).

For instance, there are no personages in them and the only living beings are a few animals, unevenly visible in the pictures according to a rhythm which does not make very good sense. The absence of people gives to all the cities and buildings a deserted, dead, feeling, or else they appear as toys assembled to resemble some sort of reality (Aleppo's citadel, for instance), but which could not possibly evoke that reality. The representation of the mausoleum of Oljaytu in Sultaniyeh does not *look* like the actual building, but evokes its size, brilliance of decoration, numerous corner towers, and many other details [21] which are not supposed to make the viewer identify a specific building he has never seen and never will see, but to let the viewer's imagination operate in recalling the glories of Ilkhanid princes made visible to Suleyman. The arrangement of the city of Khoy may suggest a city with trees between houses arranged in neat rows, but may also indicate that this particular city was different from other cities or that all cities are different from each other. We may never know what the original expectation of these images was, but the fascination of Matrakçi's paintings is that, just as with Sinan's domes (but without their technical quality), the images which are given still provide a range of possible interpretations, they open up the onlooker's field of vision and enrich him with visions and questions on the fundamental issue of how the human eye and memory recognize an architecture they has never seen and how they interpret it. These images are at least interesting as specific documents and most fascinating as examples for any theory of representation.

Outer

My "outer" gate has not been as popular in recent years as it was in the past. It consists in identifying and elaborating on the impact of Ottoman art outside of the empire's boundaries. The psychological make-up of the past two or three decades has seen something foolish, at times even embarrassing, in arguing whether St Peter or the Selimiye had better domes, or why the traditional French painter Van Loo represented "The Concert of the Sultan" as a wonderfully silly European costume party. The large series of allegedly Turkish women or of aristocratic men and women dressed up in Ottoman or Indian clothes remains as an interesting illustration of various Western European psychological problems which will culminate in the more dubious "Orientalism" of the nineteenth century. At its most benign, the *turquerie* was the acknowledgement of a quality possessed by the material culture of several Asian traditions, and so-called "Turkish" themes predominated for a while because the Ottoman empire was closer than China or India, and because there existed a whole intermediary world of Christians and Jews who were fully part of the Ottoman world, yet who had a privileged connection with Western Europe.

However one is to deal with the detail of this rich body of information in many media, from many lands, and over 300 years, the broad problem is this. There is nothing new about Western Europe finding its arts of luxury in the Muslim world; the phenomenon is as early as the eighth century of our era. But, whereas the earlier instances can be explained by the low level of Western technology, this is no longer true in the Baroque age. We are dealing, therefore, with a decision of taste or, possibly, of economic opportunities. Did the economics of manufacturing and selling textiles, ceramics and other luxury objects in the Ottoman empire affect their export to external markets, like Korean or Japanese cars today? Or is it, as for Jaguars or Mercedes, a European need for expensive exotica that was involved? But what was the nature of that need? What are its impulses? Some combination [22] of taste and economics is probably involved, but the subject certainly merits the attention of historians (for instance, how conscious were the Ottomans of the value of their products elsewhere? Did they, like Chinese textile and ceramic makers, create certain wares or silks for export only?), of social and economic historians of the West, and especially of all those who can see the broader spectrum of cultural history. For, in this "outer" gate, the Ottoman world plays a curious role which is partly typological – one of many forms of exoticism – and partly unique – the Turk is not the Chinaman and the *turquerie* is not the *chinoiserie*. Why the differences?

Satellite

The third gate would have been called "provincial" only a few years ago. I prefer to call it "satellite" now on the possibly mistaken assumption that there is more dignity in being a satellite than a provincial. The silliness of this statement underlines something of considerable importance, which is that what can be called the Turkish artistic expression was transmitted and extended over many territories. The major instrument for that transmission was the Ottoman empire. Algeria, Tunisia, Egypt, the whole Levant, Iraq, and all the countries of the Balkans are covered with buildings copied from or inspired by Istanbul architecture; clothes and objects as well as the terminology of visual and material forms are often Turkish; cooking as well as other practices of daily life acquired an Ottoman taste. All this is well known and it is important to realize that the monuments of that art have now become signs and symbols of local Bosnian or Syrian national heritage, not remains of Turkish or Ottoman taste.

The historian or the critic is faced with an interesting dilemma of our time, which is whether the chronologically correct definition of an Ottoman art independent of its ethnic – Turkish or other – components should take precedence over the politically correct definition of national and ethnic

pride and allegiance. Should a mosque in Plovdiv be called Bulgarian, Ottoman, or Turkish? Can it be all three?

A further complication is that, while the Ottoman phenomenon is well known, there is another Turkish "satellite" formation which is now beginning to emerge again, even though it had been badly damaged by the tragic history of this century. I mean the Mongol or Tatar satellization of Northern Asia and Eastern Europe. In Crimea, the Caucasus, Azerbayjan, Chechenya, the lands of the Volga Tatars, southern Siberia, Kazakhstan and Transoxiana, the Tarim basin, there is a whole world of architectural and material forms which derived from the great Timurid syntheses of the fifteenth century and which was carried out by Turkic rulers and ethnic groups. I have only just begun to realize how narrow-minded has been our Mediterranean or even Central Asian conception of the arts involving Turks of different kinds. Already in the twelfth century distinctions between Turks and Turkmens implied a distinction between two traditions, one which gravitated toward major centers of power [23] – Baghdad, Herat, Samarkand, Istanbul – the other which spread everywhere and often split into all sorts of local entities. There is here, once again, a fascinating broad topic for further research and intellectual refinement on the part of some energetic young man or woman. Several separate orbits of artistic life can be connected to the political, linguistic and social presence of Turks in the post-Timurid era. Whether there are genetic ties between these orbits remains to be established.

Imports

I shall be brief on the gate of "imports," because it is the easiest to deal with. Like any art, Ottoman art was affected by the arts of other lands. Western Europe appears already in details of representation in the sixteenth century and in architecture later on. But the real issue is not to make a list of imported details. It is much rather to note the relative paucity of Western European themes, techniques, or ideas in most of Ottoman art before 1800. The existence of a Turkish Baroque does not mean copying or imitating Baroque forms from Vienna or Italy; it means, much more interestingly, transformations of Ottoman forms in ways which may well reflect a general *Zeitgeist* rather than the direct impact of Western ideas or of a Western taste. The point is interesting both for an overall understanding of what "baroque" means and for the inner operation of Ottoman taste and culture. Another side of the issue lies also in the existence of the two illustrated *Sulnames* with their representations of festivals in a manner so common in European representational art and yet without any suggestion of Western impact. With the Ottomans, it seems, the art of representing ostentatious performances was for limited internal use only – or was it?

The second obvious foreign import in Ottoman art is from China and a specific category of motifs was called "çini." In contrast with the subdued relationship to European art, Chinese forms and techniques appear clearly in the designs of ceramics and textiles, occasionally in certain categories of drawings, especially of dragons.[3] The problem is not that these Chinese motifs existed but why they are present. It is not that designers and technicians of Ottoman times could not develop their own techniques and designs. It is rather that something in the very make-up of Ottoman culture required an acknowledged Chinese component. The assertion of Chinese superiority in the arts of representation was an old cliché of Islamic culture which developed together with the Iranian myths of the tenth or eleventh century. But, while this may explain the sources of the idea in Ottoman taste, it does not provide a psychological explanation for its continuing presence. This explanation lies, I believe, in the choices every culture, even a relatively closed one like the Ottoman, makes about what will be its own exoticism. And within everyone's need for exoticism, there are gradations. [24]

And then there is, especially in painting after some fifteenth-century examples in architecture, the relationship of Ottoman art to Iran. The issue is not whether the palette of Ottoman miniatures, the scale of their personages in relationship to nature, the composition of groups and other details of technical and formal analysis should be given an Iranian or an Ottoman nationality or genetic structure. These distinctions are as useful or as unimportant as those which distinguish Florence from Siena or Bologna or Bruges from Antwerp: they are primarily museum labels with occasional references to patronage. To any external eye, the common ways of organizing space, depicting people and treating a subject far outweigh differences. But, in dealing with Iran, I am less sure that terms like "impact" or "influence" are pertinent. Rather, just as the Arabic alphabet came with the faith of Islam to acquire unique Ottoman expressions, so did a process for representation developed in Mongol Iran. These features were, I would argue, part of the genetic structure of Ottoman art, not temporary mutants.

It is intriguing that the mere consideration of "imports" into Ottoman art leads in each case to entirely different art-historical concerns: parallel structures, exotic needs, common language. This gate, like the following one, illustrates a point made by Kuban many years ago at a symposium we attended together: the Muslim world whose most powerful force was the Ottoman world was the only cultural entity to be in physical touch with every part of the African and Eurasian continents.[4] But all lands were not

3 S. C. Welch, "Two drawings, a Tile, a Dish, and a Pair of Scissors," in R. Ettinghausen, ed., *Islamic Art in the Metropolitan Museum* (New York, 1972).

4 The occasion was a symposium in Dammam in Saudi Arabia held in the late 1970s. I am unable to lay hands on a copy of its proceedings.

equally present in Ottoman consciousness, another topic for meditation and investigation.

Collecting

The gate of "collecting" has been recognized since the Skira volume on *Treasures of Turkey* published in 1967.[5] The Ottoman treasure received and kept gifts from many lands and it became as a result the repository of objects and works of art from all over the world. Furthermore, the looting of the treasures of defeated enemies also enriched Ottoman possessions. There is no particular originality in that, as the maintainance of treasures is a characteristic of all empires. It is in fact reasonable to argue that the artistic possessions of most rulers were generally alien and not native and that native productions were kept in courts either for immediate use (clothes or dishes) or for gifts to visitors, foreign or not. The more complicated problem is to evaluate the impact, if any, of these treasures. Around the albums, it seems clear that original Chinese paintings [25] were used as models for other paintings and drawings or as exercises. Are there other examples of use of objects by princes, their households, or artisans attached to the *naqqashhane*? Another question to emerge is whether anyone at the Ottoman court ever initiated acquisitions for the treasure in the manner of German, Swedish, or Russian rulers at that time. I argued some years ago that the *Suleymanname* reflected in its illustrations the relationship between the sultan and the establishment from which the grand viziers of his time emerged, because the book was an internal gift.[6] But I am not sure that a pattern of internal gifts reasonable for the sixteenth century is still valid for the seventeenth or eighteenth. In short, the fact of collecting works from many lands and for many purposes is in itself an important subject of investigation with ramifications into social and cultural history. But it is not a chronologically stable phenomenon and it contains many variants.

Intermediary

The sixth gate derives from the fact that between 1453 (actually 1517 and the conquest of Egypt is probably a better starting point) and Napoleon's expedition to Egypt in 1798, the Ottoman empire was visually, culturally, psychologically and intellectually the only port of entry into the Muslim world. This single entry affected much of the knowledge Europe in general and scholarship in particular had of the Islamic world. The example I will

[5] E. Akurgal et al., *Treasures from Turkey* (Geneva, 1967).
[6] O. Grabar, "An exhibition of high Ottoman art," *Muqarnas*, 7 (1989).

use is that of Louis-François Cassas, a draftsman and painter attached to the French embassy in Istanbul, who was sent on a mission to Syria, Palestine and Egypt, and who came back with drawings and paintings which have been the subject of a recent catalog and exhibition.[7]

In his work and in the work of many others, an Ottoman conception of the Muslim world became the prism which affected several centuries of knowledge about the Arab world, Iran, Byzantium, the classical world other than Rome, and all ancient Near Eastern histories. Some effects of this prism are silly, like the turbans and robes on the artificial groups in so many pictures. Others are more significant, like the assumption of a *shari'ah* based Sunnism as the norm for the Muslim world, or, in the arts, the aesthetic importance given to calligraphy, engineering logic and structural simplicity. Even when, in the nineteenth century, Andalusia, Egypt, Iran and Muslim India did become entries into very different parts of the Muslim world, it was in Istanbul that the manuscripts and archives were kept, and few scholars of any aspect of Islamic art can manage without leaning on the collections established by the Ottomans and on their vision of the Muslim world available in Istanbul. And it is the much-simplified and reduced Ottoman mosque which has become, from Indonesia to New York, the sign of Muslim presence and the symbol of the true faith. [26]

What is involved in all of this is in fact a very complicated process whereby the imperial and ideological transformations of the sixteenth century, with the incorporation of Jerusalem, Cairo, Mecca, Medina and Baghdad within the space of a dynasty of Turkish ghazis and with their control over an enormous population of non-Muslims, created an Ottoman threshold for access to Islam, to the sources of Judaism and Christianity, and to the ancient cultures of Western Asia. It is easy to identify the threshold in practical ways (for instance, the politics of excavations in the nineteenth century); it is more difficult and more interesting to wonder how much it has affected the intellectual, academic and emotional make-up of all those outside of it who dealt with its space and of those who today are the heirs of that empire. Volney visited Syria and Egypt in the 1780s. Here was a bored Western intellectual who had inherited some money and wanted to improve his mind. His choices, he writes, were either to look at the future and take a trip to the Americas or to understand the past and go to the Ottoman empire.[8] The implications of his dilemma and of his decision to go eastward are quite interesting. But, for our purposes, what is important is that the Ottoman empire was the guardian of Europe's past: it owned Athens, Jerusalem, the Pyramids and Babylon. In the nineteenth century, this

7 Annie Gilet, *Louis-François Cassas, 1756–1827* (Mainz and Tours, 1994). For further comments there are other examples; see Gereon Sievernich and Hendrik Budde, *Europa und der Orient, 800–1900* (Berlin, 1989).

8 C. F. Volney, *Voyage en Syrie et en Égypte* (Paris, 1807).

guardianship became part of the political struggles of the time, but how aware was the empire of this role before 1800?

Aesthetic

My last gate of or to Ottoman art is the "aesthetic" gate. The question is a fundamental one in two parts. One is by what criteria did the Ottoman world itself decide on the quality of the objects and monuments it sponsored, made, or used. The elaboration of an answer lies in some sort of equilibrium between philosophical and theological fashion in Ottoman thought, the make-up of the patronage, and the possibilities of the techniques employed. The other one is of a more universal importance. Can one identify and define the attraction, the pleasure, provided most exclusively by Ottoman art to the sensibilities of today? Are there visually potent values which are most particularly exemplified by works of Ottoman art?

The matter is relatively easy in architecture, where the geometry of construction and the typological standardization of forms have been mentioned more than once. Aesthetic issues are much more difficult to handle when one turns to the ceramics, textiles and ways of writing, which have constantly been collected and praised. Something in the best objects of Ottoman art elicits a sensuous response, whereby one wishes to touch them and/or to contemplate them. The more precise nature of this response still needs investigation and thought, possibly even the development of a particular aesthetic vocabulary. It is this particular gate that requires the most work, because the very nature of the issues it raises has not yet been fully identified.

Chapter XX

The Crusades and the Development of Islamic Art*[1]

Among the numerous catchy but arrogant as well as intellectually dubious aphorisms attributed to great men is Napoleon's statement "l'intendance suivra." The idea is, I guess, that, once a brave and well-led army has moved forward, conquering territories and defeating enemies, the paraphernalia of practical institutions and needs required to make an army function and to lead it to other successes or, alternately, to keep conquered territories under control, follows automatically.

Historians of art and of anything else have followed this Napoleonic adage in assuming that major events affect culture and the arts. It is, so the assumption goes, legitimate to argue that the French or Russian revolutions, Alexander the Great's conquests in Western Asia, the Mongol invasions, the appearance of Islam, the spread of Buddhism, and other such momentous episodes in the history of mankind had an impact on the arts or modified existing ways of doing or seeing things in some significant manner. Such impacts or modifications can be the culmination or expression of internal, culture-bound, seeds which would be shaken into revolutionary novelty because of an event, as with constructivism in twentieth-century Russia, the evolution of David and the formation of Ingres in late eighteenth- and early nineteenth-century France, or the merging of Hellenistic with Roman sculpture. Or else these novelties can be attributed to the sudden appearance of the new and foreign element, like the art of sculpture in India, apparently revolutionized by Hellenistic models, floral ornament introduced into Chinese art by the spread of Buddhism, or French painting and architecture transformed by the invasion of Italy in the last years of the fifteenth century.

The mode of operation of these changes varies. There are destructions of the old and its replacement with something new through the will and

* First published in A. E. Laiou and R. P. Mottahedeh, eds, *The Crusades from the Perspective of Byzantium and the Muslim World* (Washington, 2001), pp. 235–45.
[1] This paper is more or less the one delivered as a lecture at the occasion of the Dumbarton Oaks symposium on the Crusades. Only the most elementary bibliographical references have been added and a few rhetorical changes made.

decision of whoever wields power, as often happened with changes in religious spaces when temples became churches and churches or fire-temples became mosques. At other times, artists and artisans as well as techniques of all sorts are brought in and become the instruments of the transformation, as when Persian painters went to India in the sixteenth century, or when the Umayyads in the seventh and eighth centuries, like the Normans of the twelfth, [236] acquired the financial means to hire whomever they wanted for their ambitious programs of construction and decoration.

The assumption is that the revolutionary or unusual event, whether or not it involves an invasion, leads either to some triggering within the affected culture which brings out new and perhaps unexpected features hidden in the existing cauldron of memories and competencies or else compels new patterns of cultural life through the importation of foreign technicians, models, taste, or behavior.

A priori, the phenomenon of the Crusades can legitimately be considered as such an epic or at least momentous event. New men and women with a Western European and Latin culture established themselves in a land that had existed for more than three hundred years in an Islamic culture blissfully ignorant, for the most part, of the Latin Christianity about to appear on its territory. That new and unexpected event was kept alive and active for nearly two hundred years, until the late thirteenth century, and survived far longer in cultural memory. There were large-scale, if temporary, movements of people, including artisans and construction workers brought from afar to replicate as many aspects as possible of the homelands of the Crusaders. We have an enormous program of construction, as Jerusalem, Bethlehem, Hebron, the coastal cities of Syria, Palestine, and Lebanon and several interior areas (I am thinking of the Crac des Chevaliers to the north, now in Syria, and Kerak or Shaubak to the south in Jordan) are all covered with monuments of a new imported architecture. Manuscripts are illustrated in the Latin Kingdom of Jerusalem and, although I am not aware of many remaining objects made specifically for the Latin inhabitants of Palestine, the emblems of their presence are still visible in their coins and seals, and a number of reliquaries were probably done in Palestine as well.[2] All of this was happening at the height of the Romanesque artistic explosion and of the sophisticated Byzantine pictorial wealth under the Komnenian dynasty.

It is equally important to recall that the twelfth century, and especially its second half, witnessed an extraordinary set of quantitative and qualitative changes in Islamic art. Hundreds of new buildings, for the most part *madrasas* and other social functions of pious architecture but also caravanserais and bazaars, were sponsored in every city from Central Asia to the Mediterranean coast in order to meet a set of newly developed ideological and economic

2 The bibliography on the art of the Crusades is enormous. The most recent thorough survey is J. Foida, *The Art of the Crusades in the Holy Land, 1098–1187* (Cambridge, 1995).

purposes. It is in the twelfth century that the *muqarnas*, that ubiquitous and unique form of Islamic architecture about which I will have more to say shortly, spread all the way to Morocco from its origins in Iraq and Central Asia, with all sorts of intermediary stops like the Cappella Palatina in Palermo. Thanks to a patronage expanded from the courts to the mercantile elites of the cities, new techniques in the decorative arts made possible representations of people, animals, and at times whole narratives, on relatively common and inexpensive media like ceramics. Metalwork was modified by the expansion and refinement of the technique of silver inlaying, which allowed for clear and very detailed representations and ornament. At the end of the century the first known dated manuscript with illustrations inaugurates the short-lived but brilliant school of Arab painting in the thirteenth century. These novelties [237] also affected Christian art within or at the periphery of the Muslim world, as is clear by the changes that occurred within Armenian, Syriac and Egyptian Coptic traditions.[3]

Conventional academic wisdom attributes these changes in Islamic and Islamicate art to an expanded patronage made more sophisticated through international trade, through the industrialization of the manufacture of paper with all sorts of important ramifications for all the arts, and through new techniques, especially in ceramics and metalwork, developed first in northeastern Iran and in the area of Baghdad.[4]

The main question is, then, a relatively simple one: is there a connection between the forceful Latin (and perhaps more generally Christian) reappearance in Syria and Palestine and the major, often revolutionary, modifications brought into Islamic art at about the same time? And there are subsidiary questions: was there an impact of Islamic forms on the arts made for the newly arrived Christians and their co-religionists back home? Or are there examples of the opposite, Western features in Islamic objects? Did the Crusaders affect the long-range development of Islamic art in the Levant?

The only one of these questions that has been the subject of discussion and of published studies is that of a possible or actual impact of Islamic art on Western art, and I shall not deal with it at all except for one small observation later on. I shall be brief on the matter of direct or indirect traces

[3] The easiest access to this material is in R. Ettinghausen and O. Grabar, *The Art and Architecture of Islam, 650–1250* (London, 1987), in particular chs 7 and 8; a new and considerably revised version of the book by R. Ettinghausen, O. Grabar and M. Jenkins-Madina has appeared in 2001. For Christian material from the Near East, see J. Leroy, *Les manuscrits syriaques à peintures* (Paris, 1964); J. Leroy, *Les manuscrits coptes et coptes-arabes illustrés* (Paris, 1974); H. C. Evans, "Cilician Manuscript Illumination," in *Treasures in Heaven: Armenian Illuminated Manuscripts* (New York, 1994), pp. 66–83.

[4] Some of the interpretations were formulated a long time ago by O. Grabar, "Les arts mineurs de l'Orient musulman," *CahCM*, 11 (1968), pp. 181–90. Additional and alternate views appear in J. Allan, "Silver: The Key to Bronze in Early Islamic Iran," *Kunst des Orients*, 11 (1976–77), pp. 5–21, and in Jonathan Bloom, *Paper before Print* (New Haven, 2001).

1 Cairo, mosque *madrasa* of Sultan al-Nasir, portal from Ascalon, *c.* 1303

of Crusader art in contemporary or later Islamic art, because there is, to my knowledge, no systematic survey of existing evidence; I cannot, therefore, propose even a reasonable scheme for the organization of the material. What follows are a few random examples.

In Cairo the complex of Muhammad al-Nasir (*c.* 1303) (Fig. 1) has a Gothic portal brought by boat from Acre and used as a trophy; it is also possible to argue that certain features of the slightly earlier complex of Qala'un, for instance the articulation of the exterior façade and of the windows, owes something to Western architecture, although it may simply be that it uses forms associated with the holy city of Jerusalem and not with the art of another culture.[5]

In Anatolia the mosque and hospital at Divrigi dated around 1229 contain unusual features on their façades which are difficult to connect to local Anatolian, Christian or Muslim, traditions; this is especially true of their elaborate gates with most unusual splayings (Fig. 2) and with a prominent stone sculpture in high relief with vegetal rather than figurative motifs

5 For these buildings, the basic publication is by K. A. C. Creswell, *Muslim Architecture of Egypt*, vol. 2 (Oxford, 1959), pp. 190 ff. Summary in S. Blair and J. Bloom, *The Art and Architecture of Islam, 1250–1800* (New Haven, Conn., 1994), pp. 72–7.

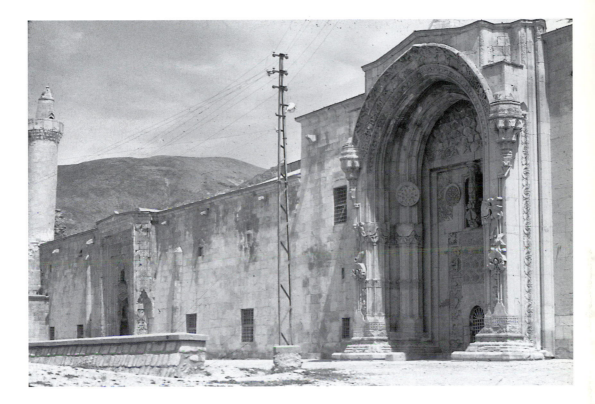

(although some figuration is actually hidden in the vegetation) belonging to an interesting subgroup of late Romanesque art found from southwestern France [238] to east of Moscow. Whether in Anatolia or in Russia, the motifs of this art and, even more so, the very fact of its existence seem to reflect Western and most particularly Latin models. The assumption of such models may actually explain other innovative features of thirteenth-century Anatolian architecture, although none are as original as those of Divrigi. One should add the alternate possibility of an impact coming from Armenia and the Caucasus.[6]

Examples of Crusader parts reintegrated in Muslim monuments of the Mamluk and even later periods abound in Jerusalem, Hebron, Bethlehem, Beirut and Tripoli. Although I am not well acquainted with military architecture, I take it as a valid proposition that large Crusader fortifications had an impact on the citadels of the Muslim world in Syria, Jordan, and Anatolia and merged with an older and somewhat different tradition of the urban citadel which had already begun in eastern Iran in the tenth century, but for entirely different reasons.[7]

2 Divrigi, mosque, northwest portal, thirteenth century

[6] Among other places, R. Hillenbrand, *Islamic Architecture* (Edinburgh, 1994), pp. 96–7.
[7] H. Kennedy, *Crusader Castles* (Cambridge, 1994). D. Pringle, *The Churches of the Crusader Kingdom of Jerusalem* (Cambridge, 1993).

It is more difficult to detect a visual or formal impact of the Crusades on arts other than architecture. What did, however, happen is the use of forms to communicate the political and ideological ambitions issued from the Crusades. Such is the case of Nur al-Din's inscriptions, which charge *madrasas* and mosques from Mosul in northern Mesopotamia to Damascus in Syria with a new militancy, as has been so well demonstrated by Yasser Tabbaa.[8] And, in a particularly spectacular way, such was the meaning given to the minbar, now destroyed, made in Aleppo for a Jerusalem that had not yet been reconquered. In all these instances, forms and functions owe little, if anything, to the Crusades, but the meaning to be given to these forms is very much tied to the existence of the Latin kingdom.

These examples from the Levant lead to the conclusion that the art of the Crusaders did leave traces in the Muslim world, but these traces are, relatively speaking, minimal (except perhaps in military architecture), and almost any one of them is a unique case which can be explained through special circumstances. Only in Palestine is it possible to argue for a sort of symbiosis of imported Western and local forms and techniques. This symbiosis, as it appears for instance in the eastern wall of the Aqsa mosque or in the fountain at the *bab al-silsilah* also in Jerusalem, was a natural meshing together of building traditions, and, if it strikes us today as awkward, it probably was not so at the time. The handsome screen of wrought iron built by the Crusaders around the rock in the Dome of the Rock remained there until the 1950s. One can understand the historical (actually more antiquarian than historical) and national reasons for its removal, but the interesting point is that it made visual sense inside the building – it enclosed and protected its holy spot – even if it was not the building's original message to highlight the rock in this fashion. A possibly more curious impact of that screen occurs in Cairo. There the mausoleum of Qala'un was based on the Dome of the Rock and provided [239] with a fancy wooden screen around the tomb of the sultan, because it was there in the model as the early Mamluks knew it, not as it had been at the beginning.

Some scholars have even argued for a Palestinian quality to the Romanesque sculpture in the Holy Sepulcher and elsewhere in the Christian sanctuaries of the Holy Land.[9] These arguments have not been accepted by all scholars, but, even if they are valid in part or as a whole, they would still be mere examples of what I would call the micro effect of the Crusades on the arts: an intrusion within the archaeological texture of Palestine and of the Syro-Lebanese coast and occasionally monuments elsewhere in which, for known

8 Y. Tabbaa, "Monuments with a Message," in *The Meeting of Two Worlds: Cultural Exchange between East and West during the Period of the Crusades*, ed. V. P. Goss and C. Bornstein (Kalamazoo, Mich., 1986), pp. 223–40, and for the specific case of Aleppo, idem, *Constructions of Power and Piety in Medieval Aleppo* (University Park, Pa., 1997).
9 N. Kenaan, "Local Christian Art in Twelfth Century Jerusalem," *IEJ*, 23 (1973), pp. 167–75, 221–9.

or obscure reasons, something Western pops up. This micro effect recalls the
French women of one of Zoe Oldenbourg's novels dealing with the Crusades
who were remembering the lush landscape of Picardy while working as
indentured servants in the harsh and dry fields of central Syria. They were
touching minor episodes within a grand history.

This could be the end of the paper with the simple conclusion that the
Crusades hardly mattered in the artistic life of the Muslim world. Matters
are far more complicated when one turns to the reflection of Islamic forms
in Western art. They are complicated because the range of these reflections is
much wider and the specificity of the Crusades in their existence more
difficult to determine. There is the simple exoticism of imported forms and
techniques, as with so many textiles, bronzes, or ivories reused for relics or
for the ornamentation of churches and of ecclesiastical vestments, with the
construction of a very Syrian Islamic mausoleum for the Norman prince
Bohemond, or with the random imitation of the Arabic script found all over
medieval art and especially in textiles. There may well have been subtler
impacts, as the memory of the Holy Land may well have affected the
architecture of late Romanesque cloisters. Altogether, at this mini level, the
presence of Islamic forms was greater in the West than that of Western forms
in the Islamic world, that presence is only partly to be related to the
Crusades, and it was but a minor bit player in the very active changes of the
twelfth and thirteenth centuries.[10]

On the levels of exchanges of forms or of affecting artistic creativity
directly and immediately, there is not, I believe, much more to say except to
continue listing examples. But there still looms the broader issue that too
many changes occurred in the twelfth century, and especially all around the
Mediterranean, not to feel that the most unusual event of that century
should not somehow be connected with these changes. In other words, there
may well have been a macro impact of the Crusades. Perhaps some term
other than "impact" is the appropriate one for a very different type of
relationship from that of immediate connection. Let me investigate the
matter around two series of documents. One, the thirteenth-century Islamic
metalwork with Christian scenes, is a tight [240] and small group of objects
from a very limited and specific area, northern Mesopotamia and Syria. The
other one roams all over the place and consists of works of art, of motifs,

10 There is no overall survey of Islamic themes in Western art. See P. Soucek, "Artistic
 Exchange," in C. Bornstein and P. Soucek, *The Meeting of Two Worlds: The Crusades and
 the Mediterranean Context* (Ann Arbor, Mich., 1981), pp. 15–16; A. Shalem, *Islam
 Christianized* (Frankfurt, 1996); G. Sievernich and H. Budde, eds, *Europa und der
 Orient, 800–1900* (Berlin, 1989); and the very thoughtful observations of R. Ettinghausen,
 "The Impact of Muslim Decorative Arts and Painting on the Arts of Europe," in *The
 Legacy of Islam*, ed. J. Schacht and C. E. Bosworth (Oxford, 1974), pp. 292–320, repr. in
 his *Collected Papers* (Berlin, 1984), pp. 1074 ff. All these studies are provided with good
 bibliographies.

and even of problems that do not fit into any common category of understanding but illustrate something quite important about the twelfth century.

There are eighteen remaining inlaid bronzes with Christian scenes.[11] Some have often been illustrated, others are hardly known, very few have received the detailed attention they merit, in part because each one contains details in its alleged or demonstrated Christian features that are unusual or do not make sense.

Three broader characteristics of these objects are more important for our purposes than a search for an explanation of individual details. One is that they are for the most part in a technique – bronze or brass inlaid with silver, occasionally with copper – and for purposes – lighting, serving, writing, washing, pouring water or other liquids – that are common in metalwork made for feudal lords and for the notables of Muslim cities since the middle of the twelfth century. This new metalwork appeared first in northeastern Iran and culminated in the great thirteenth-century series of works associated with the city of Mosul in northern Mesopotamia, but found all over Egypt, Yemen and the Levant. All objects with Christian scenes are in the same technique, and the shapes and functions are also quite common, except for an extraordinary canteen in the Freer Gallery of Art in Washington whose actual purpose and function are still very much of a mystery.[12] One can still wonder whether there is any connection between the possible uses of these objects and the Christian motifs of their decoration, but, so far, none has been discovered, and it is more reasonable to conclude that these objects belonged to a common body of things and designs for the upper classes of society in Muslim lands during the first half of the thirteenth century regardless of ethnic or religious affiliation. It is curious that one of them, a tray now in St Petersburg, was found near Kashgar, today Kashi, at the frontier of the Islamic world and of China. In short, Christian themes simply became one of the possible options in the standard imagery available within the Muslim world.

The second characteristic of these objects is that, even though several among them are provided with inscriptions, none of the inscriptions implies that the object was made for a unique purpose or a specific individual, least of all that it was made for a Christian. Most of the inscriptions are standard series of good wishes without, insofar as I have been able to figure out, anything separating them from other metal objects of the same class. There are three references to the Ayyubid amir al-Malik al-Salih, who ruled, at

11 The standard book on the subject is E. Baer, *Ayyubid Metalwork with Christian Images* (Leiden, 1989); see also R. Katzenstein and G. D. Lowry, "Christian Themes in Thirteenth-Century Islamic Metalwork," *Muqarnas*, 1 (1983), pp. 53–68.

12 An interesting and original explanation of this canteen has been proposed by Nuha Khoury, "Narratives of the Holy Land," *Orientations*, 29.5 (1998), pp. 63–9.

various times, in northern Mesopotamia, Egypt and Damascus between 1232 and 1249 and who was involved in complicated alliances with or against the Crusaders. But even these references are of a general nature, not personalized, and the more frequent lists of [241] good wishes have an anonymous quality suggesting objects made on speculation, for sale at some court or to a wealthy buyer possibly from the nonmilitary class. These objects reflect the needs or opportunities of a market, and it is the thoughtful but cautious requirements of a market that may explain the absence of scenes like the Crucifixion or the Ascension, which are peculiar to Christianity and which could be seen as offensive or at least inappropriate by Muslims, as well as the prominence in nearly all these objects of rows of standing personages, these priestly and monastic figures that has been admired by Muslims since the time of the Prophet. These objects breathe a quiet pietism that is not so much ecumenical as areligious. It may well, as has been suggested, correspond to the spirit of the area, at least at the upper feudal level, after the 1229 treaty between Frederick II and Malik al-Kamil, a time when conflicts were feudal and territorial rather than religious and national. The sources of the Christian images are probably for the most part local Syriac ones, possibly Byzantine, very little Western, although one Western iconographic detail has apparently been identified.

And the third important characteristic of this group of motifs is that they disappear after the middle of the thirteenth century, whereas the technique of inlaying remains, as do the functions of most of these objects. It is, of course, true that representations of other kinds also diminish in the latter part of that century, and Christian images could have been the victim of a general revival of aniconism all over the Levant, in spite of major exceptions like the Baptistère de St Louis in the Louvre.[13] But, even if this is so, it is remarkable that Christian themes entered, for a short while, within the mainstream of Muslim private art. Iconographically, this phenomenon cannot easily be connected with the Crusades since, at least within the boundaries of research known to me, no representation on the bronzes has been connected with the art of the Crusades. Nor are there any stylistic parallels between the images on objects from Muslim workshops and the little we know of comparable Latin or Byzantine art. But it may be possible to argue that the very special political mood established by the negotiations that followed the recapture of Jerusalem by Saladin in 1187 permitted, at least for a while and within a certain class of Muslims or of dignitaries within the Muslim world, an acceptance of identifiably Christian but nonthreatening motifs as a sort of worldliness acceptable on secular objects. This possible fact of contemporary taste, rather than the motifs themselves, would have been the result of the

13 This fascinating object has received much recent attention long after its initial publication by D. S. Rice, *The Baptistère de St. Louis* (Paris, 1953). See D. Behrens-Abouseif, "The Baptistère de Saint Louis: A Reinterpretation," *Islamic Art*, 3 (1989), pp. 3–13.

presence of the Crusaders in the Levant. What remains to be worked out is the probably considerable role played in this development by the Christians of the Near East, who, as is well known, ended up as the main victims of the whole adventure but served as important agents of change in the twelfth and thirteenth centuries.

However they are to be interpreted, the Islamic bronzes with Christian topics form a neat and coherent set. Incoherence is what characterizes my second group of examples. It consists of several peculiar objects, of an architectural invention, and of a chronological [242] problem. Individually these items have nothing to do with the Crusades, but as a group they may perhaps best be explained as willed or accidental effects triggered by the Crusades.

The first of these items is a container in the shape of a peacock now in the Louvre (Fig. 3).[14] Art historians have tended to date the object and the whole group of zoomorphic containers with which it forms a set to the twelfth century and to attribute it to Spain or to Sicily, with one, to my mind unsuccessful, attempt to give this peacock an Iranian origin. The curiosity of the object lies in part in the manner in which it was meant to function, but this will not concern me in these remarks. The other reason for its notoriety is that it has two inscriptions certainly engraved at the same time in a space provided for them. One is in Arabic and reads: 'amal Abd al-Malik al-Nasrani, "made by Abd al-Malik the Christian." There has been some controversy about the correctness of the translation, but the alternate ("made by the servant of the Christian king") poses both grammatical and historical difficulties. The other inscription is in Latin and has been read as opus Solomonis erat, a curious sentence, which should be translated as "it was the work of Solomon," suggesting either a maker by that name or, in a metaphoric way, a "beautiful work," so to speak worthy of Solomon. A Spanish attribution for the bird seems reasonable because it is only in Spain that this particular Latin formula occurs on a couple of other objects. The peacock was thus seen as belonging to some sort of exchange between Muslims and Christians for which the following scenario can be proposed: someone, a merchant perhaps, orders from a Christian metalworker by the name of Abd al-Malik a fancy container of a known type (we have at least two other examples) and decides to broadcast the value of the object by calling it Solomonic in beauty or perhaps to imply, by the use of erat instead of the more normal est or the more accurate fuit, that this object imitates or actually is something belonging to Solomon and brought from the Holy Land, at the very least copying something that would have belonged to Solomon. The market for the object would have been Latin. But value is

14 The object has often appeared in catalogs, e.g. L'Islam dans les collections nationales (Paris, 1977). The first publication was by A. de Longpérier, "Vase arabo-sicilien," RA, n.s., 6 (1865), pp. 356–67. See now O. Grabar, "About a Bronze Bird," in E. Sears and T. Thomas, eds, Reading Medieval Images (Ann Arbor, Mich., 2002), pp. 117–25.

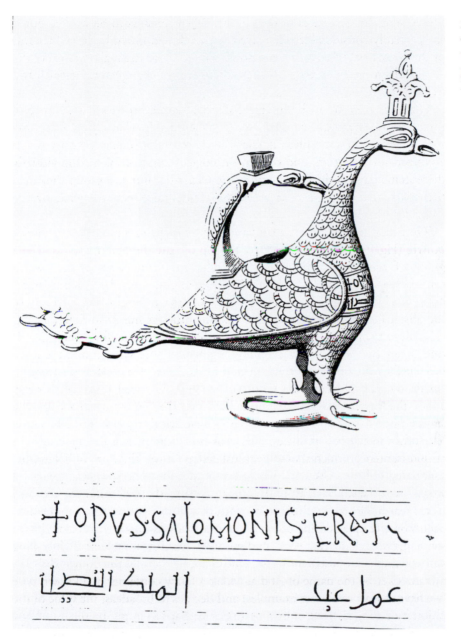

3 Louvre, ewer or aquamanile in the shape of a peacock, inv. no. MR 1519

provided by the artisan's name written in Arabic, yet identified as a Christian. It could have been an example of the sort of mercantile and vanity-driven artistic contact made possible by the Crusades.

The trouble with this traditional interpretation is that it may have been based on a misreading of the Latin text. In an article that came out almost twenty years ago but which did not attract much attention among historians of art, the palaeographer Robert-Henri Bautier argued that, after *opus Solomonis,*

4 Urtuqid plate, first half of the twelfth century, Innsbruck

we should read *era T* and then a small x.[15] T, as it turns out, was in central Spain, and until the twelfth century, the symbol for the Latin M to mean 1000, and the era involved in this system began in 38 BC. Thus we have an object dated to 962 or 972, depending on how one interprets the doodad after T. And historians of art throw their arms up in despair, for something they would have sworn to be twelfth century turns out to be two centuries earlier and dated to boot. The [243] whole neat and elaborate scenario I proposed a few sentences ago falls apart in its most interesting part; certainly the Crusades could not have had anything to do with this object, unless it is legitimate to talk of a pre-Crusade Crusade culture in Christian Spain. But is Bautier's reading right? I do not have a solution at this stage, and I certainly have difficulties putting this bird in the tenth century. Should one imagine for the late tenth century in Spain some prefiguring of a type of mercantile and symbolic activity more common later on? Should it belong on the Spanish frontier or to something comparable to Akhtamar on the Anatolian one and from which the Crusades were absent indeed, but which exhibits multicultural features to be found more frequently later?

The second object I will deal with is the celebrated Innsbruck plate (Fig. 4).[16] It was made for a minor Urtuqid ruler of eastern Anatolia between 1114

15 R.-H. Bautier, "Provenance du paon aquamanile," *Bull. Soc. Ant. Fr.* (May 1978), pp. 92–101.

16 Innsbruck, Institut für Kunstgeschichte, *Die Artuqiden-Schale* (Innsbruck, 1995) with all appropriate references.

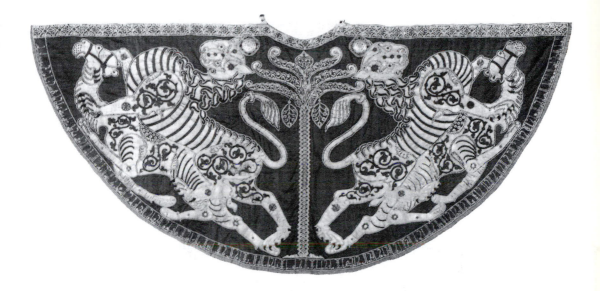

5 Mantle of Roger II, dated 1133–34, Vienna

and 1142, during the most successful decades of the crusading enterprise. The plate is unique for being enameled on both sides with themes that find parallels in Byzantine art from Constantinople, in Georgian art, and even in Limoges. I can easily imagine a successful prince in the upper Euphrates valley being persuaded by a Georgian goldsmith, traveling, as many artisans did at that time, from one court to the other, that, for the proper financial reward, he could have on one copper bowl all the themes that appear in Byzantine imperial art, that he could thereby impress Frankish knights with the inventiveness of his patronage and his subjects with Arabic *and* Persian statements, the latter being quite ungrammatical and for practical purposes illegible. There is something slightly vulgar and nouveau riche in this display of colorful wealth, but it may well illustrate the taste of many other feudal lords and barons than a relatively minor Urtuqid prince.

The third example of an odd object is even better known. It is the mantle of Roger II (Fig. 5), now in Vienna, to which I shall also return in a slightly different way in my conclusion. All that matters at this stage is to point out two obvious and well-known contrasts in it. One is that it contains an inscription that gives its date (1133–34) and place of manufacture (Palermo) as well as many good wishes but no indication of owner, maker, or use. This inscription is in Arabic, but the shape and probable function are Latin. The carefully woven decoration of the mantle is without direct parallel anywhere but probably reflects a very concrete astrological or astronomical configuration on one side and the royal court on the other.[17] The Crusades may not have

17 A large study of the mantle will be found in the contribution I made for the fifteenth Levi della Vida Award symposium, "The Experience of Islamic Art," hopefully to be published at UCLA. The object itself is often illustrated.

been directly involved in the manufacture of this mantle, but they are so much part of the wealth and ambitions of Roger II that it is perhaps not unreasonable to see them as part of the climate that made the robe possible.

My last two examples are of a different type. One is the peculiar adventure of the *muqarnas*, that quintessentially Islamic form developed probably in Iraq in the tenth century and appearing in northeastern Iran and Egypt in the tenth and eleventh centuries. What is interesting about it for our purposes is its spread westward: new mosques in [244] Tinmal and Fez, both in Morocco, among many other places, use *muqarnas* ceilings in the thirties of the twelfth century, and the largest and most brilliant example of the technique is the ceiling of the Cappella Palatina, completed by 1142.[18] The form itself has been given various symbolic and possibly religious meanings within the Muslim tradition, and a cosmic meaning is implied by Philagatas in a celebrated sermon delivered in Palermo, although there is some doubt whether such meanings should be attributed to all uses of the form or to its inception. What really matters is that it is after the formation of the Latin kingdom in Palestine and after the Mediterranean had become the lifeline of the kingdom's existence that the new form spread to become the common ceiling ornament of religious as well as secular buildings in Muslim as well as Christian lands.

And, finally, there is a peculiar and difficult problem connected with the chronological rhythm of figural representations in Islamic art. As is by now well known, such representations were never entirely given up, but they diminished in number and in variety during 'Abbasid cultural preeminence in the ninth and tenth centuries. This was especially true for objects that had some public visibility. Thus Spanish courtly and private ivories could have masses of images in the tenth century, although fewer in the eleventh, and the representational vocabulary on ceramics was on the whole quite limited; there were on them more rabbits and birds than people. All this changed in the middle of the twelfth century, most strikingly in the ceramics and metalwork from Iran. Yet the earliest signs of change occurred in the eleventh century and in the primarily luster ware of Fatimid Egypt, where representations of considerable thematic and stylistic variety make their appearance. We do not know very well how to date these ceramics and how to establish stylistic and chronological sequences within them. But it is on the ceilings of the Cappella Palatina that many of these Fatimid themes appear before the middle of the twelfth century and before the true explosion of images elsewhere in the Muslim world. Is it entirely an accident that a major change in Islamic art, which had begun to take place in the

[18] Much has been written on the *muqarnas* over the years, but there is as yet no definitive and coherent explanation. See Y. Tabbaa, "The Muqarnas Dome," *Muqarnas*, 3 (1985), pp. 61–74, and "Muqarnas," *Dictionary of Art*, ed. J. Turner, vol. 22 (London, 1997), pp. 321–5; also his *Constructions of Power and Piety*, esp. p. 144. For Palermo, arguments and interpretations are found in W. Tronzo, *The Cultures of His Kingdom* (Princeton, 1997).

Mediterranean area, spread elsewhere just as the Crusader state and culture were establishing themselves in the Levant?

These examples – and there are others – do not demonstrate nor even suggest an impact of the Crusades, neither on concrete levels of forms and techniques nor even in ideological or sociopolitical programs. What they do show is the existence of a concentration of creative energy in the twelfth century, wherever one looks. The Crusades are part of that energy, and they established an enabling focus of power in an artistically underdeveloped area, for such was the case with Syria and Palestine in the eleventh century. That power led to major changes in that area and, even more remarkably, in adjacent and surrounding areas: a revitalized Syrian interior, an Anatolia bursting with building activities for all sorts of religious and secular purposes, a northern Mesopotamia [245] with new cities and centers growing along reestablished trade routes, and even a transformation of the coast and hinterland of North Africa. That focus of power led to the expansion and development of motifs and ideas like the *muqarnas* and like representations of almost anything to satisfy the needs of a newly and intensely recharged Muslim society and ethos. The results were sometimes bizarre, as with the Innsbruck plate or the Louvre bird, but the point is that of a wealth of accomplishments often based on seeds planted earlier in a more haphazard fashion in the East or in Egypt and in Andalus, perhaps, as has been suggested by some, in the pan-Mediterranean culture of the eleventh century.[19] The seeds might have taken much longer to spread all over the Muslim world and to grow in quality and quantity, had it not been for the new impulse created by the Crusades, an impulse of energy, not of forms.

In a sense and quite paradoxically, one could argue that the most spectacular Islamic art of the time of the Crusades is the Norman art of Sicily, primarily under Roger II, but also under William II, when, in a spirit of unwitting ecumenism, *muqarnas*, figures, inscriptions and astronomy all combine to create a stellar series of highly original works of art. They do not form an eclectic combination of forms from different sources but a genuine entity, illustrating not a clash of civilizations, to use an abominable, recently coined, expression, but a truly operating manipulation and enjoyment of commonly accepted forms. Of course, like the Crusades themselves, this Norman creativity left no posterity, but, because it is a work of great art and artifice charged with obscure memories, a robe with a camel subdued by a lion, framed by an Arabic inscription praising sensual pleasures, became the formal coronation robe of the holy Roman emperors north of the Alps, and no one ever worried about the original meaning of the motifs on it.

19 P. Soucek in *The Meeting of Two Worlds* and several articles by Hans Belting.

The century of the Crusades was thus far more interesting and far more creative than the Crusades themselves. In the Norman art of Sicily it almost succeeded in managing something that was hardly imagined by either the Crusaders or their opponents: a formal setting accessible visually and intellectually to all the actors of the century in the Mediterranean. On a much more limited scale, something comparable may have been present with the bronzes with Christian scenes in Syria and northern Mesopotamia and possibly in the architecture of thirteenth-century Anatolia. On the whole, however, after 1250 or thereabouts, the creation of man became Muslim or Christian, Saracenic or Infidel, ours or alien. The latter became the others who could be hated and despised or, at best, exotic. The modern age had begun.

PART FOUR

ISLAMIC ART AND THE WEST

Chapter XXI

Islamic Architecture and the West: Influences and Parallels*

It is not by accident that most discussions of Oriental and more specifically Islamic influences in Western art have dealt with objects or with motifs found on objects. Textiles, metalwork, even glass and ceramics traveled easily; they were essential ingredients of an East–West luxury trade and, after the beginning of the Crusades, became almost automatic items of the loot brought back from the East. The impact of such objects appears in architectural decoration, such as in imitations of Arabic writing like those on the doors of the cathedral at Le Puy in central France, in the use of Persian and Syrian ceramics in several churches of northern Italy, or earlier in the mosaic decoration of Germigny-des-Prés. During and after the Renaissance orientalizing elements derived from objects continue to appear, whether as precisely depicted curios (e.g., rugs), as ornamental devices (the pseudo-Kufic inscriptions on the robes of Virgins being the most obvious examples), or, somewhat later, as exotic *turqueries*. How significant these elements of Islamic origin really were within the rich creativity of Western art, whether they were accidents, minor themes, or major sources of inspiration, is still debatable, although their existence is easy to demonstrate and historical logic can in most cases explain their presence.

Matters are quite different when we turn to architecture. Since its monuments are immobile, influences and impacts can only take place if one of three types of events occurs: (1) masons, architects or other technicians move from one area to another; (2) patrons or other influential taste-makers carry with them the impact of an alien architectural monument or effect and seek to translate their memories into local techniques; and (3) drawings, photographs, and at times literary descriptions transmit technical or aesthetic impressions which are then used or transformed by some receptive milieu. In the first part of this paper I will discuss a few instances which seem to me to illustrate these three possibilities and bring up some of the problems and

* First published in *Islam and the Medieval West*, ed. Stanley Ferber (Binghamton, 1975), pp. 60–66.

difficulties raised by them. But it also seems to me that the relationship
between Islamic and Western architecture should not be limited to the
identification and evaluation of direct or indirect imitations and influences.
A far more interesting and important historical problem is that of parallelisms,
for both architectural traditions were based in large part on the extraordinary
heritage of Roman forms and techniques. Both utilized this inheritance for
comparable purposes, secular and religious, public or restricted, while neither
experienced a technical revolution comparable to the development of concrete
or vaults in Rome or cantilevering in the nineteenth century. In other words,
at least *a priori*, only cultural and ecological variables would have led to
differences in the development of the same vocabulary of forms. The problem
is whether the Western and Islamic evolutions remain indeed comparable
during most of the Middle Ages or whether cultural differences were sufficient
to make the results of the two artistic traditions incompatible. It is obvious
that any conclusion or hypothesis which can be reached on this sort of
question has implications which extend far [61] beyond the field of medieval
trans-Mediterranean art. Since the methodology available for possible answers
to the problem has not yet been properly developed, I shall limit myself to a
few tentative considerations.

The remarks which follow must be considered as only very preliminary
observations on this complicated subject of influences and parallels, for
existing research has not yet made it possible to move easily from very
concrete details to broadly significant generalizations. What I have tried to
do is to discuss some of the directions which further work may take in order
to improve our understanding of the problems involved.

Influences and Imitations

Influences and imitations are easiest to detect and most obvious in areas
where the two cultures coexisted for any length of time or where Christian
rule replaced Muslim hegemony. Such is the case of Spain, where a whole
architecture style, what is known as *mudejar* art, is clearly derived from
Islamic art. Its major monuments are in the cities of Zaragoza, Toledo and
Seville, though hardly a province of Spain outside of the extreme northwest
has escaped the impact of Islamic forms. Even Renaissance palaces in Seville
(Casa de Pilatos) and Guadalajara (Palacio del Infantado) still maintain
strong traces of Muslim motifs. It is important to note, however, that this
impact did not affect all aspects of architecture. It was minimal in the
development of plans and in such details as supports like columns. It was
very influential in the design of cupolas, where the Andalusian system of
intersecting (fake or real) ribs is carried to some of its most baroque extremes,
and in the development of polylobed arches, in exterior masonry as with the
use of polychrome effects, and particularly in the consistent theme of blind

arcades. The Islamic impact may or may not be present in the character of single or attached towers, such as the square towers of Teruel or the octagonal ones in Zaragoza reminiscent of Muslim minarets, both Andalusian and oriental. It is consistent in certain types of composition, such as the doorway or window whose arch is set in a rectangular frame. It is overwhelming in architectural decoration, as exterior or interior wall surfaces and vaults or wooden ceilings are covered with motifs and techniques of Islamic origin. Although a monument like the fourteenth-century Alcázar in Seville followed the Islamic model in almost all respects, for the rest of Spain there seems to be a peculiar rhythm to Islamic influences, certain motifs predominating in one area or another and maintaining themselves for a more or less long period of time. Thus in the area of Zaragoza exterior masonry and decoration are often more Andalusian than the interiors, whereas in the provinces of Burgos and Valladolid, interior stucco decoration of Islamic background has remained much longer.

There is altogether a whole "ecology" of Islamic influences in Spain which still awaits a historian. Two points about it may serve as possible initial hypotheses. One is that secular architecture may have maintained such influences far longer than religious building. In Burgos, for instance, it appears stronger in the royal chapel than in the churches themselves and in Tordesillas almost a complete secular building has been largely preserved. The explanation [62] is probably that Christian Spain, until the height of the Renaissance, did not possess alternate models for an architecture of royal prestige, at least not until Charles V's palace in Granada or Philip II's Escorial. The second point is that, with regional variations, Islamic motifs did not begin to disappear until the middle of the fifteenth century when their integrity became either lost or difficult to disentangle from a strange mixture of Gothic and Renaissance designs. Such examples as the Seo of Zaragoza or the crossing of the cathedral of Burgos may serve to illustrate the point.

In the Spanish example we can assume, if not always demonstrate, both the presence and movement of artisans and the formation of a taste among patrons which explain the constancy of Muslim influence. The only similar area is Sicily. Muslim occupation there was short-lived but an orientalizing taste can be demonstrated through literary sources from the time of Frederick II in the early thirteenth century. It is, however, much more difficult to show in architecture, for, outside of the Cappella Palatina in Palermo with its spectacular Islamic ceiling, only fragments have remained, and it is not possible to illustrate precisely the actual depth of an Islamic impact in Sicilian and southern Italian architecture. Just as in Greece or the Balkans, the impact on architecture seems to have been less than that on the other arts, possibly because there were fewer available artisans and because the Christian patronage of these areas did not sponsor architectural monuments on the scale of the Spanish patrons from the thirteenth century onwards.

The problems of the significance and character of patronage and of the availability of works acquire their full meaning when the situation is compared with a non-Western area of Islamic impact which may serve as an interesting historical parallel. I refer to Armenia, where, from the early tenth century, a strong and original local architecture was constantly influenced by – just as it influenced – Islamic developments.

When one moves out of Spain and Sicily, matters become much more complex. All scholars have agreed that certain ornamental motifs, for instance Kufesque writing, are of Islamic origin. Beyond that the tendency has been either to indulge in orientalizing orgies, whereby almost any motif or novelty is given an Islamic background since a high Islamic technical growth occurred earlier than in the West, or in denying "Saracenic" influences altogether, on the grounds (to which I shall return in the second part of this paper) that there is no need for Islamic influences to explain certain Western architectural developments. That both extremes are probably incorrect is certain, but where does a reasonable middle ground lie?

On methodological grounds I should like to suggest three kinds of direct or indirect influences or imitations. The first kind may be called *regional*. It seems fairly clear and makes historical sense that, as the great pilgrimage routes of the Romanesque period were established, contact with Spain became the norm for many actual or potential patrons and taste-makers in Romanesque Europe. As a result, by processes of osmosis which are still very obscure, themes and motifs were carried from south to north. The Roussillon definitely shows many Andalusian motifs; these are more selective in the Languedoc or Poitou, seem to increase in intensity in the Auvergne, and are but occasionally found in Burgundy or Provence. For the most part they consist of architectural [63] details, horseshoe arches, polylobes, masonry of stones of alternating colors, roll corbels, impost blocks, certain kinds of vegetal ornament, tendency in some monuments to cover entire surfaces with ornament. A complete survey of a characteristic Romanesque feature like the sculpted capital would no doubt bring out many points of Islamic influence. While the Romanesque period in France is the most obvious example of this sort of regional impact, it is not the only one. In Romanesque and even Gothic and Renaissance Italy proximity to Islamic centers certainly played a part in developing certain architectural motifs. The bichromy of masonry in churches in Siena and in Pisa, the towers of San Gimignano and the complex surfaces of official and secular monuments in Venice (even some details in San Marco) are just a few examples of tastes and techniques derived from the Muslim world. In the instance of Italy it is probably merchants and travelers rather than workers who returned with memories of Islamic lands and, as a result, one encounters less frequently than in Spain or southern France the small consistent detail, the tell-tale motif. Except in the south, it is rather an overall impression which was being imitated and its evaluation is correspondingly more difficult to make. In the same vein,

Islamic influences are also recurrent in, though not always easy to extract from, the Russian art of the Middle Ages and even in the pre-Petrine Kremlin, where Italianate and Oriental motifs are often inter-mixed with local traditions.

Regional impacts pose two distinct problems. One is to try to date their rhythm as securely as possible. The other is what may be called the "ripple effect." For, in theory at least, the farther one is from the source of contact and the later in time, the less prominent the influence is. The question is whether this proposition is really true or whether it only applies to the impact created by actual artisans, for the impact of a patron is less specifically tied to geography and could occur anywhere. At which point, in dealing with an architectural motif, do we begin to deal with exoticism rather than the movement of a motif?

Next to regional influences of several kinds, there are *unique* and problematic instances. The most obvious example is that of Le Puy in central Auvergne, where the long study by A. Fikry has suggested that, beyond the usual ornamental motifs which could have traveled along regular routes, a great deal of the actual construction of the cathedral (along with several other monuments) is unusual within Romanesque architecture and exhibits major similarities with Islamic architecture. The emphasis on cupolas rather than on vaults and the use of a wide variety of squinches relates Le Puy to Kairouan and North Africa rather than to Spain, and thus a unique and still not very satisfactorily solved problem is posed. Another apparently unique example occurs in seventeenth-century Turin, where the Baroque architect Guarini created a type of intersecting ribs for several churches which are strikingly reminiscent of those of Cordoba and its descendants in Spain. Guarini's manual with drawings of his own monuments was published in 1686 and made its way to Spanish America where it is supposed to have influenced the design of a number of Mexican churches as well. Whatever impact they may have had, the examples of Le Puy and of Guarini seem at the moment to be unique and, unless they can in the future be fitted into some pattern, they must be explained by unique circumstances, each of which deserves extensive research. One point about the two examples I have cited may deserve special emphasis. It is that, in contradistinction [64] to that which seems to occur in what I called regional impacts, unique ones tend to relate directly to major centers of Islamic architecture – Ifriqiyah and Cordoba – and cannot be explained as the result of popular osmosis.

The third kind of imitation or influence may be called *interpretative*. What I mean by this term is that the source of the impact was not necessarily a contemporary monument or group of monuments, an architect, or a team of artisans, but some knowledge acquired directly or indirectly about something Islamic. Such instances do not seem to me to have been frequent in the Middle Ages, although one may wonder whether the Islamic elements in the palace of Theophilus were carried directly or through stories and

literary accounts. Something like this may have occurred, at least in part, with the Norman kings of Sicily or with Frederic II, or else with whatever the returning Crusaders may have sought to create in their homeland. On the whole, secular art seems to have been more frequently affected by this type of influence, but unfortunately it has been less well preserved.

But this type of impact is not limited to the Middle Ages. It appears most significantly in the nineteenth century, as romantic curiosity led to a new awareness of the Orient. It was at times somewhat ludicrous, as in Brighton's pavilions reproducing all sorts of Islamic motifs. It becomes more interesting when practicing architects like Jones, Prisse d'Avernes, Bourgoin, Coste, Flandin bring back and publish the first detailed drawings we possess of Granada, Cairo and Isfahan. The evaluation of their effect on nineteenth- and twentieth-century architecture has not yet been attempted, but one may wonder, among several possible examples, whether Louis Sullivan and some of his contemporaries were not influenced by the striking solutions found in the Sultan Hassan *madrasa* in Cairo for the problem of long and tall continuous walls. Similarly Jones's publication of the Alhambra introduced into Western architecture a totally new conception of the relationship between outside and inside, covered and open spaces, construction and decoration. An Islamic influence cannot but be considered as a very secondary feature in the growth of modern architecture, but it is just possible that it was greater than has usually been imagined and that it went beyond a Hollywoodian exoticism.

Parallels

Although, as I mentioned earlier, the methodology for the study of parallels is far from being properly worked out, there are three broad areas in which its investigation seems to me to be particularly profitable.

One such area is that of construction. The idea developed in the 1930s that Gothic vaulting may have had its origins in Iranian architecture of the eleventh century is not tenable. What is true, on the other hand, is that both Islamic and Western architects were faced with the problems of light and of height within an architectural system based on multiple supports for ceilings and roofs. Both were searching for ways to minimize reliance on continuous [65] walls and to build efficient vaults. As a result both sought to develop systems of ribs used for actual construction and for carrying thrusts down, and both sought to alleviate wall surfaces. The ultimate results were quite different, as Islamic ribs became integrated within the vault's mass, unlike the partly independent Western units; yet the Muslim world developed the *muqarnas* which did emphasize in its own fashion the architectonic value, if not structure, of the vault. Thus also the Muslim world alleviated its walls by extensive surface decoration rather than by the striking thinning out of

walled areas, but the intent was the same in both cases. The eventual development of stained glass in the West may be compared to that of faience tiles in the Muslim East. It has even been argued that the rose-window is of Islamic origin. While not excluded on purely chronological grounds since its earliest known instance is in the Umayyad palace of Khirbat al-Mafjar, this conclusion seems highly suspect to me, for the means of transmission of the motif have not been made clear. Nor is it necessary to imply in this case a direct influence, for the parallelism of concerns might easily have led to the same results. That both cultures were frequently operating on practically the same kind of "track" is further suggested by the visual and aesthetic similarities between the ornamental values of flamboyant vaults and Islamic architectural decoration. It is not very likely that a direct impact of one on the other can be demonstrated, and we are certainly dealing with parallel growth.

The second area of investigation of parallels lies in the utilization and development of certain common units of composition. One example is that of the porticoed court adjoining an enclosed building. Whether we are in the cloisters of Spanish monasteries or of Mont St Michel, or in the courts of mosques and palaces, we are dealing with a relatable type of transformation of an open area into a place where different activities can take place simultaneously but where an aesthetic cohesion of the whole is maintained. At a certain moment, for internal cultural reasons, such cloisters will lessen in importance in the West, while in a building like the Alhambra, a unique mix of covered and open, interior and exterior, space will be created, but the initial formal concerns are very much the same, even if the ultimate results are not. A similar method of reasoning could be used with respect to large congregational spaces, as Western churches or Islamic mosques tried to create interior spaces which could hold enormous crowds while maintaining symbolic, liturgical, or aesthetic foci.

Finally there are parallels between the two cultures in the relationship between patronage and architecture. The development in Gothic times of churches and cathedrals to accommodate secular patrons, often buried there in their private chapels, finds a remarkable analogy in the private mausoleums attached to privately funded religious institutions in Islam. And it is possible that certain characteristics of a mercantile architecture in Flanders or in Italy could be compared to similar features in Islamic urban architecture. But perhaps at this level, as for instance with military architecture, universal functional needs begin to predominate and the comparison between two very specific features loses its significance. [66]

Bibliographical Guide

Islamic influences and Western–Islamic contacts have been discussed in a very large number of usually small articles. A full bibliography would take

dozens of pages and I have limited myself to three very recent works dealing with architecture which lead to most other pertinent studies:

E. J. Grube, "Elementi Eslamici nell'architettura veneta del medioevo," *Bolletino del Centro Internazionale di Studi d'Architettura A. Palladio*, 8 (1966).
R. A. Jairazbhoy, *Oriental Influences in Western Art* (New York, 1966).
I. Watson, "French Romanesque and Islam," *AARP*, 2 (1972).

Chapter XXII

Patterns and Ways of Cultural Exchange*

My remarks bear on three issues raised during the symposium: are we really talking about two worlds? What were the points of access for cultural and artistic influences or relations? What was the impact of whatever relations did occur? In order to reflect what actually happened during the symposium and to stimulate even further debate, these remarks are kept in the general form in which they were given, inasmuch as most of the examples are either of very well-known works of art and events or would have been quoted or discussed by other participants.

Two Worlds

However fashionable it may be to think in terms of two worlds (Christian West and Muslim East) or even of three (Catholic West, Byzantine East, Islam), in reality the period of the Crusades witnessed the participation of an extraordinary number of "worlds." These can be identified either in geographical terms or in theoretical ones.

Within Eastern Christianity, Byzantium proper, Armenia, Georgia, Syriac or Coptic Monophysites form separate religious entities, often at odds with each other. But there are also clear regional distinctions; Cyprus is not Greece, nor is Christian Egypt the same as Christian Syria. All are different from Comnenian Byzantium or from the New Balkanic kingdoms. Matters are even more complicated in Islam. On a dynastic level, the Fatimids, Zenguids, Ayyubids, Zirids, Hammadids, Almoravids, Almohads and Hafsids all represented different interests and sources of power; however, while some of these dynasties succeeded each other on the same territories, it is very rarely that the same regions formed foci of power under successive dynasties. Ethnic diversity is just as striking, as the rulers and the military were predominantly Turks, Kurds, or Berbers, while the cities were Arabicized and the countryside still preserved a mosaic of people from many origins. Sectarian differences were perhaps less acute than they had been in the tenth

First published in V. P. Goss, ed., *The Meeting of Two Worlds* (Kalamazoo, 1986), pp. 441–6.

or eleventh centuries. The great Sunni synthesis formulated in Baghdad dominated most of the Muslim world west of Iraq, but several [442] branches of Shi'ism were still forcefully present, Sufism was making inroads whose importance is difficult to assess, and here and there (southern Syria or southern Algeria), older and more restricted sects were maintaining themselves. It is true that the ideology and rhetoric of a unified *dar al-Islam* frequently overshadowed local peculiarities and that a partly Iranized Baghdad was the intellectual metropolis, but it was remote and a bit unreal to a merchant in Ifriqiyah or to a warrior in central Anatolia.

I feel less competent to deal with the Christian West, but it seems clear to me that the Castilians of the Reconquista, the Normans of Sicily, the Crusaders, and the merchants of Venice or Genoa all illustrate very different entities, only occasionally tied to each other in a common venture.

These numerous "worlds" should not be seen only as geographical or regional entities, as places with certain internal constrictions and expectations, characteristics and traditions, memories and reputations. The whole Mediterranean world can be seen as several orders of "worlds" which cut across the traditional ethnic or territorial divisions. There is a social order, as princes and kings shared skills, habits and taste, regardless of their regional origins, or as merchants of many lands sold silks, spices, or slaves wherever needed and learned from each other navigational techniques or appropriate markets. There is a pious order, as Islam and Christianity both preserved an official religious structure and a variety of sectarian movements. There is a technological and scientific order, and probably many others. My point is simply that, as one sets the problem in terms of a "meeting of two worlds," it may be easier to think of it in terms of clashing, contrasting, or collaborating regions, but in reality the "meeting" was also one of different social classes, of different religions and intellectual tendencies, of different levels of learning. This kind of "meeting" occurred within every regional entity and ought to be studied comparatively.

Influences and Points of Access

The central question dealing with "cultural contacts" is whether these should be defined as influences, impacts, or points of access.

Two initial observations are pertinent. One is that, because of the Crusades or for any number of other reasons, there occurred, in particular in the twelfth century, an extraordinary increase in the number of "points of access," that is, of places where contacts could be and were made, as well as in the variety of these contacts. What happened in Norman Sicily is not what happened in Pisa or Amalfi. The Holy Land, with its Western knights and ecclesiastics imported into a non-Western setting, is different from Anatolia, where Turkic soldiers and holy men settled in the midst of a Hellenized or

Armenian population. Sophisticated and intellectual Toledo was not like the vast emporium of Mahdiya on the Tunisian coast. Acre and Haifa became places where a Frankish knight or pilgrim would almost feel at home, [443] whereas Bagiyah (modern Bougie in Algeria), an exclusively Muslim city, had a Pisan ambassador with the wonderfully evocative name of Abu Tamim Maymun b. William. All these places, and hundreds of others, were places where contacts between different cultures were or would be established. Two variables must be introduced. One is chronological. For instance, the contacts between Western Christendom and Islam were extensive on the Tunisian and Algerian coasts during the twelfth century but not during the thirteenth, while Seville, Jerusalem, Damietta and Constantinople remained important points of contact during most of these centuries. The second variable is a qualitative one. Much deeper and much more far-reaching contacts occurred in Spain, Sicily, or Anatolia than in southern Italy or Egypt. It would, in other words, be highly desirable to draw up maps of identifiable points of access for every quarter of a century with whatever evidence we possess and then, if possible, charts of the kinds of exchanges which can be determined.

The second observation concerns the complex issue of influences, to which I shall return later, and what may be called the principle of communicating vases. In the case of the latter, similar concerns and similar needs lead to an almost automatic transfer of information. Such are the cases with much of the so-called scientific impact of the Muslim world on the West and with philosophy and theology, where the Christian West, as opposed to the Christian East, turned to Islamic ideas and interpretations because the same issues of faith and reason had been posed, not because of a precise influence of Islamic thought on the West. An appropriate parallel would lie in more contemporary times, as we should make a distinction between Pasteur's discoveries, which are only incidentally French, and the impact of Byron on continental literature, which is a willed influence.

To put it in more abstract terms, it is appropriate to talk of influences when the receiving organism adopts features from an alien source without being driven to them, without requiring them. Anything else is either an impact, often temporary and without long-range trace, or the result of unique circumstances.

In this restricted definition of influences, specific examples during our period are very few. Limiting myself to the visual arts, the most obvious one is that of *mudejar* art in Spain, where motifs and ideas developed in Muslim Spain become incorporated into the very fabric of Spanish art. Another example occurs in the modifications brought in the thirteenth century in the arts of ceramics, textiles and metalwork from Spain and Italy. It is also possible that direct influences lie behind the development of an architecture of urban citadels, although the subject still needs further investigation. Finally, there is the short-lived attempt by Roger II and William II to blend three separate artistic traditions into a unique Norman synthesis. It is curious

that the Byzantine world seems to have escaped either receiving or providing significant influences from and to the West or from and to the Islamic world [444] during the twelfth and thirteenth centuries, but this point may need correction.

On the other hand, examples abound of impacts on a limited scale and for limited periods of time. Nearly all of them are unique monuments or groups of monuments which are difficult to assess properly. The celebrated Innsbruck plate, made toward the end of the first half of the twelfth century, uses a Byzantine and possibly even Western technique of enamel and motifs of many sources for a minor prince of northern Mesopotamia. The portals of thirteenth-century Anatolian buildings exhibit a bewildering variety of types, whose parallels range from Western Christian to Iranian art. A last example consists in a group of inlaid bronzes probably from Syria; they are all of the first half of the thirteenth century, and their peculiarity is that they contain Christian subjects next to the traditional themes of the Muslim princely cycle. A recent study has proposed to explain these as objects made for the feudal taste of the Muslim or Christian aristocracy during the peculiarly symbiotic arrangements which followed the Muslim takeover of Jerusalem and preceded Mamluk rule.

The conclusion I would then propose for discussion is that, with the partial exceptions of Spain and Sicily, this period of intensified cultural contacts did not create many instances of meaningful syncretisms which would have taken root wherever they occurred. What happened instead is that specific and short-term conditions led to a relatively small number of idiosyncratic instances of single monuments or groups of monuments which can best be explained by the cultural contacts of the time.

Impacts

One can only speculate about the reasons why two centuries of increased contacts did not lead to deeper and more lasting artistic impacts. One reason may well be that forms had not acquired as yet a national, ethnic, or even religious identity. On a methodological level, what this means is that the historian of art tends to use systemic criteria (i.e., criteria based on the formal or cultural orders to which any one feature belongs) before having properly defined the syntagmatic character of a monument, that is, its own justifications for whatever formal devices appear in it. Thus, the representation of Roger II in the Martorana forcefully emphasizes his imperial Byzantine clothes. These examples are rare, however, and, on the whole, formal choices were made for other reasons than the cultural associations which can be proposed for them. A silk was chosen for its beauty or its value, not because it was Muslim or Constantinopolitan. Matters will be quite different after the end of the thirteenth century, when conscious exoticisms will appear.

Another conclusion which can be proposed is that the deepest effects of increased cultural contacts lie not in material influences but in an increased [445] awareness of one's self. The Eastern Christian world begins to formulate its own justification for its particularities when faced with the presence of other Christian groups. The Muslim world develops and hones its own theory of Holy War and of the sanctity of Jerusalem under the impact of the challenge of the Crusades. Italian towns and Balkan states, Armenians in Cilicia or Armenia proper, Monophysite Christians in Syria and northern Mesopotamia, are only a few among many cultural or political entities which become more fully aware than they had been before of whatever it was that made them unique.

The paradox would then be that increased contacts in the Mediterranean led, in the final analysis, to the weakening of a Mediterranean unity which stayed on for a far longer time than had been previously thought. On the positive side, there was created a much richer and much more diverse Mediterranean world. One last example taken from the world of forms may strengthen my conclusion. With the increase of all sorts of activities throughout the twelfth and thirteenth centuries, nearly all lands rediscovered their Roman or Late Antique past. The Muslim monuments of Aleppo, Damascus, Harran and Diyarbakr are full of classical reminiscences, as are the churches and sculptures of Italy and southern France. The new painting of Iraq or Egypt has a complex so-called "Hellenistic" past and, while less clear in the thirteenth century, the architecture of Anatolia does begin its dialogue with the dome of Late Antiquity and early Byzantium. One could argue that these revivals unify the various discrete regions of the Mediterranean. It is, however, more important to note that each area will use these forms in very different ways, from the classical explosion of Italy to the abandonment of its themes in Syria. Thus, once again, a common experience between 1100 and 1300 led to entirely different results, because these centuries of increased contacts ultimately strengthened or developed the separateness of each area.

Chapter XXIII

Europe and the Orient: An Ideologically Charged Exhibition*

Between 28 May and 27 August 1989, the Martin Gropius house in Berlin, a monument of, and to, modern architecture, hosted an unusual exhibition which received only minimal coverage in the popular press and professional publications.[1] Divided into fifteen very unequal sections, it included 636 items in nearly all the media of artistic creativity short of whole buildings, and in many media, such as paper, that are generally informative but not always art. The catalog has almost 1,000 pages and weighs over ten pounds. It belongs to the by now common category of abominable catalogs which are useless when visiting the exhibition and cumbersome to work with afterwards. Too thick to peruse in comfort, their overburdened bindings are too fragile to adorn coffee tables or desks. Catalogs like this one may well be useful records of an event, but I fail to see why they could not at least be printed in fascicles that could be sold together but used separately.

This particular request is likely to remain unheeded, and by the time the exhibition is over, all that will remain of it will be the catalog. Its magnitude; its excellent illustrations – 948 altogether, and over 300 more than the number of items in the show – many in color; its lengthy essays on a variety of subjects and often elaborate (or at least long) notices on exhibited objects; and its all-encompassing title *Europa und der Orient 800–1900* guarantee that the catalog for a temporary event has, or soon will, become a book of lasting value. This is the reason why it deserves a review, even by someone who did not see the exhibition itself and even if it appears long after the event. Just as the size and spread of the great London exhibition of 1976 made its catalog, *The Arts of Islam*, a standard reference book, so will the quality and quantity of data in this catalog not be repeated for many a decade; it will be used for a generation, even by those who do not read German. Furthermore, the topic of the exhibition touches on many issues which have often and at times emotionally been discussed in recent years and which touch the most sensitive

* First published in *Muqarnas*, 7 (1990), pp. 1–11.
[1] The only review – a negative and rather mean one – that I have seen appeared in the *Süddeutsche Zeitung* for 21 July 1989; I owe a copy of it to Catherine Ševčenko.

nerve in the difficult relations between a culturally dominant Western world and the Islamic cultures of Asia and Africa, and perhaps other non-Western cultures.[2]

The organizers of the exhibition, although apparently aware of "Orientalism," more or less as defined by Edward Said in 1978, hardly considered the twin questions of authenticity and identity which are at the core of the Orient's own contemporary discourse. In several different ways I shall return to this omission, but the most immediate criticism to be leveled at this catalog – and a criticism valid for nearly all of its companions in gigantism known to me – is its absence of conclusions or of statements that emerged from the exhibition and from the studies which led to it.[3] It seems absurd that those who by creating a show raise questions should not then bother to propose some answers, but leave that task to writers less familiar with the evidence and less involved with it. One wonders, as is so often the case nowadays, whether simply mounting the show was in itself the sole objective of the sponsors of the exhibition and of the events surrounding it. If so, then comments about or deductions drawn from the show may in fact be irrelevant to it.

Yet there are many important questions raised, consciously or not, by the choice of objects shown in the exhibition and by the text of the catalog. Answers to some of these questions are occasionally implied, and the whole event is a reasonable starting point for discussing a variety of considerations on the burning issues surrounding East–West cultural relations. This essay will deal with some of the hypotheses and conclusions that could have been derived from the exhibition in three general areas: (1) what the exhibition was and criticisms of it; (2) varieties of functional and ideological relationships between Europe and the Orient over time; (3) the chronological sequence of these relationships and its implications.

[2] The issue is primarily cultural and visual, not political and economic. This is why the general term of "non-Western" seemed preferable to "Third World," "developing worlds," or "north–south."

[3] It would be interesting some day to identify and evaluate those exhibitions that have made a lasting impact on scholarship or on the general public. For Islamic art, the 1910 shows in Munich and at the Musée des Arts Décoratifs in Paris, the 1931 exhibit of Persian art in London, and the 1976 World of Islam exhibit also in London all led to significant alterations in the prevailing conception of Islamic art and affected the quantity, probably also the quality, of the scholarly work which followed them. The point has been demonstrated for Persian painting: Nasrin Rohani, *A Bibliography of Persian Miniature Painting* (Cambridge, Mass.: Aga Khan Program for Islamic Architecture, 1982), p. 144. For a broader perspective on exhibition and ideology, see Oleg Grabar, "Geometry and Ideology," in F. Kazemi and R. D. McChesney, *A Way Prepared: In Honor of R.B. Winder* (New York, 1988). Why did some shows succeed and others not?

The Exhibition and its Catalog

The event – the exhibition and the catalog together – is consciously and willfully Europe-centered and [2] seeks to show what a Middle Eastern or Western Asian "Orient" has meant to Europe. It does not try to understand that particular Orient on its own terms, and there is no point in criticizing it for something it does not try to do. But it does assume, as early as the introduction (p. 15), that there is a European culture and that it has had a history of contacts and relations with an Orient. The latter is true enough; the former is a myth which may finally become a creative reality by the end of the twentieth century. Earlier, mostly in the eighteenth and nineteenth centuries,[4] it was an exclusive, elitist and basically racist club that ended in 1914, when it entered into a self-destructive period of some thirty years during which Europeans killed around eighty million other Europeans and, directly or indirectly, were responsible for probably as many murders all over the world, and for many yet to come. I shall return later to the significance of this point to the system of relationships between Europe and the Orient suggested by the Berlin show.

Almost half the catalog is taken up by twenty-two "essays" (the English term is used in the book to distinguish these pages from the catalog proper) on a wide range of topics. Some, like Dirk Syndram's on the fascination of Europe with ancient Egypt or Michael Scholz-Hänsel's discussion of the ways in which "Moorish" Spain dazzled the European nineteenth century, are learned surveys. Others, like the chapter on "Tulipomania" in Europe by Pieter Bisboer, Karl Syndram's original approach to the Orient in European literature, and Karl-Heinz Kohl's "Cherchez la femme d'Orient," are on broader topics. Two essays were taken from earlier publications, one by Gerhard Stamm on Raimond Lull, the other one by the late Richard Ettinghausen from *The Legacy of Islam.* A number are dedicated to the presentation of specific documents: Renaissance artists and the Orient (only pictures), views of Turkey by Pieter Coeke van Aelst and Melchior Lorch, the personality of the French draftsman and traveler Louis-François Cassas, and so on. Two essays deal with music, and performances of music and dance of many sorts were among the activities surrounding the exhibition.

4 The universalization of a humanistic view of man developed by the eighteenth century and proclaimed by the French Revolution demanded a practical leadership, and this led to the idea of the Concert of Europe, to which others were not invited, or, if they were, only as curiosities. One of the most bizarre representations of "others" together with Europeans (Americans are curiously absent from either group, as is the Ottoman sultan) is the painting *Hommage à la République* exhibited by Henri Rousseau le Douanier in 1907. It is beyond the timespan of the Berlin event, but reflects the tail end of the show's concern. In it are shown, to the side of a group of Europeans, a collection of small figures, "Easterners," including the shah of Persia and the emperor of Ethiopia (New York Museum of Modern Art, *Henri Rousseau* [New York, 1985], p. 178).

Some were classical and somewhat esoteric; others were more popular and catered to the sizable Turkish and Pakistani communities of Berlin.

The quality of the essays is on the whole reasonably high. They are heavily illustrated with items from the show, as well as many which were not in it, thus increasing considerably the information in the book. Each essay deserves comment, but that task is beyond both the purposes of this review and the competence of any one reviewer. Two remarks are, however, pertinent to the broader objective of assessing the value of the book. One is that seven of the twenty-two essays deal exclusively with connections between the Ottoman world and Europe, and three or four more prominently feature the Ottomans as well. Part of the explanation is simple enough: the Ottomans were closest to modern Europe and therefore many more documents by and about them have been preserved; furthermore, there is a significant Turkish audience in Berlin, although the emotional or aesthetic relationship between Turkish workers and the Ottoman world remains unclear to me. But there is also a more profound explanation for the predominance of Ottoman material, to which I shall return later.

The second comment is that there is no attempt by anyone to explain the relationship in any depth or with any sense of perspective of either European or Islamic art, history and culture. The relationship is presumed, even perhaps demonstrated, at least as a one-way movement from East to West, but it is never clear whether we are dealing with something important or with peculiar freaks of history.

The essays are followed by a catalog arranged in fifteen chapters varying considerably in length. The first, on the discovery of the Orient, has 259 items; the fourth, on treasures, has 142 items; the seventh, on images of enemies in war and art, has 106. These three sections contain three-quarters of all the items shown, and thus the tantalizing titles of some of the other twelve chapters (the Vikings and the Orient, Charlemagne and Harun al-Rashid, Bellini and Dürer, women in Orientalist painting, and so on) do not lead to equally profuse illustration. There is nothing wrong with such imbalance; it may at times have been required by the layout of the show, but it can also be legitimate in itself. It is obvious, for example, that it takes more objects to illustrate treasures through ten centuries than it does Melchior Lorch (chapter 10) or Western embassies (chapter 11). The result is, however, that the visual impact, presumably of a visit to the show and certainly of a perusal of the catalog, does not match the intellectual, scholarly, or even sensory objectives and potential of the event. Once the broad theme of Europe and the Orient has been launched with a brilliant fanfare of fancy pictures and heavy essays, there is practically nothing to guide the viewer toward the objects.

Within the category of treasures, for example, is a group of nine fantastic birds and griffins (4/74–4/83). [3] Some are of Middle Eastern provenance; others were made in the West, and one example is a seventeenth-century

German woodcut of Moses leading the Israelites out of Egypt with a dragon and a griffin in the foreground wonderfully poised for battle. The selection is a good and interesting one, and it is indeed remarkable that a group of objects with a related power of expression, a comparable technique of manufacture, and reasonably similar ornamentation could have been manufactured in places as widely separated as Egypt, Lorraine, North Germany, Flanders, Saxony, Mesopotamia, Sicily and Andalusia. Whether these geographic attributions are wild guesses or reasonable conclusions is really not very important, because the ground has not been prepared for a discussion of metal objects from different regions, and no reference is made to the ground-breaking, even if controversial, studies by Boris Marshak on some similarly related groups.[5] The point of Marshak's work is to establish a "genetic" relationship between objects grouped together by shape and technique. Such a relationship, even if tentative and tenuous, at least allows us to see the objects in historical perspective, as the remnants of an evolution or development.

Alternately, objects can be seen as individual works of art to be appreciated and understood on their own merit. To do so, however, would have required a real study at least of the most important of these objects. And here another problem arises. For, if one takes an object as well known as the Pisa griffin (4/83), the largest extant metal object in Islamic art, one finds in the book a thoughtless description that does not even reflect two recent studies on the griffin, which may or may not be correct, but which give it a completely different provenance and date.[6] This is a serious scholarly failure which makes one doubt many other references and explanations. But scholarship, after all, is for scholars and not the general public, so why does it matter? In the case of the Pisa griffin it matters because the entry does not even begin to explain the several levels on which this striking object can be understood: in its own time and place of manufacture somewhere in the Muslim world for functions as yet unknown; in Pisa, where it may well have been put in the cathedral to commemorate a victory; later in Pisa, when the memory of the victory had faded, and the griffin became an ornament with or without any identification of its origins; and finally as a treasure expressing something about East–West relations in a museum. In their passion for repetitive descriptions of what one can anyway see in the illustrations, the entries are for the most part of as little help to learning as those recorded voices on cassettes that now accompany art shows.

5 Boris Marshak, "Bronzovoi Kuvshin," *Iran i Sredneia Azia* (Leningrad, 1973); "Ranneislamskie Blundy," *Trudy Hermitage*, 19 (1978).

6 Marilyn Jenkins, "New Evidence for the History and Provenance of the Pisa Griffin," *Islamic Archeological Studies*, 1 (1978); S. Melikian-Chirvani, "Le Griffon Iranien de Pise," *Kunst des Orients*, 5 (1969); and B. Spuler and Jeanine Sourdel-Thomine, *Islamische Kunst* (Propyläen Kunstgeschichte) (Berlin, 1973), p. 263 (a work listed in the bibliography of the catalog, but obviously not read).

In short, most of the entries deconstruct the objects to the point of making them utterly boring, and nearly all the images are more interesting than the texts accompanying them. But, it can be argued, what matters is the more than twenty-five pages of bibliography which should lead back to the true "deep" scholarship about objects, even if the authors of most of the entries do not do so. For many objects, it is true, this scholarship does not exist, a fact that could usefully have been acknowledged in the book itself. The usefulness of the bibliography was weakened for me in particular by the appearance of several references to a certain "Grabar, Oleg-André," which shows a discouraging ignorance of art historians and their relationships. In addition, many other works by these two authors combined into one could have been cited as appropriately, or uselessly, as the ones that were, and it is clear that few of the many books and articles listed in the catalog have been read. These lists are a parody, and a bad one at that, of bibliographical exercises common in my youth; they look thorough but they are in fact incomplete and unused. The enormous bibliography is an uncritical, unthoughtful compendium probably by a computer or by someone who knew nothing about the topics involved. The same false learning is often found in the footnotes; it was as though the mere addition of a note took precedence over its content or its relevance. On an informational level, then, the photographic record is stupendous in its sheer size and in the quality of the prints in black-and-white or color. The choice of objects is impressive and in some cases, like the small but little-known group from the land of the Vikings or the various views of Istanbul and Turkey, the documentation is rare and important. If only more thought had been given to the individual objects and to the ideas that can be derived from them!

Varieties of Functional and Ideological Relationships

The objects in the exhibition and the catalog can be organized according to seven kinds of relationships between Europe and Western Asia. There is some overlap between these categories, and more than one item pertains to several, but, as an initial organization of my own reaction to the material, these seven categories represent a way of seeing both individual objects [4] and the complex psychological and intellectual attitudes which affected both their manufacture and contemporary or later reactions to them. Each one of these categories, except perhaps the first one, deserves deeper study than I have given to it here, and I have tried to indicate some of the directions further discussions may take. The order in which I have put them is not entirely arbitrary, as it moves from near neutrality of value to the complete subjection of an object to a more or less acknowledged purpose. I am, of course, aware of the fact that neutrality is, in the eyes of many contemporary thinkers or writers, impossible, and I may well agree that neutrality is rare in

the attitudes of people, even the most conscientious scholars, and possibly that neutrality is itself immoral in that it denies truth by always seeing "another side." But my point of departure is the existence of objects which are (or were) part of an event. The event is not neutral and may well have used objects for some justified or evil purpose, but the bias of the event does not necessarily affect the objects, and they are my primary concern.

The first category can be called "contact and souvenir." The seventh chapter of the exhibition, with the title "Images of Enmity: War and Art" ("Feindbilder: Krieg und Kunst"), contains, in spite of its title, a series of written documents which record wars, truces, protests, questions, answers, alliances, and other common ways countries use to deal with each other. These documents contain valuable data, but they do not in themselves mean much. A slightly more complex issue comes from items brought to Europe after violent or peaceful encounters with the Muslim world. These items are of varying importance (a sword, a helmet, a knife; *the* sword attributed, probably incorrectly, to the last Muslim ruler of Granada), but none of them had an impact on the arts or on culture (as opposed, for instance, to the exotic object with which I shall deal shortly). They remained less as memories than as souvenirs.

A particularly complex issue revolves around the two sieges of Vienna by the Ottomans, in 1529 and 1683. If one adds the battle of Lepanto in 1571, we have three violent contacts which have been recorded with considerable care and at many levels, both the events themselves and all of the participants – images abound of European and Ottoman leaders done almost exclusively by Western artists. These are all records of specific moments in history which affected Western Europe's sense of its successful defense of its alleged territorial space. It is striking, if it indeed becomes fully demonstrated by further research, that these images are rarely interpreted in ideologically charged fashion, as were nineteenth-century paintings of the Greek War of Independence and especially the French conquest of Algeria. Horace Vernet's *La Première Messe en Kabylie*, in which noble Arabs witness the religious ceremony in front of a huge wooden cross, is all the more ironic (and certainly unwittingly so), as the troops protecting the celebration of the liturgy are all European zouaves dressed in pseudo-Oriental clothes. This ideological manipulation of the contemporary realm seems to me to have been rarer in the sixteenth and seventeenth centuries, when contact, even military and destructive contact, could be seen simply as something that happened, perhaps with an identification of bad and good guys, but without any unusual distortion of the shape of the event.

The second category is learning. Both the essays and the catalog contain a great deal of information about the discovery of a historic Orient, the fascination with ancient Egypt, the explorations for ancient Mesopotamian remains, some truly astounding pictures of Persepolis (p. 475), and eventually the discovery in the Orient of Hellenistic and Roman art, at times under the

patronage of Semitic rulers, as in Petra or Palmyra. The reasons for these searches for knowledge were, as they still are, Europe's own search for its origin. Because of Herodotus and other Greek and Latin writers, Egypt and Persia were central to this search, and the Bible had made the whole eastern Mediterranean the land in which holy history was made visible. Both believers and new rationalists wanted to understand how Judaism and Christianity came into being and what spaces and environments shaped this growth. And then the culture and an ethic raised on Plutarch could not escape imagining where the Ptolemies, the Seleucids, Croesus, Antony, or Mithridates had lived and acted out their heroic deeds or ghastly misdeeds.

Fascination with learning the past, one's own or that of others, is a fine thing, but the extraordinary point about European learning is how little it involved the Muslim world, the contemporary reality of the Orient. There was a superficial description of it (of which more anon), but very little on its languages or culture. Hieroglyphs and cuneiform tablets held more fascination than the Qur'an or mosques. The exceptions to this generality are Andalusia, whose Islamic past was necessary for understanding Granada and Cordoba, and Cairo, where a small number of French and English painters and writers did record the contemporary world with sympathetic romanticism.[7] This attitude will later [5] be understood as a contemptuous paternalism which indeed appears in literature much more than in the visual record.

In short, then, learning about the past, its history, art and philosophy, was a reason for Europe to turn toward the Orient, but it was not in order to learn how the living world of the Orient functioned except on very limited levels. The only exception, that of the sciences, lost its pungency in the fifteenth century, even if, as several sections of the catalog make clear, the knowledge of a debt to the Muslim world and the use of certain astronomical tables remained until much later.

The third category is exoticism. By this term I mean the use of foreign objects and motifs or the representation of alien scenes in order to satisfy needs of one's own. In dealing with the Middle East, what are these needs? Two predominate from the evidence of the exhibition. One is luxury, as from the beginning of the ninth century until today the Muslim world furnished Europe with its expensive objects in metal, ceramics, glass, crystal, and especially silk, cotton and wool. The rhythm and extent of this relationship varied over the centuries. At the time of Harun al-Rashid and Charlemagne, almost everything that was *de luxe* in Western Europe came from the Orient, though admittedly the Byzantine Christian Orient rather than the Islamic one. By the end of the twentieth century, carpets and a few weaving techniques alone have remained as luxury creations from the same

7 Nearly all the painters and draftsmen involved are mentioned in chapter 14 of the catalog; the names of John Frederick Lewis and Pascal Coste are particularly noteworthy for their images, while Stanley Lane-Poole was the outstanding writer of that time.

Orient, and even these are about to be replaced by machines. Why the Orient was able to feed Europe's luxury needs is easy enough to explain in terms of taste. The Orient's products were of a quality unknown in Europe for a variety of reasons.[8] At some point things were turned around, and luxury in the Orient today comes almost entirely from the West and Japan. A curious variable in the receptivity to Oriental things lies in distinctions from area to area. Why are there so many rugs in Flanders and so many imitations of Arabic inscriptions in Italy? Why are high Spanish, French, or German paintings immune to Oriental themes until the nineteenth century, when French painting in particular picks them up with a vengeance?

All these questions can only be answered through a study of European history and culture, as is also true of the dominant nineteenth-century theme of sensual sexuality associated with the Muslim world. The theme is given much prominence in the catalog and essays and is accompanied by a particularly voluptuous choice of images. Many difficulties of interpretation surround this particular side of exoticism, none of which has as yet been seriously discussed.[9] For instance, its growth parallels that of Romanticism and of the first statements of some depth about Islamic art and literature made by European writers. They all come from Kant, Goethe and Hegel. Goethe, in fact, wrote on the arabesque much before it had been recognized by Owen Jones.[10] Why should the odalisque, whose filiation out of the Late Renaissance reclining Venus is generally accepted on a formal level, have appeared at this time? Whatever answers are eventually found to questions such as this one,[11] they will be found in the peculiar paths of Western culture, and they are not likely to enlarge our knowledge of the Orient.

[8] There is no good history of luxury trades in the Middle Ages. Part of the reason for the superiority of Middle Eastern luxury products lay in the concentration around Baghdad (from where it spread everywhere in the Muslim world) of an enormous amount of capital and of a market of consumers, but the details of how it worked are yet to be sorted out; see R. Hodges and D. Whitehouse, *Muhammad, Charlemagne, and the Origin of Europe* (Ithaca, 1983); M. Lombard, *L'Islam dans sa première grandeur* (Paris, 1971); S. D. Goitein, *A Mediterranean Society*, esp. vol. 4 (Berkeley, 1984).

[9] John Sweetman, *The Oriental Obsession* (Cambridge, 1988), deals primarily with architecture, but its conclusion, which does handle paintings, belies the noun in its title. It is one of the most balanced statements about what Islamic themes meant to Western Europe. Sweetman emphasizes the positive values of an eclectic approach which sought to learn and accept all possible models if they helped or satisfied genuine aesthetic and social needs. This position is largely antithetical to those who, like Edward Said (*Orientalism* [New York, 1978]), insist that any modification of original and specific traits is a willful or accidental betrayal of the model. Said, of course, did not deal with the visual world, which is quite different from the verbal discourse of his concern, but his approach can easily be applied to some of the paintings of the orientalist tradition. Whether it is correct to do so remains an open subject.

[10] For sources and a preliminary discussion, see Frank-Lothar Kroll, *Das Ornament in der Kunst des 19.Jahrhunderts* (Hildesheim, 1987), a work unmentioned by the organizers of the exhibition.

[11] I suspect that a fruitful approach lies in the reading of travel literature, of the drawings which were inspired by it, and especially by the immensely complicated and

Exoticism can also be seen as escapism, as a way to disappear in imagination or, as through architectural decoration, into the artificial surroundings of domestic interiors.[12] Escapism can be physical, an invitation to deserts, to sun-filled spaces, to mysterious bazaars, even to such sexual adventures as permeate the Oriental experiences of Gustave Flaubert, André Gide, T. E. Lawrence, or Richard Burton. Escapism can also be an attitude given to one's subject. Fromentin's Egyptian girls (p. 867) and most of John Frederick Lewis's women from Cairo (pp. 871 and 873) seem to be pre-Raphaelite heroines in Oriental costume dreaming some impossible dream. This longed-for escapism in the representation of exotic women permeates their disquieting message and transmits a judgment of the world of others, of the Muslim Middle East in this case. In its intense form, beauty and luxury mean misery, moral degradation and a desire to escape. There is something depressing about these images, however beautiful they are, and they do indeed deserve a more developed analysis.

I can be brief on the fourth category of relationships, which is imitation. Since the treasures of Scandinavia (a tenth-century one is discussed on pp. 522–3) and the coins of King Offa in the British Isles which imitated early Islamic coins, Europe has copied the techniques of the Orient so closely that the place of manufacture of many chess pieces, silks and bronze lions or dragons cannot be securely identified. These fairly well-known examples are abundantly illustrated in the exhibition, but two – imitation in clothing and Egyptomania – are more original. The former is developed in two short chapters (pp. 759 f.) with fascinating and often very beautiful examples taken from paintings, ceramic figurines and theater costumes. It is also prominently featured in a chapter dealing with portraits. Egyptomania dominates the first chapter with literally hundreds of examples of ancient Egyptian themes in nearly every [6] conceivable form. Three essays, including one on the rather astonishing museum of Aegyptiana created in 1651 by the learned eccentric Athanasius Kircher, deal with the topic, and it is amazing that, by comparison, ancient Mesopotamia and Iran did not affect artistic creativity until the late nineteenth century, and even then to a much smaller degree. In general, however, imitation was constant; it existed in all European lands, but varied in intensity according to rhythms which are still to be investigated. Among its most extraordinary examples is a late-fourteenth-century miniature of Gluttony painted in Genoa entirely in the manner of a Persian miniature (p. 627).

My last three categories – recording, representation or re-presentation, and manipulation – form a sequence in intensity of ideological charge.

psychologically as well as intellectually shaky eighteenth-century positions on "others." On the one hand, they (i.e., the others) cannot but exist and must therefore represent some stage in the growth of mankind. On the *other* hand, the universality of high culture was an item of faith, and other cultures had to be morally wrong. For a debated statement, see Barbara Stafford, *Voyage into Substance* (Cambridge, 1984).

12 Sweetman, *Oriental Obsession*, p. 249.

Recording is, at first glance, easy enough to understand. Hundreds of images exist which are supposed to show what some observer has seen, and scholars have already for several generations used Melchior Lorch to explain Istanbul and other reporters like him to explain Aleppo, Damascus, Jerusalem, Persepolis, Cairo, or Granada. Some of these visual statements seem indeed to be factual records of existing buildings or cities and of correctly rendered clothes, uniforms, objects, or events. The various portraits of Mehmet the Conqueror or Giovanni Mansueti's representations of Mamluks are first-rate standard drawings, paintings, or medals of their time and seem to be acceptable records.

But to distinguish truth from imagination is sometimes difficult. Out of dozens of examples, which show a range of "truths" and of amusing oddities, I will cite three. In 1633 a formal Polish embassy to the Pope entered Rome with a procession that included ten fantastically decked-out camels (pp. 768–9). The tent of the grand vizier entered by the victorious Austrian dignitaries in 1683 (p. 267) is a pastiche of dramatic orientalist myths arranged as for a grand opera. Even the schematic vision of a visit to a Turkish commander has been simplified almost to the point of meaninglessness (p. 267). In all three of these cases, there are many reasons to question the accuracy of the drawing, and yet they are at the same time perfectly reasonable accounts of an event.

The last two examples are in fact re-presentations. They transform an event that happened or a person who existed into the image the viewer wanted to see. Such re-presentation can be amusing, as is the frontispiece to an edition of Lady Wortley Montagu's letters (p. 327), where the fully dressed British lady, seen from the back, is greeted by a nude seated woman into a world of naked ladies who all look alike and very British, as though taken from the standard repertoire of graces in various poses. On a more serious level, the dozens of representations of all sorts of Ottomans, from ruling sultans to simple people seen in streets or invented in harems, offer a huge range of transpositions of observed, copied, or invented details into images which can be very successful works of art (as with Dürer's and Rembrandt's drawings or with Carpaccio's and others' paintings of events taking place in Jerusalem[13]) or caricatures, at times benevolent, at other times cruel. A similar set of transpositions occurs with events which are transformed to fit the visual habits of viewers. For instance, a Dutch traveler transforms Persepolis into a mixture of Rome and San Marco or perhaps into an Indian mosque (p. 475).

The last step would be manipulation, that is, the transformation of a topic in a way that would invite hate, contempt, or, much more subtly, alienation from the world for which it is destined, as though it does not

13 Julian Raby, *Venice, Dürer, and the Oriental Mode* (London, 1982).

belong with the "civilized" world or else exists only for certain clearly defined functions. One miniature (p. 635), by Jacop Ligozzi, who died in Florence in 1627, shows the *"Mufti, il Papa delli Turchi"* accompanied by an extraordinary emblem identified as a monster. It is a powerful image of the kind of hate-mongering that had existed since the Middle Ages. I have alluded earlier to the manipulation of events around the conquest of Algeria and around the representation of women. Images of Algeria show the victory of Christianity through military means (an echo of the Crusaders, who appear more than once in the images of the show), while women are shown in a sensuous world from which men have been banned. There is still something so vulgar and obvious in these manipulations that it is difficult to take them seriously, except for the fact that, in the case of some of Ingres's paintings among many examples, we are dealing with masterpieces of composition and color, truly great works of art, almost escaping this immorality. It is only toward the end of the period considered by the Berlin show that people began to manipulate their vision of the "Orient" through international exhibitions.[14] It was a "true" manipulation because it thought that this vision was the correct one, and it thus transformed the attitude, not so much of the Europeans who visited the exhibits, as of the Egyptians, Ottoman Turks, Iranians, and other "natives" who took part in them and began to believe, according to a recent hypothesis, that this is what they were.[15] [7]

I am not prepared at this time to agree or disagree with this particular hypothesis. What I am trying to argue, however, is that no light is generated by simplifying the evidence, and if one positive conclusion can be derived from the Berlin event, it is that there have been in the past and probably are now many kinds of relationships between the Islamic Middle East and Europe. These many relationships need to be thought through and investigated in their manifold details before firm conclusions can be reached on anything.[16] And, most important, critical judgment or even condemnation

[14] Several studies are in preparation on the topic of the Orient and exhibitions. In the meantime, see Elizabeth Gilmore Holt, *The Expanding World of Art, 1874–1902*, vol. I (New Haven, 1988), and Timothy Mitchell, *Colonizing Egypt* (Cambridge, 1988). A fascinating much later and little known episode of manipulation through form is the making during World War II of Persian miniatures with Stalin, Churchill and Roosevelt winning over Mussolini, Hitler and Tojo; see A. R. E. Rhodes, *Propaganda* (New York, 1976), p. 136.

[15] T. Mitchell, "The World as Exhibition," *Comparative Study of Society and History* (1987). I do not necessarily subscribe to all of Mitchell's conclusions and hypotheses, but they are far more exciting than most of the prevailing ones.

[16] The exhibition deals exclusively with Western Europe, but there has been a long-standing relationship between the Eastern European world and the Islamic Middle East. It is a very different relationship until the eighteenth century, when Poland and then the Russia of Peter the Great adopt and put in their own version of a generalized Western view. Then in the nineteenth century the conquest of the Caucasus in particular created a Russian Oriental romanticism which affected, among others, Lermontov and Tolstoy.

of certain attitudes should be muted until these attitudes have been understood. It does not, of course, require much sensitivity or intelligence to be offended by the erotic representation of women in orientalist paintings. But is the offensive part the treatment of the women? Or is it the vision of the Orient? What is the relationship between the two?

Edward Said and others have written eloquent pages on the reification of an image of the Orient in order better to subjugate it, and it may well have been so in the convoluted minds of some and the sick imagination of others. But there is no need to exaggerate. For every Gérôme there is a Manet, and Ingres was not only a depicter of flesh. In the overall sweep of Western art, the handling of the Orient was a minor occurrence. Too much should not be made of it except to note that it was there, that it was profoundly permeated with prejudices, that some of those that now seem offensive, like association with the desert or sensual beauty, were originally meant as compliments, and that their impact on the Orient itself was minimal, at least until the last decades of the nineteenth century.[17]

Chronology

A typology of visually perceptible relationships between the Orient and Europe is a taxonomic list of convenience which may or may not require additional discussions and elaboration. It acquires life when seen in concrete examples and set in time. Each object has its own specific and at times even unique moment, like the Rosetta Stone, which opened up the field of Egyptology, or the years of Melchior Lorch's sojourn in Istanbul (1555–59), which provided us with a very precise image of the Ottoman capital. Most objects are also part of sequences of objects like the often bizarre transformations of ancient Egyptian motifs which formed a timeless Egyptomania (one of the very successful and original chapters of the exhibition) or the succession of views of Cairo and Istanbul, which were most useful as representative of an evolution in the technique of recording cities and in the appearance of the cities recorded.

At some point it will be possible to establish a correlation between types and various periods of history and probably various places, countries, or

For any sort of thorough scholarship on the subject, the Polish and then Russian phenomena should be examined and, much later, the vision of the Balkan states and of the Christians of the Near East, which is yet another story. It is interesting to note, however, that the Greek War of Independence became a major literary and artistic motif in Western culture (Byron, Dumas, Delacroix), but Turgenev wrote about Bulgarian and Serbian "patriots."

17 There is little study of the ways in which the visual impressions are made and retained. I assume that historians and social scientists have probed into the tensions or conflict between the truth of what one is and the image others expect of one. To all of this India was probably an exception; the most immediately effective introduction is S. C. Welch, *India, Art and Culture 1300–1900* (New York, 1985).

societies. All I can do at this stage is sketch out, from the exhibition itself, some key moments in the making of contacts between Europe and the Orient, some specific places involved in these contacts, and a few hypotheses for an evolution.

Three "key" moments are clearly visible, and it would be interesting to know whether they do in fact stand out over all others. Keeping in mind that I am dealing with visual evidence alone, these are the Crusades, the two Ottoman attacks on Vienna, and the European conquests in the nineteenth century, especially of North Africa. There is also British India, almost entirely absent from the exhibition, which played a significant part in the architectural imagination of Great Britain, but with nothing comparable to the "Oriental" inspiration of Ingres, Delacroix, and eventually Matisse, not to speak of dozens of lesser lights in France.

The Crusades are directly reflected in the appearance of Eastern objects in the West and perhaps in a few new themes in decoration or techniques of manufacture. But if one considers the time of the Crusades, the twelfth and thirteenth centuries, rather than just the fact of the Crusades, the wealth and complexity of the contacts increase enormously, as the archaeology and artistic history of Sicily, southern Italy and Spain demonstrate. This catalog is, however, far too superficial and unhistorical to focus properly on the immense variety of these contacts and on their actual operation. Some key examples of the works brought West because of or through the Crusades are missing.

The Ottoman attacks on Vienna provided the occasion for fascinating imagery in every detail, as personages and artefacts and, in fact, the whole topographical setting were lovingly recorded, as an earlier exhibition in Vienna had fully shown.[18] We still miss, however, interpretations of these images within the social and ideological contexts of the late sixteenth century and of the late seventeenth. It is also an instance, especially for the sixteenth century, where there is an Ottoman visual record which could be contrasted with the European one, if only to evaluate the latter properly. To deal with the nineteenth century is difficult because the partly justified passions which have arisen around Orientalism as an expression of colonialism and imperialism [8] have contributed very little to the understanding of the visual impact made by North African and Middle Eastern forms on European eyes. Flaubert, Loti, Gérard de Nerval, even Mark Twain, wrote a lot of nonsense about the Orient they had encountered and, in the case of Loti, liked. Delacroix and Gérôme, and later Matisse, made beautiful paintings out of their experience, just as Ingres did with the rather vulgar topic of vast numbers of women in harems. Why is it that the "word" or the pen of Europe seems to have been so much less successful than the brush in

[18] Vienna, Historisches Museum, *Die Türken vor Wien* (Vienna, 1983).

creating attractive works of art? The answer lies probably in some fundamental distinction between visual and verbal expression which lies beyond my competence.

The places through which and in which contacts were established are more obvious. Istanbul and Cairo dominate all knowledge of the Orient until the appearance of North Africa within a specifically French context. Until the seventeenth century, the pictures of Italy and Northern Europe dominate. England and especially France appear with a vengeance in the eighteenth century and dominate the nineteenth.

It is worthwhile to single out the peculiar state of Istanbul and of the Ottoman empire in the image provided by the exhibition. It was both alien and quite familiar to Europe, as it issued out of the same matrix of behavior and of memories of spaces known since Herodotus. It hovered between being just an enemy (a concept European countries developed among themselves) and an alien enemy, and this ambiguity affected many images. In addition, the two areas closest to the Muslim Orient, which either fought it or lived in more or less successful coexistence with it, are almost totally absent from the exhibition – I refer to the Iberian peninsula and the Eastern European world. The latter means primarily Russia, although there is also a fascinating Polish Orientalism. From a strictly scholarly point of view, the robes and arms of the tsars before Peter the Great and the liturgical clothes of many bishops could have been included, and many medieval or pre-modern objects found on Russian or Ukrainian territories belong to the same groups as the Western ones. At the end of the nineteenth century Vereshchagin and Repin are only the best known of many painters who went east or south with conquering armies and depicted the Orient or, in the case of Repin, episodes from a history of hostile relations between the Ottomans and various Slavic entities. All this could have been included, but I suspect that the Europe of the organizers of the exhibition stops short at the Oder–Neisse line. Much more puzzling is the absence of Spain, and my own lack of familiarity with the Iberian peninsula after the Alhambra only permits me to raise the question whether the visual memory of the Muslim world disappeared during the subsequent centuries of Spanish history or simply remained unseen because no one looked for it.

The most interesting conclusion suggested by the exhibition however, concerns the chronology, of the history of the relationship. There, it seems to me, granting some exceptions among rugs and other textiles, a clear break occurs somewhere in the sixteenth century, in the midst of the Renaissance. Until then most of the contacts through objects or images could be called practical and culturally consistent. Textiles made for Muslim princes may have been used to bury Christian saints, but it was a function of textiles to be used for burial. Aquamaniles still carried liquids and, even if handles were added to rock-crystal ewers, the basic function of ewers remained. Certain types of bronze griffins were copied, while others were used for new functions,

and Arabic letters or Muslim designs were carefully, if senselessly, copied. In all of these examples, perhaps a hundred of which are in the catalog, there is a continuity of functional use which keeps most of these objects alive until they enter museums. To use an architectural parallel, the mosque of Cordoba is still a religious space, even if the religion is different. Hagia Sophia, having been a museum for nearly seventy years, is religiously dead for Islam *and* for Christianity.

After the Renaissance, and always with some exceptions, practical objects gave way to images. Some of these carefully depict a reality out there, a pyramid or a uniform; many are interpretations and often falsifications of reality, whether archaeological reality or social truth. One detects fear, as the fear of the "Saracen" was one of the visceral fears of seventeenth-century Europe,[19] curiosity at quaintness and difference of customs or clothes, at times even awe. Exterior details like clothes become theatrical props for beautiful exoticism. Oriental landscapes could be made dramatic or sensible, but they are always set in terms of a Western imagination about nature.

One could easily follow various recent studies and simply argue that, after the Renaissance, the Orient was no longer seen as a reality but as an image to be represented, rather than felt or understood.[20] This, however, is too simple-minded an answer to the images of the show, because it implies, as in a great deal of leftist cultural history about other worlds, that life and art were wonderful, sensible, and attuned to ecological [9] surroundings and social context, until disrupted and eventually ravaged, not merely by the physical presence of Europe, but also by the visions and prejudices carried by these Europeans.

Leaving aside for the moment the question of the eventual impact, if any, of post-Renaissance images on the Orient itself, what impression is provided by the mass of some three or four hundred post-1500 objects and images from Western art? First of all, a further chronological distinction must be made between the middle of the nineteenth century and what preceded it. Before 1850 or so, we have some beautiful pieces (by both celebrated and little-known artists), a large number of informative ones, a few cute things, and quite a bit of bad, if occasionally curious, art. The Orient seems to be a minor theme of Western art, and the most interesting and useful works are those which belong in the learned and recording categories. Very often, because of the Western propensity to make images, these are our only documents about the past and present of many lands.

But after the conquest of Algeria, the appearance of photography almost eliminated the need for recording places and events in drawings and paintings. The Orient soon became a playground for visual and other sensuous experiences for new classes of people weaned on Romanticism and its own

19 Jean Delumeau, *La Peur en Occident, XIVe au XVIIIe siècle* (Paris, 1978).
20 This is one of the themes in Mitchell's work.

vision of an Orient that had come primarily from mysticism and Persian poetry. Protected by the military, painters and writers would seek in the Orient aesthetic excitement and sensory titillation. Rimbaud went to Ethiopia and Aden to find something for his writing of poetry that he could not satisfy in France; parallel examples are Sir Richard Burton and Isabella Eberhardt. The point of importance, however, is that all of this is supremely irrelevant to the Orient, Algeria, Iran, or the bazaars of Istanbul. It is as though, in the vast sweep of its artistic history, medieval Europe essentially competed with an Islamic Orient which held for centuries most of the trump cards of learning and artistic technology; a post-Renaissance Europe looked at and observed, sometimes acutely, sometimes humorously, sometimes wickedly, all sorts of strange people who hardly threatened anyone any more; and, finally, a minor stratum in Europe went south and east to find something for its enrichment or its pleasure.

Assuming these various thoughts and ideas are reasonable, we can draw three broad conclusions from them. One is that, however interesting and valuable have been the many examples of contacts and relationships between Europe and what is here called the Orient, they are a relatively minimal part of the art and culture of either world. The common game of drawing up rosters of successes and failures, of influences in either direction, of counting up who invented what first is a silly and counter-productive game except when certain circumstances – temporal, as in the thirteenth century; spatial, as in Spain; historical, as in Sicily, Istanbul, or Cairo – make the relationship obviously important for the understanding of any one of these topics. All this changed somewhat during the short century of colonialism, and much has been written about these decades and on their architecture, but not on their art. It changed even more after independence, when the technological and cultural domination of the Orient by Sony, Mercedes-Benz, Hollywood and Yves St Laurent is far greater than the domination of Western markets by Oriental silks and metalwork was in, say, the twelfth century. It is also technology that cannot be reinvented in the Orient, as luster faience or inlaying were in the West. The revolution of today's technology is so complete that the events of the past, however much fun they are, are only pertinent to history. They have no meaning today.

My second conclusion, then, is that this exhibition, with all of its obvious qualities, contributes to making history irrelevant or useless because the knowledge provided is not meant to illustrate a period of time or a development through time, but to demonstrate attitudes that are more contemporary than the objects displayed, and because so little concern is given to work already done. This may be sad, but it may also be good for us to realize that the construction of today and of tomorrow does not need the past, because a true understanding of the past requires patience, humility, openness of heart and mind, understanding of ancient failures and forgiveness of past misdeeds. None of these are common attitudes, and none are likely to become common.

Historians may regret being of limited use, but they must rise up against the misuse of their domain by ideological and political forces which find justifications for today in what they claim to be the past or history. By talking of Europe and the Orient when one means a segment of Europe and a fictitious Orient, the exhibition requires of its viewer and reader a simplification of a very varied past. Seventeenth-century Vienna had a relationship to the Ottoman world which had no parallel in seventeenth-century France or England, whereas no other country in Europe had the relationship France had with North Africa. And even in these cases, it is [10] probably wrong to talk of whole countries, as, in any given time, for every categorical statement in one direction there were four or five that understood the same things or events quite differently. The historian is compelled to argue for dozens of types of contacts and for endless variants from time to time or area to area, in short for the infinite complexity of reality. The show implies broad generalities valid for all times and all places. It does, therefore, reflect a concrete ideological message which is accurate in all of its details, but false in its overall design. The message is one of consistent misunderstanding of the Orient by Europe, leading eventually to the invention of an Orient that satisfied European needs. It is true enough that misunderstandings occurred and that the Orient served to feed the fantasy of others, but it is wrong to limit contacts to these themes alone, or to make them the dominant ones.

Finally, more than ever this exhibition requires that serious attention be given to what the Orient saw in Europe. The only recent attempt to do so[21] restricted itself too much, I believe, to Muslim travelers or visitors rather than to reactions within the lands of Islam. Except for India, the visual record is not likely to be very impressive because the making of pictures has never been a major form of expression in Muslim civilization. Even the written record is not always as strong as one would like, because the practices of confession and later of Dr Freud were not there to premiate those who talk about themselves. This is precisely, I believe, where the ingenuity of contemporary social scientists should be able to put together successively better models than exist of the images in the mind rather than on paper or canvas. No fruitful understanding of the relationship between Europe (the West) and the Orient (the Muslim world) can occur unless both (or all) sides are equally well understood. The fact that so many different types of evidence need to be sifted in order to get results should not be a reason not to do the work.

21 Bernard Lewis, *The Muslim Discovery of Europe* (New York, 1982).

Chapter XXIV

Classical Forms in Islamic Art and Some Implications*

The city of Kashgar (known as Kashi in contemporary Chinese) is located in the extreme west of China, some two hundred kilometers north of Kashmir and the Himalayas, three hundred kilometers northeast of Afghanistan and east of Samarkand in Uzbekistan. It has been a Muslim city for six or seven centuries and is presently populated, for the most part, by Uighurs speaking a Turkic language. At the entrance to the city on the road from the airport, there stands (or, at least, stood, some twelve years ago) a larger-than-life-size statue of Mao Tse Tung in the pose and with the gestures of Augustus of Prima Porta. In the center of town the public library and several other administrative office buildings have façades composed according to the canons created by the Renaissance from its view of the Vitruvian and Roman imperial practices and revised by the taste of tsarist St Petersburg and, in the last instance, by the visual habits of the Stalinist Communist world.

Thus it is that, still today and in the most unexpected and most remote parts of the Islamic world, classical forms and classical themes or themes obviously derived from classical art are used to express, in these particular instances, authority and social significance. It is unlikely that many of the inhabitants of Kashgar are aware of the filiation behind these obvious monuments in their midst, not because they are not aware of the significance of these creations, but because the classical tradition as such is not pertinent to their taste nor to the vocabulary of their traditional artistic expressions.

We can draw two contradictory conclusions from these examples. One is that the classical world of the Roman empire established universal means of expressing anything, or perhaps at worst only some things. But, whatever the limits or the range of a classical appearance in forms, such components of forms that can be identified as classical have had, in the example of Kashgar, the classicism of that component eliminated, or, at the very least,

* First published in *Künstlerischer Austausch: Artistic Exchange, Akten des XXVIII Internationalen Kongresses für Kunstgeschichte*, Berlin, 15–20 July 1992. Herausgegeben von Thomas W. Gaehtgens, pp. 35–42.

made immaterial, like some minor chromosome in the genetic pool of what are the image of a by then semi-mythical ruler and the façade of a space for learning in a provincial town. The second and alternate conclusion is that classical expressions are among the many ways in which Western cultural and ideological domination expresses itself, and, secondarily, that the vehicle of this domination can even be communism. With this conclusion, the classicism of the images becomes a dominant rather than a dormant trait and leads to [36] other ways of behaving with these forms. Instead of ignoring them as immaterial because they are without a specifically classical passport or label, we must judge them and praise them as examples of a triumphant acceptance of Western forms for universal purposes or condemn them as acts of imperialistic control over genuine local ways.

I shall return to other aspects of these issues in conclusion, but I begin with two contemporary and remote examples in order to suggest that, like most genetic problems of the history of art, the question of classical forms in this or that tradition is not merely a historical problem of accounting, of bookkeeping, and of making lists of the percentage of features in this or that object which belongs to a classical (or, for that matter, any other) heritage. Nor is it an iconographic or formal problem of evaluating the degree of presence of one tradition in another or of possible meanings attached to forms. It is rather an aspect of something much more fundamental, I believe, to the discourse on the visual arts, which is to identify the equilibrium, in the forms we see, between meaningless redundancies, willed messages of the time, and operating requirements of the analyses and judgments made by anyone at any time, and most particularly by Western and Western-trained observers today. In order to demonstrate my point, I shall first provide eleven examples of the presence of the Antique in works of Islamic art. I shall be brief about these examples which, somewhat on purpose, I shall present, more or less, in chronological order rather than in any intellectual or methodological sequence. I shall then conclude with some more complicated and perhaps more controversial hypotheses.

I.

The Umayyad mosque of Damascus was built between 705 and 715 of our era. Its dimensions and proportions, its stones, most of its columns and capitals, and its technique of mosaic decoration not only derive from a classical tradition maintained in early Christian times, but are in fact *the* proportions and the building elements of the Roman and possibly even Hellenistic *temenos* built many centuries earlier.[1] The only significant novelty

[1] Most of the basic information and bibliography are found in K. A. C. Creswell/J. W. Allan, *A Short Account of Early Muslim Architecture* (Aldershot, 1989), pp. 46–71. For a

is the syntax or ordering of these elements, not the elements themselves, which are all visual phonemes for a classical text dismantled and recomposed to be made into an early medieval one.

2.

The platform of the Haram al-Sharif in Jerusalem serves as the operational space for the Dome of the Rock built in 691 and for a long and complex series of Islamic religious associations. Although nearly every stone in or on it is a Muslim creation or has a clear Muslim meaning, its dimensions and almost all of its gateways, especially monumental ones like the Golden Gate to the east or the Double Gate to the south, were planned, with a full awareness of Hellenistic practices of design, for the Jewish Temple of Herod the Great, and correspond to functions and to symbolic associations that are quite different from those of the medieval Muslim world. Here the simple phonemes are, with exceptions, primarily [37] medieval and Islamic, but the basic structure of the space is antique. During the short time of the Crusades, a mythology of Old Testament themes from the West was transferred to the Islamic reworking of an antique space and added a special complexity to the implications of the present space,[2] as a Muslim sanctuary became the *Templum Domini*.

3.

Several of the country villas sponsored by the *nouveau riche* Umayyad princes of the first half of the eighth century were covered with mosaics, paintings and even sculptures, an ancient technique which had been revived by Muslim patrons, probably in imitation of an orally transmitted memory of Roman or Hellenistic palaces than of some specific monument. Classical themes, in addition to techniques, appear as well, usually mixed with subjects and styles of different origins. In many instances, as with very geometric mosaics, it is even possible to suggest a deliberate return to topics and to manners of execution of the first centuries.[3]

discussion of the building according to lines suggested here, cf. Oleg Grabar, "La Mosquée Omeyyade de Damas," in *Synthronon* (Paris, 1968). For a recent survey of the evidence, cf. Klaus S. Freyberger, "Untersuchungen zur Baugeschichte des Jupiter-Heiligtums in Damaskus," *Damaszenische Mitteilungen*, 4 (1989).

[2] There is no accessible description of the space of the Haram, except in guidebooks, some of which, like the recent (1989) *Guide Bleu*, are excellent. For a popular description, cf. Alistair Duncan, *The Noble Sanctuary* (London, 1972); and the most recent scholarly book focusing on related topics, although with a different point of view, is Myriam Rosen-Ayalon, *The Early Islamic Monuments of al-Haram al-Sharif* (Jerusalem, 1989).

[3] The key monuments are Khirbat al-Mafjar in the Jordan valley and Qasr al-Hayr West halfway between Damascus and Palmyra (cf. Creswell and Allan, *Short Account*, pp. 135–

4.

Also in Damascus, but from the middle of the twelfth century, the *madrasa* of Nur al-Din (dated in 1154) has a façade with a superb late antique lintel surmounted by a typically Islamic *muqarnas* half-dome. What is interesting is that a carved stone, which was, almost certainly, a chance find, was used in the construction of a new building and became the module for the composition of the purely medieval *muqarnas* construction.⁴ Nur al-Din's façade is not unique and a recent study has been devoted to the complex components of the revival of antique architectural themes in the twelfth century in Syria.⁵

5.

From the same period, but a few decades later, comes a frontispiece from a manuscript of the *Materia Medica* of Dioscorides. It shows the author, identified by the inscription as a "philosopher," seated in a vaguely Byzantinizing garb at the entrance of a sort of palatial pavilion. In front of him there is a very traditional antique or late antique Nilotic landscape.⁶ A frontispiece in a Vienna manuscript of roughly the same time has new medieval topics like *shishkebab* and polo playing arranged in a composition typical of late antique and early Byzantine ivory diptychs.⁷

6.

From the same period of the twelfth and early thirteenth centuries comes another rather striking example of relationship to the Antique. In the southern Syrian city of Bosra there stands a [38] very medieval-looking fortress, heavy and lightless in its basalt masonry. It is datable to the twelfth and later centuries and belongs to a type of architecture which grew in Syria under the impact of the Crusades. But the interior of the fortress, its court, is a

45, 179–200, with further references, especially to Robert Hamilton, *Khirbat al Mafjar* (Oxford, 1959); and Daniel Schlumberger et al., *Qasr el-Heir el-Gharbi* (published posthumously in Paris, 1989).

4 Ernst Herzfeld, "Damascus, Studies in Architecture," *Ars Islamica*, 9 (1942), pp. 2–14 and figs 42–5.

5 Terry Allen, *A Classical Revival in Islamic Architecture* (Wiesbaden, 1986).

6 The manuscript is in Istanbul, Ayasofya 3704, and it is not dated (cf. Ernst J. Grube, "Materialien zum Dioskurides Arabicus," in Richard Ettinghausen, ed., *Aus der Welt der Islamischen Kunst* (Berlin, 1959), p. 172 and fig. 6).

7 Often reproduced, as in Richard Ettinghausen, *Arab Painting* (Geneva, 1962), p. 91. The relationship to Byzantine and antique works has been established by Dr Eva Hoffman in her doctoral dissertation at Harvard University (1982).

perfectly preserved Roman theater which was the module for the dimensions of the fortress and is still used today for theatrical performances.[8]

7.

In two Arabic versions of Galen's book of antidotes to poison (the *Kitab al Diryaq*), one in Paris dated in 1199 and the other one in Vienna (whose frontispiece I mentioned) usually dated around 1220, there are representations of personages who are clearly Arabs, from their clothes and facial expressions. Yet they are all identified in Arabic letters as Greek doctors and learned men of all sorts who have contributed to medical and pharmaceutical sciences.[9]

8.

In the treasury of San Marco in Venice, there is a very unusual cup probably brought back from the looting of Constantinople in 1204. An inscription in pseudo-Kufic is engraved on a mounting which surrounds a series of glass fragments with clearly classical connotations. This object is usually attributed to the middle Byzantine period, but what is important for my argument is that, to someone in the middle Middle Ages, Islamic and antique ideas were mixed together and it appeared reasonable to set them up together.[10]

9.

One of the most extraordinary documents in the history of Persian painting is a page from an album in Berlin's own Staatsbibliothek. It is signed by the Persian painter Muhammad al-Khayyam, who is known to have worked in Samarkand and Herat (in present-day Uzbekistan and Afghanistan) in the early part of the fifteenth century. The image on the page is, without any doubt, the Tazza Farnese received by Lorenzo de Medici from Pope Sixtus IV in 1471. We can only speculate and invent a novel about how this perfect Roman gem found its way into eastern Iran, why it was copied by a

[8] Flemming Aalund et al., *Islamic Bosra* (Damascus, 1990); Klaus S. Freyberger, "Einige Beobachtungen zur städtebaulichen Entwicklung des römischen Bostra," *Damaszener Mitteilungen*, 4 (1989).

[9] Bishr Farès, *Le Livre de la Thériaque* (Cairo, 1953); Kurt Holter, "Die Galen-Handschrift," in *Jahrbuch der Kunsthistorischen Sammlungen in Wien*, n.f., vol. 11, 1937.

[10] H. Hahnloser et al., *Il Tesoro di San Marco* (Florence, 1971), vol. 1, pp. 77–8.

major court painter, and how it got to Italy half a century later.[11] This seems to be a particularly strange example, but it is not unique in its genre. Many centuries earlier, when, in the middle of the eleventh century, the treasure of the Fatimids in Cairo was looted by Turkish soldiers who had not been paid, the fascinatingly rich collections of that treasure turned out to include saddles which were alleged to have belonged to Alexander the Great.[12] The saddles had been acquired by a caliph from an antique or art dealer and one can easily imagine antique dealers going, in the eleventh or fifteenth century, from court to court with recently manufactured fakes, actual fakes believed to be originals, as well as with originals and with all sorts of intermediary types of [39] objects. Within their baggage, which can at times be imagined through descriptions of royal and princely treasures, an important and presumably valuable category was that of objects with an antique pedigree, because a special and probably variable quality was given to them.

10.

Everyone in this jubilee year of Spain [1992] is aware of the Alhambra in Granada and few features in it are more celebrated than the *muqarnas* domes of the Halls of the Two Sisters and of the Abencerrajes, on either side of the Court of the Lions. They are the epitome of the structural sensuality achieved by late medieval craftsmen in the Islamic world, and much has been written or could be written about the geometry of these structures and their absolute symmetries, about the technique of their construction, and about the magic of their effect on the eyes. But, as it turns out, the design of these ceilings also has a meaning, and that meaning is provided by poems written especially for the Alhambra by the poet Ibn Zamrak and copied in the room below at eye level, so that any visitor would read the poem while looking at the ceiling. These poems describe the cupolas as domes of heaven in which constellations appear or disappear as the sun or the moon lights them up by moving around them. In short, we have to imagine the Alhambra domes as rotating heavenly domes like those built by Nero in his Domus Aurea, whose memory was preserved throughout the Middle Ages and mixed up with all sorts of other royal

[11] Horst Blanck, "Eine Persische Pinselzeichnung nach der Tazze Farnese," in *Archäologische Anzeiger*, 79 (1964), pp. 307–11; Ernst Kühnel, "Malernamen in den Berliner Saray Alben," *Kunst des Orients*, 3 (1959), p. 73.
[12] This treasure is often mentioned, but the only full discussion of its content is still that of Paul Kahle, "Die Schätze der Fatimiden," *Zeitschrift der deutschen Morgenland-gesellschaft*, vol. 89 (1935). Cf. now also the doctoral thesis of Ghada Qaddumi, *A Medieval Islamic Book of Gifts and Treasures* (Harvard University, 1990), for the translation and commentary of a particularly important related text.

myths like those of Solomon and of Khosro.[13] It is unlikely that the royal patrons of the Alhambra or the artists and craftsmen realizing their dreams, or even the poets who wrote about these domes, were really aware of the classical background of the idea of rotating domes of heaven. Following an interpretation proposed nearly a quarter of a century ago, it can be argued that here semantic continuity was maintained in mutually exclusive languages.

II.

My last example is a relatively simple one. Many explanations, not necessarily exclusive of each other, have been provided for the spectacular domes of Ottoman architecture culminating in the dark and moody Süleymaniye in Istanbul or in the festival of lit space created in the Selimiye in Edirne, both buildings designed by the great Ottoman architect Sinan in the sixteenth century. One of the explanations for these cupolas is to consider them as the technically perfect completion of an evolution which, through Hagia Sophia, goes back to the Pantheon. This genetic affiliation was actually recognized by Sinan himself, although not quite in the terms I am using in this essay.[14]

The first conclusion that can be drawn from this collection of examples is that the Antique appears in many different ways in medieval and pre-modern Islamic art. It can be a single stone or a whole space literally lying around and ready to be reused for the same purpose as before or for a new one. It can be an ancient idea translated into a new language. It can [40] be a treasured memory or a souvenir willfully or accidentally discovered and protected. It can be the subject of a transfer of one's own feelings and needs, as a sort of guarantor of quality or class, like parts of a menu that would be in French rather than in one's own tongue. It can be the original first step in an idea or a form which then, like a ripple or a sound wave, continued its movement through time and across many spaces. These are five ways for the ancient world to appear in one of the medieval ones and each one of these ways could receive a name, in line with the logically ordered procedures of a "scientific" art-historical analysis. One can learn to identify immediate or phonetic ways,

13 Oleg Grabar, *The Alhambra* (London, 1978), esp. pp. 144–53; E. García Gómez, *Poemas Árabes en los Muros y Fuentes de la Alhambra* (Madrid, 1985); J. M. Puerta, *La Alhambra* (Madrid, 1989).
14 For Sinan, cf. now Aptullah Kuran, *Sinan* (Washington, 1987). For a more complex interpretation of his art, Doğan Kuban, "The Style of Sinan's Domed Structures," *Muqarnas*, 4 (1987). A paper arguing, in particular, that sixteenth-century domes reached a geometric perfection which could not be surpassed was presented by Oleg Grabar at a congress held in Ankara in 1988, "The Meanings of Sinan's architecture": A. Akta-Yasa, ed., *Uluslararası Mimar Sinan Sempozyomu Bildirileri* (Ankara, 1996), pp. 275–83.

semantic and translated or original, possessive, projective, generative. Each one of these ways – and there probably are others – has its own history, its own rhythms, its own density within medieval Islamic culture, and many of these ways are shared with medieval Christian uses of the Antique, although without the peculiar dialog developed in Latin Christianity. And there is nothing surprising in the existence of these Islamic ways, since nearly half of the ancient world became part of the Muslim one and, at many levels of political behavior, administration, science and thought, the complex relationship between Antiquity and Islam has often been explored.[15] Although they are very different from each other, I would like to call all these ways descriptive, because, ultimately, they allow us to outline better the constitutive components of Islamic art, rather than interpretative, because they do not in themselves explain much about either Islam or the Antique.

But, if all that was achieved by the analysis and discussion of antique themes in Islamic art consisted in lists of examples arranged according to categories of understanding, we would be dealing with a scientifically interesting but slightly pedantic exercise with relatively little importance beyond a small circle of specialists. In reality, the examples I have given raise, I believe, a more interesting and more fundamental question to the historian of the arts facing millions of objects, monuments and images and asked by the scientific community on the one hand, and by the cultures with which he deals on the other, to provide a pedigree or an aesthetic appreciation of these monuments and the grounds for a judgment of their quality.

The question is whether the task of the historian should be to seek and identify an infinite number of variants and of variables in the things done by man and to provide every one, every land and every person, with something which can be called their own and which is different from what is found elsewhere, or, alternately, whether his task is to find the grand principles, the overall terms through which *anyone's* art can be seen and understood, but in which no one art or one monument predominates.

The central issues of the history of art and of the humanities in general are not technical or informational, for in the areas of technology and data gathering and processing, we know how to do our job, even if we do not always do it well. The issues are moral and aesthetic and it is in the consideration of the moral issues of the history and criticism of art that the study of the Antique in Islamic art bears its most fruitful results.

As I suggested with the examples from Kashgar in western China at the beginning of this essay, the search for the Antique in later arts can be seen in

15 For example, Franz Rosenthal, *Das Fortleben der Antike im Islam* (Stuttgart, 1965), as a collection of texts; and Richard Walzer, *Greek into Arabic* (Oxford, 1962). For the arts, cf. Oleg Grabar, "Survivances classiques dans l'Art de l'Islam," *Les Annales Archéologiques de Syrie*, 1 (1975); and Robert Hillenbrand, "The classical heritage in Islamic art," *Scottish Journal of Religious Studies*, 7 (1986).

two ways. It may be a way to glorify the achievements of the Mediterranean synthesis of the Roman empire with its numerous ramifications and variants and including the Iranian and Buddhist world of forms, or else it may be the assertion of universal values rightly or wrongly associated with the [41] Antique, but by a certain point freed of the onus of being classified as antique, remaining simply as old. In either case, the purpose of the search does not lie in improving our knowledge of the Antique, but in identifying the categories of thought through which we see and express what we see. Is it because we are Westerners that we see Roman sculpture behind images of rulers everywhere? Or is it that Roman sculpture represented a lot of rulers and, therefore, is only one illustration of a broader potential? The answer to these questions is partly one of psychology of cognition, but much in the question requires an ethical decision on our own motivation when we act as historians of art. For many statements are valid and accurate about a work of art, especially when one seeks to understand its sources and its origins, but it is the historian embedded in his or her time and in his or her values who proclaims what is true.

Chapter XXV

Islamic Art and Architecture and the Antique*

In a possibly apocryphal statement, al-Jahiz (776–869), the great *homme de lettres* of the early ʿAbbasid period, wrote: "The Byzantines have no science, no literature, no deep thoughts, but they are only good with their hands in metalwork, carpentry, sculpture, and silk weaving … The [ancient] Greeks were learned, the Byzantines are artisans."[1] Leaving aside the judgment on Byzantium, which belongs to a category of stupid generalizations often uttered by the best minds in our own times, the interest of the quotation lies in the fact that it was more or less contemporary with the period of intense translation from Greek into Arabic and of the first steps of what became the philosophical, mathematical and scientific culture of the Islamic world, so deeply indebted to past Greek accomplishments. A further curiosity of al-Jahiz's statement is the contrast it establishes between thought and the work of artisans, between what excites the intellect and what pleases the senses. As I will later suggest, when one deals with the arts, whatever relationship can be established between Islamic art and the Antique often passed through the filter of Byzantium or, more precisely, of a Christian art which, in most of the areas of Mediterranean Islam, had been under Byzantine rule. The very word "Rumi," so often used in medieval literature to identify artisans, could mean Christian, Byzantine, Anatolian and even, although more rarely, "Greco-Roman antique."

The encounter between antique art and the Islamic world was unavoidable for geographical as well as for historical or psychological reasons. But it took different forms at different times. I will define four categories of connections, and then draw some conclusions about their significance.[2] [798]

The first category, the most obvious one, can be called phonetic or graphemic. It consists in elements from ancient art which were reused,

* First published in S. Settis, ed., *I Greci*, vol. 3 (Turin, 2001), pp. 797–815 (in Italian).

[1] Ch. Pellat, "Al-Jahiz," *Journal Asiatique*, 255 (1967), p. 71.

[2] The latest survey of the subject with a lengthy bibliography is Robert Hillenbrand, "The Classical Heritage in Islamic art: the case of medieval architecture," *Scottish Journal of Religious Studies*, 7 (1986); see also Oleg Grabar, "Survivances classiques dans l'art de l'Islam," *Annales Archéologiques de Syrie*, 21 (1971) and "Classical Forms in Islamic Art and Some Implications," in Thomas W. Gaethgens, *Akten des XXVIII Internationalen Kongresses für Kunstgeschichte* (Berlin, 1992).

1 Location of
sites in Egypt,
Jordan, Palestine,
Syria,
Mesopotamia,
and Iraq
mentioned in the
text

occasionally with modifications, by Muslim patrons and artisans without
any particular recognition or meaning given to the origin of these elements.
The most common examples are in architecture. The shape of the Great
Mosque of Damascus, built between 705 and 715, was determined by the
dimensions and foundations of a Hellenistic *temenos*. Many of its columns,
several of its entrances, most of the stones used for its construction were
originally cut for the ancient complex of a temple and, thus, the very
striking proportions of the elevation of the mosque, which was to influence
many Syrian mosques for several centuries, are the accidental result of the
dimensions and proportions of the antique sanctuary in the city. The Haram
al-Sharif in Jerusalem, the third-holiest sanctuary in Islam, also acquired its
astonishing dimensions and its trapezoidal shape from the size of the
Hellenistic platform for the Jewish Temple built by Herod the Great in the
last cen-[799]tury before the common era. In Jerusalem as well as in many
early Islamic and Umayyad sites in the Syrian, Palestinian and Jordanian
countryside, there are stones with Greek or Latin inscriptions. Most of them
are spoils from older buildings, but a few graffiti in Greek testify to the
presence of those "Byzantine" artisans mentioned by al-Jahiz.[3]

Such examples could easily be multiplied from Spain to northern
Mesopotamia. They are most common in the early Islamic period, when a

[3] For early Islamic Damascus and Jerusalem, see the standard manuals, such as R.
Ettinghausen and O. Grabar, *Islamic Art and Architecture, 640–1260* (London, 1987) or
more elaborate discussions in O. Grabar, *The Formation of Islamic Art*, 2nd edn (New
Haven, 1983) and O. Grabar, *The Shape of the Holy* (Princeton, 1996).

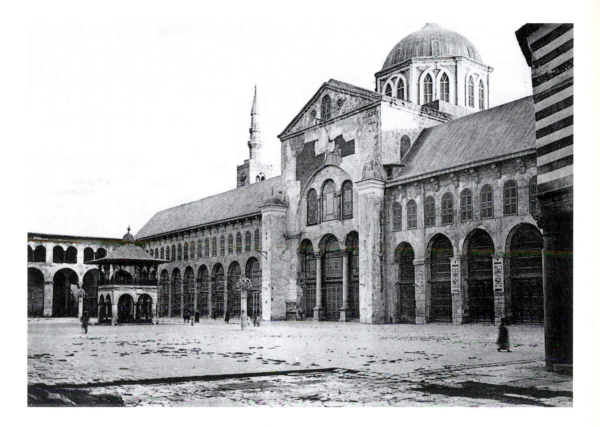

new setting and a new art were being created for new and wealthy patrons in spaces with a long history of use. But such direct, phonetic or graphemic, examples are not restricted to the seventh and eighth centuries. In the celebrated instance of the Great Mosque of Diyarbakr (ancient Amida on the upper Euphrates, now in Turkey), it is in the eleventh century that a large and heavily decorated classical entablature was used to transform the court of the mosque into a spectacular [800] festival of sculpted antique ornament.[4] There is some debate as to how much in this decoration consists of reused older material as contrasted with eleventh-century imitations. But this and a number of other examples in this century and especially in the following one have led some scholars to argue for a true revival of antique forms in Syria and in northern Mesopotamia. It is indeed true that, in Aleppo as well as in Damascus and in many smaller cities, large numbers of ancient stones, often carefully decorated ones, were placed in newly erected Zengid or Ayyubid buildings. A most spectacular example is found in Bosra, in southern Syria, where a beautiful Roman theater serves as the spectacular central courtyard of a medieval

2 The Great Mosque of Damascus

4 Terry Allen, *A Revival of Classical Architecture in Syria* (Wiesbaden, 1986); Yasser Tabbaa, "Survivals and Archaisms in the Architecture of Syria," *Muqarnas*, 10 (1993).

3 A
representation of
the Tazza Farnese
in the *Diez
Album*

fortress.[5] This phenomenon is probably easiest to explain by the sudden boom in construction which needed building materials rather than through some genuine interest in Antiquity. This is why I include these examples in the category of graphemic connections, even though some may prefer to see in them a more thoughtful intent.

In other arts, just as unconsciously, some techniques, such as the ways of manufacturing glass objects, were simply continued, maintaining practices that went back to Roman times. There are, however, here and there, curious examples of another "graphemic" function of medieval Islamic art, which was to transmit things or subjects without understanding anything about them. In the so-called Diez albums of the Berlin Staatsbibliothek (Diez A, fol. 70–73), there is a drawing signed by one Muhammad al-Hayyam, known to have been active in Herat and Samarkand early in the fifteenth century. The drawing is an almost exact representation of the "Tazza Farnese," a magnificent carved gem from Roman imperial times, now in the National

5 A. Abel, "La Citadelle Ayyoubide de Bosra," *Annales Archéologiques de Syrie*, 6 (1956).

4 Detail from the mosaic pavement in the bath hall at Khirbat al-Mafjar

Museum in Naples, given to Lorenzo de' Medici in 1471.[6] We can only speculate as to how this Ptolemaic object, apparently in the possession of Frederick II in 1234, got to Central Asia and then back to Rome. But enough indications remain to suggest that it was considered as one of the *aja'ib* ("wonders") which princes exchanged among themselves. It was not its origin nor its sub-[801]ject that were important until it reached the collection of the Medici; it was its high cost as a gem. Possibly some magic and healing virtue was attached to it, as it often was for old stones with representations or inscriptions that could not be understood. And it would be the visual curiosity of a court artist which preserved traces of an antique gem in the fifteenth-century world of the Timurids, even though there is absolutely no evidence that it had any impact on the arts of the time, not even in its collective memory.

6 H. Blanck, "Eine Persische Pinselzeichnung," *Archäologische Anzeiger* (1964), pp. 307–12; see also U. Pannati, "La Tazza Farnese," in *Technologie et Analyse des Gemmes Antiques, Atti del Convegno di Ravello* (Louvain, 1994) and Carlo Gaspari, ed., *La Gemme Farnese* (Naples, 1994).

5 Detail from
the mosaic
pavement in the
bath hall at
Khirbat al-Mafjar

6 Detail from the wall mosaic in the Great Mosque of Damascus

In all these instances of graphemic contacts, we can usually assume that the host culture – in this case the Islamic world – either served as the transmitter of an object or of a form or else used it without giving particular attention to its original meaning or purpose. The interest of these examples lies less in each individual case (curious though some of them may be) than in whatever lesson they provide on how forms circulate or become reused without significant semantic charge. It will probably some day be possible to list these examples by region and by category, to separate direct reuses from modified transfers or occasional mutants like the Bosra citadel with a theater, in general to understand the process of transmission of forms which is almost biological in its automatic and mechanical character.

Morphemic survivals and connections are identifiable by two characteristics. The main one is that it is usually possible to define a concrete decision, a specific choice, on the part of the Islamic host. The other one, a corollary of the first, is that such connections are fewer in number and their geographical spread is much more uneven.

Once again, early Islamic examples predominate. There is the interesting instance of the technique of floor and wall mosaics. Both could be considered as graphemic in the sense that early Islamic patrons simply picked up and continued a manner of decorating private and public buildings which had for centuries been common in the Mediterranean area. It is often said, although there is a scholarly debate about the truth of the claim, that mosaicists were brought from Byzantium itself to Jerusalem, Damascus, or Cordoba in the seventh, eighth and tenth centuries respectively. But what is in-[803]teresting about early Islamic mosaics is, first of all, that they are, for the most part, of a very high technical quality, as are the many mosaics of the eighth century found, in recent decades, in churches all over Jordan. And, secondly, in most instances, they are iconographically and formally

7 Stucco
sculpture from
Khirbat al-Mafjar

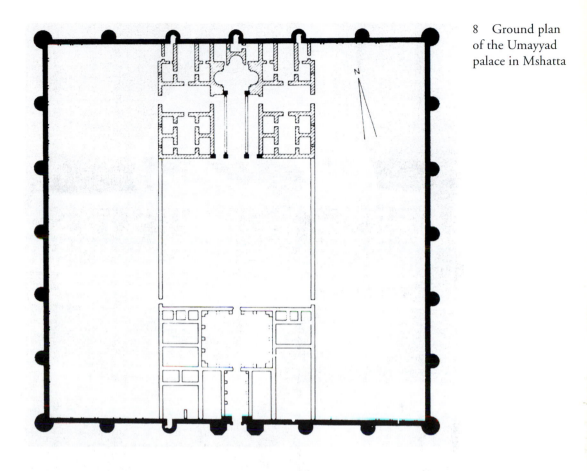

8 Ground plan
of the Umayyad
palace in Mshatta

original, as they do not simply copy Byzantine motifs. It can, in fact, be argued that, probably as a result of their desire to avoid the representation of living beings, Islamic patrons sponsored the revival of early Roman geometric ornament in mosaics, [804] as it appears on the floors of Khirbat al-Minyah and Khirbat al-Mafjar.[7] It is not reasonable to attribute the ideological motivation of a classical revival to the formal choices made by the Umayyads, as can be done for the nearly contemporary Carolingians, but some kind of decision was taken, because there were choices to be made. In the Great Mosque of Damascus, the style of some of the representations of buildings clearly harks back to early Roman imperial illusionism instead of the more contemporary two-dimensional sobriety of Byzantium. Here again choices were made, however they are to be explained.

An even more interesting example of morphemic connection occurs with the short-lived revival of monumental sculpture for the representation of people, animals, possibly even narratives in Umayyad times. An art of

7 For all these buildings, consult Ettinghausen and Grabar, *Islamic Art and Architecture* and R. Ettinghausen, *From Byzantium to Sasanian Iran and Early Islam* (Leiden, 1972).

9 Detail of the
external wall
decoration of the
palace in Mshatta

figural sculpture had more or less disappeared in the eastern Mediterranean after the fourth century, but remains of statues and reliefs could be found everywhere and were usually associated, at least in popular lore, with imperial monuments. They were signs of the awesome power of the "Caesars," the title under which the medieval world encapsulated all Hellenistic and Roman rulers. And it is probably under the visual influence of these remains that Umayyad princes adorned at least two of their palaces – Khirbat al-Mafjar and Qasr al-Hayr West – with hundreds of sculptures representing royal figures, personifications, animals, nature, and masses of other topics. Many of these remains are far too fragmentary to be fully understood. But one example from Qasr al-Hayr West, now in the Damascus National Museum, may illustrate the problem many of them pose. On the richly decorated façade of the palace, there was a partially preserved stucco sculpture which clearly copied a typical Palmyrene funerary composition of a frontally depicted seated figure next to a reclining one. It is most unlikely that a funerary connotation was meant for the façade of a palace and the whole ensemble is too obvious to have become a meaningless ornament. What new meaning could have been given to these sculptures? What associations were made with them? Answers are lacking, because, while we can explain the presence of some sculpted forms rather than

10 Wall painting in a Hellenistic mode in the bath at Qusayr ʿAmrah

11 Portal of Nur
al-Din's hospital
in Damascus

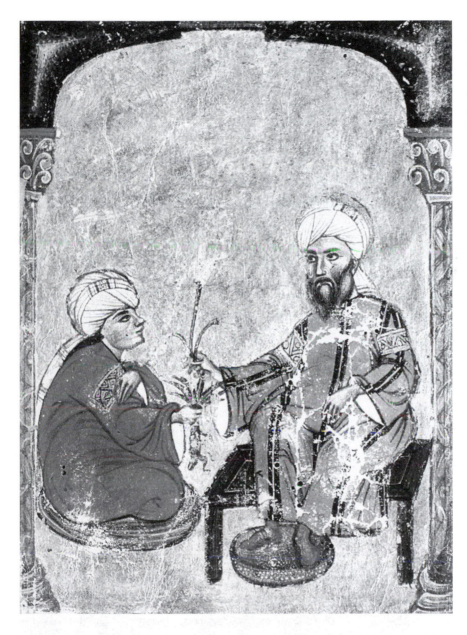

12 Student in front of a scholar. Miniature from a manuscript in Arabic of the *Materia Medica*, 1229

others, [806] we cannot, at this stage of research, penetrate the minds that made the choices or reacted to them.[8]

At Mshatta, while the general shape of the large square enclosure with massive towers bears a clear resemblance to Roman frontier architecture, the

[8] The finds from Qasr al-Hayr West have not been published systematically; the latest publication, a partial one, is the posthumous one by Daniel Schlumberger et al., *Qasr el-Heir el-Gharbi* (Paris, 1986).

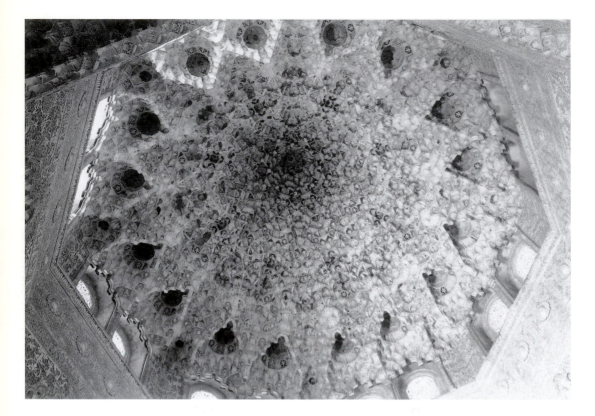

13 Dome of the Hall of the Two Sisters in the Alhambra

celebrated decoration of the façade with monumental triangles (now in the Berlin Museum) carries no structural or other connection to the antique world, except in the graphemic detail of some of its motifs. But the arrangement of the throne-room into a triconch was clearly chosen from several possible types and implies some knowledge and understanding of antique (or, at the very least, late antique) forms and of their ideological implications. Because Mshatta is a unique example without appropriate cultural context, we cannot explain how the form would have come to the attention of an architect or of a patron in the middle of the eighth century.[9] The problem is even more acute in the case of Qusayr 'Amrah, the famous small bath-house of the early eighth century in the Jordanian steppe, whose walls are entirely covered with paintings. Although more or less successfully cleaned and now beautifully surveyed for a forthcoming joint publication by the Jordanian Department of Antiquities and the French Archaeological Mission in Jordan, these paintings are still mostly known through the elaborate volumes of drawings published by A. Musil early in this century.[10] They

9 Irving Lavin, "The House of the Lord," *The Art Bulletin*, 44 (1962).
10 Incomplete publication after restorations by Martin Almagro and others, *Qusayr Amra* (Madrid, 1975); O. Grabar, "La Place de Qusayr Amra dans l'art profane du Moyen Age," *Cahiers Archéologiques*, 36 (1988); forthcoming complete publication by Claude

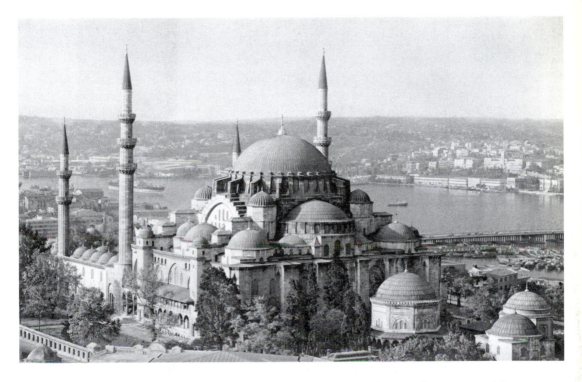

14 The
Süleymaniye
mosque in
Istanbul, by Sinan
(1550–57)

contain examples of nearly every style known in the Mediterranean and Iran since the second century, including striking representations of nude personages, an astronomical ceiling which copied a Roman globe, and topics which range from the evocation of contemporary life to personifications of rulers or of ideas, often with their Greek names next to Arabic ones. We can only assume that the patrons and users of Qusayr 'Amrah were conscious of the "antique" flavors of the motifs they used, but there is little doubt that they chose what to represent from a larger set of possibilities.

These are just a few examples of a phenomenon which was certainly [808] quite common in the seventh to ninth centuries, the willful and conscious adoption of selected antique motifs or techniques for the same or new ideological, personal, or practical purposes. The phenomenon is most typical of greater Syria and Palestine, probably of Egypt and of the Muslim West, although we are less well informed about the latter. The difficulty lies in defining the quality of the consciousness involved. Was it a purely aesthetic set of choices? Or were there ideological components attached to it? How aware were the new patrons and makers of the sources they used?

In the twelfth and thirteenth centuries, a similar outburst of morphemic connections with the Antique took place not only in Syria, but also in newly

Vibert-Guigues. An interesting interpretation of the palace has been proposed by Garth Fowden in *Empire to Commonwealth* (Princeton, 1993), pp. 142 ff. and in *Qusayr 'Amrah* (Berkeley, 2004).

conquered Anatolia and in the northern Mesopotamian area known as the Jazira. Its architectural examples are difficult to interpret properly. Thus, in Damascus, the entrance to the hospital of Nur al-Din (completed shortly before 1174) contains a superb antique lintel over the doorway.[11] This could simply be an instance of graphemic reuse. Yet, it is interesting that the dimensions of the lintel [809] served as the module for the composition of the purely Islamic *muqarnas* (stalactite) half-dome above it. The lintel may well have been chosen in order to provide a scale for the composition of the building. Similar difficulties in interpretation arise when one considers Seljuq architecture in Anatolia in the thirteenth century, where secular architecture took over many classical forms and a revival of sculpture mixed together new creations with ancient remains.[12]

Matters are more secure when we turn to objects and to the illustrations of books. The coinage of Turcoman dynasties in northern Mesopotamia and Anatolia used for a while classical and Byzantine motifs as signs or symbols identifying [810] various rulers.[13] The actual connections between the original antique motifs and the Islamic ones were, most of the time, arbitrary. This was not so with book illustrations. For reasons that have never been fully elucidated but which, almost certainly, had something to do with a new set of connections between the Islamic world and Byzantium, the Christian East, even Latin Christianity, both literary and medical or technological books in Arabic acquired illustrations in the late twelfth century and especially in the thirteenth. There are instances, especially in Dioscorides manuscripts which were often copied throughout the Middle Ages, where the very styles of Antiquity were preserved in medieval Arabic manuscripts. But these instances are relatively rare. More frequent and more original connections are found in authors' portraits representing old Greek scientists, mostly physicians. Many, as in pseudo-Galen manuscripts in Paris and Vienna, are shown in medieval Islamic garb with handsome turbans.[14] Some, as in a Dioscorides manuscript in Istanbul, have seated Byzantine authors in pseudo-antique robes (almost like Evangelists), also with turbans. And, in a wonderful frontispiece from a Dioscorides manuscript in Bologna, a Nilotic landscape is set in front of a building at whose entrance is seated, in a long robe, a classically inspired figure labeled in Arabic "Dioscorides the Philosopher."[15] The composition of some of these frontispieces recalls the composition of late antique consular diptychs, and several fragments of carved ivories in various museums

11 See Ettinghausen and Grabar, *Islamic Art and Architecture*, p. 309 and Yasser Tabbaa, *Constructions of Power and Piety in Medieval Aleppo* (University Park, 1987).
12 Scott Redford, "The Seljuqs of Rum and the Antique," *Muqarnas*, 10 (1993).
13 N. Lowick, "The Religious, the Royal and the Popular in the Figural Coinage of the Jazira," in J. Raby, ed., *The Art of Syria and the Jazira 1100–1250* (Oxford, 1985).
14 Richard Ettinghausen, *Arab Painting* (Geneva, 1962).
15 O. Grabar, "Islamic Art and Byzantium," *Dumbarton Oaks Papers*, 18 (1964), fig. 15.

(especially Florence and Berlin) were originally part of a book cover, probably for some fancy scientific or literary book.[16]

The formal, morphemic, connections between the Antique and the art of the twelfth and thirteenth centuries in Muslim lands were not, most of the time, simple accidents. They were part of a conscious set of choices made possible by two phenomena. One was the vitality of a Muslim world in cultural and intellectual effervescence and in political expansion everywhere except in Spain. The artistic component of this effervescence was an explosion of creativity, and, as in all places and at all times, moments of intense artistic activity included [811] retrospection and a search for ancient visual models. The second phenomenon is the equally brilliant growth of Christian arts, with similar searches in and observations of the past. One can even argue that in the thirteenth century, whether it was in technical manuals, like those of al-Jazari, recasting late antique Greek books, or in the more official dedicatory pages made for the benefit and glorification of feudal lords, the sense was strong of being connected to an old history of forms and images.[17] That particular Antique [812] was mostly the Late Antique, which had been kept up by Byzantium and whose styles may well have been more easily understood by medieval Muslim artisans and patrons than the illusionism of earlier times.

A third general type of connection with the Antique may be called semantic. In it, forms may or may not have maintained their connection to an ancient past, but ancient meanings are still present in new clothes. The most interesting example of this type is that of the Court of the Lions in the Alhambra and of the two halls on either side of the court with their spectacular *muqarnas* domes. The forms here are unmistakably medieval and Islamic. The context is that of spaces used for audiences, receptions, feasts and other activities typical of a weakened Muslim dynasty surrounded by a militant and combative Christian world while basking in the memory of its own glorious past in Andalusia. These covered halls are provided with poetic inscriptions written especially for the building by the court poet Ibn Zamrak. These poems were meant as guides to an interpretation of the halls and, among the many themes of these poems, two are important for our purposes. One is that of the Dome of Heaven, whereby the cupola is seen as the celestial globe and its decoration, in this case the composition of *muqarnas* which fills it, represents or symbolizes stars, constellations and other heavenly motifs. This particular theme is quite ancient and was a [813] common one in Hellenistic and Roman palace architecture, as the ruler was both supposed

[16] Eva Hoffman, "A Fatimid Book Cover: framing and reframing," M. Barrucand, ed., *L'Egypte Fatimide, son Art et son Histoire* (Paris, 1999).

[17] Ibn al-Razzaz al-Jazari, *Book of knowledge of ingenious mechanical devices*, tr. D. Hill (Boston, 1974); K. Weitzmann, "The Greek Sources of Islamic Scientific Illustrations," in G. C. Miles, ed., *Archaeologica Orientalia in Memoriam Ernst Herzfeld* (Locust Valley, NY, 1952).

to be seen under a propitious heavenly order and somewhat assimilated to a celestial body.[18] The path of this theme within Islamic palace culture is not well known, but its existence is assured in the eighth century, even if its forms are not clear. Were antique or Byzantine and Iranian forms taken over directly or had a new visual language been created for old themes? Eventually, in the Alhambra, it is newly developed forms, not necessarily created for these purposes, that were given a specific iconographic meaning through the addition of writing, just as, two centuries earlier, images rather than words gave the same celestial meaning to similar forms in the unique Christian as well as Islamic context of the Norman Cappella Palatina in Palermo.[19]

Where matters become even more suggestive is when we consider a second theme of the poems of Ibn Zamrak, which is that of a constructed rotating heavenly dome. Indeed, as the light of the sun or of the moon rotates around the base of the domes, it gives to the same, highly rigid and highly symmetrical composition, a constantly changing look which is asymmetrical and which always leaves different parts of the ceiling in the shade. Whatever its shape may have been, a rotating dome was part of the Domus Aurea of Nero in Rome and may have been suggested by some of the legends around the throne of the Sasanian ruler Khosro Parviz. No evidence exists to explain how a motif which became part of the legend of the Caesars in Rome would have traveled to fourteenth-century southern Spain. It is, however, most unlikely that it would have been reinvented there. This particular problem of the transmission of an idea still remains to be solved. In the meantime, we seem to be facing the rather interesting example of abstract forms being given concrete meanings through the intermediary of writing. The theoretical implications of this fact, if it is indeed an accepted conclusion, go much beyond the scope of this essay.

Other such semantic connections may well have existed, although they have not been studied as much [814] as the Alhambra. For instance, there is the Ottoman dome, especially after it acquired its canonical form in the sixteenth century under the impact of the genius of Sinan's designs. It is by now agreed that this dome did not originate with an attempt to copy Hagia Sophia but evolved over centuries of experimentation outside of the Byzantine capital. Yet at some point in its development, the great masterpiece of the sixth century became some sort of inspiration or model for the Ottomans. Much more than through their forms, it is through the meanings attached to domes that the Ottomans perpetuated or revived, and eventually modified, a very classical formula developed in imperial Rome and continued in

18 O. Grabar, *The Alhambra* (London, 1978), esp. chs 3 and 4; José Miguel Puerta Vílchez, *Los Códigos de utopia de la Alhambra de Granada* (Granada, 1990). For a different approach see Antoni Fernández-Puertas, *The Alhambra I* (London, 1997).

19 Ugo Monneret de Villard, *La Pitture Musulmane al Soffito della Cappella Palatina in Palermo* (Rome, 1950); for a new interpretation, see William Tronzo, *The Cultures of his Kingdom* (Princeton, 1997).

Byzantium. In all these instances there were simultaneously present technical achievements, culturally specific associations, religious or imperial, ceremonial uses, and universal or local symbolic meanings.[20] [815]

The example of Ottoman domes may well serve to illustrate a fourth type of connection between Islamic art and the Antique, that of creative continuity with variable consciousness. As opposed to my graphemic examples which are merely automatic instances of *Nachklang* or to the morphemic and semantic ones with their conscious choices leading to conscious revivals, certain forms or attitudes to forms, often first identifiable in Roman art, entered into common usage without maintaining their original identity and then underwent a variety of developments. Occasionally, they could be charged with a meaning connecting them to some well-known old monument, such as Hagia Sophia in the Ottoman case, but these instances are much rarer than in Christian art.

Altogether then, this small selection of monuments, objects, or moments in history when the art of the Islamic world appeared to connect with Classical Antiquity serves to illustrate two points. One is that, like its Christian counterparts, Islamic art west of Iran maintained a relationship to classical forms, largely because of the striking wealth of possibilities the latter offered. Many things were difficult to express without, consciously or not, turning to classical models, or at least appearing to do so. The other point is that this relationship was more visual and technical than intellectual and ideological. This may well have been so because so much of Islamic art was secular rather than religious. This provided it with a great freedom in searching the past of the lands it occupied and in reusing it precisely because they no longer had any meaning for it.

[20] Much has been written about Ottoman domes; the latest is D. Kuban, *Sinan's Art and Selimiye* (Istanbul, 1997); on this particular theme, see O. Grabar, "The Meanings of Sinan's Architecture," *Uluslararasi Mimar Sinan Sempozyomu Bildirileri* (Ankara, 1996) and "The Many Gates of Ottoman Art," in *Art Turc/Turkish Art, 10ème Congrès international d'art turc* (Geneva, 1997).

Index

This is an index of proper names only. English standard spelling was preferred to transliterations or to French spelling. The article "al" is not considered for alphabetization.